Acclaim for

LYNN H. NICHOLAS'S

THE RAPE OF EUROPA

LYNN H. NICHOLAS

THE RAPE OF EUROPA

Lynn H. Nicholas was born in New London, Connecticut. She was educated in the United States, England, and Spain, and received her B.A. from Oxford University. After her return to the United States she worked for several years at the National Gallery of Art. While living in Belgium in the early 1980s, she began research for this book, her first. Ms. Nicholas and her husband live in Washington, D.C.

THE RAPE OF EUROPA

*The Fate of Europe's Treasures
in the Third Reich and the
Second World War*

LYNN H. NICHOLAS

VINTAGE BOOKS

A DIVISION OF RANDOM HOUSE, INC.

NEW YORK

FIRST VINTAGE BOOKS EDITION, MAY 1995

Grateful acknowledgment is made to the following for permission
to reprint previously published material:
Columbia University: Excerpts from the papers of Calvin Hathaway.
Calvin Hathaway Papers, Rare Book and Manuscript Library,
Columbia University. Reprinted by permission.

The Library of Congress has cataloged the Knopf edition as follows:

Nicholas, Lynn H.
The rape of Europa : the fate of Europe's treasures in the Third Reich and
the Second World War / Lynn H. Nicholas.—1st ed.
p. cm.
Includes bibliographical references and index.
ISBN 0-679-40069-9
1. Art thefts—Europe. 2. Germany—Cultural policy.
3. World War—1939–1945—Art and the war. 4. Germany—Politics
and government—1933–1945. I. Title.
N8795.3.E85N53 1944
709'.04'3—dc20 93-11317
CIP
Vintage ISBN: 0-679-75686-8

Manufactured in the United States of America
10 9 8 7 6 5 4 3 2 1

FOR ROBIN
AND IN MEMORY OF MY GRANDMOTHER, MISS BECKY,
WHO TAUGHT ME TO READ

CONTENTS

ACKNOWLEDGMENTS

Writing this book has been a long and exciting voyage of discovery for me. The propaganda, fear, and fervor of World War II were an important part of my childhood. In 1948 my family and I went to Germany and saw the shambles of her cities; in Holland I heard tales of resistance and escape. Much later the fate of works of art in this ambience became of interest to me. This book is the result of my desire to understand what happened to both people and their possessions at that time.

I have been amazed at the generosity of everyone with whom I have come in contact in the course of my research. Many of those I interviewed opened not only their archives but their hearts to me. All those concerned with the recovery of Europe's patrimony are rightly proud of their achievement and their memories are vivid. My greatest regret is that I could not include every single story in this book; for each one told there are many more. I have also had to limit the number of countries covered. Events similar to those I have described took place in every nation overrun by the Nazis; each account could fill a book, all the more so given the recent opening of the archives of Eastern Europe.

My very first thanks must go to the Brussels friends who encouraged me to start this project: Julia and Christopher Tugendhat, Carole Drosin, Penny Custer, and Michele Bo Bramsen.

In Washington I have worked principally at the National Archives and the National Gallery of Art. Former director J. Carter Brown at the Gallery was enthusiastic from the beginning and generously allowed me access to the wartime correspondence of his father, John Nicholas Brown. John Wilmerding gave me precious work space. Maygene Daniels guided me through the newly organized archives and Lisi Ferber shared her amazing fund of knowledge. Most wonderful were the entire staff of the library—and especially Neal Turtell, Caroline Backlund, Ariadne DuBasky, Ted Dalziel, Lamia Doumato, and Thomas McGill (who can find any book in the world). Ruth Philbrick, Jerry Mallick, and Wendy Cole of Photo Archives supplied pictures and companionship. I was particularly fortunate to be able to work with Craig Smyth, Kress Professor at the National Gallery, 1987–1988, on his own book on the Munich Collecting Point. Among many others who assisted were Bob Bowen, Kathy and Ira Bartfield, and Anna Rachwald.

The National Archives with its remarkable holdings of both German and Allied documents was no less important, and there I must above all thank Jill Brett, former director of Public Affairs, for her tremendous help, which included introductions to John Taylor, Dane Hartgrove, and Michael Kurtz. I wish I could mention every person in the various research rooms. Never have I met a more helpful group of people.

In other areas I would like to thank Constance Lowenthal of IFAR, who persuaded me I could give a lecture, Irène Bizot of the Réunion des Musées Nationaux, Isabelle Vernus of the Archives Nationales in Paris, Ely Maurer of the State Department, Cynthia Walsh at the Getty Center in Los Angeles, and the staff of the Archives of American Art in Washington. Cay Friemuth, of Gütersloh, Germany; Dr. Klaus Goldmann of the Museum für Vor- und Frühgeschichte, Berlin; Agnieska Morawinska and Professor Wojiech Kowalski of Warsaw; Patricia Dane Rogers; and the late Christopher Wright (through Marcia Carter) all supplied valuable documentation. Others who helped in many ways include Roger Mandle, Mrs. Robert Seamans, David Rust, Lynn and Arnold Lipman, John Richardson, Pierre de Séjournet, Thomas Blake, Eliza Rathbone, Stuart Feldman, Doda de Wolf, Hector Feliciano, David Gibson, and most especially my brother Chip Holman, whose library I raided. To all who read and criticized unedited copy, particularly Professor S. Lane Faison of Williams College, my gratitude; and special thanks to Marion Evans, who dealt cheerfully with the stacks of paper.

I am indebted to Alan Williams, Pat Hass, Deborah Shapley, and Robert Barnett, who gave me advice on the writing and publication process, and most particularly to Preston Brown and Stuart Blue, through whom this manuscript so serendipitously found its way (via Ash Green) into the unwaveringly patient and encouraging hands of my editor, Susan Ralston. Also at Knopf I would like to thank Jennifer Bernstein, who actually *can* read my writing; and Peter Andersen, who designed this volume.

Most of all I am grateful to my husband, Robin, and my sons, William, Carter, and Philip, for their love and humor; to my mother, Daisy; and to all the rest of my family and friends who cheered me on.

Washington, D.C.
1993

THE RAPE OF EUROPA

Fischer Gallery, Lucerne
(*Switzerland*)
IMPORTANT AUCTION SALES IN 1939

Auction in Lucerne June 30, 1939

PAINTINGS & SCULPTURE BY MODERN MASTERS
from GERMAN MUSEUMS

Braque, Chagall, Derain, Ensor, Gauguin, Van Gogh (Self-portrait), Laurencin, Modigliani, Matisse, Pascin, Picasso, Vlaminck, Marc, Nolde, Klee, Hofer, Rohlfs, Dix, Kokoschka, Beckmann, Pechstein, Kirchner, Hecke, Grosz, Schmidt-Rottl, Müller, Moderson, Macke, Corinth, Liebermann, Amiet, Baraud, Feininger, Levy, Lehmbruck, Mataré, Marcks, Archipenko, Barlach.

EXHIBITION in ZURICH: Zunfthaus z. Meise, May 17 to 27, 1939.
EXHIBITION in LUCERNE: Fischer Gallery, May 30 to June 29, 1939.
AUCTION in LUCERNE: Fischer Gallery, June 30, 1939.

Auction in Zurich May 10, 11, 12, 13, 1939

SPITZER COLLECTION OF PARIS
FURNITURE FROM MR. L., PARIS
PAINTINGS BY OLD & MODERN MASTERS

Furniture, tapestries, carpets, stained glass, silver, porcelain, sculpture, pewter, antiquities.

EXHIBITION in ZURICH: Zunfthaus z. Meise, April 30 to May 9, 1939.
AUCTION in ZURICH: Zunfthaus z. Meise, May 10, 11, 12, 13, 1939.

Auction in Zurich May 10, 1939

IMPORTANT ARMS AND ARMOR
FROM A WELL KNOWN AMERICAN COLLECTION
AUSTRIAN ARISTOCRACY

Gothic horse armor, complete historical suits of armor, fine guns and pistols.

EXHIBITION in ZURICH: Zunfthaus z. Meise, April 30 to May 9, 1939.
AUCTION in ZURICH: Zunfthaus z. Meise, May 10, 1939.

Separate Illustrated Catalogue

Auction in Zurich May 15, 16 & 17, 1939

LIBRARY of the PRINCE OF ESSLING
DUKE OF RIVOLI, (Part I)

Illustrated books of the XV, XVI and XVII centuries.

EXHIBITION in ZURICH: Zunfthaus z. Meise, May 10 to 14, 1939.
AUCTION in ZURICH: Zunfthaus z. Meise, May 15, 16, 17, 1939.

Auction in Lucerne August 18 & 19, 1939

Collection of The Late Dr. ROMAN ABT, Lucerne

Important religious works from the XII to the XVIII centuries. Silver collection. Mediaeval jewelry. Stained glass. Paintings by old and modern masters.

EXHIBITION in LUCERNE: Fischer Gallery, July 10 to August 17, 1939.
AUCTION in LUCERNE: Fischer Gallery, August 18 and 19, 1939.

Five Illustrated Catalogues in preparation. Price 20 Swiss Francs each. Please apply to:

FISCHER GALLERY, LUCERNE, Switzerland

Catalogues may be seen, in the near future, at the offices of The Art News, 136 East 57th Street, New York.

Advertisement for the Lucerne auction in Art News, New York, April 29, 1939

PROLOGUE:
THEY HAD FOUR YEARS

Germany Before the War: The Nazi Art Purges

On the afternoon of June 30, 1939, a major art auction took place at the elegant Grand Hotel National in the Swiss resort town of Lucerne. Offered that day were 126 paintings and sculptures by an impressive array of modern masters, including Braque, van Gogh, Picasso, Klee, Matisse, Kokoschka, and thirty-three others. The objects had been exhibited for some weeks before in Zurich and Lucerne and a large international group of buyers had gathered.

Next to the well-known German dealer Walter Feilchenfeldt and his wife, Marianne, who had moved in 1933 to the Amsterdam branch of the Berlin-based Cassirer firm to escape the drastic anti-Jewish laws at home, sat the famous producer of *The Blue Angel,* Josef von Sternberg. A group of Belgian museum officials and collectors led by Dr. Leo van Puyvelde, director of the Brussels Museum of Fine Arts, were in the next row.[1] Joseph Pulitzer, Jr., in Europe on his wedding trip, was there with his two friends, dealers Pierre Matisse and Curt Valentin.[2] Valentin, formerly of Berlin's Buchholz Gallery, and only recently established in New York, had persuaded Mr. Pulitzer to attend; armed with commissions from various museums and collectors, he had come prepared to buy.

An auction of this nature was not in itself an unusual thing in 1939. There had been large sales in London and elsewhere that spring. What made this one exceptional was not only the very contemporary nature of the lots but more especially their provenance. For these pictures and sculptures came from Germany's leading public museums: Munich, Hamburg, Mannheim, Frankfurt, Dresden, Bremen, the Wallraf-Richartz in Cologne, the Folkwang in Essen, and Berlin's Nationalgalerie. Nor could the lots be considered minor examples of each artist's work, which might be sold to clear a museum's storerooms. They included Picasso's *Absinthe Drinker,* described in the catalogue as "a masterpiece of the painter's Blue Period";

van Gogh's great *Self-Portrait* from Munich, which Alfred Frankfurter would buy for Maurice Wertheim for SFr 175,000, the highest price of the day; and Matisse's *Bathers with a Turtle*. Indeed, Pierre Matisse, bidding for Pulitzer, considered the *Bathers* one of his father's masterpieces, and had been prepared to go far higher than the final bid of SFr 9,100.[3]

Missing at Lucerne were the joy and excitement usually felt at such a sale. Joseph Pulitzer remembers quite different emotions: "To safeguard this art for posterity, I bought—defiantly! . . . The real motive in buying was to preserve the art."[4] It was widely felt that the proceeds would be used to finance the Nazi party. The auctioneer had been so worried about this perception that he had sent letters to leading dealers assuring them that all profits would be used for German museums. Daniel Kahnweiler, whose own collection had been confiscated and auctioned by the French government after World War I, was not convinced and did not attend.[5] Alfred Barr, director of the Museum of Modern Art, in Paris arranging its upcoming blockbuster Picasso show, did not go either, feeling that the museum should not be linked in any way with such an unpopular sale. He also instructed his staff to state firmly that recent acquisitions from Germany had been bought from the new Buchholz Gallery in New York.[6]

Those who did attend were torn. Marianne Feilchenfeldt remembers that some who had agreed not to bid finally could not resist. She and her husband, appalled to note that one of the lots was a Kokoschka, *Cathedral of Bordeaux,* which they had donated to the Nationalgalerie in Berlin, did resist, and the picture did not sell. Friends with them eventually succumbed to the temptation of the low prices and bought Nolde's *Red and Yellow Begonias.*

The French journal *Beaux Arts* called the atmosphere at the Grand National "stifling." The hall, it said, was filled with curious Swiss spectators, interested in the politics of the sale. American dealers bid low, and no French bidders were in evidence. The auctioneer did not conduct the proceedings as one would expect:

> The sale was efficiently conducted by M. [Theodore] Fischer, who was not always able to hide his disdain for certain degenerate pieces. Presenting *Man with a Pipe* by Pechstein, he said, with a little sneer, "This must be a portrait of the artist" . . . when he withdrew other lots, which he had started at rather a high minimum, he took wicked pleasure in observing loudly, "Nobody wants that sort of thing," or "This lady doesn't please the public" . . . and he smiled when he said the word "withdrawn."[7]

Other accounts were not much kinder.

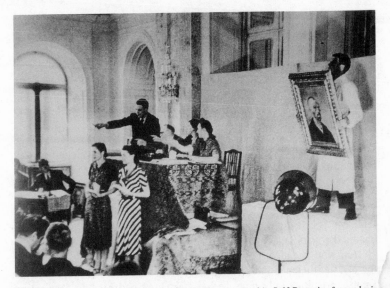

Theodore Fischer (left, standing) *takes bids for van Gogh's* Self-Portrait, *formerly in Munich's Neue Staatsgalerie.*

In the midst of all these passions, the quiet Belgian group did the best of all, acquiring a top Ensor, Gauguin's *Tahiti,* Picasso's *Acrobat and Young Harlequin* from Wuppertal, Chagall's *Maison bleue* from Mannheim, and works by Grosz, Hofer, Kokoschka, Laurencin, and Nolde. In his wildest dreams, the Brussels banker who bought the Picasso could not have imagined that it would sell for over $38 million forty-nine years later.

When the auction was over, twenty-eight lots remained unsold. The sale did not bring in nearly as much as had been hoped. The proceeds, about SFr 500,000, were converted to, of all things, pounds sterling, and deposited in German-controlled accounts in London. The museums, as all had suspected, did not receive a penny.

These pictures had been banished from Germany as "degenerate art," but the Nazi authorities were well aware of their usefulness as a convenient means of raising urgently needed foreign currency for the Reich. To Alfred Hentzen, a curator at Berlin's Nationalgalerie who had been furloughed from his job for nine months in 1935 for showing excessive interest in modern art, it seemed that, with this auction of its national pat-

rimony, the German government had reached a degree of shamelessness and cultural decay unparalleled in the history of art.[8]

With hindsight, the gradual progress toward this "shameless" event is clear to see. In the world of art, as elsewhere, the Nazis simply took existing prejudices and attitudes to incredible extremes. Few could believe or wanted to acknowledge what was taking place before their very eyes.

In 1933 Alfred Barr, while on a sabbatical year in Europe, wrote three articles on the National Socialist art phenomenon, which were universally rejected by major American periodicals as being too controversial.[9] Only his young associate Lincoln Kirstein was bold enough to print one in his new magazine, *Hound and Horn*. The others were belatedly published in October 1945 by the *Magazine of Art*. Jacques Barzun noted in that issue that "Mr. Barr's three pieces are an embarrassing reminder of the public apathy that very nearly cost us our civilization."

Barr, who attended the first public meeting of the Stuttgart chapter of the Nazi-affiliated Combat League for German Culture (Kampfbund für Deutsche Kultur) only nine weeks after Hitler had become Chancellor, was one of the first outsiders to hear the new regime's cultural theories. To a theater crowded with the cultural elite of the city, the director of the Combat League set forth the new ideas:

> It is a mistake to think that the national revolution is only political and economic. It is above all cultural. We stand in the first stormy phase of revolution. But already it has uncovered long hidden sources of German folkways, has opened paths to that new consciousness which up till now had been borne half unawares by the brown battalions: namely the awareness that all the expressions of life spring from a specific blood . . . a specific race! . . . Art is not international. . . . If anyone should ask: What is left of freedom? he will be answered: there is no freedom for those who would weaken and destroy German art . . . there must be no remorse and no sentimentality in uprooting and crushing what was destroying our vitals.

Applause, hesitant at first, by the end was stormy.[10]

Action had, in fact, gone before words in Stuttgart. A major retrospective of the painter Oskar Schlemmer which had opened on March 1 was closed twelve days later, following an exceedingly nasty review in the local Nazi press: "Who wants to take these pictures seriously? Who respects them? Who wants to defend them as works of art? They are unfinished in every respect . . . they might as well be left on the junk heap

where they could rot away unhindered."[11] Intimidated, the museum locked up the whole show in a remote gallery. The Nazis had won their first parliamentary majority only six days before.

Alfred Barr, who was admitted to the show only because he was a foreigner, was so furious that he asked architect Philip Johnson to buy several of the best pictures "just to spite the sons-of-bitches." Johnson complied and one, *Bauhaus Steps,* has been at the Museum of Modern Art in New York ever since.[12]

Acceptance of these warnings was not made easier by the very mixed reception all modern art had endured for many years. As late as 1939 a Boston art critic, reviewing a show of contemporary German works, many of which had come from the Lucerne auction, sadly declared: "There are probably many people—art lovers—in Boston, who will side with Hitler in this particular purge."[13] In Germany itself there was a long antimodern tradition, reaching back to Kaiser Wilhelm's 1909 firing of Hugo von Tschudi, director of the Nationalgalerie, for buying Impressionist paintings. Max Nordau, a Jew who fortunately did not live to see the use made of his theories, had declared all modern art to be "pathological" in his 1893 book, *Entartung* (Degeneracy). He included Wagner, Mallarmé, Baudelaire, and the Impressionists.[14] Newspapers covering New York's famous Armory Show in 1913 picked up this catchy phrase, referring to the "degeneration of art" exhibited there. In the same year an exhibition of Kandinsky's works was described in a Hamburg newspaper as a "shoddy tangle of lines" and the artist himself as "this insane painter, who can no longer be held responsible for his actions."[15] Before 1914 protests and counterprotests flew back and forth between conservative and modern painters. The fight became political enough to be discussed in the Reichstag, and the Prussian parliament even passed a resolution against the "degeneration" of art. But as was the case in other countries, the controversy remained in the realms of opinion and taste.

In the years following World War I the future "degenerates" enjoyed growing acceptance. Encouraged by the liberalism of the new Weimar Republic, museums showed their work extensively. Official sanction was given when Berlin's Nationalgalerie opened a "New Wing" in 1919 in the Kronprinz Palais, which the fall of the monarchy had left empty. Critics of both left and right wrote negative articles, but this museum soon became a model for other such establishments at home and abroad.[16] Upon the death of the collector Karl Ernst Osthaus in 1921, the city of Essen, with funds raised by local business associations and Ruhr mining companies, bought the very contemporary contents of his Folkwang (Meadow for the

People) Museum and opened it to the public. By the late twenties modern works hung in most of Germany's major museums. The government itself appointed a liberal, internationally oriented official as federal art officer in the Ministry of the Interior. In the city of Weimar, the Bauhaus, founded in 1919 by the architect Walter Gropius, though controversial, received state support, and gathered an extraordinary array of artists, architects, and craftsmen.

Despite this encouraging atmosphere, the opposition was always there. In the twenties there appeared a group of art "philosophers" who, building on Nordau's themes of degeneracy, produced the outlines of the future Nazi art creed. Their ideas were confusedly racist, and ultimately nonsensical: "The Hellenic image of beauty is absolutely Nordic . . . one could demonstrate the history of Greece as the conflict of the spirit of the Nordic upper stratum with the spirit of the lower stratum of foreign race,"[17] declared one Professor Guenther. Their fulminations were not limited to modern art. Great difficulty was found in dealing with the fact that the undeniably Nordic Rembrandt had painted so many works representing Jews. Matthias Grünewald (c. 1465–1528) was attacked for having the "psychosis of original sin" and even Albrecht Dürer was considered suspect because of "influences" he had absorbed on his trips to Italy in the sixteenth century.[18]

These ideas became more extreme as the Nazi movement gained momentum. In 1928 Paul Schultze-Naumberg, a well-known architect, published *Art and Race,* a book in which photographs of diseased and deformed people, taken from medical texts, were paired with modern paintings and sculpture. The culmination of this school of thought was Alfred Rosenberg's *Myth of the Twentieth Century* (1930), an unreadable tome which characterized German Expressionist art as "syphilitic, infantile and mestizo." In it Rosenberg further claimed that the Aryan Nordic race had produced not only the German cathedrals but also Greek sculpture and the masterpieces of the Italian Renaissance. Even Hitler, who took Rosenberg into his inner circle, could never understand how this book had sold hundreds of thousands of copies.[19] He nevertheless agreed completely with its basic ideas. Rosenberg's impeccable anti-Semitism and his role as founder of the Combat League for German Culture would soon bring him to great prominence in the new regime.

The Nazis had early shown particular eagerness to act on their artistic theories. In 1929 they won enough votes in the Thuringian elections to claim seats in the provincial cabinet. Dr. Wilhelm Frick, former director of political police in Munich, became the Thuringian Minister of the Interior and Education. Although all Bauhaus personnel had left Weimar in

1925 after their contracts had been cancelled by a right-wing majority in the local government, Frick, feeling that every trace of this sinister institution must be obliterated, turned his attentions to its buildings. Oskar Schlemmer's murals on the staircases were painted over. A German crafts organization moved into the premises, under the leadership of the newly politicized Professor Schultze-Naumberg.[20] Frick was so determined to eliminate all "Judeo-Bolshevist" influence that he next removed the works of Klee, Dix, Barlach, Kandinsky, Nolde, Marc, and many others, seventy in all, from the galleries of the Schloss Museum; banned Brecht's film of *The Threepenny Opera;* and forbade the playing of Stravinsky or Hindemith at concerts. The rest of Germany regarded this as provincial excess, and Frick was fired in April 1931. They could hardly foresee that he would become the national Minister of the Interior in less than two years.[21]

Weimar was not the only city in which such things were happening. In 1926 an Expressionist show in Dresden was condemned by no less than seven Pan-German, *Völkisch,* and military organizations, which accused the artists of insulting the German Army. The German Artists League criticized the Nationalgalerie for raising money to buy van Goghs rather than German works. The director of the Zwichau Museum, Dr. Hildebrand Gurlitt, was fired in 1930 for "pursuing an artistic policy affronting the healthy folk feeling of Germany," and a show of "New German Painting" sent to Oslo aroused a furor of protest.

In January 1933 Adolf Hitler became Chancellor of Germany, and in March elections his party, aided by the fear and chaos surrounding the Reichstag fire and the suspension of civil rights, won its first majority. On April 7 a law was passed for "the re-establishment of the professional civil service." This legalized the removal of any government employee who did not please the National Socialists. Museum directors and staff members, artists teaching at art schools and academies, city planners, and university professors were all employees of the state. For those who were not, Joseph Goebbels, the new Minister of Propaganda and Public Enlightenment, had proposed, on March 13, a new entity which would eventually regulate everyone connected with the arts: the Reichskulturkammer, or Reich Chamber of Culture. Membership in this umbrella organization was required of all artists, writers, musicians, art dealers, architects, and so forth. Those who did not belong could not hold jobs, sell or exhibit their works, or even produce them. Among those not accepted were Jews, Communists, and eventually, in the area of the fine arts, those whose styles did not conform to the Nazi ideal.

Art was very fashionable in the new regime. In October 1933, only months after becoming Chancellor, Hitler laid the cornerstone of the Haus

der Deutschen Kunst in Munich, his first major public building project. Only later did the fact that the ceremonial hammer broke in his hands assume significance.[22] Alfred Rosenberg, the erstwhile art theorist, was made intellectual head of the Party, with the unbelievable title of "Custodian of the Entire Intellectual and Spiritual Training and Education of the Party and of all Coordinated Associations." Frick was now named Minister of the Interior, and began appointing art commissioners in the provinces. Even the SS had an art branch, the Ahnenerbe (Ancestral Heritage), which sponsored archaeological research worldwide in the hope of finding confirmation of early and glorious Germanic cultures. Councils of hitherto obscure artists appeared overnight to herald the *Völkisch* ideals; magazines proliferated: it was the hour of the opportunist. And alongside all these new organizations remained the old Ministry of Culture, trying as best it could to navigate the new waters in order to save itself and the treasures of its museums. It took four years to "refine" the Nazi art criteria; in the end, what was tolerated was whatever Hitler liked, and whatever was most useful to the government from the point of view of propaganda.

At the time of the dedication of the Haus der Deutschen Kunst, a fancy booklet was published in several languages. The English version, *The Temple of German Art,* was aimed at the potential tourist trade in Munich. Along with site plans and architectural drawings, it featured reproductions of nineteenth-century German genre works by painters such as Spitzweg, von Kaulbach, and Boecklin, and a text in extraordinarily bad taste:

> Vital powers will stream from the great temple of art, the enchanting breath from the mountain ranges in the south will course through its colonnades and around its cornices of lime-stone, and the blue sky of Munich will captivate the German and foreign visitors and will persuade them to tarry at the Bavarian city, the birthplace of national rejuvenation.

The "false art" of "mocking and contemptuous defamers of virtue and truth," the fortunately anonymous author continued, had been shaken off by the people "at the clarion call of one who united within himself in highest potency all the noble characteristics of his race"; it would be replaced by truly Germanic art: "the breath of [the] nation's nostrils."

Just what this "breath" encompassed was not, at first, entirely clear, even to Hitler's inner circle. Albert Speer, commissioned to decorate Goebbels's house, wrote later:

> I borrowed a few watercolors by Nolde from . . . the director of the Berlin Nationalgalerie. Goebbels and his wife were delighted with

the paintings—until Hitler came to inspect, and expressed his severe disapproval. Then the minister summoned me immediately. "The pictures have to go at once; they're simply impossible."[23]

Hitler wanted a complete break with the defeatism and leftist ideas of the Weimar years; he wanted no representation of the true face of war, and he had a basically petit bourgeois distaste for what he called "unfinished works." The art-oriented could not fathom this for a long time. Some tried compromise. Max Sauerlandt, director of the Hamburg Kunsthalle, presented the Expressionists as exemplars of Nordic Germanic art. Others simply disagreed. In June 1933 National Socialist students in Berlin staged a demonstration protesting the increased prominence of "middle-class art" and praising the modern collections formed by Dr. Ludwig Justi, director of the Nationalgalerie since 1919. Despite this show of support, Justi was asked to leave his post by Ministry of Culture bureaucrats who wanted a more pliant director able to defend the modern collections while toeing the Party line. But Justi refused to "retire," and embarrassed Culture officials were obliged to transfer him to a post in the art library until he reached the proper age.

The new director, Alois Schardt, a former assistant of Justi's who had built up a similar collection at Halle, was immediately attacked by Rosenberg, Frick, and Schultze-Naumberg. In order to quiet the controversy, Schardt gave a lecture in which he attempted to define the nature of German art. Everything German was "dynamic," he said. He approved of Gothic art, called Dürer's Italian sojourn a "mistake," applauded Grünewald, and claimed that dynamic consciousness had been returned to Germany by the Romantics and Expressionists whose styles he linked to ancient Germanic folk forms. The students were pleased with this association of revolution and nationalism, which made Expressionism an acceptable German tradition, but this was not what the Party had in mind and the Nationalgalerie was closed for "reorganization."

Again Schardt compromised. He filled the lower floors with representational works by artists such as Caspar David Friedrich, Hans von Marées, and Feuerbach. The controversial paintings were put way upstairs, but in an elegant new installation in galleries beautifully painted in varying textures to match the predominant tones of each artist. Top works from other museums were brought in to fill gaps in each display. Nolde himself lent his *Christ and Children* from Hamburg. Schardt's only concession was to leave out Klee and Beckmann, who were not his favorites in any case. Van Gogh and Munch were shown as "Germanic forerunners."

Schardt had hoped to win over the regime with this spectacular presen-

tation. When Minister of Culture Bernhard Rust came to preview the installation before the opening, his only comment was, "Such a mule. . . ." Schardt was fired. Rust did not dare reopen the museum, which was the subject of great speculation in art circles, as Schardt had left it. The minister now asked Eberhard Hanfstaengl, director of Munich's Städtische Galerie, to take over in Berlin. This was considered a clever choice, not only because Hanfstaengl was an eminent expert on Hitler's favorite nineteenth-century German art but also because his name was the same as one of Hitler's well-known friends, "Putzi" Hanfstaengl. By judiciously juggling the exhibits and storing the more "offensive" works, Hanfstaengl was able to calm everyone down for the time being.[24]

In the provinces the process of eliminating unacceptable members of the art community was moving much faster. Museum directors who had promoted modern art were attacked one after another. Gustav Hartlaub, inventor of the term *Neue Sachlichkeit* (New Objectivity), which was applied to the most advanced group of German painters just after the war, was caught hiding "controversial" works in the cellars of his museum in Mannheim. One of them, *Rabbi* by Marc Chagall, was paraded around the city on a wagon with a picture of Hartlaub and the price he had paid for the painting mounted on the back.[25] The Folkwang Museum in Essen was handed over to an SS officer, Count Klaus Baudissin, one of the few art historians in the Party. The Count promptly painted over the last of Oskar Schlemmer's famous wall paintings, which adorned the rotunda of the museum; but until 1935, even he could not bring himself to close the last gallery in which works by Kokoschka, Lehmbruck, Marc, and Nolde were displayed.[26]

Dealers in "degenerate" art were not immune. In May 1936 the Nierendorf Gallery in Berlin, which had been under observation for some time, opened an exhibition of the works of Franz Marc, an Iron Cross winner in World War I. Schardt, now ex-director of the Nationalgalerie, was to give a lecture at the vernissage. The party and the exhibition were abruptly closed down by the Gestapo, and the next day the gallery owners received a letter explaining that a lecture on and exhibition of Marc's works would endanger National Socialist *Kulturpolitik* and by extension "Public Safety and Order." Schardt wisely departed for the United States, as one of the Nierendorf brothers had already done.[27]

The artists themselves were removed from their posts as teachers and members of public institutions: Klee in Düsseldorf; Kollwitz, Hofer, and Beckmann in Berlin; Dix in Dresden. Oskar Schlemmer, falsely accused by Nazi students of being a Jew, asked his employers for official confirmation of his position, and was given a "vacation" instead. On May 13, 1933, the Prussian Academy of Arts asked ten members, some elected as

recently as 1931, to tender their "voluntary" resignations. Dix, Schmidt-Rottluff, Kollwitz, and Liebermann (the president of the Academy and a Jew) obeyed, but Kirchner, Mies van der Rohe, Mendelsohn, and the ever-hopeful Nolde refused to comply. By 1938 all these, as well as Barlach, Pechstein, Hofer, and Kokoschka, had given up, and only Nolde, still a Nazi sympathizer, held out, believing it was his duty to "open the eyes of the people to art."[28]

In response to this growing discrimination, many artists chose to leave Germany. Those who did not were condemned to limbo. The thorough fiendishness of the Nazi rules for artists who did not please the Chamber of Culture is still hard to believe, even after all we know of the National Socialist madness. It was not enough to destroy and ridicule their work and forbid its sale or exhibition. They were not allowed to work at all. "Degenerate" painters were even forbidden to buy art supplies. To enforce this, Gestapo agents made unexpected visits to their houses and studios. The smell of turpentine in the air or a container of wet brushes was grounds for arrest. The painter Willi Baumeister wrote:

> No one knew I continued to paint, in a second story room in utter isolation. Not even the children and the servants must know what I was doing there. . . . Terrible was the idea that one would never again be able to show such pictures in public.

Eventually even this secret activity ceased when an SS captain was billeted in the second-story room.[29]

From Hitler's point of view the measures were a success. In 1938 Oskar Schlemmer took a job with a firm which specialized in painting commercial murals in Stuttgart. By 1939 he was painting camouflage on factories and military buildings. Later he found refuge at an experimental paint factory in Wuppertal whose owner also employed Gerhard Marcks and several other banned artists. Schlemmer died in 1943. Ernst Kirchner committed suicide in June 1938, depressed by the expulsion of his life's work from the German museums. Max Liebermann's eighty-five-year-old wife was also a suicide in 1943, when she was faced with deportation to Theresienstadt. Liebermann himself had not long survived his forced resignation as president of the Prussian Academy. His highly representational pictures, just what Hitler normally loved, later would cause the purgers agonies of indecision.

Emil Nolde, who clung to his membership in the Chamber of Culture and the Nazi party even after hundreds of his works had been reviled or burned, conducted a long correspondence with Goebbels, trying to have what was left in the museums sent back to him. In 1939 the pictures were returned, but in 1940 he was again required to submit his entire artistic

production for the year to be examined. He was finally expelled from the Chamber of Culture on grounds of unreliability in August 1941 and from then on forbidden to paint. An official wrote him in November to say that his paintings had been presented to the Committee for the Assessment of Inferior Works of Art and as a result had been confiscated by the police. By now more than a thousand of his works had been taken. Nolde, then aged seventy-four, retreated to his house in the north of Germany, and despite the *Malverbot* (painting ban), resorted to what he called his "Unpainted Pictures"—hundreds of postcard-sized watercolors, painted on scraps of paper which could be easily hidden. In April 1943 he noted on the margin of one of these, "All my friends and acquaintances want to get me canvas, paper, and brushes, and cut the bonds that tie my hands—no one can."[30]

Those not actually forbidden to work fared little better. Despite the fact that her son Peter had been killed in the First World War, Käthe Kollwitz was expelled from the Prussian Academy for her left-wing and antiwar ideas and forced to give up her studio in Berlin. She was allowed to carry on at home, but her works were banned from exhibitions and removed from museums. After one such episode she wrote:

> There is this curious silence surrounding the expulsion of my work from the Academy show. . . . Scarcely anyone had anything to say to me about it. I thought people would come or at least write—but no. Such a silence all around us. That too has to be experienced.[31]

It was only after the purge of artists and personnel that the new cultural mentors began to concentrate on the actual placement of the works of art. At first they contented themselves with a new sort of exhibition, designed both to show the Weimar government as extravagant and representative of all that was decadent and wrong with Germany and to turn public opinion against the type of art they considered symbolic of the forces which had so unjustly humiliated Germany in 1918. The format was generally the same: the pictures were badly hung, often without frames, and labelled with the prices paid at the most inflationary period of the Depression. Rude political and moral comments and slogans were painted on the gallery walls. But the pictures were still there, and could be seen.

That this humiliation of modern artists was not merely the idea of self-interested underlings was firmly established when Hitler made a surprise visit to the Nationalgalerie to see a show of paintings by Karl Leipold, a protégé of Rudolf Hess. Paul Ortwin Rave, a curator there at the time, described the scene:

Leipold's paintings . . . made apparently no impression on Hitler, so little did even his closest colleague know his taste. But the visitor, once there, went on . . . looked at the works of the Expressionists, but did not open his mouth, asked no questions, satisfied himself rather with derogatory gestures. He looked out the windows, and commented on the nearby buildings: the Zeughaus, the Wache, the Staatsoper, and only when he saw the Prinzessinnen Palace designed by Schinkel, did he become truly lively, and hold forth to his silent followers.[32]

Despite this encounter, and attacks in the SS newspaper *Schwarze Korps* recommending a cleanup of the Nationalgalerie, Hanfstaengl, the new director, did not seem to get the picture either. All through 1935 he had continued to add works of new, young painters to the collection and to accept gifts from banned artists, though he had published a carefully edited catalogue of the museum's holdings, which discreetly left out some of the more controversial objects. In this he was still tacitly supported by Rust at the Ministry of Culture, who even consented to the continued exhibition of works by the Jewish Liebermann. Hanfstaengl made sure that his museum was not left out of a citywide "German Art Since Dürer" show. His swan song was an exhibition entitled "Great Germans in the Paintings of Their Time" put on to coincide with the 1936 Olympics in Berlin. All floors of the museum were thrown open, with artists from Corinth to Klee in full view in the New Wing. The attendance of more than ten thousand a week broke all records. But Jesse Owens and modern art were too much for the Nazis. As soon as the tourist flow had slowed, on October 30, Rust, taking advantage of Hanfstaengl's absence in Italy and following orders from the "highest places," closed the New Wing of the Nationalgalerie. And a few days later orders were given to close similar installations in all the museums of the Reich.

Meanwhile, Hitler's "Temple of Art" in Munich was nearly finished, and would soon need to be filled. In a speech at the Nuremberg rally of 1934, the Chancellor, fresh from eliminating political opposition in his own party by his murders of Ernst Roehm and hundreds of other SA members, had begun to define more precisely the permissible range of art. Cubists, Futurists, Dadaists, and others were

mistaken, if they think that the creators of the new Reich are stupid enough or insecure enough to be confused, let alone intimidated, by their twaddle. They will see that the commissioning of what may be

the greatest cultural and artistic projects of all time will pass them by as if they never existed.[33]

The continuing absence of absolute rules would show in the choice of works for the opening exhibitions of the new Temple of Art. Hanfstaengl, despite his resistance to National Socialist theories, was called to Munich in July 1936 to help decide what would hang in the new museum. Hitler wanted a "comprehensive and high-quality display of contemporary art." The jury, which included several mediocre artists such as Adolf Ziegler, a painter of realistic nudes known in art circles as "the Master of the Pubic Hair," and Gerda Troost, wife of Paul Troost, the architect who had designed the museum, was by now only too aware of what was not acceptable, but still not sure what was. They decided on an open competition. The only requirement for entry was German nationality or "race." When Hanfstaengl asked if Nolde and Barlach could submit works, the Bavarian Minister of the Interior replied: "We will only refuse works, not names." More than fifteen thousand works were sent in; nine hundred were chosen. Hitler himself came to see the selection and in one of his famous rages threw out eighty of these, declaring, "I won't tolerate unfinished paintings."

To improve subsequent shows, held annually for the next seven years, Hitler also threw out most of the jury, and put his chief photographer and art adviser of the moment, Heinrich Hoffmann, in charge. Hoffmann soon became quite efficient at dealing with the thousands of works submitted: he would speed through the galleries in a motorized wheelchair, shouting "Accepted!" or "Rejected!" to scurrying assistants as he passed each picture. "I drove by two thousand pictures only this morning," he proudly told a colleague. "How else could I get ready in time?"[34]

In late November of the same year, Goebbels, further tightening control, forbade all art criticism:

> I granted German critics four years after our assumption of power to adapt themselves to National Socialist principles. . . . Since the year 1936 has passed without any satisfactory improvement in art criticism, I am herewith forbidding, from this day on, the conduct of art criticism as it has been practiced to date. . . . The art critic will be replaced by the art editor. . . . In the future only those art editors will be allowed to report on art who approach the task with an undefiled heart and National Socialist convictions.[35]

And on June 30, 1937, he authorized Ziegler, who had survived the jury purge and been further elevated to the presidency of a branch of the Reich Chamber of Culture, to "select and secure for an exhibition, works of

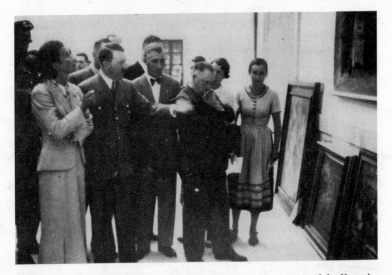

Frau Troost, Hitler, Ziegler, and Co., choosing objects for the opening of the Haus der Deutschen Kunst, 1937 (Photo by Heinrich Hoffmann)

German degenerate art since 1910, both painting and sculpture, which are now in collections owned by the German Reich, by provinces and municipalities."

Ziegler was not a great artist, but as an exhibition organizer he excelled. Although not given the official orders for seizure of works until June 30, he and his committee were able to "select and secure" hundreds of works, sort them out, and produce a show by July 19—a feat any museum director would admire. The swiftness of the action gave curators little time to react. In Berlin, Ministry of Culture officials hastily telephoned museums in Prussia to warn of the coming purge. To get pictures out of their buildings, curators everywhere rushed to return those on loan from private owners or artists, such as Erich Heckel's famous *Zeltbahn Madonna,* which the artist buried in his studio for the duration. Works by Picasso, Braque, Dufy, and Munch belonging to the Friends of the Nationalgalerie were sent by Baron Edmund von der Heydt, president of the association, to the vaults of the Thyssen Bank. These were later sold in a panic by the Friends, after the issuance of a 1938 decree which declared that the government would not pay compensation for confiscated art.[36]

On July 7 the exhibition committee arrived, lists in hand, at the Nationalgalerie. Heading it was Ziegler himself, assisted by Count Baudissin,

Wolfgang Willrich (the fanatically racist author of a volume entitled *The Cleansing of the Temple of Art*), and several others of the same ilk. Hanfstaengl refused to receive them, and the job of escort again fell to his assistant Paul Ortwin Rave.

In this first swoop 68 paintings, 7 sculptures, and 33 graphic works were taken. Similar scenes were repeated in museums all over Germany. At the Kunsthalle in Bremen, a Professor Waldmann, quoting the purgers' own rules, managed to save 9 Liebermanns by saying they could not be exhibited because the artist was Jewish, and were therefore in storage and could not be removed. From Essen's Folkwang Museum a staggering total of 1,202 objects left for Munich, the Nazi director, Count Baudissin, not being interested in saving any of these works. Among them was Matisse's *Bathers with a Turtle*, soon to be rescued by Joseph Pulitzer. Hamburg lost 1,302. Karlsruhe was honored with 47 works in the planned show. By Friday, July 9, Ziegler and Co. had progressed to Munich, where they appeared in the offices of the director of the Bavarian State Collections demanding to be taken to the Neue Staatsgalerie, the exhibition spaces of the library, and the storage rooms. For the moment the Bavarian painting collections, whose director had close ties to the Führer, lost only 16 works.[37]

The culmination of the frantic activities of these juries and committees came in what must be the strangest three days the world of art has ever experienced. On July 17 the Reich Chamber of Culture held its anniversary meeting. With Hitler in the audience, Goebbels spoke of the "grave and fatal illness of the times, whose abominable symptoms, in the form of insolent and provocatively inferior works, slumber in the cellars and lofts of our museums." Ziegler, in a flattering echo of recent outbursts by the Führer, added that:

> He who paints our youth as wasted idiots, and the German mother like a Neanderthal woman, has shown undeniable proof of his degenerate character, and he who submits a bad, mediocre or unfinished work to such a perfect House of Art, proves that he has not understood the cultural demands of our time.[38]

The next morning, a lovely Sunday that had been declared the "Day of German Art," the people of Munich were treated to an extraordinary spectacle. A pageant of more than seven thousand people, animals, and machines wound through the streets toward the new museum. The interpretation of "German" was broad: golden Viking ships were mixed in with ancient Germanic costumes. There were priests and seers from the sagas. Charlemagne walked just ahead of Henry the Lion and Frederick

Königsplatz, Munich: parade for the Day of German Art, July 18, 1937

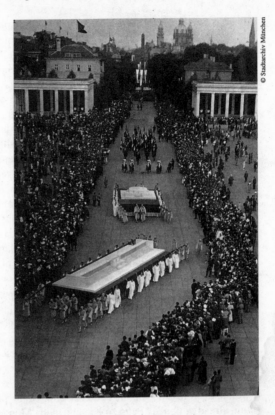

© Stadtarchiv München

Barbarossa. Participants costumed as German artists of the Renaissance were preceded by a troop of armored mercenaries. Enormous scale models of new Nazi edifices were included. The Nazi newspaper *Völkische Beobachter* enthused:

> In the shadow of their sword, Dürer, Holbein, and Cranach created their works of art for the German people. Are they not brothers, the artists and soldiers?

Perhaps to leave no doubt about this point, the last "tableau" was made up of units of the Wehrmacht, SA, Work Corps, Motorized Corps, and SS.

Here, before the gleaming marble of his first public building, Hitler delivered the coup de grace to his nation's modern collections. Rave gives us this chilling account:

People had expected that Hitler, given the happy occasion of the opening of the Haus der Kunst, would strike a note of celebration and give his people recognition and encouragement. In his speech there was little of that. People had become accustomed to invective and threats in the long political campaigns, but this ceremonial speech had a particularly frightening tone. After a long, dull introduction on the contrast between Modern and German ideas . . . and the difficult academic questions of Will and Knowledge in art, which he would have done better to leave out, Hitler did praise the merits of the new Haus, and his own share in it. Then, suddenly, in power-mad, overblown, scornful words, came the true message. He forbade artists to use anything but the forms seen in nature in their paintings. Should they nevertheless be so stupid or sick as to continue their present ways, the medical establishment and criminal courts should put a stop to the fraud and corruption. If this could not be achieved in one day, no one should deceive himself . . . sooner or later his hour would strike. With every sentence, Hitler's manner of speaking became more agitated. He seethed with rage . . . saliva flowed from his mouth . . . so that even his own entourage stared at him with horror. Was it a madman who twisted convulsively, waved his hands in the air, and drummed with his fists . . . ? "We will, from now on, lead an un-relenting war of purification," he shrieked, "an unrelenting war of extermination, against the last elements which have displaced our Art."[39]

Stunned by this speech, the audience entered the portals of the new mu-seum, already dubbed "Palazzo Kitschi" and "Munich Art Terminal," to a stultifying display carefully limited to idealized German peasant families, commercial art nudes, and heroic war scenes, including not a few works by jurist Ziegler himself. The newly disciplined art press dutifully re-ported that "sketchiness had been rigorously eliminated" and that "only those paintings had been accepted that are fully executed examples of their kind, and that give us no cause to ask what the artist might have meant to convey." Despite the fact that the Führer was portrayed "as a mounted knight clad in silver armor and carrying a fluttering flag" and "the female nude is strongly represented . . . which emanates delight in the healthy human body," the show was essentially a flop and attendance was low.[40] Sales were even worse and Hitler ended up buying most of the works for the government.

Quite the reverse was true of the exhibition of "Degenerate Art," which opened on the third day of this Passion of German Art. Ziegler, who must

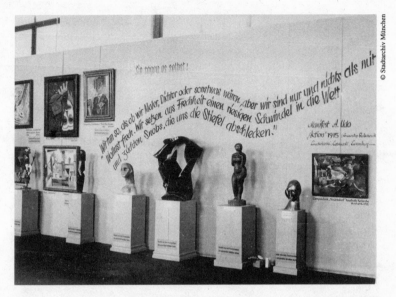

"Degenerate Art" show: typical installation showing "Anarchist-Bolshevist" wall (Inscription: " 'They say it themselves: We act as if we were painters, poets or whatever, but what we are is simply and ecstatically impudent. In our impudence we take the world for a ride and train snobs to lick our boots.' Manifesto A. Udo, Aktion, 1915. Anarchist-Bolshevist: Lunarscharski, Liebknecht, Luxembourg.")

have been quite exhausted by now, again began the proceedings with a speech echoing Hitler's words of the previous day, adding a condemnation of museum directors who had expected their countrymen to look at such "examples of decadence."

In a run-down building formerly used to store plaster casts were jammed the hundreds of works removed from the museums in the previous weeks. Over the door of one gallery were inscribed the words "They had four years." One hundred thirteen artists who had not understood the message were represented. Schlemmer and Kirchner illustrated "barbarous methods of representation." The antimilitary works of Dix and Grosz were called "art as a tool of Marxist propaganda against military service." Expressionist sculpture was accused of promoting "the systematic eradication of every last trace of racial consciousness" for its depiction of blacks. Another room was "a representative selection from the endless supply of Jewish trash that no words can adequately describe." Abstract and Constructivist pictures by Metzinger, Baumeister, and

Schwitters were simply called "total madness." The catalogue, a badly printed and confused booklet, was laced with the most vicious quotes from Hitler's art speeches. The walls were covered with mocking graffiti. To "protect" them, children were not allowed in.

Before it closed on November 30 more than 2 million people poured through this exhibition, which was often so crowded that the doors had to be temporarily closed. Reactions were mixed. An association of German officers wrote to the Chamber of Art to protest the inclusion of the works of Franz Marc, who had been killed at Verdun and awarded the Iron Cross. Marc's *Tower of Blue Horses* was quickly withdrawn, but four other pictures by his hand remained. Although the Hannoverian collector Dr. Bernhard Sprengel was inspired to rush out and buy Nolde watercolors from a Munich gallery, and many art lovers came to see their favorites for the last time, both Hentzen and Rave sadly note that the propaganda had had its effect: the government had successfully exploited the desire of all Germans to forget the grim harshness of the recent past, and the reality of a world in economic and social turmoil. This their modern painters would not let them do. The new reality would be fashioned by the Nazi regime alone.

A few weeks after these momentous ceremonies, "total purification" began in earnest. Curators continued their delaying tactics, often aided by continuing aesthetic confusion on the part of the purgers:

> In Berlin the commission at first confiscated anything even a little impressionistic. . . . When Ziegler came the next morning and moderated the guidelines, a large number of pictures were put back. Herr Hofmann found everything Degenerate . . . especially the landscapes of Slevogt and Corinth. . . . The *Inntal Landscape* (1910) by Corinth was . . . according to Hofmann a typical case of how, in one picture, genius and decadence could be combined. . . . The landscape brilliant—the sky decadent![41]

Fortunately for this picture, the landscape prevailed, and it hangs in Berlin to this day. (Corinth, whose early works were widely acclaimed as "very German," posed a problem that was neatly resolved by barring only the works he painted after 1911, the year in which he had suffered a stroke.)

All over Germany curators presented excuses in their desire to preserve their collections: pictures were in the photography studio or being restored. Corinth's *Trojan Horse* was saved when Rave suggested that the Nationalgalerie quickly trade it for a less "degenerate" work still owned by the artist's widow. Some officials refused any removal order not in writing. In Berlin's Print Room the purification committee was presented with

stacks of boxes containing more than 2,000 prints. After pulling out 588, they left, confused and exhausted. That night curator Willy Kurth managed to replace some of his most valuable prints with lesser ones by the same artists from another museum, and thus to preserve many priceless works by Munch, Kirchner, and Picasso.[42] Not all museums were so scrupulous: officials in Hamburg turned over some of their forbidden pictures, including a Degas, to eager dealers. But all these subterfuges saved only a tiny fraction of the collections. In the end, the confiscation committees removed nearly 16,000 works of art from German public collections.

There now arose the problem of what to do with this mass of art. The "Degenerate" show, touring Germany after its Munich opening, only took care of a few hundred works. For the time being the purged objects were taken to Berlin and stored in a warehouse in the Copernicusstrasse. The Bavarian Museums carefully insured their shipment before it left, declaring "substantial market value," and the Chamber of Culture generously paid the premium.[43]

Goering, who had been forming his own collection for some time, was the first to recognize the potential monetary value of this trove. He sent his agent, Sepp Angerer, to put aside paintings which would have value abroad, a foray which netted him pictures by Cézanne, Munch, Marc — and no fewer than four van Goghs. These he used to obtain cash for the Old Masters and tapestries he preferred. Angerer sold Cézanne's *Stone Bridge* and two of the van Goghs, *Daubigny's Garden* and the *Portrait of Dr. Gachet,* to the banker Franz Koenigs in Amsterdam for about RM 500,000.[44] Goering, always scrupulous about appearances, paid the Nationalgalerie RM 165,000 for its purged work, a bargain since, according to Rave, *Daubigny's Garden* alone was worth more than RM 250,000.

Hungry for foreign currency, other Nazi leaders also secretly cashed in on this bonanza, but their dealings were only a drop in the bucket. In March 1938 Franz Hofmann, chairman of the confiscation committee, declared the museums to be "purified." The fate of the remaining works awaited the Führer's orders. Hitler had seen the deposits for himself in January. In June he signed a law freeing the government from all claims for compensation for the "safeguarded" works, one of the first official uses of the euphemism which was to become an international watchword in the next decade. His action opened the way to unrestrained commerce. Goebbels was pleased and wrote in his diary that he hoped to "make some money from this garbage."[45] A Commission for the Exploitation of Degenerate Art was formed. On it sat the chief of Alfred Rosenberg's art op-

erations, Robert Scholz; Ziegler; photographer Heinrich Hoffmann; and, in an arrangement that makes modern insider-dealing scandals seem childish, Berlin art dealer Karl Haberstock, who had begun his career at the Paul Cassirer firm and had ties to all the major European dealers. To avoid any appearance of impropriety the commission members were supposed to refrain from selling. Four well-known dealers were appointed to take over the actual marketing of this extraordinary inventory: Karl Buchholz, Ferdinand Möller, Bernhard Boehmer, and Hildebrand Gurlitt. All were men who had handled modern art for years. Möller had represented Nolde and Feininger; Boehmer was a friend of Barlach's. Gurlitt had been fired from Zwichau for exhibiting modern artists, and Buchholz was the mentor of Curt Valentin, who had named his New York gallery in Buchholz's honor and who would be present at the Lucerne auction.

The international market had already been well primed for these sales, as such farsighted museum directors as Count Baudissin had begun deaccessioning "unacceptable" works soon after Hitler's advent to power.[46] The dealers were instructed to sell for foreign currency without "arousing positive evaluations" at home. Fortunately, the operation was managed by an enlightened lawyer and amateur art historian, Rolf Hetsch, who knew the true value of the contents of the warehouse. He set up a salesroom in Schloss Niederschonhausen, just outside Berlin. The four dealers could buy things for very little as long as they paid in foreign currency. Even Germans could buy if they had dollars, sterling, Swiss francs, or objects of interest to the Führer.[47] A painter of modest means, Emanuel Fohn, who lived in Rome, heard of the sales in late 1938. Remembering Ziegler from student days at the Munich Academy, he rushed to consult him and was given Hetsch's name. Hetsch agreed to accept works from Fohn's collection of nineteenth-century German paintings in exchange for "degenerate" ones. Fohn took them back to Italy and promised to return these paintings someday to Germany. At his death the collection was indeed left to the Städtische Museum in Munich, the birthplace of his wife, Sofie.[48]

Word of the trade soon went much farther afield. The director of the Basel Kunstmuseum, Georg Schmidt, persuaded his city fathers to give him SFr 50,000 to invest, declaring that it was their duty to save good art. He spent it well both at the Schloss and at the Lucerne auction. Curt Valentin, still a German citizen, was able to obtain from this source much of the inventory which established him as a major New York dealer, and continued to make frequent and risky trips to Berlin. Hetsch sold works for practically nothing, simply to get them out of the country. A postwar study lists more than twenty pages of objects distributed from the Nationalgalerie's collections alone. Even a little sample of the prices paid makes unbelievable reading:

M. Beckmann	*Southern Coast*	$20 to Buchholz
M. Beckmann	*Portrait*	SFr 1 to Gurlitt
W. Gilles	5 Watercolors	$.20 each to Boehmer
W. Kandinsky	*Ruhe*	$100 to Möller [now Guggenheim Museum, New York]
E. Kirchner	*Strassenzene*	$160 to Buchholz [now MoMA, New York]
P. Klee	*Das Vokaltuch der Sängerin Rosa Silber*	$300 to Buchholz
Lehmbruck	*Kneeling Woman*	$10 to Buchholz[49]

Needless to say, the anointed dealers often did rather better on the resales, which they did not always report to the Commission.

In the fall of 1938 Exploitation Commission member and dealer Karl Haberstock suggested to Hitler and Goebbels that a public auction would increase these minimal revenues. He brought a Swiss crony and fellow Cassirer alumnus, Theodore Fischer, to look over the depositories. Together they chose the 126 works which would be sold in Lucerne on that sunny day the following June. It was none too soon. Despite all the trading activity, the Copernicusstrasse warehouse remained distressingly full. Franz Hofmann, fanatically desirous of carrying out Hitler's purification policies to the letter, pushed to get rid of the remaining works, which he declared "unexploitable." He suggested that they be "burned in a bonfire as a symbolic propaganda action" and offered to "deliver a suitably caustic funeral oration."[50] Shocked at the idea of such destruction, Hetsch and the dealers took away as much as they could. But Goebbels agreed to Hofmann's plan, and on March 20, 1939, 1,004 paintings and sculptures and 3,825 drawings, watercolors, and graphics were burned as a practice exercise in the courtyard of the Berlin Fire Department's headquarters just down the street. The works in Schloss Niederschonhausen were reprieved and gradually sold or traded away. The whole process of "purifying" the German art world, and its "final solution" in flames, eerily foreshadows the terrible events to come in the next six years.

The German pavilion at the Paris World's Fair, 1937 (Photo by Heinrich Hoffmann)

PERIOD OF ADJUSTMENT

The Nazi Collectors Organize;
Austria Provides, Europe Hides

To art professionals outside Germany the advent of Nazism and the bizarre goings-on of its art establishment were regarded at first as a passing phenomenon which would require some minor adjustments in international dealings. Even Alfred Barr, so upset by National Socialist ideas, planned to publish his exposés anonymously lest he alienate German museum officials who might later deny important loans to the Museum of Modern Art.

In the great museums of Europe the schedule of exhibitions and exchanges seemingly went on as it always had. Despite German militarization of the Rhineland and the outbreak of the Spanish Civil War, planning for the 1937 World Exposition in Paris was not interrupted. The German pavilion, designed by Albert Speer, was given one of the most prominent sites by the French, who had naughtily placed it directly opposite the Soviet pavilion, which was surmounted by two huge figures with hammer and sickle who appeared to be attacking the German building.

Later in the year, just after the "Degenerate Art" show, there was particularly enthusiastic response to an International Hunting Exposition put on in Munich by Hermann Goering in his capacity as Chief Huntsman of the Reich. In hopes of easing rising diplomatic tensions, the British Ambassador, Sir Nevile Henderson, felt that his country should be represented along with the rest. Though they were late in getting organized, the British managed to produce mounted heads of game bagged by the King and Queen in their Dominions, a stuffed giant panda, and other colonial trophies, which won them first prize in the "Overseas" section. France sent foxhounds and splendidly dressed huntsmen but was edged out by Poland for the first "European" prize. The walls of the exhibition hall were filled with paintings and prints of hunting scenes contributed by every nation. Hitler came despite the fact, according to the British Ambassador, that "he

hates all sport and deplores in principle the taking of animal life." It was not all fun. The Ambassador had persuaded the new Prime Minister, Neville Chamberlain, to send Lord Halifax, Lord President of the Council and a famous huntsman, to Munich to take part in the festivities. In the course of his stay Halifax was introduced to Hitler, Goebbels, von Neurath, and Goering, "in the hope that personal contact between a British statesman and the Nazi leaders, which Hitler was believed to seek . . . might lead to better understanding."[1] Henderson need not have bothered: two weeks earlier, Hitler had held the now famous meeting at which he ordered his generals, in a four-hour harangue, to prepare their forces for the implementation of his Lebensraum policies by 1938. Unaware of this, Halifax wrote that "the German Chancellor and others gave the impression that they were not likely to embark on adventures involving force."[2]

Until 1937 German collectors and museums were still lending generously to such shows as the seventy-fifth anniversary of the Frans Hals museum in Haarlem. But by 1938 exhibition organizers outside Germany began to notice a certain reluctance to loan Old Masters on the part of German museums. A major Rembrandt show at the Rijksmuseum, intended to celebrate the Jubilee of the Dutch Queen Wilhelmina, was threatened with cancellation when none of the planned German loans were forthcoming. The desperate director of the museum rushed to Berlin to plead with the Ministries of Culture and Propaganda and the Foreign Office but was turned down.

Meanwhile, requests for loans from other countries had piled up unanswered at the German Foreign Office. Late in July the overwhelmed and confused official in charge of these matters asked for clarification of his government's policy. He had received requests from Bern for an Altdorfer show, and from Milan for Leonardo drawings. Liège had asked for fiftyseven pictures with water themes by artists ranging from van der Weyden to van Gogh, including eight canvases which had now been declared "degenerate." The Belgian Ambassador was pressing for an answer to a May request for twelve Memlings for Bruges. The beleaguered bureaucrat had been told by the Propaganda Ministry that the Führer had forbidden all such loans in a 1937 decree, but when he had made inquiries the Reichschancellery had said that the Führer had no objections to the Memling loan. With some indignation he declared that it would be helpful if the ministries could decide on a single policy. Goebbels and Martin Bormann, Hitler's personal assistant, under pressure from museum officials who felt that these refusals would hurt Germany's image, agreed to discuss the question with their chief again. He did not relent: exceptions were permissible only for urgent foreign policy reasons. Other nations should not

be upset if Germany was reluctant to loan fragile and irreplaceable treasures. As an example of such a work Hitler cited the *Discus Thrower,* which, with Mussolini's sanction, he had recently bought from Prince Lancelotti and imported from Italy. In the future the Führer would decide each case personally.

Eight Memlings were finally allowed to go to Bruges, probably thanks to their religious themes, which Hitler disliked almost as much as modern art. In Bruges the Memlings, which included the magnificent *Polyptych of the Calvary* from the Cathedral of Lübeck, were shown alongside four lovely little panels representing angels playing musical instruments, lent by the Dutch dealer Jacques Goudstikker. Liège, Milan, and Bern were not so lucky, though in the case of Milan, Hitler hastened to state that no insult "to our Italian friends" was intended. No works of the first rank were to leave Germany before the outbreak of war, a restrictive policy that Intelligence professionals like to call an "indicator."[3]

Although permission was granted for a few modern works to be sent to San Francisco's 1939 International Exposition, nothing went in the end, and official Germany was conspicuously absent from both San Francisco and the New York World's Fair of that year. Its only representation was a splendid group of thirty-four Expressionist works sent to California by the refugee dealers Curt Valentin and Karl Nierendorf. Hitler did not care that these "degenerate" pieces were in the uncultured United States: his masterpieces were safe at home.

The rest of the world, including future belligerents Italy, Japan, and the USSR, had blithely sent more than five hundred paintings and innumerable other objects to both events. A Belgian show was shipped ahead to Worcester. Mussolini upstaged them all by allowing Botticelli's *Birth of Venus* to cross the seas for the first time. She was accompanied by distinguished friends, among them Verrocchio's *David,* Raphael's *Madonna of the Chair,* and works by Michelangelo and Fra Angelico. The French government, in addition to installations of entire period rooms and loans of paintings to the fairs proper, had sent over René Huyghe, curator of paintings at the Louvre, with a large travelling exhibition entitled "From David to Lautrec." Huyghe was in Buenos Aires with the show when war was declared. He rushed back to France, leaving the exhibition in the care of an assistant who managed to return it to the United States.[4]

This and several other groups of stranded treasures from the two expositions would spend the war years in America, at first travelling from one museum to another, often in aid of war-effort fund-raising, and later in various storage depots. They were an unexpected windfall for American museums. When at one point the Italian, French, and Dutch representa-

tions, along with a rarely loaned pair of works by Hogarth and Constable from London's National Gallery, were being shown in Chicago and Detroit simultaneously, critics noted that it was "the greatest opportunity the Middle West had ever had to study some of the highest attainments in the history of art."[5] Few museum directors, especially the less established ones, could resist taking advantage of such an opportunity. The Italian collection next appeared, somewhat out of context, at the Museum of Modern Art. In a spread which took up most of the *ArtNews,* Alfred Frankfurter commented on the "shrewd, nimble, publicity-consciousness of the MoMA in grasping an opportunity which its larger sister institution [the Met] had clumsily let slip."[6]

The situation had not only brought American cities enjoyable Old Master shows. From 1937 on there had been small exhibitions of Germany's banished art and artists. The advent of war in 1939 brought these into the spotlight. In the show which opened MoMA's new building were five purged works, all bought as Barr had wished, through Buchholz. The *ArtNews* felt that the acquisitions gave "the strongest condemnation to the policies which barred these."[7] President Roosevelt, who spoke at the opening, said that "the arts cannot thrive except when men are free to be themselves."[8] Boston's fledgling Institute of Contemporary Art, directed by James Plaut, put on a German modern show with loans from refugee dealers Valentin, Nierendorf, and Otto Kallir. The pictures themselves were not popular, but Plaut saw them as "terrible pictures, which are the more terrible for their intensity as a dread warning to civilized man."[9] Little did he know that he would soon be responsible for investigating the most intimate details of the art dealings of the Nazi leaders.

The international art trade which in the mid-thirties had begun to show markedly improved activity was also affected by Hitler's programs. Within Germany adjustments were made to deal with the new rules governing aesthetics and race. Jews working for some firms moved to branch offices in New York, Paris, or Amsterdam. Other businesses sold their names and assets to gentiles, a process called Aryanization. At first this was voluntary. In 1936 Franz Drey, owner of the well-established Munich firm of A. S. Drey, decided to move to the United States for the duration and asked Walter Bornheim, an "Aryan" dealer, to take over his establishment. Bornheim paid some RM 30,000 for the firm and also took over its stock, valued at RM 300,000. He was to pay this amount back after five years at the rate of RM 50,000 a year. He also agreed to hold certain works, which were considered German national treasures and could not be exported, until the situation changed and the Dreys could return and re-

sume business as usual. The German government approved the transaction and the Drey family left for New York with the stock and assets it had been allowed to take out.[10]

Numbers of others followed their example, a migration of dealers and collectors that brought a flood of art works to the market. In order to pay off debts and satisfy government-required exit fees, families sold objects which in normal times they would never have let go. The ban on the exportation of cash led many others to invest in works of art and other valuables which, until 1939, could be taken out as personal property. It also soon became clear that many in the Nazi leadership had a penchant for works of art. Robert von Hirsch, taking advantage of this trend, managed to get permission to take his great collection to Switzerland by bribing Goering with a work by Cranach. Within Germany a new market was thus created, virtually overnight, and a group of dealers, not previously considered to be in the top rank, rushed to fill the gaps left by the departure of their Jewish colleagues and to take full advantage of it. The art trade was headed for a boom.

Hitler, the artist manqué, had been collecting for some years in a very modest way. His first adviser was his old friend Heinrich Hoffmann. By 1936 Hoffmann had made a fortune from his monopoly on all photographs of Nazi proceedings, which were eagerly sought after by the foreign media, and through his art magazine, *Kunst dem Volk,* required on the coffee tables of the faithful. Later he increased his income further by obtaining exclusive rights to royalties on the postcards sold at the Haus der Deutschen Kunst, of which he had become director. Hoffmann knew virtually nothing about art, but Hitler enjoyed their dealings and encouraged the photographer to seek out available works of his favorite nineteenth-century genre school.

This was not a task Hoffmann could tackle alone and he soon enlisted the help of other dealers. The first was Maria Almas-Dietrich, a lady with whom he reportedly had had a longtime liaison, whose daughter was a friend of Eva Braun's. Frau Dietrich ran a small shop in Munich specializing in rug repair and second-rate objets d'art, including plenty of the sentimental scenes admired by Hitler. Her "eye" was, if anything, worse than Hoffmann's, but what she lacked in talent she made up for in sheer aggressiveness. One source stated that "she was the equal of five men."

In 1936 Hoffmann took her to see the Führer. She brought along a selection of her wares. Hitler, a novice collector, felt quite comfortable with the unglamorous Dietrich. Having gained this entrée, she worked tirelessly to please him. Her physical stamina was astonishing: once, having

shown Hitler a selection of pictures in Berlin, she flew back to Munich while he travelled there on his special train and had a new lot waiting for him at the Führerbau when he arrived. When Hitler's collecting had become more sophisticated he kept her on, much to the horror of the experts, who were appalled by the exorbitant prices she paid for her finds, which were often fakes. Hitler himself fussed at her more than once, and Ernst Buchner, director of the Bavarian State Painting Museums, who was frequently called in by Hitler to give opinions, even threw her out of his office "in exasperation at being shown so many second-rate and fake pictures." But in the end she sold more to Hitler than any other dealer, some 270 paintings.

Hitler's patronage is all the more mysterious, and Frau Dietrich's frenetic activity all the more understandable, when one reads the postwar investigations into her background. At a very early age she had given birth to an illegitimate daughter fathered by a German-American Jew. Later she was briefly married to another Jew, this time a Turkish rug and art merchant with whom she had set up her shop. The Gestapo and Rassenamt investigated her at frequent intervals and she was denied German citizenship until 1940. As late as 1943 she had to be rescued from the Gestapo by Hoffmann. Her half-Jewish daughter was not allowed to marry her "Aryan" fiancé, and spent the war years semi-hidden in her mother's shop. The Führer need not have feared dishonesty on the part of Frau Dietrich; her misattributions were due to ignorance, not guile. For her there was far too much at stake.[11]

Quite another cup of tea was the next adviser to enter the Führer's art circle. This was the same Karl Haberstock, well established in Berlin, with an office in London and international contacts, who would eventually serve on the Commission for the Exploitation of Degenerate Art. Fortunately for him, he had made his name selling nineteenth-century German artists such as Trübner, Leibl, Thoma, and Feuerbach—Hitler's favorites. As the National Socialists rose to power, Haberstock schemed unceasingly to ingratiate himself in right-wing circles by promoting Alfred Rosenberg's Combat League and supplying important Nazi supporters with suitable art. To this group he demonstrated a ferocious anti-Semitism quite in sympathy with theirs, as well as the requisite contempt for modern works. He joined the Party in 1933, by his own admission, "because I hoped to gain influence, and be able to avoid extreme measures."[12] Haberstock used every conceivable method to influence officials at the Ministries of Culture and Propaganda, some of whom valiantly tried to maintain the traditional distance between dealer and museums, but who often suffered when Haberstock complained to his Party cronies.

Because of his connection with the Combat League, he was one of the first to recognize what profits could be made from the coming purge of modern works and thereafter actively promoted it. As early as 1935 he was said to be behind a scheme concocted with Propaganda Ministry officials to sell French Impressionist works from German museums to an unnamed but "important" Parisian for RM 5 million, to be used to refurbish the Four Seasons Hotel in Munich and establish a fund for German artists in the Reich Chamber of Culture.[13] The details were to be handled through a Swiss investment company represented by a Dr. Franz Seiler. Several German directors were approached by this gentleman. Hanfstaengl at the Nationalgalerie told Seiler that such a sale was not possible and suggested he try private collectors such as the Oppenheims, who were selling. The pictures Seiler had picked out were top quality: three each by Cézanne, Renoir, and Manet, including Manet's famous *In the Conservatory*. Soon after Seiler's visits the museum directors received orders from the Propaganda Ministry to send photographs and valuations of the works discussed. The implication was that the Führer himself had instigated the operation. Suspicious, Hanfstaengl reported these events to the Ministry of Culture. Similar complaints came from other museums. A Ministry official named Kunisch wrote a strong letter to Hitler himself to say that such a transaction would not only insult the French, who would see it as derogatory to their culture, but would put Germany on the same level as the Bolshevists in Russia who had sold off their museum holdings for foreign currency. Later Kunisch forbade the museum directors to sell any work which would be "an irreplaceable loss to a public collection" or which had been donated or whose resale was forbidden on "legal or moral grounds." For anything they did sell they must receive enough compensation to replace it with a work of equal stature—which of course eliminated all the pictures Seiler had chosen.[14] When the matter was actually presented to Hitler, he rejected any such dealings.

Haberstock had been a little premature, but the purges of 1937 would be just what he needed. During that operation he did manage to obtain Gauguin's beautiful *Riders to the Sea*, newly removed from the walls of the Wallraf-Richartz Museum in Cologne. Casting aside his anti-Semitism, he sold an interest in the picture to Georges Wildenstein in Paris, who, after some months, resold it through his New York branch to the actor Edward G. Robinson. Haberstock was upset and suspicious at the delay and Wildenstein was forced to write several times to explain that patience was necessary if the picture was to be sold "*dans de bonnes conditions*."[15]

Over and over again he tried to con the German museums. The director of Leipzig was offered a ludicrous price for a Hans von Marées on the

grounds that Marées's mother had been Jewish. Later Haberstock tried to trade a Spitzweg, which the mayor of Nuremberg wanted to give Hitler for his birthday, for a top Pieter de Hooch in the Germanisches Museum. When the director, Dr. Zimmermann, objected, Haberstock tried to use his influence to have him fired. Despite this, Zimmermann was later named director of the Gemäldegalerie in Berlin. Nothing daunted, Haberstock sent him a congratulatory cake. Zimmermann sent it back. In the meantime, the Spitzweg had proved to be a fake.

After the director of Hamburg was fired for having invested in modern works, Haberstock tried to talk his way into the museum storerooms, to see what might be available. A city official who threw him out was reprimanded. Meanwhile, Haberstock had had the audacity to call the Jewish dealer Walter Feilchenfeldt, who had long since fled to Amsterdam, to ask him which picture he should take from Hamburg, the "little Degas of Mlle. Daubigny" or a Renoir.[16] He got the Degas, and later sold it abroad.

Haberstock did help those who might be useful to him. Once he had become established as one of the Führer's favorite dealers he persuaded Hitler to reinstate Dr. Hans Posse, who had been fired from his post as director of the Gemäldegalerie at Dresden for his refusal to join the Party and his purchases of unsuitable art. Posse, who had held the directorship at Dresden for some twenty years, wrote a thank-you letter to Hitler at his lodgings in Haus Wahnfried at the Bayreuth Festival, telling the Führer that he was "infinitely grateful" to have his "mission in life," his work in one of the most beautiful museums in Europe, and one of the "most important monuments of the German Cultural Will," restored to him.[17] Posse was never allowed to forget this favor, which would soon bring him powers beyond his wildest dreams.

Hitler seemed to be unaware of all these nefarious goings-on, and began his collection of Old Master paintings through Haberstock. His first acquisition was a Paris Bordone Venus and Amor, which hung in the salon at the Berghof, his mountain retreat, all through the war. Speer described it as "a lady with exposed bosom."[18] The Führer's early buying was all very low key. Dealers would show their wares at little shows arranged at the Führerbau in Munich. Hitler would view the works and choose those he liked. Experts such as museum directors Buchner and Posse would sometimes be asked for their opinions. By 1938 Hitler had gathered a modest collection paid for from the royalties on Mein Kampf and by a surtax on the postage stamps bearing his likeness.

In the four years it had taken to make quite clear what Hitler liked, Hermann Goering had not failed to indulge his own collecting fancies. With

vast amounts of government funds now at his disposal, he soon was oper-
ating on a large scale. Goering was virtually the only member of Hitler's
inner circle who had an upper-class background and who had moved in so-
phisticated international society. His adored first wife, Carin, was from an
aristocratic Swedish family, and at Schloss Veldenstein, near Nuremberg,
which belonged to his Jewish godfather, Baron Epenstein, he had become
accustomed to considerable creature comforts. Immediately upon Hitler's
accession to power in 1933, amazing quantities of presents began to be
showered upon the sociable Goering as industrialists and office seekers
scrambled to establish themselves with the new rulers. No one was quite
sure, at first, how to approach the austere Hitler, but it was abundantly
clear that the way to Goering's heart was through his collections.

Released from years of living hand-to-mouth in exile, Goering wanted
it all, and fast. He denied himself nothing. By 1936 he was Prime Minis-
ter of Prussia, head of the Luftwaffe, director of the Four-Year Plan, and
official successor to Hitler. The salaries of all these posts flowed into his
accounts. In 1934 he had obtained government funds to start the construc-
tion and furnishing of a country house fifty miles from Berlin. This was in
addition to the refurbishment of the in-town villa which served as his of-
ficial residence as Prime Minister of Prussia. The latter house, safely shel-
tered behind government buildings in the Leipzigerstrasse, was described
by Speer as "a romantically tangled warren of small rooms, gloomy with
stained glass windows and heavy velvet hangings, cluttered with massive
Renaissance furniture. There was a kind of chapel presided over by the
swastika, and the new symbol had also been reiterated on ceilings, walls
and floors throughout the house."[19] The palatial effect was completed by
two Palma Vecchios, a Jan Breughel *St. Hubert,* and five other very nice
pictures "lent" by Berlin's Gemäldegalerie. Speer felt that this decor
"rather fit Goering's disposition," but when Hitler criticized it as "too
dark," Goering immediately ordered Speer to do the whole thing over in
the light and bare style favored by the Führer, complete with enormous
study and oversize furniture designed to intimidate the visitor. Still, the
baroque in Goering's character could not be entirely denied, and he kept a
few objects about, such as a huge Rubens *Diana at the Stag Hunt,* also bor-
rowed from the museum, which he used to cover up his movie screen.[20]

At the country house, named Carinhall in memory of his wife, Goering
did not concede anything to Hitler's style, but indulged his love of excess
to the hilt. The house, which started as a rather elaborate log cabin, was
constantly added to, until it reached Versailles-like proportions. To justify
this display, he promised that the house and its contents would eventually
be given to the German nation. Here, frequently toying with policies quite

divergent from those of his Führer, the Reichsmarschall would receive dignitaries, foreign and domestic, and proudly show off his possessions. His costumes at these meetings were outlandish, ranging from forester to sultan, with an extraordinary range of specially designed uniforms, covered with medals and tending to pastel shades of white, blue, and gray. He loved jewelry, often wearing several very large diamond and emerald rings on each hand, and kept a pot filled with more diamonds on his desk to play with. Not everyone was favorably impressed by the spectacle. The American special envoy Sumner Welles, sent to Europe in March 1940 in a last-ditch effort to stop the spreading conflict, was contemptuously driven out to Carinhall in a drafty, canvas-covered touring car. After his interview, he wrote:

> Goering insisted upon showing me the vast and innumerable rooms of his palace. It would be difficult to find an uglier building or one more intrinsically vulgar in its ostentatious display. The walls of the reception rooms and of the halls were hung with hundreds of paintings. Many examples of the best Italian and old German masters were placed side by side with daubs by modern German painters. He had made a specialty of collecting Cranachs. Two of them I recognized as being from the collection in the Alte Pinakothek in Munich. . . . In the entrance hall, lined . . . with glass vitrines, there were displayed gifts presented to the Marshal by foreign governments.[21]

Goering's interests were not limited to paintings, jewels, and objets d'art. "Renaissance man" that he was (or at least would later call himself), he also collected rare animals—bison, elk, and lions were apt to greet one at Carinhall. He had yachts, books, and toy trains, and his collection of houses soon numbered eight.

By 1937 Goering's art operations were very well organized. His early, disparate purchases from Sepp Angerer, a carpet and tapestry merchant who reported finds from his travels around Europe and was useful as an agent, and various other Berlin firms including that of the ubiquitous Haberstock, were now coordinated by a former small-time dealer, Walter Andreas Hofer, hired as a full-time curator. Frau Hofer, a restorer who had once worked for Duveen in New York, kept the collection in condition.

After Goering had received a few unsuitable birthday presents, which his dealers had had to sell, even this aspect of his life was systematized. Hofer would leave a list of desired objects, at different price levels, with prominent dealers such as Walter Bornheim of Munich.[22] All the prospective donor had to do was send a check to an "Art Fund" which Goering had set up especially for this purpose. One who did this on a truly princely

The interior of Carinhall: a few of Goering's choice acquisitions

scale was Philip Reemtsma, who controlled Germany's cigarette production. His donations came to some million marks a year, possibly in gratitude for Goering's pardoning of major tax liabilities he had incurred before 1933. The carefully kept records of donors list many others of all varieties from the city fathers of Cologne to Prince Bismarck, who gave Frau Goering "a single decorated goblet."[23] By early 1938 Goering's collections had far surpassed those of his Führer, but this was soon to change.

In the early hours of Saturday, March 12, 1938, German troops crossed the Austrian border, followed later that afternoon by Hitler himself, who was received with wild rejoicing all along his route. For the Führer, overcome with emotion, it was the fulfillment of one of his fondest dreams: the union of his native land, corrupted by the decadence of the Hapsburg monarchy and its dangerous flirtations with the Slavic civilization to the east, with the soon-to-be pure German Reich which he now ruled. This triumph was also the culmination of several years of mostly subversive political and diplomatic effort which had reached a frantic pitch in February 1938.

As Hitler responded to the enveloping crowds in Linz, his childhood home, he was met by his handpicked successor to the Austrian Chancellery, Dr. Arthur Seyss-Inquart. Then and there, to the Austrian's sur-

prise, Hitler insisted on preparing the legal documents which would trans-
form the Austrian nation into an integral part of the Reich, henceforth to
be referred to as the Ostmark. The next day, forced to linger in Linz by the
embarrassing breakdown of large numbers of German tanks and trucks
which had completely blocked the roads to Vienna (indeed, the British
ambassador to Berlin described the whole invasion as "a slovenly perfor-
mance"[24]), Hitler made the best of things by laying a wreath on his par-
ents' nearby grave and meeting with the director of the Linz Provincial
Museum to discuss plans for rebuilding the town, which, along with Mu-
nich, Nuremberg, and Berlin, was to become one of Germany's "ceremo-
nial cities."[25] It was not until Monday, March 14, that an irritated Hitler
was able to make his triumphal entry into Vienna, the armored vehicles in
the parade having been rushed to the city on railroad flatcars.

It was not a happy day for everyone. In the middle of the night of March
11–12, Heinrich Himmler and his SS staff had flown to Vienna to super-
vise "security" arrangements. The borders were sealed.[26] Using intelli-
gence carefully gathered in the previous months, plus Austria's own files
on political undesirables, the SS imprisoned thousands, first at Dachau
and later at a new camp at Mauthausen. The Austrian Nazis, catapulted
into power, now revealed a degree of vicious anti-Semitism which sur-
prised even the Germans. Historian William Shirer, in Vienna for CBS, de-
scribed the scene:

> On the streets today gangs of Jews, with jeering storm troopers stand-
> ing over them, and taunting crowds around them, on their knees
> scrubbing the Schuschnigg signs off the sidewalks. Many Jews killing
> themselves. All sorts of Nazi sadism, and from the Austrians it sur-
> prises me. Jewish men *and* women made to clean latrines. . . .[27]

Along with humiliations of this nature came the blatant looting of Jew-
ish personal property from shops and houses. This too went far beyond
anything which had thus far taken place in Germany. The magnificent col-
lections of Vienna's prominent families were among the first to go. Baron
Louis de Rothschild was forcibly returned to his Vienna residence from
the airport as he tried to leave on March 12, and jailed later in the day. His
arrest was unusual: the first SS officers sent for him were told that the
Baron was at table, and were asked to make a later appointment. They
obeyed.[28] A few hours after his incarceration, his cell is said to have been
supplied by his valet with all the comforts of the Rothschild home, from
tapestries to orchids. But the Nazis were deadly serious. The collections
of Baron Louis's brother Alphonse, who had left the country only days be-
fore, were immediately confiscated, as were the paintings and library of

Baron Gutmann, the Bloch-Bauer porcelains, the Haas, Kornfeld, Trosch, Goldman, and Bondy collections, and many more. Shirer, trying to get to his own apartment near the Rothschild palace, saw the first things being taken away:

> We almost collided with some SS officers who were carting up silver and other loot from the basement. One had a gold framed picture under his arm. One was the commandant. His arms were loaded with silver knives and forks, but he was not embarrassed.[29]

Less prominent families fared no better. Those who had managed to flee before the borders closed left houses full of possessions behind, which were quickly stripped by SS troops or the neighbors. Those who remained were soon required to register their property with the Gestapo, thus providing excellent inventories for future confiscation. No one could be trusted. Dealers, conservators, and friends suddenly revealed a new allegiance. Customs and shipping agents broke open packed cases and removed valuable items. It was Goering who had personally ordered the sealing of the borders. Although it was avowed Nazi policy to encourage Jewish departures, the demand for funds under Goering's Four-Year Economic Plan was too great to allow their considerable assets to slip away.

In the next year and a half, before the outbreak of war, more than eighty thousand Jews would be allowed to leave Austria, but only by buying their way out. Exit visas could be obtained by surrendering one's possessions to the Office of Jewish Emigration, organized under the aegis of Karl Adolf Eichmann. Strict application of all the German racial laws and increasing imprisonments encouraged participation in this program. The expropriation of Jewish property was made even more torturous by requiring reams of paperwork, multiple notarizations, and visits to different agencies. The American Consul General in Vienna observed in July:

> There is a curious respect for legalistic formalities. The signature of the person despoiled is always obtained, even if the person in question has to be sent to Dachau in order to break down his resistance. The individual, moreover, must go through an endless series of transactions in order to liquidate his property and possessions, and proceed abroad penniless. He is not permitted to simplify matters by making everything over en bloc to the state.[30]

By the fall of 1938 Eichmann's office was requiring the completion of three hundred dossiers daily, a nearly impossible demand given the shocking reluctance of other countries to issue entrance visas.

The liquidation of the Rothschild properties was particularly protracted.

Because of the multinational character of their holdings, it took a year of negotiations to satisfy the Nazi mania for the "legal," during which time Baron Louis remained in prison. In the eyes of the Reich Finance Ministry, the art collections were inextricably bound up with the rest. When at last the final signatures were affixed and Baron Louis was released, the Ministry initiated proceedings to sell off the works of art at auction in order to satisfy tax claims.[31]

In the meantime, thousands of German officials and entrepreneurs poured into Austria to take over government posts and dispossessed businesses and to celebrate the Anschluss with sprees in the restaurants and shops of Vienna. Albert Speer, repelled by the frenzy, limited himself "to buying a Borsalino."[32] The influx left no doubt as to who would really be in charge in Austria. It was an unpleasant revelation to Chancellor Seyss-Inquart and his newly appointed State Secretary for the Arts, Dr. Kajetan Mühlmann, a sometime Goering confidant, both of whom had been intimately involved at the highest levels in the traitorous negotiations which had brought down the Schuschnigg government. Over their heads Hitler immediately installed a German "Reichskommissar," Joseph Buerckel, thereby rendering the Seyss-Inquart administration virtually powerless.

Delicious pastries and Borsalinos were not all some Party members wanted from Austria. The mayor of Nuremberg had a much bigger dream: the crown jewels of the Holy Roman Empire. The thirty-two spectacular objects, which included Charlemagne's bejeweled prayer book, several sceptres, orbs, swords, reliquaries, jewel-encrusted gloves, and other coronation arcana, had been kept in Nuremberg for some four hundred years before they were taken to Vienna in 1794 to save them from Napoleon. There they had remained, enshrined at the Hofburg, since the dissolution of the Holy Roman Empire in 1806.

As early as 1933 Mayor Liebl had plaintively revealed his desires in a speech welcoming Hitler to his city. For the 1934 Party congress the mayor had reproductions brought to Nuremberg, after a vain attempt to borrow the real things. Immediately after the Anschluss the curators of the Germanisches Museum prepared a report enumerating which items had been "plundered" over the years, and which, in particular, had been removed from Nuremberg in 1794. And by June 1938 Liebl had written to the Reichschancellery saying that it was the "Führer's wish" to have the regalia at the next Party congress on September 6, and that arrangements for its transfer should begin immediately. The city of Nuremberg paid for a heavily guarded special train and gourmet meals for the escort. Liebl must have been disappointed that Hitler had decided only the week before not to take part in the acceptance ceremony. Alas, the mayor's long-hoped-for moment

of glory had coincided with some of history's most dramatic weeks: Hitler's takeover of the Sudetenland, and the Munich Conference.[33]

Meanwhile, the confiscated collections were being stacked up at the Hofburg and the Kunsthistorisches Museum. Seyss-Inquart urged Hitler to distribute them quickly, as the accumulation of such valuables was inciting "various desires."[34] The attraction of this treasure trove was tremendous. According to several sources, "a consortium of three Jews" representing Lord Duveen, possibly sent at the behest of the exiles themselves, had contacted Mühlmann in the summer of 1938 and offered £1 million for the Alphonse Rothschild and Gutmann collections. Others were also interested, so much so that the new director of the Kunsthistorisches could not be sure if it was "a competition between Duveen, Fischer of Lucerne and German dealers, or an alliance between them."[35]

These overtures were rejected by Goering, who was negotiating the takeover of the Rothschild industries, and who had his own eye on the works of art. In early 1939 Karl Haberstock too appeared in Vienna claiming to be Hitler's "commissioner for Jewish collections." Mühlmann, closer to Goering than to Hitler, and hoping to keep the collections under his own control, "showed him the door" and told Martin Bormann that he and all the staff involved in cataloguing the confiscated works would resign if Haberstock were given control. Bormann replied that the Führer would come to Vienna and see the collections for himself before deciding their fate. In the meantime, Mühlmann was to draw up a plan for dividing them; when Hitler viewed the repositories in June 1939 Mühlmann presented a plan which would keep the whole lot in Austria. A short time later he was fired for being too pro-Austrian. Quite another fate awaited the now "ownerless" objects.[36]

Hitler by now had his own dream. For years he had done little sketches for new buildings for the town of Linz. His visit there en route to Vienna had confirmed his determination to turn the city into a "German Budapest," and much had happened since then to focus his vague ideas. In May 1938 he visited Mussolini in Rome, one of his first forays outside the Germanic world. The artistic and architectural glories of the Eternal City made Berlin seem inadequate to the Führer, though he must have felt some satisfaction at the thought that his architects were already at work on plans which would transform Berlin into a city of such monumentality that it might eventually eclipse the Italian capital.

His tour of smaller-scale Florence, where he was welcomed by cheering crowds lining the decorated streets, made him feel much better. He was the

Rome: Hitler and Mussolini, accompanied by Goebbels and Himmler, tour the Borghese Gallery (Photo by Heinrich Hoffmann)

more deceived: rumor had it that the city fathers had used most of the money sent from Rome for the ceremonies to improve the sewer system.[37] Hitler exhausted his Italian host by spending four hours in the Uffizi. Mussolini, trailing behind, was heard to murmur in exasperation, "*Tutti questi quadri* . . . [All these pictures . . .]." Their guide, the anti-Nazi director of the German Art Institute, Dr. Friedrich Kriegsbaum, tried to keep the Führer moving along, fearing that Mussolini might give Hitler something he particularly admired, such as Cranach's famous *Adam* or *Eve*.[38] This trip made abundantly clear to Hitler that Germany's existing public collections would not suffice to adorn the multiple new museums being planned for Berlin and Linz.

The confiscated Austrian collections instantly came to mind. In addition to these, large quantities of objects were becoming available in Germany itself. In the months following the Anschluss, perhaps as a result of events in the Ostmark, pressure on the Jews of Germany greatly increased. On April 26, 1938, a decree was issued requiring them to report their assets, but this did not yet include personal property. Arrests and anti-Semitic violence in the streets increased all during the summer and fall, culminating

in the hideous and carefully orchestrated events known as Kristallnacht, which took place in the dark hours between November 9 and 10. Now the personal possessions and businesses of the Jews were fair game.

Confiscation of private property was openly organized. In Munich, Gauleiter Wagner called together the directors of the state collections "for a conference about the safekeeping of works of art belonging to Jews." The museum officials were told that teams of Gestapo officers and art experts, dealers, or curators were to carry out the confiscations. The hall of the study building of the Bavarian National Museum was requisitioned for storage; only the Gestapo had the key. Large objects were to be left in the houses; coins and jewelry would be taken over by the Gestapo itself. The victims would graciously be allowed to keep family portraits. "Protocols" were to be typed in the presence of the proprietors, who could make notes but would not receive a copy or a receipt. Hundreds of these documents survive in the National Archives of the United States. They make sad reading:

> 25 November 1938. Protocol, recorded in the residence of the Jew Albert Eichengrun, Pilotystr. 11/1, presently in protective custody. The housekeeper, Maria Hertlein, b. 21/10/1885, in Wilpolteried, BV., Kempten, was present. Dr. Kreisel, Director, Residenzmuseum, and Criminal Investigators Huber and Planer officiated.[39]

From this house five nineteenth-century German paintings were sent to the depot, where another museum official signed a receipt. On the same day, at the "residence of the Jew Moses Blum, his wife Frieda Moses being present," fifteen paintings were registered, and picked up the next morning by a local moving company. Some were luckier: three faience platters taken from Dr. Ernst Darmstadter on January 18 were returned as being of "no cultural value." A series of laws passed ex post facto over the next few years would "legalize" these procedures and change the status of the objects from "safeguarded" to "confiscated." To speed emigration of the still reluctant, an organization based on Eichmann's successful example in Austria was set up under the equally infamous Reinhard Heydrich. All sorts of ingenious schemes were devised to hide, sell, or export possessions, but by now, for most, it was much too late.

And there was more: just one year after the Austrian windfall, the inventory of objects was increased by the taking of the rest of Czechoslovakia. Here the confiscations were not necessarily limited to the non-Aryan. The Czechs were not fellow Germans, but Slavs. Insufficiently Germanic private and public collections could be taken to benefit the master race. The library of Prague University, the Czech National Mu-

seum, the palaces of the "decadent" Hapsburg Archduke Franz Ferdinand, Count Colloredo, and Prince Schwarzenberg, and the Lobkowitz collections of armor, coins, and paintings (including Breughel's famous *Hay Harvest*) were all eventually raided, and the Bohemian crown jewels joined the Holy Roman regalia in exile. In an attempt to legitimize this expropriation, the jewels were handed over by President Hacha of Czechoslovakia in an elaborate ceremony staged by the Nazis. But an official photograph tells all: the tiny, frail President stands sadly before the dazzling display, flanked by the newly named Reichsprotektor of his country and other Nazi officials, who tower over him, splendid in their dashing uniforms.

By the early summer of 1939 the Führer had realized that the burgeoning storerooms of confiscated art and the greedy dealers and officials hovering about them must be dealt with in an organized fashion. On June 26, 1939, from Obersalzburg, Hitler authorized Hans Posse, only recently back in control of the museum in Dresden, to "build up the new art museum for Linz Donau."[40] From this moment on, there ceased to be any distinction between Hitler's personal possessions and those destined for Linz.

Posse was an excellent choice for this job, a totally professional art historian and an aggressive acquisitor. Not interested in politics but without any doubts as to the greatness of Germany, he threw himself into the already monumental job of sorting out the available works. He was backed by a large staff, and had access to the highest levels of the government and to virtually unlimited funds. The first appropriation for Linz in 1939 was RM 10 million; by December 1944 the total had reached 70 million.[41]

All during its existence, the Linz organization remained under Hitler's direct control. Until he died in 1942, Posse corresponded almost daily, in minute detail, with Martin Bormann. A great percentage of the letters are marked in Bormann's writing: "shown to the Führer." On July 24, 1939, Bormann informed Reichskommissar Buerckel and other authorities that all confiscated collections in the newly conquered areas were now to be kept intact so that Hitler himself, or his curator, could choose what they wanted for Linz.[42] A bit later, just to avoid loopholes, he wrote again to say that "safeguarded" as well as "confiscated" collections were included in this order. The resulting mass of objects was henceforth known as the Führervorbehalt (Führer Reserve).

It took a little time for this arrangement to sink in. As late as November 1939 Goering's secretary was forced to write several times to the Viennese administrators of confiscated goods, to make clear that her chief "upon orders of the Führer . . . will have to desist from the purchase of secured art

objects."[43] Bormann had also immediately written to a Munich official to tell him to look for "several very large spaces in which the art treasures for the new Linz galleries can be stored, as a large number of paintings—four to five hundred— would soon be arriving from Vienna." Hitler himself wondered if a suitable schloss could be found in which the pictures would not be crowded together, as they now were at the Führerbau, but might be arranged "more like a gallery."

So varied were the works already assembled by 1939 that subordinate curators had to be appointed for armor, coins, and books. The plans for Linz soon expanded exponentially, from one

Hans Posse: Hitler's grand acquisitor

museum for nineteenth-century German art to a complex with separate buildings for each discipline. By late October, Posse had won a few bureaucratic battles. With the backing of his colleague Fritz Dworschak, director of the Kunsthistorisches Institut in Vienna, he had managed to get the Führer to authorize the separation of the Rothschilds' art collections from the rest of their assets and their inclusion in the Führervorbehalt. He had also looked through all the Vienna pictures and chosen 182 for Linz and 43 for other provincial Austrian museums. Forty-four more were designated for the Kunsthistorisches, a proposal later rejected by Hitler, who stated that Vienna, which he had always hated, "already has enough works of art, and it is right to make use of these art objects for Linz, or as a foundation for other collections."[44]

Posse also now had to deal with the objects which had been confiscated in Germany itself. In Bavaria, those gathered by the Gestapo teams had already been sorted out according to medium and quality. The best pictures were put on exhibition at the Munich Association of Artists, in the former premises of the well-known Jewish firm of Bernheimer, much of whose stock was included. Hitler and Posse both visited the gallery, and made their choices for Linz. It was then opened up to representatives of the German museums, who were allowed to keep their choices as "loans from the State." What remained was made available to dealers or sold at auction.

After this first show, the museums were obliged to buy what they wanted from the confiscated stocks, using money from their regular acquisition funds, special grants from the Ministry of Culture, or cash raised by selling off lesser museum holdings. The proceeds went, for the time being, into a special Gestapo account.[45]

Keeping control of all the confiscated objects at home was not easy. The SS, Gestapo, Finance Ministry, Reich Chamber of Culture, local Nazi organizations, museums, and others were all happily carting things away, or making plans and claims for them. The temptation to do a little dealing was overwhelming. Posse, who hated the idea that anything might escape him, wrote anxiously to Bormann in May 1940 to say that in various provinces of the Reich, officials were disposing of confiscated objects on their own. The valuable collection of the "expatriate" Dr. Fritz Thyssen, an early supporter of Hitler who had seen the light and fled abroad, was about to be divided up by the Rhenish museums, he complained, and the Goldschmidt-Rothschild collection had reportedly been sold to a private collector. Posse implored Bormann to ask Hitler to reserve the same exclusive rights to all confiscated collections in Germany for himself, as he had in the occupied areas.[46] This was not done until much later—but of course things got to be rather busy at the Reichschancellery in the spring of 1940.

Meanwhile, the energetic Posse had sifted through all the works in the Führervorbehalt and made his choices. For Linz it was nothing but the best. By July 1940, 324 paintings had been selected from the hundreds presented for his inspection, and 150 more chosen as a reserve. These included most of the pictures previously acquired on the market by Hitler. Although there were some impressive items, the collection was not yet in the class of those of the great museums and was top-heavy in the genre paintings that Hitler loved. To remedy this, Posse had already started to buy from dealers and collectors in Austria and Germany. He snapped up the drawings collection of the late Prince Johann Georg of Saxony in Leipzig, found a Waldmüller portrait of young Prince Esterhazy for "the exceptionally low price of RM 10,000," and bought 37 more works by Rubens, Hals, Lorenzo Lotto, and Guardi.[47] But he was hoping for much, much more.

In a report cleverly designed to fuel Hitler's competitive collecting instincts and lead him beyond his limited tastes, Posse set out his plans for Linz. Even with the vast funds at his disposal, he sadly recognized that it would be impossible to gather together an in-depth collection ranging from the prehistoric to the modern. The early German period would have

to be limited to a "small but elegant" collection, an attitude which may have reflected Posse's reluctance to tangle with Himmler, whose specialty this was. The Romanesque and Gothic periods, however, should be greatly increased "from the holdings of the monasteries of the Ostmark," which could also supply objects for the German Renaissance galleries. For this reason "removal of works from the monasteries should be carefully monitored in future." Posse had in mind, among other things, the great altarpiece by Altdorfer at the Monastery of St. Florian. He wrote that they could hardly hope to get works by Dürer, Holbein, or Grünewald, but that there were plenty of Cranachs available. The seventeenth-century Dutch school was already strongly represented, but major works by Rubens, Rembrandt, and Vermeer, plus some sixteenth- and seventeenth-century Italians, were needed to "round off the collection." There was one bright spot: they could do a nice French gallery with the paintings, furniture, and tapestries already at hand, supplied almost entirely by the Austrian Rothschilds. To flatter Hitler, Posse hastened to conclude with the promise that the *Hauptabteilung,* or central collection, of the museum would, of course, be the "valuable collection already assembled in Munich," i.e., Hitler's favorite nineteenth-century Germans.[48]

Posse knew exactly which pictures he wanted and where they were. He and his chief would stop at nothing to get them. The Vermeer Gap was the first to be filled. Negotiations for this prize went on for nearly a year and Posse almost lost it to Goering. The picture, which represented an artist in his studio, belonged to two brothers, Eugen and Jaromir Czernin, and had been exhibited to the Viennese public for years in a gallery belonging to the family. Previous offers from such majors as Duveen and Andrew Mellon, said to range from $500,000 to $6 million, had been blocked by the refusal of the Austrian courts to allow the picture to leave the country. Now that the Anschluss had made Germany and Austria one, this barrier no longer seemed a problem, at least to the rulers of the Reich.

In December 1939 Count Jaromir Czernin, who was the majority (60 percent) owner of the picture, received a new offer of RM 1.8 million from Philip Reemtsma, the German cigarette mogul who had been supporting Goering's Art Fund so generously. This supposedly private offer was accompanied by a telegram from Goering authorizing the transaction. The director of the Austrian Monuments Office, Dr. Plattner, was not pleased. He immediately appealed to Hitler to block the private sale of a work so beloved by Austrians and tourists alike, which had been officially reconfirmed as a national treasure subsequent to the Anschluss. In his letter he stated, as he must have regretted later, that the Vermeer should only be sold to a "state museum," clearly with the Kunsthistorisches in mind. He

then made the mistake of saying that Vienna's cultural life should not be further diminished "so soon after the removal of the Holy Roman Regalia to Nuremberg."

Plattner had also expressed his opinion to Goering's chief of staff, who had retorted that Reemtsma, "who had already given the Reich a great deal, would surely offer the picture to a museum if given the opportunity." Before any action could be taken Plattner was furiously denounced by Gauleiter Buerckel, who said that he could not permit anyone in his service to interfere in the business of Marshal Goering. He then ordered Plattner to release the painting and send it to Reemtsma in Hamburg. In the meantime, Hitler's staff had consulted the German Ministry of Culture, which backed Plattner, noting that the Vermeer was mentioned in the Baedeker, and that without it the Czernin Gallery would be worthless. Buerckel was advised by telegram that the Führer wished the picture to stay in the Czernin Gallery and not be moved without his personal permission. To save some dignity, Goering also wired Buerckel to say that he had had no idea that it was for sale and that his chief of staff had "mistakenly sent off the telegram before I saw it." The wire thanked the Gauleiter for his loyalty. The Vermeer would have been a nice present for Goering's birthday, which was only a few weeks off.

A month later, stimulated by this success, Plattner wrote to the Reichschancellery again, proposing in a rather flowery letter that the painting be bought for the Kunsthistorisches, which, although it was a great museum, had not one Vermeer. He suggested that the Czernins might lower the price if they were forgiven certain taxes or were paid with land in Czechoslovakia. Cash could be raised by selling the confiscated collection of the Czech Jew Oscar Bondy, worth over RM 1 million. Plattner felt that Count Jaromir Czernin would be pleased by the "state" purchase. The only trouble was that Plattner had the wrong museum. Hitler wanted the picture for Linz, not Vienna, though he did not say so.

Plattner was ordered to ask for an exact price, which he put at RM 1.75 million. In late April 1940 he asked for a subsidy of RM 750,000 from the Führer so that he could close the deal and "enter the picture in the Kunsthistorisches's inventories." By July, not only had no funds arrived from Berlin, but the Bondy collection, instead of being sold, as Plattner had hoped, had been made part of the Führervorbehalt. Hitler would have to come up with the whole price, which he considered high. He now had the Czernins investigated for outstanding tax liability, to see if they could be forced to auction the Vermeer, but could find none. There was another problem: Eugen Czernin did not wish to sell, and a special envoy had to spend three days convincing him that resistance was useless. It was not

until September that Hitler authorized Posse to buy the picture. The contract was signed on October 4. There was no mention of Linz in any of the documents. Indeed, on October 7 Reichschancellery assistant Hans Lammers wrote that the "question of whether or not the work will be assigned to Vienna is still open." It was not very open. The painting was secretly taken to the Führerbau in Munich by Dworschak on October 12, where it was immediately given Linz No. 1096 by registrar Hans Reger. The financial details were not settled until more than a month later. Once the money was in the bank Count Jaromir Czernin wrote a gushing acknowledgment on his elegant blue notepaper with its little seal and crown. For him there seemed to be no mystery about the destination of the Vermeer. His deepest thanks were augmented by the "wish that the Picture may, My Führer, always bring you joy."[49]

Posse would soon be able to begin buying all over Europe at this level. The powers he held would be the dream of any museum director whose acquisitions are limited, in the normal course of events, by lack of funds, reluctance of owners to sell, and the need to convince boards of trustees or Ministries of Culture of the need for a particular item. Posse had none of these problems: there was no end to the money, and pressure of an unpleasant nature could be applied to reluctant sellers.

It is rare for a museum to acquire more than two or three major works in a year, unless it happens to get a whole collection. Washington's National Gallery of Art opened in 1941, just as Linz was getting started, with 497 paintings. Fifty years later, the vastly expanded museum has about 3,000. Amsterdam's Rijksmuseum has 5,000. Posse's total of 475 paintings for his first year was, therefore, impressive. By 1945 it would be an incredible 8,000, not counting those acquired by other Nazi agencies, which he and his successor could call in at any time.

Despite their determination to maintain business as usual, those responsible for Europe's museums were very aware of the imminence of war and could not ignore the happenings in the nations annexed by the Reich. They did not always have an easy time convincing their governments that precautionary measures were necessary. Uppermost in their thoughts were the increasing dangers of long-range artillery barrages and aerial bombs, which had been the principal causes of damage in World War I. As early as 1929 the Dutch Minister of Education had requested a study of plans to protect his national collections, and a British committee had begun discussions of air-raid precautions in 1933. There was still no sense of urgency. But events in Madrid in the fall of 1936 dramatically focused curatorial thinking.

At the outbreak of the Spanish Civil War, which was to become a testing ground for the latest models of weaponry produced by the supporters of each side, the Prado's collections had been taken down and stored in interior galleries on the lower floors. Large paintings such as Velázquez's great *Lanzas* were rolled and carefully packed. Although the Prado had no underground storage, everything seemed quite safe in the darkened ground-floor areas.

On October 21 news came that the Escorial, the monastery-palace only thirty miles from Madrid, was under attack. Museum officials rushed out to evacuate its galleries and library. As planes bombed the local hospital and strafed the roads, packers, curators, and the mayor of Escorial himself worked frantically, rolling El Greco's huge *St. Maurice* onto a wooden cylinder, and packing van der Weyden's *Descent from the Cross* and dozens of other masterworks into a truck which took them to Madrid, where space had been cleared for them in the Bank of Spain. Defeated by the narrow, six-foot-wide opening to the vaults, the exhausted rescue team went on to the Prado.

Two weeks later the bombs began to fall on the roofs and garden of the museum itself. All around, buildings including the Palacio de Liria, containing part of the collections of the Duke of Alba, lay in flames. The Prado did not burn, but all its windows were broken, and the upper galleries were filled with glass and debris. As the bombing continued, the curators, horrified by the destructive power of the new incendiary bombs and the great range of the aircraft, decided to send their most important paintings to Valencia, where the established government had already fled. Wood for packing cases had to be brought in an armored train from a lumberyard near the front lines. At dawn a few days later, Velázquez's *Las Meninas,* Goya's "Black" paintings and *Disasters of War,* and three hundred other major works left in trucks surmounted by "enormous castles of wood" to cross Don Quixote's old territory on their way to Valencia. The motorcycle escort was told of the marvels they guarded. Every hour, mayors and citizens along the route telephoned back to report on the safe arrival of the convoy to the anxious museum staff in Madrid, who followed its progress all through the night and into the following day. A year later the collections had to be moved again, to the Castle of Peñalda, near Barcelona.[50]

Galvanized by the Spanish operations, and mindful of the too hasty evacuation of the Louvre's holdings to Toulouse late in World War I, when an invasion of Paris had seemed imminent, the French began immediate planning. Preparations of the most meticulous nature were well under way by 1937. Lists were drawn up of all important works in the museums of Paris

and the provinces. Each French département was surveyed for châteaux, abbeys, and churches suitable for storage. Evacuation routes were carefully planned. The works would go first to staging depots and from there be spread among the designated refuges. These were chosen both on the basis of their distance from the presumed front, which would, according to French military thinking, be at the Maginot line, and their proximity to England, to which the collections could be quickly evacuated in case of total disaster.[51]

In 1938, as the Czechoslovakian crisis deepened, the Service d'Architecture des Monuments Historiques started stockpiling sandbags and lumber. Two thousand specially fitted cases were built for the most valuable pictures in Paris, which were adorned with dots of different colors according to their importance. Arrangements were made with packing companies for trucks, and lists of expert workmen were compiled. Special attention was lavished on the great stained glass windows in the cathedrals of the north of France. Hard cement surrounds were replaced with a soft putty-like material so that the windows could be removed quickly and be gently packed into the special case assigned to each one.[52]

British museum directors also had begun preparations in 1938. They too planned the removal of objects to repositories in the northwest of the country, principally in Wales, but, unlike the French, the British intended to rely almost entirely on their rail system. This limited the choice of sites. Kenneth Clark, then director of the National Gallery, wrote:

> The difficulties were great. The house had to be near a town and a station, but remote, as far as we could then suppose, from any target that might invite air attack. It had to be strong and dry; and above all it had to have one door or window big enough to allow the passage of the largest [367 × 292 cm] picture in the gallery, Van Dyck's *Charles I on Horseback*.[53]

One of the few places that met these requirements was Penrhyn Castle near Bangor, which was reserved for the big pictures. In London itself, unused sections of the Underground were set aside for storage. Military planners, convinced that England would be invaded immediately, advised armed escorts for the trains. At the National Gallery, the frames of the larger pictures were specially cut so that the paintings themselves could be pulled out quickly and rushed to their packing cases in the basement. After many drills, a big gallery could be emptied in seven minutes. For things which could simply not be moved, such as Raphael's enormous, fragile cartoons at the Victoria and Albert, ingenious and bizarre protective structures were built right in the museums.[54]

The Munich crisis gave everyone a little practice. At the Tate, in Lon-

don, major pictures were taken down and replaced by similar but lesser ones. The National Gallery was closed, section by section, and the pictures removed. Before the crisis ended, several carloads had reached Wales. The Louvre pictures were sealed in their cases too, and the *Mona Lisa* was rushed to Chambord. In Holland (still relying on its neutrality), the report requested some ten years earlier was finally produced, but its suggestions for shelters to be built under the Mauritshuis and the Rijksmuseum were rejected as too expensive. Officials were merely advised to put things "in the safest place in each building."

Nineteen thirty-nine did not begin in an encouraging manner. The plight of the exiled Prado pictures again gave the museum world a foretaste of what was to come. As the Civil War had closed in around Barcelona, the collection had been moved several times to more and more remote areas. Now it was cornered between the two belligerents in rock quarries near the village of Figueras only a few miles from the French border. The desperate guardians managed to send an appeal for help to museum administrations in London and Paris. Messages were transmitted to General Franco through the Duke of Alba in London, imploring him to halt bombing operations near Figueras so that the pictures could be removed. Franco agreed. In an extraordinary international effort, a Committee for the Salvage of Spanish Art Treasures, cooperating with the League of Nations, as well as French and British cultural agencies, and backed by private money raised in little more than twenty-four hours from collectors in Europe and America, organized a truck convoy to move the collection to France. There the precious cases were loaded on a special twenty-two-car train and taken to Geneva, where they were exhibited in a show not likely to be equalled, for these are things which never normally travel, and certainly not en masse: all the great Velázquezes, Bruegel's *Triumph of Death,* 26 El Grecos, 38 Goyas, Dürer's *Self-Portrait:* 174 paintings in all.

Anyone who could, from Kenneth Clark and Bernard Berenson to Matisse and Picasso, travelled the long road to see it.[55] Late in August one of the last visitors, the Paris dealer René Gimpel, wrote in his diary:

> The conflagration is not far from bursting upon us. We have been here for forty-eight hours to see the Prado Exhibition. . . . Death hangs over our heads, and if it must take us, this last vision of Velázquez, Greco, Goya, Roger van der Weyden, will have made a fine curtain.[56]

A year later, Gimpel, a Resistance fighter, would die in a concentration camp.

The pace of preparation in the great museums intensified during the summer of 1939 and Europe's inexorable progress toward war. Everyone

Rembrandt's Night Watch
rolled for storage

feared that closing the museums would be a terrible blow to public morale, but the breaking point was reached with the announcement, on August 22, that a German-Soviet nonaggression pact was about to be signed. The National Gallery in London closed on the twenty-third. King George had stopped by to watch the packing at the Tate, which cleared its galleries one by one at midday on the twenty-fourth. Along with the trains taking millions of Londoners to safety went the Royal train, filled with the packed treasures of the capital, creeping along at ten miles an hour to keep vibration to a minimum. The Dutch museums got word of their colleagues' actions and immediately followed suit. The museums of Paris were authorized to close their doors on the afternoon of Friday, August 25. Like an enormous kaleidoscope, the treasures of Europe would soon be flung outward into a strange new pattern.

The careful preparations were now more than justified. Most of the British objects reached their designated refuges even before the formal declaration of war on September 3. By the fifth virtually everything of importance had been moved. In Holland, after dutifully putting some things in the storage areas of the museum, the director of the Rijksmuseum sent the *Night Watch* and his other most important pictures to a castle in

Medemblik, north of Amsterdam. The Mauritshuis availed itself of the vaults of a local bank, and in one of the most unusual solutions to the problems of protection, the Stedelijk Museum stored its collections on barges grouped on a canal near Alkmaar. On September 13, nearly two weeks after the outbreak of war, the Ministry of Education appropriated DFl 2 million for the building of shelters. The Belgians, more relaxed, also put their collections in their basements and vaults, but decided they might as well leave the Memling show in Bruges open, as it only had a few weeks to run.[57]

At the same time the carefully designed French plan was initiated. Orders to take down the stained glass windows were issued on August 27; within ten days more than eighteen thousand square meters of windows from the Sainte-Chapelle in Paris and the cathedrals of Bourges, Amiens, Metz, and Chartres were secured. At the museums, curators and technicians who had left for the sacred August vacation were recalled by telegram. Within hours the great gallery of the Louvre looked like a gigantic lumberyard. In the midst of boxes and excelsior, secretaries typed lists in quadruplicate of the contents of each case, marked only with numbers to disguise their contents, while the official assigned to each section coordinated the order of packing. One curator was amazed to find her packers, recruited from two department stores, the Bazar de l'Hôtel and the Samaritaine, dressed in long mauve tights, striped caps, and flowing tunics, as if they had just stepped out of the fourteenth- and fifteenth-century Italian pictures they were about to wrap.[58] As the ultimatums flew back and forth the pace increased. Many of the exhausted, dust-covered workers slept their few hours during the nights of September 1 and 2 in the Louvre itself.

On the afternoon of September 3 news of the formal declaration of war was announced to many of the Louvre staff as they stood in a group at the top of the staircase, around the great *Winged Victory of Samothrace*. They were informed that all the most important works must be out by that night. The *Victory* now had to descend the long staircase and be taken to safety:

> Monsieur Michon, then curator of the department of Greek and Roman antiquities . . . gave the order for the removal. The statue rocked onto an inclined wooden ramp, held back by two groups of men, who controlled her descent with ropes stretched to either side, like the Volga boatmen. We were all terrified, and the silence was total as the Victory rolled slowly forward, her stone wings trembling slightly. Monsieur Michon sank down on the stone steps murmuring, "I will not see her return."[59]

Paris: Winged Victory *descending a staircase (Photo by Noel de Boyer)*

Scenery trucks from the Comédie-Française had been brought in to move the biggest paintings. Although some had been rolled, Géricault's enormous *Raft of the Medusa* was too fragile for this treatment. The trucks moved off at six in the evening, just as darkness was falling. In the careful planning, which had included measuring all the bridges between Paris and Chambord, the trolley lines in the town of Versailles had somehow been overlooked, and the *Raft* became hopelessly ensnared in crackling wires. Magdeleine Hours, sent off in the total darkness to wake her colleagues at the Palace of Versailles, vividly describes in her memoirs the terrifying

task of finding the doorbell, somewhere on the vast entrance gate. In the end, the *Raft* and some of its companions were left in the Orangerie until chief curator René Huyghe could rescue them some weeks later, this time accompanied by a team of post office employees who carried long insulated poles to raise any threatening wires.

Through the night the precious convoys crept toward Chambord. It was not easy to keep them together. Most of the drivers had never driven outside Paris or at night, and the blackout forbade the use of headlights. The roads were also jammed with the populace of the city, seeking refuge beyond the traditional protection of the Loire. Military cars and travelling circuses were mixed with the rest. One curator looked at a passing van and recognized the insignia of the Banque de France on its door; pictures were not the only treasures leaving Paris. Just outside Chambord, the progress was further slowed by thick fog. A vehicle check revealed the absence of the truck containing all the Watteaus. The driver had followed a bicycle light in the fog, and come to a terrified halt only a few feet from the riverbank. Dawn was breaking as the convoy arrived at the great peaceful château.[60]

The exodus continued everywhere well into October, as lesser collections followed the masterpieces. By the first of November almost everything was where it was supposed to be, firefighting equipment was in place, sand spread on floors, hygrometers working, and guards and their families settling into their new country lives. Having little now to do, John Rothenstein, director of the Tate, whose job was still considered too important to allow him to join the Army, went off to the United States to promote the British cause. Kenneth Clark volunteered for work at the brand-new Ministry of Information. In France most of the male curators were drafted. Everyone was glad that the collections were safe. They could not know that the frantic days of packing and evacuation had only been a dress rehearsal.

III

EASTERN ORIENTATIONS

Poland, 1939–1945

Blitzkrieg it will be forever called: a revelation to the world, a sudden, devastating, preemptive campaign coming from nowhere. A strike which was over before anyone knew it, before Poland's supposed allies could bestir themselves. A perfect military operation, using surprising new techniques against the heroic but antiquated Polish forces. Film footage preserves for us the drama of lines of tanks rolling past dead horses, infantry with ancient rifles running from dive bombers, the elegant Prussian war machine at work, arrogant in its reclamation of areas taken from its control by the hated Treaty of Versailles.

Never had lightning been more carefully directed. The location and execution of the Polish campaign should not really have surprised anyone. In 1926 the obscure Hitler had written a whole chapter on "Eastern Orientation" in *Mein Kampf,* advocating expansion beyond the "momentary frontiers" of 1914 "to secure for the German people the land and soil to which they are entitled on this earth . . . if we speak of soil in Europe today, we can primarily have in mind only Russia and her vassal border states." He even foresaw "the general motorization of the world, which in the next war will manifest itself overwhelmingly."[1] All this was not taken seriously at the time, but by 1939 these ideas had become his firm policy.

For many months detailed plans had been ready at the German General Staff for this invasion, spelled out even down to the date in the famous "Case White" directive of April 3, 1939. For many more months, Hitler had kept relentless economic and diplomatic pressure on Poland by demands for access to Danzig, propaganda barrages at home, the expulsion of Polish Jews from the Reich, and unequal trade proposals, creating, as he readily admitted, "propagandist reasons" for the long planned attack.[2]

Hoping beyond hope, the Polish government waited well into the summer of 1939 to warn its citizens to prepare for war. A United States embassy cable reported the first precautionary measures on June 26. Landowners in the western provinces were advised to send their livestock

"to the interior," and to speed up the harvesting of cereal crops. "Secret advice" was sent "to all persons living in the aforementioned zone and possessing valuable works of art or other transportable factors of value, to move them gradually to the interior. Particular emphasis is laid on the necessity of conducting these movements in such a way as to cause the minimum attention and alarm amongst the local community." To the rest of the populace they only announced that each house in Warsaw should provide itself with a bomb- and gas-proof shelter by August 1.[3]

Perhaps with a sigh of resignation many of the Polish gentry once again sent their collections eastward to what they hoped was safety. The "continual need to rescue the evidence of ancient history and culture from the destructive power of the Partitioning Powers" (Austria, Prussia, and Russia) had kept Polish collections in a state of flux for nearly two centuries. Objects had repeatedly been carried off to Berlin or Russia, or been evacuated by their owners to Paris and Switzerland. The famous Czartoryski collections, consisting of more than 5,000 paintings, antiquities, porcelains, and graphics, were removed from the family-built museums in Goluchow (outside Poznan) and Cracow, and taken to the vaults of a country house at Sienawa. Into the darkness went Leonardo's *Lady with the Ermine,* Rembrandt's *Landscape with the Good Samaritan,* and Raphael's *Portrait of a Gentleman.* From many other country houses, such collections found refuge with friends and relations in the East or were sent to Warsaw's National Museum. The Tarnowskis, to be extra safe, sent twenty of their best pictures to the museum founded by the Lubomirskis in Lvov, where that family's magnificent collection of Dürer drawings was also kept. Others could not be bothered: Prince Drucki-Lubecki buried his silver in the basement, and Count Alfred Potocki at Lancut packed away the best things in the usual hiding places and left the rest where they were.[4]

For the state museums of Poland the need to store or evacuate their holdings was a particularly cruel blow. Warsaw, Cracow, and Katowice were still working out the problems of installation in the brand-new museums being designed to receive the reorganized national collections, much of which had been recovered from Russian confiscation only in the early twenties. Warsaw Castle, the residence of the President of Poland, and the Wawel Castle in Cracow had been splendidly restored and furnished thanks to state expenditure and private donations. Reluctantly, curators returned to the construction of packing cases. Museums close to the German border sent things eastward, but Warsaw itself was considered quite safe; there, objects were simply put in the storage areas.

This was perhaps the wisest decision from the curatorial point of view, when one considers the extraordinary peregrinations of the 136 magnifi-

cent hangings from Arras known as the Jagellonian tapestries, which had decorated the castle at Cracow. The series, depicting animal and biblical themes, had been commissioned by King Sigismund Augustus and given to the nation in 1571. These were evacuated just as hostilities began. By a miracle they arrived eventually in Canada. Count Raczynski, the Polish ambassador to London at the time, described just how:

> They arrived at the Embassy one day in a lorry. . . . There were seventy items altogether, consisting either of tin boxes or of bundles sewn up in cloth. They had been brought by the Curator and his assistant who, to their great credit, managed to get them away safely, first from Poland and then from France. They first of all shipped them down the Vistula on a barge from Cracow, which was bombed at Kazimiersz near Lublin; they then requisitioned some lorries and drove all the way to Roumania, whence they reached France via Italy. They tried to entrust the treasure to the Pope, but the Vatican refused for fear of political complications, so they took it with them to France. After the capitulation they succeeded, with the help of some Polish refugees, in loading the consignment onto a tramp steamer which brought it to England. . . . After a short respite, the zealous guardians were ready for a further stage of their journey: they secured a passage in July 1940 on the Polish ship Batory bound for Canada.[5]

As relations with Germany deteriorated, churches, synagogues, and monasteries dismantled their altars and cleared their treasuries. The Bishop of Pomerania ordered the most sacred objects of his diocese sent to Torun. Exquisite gold vessels, ancient vestments, and altarpieces were piled up in the city museum. In the Church of Our Lady at Cracow, the larger-than-life polychromed figures of the Veit Stoss altarpiece (which had been restored at great cost in 1933) were taken down from their towering framework and also floated by barge down the Vistula to the vaults of the Cathedral of Sandomierz. Smaller parts of the altarpiece were hidden in the University Museum in Cracow. In the midst of all this activity came the devastating announcement, on August 23, of the signing of Hitler's alliance with Stalin. There was now no place to hide.

Within hours of the German crossing of the Polish frontier on September 1, observers noticed that this campaign seemed to have an extra edge of viciousness. Herman Field, representative of a British Committee for Refugees, fleeing Poland in his car, witnessed the bombing of small rural towns and farms well behind the front lines: "It became so evident that we always stopped our car when planes came overhead, *away* from any farmhouse."[6] Later, members of the United States mission, making their sepa-

The Veit Stoss altar in the Church of Our Lady, Cracow

rate ways to Romania "in order to avoid attracting attention," saw more of the same. The military attaché noted the unnecessary use of incendiary bombs, which would "seem to indicate [the Germans'] intention to use the presence of railways, highways or telephone lines as a justification of terroristic bombing of the civil population. . . . The excuse of inaccuracy seems devoid of foundation." Even Walter Schellenberg, in Poland as intelligence adviser to Himmler, was surprised by the ferocity of destruction in Gdynia:

I was deeply struck by the total destruction of the residential districts, and I could not help asking myself why the Wehrmacht had carried the war into these parts. Until then I had had no real conception of what total war meant.[7]

But just as the Blitzkrieg was no bolt from the blue, this treatment of the Polish people had been carefully drilled into Hitler's military leaders. In an extraordinary speech to his highest commanders, delivered on August 22 just after he had agreed to sign the Russian treaty, Hitler had urged his forces to "act brutally . . . be harsh and remorseless," and had encouraged them to "kill without pity or mercy all men, women and children of Polish descent or language" in the coming "invasion and extermination of Poland."[8]

For Poland was to become Germany's creature totally. Its culture and peoples were to be eliminated and replaced by Hitler's "New Order." The Nazis were only too eager to put their racial theories into actual practice in a place where resistance could be countered with total brutality. They believed without any qualms that Slavs, Christian or otherwise, were so inferior that they could not be considered human. They, along with the Jews, were the "degenerate art" of the human race.

At a conference of SS officers on September 21, before the surrender of Poland and over the objections of the regular Army command, who did not like this threat to their authority, Heydrich and Eichmann drew up instructions for their Einsatzgruppen (Special Forces) to "prepare lists of Polish government leaders, nobility, clergy, professionals, and intellectuals of all types, for a fate as yet unclear." The Jews would be concentrated in ghettos "for better control." Hitler was less subtle: in a dinner conversation with Bormann and Hans Frank sometime later, he declared that "the Poles shall be the slaves of the Greater German Reich."[9]

Monuments and works of art would be no less required to fit into the new Germanic scheme of things than people. A certain amount of damage and looting are inevitable in the heat of battle, but in this invasion two unusual elements were quickly evident: excessive destruction of Polish monuments, and singularly detailed knowledge of the locations of works of art.

The bombing of the monastery which contained the miraculous picture of Our Lady of Czestochowa and was Poland's holiest shrine and pilgrimage place could not have been a military necessity, but it was not until his armies reached Warsaw that the depths of Hitler's hatred of the East were revealed. Irritated by the stiff resistance of the city, which had halted their previously unstoppable advance, the Germans, at one point directed by Hitler himself, poured incendiary bombs and artillery into the oldest parts of the town. The Royal Palace, an excellent target, was badly damaged. Water mains burst; fire control was impossible. Otto Abetz, a member of Hitler's entourage who later became the Nazi ambassador to France, recalled that the Führer had been reading a history of Genghis Khan during the siege.[10]

The German armies had done much better in the rest of Poland. The Fourteenth Army, under General List, had arrived at Sandomierz on September 8. Within the week an SS unit had opened the repository containing the Veit Stoss figures and in the first week of October they were sent off to Berlin. The conditions were not ideal. SS Untersturmführer Paulsen, who was in charge of the operation, wrote to a friend:

> Transportation of the Veit Stoss figures turns out to be rather difficult. Military movements are a serious hindrance to the ride. . . . The boxes in the Sandomierz Cathedral are rather large. Four of them weigh eight hundred kilograms apiece. On account of bad road conditions we had to drive without a trailer, and for reasons of security the ride could only be made during daytime.[11]

The bricked-up vaults containing the Czartoryski collections at Sienawa were immediately betrayed to the Gestapo, who made off with a set of famous twelfth-to-sixteenth-century Limoges enamels, a magnificent collection of goldsmith's work, coins, invaluable Polish relics, and a large number of engravings by Dürer, Lucas van Leyden, and others.[12] The priceless pictures, too hard to move or hide, were, for the moment, left behind.

All through the countryside big houses on the routes of the advance were ransacked. Count Julian Tarnowski was forced to reveal the location of his collection under Gestapo duress, but some were luckier. Countess Matgozata Radziwill had sent her widowed daughter-in-law, Jadwiga Potocki, rushing back to Warsaw from their country house near Bialystok with instructions to retrieve the family jewels from a safe-deposit box. She was dismayed to find the bank in German hands. Nazi officers were methodically opening every box to inspect the contents. When the manager laid the fabulous collection before them, he laughed and said, "What a pity none of this is real!" The Germans did not seem to know the difference, and waved the box on. The delighted manager whispered triumphantly to his client, "We have saved the Countess's jewelry!"[13]

The occupation of Poland was well organized even before the final surrender of the Polish armies on October 5. On the seventh the country was divided into several areas. The western districts were annexed to the Reich, while the Russians took the easternmost provinces. The south-central area, which included the major cities of Warsaw, Cracow, and Lublin, became a special entity called the Generalgouvernement. Within this zone some modicum of Polish life would be allowed to continue. Supreme power in this region of some 14 million souls, covering 120,000

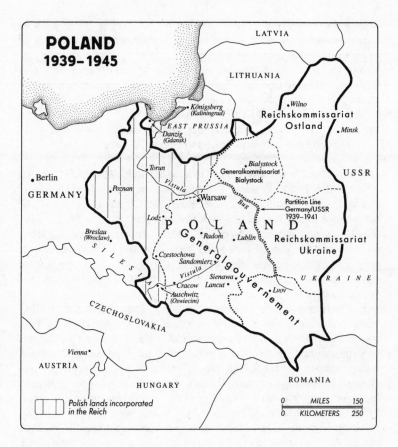

**POLAND
1939–1945**

LATVIA

LITHUANIA

*Königsberg
(Kaliningrad)*

EAST PRUSSIA

*Danzig
(Gdansk)*

Wilno

Reichskommissariat
Ostland

Minsk

Torun

Bialystok

Generalkommissariat
Bialystok

USSR

Berlin

GERMANY

Poznan

Vistula

Warsaw

Bug

Partition Line
Germany/USSR
1939–1941

Lodz

P O L A N D

Generalgouvernement

Radom

Lublin

Reichskommissariat
Ukraine

*Breslau
(Wroclaw)*

S I L E S I A

Czestochowa

Sandomierz

Vistula

Sienawa

Lancut

U K R A I N E

Cracow

*Auschwitz
(Oswiecim)*

Lvov

CZECHOSLOVAKIA

Vienna

AUSTRIA

HUNGARY

ROMANIA

Polish lands incorporated
in the Reich

| 0 | MILES | 150 |
| 0 | KILOMETERS | 250 |

square kilometers, was handed over to Hans Frank, Hitler's former defense lawyer.

In the areas annexed to the Reich, "Germanization" was immediately begun by Heydrich's Special Forces, under the overall supervision of SS chief Himmler himself, graced since October 9 with the glorious title of Reichskommissar for the Strengthening of German Folkdom. All Poles, Jewish and otherwise, were to be deported and eliminated. Their businesses, houses, villages, and possessions were to be given or sold to ethnic Germans, who would be brought in from the Reich itself or from various German settlements such as those in the Baltic states. Victims

were given virtually no notice of what was to happen. Families were rudely awakened in the middle of the night, often separated, and sent off to the Generalgouvernement in freezing cattle cars, leaving all their possessions behind. After November 15 the SS put the entire rail system at the disposal of the resettlement program. The Nazis had hoped to achieve this initial "cleaning out" within a month. It took nearly six, still impressive considering that more than a million people were displaced. In the following years of the occupation, further tens of thousands were shipped to Germany and various sites in Poland to be used as slave labor.

In all areas the Church was reduced to almost nothing. Hundreds of priests were murdered, and no services, confessions, or hymns were allowed in Polish. Inscriptions on tombs were erased and rewritten in German. All but a minimum of regalia and treasure were removed and the churches themselves were converted to dance halls, hay barns, garages, and storerooms. Roadside shrines were sadistically desecrated. Synagogues were simply burnt or otherwise destroyed, their holy books and scrolls often thrown onto bonfires, and the headstones of Jewish cemeteries were used as paving stones.

The "extermination of the nobility" was not such a simple matter. Many of the great families of Poland were related to those of Germany. They could not, therefore, exactly be considered "*Untermenschen.*" The SS and Gestapo constantly watched and interrogated them, punishing the slightest suspicion of resistance with imprisonment, but many in the upper echelons of the more aristocratic Wehrmacht often simply ignored Hitler's harangues. This was particularly true in the Generalgouvernement, where Frank managed to keep Himmler at bay. As had been the custom in past wars, the Germans billeted themselves in the best apartments in Poland's castles, forcing the occupants into lesser quarters or throwing them out altogether. Occasionally they could be helpful: officers taking over Rodka, the house of Jadwiga Potocki—who had returned triumphant from Warsaw with her mother-in-law's jewels—warned her that the Russians would soon arrive, and urged the family to leave. In two horsedrawn carts the Potockis fled to Cracow, taking with them the jewels and numerous bundles which, they were horrified to find later, contained no other valuables: the servants, ordered to "pack up everything," had brought only the children's clothes, assuming that it would be a trip like any other. In Cracow they moved into the top floor of a family town house, the lower floors having been requisitioned as offices for the administration of the Generalgouvernement. Thomas Potocki, a small boy at the time, remembers spitting down on the helmets of the Nazi guards outside. There they existed, selling a bit of jewelry from time to time.

Desperate and frightened families such as this were at the mercy of all sorts of entrepreneurs. A man calling himself a Dutch diplomat convinced the Countess Radziwill to let him take a large quantity of jewelry to her cousins in the West. Alas, the "diplomat" sold most of it, but by a miracle, a few pieces, one of them a diamond-and-emerald tiara, were recovered after the war. With this the family, who escaped from Cracow in Swiss Red Cross trucks in 1945, was able to buy a house in London.

Another Potocki, Count Alfred, whose great palace at Lancut was only a few miles from the line separating the Russian and German Zones, managed much better. As in World War I, the palace was occupied by a constant stream of German generals and their staffs, including the military administrator of Poland, Field Marshal von Rundstedt. The Count, a godson of Kaiser Wilhelm I and a well-known member of international café society, had entertained von Ribbentrop at Lancut in 1935 (and remarked that his golfing style "lacked rhythm"). He was generally treated with respect by the Wehrmacht, but the Gestapo, always ready to pounce, twice took him off to be questioned about Resistance activities, which were indeed going on in various hidden corners of the estate. Their agents searched the family archives and inventoried the contents of the castle. Twenty-two works, among them a *Portrait of a Man* by Makkart, one of Hitler's favorite artists, were later listed in a Nazi catalogue of "safeguarded" objects but never actually removed. Potocki attributed this to the intervention of Wehrmacht General von Metz, who had been billeted at Lancut.

Fear and hatred of the Red armies sometimes created bonds between the German occupiers and the Poles. After the Germans had taken Lvov from the Russians in 1941, the chief of the Nazi confiscation organization himself came to reassure Potocki that collections he had left there were intact, and the Count was driven to Lvov in a German military car to inspect damage to his estates. This was not pure altruism: testimony after the war revealed that Hitler himself had ordered that the Alfred Potocki collections should "remain in their place," perhaps a result of the fact that Potocki's mother had so charmed the Führer from afar, at the Olympic Games in Berlin in 1936, that he had asked to meet her, a request she could hardly refuse.[14]

The ruins of Warsaw were still smoking when the SS and other Nazi agencies and individuals began zealously carrying out Hitler's exhortation to "eliminate" Polish culture. While the museums, buildings, libraries, and palaces of the city clearly could be called "Polish," much of their contents were patently not. Since Poland was no longer recognized as a nation, its collections were there for the taking. But with the experiences of Austria

Governor General Hans Frank and Kajetan Mühlmann confer at Cracow Castle. (Photo by Heinrich Hoffmann)

and Czechoslovakia behind them, Hitler and Goering knew that the "safeguarding" of confiscated art works had to be carefully controlled. Goering quickly recognized the need to have his own man on the spot. Acting in his role as head of the Four-Year Economic Plan, which allowed the requisition and exploitation of whatever assets could be removed from conquered territory for the improvement of the Reich, Goering appointed the former Austrian art commissioner Kajetan Mühlmann Special Commissioner for the Protection of Works of Art in the Occupied Territories.

Mühlmann was greatly pleased at this opportunity, his recent disagreements with the Gauleiter of Vienna and his dismissal by that gentleman in June 1939 having led to visions of combat duty. Upon hearing of the appointment Hitler apparently remarked: "Mühlmann—you are sending him there? I had to kick him out of Vienna . . . he did not want to let anything be taken out. . . . Beware that he does not carry everything to Vienna."[15] His job now was to inventory the thousands of works of art being jammed into repositories at the National Museum in Warsaw, and the Wawel in Cracow, classify them according to quality, and take the best to safe storage areas so that Hitler could decide what he wanted.

Mühlmann arrived on October 6, one day after the surrender, to find that much—such as the Veit Stoss altarpiece, as we have seen—had already been moved. Even worse, the ruins of the Royal Palace in Warsaw had become a sort of open bazaar for German officials. Governor General Frank himself, on his first tour of the castle with a large entourage, had not set the best example when he tore silver eagles off the canopy over a throne and pocketed them. Furniture, silver services, and other useful objects

were being sorted out for removal to the residences of high officials and their wives. The frantic efforts of Polish architects and curators, many working as volunteers, to repair bomb damage and protect the panelling and ceilings by means of a temporary roof were halted on October 18. In early November engineers drilled holes for dynamite charges all around the castle, and German police, using forced Jewish labor, began to tear out the interior fittings of the state rooms. The painted ceiling by Bacciarelli in the Audience Chamber was thrown down into the courtyard. By January only bare walls remained. But the Germans did not use their dynamite in 1940. Later they would find a better reason.

Other collections were faring no better. An eyewitness described the emptying of the Zacheta—the Warsaw Society for the Encouragement of Fine Arts:

> Today I was the witness of a scene particularly painful to me. Passing the Zacheta . . . I saw a long row of lorries standing outside. Workmen were shifting about some heavy objects on the pavement. Through the wide open windows I could see the golden glimmer of picture frames. Although I knew it was a very foolish thing to do, I went closer to see what was happening. Something was being thrown out through the window, something which shone with all the colours of the rainbow in the bright light of the sun. Those bits and pieces were pictures, there was my beloved *Barbara Radziwillowna* dropping in front of me. The workmen apathetically lifted those treasures of Polish art and threw them into the waiting lorries. Soon afterwards they were driving away to an unknown destination . . . it seemed like seeing old friends being murdered.[16]

Bringing all this under control was no easy assignment. An order from Frank's office gave Mühlmann's office sole authority for further "safeguarding" in the Generalgouvernement. Soon he was so busy he had to bring his half-brother Josef in to assist him. Josef, unfortunately, had to be fired when it was discovered that he was giving his mistress confiscated objects, but he was a great help for a time.

On October 19 a Haupttreuhandstelle Ost (Central Trustees Office, East) was set up in Berlin by Goering to organize the whole process. SS operatives, who had been in charge of "safeguarding" procedures since mid-September, did not appreciate the appearance of this agency and wrote furious letters to headquarters urging that objects of interest to the SS be immediately shipped to their own storage places in Germany. But on November 10 Himmler sent a long memo to all agencies ordering them to cooperate with Mühlmann. The SS obeyed, but made constant efforts to

monopolize the confiscation of valuables all through the rest of the occupation. These attempts were quashed at regular intervals by reissuance of Himmler's decree and by sharp reminders by such luminaries as Rudolf Hess and Bormann of Hitler and Goering's exclusive rights to all safeguarded objects.[17]

By the winter of 1940, with the help of a phalanx of distinguished German art historians, Mühlmann had gathered together the most important works in the Generalgouvernement, sequestered them in Cracow, and published an elegant catalogue, complete with photographs and the provenance of each object. Second-class works were simply stored, while third-class objects were made available to Frank's interior decorators and architects for the refurbishment of offices and residences.

It was not long before Hitler's art deputy arrived to have a look. Posse made an inspection trip in late November 1939; his report to Bormann gives us an excellent picture of Mühlmann's operations and of his own adherence to the highest standards for Linz. It also makes clear his low opinion of the Polish collections, which would not fill many of the gaps in his wish list, and his assumption that the Führer's eastern ambitions would not stop with Poland:

> In Krakau and Warsaw I succeeded in visiting public and private collections as well as church property. The inspection confirmed my supposition that, except for the higher class works of art already known to us in Germany (e.g. the Veit Stoss altar and the panels by Hans von Kulmbach from the Marienkirche in Krakau, the Raphael, Leonardo and Rembrandt from the Czartoryski collection) and several works of the National Museum in Warsaw, there is not very much which could enlarge the German stock of great art. The Polish store of applied art is richer and more varied. . . .
>
> I should like to propose now that the three pictures of the Czartoryski collection . . . which are at present located in the Kaiser Friedrich Museum in Berlin, be reserved for the Art Museum in Linz. . . .
>
> I further beg to point out that together with the Lvov Museum, a series of beautiful drawings by Dürer and other German masters fell into Russian hands. Perhaps it will be possible later on to salvage for Germany the twenty-seven sheets by Dürer.[18]

The Czartoryski "Big Three" were indeed already in Berlin. Mühlmann had rushed them there in mid-October and presented them to Goering, who, in his capacity as Prime Minister of Prussia, put them in the Kaiser Friedrich Museum.[19] Governor General Frank was unhappy at the loss of

"his" greatest masterpieces, and Mühlmann was ordered to bring them back so that Frank could hang them in his baronial apartments in the Wawel Castle, along with the Rembrandt *Portrait of Martin Soolmans,* from the Lazienski collection, given to him as a present by the Gestapo. Frank was new to collecting, and Mühlmann was later forced to reprimand him for hanging the delicate Leonardo over a radiator. Goering was furious about this loss; perhaps to appease him Mühlmann brought him a nice Watteau, *The Pretty Polish Girl,* also from the Lazienski collection. "For reasons of safety" the three Czartoryski pictures were returned to the Reich capital just before the Germans attacked Russia. By late 1942 they were on the road east again, this time to escape the increasingly heavy bombing of Berlin. When one considers the air-conditioned crates and armored escorts used to transport such sister paintings as the *Ginevra de Benci* and the *Mona Lisa* today, one can only marvel at the survival of the *Lady with the Ermine,* though Mühlmann did later testify that he always carried it himself on the train between Berlin and Cracow.

Mühlmann was soon able to fulfill Posse's wish for control of the twenty-seven Dürer drawings, which he had been ordered by Frank and Goering to secure at the earliest opportunity. The drawings, removed in a distinctly illegal manner by Napoleon's chief confiscator from the Albertina in Vienna in the early 1800s and sold to dealers, were considered by Hitler to be unequivocally part of the German patrimony. Only six days after the German attack on Russia in late June 1941, while combat was still raging in the area, Mühlmann went to Lvov and brought the Dürers back to Cracow. On Goering's express orders he continued on to Berlin that same night and handed the drawings over to the Reichsmarschall at Carinhall. By the late afternoon they were in Hitler's possession. These drawings were among the few works of art which he always kept at hand. He even took them with him to his Eastern Front field headquarters. In September 1941, visiting the HQ on other art business, Mühlmann mentioned to Hitler that he was worried about the drawings, as they were technically his responsibility. Hitler replied, "I have personally relieved you of this responsibility. Here . . . they are as safe as they would be in Cracow, and besides, I can see them more often."[20]

Posse did not return to Poland, feeling that his decorative arts and coin curators could take care of what would be of interest to Linz. The "Big Three" were never actually catalogued in the Linz collection, but there is no question, as Mühlmann testified at Nuremberg, that they would have gone there had Germany won the war. Meanwhile, Frank was allowed to keep them.

Rather as an afterthought, the German authorities issued a series of de-

crees "legalizing" the confiscation of the property of the Polish state during November 1939, and another more definitive one on December 16 which authorized taking "the entire range of objects of art . . . in the public interest." This included private and church collections. Curators and owners were required to report their holdings, and the concealment, sale, or removal of works of art from the Generalgouvernement was punishable by imprisonment.

Once things had settled down, eager German museum directors, heavily backed by their city governments, scrambled to fill the gaps in their collections from the Polish stocks. The mayor of Nuremberg, not content with the Holy Roman regalia, came to Cracow in early 1940 to get the rest of the Veit Stoss altarpiece for his Germanisches Museum.

Stoss had became the darling of the Poland-is-really-German school. Elegant portfolios of high-grade photographs were published showing his works from every angle. The Institut für Deutsche Ostarbeit (Institute for German Eastern Studies), a sort of Nazi think tank dedicated to the Germanization of Poland, put on a big Stoss show in 1942 with objects graciously lent by Mühlmann's agency and Governor General Frank. The artist's German birth remained unsullied by the unfortunate Italianate ideas which had somewhat diminished Dürer in Nazi eyes. Everyone forgot that Stoss had worked not only for the German community of Cracow but also for the Polish King Kasimir IV Jagiello, and that he had died in disgrace, blind and forsaken by his children, having been convicted of forgery upon his return to Nuremberg after seventeen years in Cracow.

The mayor had persuaded Hitler that what was left of the altarpiece would be damaged by Polish saboteurs if left in place, and should be protected in Nuremberg's unique bomb shelters. The director and a curator of the Germanisches Museum were dispatched to bring back the framework. Special railroad cars had to be built for the purpose, after the museum officials managed to prevent SS engineers from sawing the enormous forty-by-thirty-four-foot structure into more convenient segments. There was no doubt of the expertise of the Nuremberg delegation: the curator, Eberhard Lutze, had published a monograph, considered definitive to this day, on Stoss in 1938 and had helped organize a major exhibition of his works at Nuremberg in 1933. Once the armature was safely there, Lutze was also sent to collect the glorious figures which had been stored in the Reichsbank in Berlin. Nuremberg could now display a second purloined national treasure next to the Hapsburg crown jewels. A German official reported to Frank that the stripped Church of Our Lady in Cracow really looked better now, "due to the space gained by the removal of the altar."[21]

Less successful were the efforts of the mayor of Breslau and the director of its museum, Dr. Gustav Barthel. Dr. Barthel, one of Mühlmann's principal assistants, was another strong believer in the Germanic origins of anything of value in Poland. As early as December 1939 he sent a memorandum to Mühlmann listing his choices for Breslau. The first few lines give us an idea of his mentality:

> Due to the comprehensive safeguarding of works of art in the Occupied Polish territory, there are today again available to us works which Polish scholars have falsely claimed as the achievements of their own artists. Their place in the true context of the mighty Germanic cultural tradition in the East can now be assured.[22]

After continuing in this vein at some length, Barthel gets down to specifics. First come works "made in Silesia," but as there do not seem to be too many of these, he moves on to "works made under Silesian influence," rather a large selection made up principally of sculptures from Polish churches. He would also like selections of furniture, textiles, and goldsmith's works—none specified as to national origins. By the time we get to the paintings, Germanism has given way fully to greed: if he cannot have an entire collection such as the Lazienski (mostly Dutch), he will be happy with a list which includes the Czartoryski Rembrandt, Rubens's *Descent from the Cross* from Warsaw, and a Canaletto "of the quality of those from Warsaw Castle." Ethnographical objects and books should be included, as they will be "handled from the political point of view" in Breslau. To top it all off, he would like the entire library of the Warsaw Museum (about eleven thousand volumes) and the holdings of the former Art Institute of Cracow.

Over the course of two years a thick file of letters, on impressive letterheads festooned with swastikas, flowed to Hitler's offices in Berlin promoting the claim of Breslau to this assemblage of confiscated works. It has all the trappings of a major lobbying effort: a very long analysis of the existing collections written in flowery language, plans for a new museum building, obsequious letters from high provincial officials and art historians, and more lists of the desired objects. By early 1942, after numerous refusals Reichschancellery official Lammers wrote testily that in view of the fact that Hitler had declared the request of Breslau to be "completely out of the question, and had noted that he had decided to send the objects to Königsberg," it did not seem useful to present the case to the Führer again. Nothing daunted, the Breslau group then requested part of a recently confiscated Dutch Jewish collection. Again they were brusquely put down; Posse himself wrote to say that the collection in question (of which

we will hear more later) was to be used for "the enlargement of the Linz collections."[23]

Although Kajetan Mühlmann had successfully established his power base in the Generalgouvernement, the "annexed" provinces and, after the invasion of Russia, certain eastern areas remained the exclusive bailiwick of the SS, whose archaeological unit, the Ahnenerbe (est. 1935), was by now financing exotic projects worldwide. These ranged from the study of Indian medicines in South America to the gruesome analysis of human skulls collected from the death camps. By the late thirties the Ahnenerbe controlled virtually all the archaeological research in Germany. Its monographs were published by respectable houses, and were catalogued without suspicion by libraries. So determined was the Ahnenerbe to prove that the Germanism of the occupied areas reached to earliest prehistory, that even Hitler was embarrassed:

> Why do we call the whole world's attention to the fact that we have no past? It isn't enough that the Romans were erecting great buildings when our forefathers were still living in mud huts; now Himmler is starting to dig up these villages of mud huts and enthusing over every potsherd and stone axe he finds. All we prove by that is that we were still throwing stone hatchets and crouching around open fires when Greece and Rome had already reached the highest stage of culture. We really should do our best to keep quiet about this past. . . . The present day Romans must be having a laugh at these revelations.[24]

Under the aegis of this august organization, SS functionaries were combing the annexed territories "village by village, castle by castle, estate by estate" for every possible object that might be subject to confiscation. From his office in Berlin, an SS Obersturmführer with the exceptionally appropriate name of Kraut sent out barrages of letters following up even the smallest fragments of art intelligence.[25] There was no tolerance for the aristocracy in this operation. What had not been taken from private houses in the initial sweep at the time of the invasion went now. Armed with detailed lists, the SS searched for such treasures as Princess Elna Radziwill's love letters to Kaiser Wilhelm I. The Reichsarchiv in Danzig sent a helpful catalogue of private libraries which were hauled off and heaped up in a church in Poznan—2.3 million volumes by February 1941.

This thoroughness did not only apply to "acceptable" works. Jewish and Polish art, termed *Kulturkitsch,* was to be collected and preserved as well. The travelling commandos were ordered on February 23, 1941, "to also respect these things and collect them, so that they can be stored sepa-

*SS Ahnenerbe archaeologists at work, 1935 (*third from left, *Himmler)*

rately." In the vein of the "Degenerate Art" shows at home, the SS had plans to exhibit some of the worst examples of this *Kulturkitsch* in Berlin. Paintings showing subjects such as Polish cavalry slaughtering German soldiers still in the trenches ("an especially gross example of Polish art chauvinism") would further justify the conquest of Poland in the eyes of the German public. We do not know that any such exhibition actually took place, but an exhibition of photographs of the occupied areas was reviewed in glowing terms in the *Berliner Morgenpost* in February 1942:

> Exhibition of large photographs in the Kunsthalle. One of the experiences of the east is that astonishment at coming suddenly upon the gleaming white facade of a German baroque church amidst the waste lands of Polish mismanagement or Bolshevist lack of culture. . . . In lands which German culture has penetrated, foreign influence later came in. Now what was overcome awakens again.[26]

Occupation officials dealing with more pressing problems often did not approach this "survey" of art objects with the zeal of the SS headquarters personnel. It had been so hard for his teams to obtain cars and gasoline in

the weeks following the German attack on Russia that Kraut was forced to complain to Himmler himself. By December 1941 Kraut was concerned that local officials, although provided with lists of objects to be gathered and stored in the local museums "so that no sales of objects which are meant for museums will take place," had not done so. The governor of Kreis Zichenau explained unconvincingly that the objects were too valuable "to be moved hastily," and pled that personnel shortages and fuel rationing had made it impossible to pick up items from more remote areas. It took six more months to complete Kraut's project, and by then the sequestered Polish works had company. Because of the now heavy Allied bombing of Berlin, the contents of the SS storerooms there were being evacuated to the East. Despite frequent incidences of officials helping themselves, most of the objects collected remained in storage, virtually uncared for, to the end of the war, vainly awaiting total German victory and the moment when Hitler would make his choices. With the exception of a few top items, only precious metals and jewelry were immediately sent back to Germany, where objects of museum quality were set aside and the rest melted down to replenish the Reich's treasuries.

Even the most distinguished German scholars were not immune to the opportunities presented by a cultural scene so open to exploitation. After the war the Poles accused these learned gentlemen of preparing for the looting of Poland's treasures far in advance; it is certainly unquestionable that once the country lay at their feet many of these academics felt not the slightest qualms at transferring the collections, libraries, and even research notes of their erstwhile colleagues to their own use. There was no one around to make them feel guilty. All Polish universities, institutes, and schools had been closed, and their staffs dismissed. The entire faculty of the Jagellonian University at Cracow, called to a meeting ostensibly to hear a lecture entitled "The Attitude of the German Authorities towards Science and Teaching," was summarily arrested and sent through a series of brutal detention camps before being incarcerated at the concentration camp of Sachsenhausen near Breslau. Similar treatment was given their colleagues at other institutions.

Among the intellectual opportunists was the distinguished Michelangelo scholar Dagobert Frey, a professor at the University of Breslau, who had also written a series of studies on the monuments of his native Austria and eastern Germany. In 1934 and again in 1938, he and several colleagues had toured Poland to study Western influences on monuments there. They covered more than thirty-five hundred miles and visited innumerable sites and collections, kindly shown to them by local curators. Frey

took rather bad photographs which, along with his notes, were sent to Breslau University, where, in the late thirties, he founded the Ost-Europa Institute, which specialized in studies of Silesia and Poland.

When war broke out, Frey volunteered his services to the Ministry of Culture, urging the establishment of an Art Protection Unit to work with the Army, as had been done in World War I by Dr. Paul Clemen, who had afterward compiled several impressive and well-received volumes on the subject full of scholarly studies of affected monuments, photographs, and essays on the negative effects of war. The Ministry approved of Frey's plan and he went to Warsaw. Certainly his studies of the past years had prepared him for this job, but his attempts to persuade the Wehrmacht to establish a post for him came to nothing, principally due to the fact that the old-school Wehrmacht command was no match for the true Party operatives such as Mühlmann, Barthel, and Frank.

There is little doubt that Frey opposed the physical destruction of Polish monuments; he is even credited with having argued successfully against the dynamiting of Warsaw Castle in 1939 and 1940.[27] But he never questioned the propriety of the German presence in Poland or the right of his countrymen to exploit its patrimony in the cause of Germanism. Despite his failure to obtain an influential position in the "safeguarding" agencies, he remained very much on the scene for some time, acting as consultant for the SS Ahnenerbe and vainly attempting to promote the proper handling of churches, palaces, and their contents. Mühlmann and the rest of the Nazi hierarchy simply ignored him, and Frey eventually abandoned his efforts.

He did, however, continue to pursue his intellectual interests in Poland, for we next find him speaking in Cracow at the elaborate ceremonies for the opening of the Institut für Deutsche Ostarbeit. His articles appeared regularly thereafter in its publications. The 1943 Baedeker of the General-gouvernement contains his article on the art history of the region, in which he refers to Cracow as "an Eastern outpost of Nuremberg art." The catalogue of "safeguarded" art put together by Mühlmann, which unblushingly lists the provenance of each object, includes him among its consultants, and in 1941 he published *German Architecture in Poland* (recommended reading in the Baedeker). In a posthumous volume of Frey's essays, published in 1976, a colleague referred fittingly to his "intellectual agility and his capacity to adapt himself quickly and logically to new ideas and situations."[28]

Kajetan Mühlmann was not subject to such intellectual pretensions. Once he had secured and catalogued the confiscated Polish goods, other fields

beckoned. In 1940 his Austrian colleague, Arthur Seyss-Inquart, was transferred from his post as deputy to Dr. Frank to head the German occupation of Holland, and invited Mühlmann to come help with art operations there. Mühlmann accepted with alacrity, but this was not the end of his Polish connections—quite the opposite. The new ruling class of Poland was now very much at home in its conquered realm. German beer halls and restaurants, with suitable decor, were set up in former Polish palaces and houses. The statue of Copernicus in Warsaw was relabelled "the Great German," and the new Baedeker for the Generalgouvernement, historically and culturally up-to-date, somewhat schizophrenically recommended the area as both a "strong reminder of home" for those returning from Russia, and "the first greeting of the East" for those going in the opposite direction.

The occupiers, while keeping the populace in a state of constant fear, cultural deprivation, and near-starvation, had themselves developed an insatiable appetite for luxury. Frank's extravagant lifestyle was considered scandalous by home office officials of both the SS and the Wehrmacht: not only did he occupy the Wawel Castle in Cracow, but in Warsaw he had the Belvedere Palace, formerly the residence and museum of Pilsudski, one of Poland's greatest heroes, restored and decorated as his residence, and for country weekends refurbished a Potocki seat outside Cracow at Krzeczowice, renamed Kressendorf. Frau Frank and her friends regularly visited the Ghetto to bargain-hunt for objets d'art and furs in its thriving black market, which was a vital lifeline for the remaining Jews, and everyone shopped in the numerous antique shops stocked with leftover loot and pawned family possessions.

Mühlmann soon had a nice business going selling works bought and confiscated in the West to clients in Germany and Poland. Frank regularly sent Polish occupation money to Seyss-Inquart in Holland, who deposited it in an account at Mühlmann's disposal. Most of it went for lesser paintings and decorative objects, which were shipped by rail to Cracow. (On the way the train passed through the town of Auschwitz, described in the Nazi Baedeker as "a small industrial town on the rail line.") Mühlmann shopped all over Europe, and spent freely. A single 1941 invoice from Jansen of the rue Royale, Paris, lists FFr 560,000 worth of rugs, crystal lamps, and antique furniture from Louis XIV to Louis XVI. Millions more were expended in this fashion for the account of M. le Docteur Frank, who also furnished a little pied-à-terre for his mistress in Munich with Mühlmann's help. He was in distinguished company: other clients included Hitler and Goering. Dr. Lutze of the Germanisches Museum got a picture or two, as did Dr. Barthel, Frau Goering, Baldur von Schirach, and hundreds of oth-

ers. The list of all Mühlmann's known transactions compiled from his files after the war runs to over seventy single-spaced legal-size pages.[29]

Mühlmann was replaced in 1943 by Dr. Wilhelm Ernst de Palezieux, an architect less interested in commerce, who had been on Frank's staff for some time. Indeed, Mühlmann was so busy taking care of Goering's interests and his own dealings in the West that he could not have spent much time on the maintenance of the Polish repositories, which were in some disarray, a situation much resented by Frank. Mühlmann withdrew without much protest, for the future of Poland was by now all too clear. One of his last acts was to bring the remaining works of art stored in Warsaw to Cracow. According to his later testimony, contacts in the Polish Resistance had warned him of "possible future violence" in the capital, and he was well aware of the unbelievable acts of destruction and murder which the SS had used to crush resistance in the Warsaw Ghetto that summer. The explosion did not come for almost a year, and when it did, in August 1944, the suppression of the uprising was again handed over to the SS, the Wehrmacht being otherwise occupied. In the two months of vicious fighting that followed, while the Russians cynically waited close by, the Germans bombarded what remained of the city almost continuously with aircraft and heavy artillery. Whole sections were methodically set afire. Carloads of uncatalogued loot of all kinds were sent to Poznan or stolen by the virtually out-of-control troops before order could be restored and the engineers could finally use the demolition holes drilled in the foundations of Warsaw Castle in 1939.

By the late summer of 1944, those responsible for collections in the Eastern Reich knew that it was high time to move anything they wanted to save as far west as possible. Indeed, some collections had already gone. Count Alfred Potocki, sure that his lands would inevitably be in the center of combat, had started to pack the treasures of Lancut as early as March 1944. At first he thought of sending them to Cracow, but as the Russian advance continued, his thoughts veered toward Vienna. Governor General Frank authorized this move, and in fact must have helped Potocki procure space on the overburdened trains which moved back and forth through the Reich, carrying food, ammunition, wounded, and pitiful human masses to their deaths. Between May and late July 1944 the Count shipped more than six hundred cases filling some eleven freight cars first to Vienna and later to Liechtenstein. It was none too soon. The Russians arrived at Lancut on July 26.[30]

Space to house the massive confiscated collections in Silesia and Thuringia was at a premium, as authorities in the western part of the Reich

Portrait of a Young Man:
*the "Czartoryski"
Raphael presumably
taken to Germany by
Hans Frank and still
missing*

had simultaneously determined that they should move things as far *east* as possible. Arrangements for storage space in this area had been in place for some time. In 1942 Dr. Günter Grundmann, the Provincial Curator for Lower Silesia, had requisitioned nearly eighty repositories in castles, monasteries, parish houses, and warehouses for this purpose. In 1943 and 1944 a steady flow of objects from northern and central Germany came to these shelters and were distributed among them by Grundmann. By late 1944 he had begun to suggest that much of this be sent back to central Germany. These suggestions were considered "defeatist" by the Party hierarchy, who in turn arranged to send Grundmann to do manual labor on border fortifications. His superiors intervened, but before he could deal with the relocation of the objects, an official arrived from Warsaw to request space for works from the Generalgouvernement. Grundmann assigned them four castles to the west of Breslau: Muhrau, Kynau, Warmbrunn, and Konradswaldau. A fifth, Siechau, belonging to Count von Richthofen, had already been placed at Governor General Frank's disposal. Shipments from the Generalgouvernement began to arrive in November 1944. Other shipments from the annexed areas flowed to repositories in Thuringia.[31] By De-

cember, with the Red Army approaching Cracow, even the Nazi party men had to admit that moving the most important objects to central Germany was not entirely defeatist.

Not only works of art were moving west. Although Frank kept up appearances to the last—on December 17 he gave a long patriotic speech to a women's group, extolling the achievements of the Reich and urging the ladies not to lose their nerve—his wife, administrators, and trainloads of records and possessions were rapidly leaving the city. The Institut für Deutsche Ostarbeit too quietly moved itself and its libraries to two castles near Kotzding in Bavaria.

On January 16 Frank, in Cracow, was told that the Russians were in Czestochowa, only sixty miles away. He was about to lose his little kingdom, but he did not intend to leave empty-handed. That night he called an aide in Kressendorf and told him to "drive the truck to Siechau" in view of "the importance of its cargo." The *Lady with the Ermine* was on the move again. The next day he handed over the keys of the castle to the Sergeant of the Guard and left Cracow by car "in the most beautiful winter weather and bright sunshine." His curator Palezieux rode with him. By the evening of the eighteenth they had arrived at the von Richthofen castle. By the next day the Russians were at the Oder, just north of Breslau, and only thirty miles away. Frank ordered everyone who could be spared to leave Siechau immediately. The morning of Sunday the twenty-first was spent burning documents, after which the von Richthofens calmly entertained Frank and Palezieux at lunch. On Tuesday the twenty-third, Palezieux and a companion set out in a truck loaded with art in the direction of Frank's villa at Neuhaus, just south of Munich. The Governor General followed two days later. Here, in a small hotel on the Schliersee, the Generalgouvernement of Poland set up its offices in much reduced circumstances.[32]

In the meantime, the unfortunate Dr. Grundmann had rushed off to check as many repositories as he could, and direct westward any cars still unloaded. On January 26 he was given the sort of order and overwhelming responsibility which would become all too familiar to curators in the disintegrating Reich. A summary of his later testimony speaks for itself:

> On the 26th of January Grundmann received the following wire: S. Berlin, F., 25 Jan. 1945, 1730 hours "Request urgently with Wehrmacht assistance the removal to Central Germany of the most important moveable objects and the oldest archival material. From Reichsminister of Education Hiecke." This started off a series of hurried trips to as many repositories in the battle area as could be

reached. . . . At Warmbrunn he learned for the first time that Polish art treasures were stored in Muhrau. On that occasion Secretary of State Boble asked Grundmann to fetch from Muhrau the Czartoryzki Rembrandt and Leonardo. (He did not mention the Raphael.) At the end of January, Grundmann tried to reach Metkau to where the files of his office had been evacuated. Because of tire trouble, Metkau was never reached, but since Muhrau was only twenty kilometers distant, and night was falling, he walked there on foot. On arriving in Muhrau he found that . . . the building was occupied by a Tank formation. The commander, Major Dr. Fuchs, informed Grundmann immediately that most valuable art objects from Poland were in the castle, that the Russians were expected within two or three days at the latest, and that the place would be defended. [Fuchs] placed at G.'s disposal two trucks with which to take some of the objects to Warmbrunn, about fifty kilometers further west. In spite of his exhaustion, G. immediately set about packing the most important pieces such as the altar of Suess von Kulmbach, the Cranachs, Dutch paintings and the Warsaw Castle Canalettos, and continued throughout the night. To protect the pieces, he wrapped them in rugs and in three Gobelin tapestries. Half the items had to be abandoned as there was no room for them on the trucks. Nor was there time to take an inventory of the objects taken or left behind, for already the rumbling of the guns could be plainly heard. By noon of the next day the packing was finished and at 1700 the trucks set out for Warmbrunn.[33]

From Warmbrunn the objects would be moved two more times under similar conditions, until they came to rest in a large garage at Callenberg Castle near Coburg.

On March 17, as U.S. forces were entering Koblenz, the new offices of the Generalgouvernement received an unexpected visit from Professor Buchner, general director of the Bavarian State Museums. The Führer had informed him that a number of valuable works of art from Poland that were to be found in this "temporary location" should be stored with the Linz collections in a remote and secret repository. Buchner said he would make the necessary arrangements and after taking tea with Frau Frank returned to Munich.[34] But the Führer's days of total control were over, and no one ever came. Frank managed to keep the *Lady with the Ermine* until the last. She and eight other pictures—but not the Raphael, which has never been found—were with him when he was arrested by the Americans.

LIVES AND PROPERTY

Invasion of the West; The Nazi Art Machine in Holland

ARTICLE 46

The honor and rights of families, the lives and private property of citizens, as well as religious convictions and practices will be respected. Private property will not be confiscated.

—Rules of Land Warfare
The Hague Convention, 1907

After the lightning attack on Poland came a strange limbo period in the West. It has names too: phony war, *drôle de guerre,* sitzkrieg. Mobilized armies sat facing each other while thousands of ordinary citizens, already displaced once, or fearing the coming conflict, agonized over how best to survive. On October 6, 1939, Hitler spoke to the Reichstag. The Allies, he proclaimed, should give up in Poland, and there would be peace. Four days later he secretly ordered immediate preparations for the invasion of France and the neutral nations of Holland, Belgium, and Luxembourg, an idea he had first proposed to his reluctant generals in late September. The date he had in mind was November 12. Above all else Hitler wanted to defeat and stabilize the nations of the West so that he could turn on Stalin before the latter turned on him. The November invasion was called off only hours before it was to begin. Thirteen more times during the course of the winter, the German armies would be ordered to the brink of attack, only to be held back at the last minute.

From our perspective the situation of the Western European countries is much like a bad silent movie: the maiden walks innocently along, not noticing the obvious monster behind the fence. We would like to shout a warning at her. It is unbearable. Finally the monster bursts forth and she

runs, but it is too late, and she is trapped at the edge of a precipice, her back to the sea. To some who had escaped the monster elsewhere or lived through earlier wars, the danger was clear, and they continued to search for ways to get to England, Switzerland, and the Americas.

The Dutch drawings collector Frits Lugt and his wife moved from Paris to Switzerland in September 1939, taking little with them. Once there, they simply had the most important works in their collection sent to them in some sixty registered letters. In May 1940 they moved on again to the United States, where Lugt took a post as a lecturer at Oberlin College.[1] Walter Feilchenfeldt, having left Berlin for Amsterdam in 1933, did not hesitate now either; even before the German armies had crossed into Poland, he sent his Cézannes to London, and "instinctively" took his family to Switzerland for their summer vacation, where they managed to stay for the duration of the war. The Cézannes went on by sea to New York, uninsured, along with the collection of the writer Erich Maria Remarque, who sent the Feilchenfeldts a one-word cable—"Congratulations"—to announce the safe arrival of the pictures.[2] Such early action was wise, for the nations of refuge, having already taken in a certain number and fearing a huge influx, were becoming less and less generous with their visas.

For many the effort of removal to Holland or France had seemed sufficient, and difficult enough, and they had begun new lives with whatever possessions and assets they had been able to bring, smuggle, or launder out of the Reich. For those who were citizens of the soon-to-be-occupied nations, it was, even as they helped refugees move on or establish themselves, much harder to contemplate departure. Despite events in Poland, the image of World War I prevailed. It was beyond the comprehension of most that Nazi conquest, should it come, would not simply be territorial, but that the New Order would be applied in every aspect to their countries.

Nonetheless, as consciousness of the potential situation grew, certain precautions were taken in the Jewish community in Holland, by those who could afford it. Aaron Vecht, owner of a business established in Amsterdam for generations, closed his shop and sent much of his stock to the United States and England—but stayed in Holland with his family.[3] Siegfried Kramarsky, resident in Holland since 1922, and director of the Lisser-Rosencrantz Bank, also sent paintings and other assets to the United States. They included van Gogh's famous *Dr. Gachet* and two other pictures purged from Berlin's Nationalgalerie, which Goering had sold to Franz Koenigs, who in turn had had to relinquish them to Kramarsky to settle a debt. Kramarsky then booked passage to the East Indies on the only boat from a Dutch port which still had spaces. Departure was scheduled for the following spring. But on November 11, 1939, he was called

by a friend in Germany, privy to Hitler's invasion plan for the next day, who casually remarked that "it is going to rain tonight." The invasion was cancelled but the banker left with his family on the next train to Lisbon, whence they and hundreds of others crossed to New York on a privately chartered steamer. They finally ended their travels in Canada, having been denied an American visa.[4]

Not everyone had this sort of courage. Jacques Goudstikker, the most flamboyant dealer in Amsterdam, went with his young wife to London for a few days in May 1939, taking with him a few minor paintings which he stored there. He deposited $50,000 in an account in New York, and gave his lawyer the authority to take over the ninety-four-year-old Goudstikker firm in his absence. Passage to America was booked for the fall on the steamer *Simón Bolívar,* and two precious American immigration visas, valid until May 10, 1940, were stamped in their passports. But Goud-stikker's heart was, understandably, not in this plan. He had taken over the small family firm in 1919 and transformed it into a flourishing interna-tional operation with customers of the ilk of William Randolph Hearst. At Castle Nyenrode, his art-filled property outside Amsterdam, spectacular entertainments took place. For one such evening, in 1937, Goudstikker had engaged the entire Concertgebouw Orchestra. With them as soloist came the Austrian soprano Desirée Halban, whom he would marry a few months later. When the time came to sail on the *Simón Bolívar,* Goud-stikker could not bring himself to leave. In the cold mid-Atlantic the *Simón Bolívar* was torpedoed and all on board perished. Goudstikker took this to be an omen that he should stay in Holland.[5]

German forces crossed the Dutch border at dawn on Friday, May 10, 1940. Urgent warnings from the Dutch military attaché in Berlin were not taken seriously, the poor man having given so many previous warnings of each of Hitler's cancelled invasions. The Führer's techniques of deception by propaganda and infiltration and his magnificent timing and detailed plan-ning had reached their zenith on this glorious Whitsun holiday weekend: so successful was his strategy of disinformation that the French remained convinced that he was about to attack the Balkans.

As the gallant Dutch Army (which had last fought a battle in 1830) des-perately blew up bridges and opened floodgates, panic and confusion reigned and those who had lingered a bit too long, or had been trapped in transit, tried to escape. The director of the Belgian museums, Dr. Leo van Puyvelde, in Amsterdam with his wife to open a show of Belgian art, was awakened before dawn by a call from Brussels advising him to get back to Belgium. Van Puyvelde found a taxi willing to try. He invited the Goud-

stikkers to join him, but they still hesitated. Their lawyer had died in a bi-
cycle accident the day before, leaving no one properly authorized to take
over the enormous Goudstikker interests in Holland, and Goudstikker's
widowed mother could not be persuaded to leave. Van Puyvelde set off,
but was forced to return within a few hours: all land routes to Belgium
were blocked by the fighting. The only way out was by sea. Goudstikker
meanwhile had attempted to reach the U.S. consulate in Rotterdam in
order to renew his immigration visa, which had expired that very day. He
did not succeed. By May 14 escape seemed hopeless, but the van
Puyveldes persuaded the Goudstikkers to go with them to the port of
IJmuiden. Thousands were headed toward the coast, but, aided by the
diplomatic papers of van Puyvelde, both couples managed to get aboard
the SS *Bodengraven,* which was scheduled to stop in Dover en route to
South America.[6] They were very lucky: the dealer Vecht and his family,
attempting the same escape route, were never even able to get through to
the harbor.

On the crossing to Dover the ship was attacked by dive bombers. When
they arrived only the van Puyveldes, who had diplomatic passports, were
allowed to land. The rest had to go on to Liverpool. Before the ship sailed
again all the men on board were ordered into the teeming hold to make
room for women in the cabins. Desirée, with her new baby, insisted on ac-
companying her husband. In this dreadful place tragedy struck:

> I sat with the baby held to me, and Jacques said, "I have to have some
> fresh air," and he never came back. I went from cabin to cabin like a
> madwoman, until they found him in the depths of the boat.

On the blacked-out deck Goudstikker had missed his footing and fallen to
his death through an uncovered hatch.[7] His body was taken ashore at Fal-
mouth, but his wife was not allowed to stay there either. After making the
necessary funeral arrangements under guard in the harbor master's office,
she was put back on the ship, which continued to Liverpool.[8]

As the holder of an Austrian passport, she was arrested as an enemy
alien when she disembarked, and was locked into a room in a nursing
home until the former Austrian ambassador and other London friends
could arrange her release. Dutch insurance companies refused to honor
Goudstikker's life insurance on the grounds that he had undoubtedly com-
mitted suicide, and despite the intervention of the widow of erstwhile
Goudstikker customer Hearst and an interview with Joseph Kennedy him-
self, the American embassy refused to renew her expired visa, the excuse
being that she now came under the German rather than the Dutch quota,
and the former was "filled for twenty years."

Kennedy finally told her she could get a visa "in ten minutes from Canada House." This done, Desi Goudstikker and her child, life jackets on night and day, took to the seas again. This trip was no less harrowing than the first: there were constant lifeboat drills, and the ship was damaged by torpedoes en route. But it did arrive. She was met at the dock by the Kramarskys, with whom she was to stay for some months. In this wise the lucky ones got to America.

In the first weeks of May the German armies swept on through Luxembourg and the "impenetrable" Ardennes, around the great fortifications of the Maginot line, and back up toward Dunkirk, trapping thousands of British, French, and Belgian troops in their famous *Sichelschnitt* (scythe maneuver). Behind them a far smaller German force engaged the French and British in the center of Belgium, once again destroying the library of the University of Louvain, recently restored after having been destroyed in World War I.

Brussels fell on May 18, but the Belgian Army held out for another week, thereby allowing nearly four hundred thousand French and British troops to be rescued off the beaches of Dunkirk, and three trucks loaded with Belgium's most precious movable paintings, including the Ghent altarpiece, to be sent off to drive the thousand-plus miles to Rome, where they were to be entrusted to the Vatican. At Péronne, just over the French border, the little convoy ran head-on into the lines of the legendary Panzer divisions commanded by General Guderian, speeding toward the Channel coast. This encounter, as the official record tells us with maddening understatement, was resolved "fortunately without hurt," but by the time they could start off again, the Italians too had entered the war. The Belgian treasures were detoured to shelter in the Château of Pau at the foot of the Pyrenees, still an impressive drive in the best of circumstances.[9]

In France, a belligerent nine months since, much work had gone into defensive preparations for this invasion. The only problem was that they had been concentrated in the wrong places, and that the mind-set of World War I would prove an insuperable barrier to the flexibility of response that was needed. Nothing had been learned from the defeat of Poland, regarded by the French as a "weak" nation. Nor could the psychological state of readiness which had flowered in September 1939 be sustained through the exceptionally cold winter, fraught as it was with major crises within the French government and with false alarms, and given the natural tendency of a nation not bent on conquest to want to return to life as usual. Troops at the front, forbidden to fire at the enemy, which they could see quite

Louvain Library, 1940

clearly, chafed at their dreary living conditions and took to drink and long weekends. Their officers, billeted in nice hotels, settled into a comfortable existence.

In Paris, life was affected only slightly. It was noticed that diamonds, easily portable, were selling well. Fancy ladies involved in war work, including the Duchess of Windsor, still lunched with one another, now dressed in the snappy uniforms of the Red Cross and other such organizations. Concerts, exhibitions, and horse races went on. During the rare air-raid alerts, the chic concierges served coffee and soup in their shelters, though few could compete with that of the Ritz, which is said to have been furnished with Hermès sleeping bags.[10]

Art dealers were open, but trade was slow, and stocks of contemporary works diminished as younger artists were drafted along with everyone

else. From the journal *Beaux Arts,* which had a column devoted to the whereabouts of artists, curators, and dealers, it could be learned that the brothers Durand-Ruel, Pierre and Charles, were serving as pilot and interpreter, respectively, that Bonnard was in Cannes, and Louvre curator Gerald van der Kemp was in a telegraph unit.

An amazing number of artists, anxious to sell, still remained in Paris. This worked greatly to the advantage of any collector who was on the scene, and especially of the American Peggy Guggenheim, who had come to Paris determined to "buy a picture a day" for her projected modern gallery. Indeed, the artists flocked to her, some desperate to accumulate enough money to leave France. "People even brought me paintings in the morning to bed, before I rose," she reported.[11] In no time she had works by Tanguy, Pevsner, Dali, Giacometti, Man Ray, and Léger. So optimistic was she that, even as the Germans invaded Norway on April 9, she rented a large apartment in the place Vendôme in which to hang her new acquisitions, and began to remodel it. After May 10 her circle rapidly diminished, but Peggy stayed until the last, buying Brancusi's famous *Bird in Space* on June 3 as German planes bombed the suburbs. Brancusi, who hated to sell anything, wept as she took it away.[12]

In all the apparent normalcy of the *drôle de guerre,* the empty, echoing galleries of Paris' great museums had been a sobering reminder of what might come. The French museum people had not slackened their efforts to perfect the protection of their treasures. After the major works had reached Chambord they had begun to redistribute the collections among eleven other châteaux to the west of Paris, all within a convenient radius around Chambord, and as far from the advertised battle zone around the Maginot line as possible. Six of the eleven were located north of the Loire. In November the *Mona Lisa,* resting on an ambulance stretcher in a sealed van escorted by two other vehicles, was transferred to Louvigny, near Le Mans. The curator who stayed by her side for the trip emerged semiconscious from the van and had to be revived, but Leonardo's inscrutable lady was fine. With her went Fra Bartolommeo's *Mystic Marriage of St. Catherine* and other principal works of the Italian school. The Rubens of the Medici gallery went to the Château of Sourches, where they were later guarded by the curator Germain Bazin. Courtalain, near Châteaudun, received the Egyptian collection. Just south of the Loire thirty truckloads went from Chambord to Brissac, near Angers, where they were joined by the Apocalypse tapestries from that city. Cheverny sheltered works from the Cluny Museum, and the great Talleyrand domain at Valençay took in the major sculptures: the *Venus de Milo, Winged Victory,* and Michelangelo's *Slaves,* as well as the crown jewels.[13]

At Chambord itself, curators had unpacked needed archives and gener-
ally tried to make themselves at home in the huge château, unoccupied for
centuries, in which the plumbing was as historic as anything else. Life at
this repository was somewhat more relaxed for the art professionals than
it was at the châteaux still occupied by their owners, where the country life
continued full tilt. At Cheverny there was an active hunt with its pack of
hounds whipped in by huntsmen in red and gold. Valençay's ducal owner
had a magnificent if noisy collection of parrots in cages scattered about the
premises. The curators, regarding adaptation to these new experiences as
part of their professional duty, soon learned that "thirty or forty technical
words well placed in conversation were enough to make us worthy con-
versationalists, and cure us of any inferiority complexes."[14]

All through the winter more was brought out from Paris in whatever trans-
portation could be begged or borrowed by Musées director Jacques Jau-
jard from donors, employees, and friends. Other convoys took the contents
of the museums of the Ville de Paris, separately administered, to addi-
tional châteaux in the same region. In Paris proper the cellars of the Pan-
theon and Saint-Sulpice gradually filled with sculpture and stained glass
from nearby churches and such institutions as the Comédie-Française.
One curator was highly amused to find Houdon's statue of arch anticleric
Voltaire surrounded by saints and angels pointing heavenward.[15] Similar
scenes took place all over France. In Bayeux, just in case, the mayor or-
dered the famous tapestry rolled, sealed in its special lead box, and stored
in a concrete vault.

Despite all the preparations, the reality of the invasion of Holland and
Belgium was a shock. Henri Matisse, caught in Paris, rushed to a travel
agent and booked passage to Rio on a ship leaving Genoa on June 8. As he
walked out of the agency he met Picasso by chance, and expressed his dis-
may at the dismal performance of the French armies. Picasso explained,
"C'est l'Ecole des Beaux-Arts," to him a perfect description of the Magi-
not mentality.[16]

On June 4 a great wheeling maneuver of the main body of the German in-
vasion forces placed them directly north of the clustered French reposito-
ries and only 160 miles away with no Maginot line in between. They
advanced relentlessly. Before this juggernaut millions from Belgium, the
north of France, and soon Paris, fled in a tidal wave. Exhausted, filthy peo-
ple and their children, cats, and dogs jammed into cars swathed in mat-
tresses, pushing grotesquely loaded bicycles or simply walking, streamed
into the parks of Chambord and Valençay, reminding one art historian of

Saint-Sulpice, Paris: Voltaire among the saints

Callot's *Misères de la Guerre.* Every train and station was jammed. And into this river of despair were launched, once again, the greatest treasures of France. The *Mona Lisa* was the first to depart with a few other hastily packed works from Louvigny, the northernmost depot. By June 5 she was safely in the ancient Abbey of Loc-Dieu in the Midi near Villefranche-de-Rouergue. More than three thousand pictures would join her there as a result of the extraordinary efforts of the French curators. The last convoy crossed the Loire on June 17, only hours before the bridges were blown.

South of the river, conditions on the roads were terrible. The biggest convoy inched painfully toward Valençay. One of the truck drivers, Lucie Mazauric, terrified because she had only managed to pass her driver's test the day before, later wrote:

> The hardest was the beginning, from Chambord to Valençay. Cars were going in every direction. The jammed roads slowed our progress, and I had the misfortune, driving up toward Valençay, to hook my bumper over that of Mme. Delaroche-Vernet. We would never have gotten it loose, and would have been crushed by the flood of cars being driven by dazed drivers who seemed not to see any obstacles, had a

strong youth not unhooked us. . . . This act of kindness helped us bear the rest, and the rest was difficult. . . . German aircraft constantly flew up and down the roads. If they had wanted to attack . . . the exodus would have been a carnage.[17]

At Valençay, which was already jammed with curators and refugees, they stopped for the night and slept badly, listening to the sounds of artillery barrages, for most their first experience of this. At dawn the convoy left again in the terribly beautiful weather which had blessed this whole invasion, spending a second night in a village schoolhouse on mattresses. The next day, passing through countryside where no one seemed to be in charge, they were pleased to note that mentioning the Louvre was enough to get them the gasoline they needed. They arrived at Loc-Dieu, trucks in dire need of maintenance, on the day of the Armistice.

On June 10 the French government had also fled Paris to join its masterpieces in châteaux beyond the barrier provided by the Loire. Its departure was not unexpected. So encumbered were the roads that the ministers took more than twelve hours to drive the 160 miles to their assigned domains around Tours. Now it was their turn to discover the traditional discomforts of country life. No one had remembered the minimal telephonic equipment cherished by château dwellers to this day. The equal dearth of bathing facilities led to surprising encounters of famous personages in the halls: both Churchill and the omnipresent mistress of the French Premier, the Countess de Portes, were seen wandering about swathed in voluminous red silk dressing gowns in search of bathrooms.[18] It was not until June 13 that French Commander in Chief Weygand, with the encouragement and assistance of the neutral American and Swiss embassies, declared Paris an open city.[19] This was as much a military decision as an aesthetic one: Weygand wanted to prevent the total encirclement of the Army defending the city. Churchill disapproved; he had urged that Paris be defended, as the "house to house defense of a great city" would have "enormous absorbing power."[20] German troops entered Paris the next day. Retreating again, the government, as helpless as the 8 million other refugees, moved on to Bordeaux.

Thousands of privately owned works of art were also on the move in the chaotic invasion days. The French museum administration had taken in a large number of private holdings, including many works belonging to the major Jewish collectors and dealers. At Moyre and Sourches were items belonging to the Wildensteins, various Rothschilds, M. David David-

Weill (chairman of the Conseil des Musées), and Alphonse Kann. Brissac sheltered more. But these collections, which represented only a fraction of the privately held works in Paris, were not among those which were transported south by the Musées. The rest were dealt with in all sorts of ways. Peggy Guggenheim, who had been refused space in the Louvre sanctuaries because, she later claimed, "the Louvre decided the pictures were too modern and not worth saving," frantically began removing her pictures from their stretchers on June 5. They were packed in three large crates which she man-

Paul Rosenberg

aged to send to Vichy, where they were hidden in a friend's barn.[21] Before fleeing to New York via Lisbon, the dealer Paul Rosenberg left 162 major works in a bank in Libourne, just outside Bordeaux. This deposit contained no less than 5 Degas, 5 Monets, 7 Bonnards, 21 Matisses, 14 Braques, 33 Picassos, plus a good selection of items by Corot, Ingres, van Gogh, Cézanne, Renoir, and Gauguin. One hundred more Rosenberg pictures went to a rented château at nearby Floirac.[22] Matisse, who had been staying with Rosenberg in Bordeaux, was so horrified by the maelstrom of refugees fighting to board anything that would take them away that he changed his mind about leaving France. It took him two months, moving slowly from town to town across the south of France, to reach his favorite Hôtel Régina in Nice. Once there, he wrote to his son in New York that "it seemed to me I would be deserting. If everyone who has any values leaves France, what remains?"[23] Georges Braque too was on the road, with his wife, studio assistant, and as many paintings as he could fit in his car. When he arrived in Bordeaux, Braque used the same bank as Rosenberg, entrusting to it part of his modern collection and, unfortunately as it would turn out, one Cranach portrait.

Georges Wildenstein put 329 objects into the Banque de France in Paris

Georges Wildenstein, London, 1938 (Photo by Cecil Beaton)

and had some 82 taken in by the Louvre, but plenty were left in his showrooms at 57, rue la Boétie, and in his house outside Paris when he and his family fled to Aix-en-Provence. The Rothschild items sheltered by the Louvre represented only a fraction of the family's enormous holdings, which remained scattered all over France. Miriam de Rothschild, known for her vagueness, lost forever much of her collection which she buried in an unmarked sand dune near Dieppe.[24] More cautious, the Bernheim-Jeune family sent 28 paintings, 7 of them by Cézanne, to friends at the Château de Rastignac in the Dordogne, to be carefully hidden in trunks, closets, and cabinets. Other pictures went with the family to Nice, but the apartment in Paris remained full of sculpture, drawings, and paintings of great quality.[25] And the jeweler Henri Vever put his Rembrandt etchings in his Paris bank, but took his beloved and incomparable collection of Islamic miniatures and books with him to his château in Normandy.

If the quantities involved in all these arrangements seem impressive, they pale by comparison to the shipment successfully moved through France and Spain to Lisbon during May and June by the dealer Martin Fabiani. After the death of the legendary Ambroise Vollard in July 1939, his brother Lucien had sold much of his share of the collection to Fabiani, who had worked with Vollard for years. The pictures, which had been delivered only weeks before the invasion,[26] were a staggering group: 429 paintings, drawings, and watercolors by Renoir; 68 Cézannes, 57 Rouaults, 13 Gauguins, and so forth, to a grand total of 635. British export papers having been granted, they left Lisbon on September 25, 1940, on the SS *Excalibur,* the same ship which had just transported the Duke and Duchess of Windsor to semi-exile in Bermuda.

Fabiani believed that works of this nature would be considerably more salable in the United States or perhaps Britain than to the new rulers of

France; to this end he had entered into a profit-sharing agreement with Etienne Bignou, New York, and Reid and Lefèvre, London.[27] But alas, by the time the *Excalibur* neared Bermuda, continental France was regarded by the British not as an ally, but as an enemy economy whose foreign exchange could be used to sustain Nazi aggression, now aimed squarely at England. All British consuls, working with the Ministry of Economic Warfare, had been alerted to the export of "enemy" assets, and all shipments were carefully checked when they arrived at British-controlled ports. In Bermuda, "on account of their enemy origin, and of doubts about the sympathies of Fabiani," the pictures were removed, placed in prise, and later stored in Canada in the charge of the Registrar of the Exchequer Court. There they would remain until the end of the war.[28]

Even those most versed in the little subterfuges of international trade would find that their careful plans were not only of no avail but had suddenly become quite illegal. A few weeks after the Fabiani affair, David David-Weill, head of the famed Lazard Frères international bank, sent twenty-six cases of paintings and antiquities off to Lisbon, where they too eventually embarked on the busy SS *Excalibur.* Their destination was New York, where they were to be sold by the Wildenstein branch incorporated there. There was nothing new about this arrangement. In 1931 M. David-Weill had transferred part of his collection to a British holding company called Anglo-Continental Art, Inc., which in turn was owned by a Canadian corporation also entirely owned by David-Weill. Parts of the collection had also been consigned to Wildenstein, London, for sale. Wildenstein, searching for a wider market, sent six shipments of these works to its New York branch in 1937 and 1938. There were some 291 items, valued at more than $2 million. The works on the *Excalibur* would join those in New York as property of Anglo-Continental.

But the cases, once in Lisbon, were at first refused an export certification by the British. Cables flew back and forth between Lazard branches in London and New York, referring to David-Weill only as "our common friend" in case of German intercepts, and imploring London to "use their best efforts to clear the shipment." The London office revealed that the British had heard that the works were to be exhibited and sold in New York in order to raise funds for the French "Secours National," which had suddenly become an enemy organization. This was denied, and appeals were made to the British embassy in Washington, which helpfully pointed out that the principal motivation was to keep the collection from the Germans. The shipment was finally allowed to leave Lisbon in October 1941, and arrived safely in New York, where it was supposed to be held in a blocked account.

The reluctance of the British to allow the David-Weill collection to be

sold had resulted from the fact that all the proceeds of sales of the objects previously sent to New York from London had not been sent back to foreign-currency-starved Britain, nominal base of Anglo-Continental Art. The Bank of England, in its efforts to keep dollars flowing to England, now threatened to force immediate liquidation of the entire collection at one time, which would have the effect of lowering prices. This was made clear to Wildenstein in several anxious letters from Anglo-Continental in London imploring them to remit the disputed amounts immediately. Things were made worse by the entry of the Canadians on the scene, who also claimed the credits.

All these machinations inevitably came to the notice of United States Treasury authorities monitoring the flow of foreign funds into and out of the country. Under American law, all remittances to nations under German control had to be reported and licensed, and the David-Weill shipment had unquestionably originated in France. T-men soon descended on the elegant premises of Wildenstein, New York, where the partners were found to have violated these American regulations by having sent off the very proceeds for which London clamored.

Matters were not improved by Wildenstein's transparently false claim that they were not sure who exactly owned the collection, admitting only that "there is a possibility of a French interest being involved." The T-men thought it was all an "attempt to confuse the English, Canadian, and United States authorities as to the true ownership of the collection, and in the meantime enjoy absolute freedom in the manner in which the collection was to be managed." The entire assets of Anglo-Continental were immediately frozen by the American authorities, proper licenses were obtained by Wildenstein, and proceeds from all further sales ordered to be held in a blocked account in a New York bank. This was fine with Anglo-Continental's lawyer, who all along had wanted to keep everything in the safety of the USA. For many in the art trade, who preferred to operate just as the T-men described, this unwanted scrutiny was, particularly in the circumstances, a serious blow.[29]

The fall of France caused upheavals beyond that country's borders. The British collections which had been evacuated to Wales, as far as one could get from aircraft coming from Germany proper, now lay directly in the path of German raiders flying from their new bases in France to attack the industrial cities of the Midlands. Although Bangor and its surroundings were not targets, even the remote possibility that a random bomb might wipe out the National Gallery's holdings was worrisome. At first it was decided to distribute the works over a larger area. Some two hundred pictures

London's National Gallery pictures go underground in the wilds of Wales.

of "supreme importance" were divided among a house in Bontnewydd, Lord Lisburne's estate near Aberystwyth, and Caernarvon Castle. In the first two the landlords were treated to unheard-of electric heating, far better than the ancient hot-water system at Caernarvon, where the humidity was controlled by dipping old blankets and felt in a nearby stream and hanging them among the paintings. Such logistical problems made these arrangements far from ideal, and in July, as the fear of a German invasion mounted and the air war intensified, the Gallery trustees decided to look for underground accommodations. Technical experts Martin Davies and Ian Rawlins set off across the wild landscapes of Wales, exploring "quarries, deep defiles capable of being roofed with reinforced concrete, railway tunnels, disused caves and so forth." It was not, at first, an encouraging tour. Most of the sites were immediately rejected. "Access to . . . quarries we had seen, although perfect for the transport of slates . . . filled Mr. Rawlins and myself with despair when we thought of the National Gallery pictures," wrote Davies. But in mid-September they finally discovered Manod Quarry, near Festinogg, which did have a rough road of sorts—four miles long with a gradient of 1 in 6—and a cooperative owner, who agreed not only to give them the space they needed but to dou-

ble the size of the entrance, which would allow the cases of pictures to be unloaded inside.

Fixing up the interior was no small job. Five thousand tons of slate rock had to be blasted from the floors in order to level them, and six whole buildings in which humidity and light could be controlled had to be constructed over an area of half a square mile inside the cavern. The first pictures could not be moved in until August 1941. What had been so carefully spread out now had to be brought together. Six or seven hundred pictures a week crawled up to the quarry in howling winds on a road so narrow that two trucks could not pass. Once there, cases weighing thousands of pounds had to be inched down, without cranes, onto little motorized trolleys which moved them into the buildings. Inside, there was enough wall space to hang most of the collection, "not in a pleasing way, but well enough to inspect how they behaved underground"—which, due to the excellent temperature control and absence of the public, "who are enough to disturb the most careful air conditioning," was better than at home.[30]

Other refuges were prepared in the West Country for the British Museum and the Victoria and Albert. And the bombs did come. The National Gallery was hit nine times. An oil bomb went straight through the dome of the main reading room of the British Museum; others destroyed the roof of the new Parthenon Gallery recently given by Lord Duveen. The Tate, whose collections had also been regrouped from their original refuges to Sudley Castle in Gloucestershire, was hit over and over again, until all of its galleries were unusable. Director Rothenstein, looking down from what was left of the roof, saw

> a scene of desolation and fantasy: acres of glass roofing had disappeared, and daggers of glass, some as high as a man and others minute, were lodged upright in the surrounding lawn—a dense harvest of glass dragon's teeth, glittering in the sun. Entire paving stones from the street lay on top of the walls and roof beams; others, which had fallen through glass roofing and wooden floors, lay in the basement far below.[31]

By June 21 it was all over. An exultant Hitler now controlled most of the European continent. The Nazi idea of what to do with their new Western territories was radically different from their concept of exploitation of the East. The cultural amenities of the West were supposed to be enjoyed as well as conquered. These countries would be economically integrated into the German sphere. The more "Germanic" areas such as Holland, Flanders, and Luxembourg would be structured in the same way as Germany itself, and become part of a "Nordic Reich." France, as always a special

case, would be allowed to preserve aspects of its culture which would not be tolerated in the rest of Hitler's empire, many in the Nazi regime being secretly full of admiration for the civilization of their elegant and arrogant neighbor.

There was no need for the conqueror to take away the national collections of these new "provinces"; the Thousand-Year Reich now owned them. Come the peace treaty the government-run museums would automatically fall under the control of the German Ministry of Culture, and their collections could be redistributed as indicated by the researches of German art historians. In the meantime, it was in the interest of the Reich to monitor and help preserve these collections. The newly established Nazi museums would continue to be augmented by confiscations of the property of "enemy aliens" (who eventually included all Jews no matter what their nationality) and by a purchasing program of gigantic proportions, fueled by the unlimited funds now available to the Germans from the economies of their victims.

All this preservation, confiscation, and dealing would be carried out by a complex group of bureaucracies, often in ferocious competition, whose utterly cynical exploitation of those in their power was justified within true Nazi bosoms by an equally complex series of legalisms and rationalizations. The mad grandeur of the whole thing, which envisaged nothing less than a complete redistribution and reorganization of Europe's peoples and their patrimonies, is impressive. In the purified New Order all would be perfect and homogeneous. Undesirable thoughts, sounds, images, and beings would be eliminated. Then everything would be magnificently organized, efficient, and clean, classified and arranged in the gleaming new cities, to the Glory of Germanism.

The status of the Netherlands as a future German province was underlined by the immediate appointment of a nonmilitary Reichskommissar with such close ties to the Nazi leadership that there could be no doubt of his loyalty: Arthur Seyss-Inquart, who had been so helpful in engineering the Austrian Anschluss, and who had had more occupation experience as assistant to Governor General Frank in Poland. This appointment was a surprise to the Army, which had planned a traditional military government. Within days of the Dutch surrender, Himmler, fired up to mystical fervor by the successful initiation of his plans for the Germanization of Poland, secretly toured the Netherlands with his personal adjutant Karl Wolff, "observing the sights and the peoples who would clearly be a racial benefit to Germany."[32] After Poland, "purification" of this basically Germanic region would be easy, and it would soon find its natural place, stemming

from its prehistoric Germanism, as part of the new Europa, which would form a buttress against the terrible cultures of the East.[33] By June 20 Himmler had already ordered an Ahnenerbe representative to be sent to The Hague to make contact with Dutch intellectuals and promote "Nordic Indo-Germanism" by getting rid of the Church, Bolshevism, Freemasonry, and Jewry. When a surprising animosity on the part of the Dutch to these reforms became clear, Himmler sadly attributed it to a too close association in the public mind of the Ahnenerbe with the definitely nonintellectual activities of other branches of the SS. The project, always underfunded by Hitler, was not a success.[34] Indeed, the antipathy of the Dutch people for the Germans was so intense that Goebbels would be moved to call them "the most insolent and obstreperous people in the entire West."[35]

Himmler's fellow theorist Alfred Rosenberg was not far behind. A letter from Supreme Commander Keitel notified the Army on July 5 that Rosenberg's minions, known as the Einsatzstab Reichsleiter Rosenberg, or ERR, would soon be searching libraries and archives for documents "which are valuable to Germany." They would also search for "political archives which are directed against us" and have the material in question confiscated in cooperation with the SS. The resulting accumulations of books and documents would be sent off to Rosenberg's *Hoheschule* to be used in the training of future generations of purifiers.[36] By September 1940 they were busily at work. The leader of this confiscation group was so proud of his achievements that he concluded a progress report with the comment that his men had been "working overtime for weeks now, and also, as is done on the battlefield, on Sundays."[37]

But weeks before these gentlemen had come on the scene in Holland, another familiar figure, Kajetan Mühlmann, was in full action, having arrived as an advance man for Reichskommissar Seyss-Inquart. As always he was a great help to his superior, finding him a suitable residence in a vacant villa just outside The Hague, occupation of the Dutch Royal residences having been rejected as tactless. Before Seyss-Inquart arrived, Mühlmann also called upon the chief for museums of the Dutch Ministry of Culture, J. K. van der Haagen, to inquire about the location of certain collections and repositories. Van der Haagen assumed he represented the military authorities, and only later would come to understand his true intentions.[38]

By the end of May, Mühlmann and several assistants had set up an office at Sophialaan 11, in the center of The Hague, and were busy making lists of "enemy" property and opening bank accounts: one for purchases for Goering, Hitler, and other high officials, which would be funded from

Germany; one for money from the future sales of objects to be confiscated by the agents of the "Enemy Property Service," which would be credited to a "trust fund" in Germany, as had been the case in Poland; and another with money from clients in Poland desiring objects from the West. There was no time to waste in organizing these services. Goering's curator Hofer had also arrived in early May to arrange potential purchases, and the Luftwaffe commander himself had taken advantage of the halt before Dunkirk to make a quick trip to Amsterdam on May 20 to see the results. Mühlmann and his staff would be paid by a 10 percent commission on each transaction they could generate. This office, known as the Dienststelle Mühlmann, did not bother much with "Indo-Germanism." They were all business.[39]

The actual overseeing of the Netherlands' national collections was not to be Mühlmann's concern; it was left to the Dutch under the supervision of the Seyss-Inquart government. Construction of shelters for the Dutch treasures was continued with full German cooperation throughout the first months of the occupation; after all, the Germanic patrimony must be preserved. Nothing could have been a greater contrast to Poland: sophisticated concrete buildings, with the latest in air conditioning, covered with false dunes and heavily fortified, were rushed to completion near Castricum just west of Amsterdam, and the *Night Watch* and other masterpieces were moved into these new repositories from the more vulnerable castle at Medemblik. Another bunker was constructed in the Hoge Veluwe National Park in central Holland for the collections of the Kröller-Müller Museum. In late 1941 the German authorities, fearing a British invasion, ordered the construction of further shelters in the limestone caves near Maastricht, right on the German border. Again the greatest masterpieces from the major museums and the Royal Palaces were gingerly moved to this secret place on special trains. The exact location was equally secretly transmitted to the Dutch government in exile in England by van der Haagen.

The museums themselves slowly reopened with whatever was still available. At the Rijksmuseum, the large Lanz collection was brought out of longtime storage to fill up empty walls, and Director Schmidt Degener, in office since 1922, arranged exhibitions of musical instruments and objects from the Netherlands Railway Museums in more of the echoing spaces. The Boymans Museum in Rotterdam also made do with previously stored collections, but here things were a little different. The director, Dr. Dirk Hannema, was kept so busy by his duties as a member of Seyss-Inquart's new Dutch Chamber of Culture and by his involvement in delicate sales negotiations between the museum's greatest patron, D. G. van

Beuningen, and Linz director Hans Posse (about which more later) that he had to turn over the day-to-day running of the museum to his assistant. The Boymans became quite a German favorite. By 1942 Hannema had gained the confidence of the new rulers of Holland to such a degree that he was appointed head of the Dutch museums, a job, he assured van der Haagen, he had accepted only in order to protect the Dutch patrimony. Van der Haagen later endorsed this claim, but it was in this capacity that Hannema became a participant in the only deal in which works owned outright by a Dutch national museum were transferred to the Reich.[40]

Dr. A. G. Kröller and his wife, née Müller, the chief benefactors of the museum named for them, had, immediately after World War I, bought three paintings by German artists for extremely low prices in Germany, brought them back to Holland, and donated them to the museum. Goering had had his eye on these pictures from the outset, one of them being a *Venus* by his favorite artist, Cranach. The other two, another *Venus* by Hans Baldung Grien and a Bruyn the Elder *Portrait of a Lady,* were also highly desirable. The Reichsmarschall felt that they had been bought for "unfair prices" and been unjustly removed from their Fatherland. Mühlmann, the true intent of his visit to the director of museums now revealed, was sent off to discuss a possible sale with the director of the Kröller-Müller, Dr. van Deventer.

Mühlmann offered DFl 600,000 in cash. Van Deventer was at first amazed at this offer, which was absolutely opposed by most of his museum colleagues, but after a time he consented to form a little committee to consider the matter. This body consisted of himself and his assistant, Dr. Hannema of the Boymans, and an expert from Mühlmann's staff. The Dutch felt that Goering's offer was too low. The negotiations seemed at an impasse until Mühlmann proposed that the Kröller-Müller receive DFl 600,000 in credits to be spent on the market, through his office of course, plus property concessions in the national park in which the museum was located.[41] This offer was accepted.

But Goering was not to keep all three pictures. On September 23, 1940, Posse had written Bormann that since the Baldung Grien was "one of the most beautiful and important works of the German Renaissance," it was "urgently desirable" that it be acquired for Linz, where it would be the "masterpiece of the German section." He suggested that Bormann help push along the negotiations. To make it all irresistible he enclosed a photograph. Bormann, still a bit unclear about the whole deal, showed this to Hitler, who was not. The picture was preempted for Linz.[42]

It took the Kröller-Müller officials months of fussing to choose their pictures, which included canvases by Pissarro, van Gogh, Manet, and

Degas. Nothing could have been more to the liking of the Nazis, who were thrilled to unload these "degenerate" pictures, at least two of which would turn out to have been confiscated by them in Paris. The Kröller-Müller was happy too, if perhaps not for the right reasons. And indeed it all turned out very well for them: after the war they got back the three German pictures, and got to keep all but the two pictures found to be stolen from Paris.[43]

Unaware of the noble Germanic intentions and bureaucratic machinations of the Nazi agencies, the civilian inhabitants of the Netherlands were principally concerned with the immediate problems created by the occupation. In 1940 it was not yet known that for many it would be a question of life and death, and few comprehended the totality of Nazi purification ideology. At this early date compromises of all sorts seemed possible, and while one hoped for escape or liberation, there was no reason to forgo the enormous profits to be made at the expense of the enemy. Nowhere would these be greater than in the art trade, and nowhere was the survival of the otherwise doomed more possible than through the satisfaction of the collector's fever by which the Nazi leadership was possessed.

One of the very first acts of the new Dutch occupation regime was a decree ordering the arrest of German Jewish refugees who had arrived there after 1933. Among these was the legendary art historian Max Friedländer, a former director of the Kaiser Friedrich Museum, who had reluctantly come to Holland in 1938 after having been refused entry by the Swiss. With him, as part of the deal, had come his library and archives, which were installed at the prestigious Rijksbureau voor Kunsthistorische Documentatie in The Hague. A hopelessly impractical academic of seventy-one, he and his old housekeeper had been tended by other art world emigrés from Germany, including the Feilchenfeldts and Friedländer's former protégé from Berlin, Vitale Bloch. The incarceration of Friedländer was immediately reported to Goering's curator Hofer, who was busily shopping in Amsterdam. On Goering's authority Hofer personally went to the Osnabrück internment camp to arrange for the release of Friedländer. It was explained that the arrest was a case of mistaken identity. In exchange for this rescue, Friedländer would be asked to supply evaluations for Nazi collectors for the duration of the war. In 1942, when all Dutch Jews were required to wear the yellow star, Friedländer and Vitale Bloch were declared "Honorary Aryans" and exempted after Hofer sent a memo declaring that "due to the great expertise of Professor Friedländer in German and Dutch painting, the Reichsmarschall desires that he remain in The Hague, and not be disturbed by the Delegate on Jewish Questions."[44]

When people were detained, their possessions were confiscated, and if

they were so fortunate as to escape, belongings left in storage were taken as well. Works of art from this source were collected by Mühlmann's agency and sold. A decree of August 30, 1940, also permitted them to open containers awaiting shipment abroad and remove desirable items. Museums and dealers were visited and ordered to list any private collections being held for absentee owners. Just so nothing would be missed, Seyss-Inquart authorized the removal of objects from houses abandoned during the invasion.

It was soon clear that Mühlmann's office would need more personnel. Help was provided in the person of Edouard Plietzsch, an expert on Dutch art from Berlin, who, as was true of so many in the Nazi art organizations, never was a Party member. He had written Posse soon after the invasion of Holland to ask for a job there, and had accepted only after being promised that he could remain a civilian, take a 15 percent commission on the paintings he handled on top of his regular salary, and be given travel expenses. On September 7, 1940, Plietzsch arrived in The Hague, where he shared offices with the local Gestapo representatives. By the twelfth he had provided an analysis of the major collections in Holland which might be open to offers to buy or to confiscation. This was forwarded to Bormann and Hitler. In a later report to Seyss-Inquart, Plietzsch pompously boasted of his discovery of the hiding place of "the Jewish Berlin collection of Dr. Jaffé in the Museum at Leiden, through confidential information from private quarters in Germany." This led to the seizure of the large collection, whose owner had emigrated to England. Six Jaffé works went to Hitler, and nine to his crony Heinrich Hoffmann. In the albums of photographs of available works now sent regularly to the Führer the provenance and recent history of the Jaffé works is clearly stated. Plietzsch was also instrumental in fingering works from the Rathenau, or Berlin-Kappel, collection, which had also left Berlin in the thirties. The distinctly unsavory methods he employed to recoup these works for the Reich are unabashedly revealed in his reports to Seyss-Inquart:

An Aryan co-heir had confidentially informed me that years ago the paintings had illegally been exported from Germany and some had later on, with the knowledge of the Rijksmuseum, been transported to America. Owing to my knowledge of ownership and the secret place of storage of the rest of the paintings, we were able to indemnify ourselves by seizing a series of the Kappel drawings by Menzel and the famous paintings *View of Haarlem* by Jacob Ruysdael and *Canal in Amsterdam* by Jan van der Weyden, and by paying in installments a very small amount to the Aryan joint-owner.[45]

Another Rathenau painting, Rembrandt's *Self-Portrait* of 1669, was removed from the custody of the Rijksmuseum.

Plietzsch did have his own brand of propriety about such things as long as those involved were not Jewish. In the fall of 1940 Frits Lugt's secretary, who was supposed to be taking care of the items the collector had left in Holland, reported that Lugt had ordered him to divide the collection up and hide it with friends. This the Nazis regarded as an illegal act. The Enemy Property Office confiscated the lot, and twenty-four paintings were sent off to Munich along with the Jaffé works. When, however, it was revealed that the secretary had fabricated the whole story in order to get a job with the Nazis, Plietzsch indignantly ordered the release of the rest of the collection and had the man jailed.

The Dutch art trade had traditionally had a solid relationship with Germany. The combined effects of the Depression and the advent of Nazism, which restricted the export of reichsmarks, had severely reduced its volume until 1936, when devaluation of the Dutch guilder led to a slight improvement. The outbreak of war again closed down the flow of German clients. Now the incorporation of Holland into the Reich economy reopened the trade. But this time there was nothing traditional about it. German government officials suddenly had access to millions of guilders in occupation money, forcibly siphoned off from the Dutch economy. All exchange restrictions were lifted on the reichsmark so that buying in Holland did not consume precious foreign currency. One study estimates that by June 1941 some RM 4.5 million a day were coming into Dutch banks.

Germany and its occupied lands became a giant pressure cooker of a self-contained market with little outlet for investment. No one, German or otherwise, could move money outside the Axis-controlled countries. No one could travel or buy nonexistent consumer goods. Art soon became a major factor in the economy as everyone with cash, from black marketeers to Hitler, sought safe assets. As the trade heated up, prices rose and family attics were scoured for the Dutch Old Masters and Romantic genre scenes beloved by the conquerors. German and Austrian dealers and auctioneers' agents from the houses of Weinmuller, Lange, and the Dorotheum, trying to meet the rising demand at home, poured into Holland. Newspapers were full of ads offering and seeking works of art. New dealerships sprang up left and right—so much so that the Dutch Nazi Chamber of Culture was forced to impose export limitations and issue restrictive rules in an effort to regulate auctions of "kitsch," and forbid the selling and display of "art" in such emporia as cleaners and tobacco shops.[46]

By 1941 this new commerce, which at first was allowed to flourish un-molested, had also come under the regulations of the Nuremberg laws and Jewish firms began to be Aryanized. A special agency oversaw the trans-fer of ownership to Aryan "trustees," after which the Jews, if they were still there, could run the business but were paid a salary limited by law to DFl 250 a month. The trustee could liquidate or sell the firm if he pleased. The experience of the old Amsterdam house of Jacob Stodel, which dealt principally in the decorative arts, was typical. The Stodels had cut off trade with Germany in 1933, but for more than a year after the invasion they were deluged with German customers (including the ever-busy di-rector of the Museum of Breslau) seeking seventeenth-century armoires, Delft porcelains, and minor paintings. Prices rose nicely with the increas-ing demand. In October 1941, with no warning, the shop was raided and sealed by a squad of police and civilians. The German museum directors were allowed back in to collect their purchases; apparently equally sur-prised by the raid, they smuggled a few extra objects out and delivered them to the Stodel brothers.

The business stayed closed until December, when the owners were sum-moned to meet their new "trustee," a Herr Kalb. Sales at the newly re-opened gallery increased so phenomenally during the winter that Herr Kalb decided he would like to own the business outright. The official as-sessment was reduced by two-thirds and Kalb agreed to pay the Stodels this sum over twenty-five years, as long as they kept their assets in an "ap-proved" bank. No payment was ever made. In June 1942, when all Jews were required to wear a yellow star, Kalb, declaring that having personnel so adorned was bad for business, fired them all. The Stodels managed to get to Brussels, where they survived the war.[47]

The high-level Nazi art purveyors were deeply involved in this buying frenzy and made full use of their prewar connections. Hans Posse could hardly wait to get there, and wrote Bormann on June 10, 1940, that al-though he had feared that much had been taken to America before Holland had been overrun, a great number of very high-quality works were left. Three days later Posse was authorized by Hitler to go to Holland.[48] But Goering and his minions had the same information, and got there first.

No collection was more vulnerable than that abandoned by Jacques Goudstikker. At the sudden flight of their master and the death of his ap-pointed trustee, two of the firm's employees had taken its operation upon themselves and, in the days immediately following the Dutch surrender, inveigled both Goudstikker's mother and the banks holding the firm's as-sets into appointing them as trustees.

This extraordinarily efficient wheeling and dealing while war still raged

only a few miles away seems remarkable to us now, but the vultures had immediately begun to circle here, just as they had in Austria, and the new "owners" of Goudstikker were soon approached. Two directors of the German industrial giant Persil had shown interest.[49] Others followed. The thought that the Nazis might otherwise confiscate the inventory of this Jewish firm without compensation was brought forth with varying degrees of subtlety by some of the prospective buyers. A quick sale, therefore, seemed prudent.

One of those interested was Alois Miedl, a German businessman and banker long resident in Holland and married to a Jew. Miedl's rather speculative and shady business dealings included an attempt to buy up the coast of Labrador to supply wood to Germany, a project rejected by Canada, and reputed diamond smuggling. He had several times been associated with Goering, knew the Reichsmarschall's sister, and had visited Carinhall. Goering had recommended him to Seyss-Inquart and Mühlmann as one familiar with the Dutch market. Mühlmann found that Miedl had gone rather beyond mere familiarity, and had "as a good businessman taken advantage of the panic which had taken place at the invasion" by suggesting to certain Jewish dealers that they sell to him before the Nazis confiscated their stock.[50]

Miedl had accompanied Goering's agent Hofer on his May trip to Holland, and shown him several available collections. This had been most successful. From the non-Jewish German banker Franz Koenigs, also a resident of the Netherlands, who was in financial difficulties, Miedl bought, on Hofer's advice and with the promise that he would offer Goering first refusal—and of course Hofer a kickback on any resale—nineteen paintings, of which no less than nine were by Rubens. Miedl, involved in buying out the Lisser-Rosencrantz Bank (Koenigs's principal creditor), had undoubtedly made the art sale part of the deal.[51] This purchase was also a clever preemptive move on Hofer's part, as Posse arrived only days later, ready to buy for Hitler, and had to concede these works to Goering.

Continuing the tour, Miedl introduced Hofer to another German businessman with a Jewish wife, his close friend Hans Tietje, who duly sold him a nice Cranach *Madonna and Child.* Fritz Gutmann, a German Jew desperate to leave Holland, who had sent most of his collection to Paris, offered Miedl three sixteenth-century silver cups. From Daniel Wolff, whose brother had unfortunately helped finance the Republican side in the Spanish Civil War, three more nice Dutch pictures were bought.[52] Stimulated by these eminently salable acquisitions, Miedl now wanted to begin dealing in a major way. Acquisition of the Goudstikker firm would put him in the first rank of European dealers.

The new "owners" had set the price for the firm and the rest of Goud-

stikker's assets at DFl 2.5 million, a full million more than its appraised value. Rumors that Goudstikker was heavily in debt made this high price seem reasonable and Miedl made an offer. At this point all becomes murky. It is not clear to this day if Miedl was acting in collusion with Hofer, the Goudstikker owners, neither, or both; but it is a matter of record that the contract of sale was signed by Hofer, and that Miedl paid DFl 550,000 and got the real estate: Castle Nyenrode and the Villa Oostermeer, another Goudstikker property on the Amstel River (contents included), the Amsterdam gallery, and the firm's name. Goering, who contributed DFl 2 million, got some six hundred paintings, among them the nine Rubenses and the Cranach purchased by Miedl on his shopping trip with Hofer and the four little angels which Goudstikker had so recently lent to the Memling show.

It was no bargain for the Reichsmarschall, though he considered it one. At Nuremberg he would testify that he had believed the business to be worth DFl 5 million, which is the amount Miedl had at first tried to get out of Goering's staff. After the (in fact) not so enormous debts were paid off, and the "owners" had been given large bonuses and assurances of continued employment, a considerable amount was invested in high-grade securities, chosen with the help of banker Koenigs, in the name of Desi Goudstikker. Miedl managed to protect this fund from the agencies confiscating Jewish assets throughout the war; he also supported and protected Goudstikker's mother. This altruism was somewhat offset by Miedl's precautionary measure of putting Villa Oostermeer in the names of his own children, which would seem to indicate that he did not expect Desi Goudstikker to return anytime soon. After Goering had sorted out the mass of paintings, Miedl bought back the residue. In the next four years he would sell some DFl 6 million worth of art to his countrymen from his new emporium.

Hofer bought hundreds more pictures in Holland and Belgium. Over and over again an exit visa or some special form of payment or protection was part of the deal. A Freiherr von Palm sold a Lochner *Nativity* for cash plus special forest land in Württemberg. Frau von Pannwitz, an Argentine national and member of the German jet set in Holland, who had previously entertained Goering at her house and sold him several drawings right off the wall, wanted a visa for Switzerland. Goering obligingly bought her Rembrandt, *Portrait of an Old Man Wearing a Turban,* and four other pictures which he had noticed at the dinner party, for DFl 390,000, gave her the visa, and put her house off limits to troops. The rest of her collection stayed in storage at the Rijksmuseum—which was fine with Goering, who fully intended to take it over if Argentina declared war on Germany.[53]

If the Reichsmarschall displayed a certain noblesse oblige on these oc-
casions, he was not forgiving when he was the supplicant. Soon after the
German takeover, the Belgian Emile Renders had let it be known that he
would sell his collection of some twenty very nice, if somewhat retouched,
early Flemish works if the buyer would agree to keep them together. In-
cluded in the package were several supposed Memlings and a van der
Weyden. Goering was interested and turned over details of payment to his
staff. Renders, trying to make the most of the deal, kept changing the mode
of payment from dollars to gold to securities. Irritated by this, Goering had
the collection frozen by his Currency Control unit, the Devisenschutzkom-
mando. Miedl, who had bank connections, was sent to pursue the negoti-
ations. Unbeknownst to his underlings, Goering also sent Renders a little
note saying, "Should you this time again not be able to decide, then I
should be compelled to withdraw my offer and then things would go
their normal way, without my being able to do anything to impede it."
(Mühlmann later wryly commented that Goering "did not usually put
that sort of thing in writing.") Renders settled. Miedl paid him about
BFr 12 million in securities—not an easy thing to arrange, as the stock
market was officially closed. All the paintings went to Miedl in Amster-
dam. The collector's desire to keep the collection intact was ignored;
six were reserved for Goering, and the rest were put in Miedl's stocks.
Renders could not have been too intimidated: two years later he offered
Goering his sculpture collection on the same basis. Hofer, who did
not think much of it, bought it for Miedl, and reserved five pieces for
his chief.[54]

Native Dutch dealers, many with problems similar to those of the
refugees, but not loath to partake of the millions being spent, awaited Goe-
ring's visits with mixed emotions. Next to Miedl the largest seller to Ger-
mans in Holland was Pieter de Boer. De Boer had been head of the Dutch
Association of Art Dealers since Goudstikker's death. His wife was Jew-
ish too, and he and his brother, who had dual Swiss citizenship, had ap-
plied for entry there. On his first visit in August 1940, Goering kissed
Mme de Boer's hand in the most courtly manner, examined their stock
with great attention, but bought nothing. As soon as he left, the de Boers
rushed a number of pictures into hiding. A few days later they reserved an
early German altarpiece for the representative of a Cologne museum.
When Goering suddenly reappeared in September he noticed immediately
that certain pictures were missing, and declared that he wanted the altar-
piece. The frightened de Boers said that the paintings had been sold and
the altarpiece reserved for Cologne. Goering laughed and said that that

was no problem in an authoritarian state, and bought it along with fifteen other pictures.

From then on, the de Boer firm did very well, actively courting major German clients. Baldur von Schirach spent DFl 127,000; representatives of the Dorotheum and all the major German museums poured through the shop. Private Dutch citizens, pretending not to know who de Boer's customers were, brought in things to sell on consignment. By war's end the house had sold nearly DFl 2 million worth of art (more than three hundred pictures) to their enemies and DFl 2.3 million to their compatriots. In 1943, when Jewish deportations began in earnest, the de Boers' Swiss citizenship was approved. They did not leave right away. The heyday of trading was nearly over, but there were other deals to be made. Four panels by Jan Breughel representing the Elements, taken from their hidden private collection, were exchanged with Hitler's curators for the freedom of their Jewish employee Otto Busch and his fiancée. The paintings were to be handed over to a representative of the Linz Museum upon written proof that the Busches had "crossed the frontier of a neutral nation." The Breughels went to Dresden, where they are said to have adorned the office of Hans Posse's successor, Hermann Voss, until they perished in the fire bombing of that city.[55]

Another firm which did well while it lasted was that of Nathan Katz of Dieren, near Arnhem. They had opened a branch in The Hague on May 1, 1940, just in time to partake of the coming boom. This was an old house that had gone from small beginnings to the big time very rapidly, helped by the establishment of a branch in Switzerland. The really good Katz pictures, which everyone knew were there, were never put on the market. The Germans tolerated this because Nathan Katz was the conduit for major works from several extremely important private collections. For Goering, in 1941, he procured Rembrandt's 1630 *Portrait of Saskia* and Hals's *Portrait of a Sacristan* from the Ten Cate collection, plus the van Dyck *Portrait of a Family* from the recently sold Cook collection. But the real reason Katz survived was his connection to the widow of Otto Lanz, a former Swiss consul in Holland to whom belonged the collection Schmidt Degener had just put on show at the Rijksmuseum.

Both Posse and Hofer coveted this uneven group of mostly Italian works, plus others which had gone back with Mme Lanz to Basel. Posse had personally proposed to the Führer that he keep the cream of this collection and sell the large number of leftovers at auction, which would surely bring in large sums. Mme Lanz refused to deal through anyone other than Katz, and also wished to be paid SFr 2 million. Such a quantity of foreign currency Goering could not manage, and Posse, with his direct pipeline to Hitler, won the day.

A visa to Switzerland for Nathan Katz was also part of the deal, and this was much harder to obtain than the money. Posse wrote to the Reichschancellery that Katz, "with whose activity I have always been pleased," had told him of very valuable works for sale in Switzerland, which could be obtained if the dealer could go there to arrange things. The visa request was sent on to Bormann, with the suggestion that he speak to the dreaded SS Gruppenführer Heydrich, as the fact that Katz was Jewish was "a problem." It is indicative of Posse's power that Nathan Katz indeed went to Basel in late 1941, where he of course remained for the duration of the war.

The affair did not end there. In return for Rembrandt's *Portrait of a Man—Member of the Raman Family* from his private holdings, twenty-five other Katzes, it was said, were given visas to Spain, and were able to make their way to the Americas. Posse went to Basel and from there personally spoke to German officials at the Spanish border in order to be sure they had passed; only then was the Rembrandt put into his hands. And, last but not least, Katz's mother was released from the Dutch concentration camp at Westerbork in exchange for a picture which a high SS official wanted to give Hitler for his birthday.[56]

Goering was never unpleasant in his dealings. He would arrive in high spirits in his palatial train, complete with oversize bathtub and phalanxes of elegantly uniformed adjutants, and go from one gallery to another. Even the most endangered agreed that he had a certain charm, and considering the amounts he spent, they were not reluctant to see him arrive. The less agreeable realities of the financial and human arrangements were left to the likes of Hofer and Miedl. The non-Jewish house of Hoogendijk was one of Goering's particular favorites. By prearrangement with Hofer, the management always had high-quality works, outrageously overpriced and carefully vetted by Friedländer, waiting for him.[57] Goering, who seemed quite amused by this tough trader, bought forty-two pictures from him in the course of the war.

Hoogendijk was particularly known as the dealer who handled the remarkable series of Vermeers which came to light in the occupation years and which he sold for high prices to Dutch collectors and museums. These were later found to be brilliant forgeries by the unsuccessful artist Hans van Meegeren. Hoogendijk was not the only one taken in. In 1943 de Boer too tried to sell one entitled *Christ in the House of Martha and Mary,* duly authenticated by Vitale Bloch, to Goering. Hofer refused it on grounds of its price and condition. Linz director Voss thought it was a fake and also refused. Terrified that they would lose this national treasure, the Dutch museums snapped it up.[58]

Hofer meanwhile had heard from Miedl of yet another of these "Ver-

meers," this one entitled *Christ with the Woman Taken in Adultery*. Miedl took it to Carinhall on approval in September 1943. Like the others, its provenance was unclear, and the asking price was a steep DFl 2 million. Vermeer had become all the rage among the Nazi leaders, and Goering deeply desired a picture by this artist, having been done out of both the Czernin Vermeer and, as we shall see later, the Rothschild *Astronomer,* by the Führer. But the price for the *Woman Taken in Adultery* was still too high. Unable to bring himself to relinquish it, Goering kept it at Carinhall for months, leaving Miedl to deal with pressure from the Dutch. Finally the Reichsmarschall resorted to his favorite device for acquisition without cost: the exchange. Miedl was given 150 second-quality pictures from Goering's now enormous inventory, and the "Vermeer" stayed at Carinhall.[59]

After his tours of the dealers Goering would celebrate with friends at various Amsterdam night spots. Miedl too lived high on the hog while it lasted, entertaining lavishly at his newly acquired Castle Nyenrode. Even the wife of the Nazi governor of Vienna, Baldur von Schirach, was impressed by the opulence of his dinners, which featured hard-to-get delicacies served on Goudstikker's magnificent silver and china. Such VIP visitors were also routinely given a tour of the storage rooms containing recently confiscated objects, jewelry, and clothes. When Frau von Schirach, repelled, declined to choose anything for herself, Miedl cheered her up by giving her a little Italian primitive, plucked from the walls of Nyenrode.[60]

The dour Hans Posse, unlike Goering, avoided Amsterdam's high life and stayed at the gloomy Hotel Centrale in The Hague. He was not at all pleased by the trading free-for-all which had developed in Holland, and continually urged Bormann to have Hitler issue orders which would reserve first choice for Linz. At one point he even suggested that private purchases be limited to DFl 2,000 a throw. This Hitler declined to do, as the flourishing Dutch market's profits were doing the economy no harm. Posse in most cases preferred to deal directly with collectors and leave negotiations with the trade to his underlings. His first instincts were to pursue top-grade collections and individual works he knew to be available, either for sale or by confiscation. The Lanz collection secured through Katz was one. But far more important was one of Europe's major drawings collections, comprising some 2,700 works which the banker Franz Koenigs had built up in the years between the wars.

After the crash of 1929 Koenigs was forced to negotiate loans from the Lisser-Rosencrantz Bank of Amsterdam, an institution owned by

Siegfried Kramarsky, who, as we have seen, would later leave for the United States with other works which Koenigs had been obliged to sell. The drawings were offered as collateral and in 1933 deposited for safe-keeping at the Boymans Museum in Rotterdam, where they were regularly exhibited.[61] As war approached, the directors of the bank, thinking of escape, began to call in their loans. The director of the Boymans Museum, Dr. Hannema, was asked to either buy the collection or ship it to the United States for sale. To save the collection for Holland, he persuaded Dutch coal broker D. G. van Beuningen to buy it for the very reasonable sum of DFl 2 million.

By June 1940 Posse had begun his campaign for the collection. Hannema resisted a sale of the whole thing, and indeed Posse was only interested in the best of the Italian and Northern works. By October he had made his choice and persuaded Hitler and Bormann to authorize DFl 1.5 million for the purchase. Using his favorite ploy, he urged them not to hesitate, as he wished to "arrive earlier than certain other people and catch them napping."[62] Despite this, the deal was not completed until December. It is clear that Hannema did not wish to give up any of the drawings, but the interests of van Beuningen were paramount: he needed cash to pay for paintings he had bought at the sale of the Cook collection just before the war began. He also needed to stay in the good graces of the Germans in order to protect his livelihood, his company being responsible for all transportation of German coal to the Netherlands. He therefore agreed to sell 525 of the drawings to Posse for the DFl 1.5 million, which still left him more than two thousand pieces. Van Beuningen quickly donated the remaining drawings to the Boymans Museum, thereby making them part of the Dutch national collections. Posse's relationship with the Dutch coal purveyor did not end there. A few months later he bought eighteen major paintings from him, including Watteau's *L'Indiscret* and a *Maja* by Goya.[63]

Another collection embroiled in financial trouble both in Holland and in France was that of Fritz Mannheimer, a onetime director of the Amsterdam branch of the Mendelsohn Bank. This was an enormous assemblage of more than three thousand objects, from paintings to jewelry to furniture, especially strong in decorative arts of Germanic origin: Meissen, medieval German goldsmiths' work, Gothic tapestries, silver busts once in the Cathedral of Basel, and silver table ornaments by Jamnitzer of Nuremberg, considered in the Reich to be the equal of Benvenuto Cellini. Mannheimer, a German who had of necessity become a Dutch resident in 1936, lived mainly in Amsterdam. But he was fond of France, and in 1933 had bought a large house in Vaucresson near Paris, plus a few other in-

DER REICHSKOMMISSAR FÜR DIE
BESETZTEN NIEDERLÄNDISCHEN
GEBIETE

DIENSTSTELLE DR. MÜHLMANN

Mit der wissenschaftlichen Durchführung war beauftragt:
Dr. Franz Kieslinger / Benützt wurde: Teilaufnahme des
Bestandes durch Geheimrat Otto von Falke
Fotos: Julius Scherb

Catalogue of the Mannheimer collection prepared by Mühlmann for Hitler

vestment properties. All this real estate, and his collection, were financed through the Mendelsohn Bank, as were loans he made to refugees coming through Holland. By 1924 his debt was so large that his bank too insisted on some protective arrangements. Mannheimer was also made to promise that he would collect no more.[64] This promise he did not keep. He died in France on August 9, 1939, a few months after having married the young woman who had taken care of him in his last year. At the same time the Mendelsohn Bank found itself in great difficulty, and closed its doors on August 12. Mannheimer's estate was thus embroiled in the bankruptcy, and on top of all this his taxes were found to be in arrears. Inspection of his Amsterdam house revealed that many of the most important objects had vanished. What remained was to be sold off to pay the Dutch state, but this the creditors put off, due to the low state of the market, the war in Poland having in the meantime started. It was also discovered that the missing works had been put in the name of Mannheimer's wife, and had been taken to Paris and London in a complicated operation. Even more complicated suits were brought in England and France by the Mendelsohn creditors. Soon it was discovered that Mme Mannheimer had taken twenty-seven paintings with her to the south of France, and that Mannheimer had added some DFl 2 million more in objects since his promise

to stop collecting. The exact ownership of this part of the collection was unclear.

The whole case was quite unsettled when the Germans took over the Netherlands. Seyss-Inquart was the first to help the creditors out by buying Mannheimer's wine cellar, which he brought to his new residence in Army trucks.[65] Meanwhile, the busy Alois Miedl had contacted the creditors too, and offered DFl 7.5 million for the whole collection, part of which he planned to give to Goering, while the rest would be sold for his own profit. But he had competition. Kajetan Mühlmann, who had found out about Miedl's offer from expert Friedländer, wanted to handle this fat sale through his Dienststelle and began his own negotiations with the Mannheimer curator who declared himself, in the name of the creditors, ready to sell the collection to the Nazi agency. Reichskommissar Seyss-Inquart saw no reason to spend good government money on a collection which he felt could be confiscated as German Jewish refugee property, and delayed any decision until the situation could be clarified. Mühlmann's office was meanwhile ordered to make a complete inventory and photographs of the collection.

As time passed, Posse, eager to add this trove to his Linz lists, kept pressure on Bormann. On October 10, 1940, he wrote to say that the "important collection of the refugee finance-Jew F. Mannheimer" should be reserved for Linz. Bormann, nervous about the ultimate outcome of the deal, cabled the Reichschancellery to find out if the Führer's recent decree giving him absolute right to all confiscated property in Austria applied to Holland too.[66] Lammers replied that the rule would apply to all occupied territories, and that "German" measures would take precedence over "local" ones. In a curious addendum he stated, "May I point out the fact that the Führer's reservation does not contain instructions for the seizure of art objects. It refers only to instances where confiscation has already taken or is taking place."[67]

This was encouraging, but Mühlmann, fortunately for his commission, had meanwhile discovered that the creditors were not Jewish, even if the owner had been, and that the confiscation decree could not be invoked. The stubborn Seyss-Inquart still balked at having to buy, saying that DFl 7.5 million was "a gift to the creditors," as the collection to his mind was still Jewish, much of it formerly German "public property," and furthermore contained a number of fakes. On top of this, he complained, the catalogue compiled by his staff had already cost DFl 200,000. By February 1941 there had still been no decision, and Posse again wrote Bormann to say that the collection was now in danger of falling into the hands of "speculators, who would ask exorbitant prices at auction." Hitler had

heard enough. The very next day Bormann, who knew that the pushy mayor of Breslau was also after it, replied to Posse that "the Mannheimer Collections will be bought by you on behalf of the Führer; the Reichskommissar [Seyss-Inquart] will prevent its sale to other parties, and see to it that the collection is acquired by you. . . . The Führer will decide later on the disposition of the objects after consultations with you. Send a list."[68]

Seyss-Inquart did manage to get the price down to DFl 5.5 million. Miedl got a DFl 400,000 payoff. The paintings which Mme Mannheimer had taken to Vichy were included in the contract. Mühlmann, who in the end had done very well on the deal, assured the creditors that they would receive final payment once these were retrieved. This was accomplished in 1944, and the terms of the contract were scrupulously observed, as befit an agreement between honorable men. But for that story we must go on to France.

V

LENITY AND CRUELTY

Occupied France: Protection and Confiscation

> FLUELLEN: I think the duke hath lost never a man
> but one that is like to be executed for robbing a
> church. . . .
> KING HENRY: We would have all such offenders so
> cut off: and we give express charge that in our
> marches through the country there be nothing com-
> pelled from the villages, nothing taken but paid for,
> none of the French upbraided or abused in disdain-
> ful language; for when lenity and cruelty play for
> a kingdom, the gentler gamester is the soonest
> winner.
> —William Shakespeare, *Henry V,* Act 3, Scene 6

On June 17, 1940, the aged Marshal Henri Pétain, hero of Verdun and pre-
mier of the crumbling government of the Third Republic, announced on
the radio that it was "necessary to stop the fighting." He did so without
consulting his allies or his own High Command, and before peace feelers
by his own diplomats had even been answered. The surprised Germans
immediately rebroadcast and distributed this favorable message. The fol-
lowing day the French declared all communities of more than twenty thou-
sand souls "open towns," which were not to be defended.[1] Now virtually
unopposed, the German advance continued inexorably toward Bordeaux,
where the French government, in a panic, once more prepared to evacuate,
this time to North Africa. Three days later a delegation set out from Bor-
deaux to negotiate with the Germans. Back they drove, through the con-
tinuing chaos on the roads, to Compiègne, where the Germans had signed
their humiliating surrender in 1918. Hitler, just as obsessed by World War
I thinking as the French when it came to ideology rather than tactics, had
planned a little theater. It would be his first contact with the French muse-

ums. German engineers blasted a hole in the wall of the building used to exhibit the railway car in which the 1918 Armistice had been signed, and moved it back to its original location near a white marble statue of Marshal Foch and a granite memorial inscribed: "Here on the eleventh of November 1918 succumbed the criminal pride of the German Empire," which was discreetly draped with a huge swastika flag for the present surrender ceremonies.[2]

The official cease-fire was set for 1:30 a.m. on June 25. Included in the first draft of the otherwise traditional Armistice document were a few uniquely Nazi clauses: one prohibited the transfer of assets from the Occupied to the Unoccupied Zone, and another, similar to that imposed on the Netherlands, demanded the surrender of all German refugees in France who had "betrayed their own people." The French objected strenuously to the latter provision, but in vain.[3] They did not, however, in the next four days, before the Armistice went into effect, publicize this threat, which would have allowed hundreds of refugees to escape.

The nation was divided by a jagged line drawn across it from Geneva to Tours, and from there sharply south to the Spanish border, giving the Germans control of the entire Atlantic coast, including Bordeaux. The government of what was left of France was therefore required to move to a site in the Unoccupied Zone, this being the resort town of Vichy. Here, amid all kinds of low intrigue, the Third Republic came to an end, and was replaced by the quasi dictatorship of Pétain and his manipulator Pierre Laval, who believed that Hitler would defeat Britain, and that their best advantage lay in cooperation with him. Indeed, according to U.S. ambassador William Bullitt's rather too clever observation, "Their hope is that France may become Germany's favorite province—a new Gau which will develop into a new Gaul."[4]

The Germans were not impressed. William Shirer, in Berlin at this juncture, noted in his diary that "Germany does not consider the Franco-German accounts as settled yet. Later they will be settled with historical realism . . . not only on the basis of the two decades since Versailles, but they will also take into account much earlier times."[5]

The French capital had fallen a few days before the broadcast of Pétain's message of defeat. The Germans were at first disappointed to find fabled Paris, though beautiful and intact, shuttered and silent at their arrival. Cafés, shops, and offices were closed. At night darkness and silence reigned. The Germans came at dawn on June 14, and by midday swastika flags had replaced the French colors, most noticeably in the Arc de Triomphe and on top of the Eiffel Tower. The German general staff requisitioned the Hôtel Crillon for its headquarters. Embarrassed French police

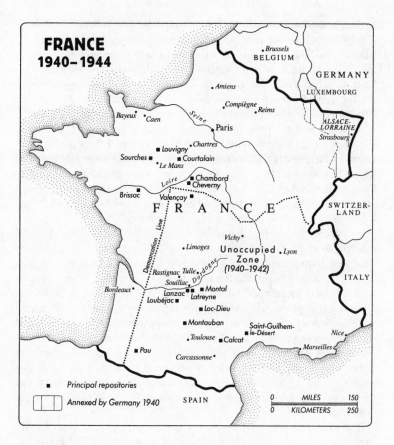

FRANCE
1940–1944

BELGIUM
• Brussels

GERMANY

LUXEMBOURG

• Amiens

• Compiègne
• Reims

Bayeux • Caen

Seine

Paris

ALSACE-
LORRAINE
Strasbourg

• Chartres

■ Louvigny
Sourches ■ ■ Courtalain
• Le Mans

FRANCE

Loire

■ Chambord
• Cheverny

Brissac •

Valençay ■

SWITZER-
LAND

Vichy •

• Limoges Unoccupied • Lyon
Zone
(1940–1942)

Rastignac Tulle •
Souillac • *Dordogne*

ITALY

Bordeaux •
Lanzac ■ Montal
Loubéjac • Latreyne
■ Loc-Dieu

■ Montauban Saint-Guilhem-
le-Désert

• Toulouse ■ Calcat Nice •

• Marseilles

■ Pau

Carcassonne •

■ Principal repositories
☐☐☐ Annexed by Germany 1940 SPAIN

0 MILES 150
0 KILOMETERS 250

could not for some time open the steel shutters barring the entrance.[6] But soon these and other shutters did open, and Germans were happily sipping champagne and ensconcing themselves in the best accommodations all over town. General von Bock, commander of Army Group B, which controlled the Paris region, after viewing Napoleon's tomb, breakfasted at the Ritz.[7] It was immediately noticed that the Germans' behavior was extremely "correct," and even friendly. They talked freely to American embassy personnel about plans to invade England, predicting that the war would be over within a few weeks.

On the day after the armistice was signed, Hitler secretly flew to Paris to see the sights, escorted by Albert Speer and his favorite sculptor, Arno

Breker, both of whom knew Paris very well. It was Hitler's first visit to the City of Light, and the meticulously planned itinerary emphasized architecture. The little party started before dawn with a special inside tour of the Opéra, its lights blazing specially for Hitler, who knew its plans by heart. In the pale morning gloom they went on to the Eiffel Tower, the Invalides, and Montmartre, where the Führer stared down on the sleeping city from the terraces of Sacré-Coeur. On the way back to headquarters he remarked to Speer, "It was the dream of my life to see Paris. I cannot say how happy I am to have that dream fulfilled today." It was perhaps this dream that had saved the city from Warsaw's fate, for Speer was horrified hours later when Hitler told him that he had often considered destroying Paris. With that, he ordered his architect to resume work on the grandiose plans for the rebuilding of Berlin; when they were finished, he said, "Paris will be only a shadow. So why should we destroy it?"[8]

It would be an emptier shadow: the very next morning General Keitel ordered Admiral Lorey, director of the Berlin military museum, the Zeughaus, to begin immediate arrangements for the return of war trophies of German origin "from the time of the Wars of Independence, through 1914/18 and to the present" which the Führer had seen in the Invalides and in other public places. He wanted quick action. Included in the letter were all the necessary travel authorizations plus a generous fund, which Keitel advised Lorey to collect immediately from the Reichschancellery.[9]

Incredibly, Hitler, the great conqueror, would never visit his dream city again, or even give himself a victory parade on its famed avenues. In this he differed markedly from most of his compatriots, who in the next four years would consider Paris the very best place they could possibly be stationed.

Behind all this jolly correctness occupation governments of extraordinary efficiency were rapidly being established in Belgium and France, as earlier in the Netherlands. The millions of documents of the German occupation government preserved in the French National Archives reveal the simply staggering attention paid to the control of every detail of life. Occupation currency had been minted as early as May 20. On the twenty-third the Germans took over the offices of absent French tax officials in the areas they had conquered to ensure that there would be no interruption of collections. Government agencies were subjected to the closest supervision. Traffic signs in Gothic script appeared on every corner.[10] France and Belgium, in contrast to Holland, got a traditional military government with the Wehrmacht in charge, but, as in Poland, the map was rearranged to the Führer's liking. For administrative purposes the northern provinces of France were linked to the French-speaking provinces of Belgium; Lux-

embourg and Alsace-Lorraine were simply annexed to Germany. By July 16 the French administration in the latter had already been thrown out, Jewish and Masonic property ordered transferred to Nazi organizations, and twenty-two thousand too overtly pro-French Alsatians expelled to the Unoccupied Zone on a half hour's notice.

To deal with relations between the military government and Vichy, a new German ambassador, Otto Abetz—a longtime promoter of Franco-German relations who had a French wife—was assigned by Foreign Minister von Ribbentrop to Paris. With less fanfare but equal immediacy the priests of the New Order began their work of control. What was and was not permissible was not yet clear even to many Germans, who were all set to enjoy the delights of Paris. After it was noted in Berlin that the elite Grossdeutschland Regiment had celebrated the victory with a Thanksgiving service in Notre-Dame, such un-Nazi religious manifestations were forbidden.[11] To the French the new rules brought daily surprises. Principal among these was the establishment of a true frontier between the Occupied and Unoccupied Zones which could only be crossed by travellers holding passes approved by the Germans.

Just who would be in charge of the French museum collections and what their fate might be in this fragmented situation was still an open question. Within the Wehrmacht command was re-created the very correct World War I art and monuments protection office known as the Kunstschutz, which Dagobert Frey had hoped to head in Poland. This was put under the command of Count Franz Wolff-Metternich, a distinguished art historian, who had most recently been Provincial Curator of Rhineland-Westphalia. The Count, descendant of the famous statesman of the same name so instrumental in the restructuring of Europe after the defeat of Napoleon, was a Francophile with many relations in France. During preliminary interviews in the winter of 1939–1940 he had been led to believe that he would be in charge of the monuments of western Germany, and was surprised to find that his job in fact concerned those countries in western Europe to be placed under military government. He was to remain a civilian and be responsible not to local commanders but to the Supreme Command.

The protection of monuments and works of art was included in Wehrmacht directives, and the rules of The Hague Convention of 1907 regarding private property were to be observed by fighting forces. Metternich felt it was his duty to enforce these international regulations to the letter. In this spirit he and his staff immediately began to put historic buildings off limits to the billeting of troops and patrol others that had been taken over. Lists of protected structures were compiled. Château owners

were advised to close up valuable furniture in certain rooms, and efforts were begun to help local authorities move objects to safety and repair damage caused during the fighting, which was major in such cities as Louvain and Beauvais. German troops helped Belgian officials take down the stained glass windows of the Cathedral of St. Gudule in Brussels, and build a protective wall around the great Rubens *Descent from the Cross* in Antwerp. In France, Metternich was soon in touch with the Duke de Noailles, head of the Demeures Historiques, and Jacques Jaujard of the Direction des Musées.[12] Within days he and his assistants had inspected Chambord and Cheverny, both carefully guarded by German riflemen. The desperately worried custodians, reassured by these art-historian officers who spoke perfect French, were amazed to find that one, a Dr. Bunjes, had even been a student of Louvre sculpture curator Marcel Aubert.[13]

But others had received instructions less compatible with international custom which to them were very specific. On June 30 Hitler had ordered that all objects of art, public, private, and especially Jewish-owned, should be "safeguarded." In sending out the directive to the Wehrmacht, Supreme Commander Keitel explained that things were not being expropriated, but would be "transferred to our care as security for the peace negotiations."[14] The responsibility for this project was entrusted to Ambassador Abetz by Foreign Minister von Ribbentrop, who had apparently not forgotten that one of his own supposed ancestors, a very Prussian official who had been commissioned by Blücher to oversee the return of works looted from his country by Napoleon, had been outsmarted in the process by the director of the Louvre.[15]

Abetz took up this task with quick if somewhat excessive enthusiasm. Having been in Hitler's entourage at the fall of Warsaw, he expected no problems from the Army and arrogantly announced to them that the embassy had been "charged with the seizure of French works of art owned by the State and cities, in the museums of Paris and the provinces . . . and with the listing and seizure of works owned by Jews."[16] The most valuable objects should be transferred to the embassy in the rue de Lille, for which task he required military transport.

But the Army had also received Hitler's June 30 directive and had interpreted it quite differently. With equal dispatch the commander of the occupation forces had on July 15 issued his own orders stating that in order to insure the safety of the "safeguarded" works, nothing should be moved from its present location without specific permission from him. This document did not distinguish between Jewish-owned and other works.[17] The stage was now set for a major struggle. The high-handed actions of Abetz vis-à-vis the newly victorious Army were so surprising

that the Supreme Command telephoned von Ribbentrop on July 23 to check on the ambassador's claims of authority, which were confirmed on August 3.[18]

Abetz, his mandate clear, got to work right away. He was sent a Baron von Kunsberg, chief of a special commando unit assigned to the Foreign Minister, to assist with the seizures. Metternich and his colleagues were supposed to cooperate with this organization. Lists were to be made of all the works of art in France and "the Führer and the Minister of Foreign Affairs would decide if the objects remain in France or if they are to be transferred to Germany."[19] The military command would be kept informed, and supply all transportation. It would all be terribly efficient. Two embassy officials were immediately sent to tour the repositories with Jacques Jaujard.

Neither the French nor the German military authorities knew that Dr. Otto Kümmel, director of the Berlin Museums, and several assistants had already been dispatched to Paris by personal order of Propaganda Minister Goebbels to do some fast research on just what would be brought back. Luckily the work was well under way. In 1939, after Hitler had repossessed the Rhineland, two art historians had begun this immense project and published a volume entitled *Memorandum and Lists of Art Looted by the French in the Rhineland in 1794.* Sworn to secrecy, they had toiled in the French museums and libraries, posing as researchers on far different subjects.[20] They were now required to list all "works of art and valuable objects which since 1500 have been transferred to foreign ownership, either without our consent or by questionable legal transactions" from all of Germany. It must include books, manuscripts, maps, musical instruments, archives, military trophies, and weapons, in addition to the more usual painting, sculpture, and decorative arts.

The three-hundred-page list which was finally produced could, according to its authors, only be considered a very preliminary overview of everything that had been robbed from, or destroyed by, foreign wars in Germany for the last four hundred years. The inventory happened to include a Dürer *Self-Portrait* and several Rembrandts badly needed by Posse to fill his Linz gaps. It claimed collections taken from Alsatian aristocrats in the French Revolution, works "smuggled" out of Germany after 1919 by dealers, jewelry melted down in various wars, and "many things, not actually proven to be lost, whose absence is still to be deplored." One section even gave an analysis of "French Looting Psychology," and in an extraordinary example of rationalization, stated that German Jews resident in France, whose possessions had been sequestered and sold in France in World War I, were to be considered "as if they were German" for the pur-

poses of the report. A convenient wish list of works located in France and the Low Countries suitable for replacement of any irretrievably lost German ones would soon be prepared.

The authors modestly pointed out that they could only suggest what measures could be taken "against France, the principal culprit, and other countries who have fought against Germany and find themselves, or will find themselves, in our power." At the end of the top secret report, of which only five typewritten copies were produced, Dr. Kümmel stated that "it is questionable, if the entire French patrimony will suffice to replace these losses" and that "the French can basically not object to the legitimacy of these claims."[21]

This devastating document, so illustrative of Nazi planning, was in fact only one more barrage in a series of claims, counterclaims, and chauvinist insults which had been exchanged by France and Germany since the days of Napoleon. Until 1940 Napoleon was the unquestioned record holder in the field of carrying off confiscated art. Previous conquerors had simply taken things away which were later retrieved or not, as the case might be, in subsequent conflicts. Napoleon complicated this traditional process by making the defeated agree to his confiscations in the humiliating peace treaties they were required to sign.

Under the supervision of Baron Vivant Denon, who could be termed Napoleon's chief curator, collections blossomed in almost every field and were installed in the Palace of the Louvre. The new acquisitions, which included such familiar gems as Rubens's *Descent from the Cross* from Antwerp, the Ghent altarpiece, Veronese's enormous *Wedding at Cana,* and the horses from San Marco in Venice, were paraded before the Paris populace in triumphal processions. Before long the French had convinced themselves that only they were worthy to preserve the great art of mankind, and when, after Waterloo, the Duke of Wellington insisted on the return of this loot, there were riots around the Louvre and the Prussians (von Ribbentrop was quite right) were only able to retrieve a portion of their belongings, and that by a show of force.

Thanks to all the commotion, and considerable stalling on the part of Denon, much was left behind in French hands. Other quantities went back to the wrong places, as fast deals were made by some of the noble heads of state. A large number of pictures from Kassel which had formed part of the Empress Josephine's private collection were sold to the Czar instead of going home, and the Crown Prince of Bavaria bought a group of sculptures taken from Rome for the Glyphtothek in Munich. (The *Wedding at Cana* was left in Paris because it was too big to move back to Italy.) Nor, despite their altruism, did the British mention such artifacts as the Rosetta

Stone, which they had captured from the French as the latter were shipping it from Egypt to the Louvre.

The Germans had never given up on their missing items, nor had the more extreme elements in France given up the idea of reconstituting the Napoleonic collections. Indeed, during the First World War, the French had drawn up lists remarkably similar to the Kümmel Report, which included all the French works in Germany, as well as such major items as Dürer's *Four Apostles* from Munich, which were to be claimed as "reparations." The claims were accompanied by negative comments on the artistic taste of the Germans. In the end, these grandiose claims were much reduced and the only major works to change hands after the Treaty of Versailles were two panels from the Ghent altarpiece, which Berlin had bought quite legitimately, and the wings of the Bouts *Triptych of the Last Supper* in Louvain, also legally owned by Berlin and Munich. The lists of claims once more gathered dust. But no one forgot.[22]

None of these documents, lists, or decrees was shared with Count Metternich. He was told of Baron von Kunsberg's appointment by one of Dr. Kümmel's assistants. Outraged, he determined to resist. It was not that Metternich entirely disapproved of the principle of retrieving certain works which had once belonged to Germany. He thought at first that Kümmel had been sent solely for the purpose of drawing up a list to be used "at the Peace Conference by a full agreement between peoples with equal rights." After the war he wrote that he "certainly would have liked to see the works of art which once adorned German churches and collections returned to Germany in a legal way. But I had not so much a one sided claim in mind as an exchange of works of art with the aim of improving by the addition of a few first rate works, German art, which was badly represented in French national museums."[23]

To Metternich the honor of the Army was at stake. Through channels he sent a report to Chief of Staff von Brauchitsch in Berlin stating that "certain agencies" were planning "special actions" to remove French-owned works of art without the knowledge and authorization of the military commander in France, which was a violation of Hitler's order to safeguard them. Von Brauchitsch replied that lists could be made, but that nothing was to be taken to Germany except by explicit permission of the Führer. Unaware of this, Abetz had met with Dr. Kümmel on August 12. Here it was proposed that a large number of works from Chambord be brought to Paris as they were "in danger of being damaged." This would include not only things "robbed" from Germany but some nineteenth-century works with no relation to past conflicts. The next day Abetz informed Metternich

of this plan, but when he could produce no written order from the Führer, the Army refused to move anything.

The ambassador did not give up. The next week he tried to have twenty-five works moved to Paris. Again von Brauchitsch supported Metternich. Meanwhile, Louvre officials were compiling the desired lists of what was in occupied France with the greatest care, the whole process, they complained, being slowed down by the terrible difficulties imposed by the division of the country into two zones. Abetz and von Kunsberg got so frustrated that they sent out assistants who forced curators at the depots to open cases at gunpoint, and tore the incomplete lists from files at the office of the Direction des Musées. This, the indefatigable Metternich again reported, "led the French to believe that they had something other than protection in mind." Accusations of "malicious" delaying followed from Abetz. Metternich replied that Abetz not only had damaged the image of the German Army in France but had provoked reports in the American press referring to "German Art Looting." The lists finally went to Berlin on August 31, but without the support of the Army nothing could move. For the time being, the repositories remained undisturbed, under Wehrmacht guard. No one wanted to challenge an army that might soon be sent to conquer Britain.[24]

Metternich's success in preventing the removal of objects from the main French repositories did not extend to the private collections of Jews and other undesirables. The same policies which had already gone into effect in Holland were immediately implemented in France by the various specialized agencies. Gestapo teams began removing objects from abandoned Jewish shops and houses. Those who had remained in residence were required to register with the authorities. Most, thinking it would merely be a matter of money and time, did so.

The Devisenschutzkommando (Currency Control Unit) was soon opening the private bank vaults to which so many had entrusted their treasures. The owner of the vault was required to be present. Not all the early investigators, whose principal interests were gold and foreign currency, knew what they were seeing. Picasso so befuddled the soldiers sent to inspect his vault, literally crammed with his own works and those of other artists, that they left in confusion, taking nothing. In the course of the inspection, he managed to convince them that a neighboring vault, which belonged to Braque, was also his, and contained nothing of value. Henri Vever's sister said not a word when officers sifting through the hundreds of Rembrandt etchings he had stored away decided that they must be reproductions as there were so many, and quickly closed his vault up again.[25] The first fruits of these depredations were brought to Abetz at the German embassy.

The same official who had so carefully arranged Hitler's tour of Paris had been given, on July 4, 1940, the names and addresses of the fifteen leading Jewish art dealers in Paris. He and von Kunsberg were to remove whatever was to be found on their premises. This time transport was no obstacle: Kunsberg simply ordered the French police to provide vans. Soon the unevacuated stocks of the Wildenstein, Seligmann, Paul Rosenberg, and Bernheim-Jeune galleries began to fill up the embassy; next came the contents of a Rothschild residence in the rue Saint-Honoré.

A Dr. Meier, especially sent by von Ribbentrop from the Berlin Museums, set about cataloguing the works and deciding which would be most suitable for dispatch to Germany. Packing began. In the no-nonsense Nazi style exemplified by Mühlmann, dealers were immediately called in to look at lesser works which had not made the cut. Certain "degenerate" items were set aside for later exploitation. But if Metternich could not prevent the seizure of this material, he could and did protest to his commanders that its removal from France would violate the Wehrmacht decree freezing everything in place, as well as Article 46 of The Hague Convention, which specifically forbade the removal of private property. The Army command stayed solidly behind him. Again Abetz and his associates were stymied, for without military conveyance they could not move anything out of Paris.

As the resistance of the Wehrmacht in France to the confiscation systems already operating so smoothly in the occupied countries under "civilian" administrations increased, the Nazi inner circle, seeking a way to circumvent these inconvenient scruples, produced one of its marvelous compromises. On September 17 Hitler directed the Army to extend all possible assistance to the Einsatzstab Reichsleiter Rosenberg (ERR) in its work, adding that Rosenberg was "entitled to transport to Germany cultural goods which appear valuable to him and to safeguard them there."[26] So far these had included few works of art, but that could always be changed. Meanwhile, the military command had ordered that all confiscated works of art be taken to the empty Louvre instead of the embassy for storage. This had required the permission of the French. Metternich prevailed upon Jaujard to accept the arrangement, hoping by this means at least to keep the works in France. Several hundred items, packed and ready to ship, were brought from the embassy.

Abetz defiantly held back three groups of paintings. Seventy-four had been "placed in the inventory of the Embassy and therefore had become Reich property." Twenty-one, surprisingly including works by Utrillo, Monet, Degas, Bonnard, and Braque, were reserved "for decoration of the house and offices of the Foreign Minister." The third group was made up of twenty-six "Jewish owned works of degenerate art . . . with undefined

titles": fourteen Braques, seven Picassos, four Légers, and a Rouault. These were to be used for "trading for artistically valuable works."[27] Meanwhile, von Kunsberg, his collecting activities restricted, devoted himself to compiling a top secret list of works of art in British castles and repositories in preparation for the invasion which all thought to be imminent.[28]

The new French government in Vichy, which had come into being on July 10, had meanwhile been passing suitably restrictive measures which would soon put it right in line with Germany and create a New Order à la française. Pétain, who had never bothered to read *Mein Kampf*, naively expected to return his government to Paris, where he would deal as an equal with the Führer in negotiating peace. Never did it occur to him or to his Prime Minister, Laval, that there would be no negotiations, and that they would remain sealed off in Vichy for four years.

Among the new decrees passed was a law stating that French nationals who had fled the country between May 10 and June 30 were no longer citizens, and that their property could be seized and liquidated for the benefit of the French "Secours National." The Vichy government, still believing itself independent, had complained that a similar law passed by the Germans a week earlier in the Occupied Zone was a violation of The Hague Convention, which forbids an occupying power to interfere with the civil laws of a conquered nation.[29] Basic to both measures were sections requiring the registration and Aryanization of Jewish businesses. The removal of private property was another bone of contention, and the Pétain government protested Ambassador Abetz's undertakings in late October. But nothing could now stop the German agencies, who merely pointed out that the possessions of the Rothschilds and so many others who had fled were no business of the French, who had themselves declared that they were no longer citizens.

Indeed, by the end of October so much material had accumulated at the Louvre that it was decided to find a more suitable space. Metternich and Jaujard chose the Jeu de Paume, the small museum used at that time by the Louvre for temporary foreign and modern exhibitions. They were then informed that the ERR would also use the premises. It was agreed that French curators, working alongside the Germans, would be allowed to inventory whatever arrived at the new depot, and Vichy was so informed. To carry out these duties five Louvre employees were sent to the Jeu de Paume to help Mlle Rose Valland, the curator who had been left in charge of the empty building.

The transfer of objects to the new location began at once. Accompanied, oddly enough, by a Luftwaffe guard, more than four hundred cases were

brought in on October 30. The next day they were unpacked with tremendous speed by the Air Force men, and works were stacked up in every gallery. Mlle Valland was prepared to start her inventory, but was surprised to find that she had no German counterpart, and that no system of registration was being organized in the frenzied scene surrounding her. Wanting to show that the French were as competent as any German, she determinedly set to work on her own. Around noon Dr. Bunjes, one of Metternich's assistants, found her at work. Glancing at her notebook, he reached down and closed it firmly: there was to be no French record. The five other employees were sent away and told not to return; only Mlle Valland, technically in charge of the building itself, and a few workmen were allowed to remain.[30]

More German officers soon arrived, among them Baron Kurt von Behr, chief of the ERR in France, wearing such a spectacular and unusual uniform that even the skeptical Mlle Valland was dazzled. The uniform was that of the German Red Cross, of which the Baron was an important official. He had, in fact, no military rank at all. Politely he agreed that the French curator should stay on. All afternoon rushed activity continued as a group of Germans sorted through the paintings, picking out the best, and hanging them as if there were to be an exhibition.

And indeed there was to be one. Exhausted and angered by his lack of success in the Battle of Britain, Goering was coming to town. All through the summer he had been making little visits to Paris from his headquarters near the Channel coast. He would lodge at the Ritz and be attended by the Luftwaffe commandant for Paris, General Hanesse. His art agents Hofer and Angerer had meanwhile been scouting the acquisition possibilities. Despite Metternich's resistance, the two agents, escorted by an official supplied by the military administration, had been given tours of certain collections which were about to be confiscated. They had ordered items they liked to be taken to the Jeu de Paume, care of the ERR. The official, adhering to the Wehrmacht decree, emphasized that it would not be possible to remove these items from France.

Goering arrived at the Jeu de Paume on November 3 to find it done up as if a major opening were in the offing. The floors were adorned with beautiful rugs and the galleries crammed with furniture and decorative arts carefully coordinated with the pictures. There were potted palms and champagne. The whole was further set off by the snappy full-dress uniforms of the German officers, who were all aware of the Reichsmarschall's love of such display. But for once Goering appeared in rather rumpled civilian clothes, looking oddly out of place in his long overcoat and soft hat.

Goering in mufti at the Jeu de Paume

The selection presented to him was staggering, eclipsing anything he had seen in Holland. He spent the entire day at the museum. But there was much more in storage, and Goering delayed his departure while the remaining works were brought out. On November 5 he again spent the day among the treasures, talking excitedly, picking up and putting down one picture after another. He chose twenty-seven for himself, mostly Dutch and French works from the collections of Edouard de Rothschild and the Wildensteins, among them Rembrandt's *Boy with a Red Beret* and a magnificent van Dyck *Portrait of a Lady*. There were four depictions of Venus and two of Diana, plus a good number of hunting scenes and *fêtes champêtres*. Among the former possessions of various members of the Seligmann family he found much to enhance Carinhall: five stained glass windows, four tapestries, three sculptures of angels and shepherds, and a nice eighteenth-century sofa with six matching chairs.

After his experiences in Austria, Goering was too smart to try to take the famous Rothschild Vermeer known as *The Astronomer,* which glowed seductively from the wall. That would go to his Führer. Goering made no attempt to remove this selection and for the time being satisfied himself with a large album of photographs, of which Hitler also received a copy. But to make quite clear what was what, he issued an order that same afternoon declaring that the objects "saved" by the Army and the ERR would be divided into several categories. The Führer's choice was first. Second were "objects which can be used to complete the collections of the Reichsmarschall." Third came items "useful" to Nazi ideologue Rosenberg for his anti-Semitic think tank. A fourth group was reserved for the German museums. The leftovers could be given to the French museums or put on the market. Everything was supposed to be appraised and paid for,

with all profits going to French war orphans. The first four categories were to be packed and sent to Germany by the Luftwaffe—so much for the Army's refusal to provide transport. In a little note at the end of the order Goering promised that he would immediately get Hitler's approval for all this. Meanwhile, the ERR, put in charge of the Jeu de Paume, was to keep up its good work.[31]

In Paris the confiscations poured in so fast that more art historians had to be brought to the Jeu de Paume to cope. The ERR teams had begun to range farther afield. Subsidiary operations were carried on in Belgium. Helpful informants led them, and other agencies, to collections hidden all over the countryside. A certain "Count Lestang" and a Paris dealer by the name of Yves Perdoux agreed to reveal the whereabouts of Paul Rosenberg's pictures at Floirac to German embassy officials in return for 10 percent of the value of the collection. This they rather excessively put at RM 100 million, or FFr 2 billion. After some time had passed with no response from the Germans, Lestang and Perdoux appeared at the embassy and announced that they knew of a second, more valuable collection, but that if their terms were not met on the first one, they would not reveal its whereabouts. They then added that "a very high German official" had heard of the second collection too, and was seeking its location. When pressed, they admitted that they meant Goering. The embassy, suspecting a bluff, had Luftwaffe General Hanesse make inquiries.

Nazi experts in the meantime had revalued the lot at FFr 3.4 million, which they felt was generous as it contained so many "*wild expressionistisch*" works by Braque and Picasso. Fearing that they might end up with nothing, Perdoux and Lestang agreed to this valuation and to payment of their commission in pictures. They were taken to the rooms where the pictures were stored and urged to choose from among the rejected "expressionist" canvases. This they declined to do, indicating instead two Pissarros and a Renoir. In the end they were given three works by Pissarro, one from the previously confiscated Rothschild collection, the Germans having decided that even though the last Pissarro was worth twice as much as the Renoir, "it presented no interest for Germany . . . since Pissarro is Jewish."[32]

Nothing further was heard from the two French gentlemen, and the Paul Rosenberg pictures from Floirac joined the hundreds of others in the sorting rooms of his Nazi namesake, as did the "other collection," which were the Rosenberg stocks stored at his bank in Libourne. While involved in this removal, the Nazis discovered Georges Braque's deposits, including his Cranach, in the same bank. Braque's possessions were technically not in danger, as he was an Aryan. But the Germans suggested that the rest

of his collection would only be safe if he sold the Cranach to them, which he did.[33]

Goering was terribly pleased with the success of these operations. From his hunting lodge in East Prussia he wrote a friendly, if loaded, letter to ERR chief Rosenberg saying how happy he was to have all the confiscated works concentrated in the hands of one agency. Noting that both the Foreign and Propaganda Ministries were "claiming" the right to seize objects, he assured Rosenberg of his support for the ERR, but emphasized that without the information he had obtained long ago through bribes and corrupt French officials the ERR never would have found most of the precious items. These activities, he proudly noted, would continue, and much could be expected from the activities of his Currency Control agents. In order to avoid any false suppositions, he informed Rosenberg that he planned to buy a "small percentage" of the ERR take to complete his own collection at Carinhall, which would one day be left to the nation. At the moment that would only be some fifteen pictures, which would leave plenty "for the offices of the Party, the State and the Museums."[34]

Worried by the proprietary tone of this letter, Rosenberg sent his assistant Robert Scholz off to Paris to find out precisely what the situation at the ERR might be. Once there, the subversion of the ERR staff by Goering was crystal clear to Scholz. He reported to Rosenberg that he thought Goering was about to ship everything back to Germany for his own benefit. Rosenberg, who still hoped to exploit the art to the profit of his own organizations, ordered Scholz to advise the Reichschancellery that he had decided to bring the confiscated works back to Berlin "in the next few days," even though they were not completely catalogued. He suggested that the fifteen boxcar loads be taken to the basements of the Reichschancellery for sorting by the ERR and requested that Bormann obtain Hitler's decision on the matter as soon as possible.[35]

Bormann was no more willing than Goering to let all these goodies be squandered on Rosenberg's fuzzy ideological pursuits. Scholz was sent a curt letter containing a copy of the Führervorbehalt order and told to get in touch with Posse immediately. To Posse, Bormann wrote simultaneously that Dr. Scholz was "obviously unaware that all art treasures in occupied territories come under the Führer's right of disposition," and that the administration of them was Posse's affair.[36]

During this struggle of the titans the protests of the Vichy government, produced after much prodding by Jaujard, and transmitted by the pathetic office they were allowed to maintain in Paris, were totally without effect. To Jaujard's dismay, his new government did not condemn the confiscations outright, but declared that the takings should be the property of the

French, and not the Germans. The protests were not even graced with a re-
sponse. Nevertheless, Jaujard and officials at the Direction des Domaines
continued their almost daily letters to the Nazi authorities in an effort to
block the confiscation of one collection after another.

In December 1940 five protests were lodged regarding the famous harp-
sichordist Wanda Landowska, whose marked scores and clavichord, plus
her wine cellar and a large quantity of soap, had been taken in September.
A correspondence of some months up and down occupation channels fol-
lowed, with much quoting of decrees and Nazi legalisms which must have
kept a phalanx of underlings busy.

By January they had determined that the possessions of the Polish Jew-
ess Landowska, who had fled German troops (a favorite recrimination),
were "ownerless," not French, cultural property. This would seem to have
been reason enough, but the investigators felt compelled to add that she
had also helped other Jews, who were well-known enemies of Germany,
and worst of all had given a concert in the Opéra to raise money for Pol-
ish relief. On top of this, a piano once owned by Chopin had "surprisingly"
been found in her house, a suspicious matter which would have to be taken
up with General Governor Frank.

As for the soap and wine, the bureaucrats explained that they had been
used for washing and sustenance by the poor packers, who had had a long
commute every day for two weeks from Paris to Mme Landowska's house.
This case was only one of many. If Jaujard could not prevent the looting,
he must at least have enjoyed the astonishing and self-deluding responses
that the conquerors felt compelled to produce.[37]

Hitler did not authorize the removal from France of any of the works held
by the ERR until New Year's Eve, 1940. Thirty-two pictures from the
Rothschild collections—including the Vermeer *Astronomer,* portraits by
Hals and Rembrandt, and Boucher's famous *Madame de Pompadour*—
went to their new owner on February 8, 1941, some still economically
packed in their original gleaming black crates marked with Rothschild
monograms.[38] Posse had chosen well. His wish list was being nicely filled.

After the Führer had taken his pick, Goering could take his. He chose
thirty-two pictures in addition to the twenty-seven he had reserved for
himself in November, including two by his favorite artist, Cranach: a
Portrait of Frederick the Wise from the Wildensteins, and the particularly
suitable *Allegory of Virtue* from the Halphen collection. Six commodes
and two eighteenth-century desks were added to the previously chosen
furniture.

Both Hitler's and Goering's choices were to be sent to the Reich on

Goering's special train, run by the Luftwaffe. The whole affair was supposed to be kept secret, but on February 9 the commander of Paris informed the German commander in chief for France of the shipment. A copy of the memorandum went to the Kunstschutz offices, with a note by a certain Dr. Langsdorff of the SS demanding to know who had leaked the information. There was no mystery: on February 5 Goering had rudely sent away Count Metternich and his assistant, Dr. von Tieschowitz, when they appeared at the Jeu de Paume stating that they were present as representatives of the Army Supreme Command, which was responsible for the safety of the sequestered works. The irritated Reichsmarschall, after exclaiming "Another organization to deal with!" said he wished to make his "tour of inspection" with a small group. The only Kunstschutz representative permitted to stay with the entourage was Dr. Bunjes, who had already fallen under Goering's influence, and who later would be rewarded with the job of director of the German Institute of Paris, but who still felt compelled to inform his superior of Goering's plans.

The Army, having been faced with the inevitable since autumn, had, in fact, already begun to prepare documents absolving itself of blame. Goering's orders of November 5 had, the Wehrmacht reasoned, superseded those of Hitler prohibiting the displacement of artistic property. The military administration was, therefore, "exempt from any responsibility for contravention of The Hague Convention." As for the French government's protests, "clearing and settling of this issue . . . has become a political affair to be settled between the Reich and the French Government." In regard to the deplorable actions of the ERR the Army recommended that "in order to express that the Military Commander in France is in no way responsible for the activity of the ERR, the Goering order of November 5 should be amended to read: 'Further confiscation of Jewish art property will be effected in the manner heretofore adopted by the ERR under my [Goering's] direction.' "[39]

Having the stuffy Wehrmacht out of the way was just what Goering had wanted. Despite his other duties, the Luftwaffe chief came back to the Jeu de Paume twelve more times in 1941, and five times in 1942. Hans Posse did not lower himself to personal visits to the ERR premises. He preferred to buy on the market, money being no problem for him. In the end only fifty-three items were formally logged into the Linz collection from the ERR, though anything Posse wanted was his for the asking. Goering indulged himself to the tune of some six hundred. To keep things "legal" the objects were evaluated by a minor French artist named Jacques Beltrand, whose pricing would vary according to Goering's desires. If the work was destined for Carinhall, the evaluation was low. If, on the other hand, it was

to be sold, it would be high. So ludicrous were some of his prices that one French source referred to him as a "half-blind engraver." Goering was to pay the stated amounts into a fund for war orphans, though there is no evidence that he ever did so. His money, much more restricted than Posse's but still substantial, was also being used to buy on the market. But he always needed more. From this need, as we shall see, developed a most ingenious scheme in which the ERR would play a large role.

Rose Valland: the unlikely spy (photographed in uniform after the liberation)

After Goering's second visit the confiscations continued apace. Truckload after truckload would appear at the door of the Jeu de Paume and be dumped there, often without any indication of provenance. There were clocks, statues, paintings, jewelry, and furniture from banks, storage warehouses, and abandoned apartments. Soon the whole ground floor was full. More and more now came from the many Rothschild country houses. Twenty-two chests containing their jewelry were brought in from a bank vault and presented to Goering on March 14. With great restraint he chose only six pieces, including two magnificent sixteenth-century pendants representing a centaur and St. George and the Dragon, which he took away unwrapped in his pocket.[40] Still more came from the David-Weill château at Mareil-le-Guyon and the Jacques Stern collection in Bordeaux. So frenzied was this scavenging that several non-Jewish collections belonging to people with suspicious names had to be returned with sheepish letters of apology.

Now that the Army had washed its hands of the whole sordid affair, the ERR could no longer be prevented from removing the Jewish collections sheltered in the French national repositories. They began to arrive at the Jeu de Paume in July 1941. Among these arrivals was more of the fabulous David-Weill collection, 130 cases worth, which was brought in from Sourches. Jacques Jaujard protested once again, this time on the grounds that M. David-Weill had left the collection to the French Musées in his

will, which was duly produced. This brought forth yet another long and reference-filled letter from the ERR denying the claim, first because David-Weill was a Jew—the reference quoted being the American *Biographical Encyclopedia of the World,* first edition, 1940—and secondly because he was not yet dead, and therefore still owned the art.[41]

In all the chaos at the Jeu de Paume, inventories could only be hastily done, to the great chagrin of the German art historians who worked fourteen and sixteen hours a day without an adequate art library, any confiscated books having already been shipped off by the non-art branches of the ERR. Their task was enormous: 218 major collections ranging from Arnhold to Zach had to be listed and given codes based on their names (ARN–Z). Thousands of uncatalogued items from lesser collections required considerably more research. Their chief, Baron von Behr, was not sympathetic. His interest was in the gathering, and in self-promotion at the highest Party levels, which meant pleasing Goering above all else.

The Baron's lifestyle was anything but modest. Alfred Rosenberg, his real boss, had encouraged him to entertain lavishly in order to gain respect for the ERR, which was held in contempt by the regular army. The aristocratic von Behr, always attired in fancy uniforms, and his English wife did what they could to push their way into high occupation society. Goering's influence was extraordinary. Officers who at heart condemned the confiscations were still dazzled enough to betray their consciences. This was certainly true of Dr. Bunjes, who when he was eventually fired by Metternich was immediately rehired by Goering as an Air Force officer.

Ideologue Rosenberg, whose scruples were of a different nature, was by now totally eclipsed within his own agency. On his one visit to the Jeu de Paume the only way people knew he was there, according to Rose Valland, was by the "funereal smell of the many pots of chrysanthemums which had been put around in his honor." Being in Paris was all-important. Rosenberg assistants such as Robert Scholz who were sent periodically to check up on the outrageous goings-on got nowhere with the clever operators *sur place,* who soon discovered that they could siphon off certain works to sell for their own profit. By all accounts the atmosphere within the ERR was fraught with terrible intrigues and jealousies exacerbated by flagrant affairs carried on with the various ladies of the staff. Indeed, von Behr's secretary and mistress, Fräulein Pütz, had to be sent home when things became too blatant; and an Eternal Triangle situation involving the reigning lady in the Paris office, her fiancé (who was a curator), and another woman badly slowed down productivity, and led to what bemused later investigators termed "hysterical slander and counter accusations."[42]

In this mad and secret scene, Rose Valland managed somehow to sur-

vive. Her dowdy looks certainly did not invite advances from the Germans, and she was regarded by all as an insignificant administrative functionary. Her presence at the heart of this undertaking, which the Germans wished to conceal from the French, was an anomaly. Dr. Bunjes had even written in one report that "all access to the Louvre must be refused, as we do not wish the French services to know of our organization and its functions, and because it would be vulnerable to espionage."[43]

This was exactly what Mlle Valland was doing. Throughout the war she met frequently with Jacques Jaujard and his assistants, many of whom were working closely with the Resistance and through whom the Free French government was kept informed of the whereabouts of the national treasures. The museum people, like everyone else, listened late into the night to the BBC, whose programs were laced with cryptic messages to underground activists all over Europe. Thus they knew that information on the relocation of the collections to Loc-Dieu and later to other refuges had been received in London when the message "*La* Joconde *a le sourire* [The *Mona Lisa* is smiling]" came crackling through the night.

Mlle Valland's main objective was to find out where the ERR takings were being stored in Germany. For Hitler's and Goering's personal acquisitions were only a part of what left France. Between April 1941 and July 1944, 4,174 cases, which filled 138 boxcars and contained at least 22,000 lots, were shipped out to the Reich.[44] There had been much discussion about where to keep all this. Posse had first suggested the basements of the Alte Pinakothek in Munich, which would hold 250 pictures or so, and which would be the most convenient place for Hitler to view them. Dr. Buchner preferred the Castle of Dachau, the folksy little Bavarian village that had become home to so many other things collected by the Reich, though he worried that its proximity to Munich would expose the paintings to bomb danger.[45] It was Hitler himself who chose the incredible pseudomedieval Castle of Neuschwanstein, built by Mad King Ludwig of Bavaria, in a remote area near the Austrian border. But so vast were the numbers of things sent there that later shipments had to be distributed to even more remote depots: Chiemsee, the Monastery of Buxheim, Schloss Nikolsburg in Czechoslovakia, and Schlosses Kogl and Seisenegg in Austria.

Four times the Germans threw Rose Valland out. The reasons were linked to the fortunes of their armies: every time an Allied landing or attack was rumored, she would be required to leave. But when the crisis had died, she would come back, talking of heating problems and maintenance, and begin her observations again. At night she took home the negatives of the archival photographs being taken by the Nazis, and had them printed

by a friend. In the morning they would be back in place. Every time there was a theft or damage she would be questioned. This, she later declared, was "very disagreeable," but she managed to stay on. Loyal French guards filled her in on details of events in those parts of the Louvre which were off limits to her. Packers and drivers told her what they were doing. Everything was reported to Jaujard and his assistant, Mme Bouchot-Saupique. (Jaujard's apartment, inside the Louvre itself, was a Resistance safe house, a key to which was hidden in a special place in the courtyard. Other corners of the enormous building contained caches of underground books and journals.[46])

French resistance to German art policy was not limited to the Louvre proper. The Musées Nationaux and the Domaines had together formed a Committee of Sequestration and Liquidation which attempted to enforce the right of the French state to the "abandoned" collections, and to give the Musées the right of preemption in the case of sales of works of national interest. The idea was that the museums would liquidate the collections to themselves, thereby making them state property. The Germans allowed this for a few second-rate works, but the committee got nowhere with major ones. Nor was another ploy of any avail: the falsification of documents of donation, brilliantly done on old paper and complete with forged stamps and signatures, used in an attempt to protect the Calmann-Levy collection.

In the Unoccupied Zone they had more success. Parts of the collections of Robert, Maurice, and Eugène de Rothschild, some of which had been found in an abandoned truck on a country road, were quickly "bought" with an entirely fictitious fund of FFr 13 million appropriated by the Ministry of Finance, parent organization of the Domaines. Curators from all the major museums were invited to take their pick of hundreds of objects ranging from paintings of every school to porcelains and furniture. They quickly catalogued the works in their regular inventories, and mixed the packing crates in with the rest.[47]

So persistent were the French protests against the confiscations, which came even from the Vichy Prime Minister and its Commissioner for Jewish Affairs, that they could not be ignored. The protests were addressed to General von Stülpnagel, commander of German forces in France. Encouraged by the Kunstschutz, he demanded that the ERR provide some legal basis for their activity. The resulting response must be among the masterpieces of perverted legalism.

The first document was produced in November 1941 by Gerhard Utikal, chief of ERR activities in the West, and was personally approved by Reichsleiter Rosenberg. It is a précis of Nazi philosophy which cleverly

makes use of the similar thinking of certain elements of the Vichy regime: By conquering France, the German Army had liberated it from the influence of international Jewry. The armistice made with the French people was not made with the Jews, who could not be considered the equals of French citizens, as they formed a state within a state and were permanent enemies of the Reich. The Jews, by their amassing of riches, had prevented the German people from "having their proper share of the economic and cultural goods of the Universe." Since most of the Jews in France had come originally from Germany, the "safeguarding" of their works of art should be considered "a small indemnity for the great sacrifices of the Reich made for the people of Europe in their fight against Jewry." The rules of war allowed use of the same methods "which the adversary has first used." Stretching it a bit, Utikal argued that since in the Talmud it was stated that non-Jews should be regarded as "cattle" and deprived of their rights, they themselves should now be treated in the same way. The Reich had done the French a favor by not confiscating real estate and furniture along with the rest, and the French people should be grateful for the objects they had obtained through the good offices of the German armies. As for The Hague Convention, the Jew and his assets were outside all law, since for centuries the Jews themselves had considered non-Jews as outside their own laws.[48]

Needless to say, this ludicrous document did not prevent further protests from the "ungrateful French." Six months later, on orders of Goering, the ERR felt constrained to produce another justification, this time written by the less confident Dr. Bunjes. Much longer than the Utikal response, it used most of the same arguments, ornamented with childish additions which reflected the deep frustration the more brainwashed Nazis felt at their rejection by the conquered peoples they ruled. More ominous were its frequent references to "the dreaded German demands for the return of art stolen by French troops in Germany." Blame for the complaints of the French government was placed squarely at the door of Musées director Jaujard and his staff. The closing sentence tells us all we need to know, as if there had ever been any doubt: "Only . . . when the Führer has made the final decision as to disposition of the safeguarded art treasures, can the French Government receive a final answer."[49]

Careful reading of the Bunjes report reveals no references to the "furniture" which the Germans, according to Utikal, had so kindly left untouched. This was for the very good reason that only a few weeks before the report was written, the ERR had started a new project: the seizure of furniture from the houses of Jews who "have fled or are about to flee, in

Paris: M-Aktion loot ready for shipment to the Reich, 1944

Paris and throughout the occupied Western territories." The furniture would be used by the occupation administrations of the East, which after the attack on the Soviet Union had come under Rosenberg's aegis, and where, Rosenberg lamented, "living conditions were frightful and the possibilities of procurement so limited that practically nothing more can be purchased." Hitler thought this was a fine idea, and all commands were informed of the coming action in January 1942.[50] In Paris the odious von Behr was put in charge of this operation, which was code-named the M-Aktion (Möbel, or furniture, Project). Indeed, according to his co-workers, the whole thing was his idea.

The M-Aktion marks a true low, even in the history of looting. Once again the ERR teams set out, but this time to search for soap dishes and armoires. The secret orders which initiated the process noted that "art treasures, precious rugs, and similar items are not suitable for use in the East under conditions prevailing there. They will be safeguarded in France." Next came a message from the High Command: the confiscations were to be carried out "with as little publicity as possible. No [public] ordinance is necessary . . . as these measures must be represented as much as possible as requisitions or sanctions."[51]

A house-by-house check of the entire city of Paris was begun, in case

some fleeing Jews or other undesirables had not been accounted for. Some thirty-eight thousand dwellings were sealed. It was pretty complicated work: only unoccupied homes were involved, and, after consultations with the embassy, confiscation officials exempted absent Jews of many nations as well as those "who work for German firms and in forestry and agriculture, or who are prisoners of war."[52] Food discovered on the premises was sent to the Wehrmacht; beds, linens, sofas, lamps, clothes, etc., were checked off on specially printed forms. A French organization, the Comité Organisation Déménagement, was set up and made responsible for measuring doorways, talking with concierges, packing, transporting, and finding railcars for the loot. The Union of Parisian Movers was forced to supply some 150 trucks and 1,200 workers a day for the operation.

The Germans were responsible for deciding what *not* to take, such as "objets d'art, books, wood, coal, wine and alcohol, empty bottles, etc." They were also supposed to supervise the French railroads so the process would not be obstructed through "inertia and ill-will."[53] Everything except art, which was sent to the Jeu de Paume, was first taken to a huge collecting area for sorting. Due to increasing acts of sabotage by the French workers, the camps were fenced off and seven hundred Jews "supplied by the SD" were interned therein, divided into groups of cabinetmakers, furriers, electricians, and so forth, and set to work processing and repairing the incoming goods, which passed by them on a conveyor belt.

Later, all storage and moving companies, including American Express, were required to send in lists of customers, as their Dutch colleagues had already been forced to do. Victims who protested could, by proving they were Aryan and obtaining a *"Certificat de non-appartenance à la race juive,"* often reclaim their belongings. The files of the endless and desperate correspondence involved in these efforts survives. A certain Mme Seligman, the Aryan widow of a Jew, was exempted, but only after she had proved that her husband had been taken hostage and shot by the Gestapo.[54] Another man had to produce the birth data of his great-grandparents before the ERR gave up. The lists of what was taken survive too, infinitely more touching than lists of Rembrandts in their revelation of just how the smallest lives were affected: "5 ladies' nightgowns, 2 children's coats, 1 platter, 2 liqueur glasses, 1 man's coat. . . ."

By August 8, 1944, when they really had to stop, the Allies being by then just outside Le Mans, the ERR had raided 71,619 dwellings, and shipped off more than 1,079,373 cubic meters of goods in 29,436 railroad cars. By this time victims of bombings in Germany proper—of which a suspiciously high percentage were classified as "Police, SS Division, and private orders"—had also been made eligible to share the take. Some of

Certificate of Aryanism

COMMISSARIAT GÉNÉRAL AUX QUESTIONS JUIVES

CERTIFICAT
DE NON-APPARTENANCE A LA RACE JUIVE

Sur le vu des pieces produites par l'interessé le Commissaire Général aux Questions Juives constate que M Adler (Harry) né Roucher
né le à Paris (11e)
ne doit pas être regardé comme juif aux termes de la loi du 2 Juin 1941.

Paris, le

3-A

the thinking on the use of confiscated items was quite creative: special crates containing everything that was necessary for a "full kitchen for four bombing victims" were put together, including the sink. Alas, the final M-Aktion report complains, despite the sharpest controls, much of their hard work was sabotaged by French, Belgian, and Dutch railroad workers. Still, overall the project was, for the Nazis, a huge success.[55]

Parallel to this low-level looting was the more industrial attack on the statues and church bells of France and the Low Countries which were to be melted down for the factories of the Reich. In France the removal order was issued by Pétain. The process was billed in one magazine as a solution to the "constant problem of statuomania . . . more than ninety-two statues chosen from the most ugly and ridiculous have been taken down." The writer suggests that they should be replaced by statues from the Louvre, "which after all were conceived for the open."[56] Needless to say, the choice of which statues were to be sacrificed, which was left to the French at first, was hotly discussed in hopes of delaying the fatal moment. In the end, in addition to the more obvious politicians and generals, Voltaire and even La Fontaine were dragged off along with crocodiles, centaurs, Tritons, and Victor Hugo, whose empty pedestal was declared by one wit to look better than the statue had. Only a few, among them Joan of Arc and Louis XIV, were spared.[57]

Although they had never seen the Kümmel Report, the French museum authorities had few illusions that their occupiers would limit themselves to

the Jewish collections. Their first instinct was to consolidate as much as they could under the wing of the Musées Nationaux. The Provincial Museums were, therefore, brought under their administration in April 1941. As little as possible was revealed, even within the Beaux-Arts offices, about the exact locations of things, in hopes that the enemy would simply overlook certain items. There were plenty of indications, however, that the Germans would eventually do as they pleased. First to go were some 2,000 objects, including 150 large cannon, granted of "German" origin, from the Military Museum at the Invalides, which were called war booty. More went from the Air Museum to the Luftwaffe. The libraries and many of the collections of Alsace-Lorraine, now a German Gau, had been removed from their storage places in the interior and taken back for the edification of the conquerors. Only the treasures and stained glass of the Cathedral of Strasbourg remained in the Dordogne, and these would finally be taken by force from the exiled Bishop in 1944.

The French also feared that the Italians might now reclaim works taken in the Napoleonic Wars, such as Veronese's *Wedding at Cana*. This was considered enough of a possibility that the Louvre archivist, Lucie Mazauric, had been sent back to Chambord only days after the fall of France to retrieve the documents proving the French right of ownership that had been granted by various treaties signed during the Revolution and the Empire and by the exchange of certain works with Italy and Austria in 1815. For Mlle Mazauric it was a frightening and humiliating journey through the new German checkpoints. Once at Chambord, she did not dare put the bulky documents in her car, and instead spent forty-eight sleepless hours copying the information, after which she scattered the originals among less interesting files. This labor of love was never put to the test.[58]

Soon after the fall of France, Jaujard had persuaded the sympathetic Metternich to allow the works evacuated to Loc-Dieu to be placed in other repositories with better conditions. Above all they needed space. At Loc-Dieu the hastily delivered cases were so crowded that they could not be opened, and every attempt at an inventory had resulted in a different total. In good weather the guardians resorted to spreading the pictures out on the lawns of the abbey, giving a never-before-seen vision of their Lorrains and Poussins. By September 1940 it was decided to move the three thousand paintings to the Ingres Museum at Montauban, a good location, dry and roomy. But having their masterpieces together in one place where fire could destroy them all was nerve-wracking. Intermittent crises such as leaks and a threatened roof cave-in kept everyone alert, as did a visit by Metternich. Pétain came too, and made museum history by exclaiming, when shown Murillo's *Assumption of the Virgin*, in which the Blessed

Mother is surrounded by a host of little angels, "What a lot of children for a Virgin!"[59]

Looking at the art was not, however, his real reason for being there. Pétain had decided in December 1940 to reward his neighbor General Franco for his continued neutrality by giving him some of the Spanish masterpieces in the French collections. One of these was the Murillo; also on the list were the ancient statue called the *Dama de Elche* and several Visigothic crowns found near Toledo by a French archaeologist who had sold them to the Cluny Museum.

The administrators of the Musées were helpless to prevent this entirely, but cleverly devised a strategy which would set an important precedent for the future: they would persuade Spain to accept the works in exchange for items of similar value from the Spanish collections. Jacques Jaujard, René Huyghe, and several others set off to negotiate with Madrid. To his credit, Franco immediately agreed to this proposal by the men who had, after all, helped save the entire Prado collection only a few years before. After months of agonizing, the Spanish museums sent a Greco portrait of Covarrubias, a Velázquez, and a number of drawings to France. Pétain was not entirely happy that his "gift" had become a trade. A Greco *Adoration,* which the Spanish were about to throw in, was removed from the list by a peremptory telegram from Vichy.[60]

The resolution of this deal came just in time to counter an attempt by von Ribbentrop to appropriate Boucher's *Diana Bathing,* one of the Louvre's greatest masterpieces. The Foreign Minister had hinted at his desire to possess the picture in the fall of 1940, and left negotiations in the hands of Ambassador Abetz, who by now had been pushed out of the confiscation business by the ERR. But Abetz had enough influence at Vichy to order the picture brought to Paris from Montauban. From there it was whisked off to Berlin. In exchange, Abetz offered the French an Impressionist painting from the confiscated stores he had held back from the ERR. This was not considered an adequate trade. To be fair, the Louvre argued, a picture of the same period and quality, such as Watteau's incomparable *Gersaint's Shopsign* from the Charlottenburg Palace in Berlin, should replace the Boucher.

The idea was immediately rejected by the German museum administration, who were not inclined to diminish their collections for von Ribbentrop's pleasure. The Foreign Minister felt constrained to return the picture, but wrote huffily to Abetz that the German museums might consider the exchange on their own "so that this example of eighteenth-century French painting would not be lost to Germany." Abetz was instructed to keep track of the whereabouts of the Boucher at all times. He reassured his nervous

boss that a simple phone call would suffice if he really wanted the picture, after which they could decide if "they should give the French anything in exchange."[61]

Hitler had fewer qualms about this sort of thing than von Ribbentrop. In June 1942 his power was at its apogee. German forces were winning in North Africa, had reached the Black Sea, and were approaching Stalingrad, the important industrial city on the Volga. He envisioned nothing less than a meeting of his armies in the Middle East, and total control of the Eastern Mediterranean. Mussolini was so excited that he flew to Tripoli to get ready for the victory parade in Cairo.

It was in this mood that the Führer decided to erase the last vestiges of the Versailles Treaty and begin the recovery of the treasures stolen from the German nation. At the top of the list were the Ghent altarpiece by Jan van Eyck and the Dirk Bouts *Last Supper* from Louvain, elements of both of which had been claimed by Belgium from Germany in 1918. The retrievals were entrusted to Hitler's early adviser, Dr. Ernst Buchner, head of the Bavarian Museums, and not to any of the established Nazi art-gathering agencies. The whole enterprise was undertaken in strictest secrecy. Correspondence implies that the reason for the removals was protection from air raids, but constant mention of the Versailles Treaty in the letters betrays the truth. For the van Eyck sortie, Dr. Buchner put together his own team in Munich. One week before departure Buchner wrote to ask the Führer if he was to bring back only the panels which had previously belonged to Berlin, or the whole thing. The answer does not survive, but after Buchner had arrived home with the whole altarpiece he wrote excitedly to his colleague Dr. Zimmermann in Berlin to tell him the good news, adding that "on the express orders of the Führerkanzlei" the "panels which were not earlier the property of the Berlin museum" had been brought back too.

The little convoy of one truck and one car crossed into Vichy France just east of Bayonne on July 29. M. Molle, the French curator in charge of the repository at Pau, refused to hand over the altarpiece, having been told that three authorizations, from the Direction des Musées, the director of Beaux-Arts in Belgium, and the Kunstschutz, were necessary for its release. Buchner's escort called Vichy and the German embassy, but it was surely Buchner's own call to the Reichschancellery which had the most effect. A few hours later a telegram arrived from Vichy chief of government Pierre Laval himself ordering the transfer. The panels were carefully examined, packed, and loaded on the truck. Buchner gave Molle a receipt and left. The altarpiece was well on its way to storage at Neuschwanstein before any of the French museum authorities or the Kunstschutz could be alerted.

Conveniently enough, Count Metternich, who had so consistently recommended that nothing be removed "until the Peace Conference," had been sent on permanent leave only a few weeks before.

A similar operation was carried out a month later in Louvain to retrieve the Bouts *Last Supper*. After the war Buchner claimed that he had been "surprised" by these missions and had never found out whose idea they were. Be that as it may, he did not recommend against them, and a memo from the Reichschancellery regarding the Louvain operation notes that "General Director Buchner, in a letter to Dr. Hansen of the Party Chancellery, suggested that the four panels of the Louvain altarpiece, which are in danger of bomb damage there, be, in the process of compensation for the injustices inflicted on Germany by the Versailles Treaty, taken to a safe place in Bavaria."[62]

Reaction to these thefts, if somewhat delayed by the secrecy surrounding the events, was dramatic. The Belgians protested strongly. Jaujard wrote to Beaux-Arts director Louis Hautecoeur that every rule and arrangement to which the Belgians and the Kunstschutz had agreed had been violated, which would give the French museums a bad name. In November a meeting of the Comité des Musées, made up of representatives of all the Musées Nationaux, was called to protest the action further. Despite the dangers of such a gathering, which clearly had political overtones, not a single curator stayed away. A petition was drawn up demanding the return of the altarpieces. The Belgians, somewhat rashly, declared they would send curators to Pau to retrieve other works stored there, implying that the French were not to be trusted, though they did have the grace to thank Jaujard and his staff for their courage.

Faced with all this, the Vichy Minister of Education, Abel Bonnard, who also had not been informed by the Germans, while condemning the petition of his curators, allowed some sympathy to creep into his correspondence. To Jaujard he wrote that he should control his emotions, "natural though they might be," and he told the Belgian consul that the altarpiece had been handed over "not by my order, but by order of the Chief of State," adding that the consul should consider "the general circumstances in which France and Belgium find themselves" before allowing himself to be "bitter."

More important was the propaganda effect abroad. The *New York Herald Tribune* ran a long article with an entirely false headline proclaiming, "Van Eyck Art Believed Vichy Gift to Goering," assuming that it had been intended as a birthday present for the Reichsmarschall, and enumerating other dubious gifts such as the Sterzing altarpiece given to him by Mussolini.[63] For Goering, who indeed had his eye on various items in French

museums and private non-Jewish collections, a different technique of acquisition would now clearly be needed.

On November 11, 1942, Hitler, who did love to rub in that date, ordered his armies to take over unoccupied France in response to the Allied invasion of North Africa on November 8. Pétain, Laval, and their cronies were left in office for the time being, but there was not much doubt about their future. As Hitler jovially told Laval, "You are the last government of France. After you there will be a Gauleiter."[64] Goering was perhaps less sure of this. In the Soviet Union, German progress had again been halted, and Allied forces were doing rather well in North Africa. A negotiated peace treaty with France seemed remote. It seemed best to get anything he particularly wanted safely within the confines of the Reich as soon as possible.

The Reichsmarschall started with a private collection, making it known that he would welcome the gift of two fifteenth-century tapestries spotted early in 1942 in the remote Château de Bort by dealers pretending to be Beaux-Arts officials. The extraordinary hangings, each more than thirty feet long, were indeed magnificent. Their owner, the Marquise de Sèze, suspicious of the "inspectors," had reported their visit to the local police. When questioned they were found to be carrying large sums of money and admitted that they were in Goering's employ.

Alarmed Beaux-Arts officials immediately asked the de Sèzes to agree to the classification of the tapestries as national treasures. To this they consented, and to be doubly safe donated them to the Musées Nationaux, which promptly whisked the hangings away to Aubusson for restoration. This did not at all suit Dr. Funk, the German Minister of Finance, who had planned to buy them for Goering's fiftieth birthday. Direct pressure was put on Laval to reject the gift. A special decree was issued to "declassify" the tapestries, and they were returned to the owners. When the de Sèzes still refused to sell, the tapestries were removed from their château by police and sent to Carinhall. Funk did pay, but not directly to the recalcitrant Marquise. He sent funds to the Caisse des Dépôts et Consignations, an account used by the occupation administrators for expenses.[65]

The works Goering desired from the national collections were all of the German schools. For propaganda purposes any raid on the French patrimony would have to be billed as a "cultural exchange" as any more outright "gifts" would, after the Ghent altarpiece flap, be bound to excite further negative press. In late November 1942 Goering approached Laval himself on the subject. Laval, who despite all was still eager to please the Germans, approved the idea. The details were left to Dr. Bunjes, now head

of the German Institute in Paris, who would negotiate with the French authorities—a grave tactical error.

Jaujard was informed of the "exchange project" by Bunjes, who unconvincingly emphasized the "European" cultural aspects of it. A few days later the museum direction was given the first summary of desired objects. From the Louvre were listed a triptych by the Master of the Holy Family and a fifteenth-century wooden figure of St. Mary Magdalene, known as *La Belle Allemande,* by Gregor Erhardt. This, in the words of a later report, was particularly suited to Goering's taste, "being both German and nude." Especially for the Führer the Rheims Museum was asked to contribute three Cranach drawings representing German nobles, and from two private collections, those of M. Martin-Leroy and M. Robert de Ganay, were to come medieval objects. To this, a bit later, Goering added one of France's rarest treasures, the Cluny Museum's solid gold eleventh-century bas-relief known as the *Antependium of Bâle,* a part of the Basel altar which depicted the Holy Roman Emperor Henry II and his Luxembourgeois wife, Kunigunde, praying at the feet of St. Benedict. Most of these items were on Kümmel's list. In return, the Germans offered a number of works from public and private collections in the Reich.

Resistance by the Musées, which had adamantly opposed the idea of such exchanges since the Ribbentrop fiasco, was immediate. Their very considerable bureaucratic energies were mobilized to the hilt in order to delay and obstruct the transfer of each item. Germain Bazin produced a long and complicated report in which the mayor of Rheims stated that he could not part with his drawings as they were an eighteenth-century legacy to the city which he was not empowered to change. To this the mayor adhered despite pressure by Vichy, and promises of two other Cranachs, not representing German luminaries, as replacements.

From then on things did not improve much for Bunjes. In March, Goering, visiting Paris, expressed a desire to see the Basel altar, which was kept at Chambord. The museums regretted that it was very fragile, and could only be brought to Paris by direct order of Pétain. Goering's curator Hofer and Posse's successor, Hermann Voss, were forced to go to Chambord to inspect it. There, despite the representation of the indubitably German Henry II, French curators challenged the idea that it was Germanic in origin, claiming that it was "a Benedictine work of international character." They also mentioned that any unequal exchanges would have a bad effect on public opinion in France. Voss and Hofer again left without the prize, but it was clear that the French arguments had not been taken seriously. Goering meanwhile increased the pressure on the Vichy government, which ordered the Musées to take the Basel altar to Paris. It came

accompanied by three curators and Minister Bonnard himself, who astonished everyone by saying that the altar could only go to Germany as a personal gift from Marshal Pétain to Reichsmarschall Goering, just what the latter wished to avoid.

From the anteroom the waiting curators could hear Goering's screams of rage and accusations, quite true, of obstruction by the French museum administration. Not to be defeated, he demanded that the altar, the *Belle Allemande,* and the triptych be delivered to Carinhall by René Huyghe and Marcel Aubert, chief curators of painting and sculpture, respectively, of the Louvre, who would then choose the objects they would like in return, and thereby be seen as consenting to the exchange. Jaujard again called a meeting of the Comité des Musées. There, on December 30, after an impassioned speech from Huyghe, the curators declared that they would give up the Basel altar only to an armed force. The other objects they would allow to be traded for items to be negotiated with Bunjes.

Bonnard was in a fix. He would have loved to fire Jaujard, and threatened to put Huyghe "below ground." But the possible resignation of all his museum personnel restrained him. Jaujard, Huyghe, and Aubert were allowed to meet with Bunjes. Before getting down to business, Jaujard managed to disconcert the German by asking politely what had happened to a former colleague whose photograph was displayed on the wall. The sly director knew full well that this unfortunate Nazi, who had displeased the Party, had been sent to the Eastern Front, where he had been killed, but he murmured sympathetically as Bunjes explained. There followed two hours of discussion during which it was made clear that further efforts to take the altar would lead to the resignation of the entire Louvre staff, and that "the English will find out." Jaujard and Huyghe, active in the Resistance, would make sure of that. Furthermore, all exchanges would have to be approved by the Comité des Musées. Bunjes conceded. The altar was saved, but the other two works did go, unaccompanied, to Carinhall.

The Musées now waited for the objects promised from Germany. Instead of the objects promised from German museums, the Louvre received a number of second-class works from Goering's collection, all of which had been acquired outside Germany by Hofer during the war. The most cynical stroke was the inclusion of a work entitled *Renaud et Armide* by Coypel, which amazed French officials immediately recognized as having been confiscated from the Seligmann collection in Paris. This exchange was never formally accepted by the Louvre, and although Bunjes continued to talk vaguely of some arrangement whereby the French would be given the much-discussed *Gersaint's Shopsign,* no other works left France in this manner. Perhaps to console himself, Goering ordered copies in

bronze or plaster of some of the most famous sculptures in the French col-
lections, and thus could gaze out at his own *Winged Victory* and *Diana of
Fontainebleau* from the terraces of Carinhall.[66]

The ever-increasing penetration of the Unoccupied Zone by German agen-
cies after November 1942 was a terrible blow to those who had taken
refuge there and after the fall of France become accustomed to their se-
cretive lifestyles. Their ranks had gradually thinned as one after another
found a way out. Never easy, these escapes soon went from bureaucratic
nightmares to physical ones. It had taken some time for the realities of the
situation to sink in. Certainly no one had expected things to go on for so
long. The first shock was the German ordinance of September 17, 1940,
forbidding all Jews to return to the Occupied Zone. This was followed by
the enforcement of the Armistice provision requiring the surrender of
refugee German nationals to their countrymen. All travellers were sub-
jected to constant and unpleasant document checks. By late fall of 1940,
food, even in restaurants, could only be obtained with ration stamps, for
which proof of permanent domicile was needed. Nonresidents were driven
to shady black-market dealings or reliance on friends.

Fortunately many local authorities were not entirely enthusiastic about
enforcing the new rules and managed to ignore the illegal presence of cer-
tain residents in their districts, even if they were as conspicuous as
Gertrude Stein and Alice B. Toklas. These two ladies, despite repeated
warnings by the U.S. consul in Lyons, had decided to stay on at their coun-
try house in Bilignin, just north of Aix-les-Bains, where they had been
since the summer of 1939. Their only foray had been in September of that
year, when they had gone to Paris to retrieve the pictures which adorned
their famous apartment. But the packing proved too difficult for them, and
they were forced to call Daniel Kahnweiler for help. He found Miss Tok-
las trying to separate the canvas of Cézanne's *Portrait of Hortense* from its
frame with her foot.[67] In the end the ladies took only that picture and Pi-
casso's famous portrait of Gertrude back to Bilignin with them. For a time
they lived frugally but undisturbed, keeping goats and chickens. Until
1941 they were protected by the neutral status of the United States, but this
was of no help to them by 1943, when the local subprefect warned them
that they must immediately cross over into Switzerland by mountain
paths, or be arrested. The twosome still refused to go, but did move into a
much more remote house at Culoz. Overhead, day after day, they could
now hear the countless Allied bombers heading toward Italy.[68]

Peggy Guggenheim, after her initial flight, had moved on to Grenoble,
where she spent the winter of 1940–1941 in a miserably cold hotel. She

too was urged to leave by the consul in Lyons. In February 1941, with the help of a dealer acquaintance (and temporary lover), she packed her pictures in with her household goods and managed to ship them to the United States.[69] In the spring she, like so many others, progressed to Marseilles.[70]

The ancient Mediterranean port city, for centuries a haven for smugglers and lowlife of myriad nations, had reached near-saturation. It seethed with desperate German refugees hiding from the Armistice-decreed roundup, Americans trying to get home, Jews and political refugees of every country, and the profiteers who preyed upon them. One passage-seeker described it as "a beggar's alley gathering the remnants of revolution, democracy and crushed intellect."[71] In this Bosch-like atmosphere there were a few islands of hope. One of these was an extraordinary operation sponsored from the United States known as the Emergency Rescue Committee, whose aim it was to help artists, intellectuals, and political refugees escape to America. Formed three days after the fall of France, its organizing committee included six college presidents and such media names as Dorothy Thompson and Elmer Rice. They had recruited Eleanor Roosevelt, who was to push for liberalization of the mercilessly strict visa regulations. Varian Fry, a former editor for the Foreign Policy Association who spoke French and German, was dispatched to Lisbon with $3,000 and a list of people who presumably needed help. On it were the writer Franz Werfel and his wife, the redoubtable Alma Mahler, and many artists of the calibre of Marc Chagall and Max Ernst.[72]

Once in Marseilles, Fry was to find his task almost overwhelming. As cover he started an American relief organization. Eager exiles soon taught him all the tricks of false papers and escape routes to Spain. Help came from such unexpected undercover operatives as André Gide, Henri Matisse, and the aged Aristide Maillol, who sent his model as a Pyrenees guide, after he himself had shown her how to cross the mountain ranges. But only Fry could help with the endless process of obtaining an American visa from the U.S. consulate, which often regarded the refugees as dangerous left-wing agitators. The lucky recipients had to be chosen, by an agonizing process of triage, from some eighty applicants a day. In one ten-day period in October he managed to get writer Lion Feuchtwanger, Werfel and Mahler, plus three of Thomas Mann's relations off to New York. The journeys were not normal. Feuchtwanger (who had been rescued from a French internment camp by a sympathetic assistant American consul with the historic name of Miles Standish), Werfel, and Mahler, who was carrying the manuscripts of Werfel's *Song of Bernadette* and Bruckner's Third Symphony in her rucksack, climbed out over the Pyrenees. The resultant publicity, though it brought in much money in the form of con-

tributions, was not good. Himmler, who visited Madrid after the escape, extracted an agreement for stricter border controls from the Spanish government. The French and Portuguese followed suit, adding all sorts of exit and transit visas to the already daunting documentation necessary for freedom.[73]

After this episode Fry felt it would be wise to be more private and rented a villa—dubbed "Château Espèrevisa"—just outside Marseilles which soon became an extraordinary artistic center. The presence of surrealist writer André Breton and his equally surrealistic wife, Jacqueline ("blonde, beautiful and savage with painted toenails, necklaces of tiger teeth, and bits of mirror glass in her hair"[74]), attracted the painter Max Ernst, who arrived after surviving a series of detention camps. A host of others lived in or spent their days at the villa, where they passed the time creating surrealist montages—Breton decorated the dinner table with an arrangement of live praying mantises—and holding exhibitions.

Word of this scene did not take long to reach Peggy Guggenheim, who, after many convolutions described at length in her memoirs, paid for the transatlantic passages of Ernst (whom she later married in New York), André Masson, Breton, and all their families, and helped the committee finance the escapes of Chagall, Lipchitz, and many more. There was a quid pro quo: for $2,000, minus the cost of the fare, Peggy asked for some of Ernst's pictures. She did well, acquiring quite a generous number. Indeed, she had never stopped buying from needy artists who, like herself, were progressing toward escape.[75]

Ernst left on May 1, 1941, having finally obtained his American visa. But his French exit papers were not in order, and at the border he was asked to open his bags. The paintings they contained were spread all over the customs area and Ernst was closely questioned about his artistic ideas. After a time the inspector informed him that his papers were not valid. He must return to Pau on the next train, which was standing on the near track. Under no circumstances, said the inspector, should he board the train on the far track, which was going to Madrid, adding, "Above all, monsieur, do not make a mistake. I adore talent." Ernst made it to Madrid and went on to Lisbon. Feeling too encumbered by baggage, he went to the post office and sent one of his biggest paintings, *Europe after the Rain II,* to the Museum of Modern Art in New York by regular mail. It arrived.[76]

Chagall, who was living in an ancient stone cottage in the village of Gordes, northwest of Marseilles, and who was very reluctant to leave, had a harder time. Fry had finally persuaded him to go, after having quieted his many worries, including the doubt that there would be cows in America, when he was arrested by Vichy police and only freed when Fry threatened to inform *The New York Times.*[77]

This ploy was successful, but the French clearly would not tolerate Fry forever. By August 1941 the United States consul and even Eleanor Roosevelt knew the operation was over. Fry tried to persuade Peggy Guggenheim to carry on for him, but the ever more frightening atmosphere of Marseilles and strong pressure from the consul were too much for her, and she declined. But it was not until she was questioned in her hotel by French police, whose chief apologetically released her upon discovery of her American papers, that she too got on a train heading for Spain.

Because of her name she was stripped and searched "for illegal currency" at the frontier, but she had none and continued on to Lisbon to meet Ernst and the rest of her family. On July 14, 1941, they all arrived in New York, where Ernst was immediately detained at Ellis Island as a German national. During his incarceration Peggy and his dealer visited him daily, crossing to the island in a small boat. After a barrage of recommendations from Alfred Barr and MoMA patrons John Hay Whitney and Nelson Rockefeller, Max Ernst too was allowed to set foot on American soil.[78]

Martin Fabiani's shop in 1943, by Utrillo (Photo by Henri Tabak)

BUSINESS AND PLEASURE

France: The Art Market Flourishes; Nazi Kultur Withers

The art market in France was, if anything, even more prosperous and fraught with intrigue than that in Holland. As the occupation government took hold, both sides had been impatient to revive the trade. The Archives Nationales files on the Kunstschutz are full of obsequious letters to Count Metternich from cash-starved countesses, Russian emigrés, and dealers of all kinds offering their possessions and wares. Everyone had apparently heard of the German propensity to spend.

Officials of the Hôtel Drouot, the famous Parisian auction house, asked permission to resume sales on September 26, 1940. This was granted by Dr. Bunjes on condition that all catalogues be sent to him, that all works valued at more than FFr 100,000 be indicated, and that the name and address of the purchasers of such items be reported.[1] Like its Dutch and German counterparts, the Drouot was about to have its most successful years of the century. In the 1941–1942 season alone they would sell over a million objects; in March 1942 a Rotterdam paper reported on its front page that the Drouot was "filled with onlookers and buyers" and that the year 1941 had beaten all previous records, citing examples back to 1824. People bought everything they could get their hands on. "For want of Watteaus they bought presumptive Paters," reported the Dutchman, two canvases by this artist having been snapped up for FFr 1.05 million.[2]

Nineteen forty-two was even better, crowned by the phenomenal sale of the late dentist Georges Viau's Impressionist collection on December 11–14. The auctioneer, Etienne Ader, had written to the Kunstschutz not to list works that would sell for FFr 100,000, which had become rather routine, but rather to report those expected to pass the million mark. Ader's estimate that only one, a *Vallée de l'Arc et Mont Ste.-Victoire* by Cézanne, would reach this figure was wildly off.[3] The 120 works together brought FFr 46.796 million, the highest total ever reached at the Drouot at

a single session, to which had to be added a 10 percent luxury tax on top of a 15 percent sales tax. The Cézanne brought FFr 5 million, for which, a German report noted, one could easily have bought a château with considerable acreage. Degas's *Femme s'essuyant après le bain* went for FFr 2.2 million, and thirteen other lots were sold for well over a million francs apiece.

The event got heavy press coverage both in Paris and Germany. Paul Colin of *Le Nouveau Journal* described the six hundred seated attendees, who were soon mobbed by a huge standing-room-only crowd, as paradoxically very "*vieille* France," noting that it was filled with "monocles, and white moustaches à la gauloise," elegant ladies of a "very certain age," and jackets adorned with the red rosettes of the Légion d'honneur. He mentioned that no Jews were allowed to attend, and nastily pointed out that "the Parisian market needs neither Hebrews nor Yankees to have sensational prices reached . . . which," he continued, "were absurd and accidental" and due to "Degas snobbism added to Viau snobbism." As for the Cézanne, "we will perhaps never again find two buyers crazy enough— the word is not too strong—to bid each other up to 5 million for a little landscape (55 × 46 cm)." The Louvre was derided for refusing the Degas in 1918, when it could have been had for FFr 20,000.[4]

German reports on the event were a bit more subtle, but no less nasty, attributing the high prices to "the needs of the nouveaux riches for capital investments." One had the impression, one writer remarked, "that the buyers were more concerned with getting rid of their newly acquired paper money as quickly as possible." He evidently did not know that the major buyer at the sale was not a French black marketeer but the German dealer Hildebrand Gurlitt, one of the buyers for Linz, who in addition to the Cézanne bought three other million-plus pictures: a Corot *Paysage composé, Effet gris;* a proscribed Pissarro; and for FFr 1.32 million a small Daumier *Portrait of a Friend.* The truth of the matter was that in France these "degenerate" works were among the hottest items in an overheated market and were being traded and bought to a large degree by those who had condemned them.

Alas for Gurlitt, both the Cézanne and the Daumier were fakes. The good dentist, it seems, loved to "finish" oil sketches by well-known artists, and copy other works outright. The little Daumier was a copy of the real picture, which had also belonged to Viau, but been sold elsewhere; the Cézanne pure invention. It is now in the study collection of the Musée d'Orsay.[5]

Individual dealers, decorators, and purveyors of every stripe were doing just as well as the Drouot. The Germans were no different from the visi-

tors who had lost themselves in the antique-buyer's paradise of Paris for generations. Behind the dignified façades of many an apartment building a colorful array of amateurs and professionals carried on an enormous secret market in their efforts to sell their conquerors everything short of the Eiffel Tower. One lady repeatedly offered Goering an entire Spanish courtyard. Another gentleman wondered if he would be interested in buying "twelve historic stone capitals which come from the Palace of the Tuileries and bear the 'N' of Napoleon," and which were now "at my house . . . where I had intended to build a temple." Monumental offers of this nature were not frivolous: inventories of the Reichsmarschall's collections reveal that he actually did buy "a small eighteenth-century circular temple with six columns" and "the Cloister of the Cistercian Abbey of Berdoues (Gers)" from dealer Paul Gouvert.

The Galerie Charpentier, at the behest of Kajetan Mühlmann's half-brother Josef, put on a show of medieval and Renaissance objects which was visited by Goering, who bought the lot. From his own very decorated apartment, the Vicomte de la Forest-Divonne sold carefully arranged objects and paintings (often obtained from ERR leftovers or the Clignancourt flea market) as if they were his own, claiming always that they had been in the family for generations. To encourage sales, clients were served champagne as they pondered. Another noble lady, the Countess de la Béraudière, worked the black market, accepting only cash transactions.[6] The art trade swarmed with middlemen fronting for French citizens who preferred not to reveal to whom they had sold. Thousands of works of art changed hands without receipts or any kind of record.

The architects helping Hans Frank refurbish the castle at Cracow came and shipped carloads full to the East. The Rhineland Museums (Krefeld, Essen, Bonn, Wuppertal, and Düsseldorf) had a whole team of curators covering Paris who spent well over FFr 40 million on French paintings and decorative arts, which even included a good number of Impressionists. Albert Speer bought twenty-five cases worth of *objets,* and the sculptor Arno Breker bought works by French artists he admired and shipped them home along with twenty tons of plaster, wine, and cologne. Dr. Hans Herbst spent FFr 15 million on items which were dispatched to the auction rooms of the Dorotheum in Vienna for resale, while Josef Mühlmann travelled the countryside to supply clients in Berlin and Poland, and a certain Herr Possbacher filled orders to the tune of FFr 4.5 million for lesser Nazi party officials unable to visit the City of Light.[7]

These purchases were subjected to brilliantly contrived and endless bureaucratic delays by a Louvre curator, Michel Martin, seconded to the French Customs, who demanded reevaluations and ever more documentation before granting export permits. He did not have any illusions about

his ability to stop the exports, but in this manner was able to keep track of where declared objects were being sent. The conquerors were forced over and over again to reveal the mailed fist by appealing to the Military Government for intervention.

All this dazzling but relatively straightforward trade pales when compared to the extraordinary international transactions involving the top Nazi procurers which would peak in 1941–1942. In these dealings the competitive rapaciousness of the buyers was evenly matched by that of the sellers, it being the universal desire to acquire as much art or cash from each other as possible. There was no dearth of either. The German dealers had the great advantage of direct access to the government funds controlled by their patrons, not to mention special travel privileges and the ability to send their purchases across frontiers without the annoyance of customs controls.

Both Hitler and Goering had full-fledged but carefully separated buying operations going on in Italy as well as in the Low Countries. The Führer's primary agent, Prince Philip of Hesse, a nephew of Kaiser Wilhelm II, was particularly well placed, as he was married to Princess Mafalda, daughter of the Italian King. He had joined the Nazi movement in the twenties and risen to its highest levels when the war began. In 1940 Hitler had asked him to help Posse find pictures on the Italian market, an assignment he eagerly accepted.[8] Hesse's expertise and entrée were invaluable. Through him Posse was able to procure such gems as the Memling *Portrait of a Man* from the collection of Prince Corsini, Rubens's *Equestrian Portrait of a Member of the Doria Family,* and a *Leda and the Swan* attributed to Leonardo from the Spiridon family. Posse made three trips to Italy in the spring of 1941, each time asking for more funds to be deposited at the German embassy. He needed them: the Spiridon Leonardo alone went for L 10.5 million, or RM 1.3 million. By May 1942 the total had reached RM 5 million, and Hesse had acquired eighty-eight works for Posse.[9] Hofer, with less money to spend, had a more complicated network of dealers and free-lancers from whom he got regular kickbacks at Goering's expense.

When the Reichsmarschall himself was in Italy, his principal dealings were with the self-made collector-dealer Count Contini Bonacossi, whose title had been granted by Mussolini. Contini had donated a large part of his collection to the Italian state, but he still had plenty for sale, as his extensive American trade was now cut off. A great bargainer, he sold more than fifty items to Goering, including a considerable amount of furniture.

In Italy the Nazi collectors had the great advantage of the cooperation of a sympathetic head of state who could help them circumvent the an-

noying export laws meant to protect the national patrimony. In 1942 Minister of Education Bottai vainly published and tried to enforce stricter export regulations to stop their depredations, but he need not have bothered: when Mussolini or his Foreign Minister, Ciano, tired of these objections they simply presented the work in question to Hitler or Goering as a gift.

France was far more complicated. When in Paris, Goering did not limit himself to the staff of the ERR, but regularly shopped on the open market in perfectly aboveboard transactions, sometimes accompanied by such major buyers as Walter Bornheim of the Galerie der Alte Kunst (formerly A. S. Drey) in Munich. Bornheim also bought for Linz, various German museums, and many private collectors. He was particularly good at choosing the birthday presents those wishing to ingratiate themselves needed for Hitler and Goering. All the French dealers loved him, as he always paid in untraceable cash, carrying hundreds of thousands of francs in his briefcase. By war's end he had dispensed some 100 million of them.[10]

The dealer who bought the most for Hitler in France, and who clearly had the most fun doing it, was Frau Dietrich. Her very special relationship with him through Eva Braun is the only possible explanation for the amazing leeway she was given in her dealings. Between 1940 and 1944 she bought some 320 paintings in Paris, of which 80 went to the Linz collection. A lot of these were bad pictures, and no small number were fakes. But Frau Dietrich was the only dealer who could sell directly to the Führer without the approval of Posse or Bormann. In Paris she had a wonderful time, having created a network of finders, ranging from a Russian princess to Goering's man at the ERR, Bruno Lohse. She was just as welcome at some Parisian galleries as Bornheim. Martin Fabiani sold her four dubious Guardi oil sketches, and ninety-nine other dealers sold her much more.

Frau Dietrich's impeccable expense accounts not only enumerate all her acquisitions but show that she truly knew how to enjoy Paris life. She may not have known much about pictures but she certainly knew her wines. On December 14, 1940, she lunched at a restaurant suitably called Chez Elle, where she consumed a filet and washed down with a nice Pomerol '29. It must have been a good day, for she dined that night at Prunier on caviar, lobster, and a little Moët. The next night she ordered Veuve Clicquot (FFr 520) at a cabaret called Don Juan in the rue Fromentin, and on the sixteenth went all out at La Crémaillière, feasting on more caviar, soup, and duck à l'orange, accompanied by a fine Château Latour. All this was subsidized by a steady flow, in the hundreds of thousands, of reichsmarks to her Crédit Lyonnais account.

Some deals did not turn out well, but Frau Dietrich was never discouraged. In July 1941 she cheerfully returned four pictures to the dealer

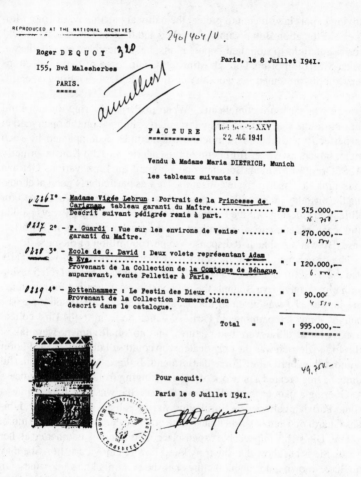

Receipt for Frau Dietrich from Roger Dequoy

Roger Dequoy, two of which had been judged fakes by Buchner and Voss, one as having been cut down, and the fourth as being "school of." Dequoy replaced them with three presumably better pictures for the same price. It was a scenario frequently repeated, but Frau Dietrich could afford to be cheerful, her yearly income having by then reached more than RM 500,000 ($200,000).[11]

Karl Haberstock took it all much more seriously. Though initially he

was prevented by Reichschancellery officials wary of his dishonesty from going to Holland with Posse, the Linz director's requests that the dealer be allowed to do business in the occupied nations could not be denied forever. By the fall of 1940 Posse had so many countries to deal with that he welcomed Haberstock's interest in acting on his behalf in France, as Prince Philip of Hesse was doing in Italy. Through Posse's influence the all-important travel documents were provided. Haberstock obtained an authorization from Goering as well. These passes gave him the great advantage of early access to the Unoccupied Zone, in which, as Posse put it, "there is much to be gotten in future, since this area for the moment had been spared from the many other German dealers."[12]

In 1940–1941 the Free Zone had also still been spared the inroads of the ERR and other agencies implementing Jewish confiscation, and was full of refugee dealers and collectors with whom Haberstock had dealt in the past. He arrived in Paris with Posse in October 1940, set himself up in great style at the Ritz, and sent out cards soliciting business from the principal dealers still in town, Jewish or not. Some of them must have been surprised. Duveen's wrote back a polite note saying they were "closed at present" and Léonce Rosenberg replied that he had only works by living painters, which were probably not suitable.

At Wildenstein's, Haberstock found only longtime employee Roger Dequoy presiding over the house and galleries, from which Abetz and the ERR had already removed the remaining stock, and would later remove even the furniture. But Haberstock was sure that Georges Wildenstein, awaiting passage to the United States in Aix-en-Provence, had other assets which would be of use to him. In November he and Dequoy went to Aix, where they met Wildenstein and came to certain agreements. Haberstock recalled this as a friendly meeting; Wildenstein, in his later conversations with the T-men in New York, did not, and said that Haberstock had been accompanied by a high-ranking German officer and had brandished a letter of recommendation from Pierre Laval.[13] Be that as it may, the French dealer was as anxious as Haberstock to make the most advantageous arrangements possible.

It was proposed that Wildenstein would exchange "acceptable" pictures from his stock for the modern works so unacceptable to the Nazis, which Haberstock would send to him in the United States. Wildenstein would sell them through the New York branch of his firm, as he had done so successfully with the Gauguin before the war. In November 1940 this was not so far-fetched: it seemed likely that the war would soon be over and Haberstock could then simply ship items to New York. The German dealer also proposed that Wildenstein buy things for him from the refugees

crowded into the Unoccupied Zone, for which he would pay in francs, marks, or lire. When Wildenstein suggested that dollars would be better, Haberstock declared that dollars would not be a desirable currency after the Germans "had finished with America." To this Wildenstein retorted, "Do you think the US is going to be such an easy job?" and Haberstock replied, "It will be an easier inside job than France was." It was further suggested that if Haberstock could somehow recover the Wildenstein pictures held by the Louvre at Sources, which the ERR also wanted, these too would be available for the market.

Haberstock indicated that he had a German buyer for Wildenstein's weekly, *Beaux Arts,* which he urged him to sell before it was confiscated or Aryanized. At the same time Wildenstein made certain private arrangements with Dequoy, who was to continue to oversee the firm's interests in Paris and try to use its European assets to buy locally, in the hope that these stocks too might be somehow transported to the Americas. Letters containing Wildenstein's instructions would be sent care of Dequoy's father-in-law in Marseilles.[14] The French dealer himself left for the United States on January 29, 1941.

While he was in the Unoccupied Zone, Haberstock made contact with a number of other refugees. From former Berlin colleague Arthur Goldschmidt he bought a Brouwer and a van Ostade, which he sold to Linz. Herbert Engel (son of the Austrian refugee dealer Hugo, who would later become part of Haberstock's Paris operations) was recruited to watch for available works in the south of France. From the brothers Ball, Alexander and Richard, originally of Berlin, who soon left for America, Haberstock gleaned vital tidbits of information on the exact location of various prominent private collections. For appraisals he found yet another person in limbo, a German expert on Spanish painting and former director of a Munich museum, August Meyer (referred to in correspondence by the code name "Henri Antoine"), whose wife and child had remained in occupied Paris.[15]

Haberstock was not the only one arranging things in this hotbed of survival intrigue. Martin Fabiani, on his way back from sending his pictures off from Lisbon, found an escaping dealer with whom he made a happy agreement: Fabiani would take over the fugitive's premises in the rue Matignon for the duration of the war, and return the business to him when it was over. This worked out very well for Fabiani, a self-confessed opportunist who, through his friendship with Dequoy, would be privy to some of the occupation's bigger deals. Louis Carré made a similar arrangement with André Weil, also of the rue Matignon, who stayed in hiding in the country while Carré did an excellent business in French modern works.[16]

On his return to Paris, Haberstock duly arranged for *Beaux Arts* to be sold to a Herr Brauer, the publisher of the German magazine *Weltkunst*. From then on the periodical kindly gave Dequoy a discount on advertising. The problem now was how to keep the Wildenstein firm going and get hold of the stocks belonging to it which were held by the Louvre—before the ERR did. On April 2 Wildenstein impatiently wrote to Dequoy to say that "there were doubtless ways and means of so doing."[17] And indeed there were. Haberstock once again would use his government's ideology to his own advantage. This time it was "Aryanization."

The program so successful in Holland was first proposed for France in late October 1940. In November French police prefects were instructed to begin listing Jewish enterprises, which were to be put under "provisional administrators." By December 4, 1940, a French agency, the Société du Contrôle-Administrateurs Provisoires, was set up to run this program under the aegis of a M. Fournier, former director of the Banque de France and president of the French Railroads.[18] Soon the premises and remaining assets of Paul Rosenberg, Bernheim-Jeune, Léonce Rosenberg, and many more were being run by government-appointed administrators whose duty it was to "suppress Jewish influence in the French economy." Attempts to circumvent such takeovers could be most unpleasant. Permission for the transfer of title to the Galerie Simon, owned by Daniel Kahnweiler, to his French Catholic sister-in-law, Louise Leiris, was granted only after arduous negotiations and the production of innumerable documents. The process was not helped by the series of anonymous notes, made up of letters cut from newspapers, which were sent to the authorities to remind them that Mme Leiris was related to the "German Jew Kahnweiler."[19]

By early April 1941 an accountant named Gras had been appointed as administrator of Wildenstein, but the Aryan Dequoy was left in charge of day-to-day operations. This was perfect. Haberstock could now claim that the Sourches pictures were private Aryan property, and should be returned to the business which owned them. Gras, who was busily selling off the private collection of Bernheim-Jeune (of which he was also administrator) via the dealer Charles Montag (who had once been Winston Churchill's painting teacher), did not object.

Haberstock used all his clout for this operation. At 6 p.m. on Monday, May 12, a Kunstschutz official, Dr. Pfitzner, received a call from Haberstock in Berlin. The dealer said that the Wildenstein pictures held at Sourches would be removed, but that they were to be reserved for Posse or himself, and were not to be released or sold to anyone else. The ERR, which was planning to claim the same items on the fifteenth, was amazed. The Kunstschutz, also startled, warned Louvre officials that an "unidentified agency" was planning to remove the Wildenstein objects.

On Tuesday, Baron von Pollnitz, an Air Force officer who was a close friend of Haberstock, appeared to make transportation arrangements. When the Kunstschutz pointed out that only the ERR could remove non-Aryan collections, von Pollnitz produced a document from Gras stating that the Wildenstein firm had been transferred to Aryan hands. The Kunst-schutz, always happy to obstruct the ERR, conceded that "since the new Aryan owner wishes the return of the pictures in order to sell them" there was no reason to prevent the transfer.

Von Behr had in the meantime asked Goering to intervene, but Goering replied that if the collection had been Aryanized he could do nothing.[20] The ERR had lost this one, and Haberstock triumphantly rushed to Paris to see the collection. He was disappointed in its quality and bought only seven pictures for FFr 930,000, of which he resold five to Linz for FFr 1.27 million. Dequoy politely wrote von Pollnitz to thank him for helping to "liberate his pictures from Sourches." But Dequoy was not liberated from Haberstock, who from then on used the Wildenstein premises and the shop of the non-Aryan Hugo Engel as his branch offices in Paris.

To complete the "Aryanization" of the firm, Dequoy and two partners attempted to buy it outright from Gras, so that it could be operated privately in Dequoy's name. The French Commission of Jewish Affairs and related German agencies were suspicious of this request, as they were perfectly aware of Dequoy's long association with Wildenstein, and felt that the price Dequoy was offering for the firm was ludicrously low. It was also rumored in the more fanatic German circles that Dequoy was hiding part of the Wildenstein collection somewhere, and therefore holding Jewish property against German interests. Only after months of correspondence, in which Dequoy swore repeatedly that he had not been in touch with his former employer since 1939 and had made no secret arrangements with him, and many letters from Posse and Haberstock invoking the name of the Führer, Goering, and various other highly placed occupation figures, which described the many works of art Dequoy had procured for the Reich, did the firm finally become his in early 1943.[21] This arrangement was to be short-lived. After the death of Posse and the subsequent eclipse of Haberstock the elegant galleries in the rue la Boétie were requisitioned in January 1944 by the extraordinarily optimistic German embassy for an Institute of Franco-German Cultural Exchange.

Dequoy, nothing daunted, continued to trade in new premises in the faubourg Saint-Honoré. Throughout, he did very well, his establishment being viewed by French and Germans alike as a continuation of the famous Wildenstein house. In September 1941 the Swiss collector Emil Bührle bought two Renoirs, a Greuze, and a David, all of which he had to leave in Paris for the time being because of strict Swiss Customs laws.

Some old clients came back too. In 1942 the wine broker Etienne Nicolas asked Dequoy to sell two major Rembrandts, the *Portrait of Titus* and *Landscape with Castle,* which he had bought in 1933 from Wildenstein, to whom they had come from Calouste Gulbenkian, who had in turn bought them from the Hermitage. This was a change of heart for Nicolas, who had promised them to the Louvre before the war, but the high prices being paid, especially for Dutch artists, were perhaps too tempting. Dequoy negotiated the sale with Haberstock for Linz, and Nicolas received the very satisfactory sum of FFr 60 million ($1.2 million) for the pair, paid through the cashier's office at the German embassy. Dequoy got FFr 1.8 million directly from Haberstock for "having found and made arrangements for the sale of two paintings by Rembrandt."[22]

Georges Wildenstein's hope for continuing business as usual with Haberstock's help on an import-export basis was not destined to succeed, but it took him considerable time to grasp the true situation. The letters with which he bombarded Dequoy were full of advice and the gossipy information so vital to the art trade, all written with little codes and disguised names (Haberstock was referred to as "Oscar"). He suggested that his former employee buy "cheaply" forty pictures by Rouault, roll them up in paper, "as Rouault does," and try to send them to New York through American Express. He urged Dequoy to keep any engravings he had as long as possible, as he had heard that prices were rising wildly. The answers came back very slowly, prompting Wildenstein to write imperiously: "I cannot understand what is happening: would you try to see if it is not possible by some means to receive your correspondence for certain?"

The problem was partly solved by routing the letters through Switzerland, but Wildenstein clearly could not comprehend the New Order in Europe. In March 1941 he wrote indignantly to complain about three cases of works held by a transit shipper in Bordeaux, "which had been at the free disposal of this firm in November 1940" and had apparently been seized. Accusing the shipper of "extraordinary negligence," he fumed that "if they were taken away, it was by the shipper, and not the Germans, who it cannot be believed would contradict an official ruling of their own." Dequoy was enjoined to do "what you can from your side." This was precious little. Dequoy had nothing much to ship, and Haberstock, for reasons which will become clear, had not been able to obtain any modern pictures to trade. Wildenstein correctly suspected that someone else had, and wrote to ask Dequoy "to find out who Oscar's competition is." He also told him that he would not be interested in any items from Haberstock "unless he can guarantee shipment."[23]

There was very good reason for this proviso. The only recorded attempt

to ship works to Wildenstein, like so many others, was plagued by the new legalities of the war. Seventeen French pictures by such "dead painters"—as the customs so elegantly put it—as Greuze, Watteau, Robert, Corot, and Renoir, with suspiciously low valuations, and which technically were the property of Wildenstein's London branch, ran into the same British blockaders as had Fabiani's lot. London had originally refused to authorize the export on grounds that "proceeds of sales made in the United States on behalf of Wildenstein's London house were not remitted to the UK," a reference to the firm's problems with the David-Weill collections.

To get around this, Wildenstein ordered Dequoy to send the pictures instead to Martinique on a French ship, the SS *Carimare*. This maneuver did not fool the British, who informed their American friends that Wildenstein had evaded blockade controls and did not deserve any consideration, as he had originally promised London not to ship the paintings. The entry of the pictures into the United States was now subject to agreement between the State Department and the French authorities in Martinique. The shipment was eventually allowed to enter, but was placed in a blocked account.[24] The ultimate fate of these works, and others in the same situation, is most difficult to trace, not least because of the vague names assigned them by their shippers. On the bill of lading for the *Carimare* shipment no fewer than twelve pictures are entitled *Painting of a Girl;* four are *Landscapes;* one is a *Virgin.*

When entry to the United States proved difficult many dealers opened branches in Buenos Aires, Mexico City, and Havana. American and British Intelligence and Treasury intercepts show reams of correspondence from Europe and the United States to South America and the Caribbean on the subject of art sales. These were only the tip of the iceberg, and before long the Allies, fearing the establishment of Nazi power bases in the Americas, would begin to try to monitor the flow of assets to the region.

After the entry of the United States into the war this trade became increasingly lively and complicated. An American professor in Panama City reported that "shipments from Germany via Spain reached Colombia quite easily. Lots of stuff was stopped by the English, but much got through."[25] One of the escaped Katz family, now ensconced in New York, sent his relation in Curaçao a number of Dutch paintings to sell there with the comment "there are so many buyers, that nobody needs to know how much you paid for these paintings."[26] There were plenty of buyers in New York too. American art periodicals in the summer of 1941 reported that the buying activities of exiles from Europe had had a "galvanizing" effect on the market. Dealers reported selling hundreds of thousands of dollars' worth of

paintings per month and Parke-Bernet announced the best season in twelve years, up 54 percent over the year before, adding that "the news is that a minority of the buyers were Americans."[27]

So Byzantine were these international trading arrangements that even the normally unflappable agents of the U.S. Treasury, who had presumably been privy to more than one convoluted deal, were sometimes at a loss to explain them, and in their reports resorted to such descriptive phrases as "a long letter filled with confused accounts of business deals, shares of profits, ownerships, disputes, etc. . . . and various juggling of citizenships as occasions suggest."[28] This was in reference to the intricate proposed dealings between a German dealer named Paul Graupe who lived in New York; Arthur Goldschmidt, his onetime partner, whom we last saw in contact with Haberstock and Wildenstein in the south of France, and who eventually escaped to Cuba; Theodore Fischer, he of the Lucerne "degenerate" art auction; Hans Wendland, a German lawyer, possibly Jewish, who was a Swiss resident; Haberstock himself; and a whole series of French dealers—a combination, according to the Treasury, "lending itself to any trickery."

Graupe had arrived in New York in early 1941. In April he received a letter from Hans Wendland suggesting a scheme very much like the one Haberstock had suggested to Wildenstein, with the remarkable difference that Wendland mentioned that dealers in Paris would buy "out of the Louvre" and not in the private sector, and ship the pictures to Switzerland, where Wildenstein or someone else would repurchase them. From there they could easily be shipped to America on neutral Swiss boats from Genoa. All this would be financed with the knowledge and help of the Germans. Graupe replied that his reception in New York had been "overpowering" and that he could use such material, but in the end he turned down Wendland's proposal.

There was no question that enormous profits could be made in this way, but the wartime censorship made negotiations very difficult. Indeed, the whole reason for the Treasury investigation had been the voluminous correspondence they had intercepted concerning the disputed ownership of a van Gogh entitled *The Man Is at Sea,* which had not left France in a normal way. Accusations, denunciations, and threats flew from dealers in Lisbon to New York, and vice versa, all being read by Allied censors and Treasury officials trying to decide what monies they should or should not block and tax. Such sharing of ownership led to numerous other inquiries, some more justified than others; but nowhere does the fact that life and death were sometimes involved enter into the reports. In the light of what was happening in Europe, the investigation of the Perls Gallery for "turn-

ing over without compensation or license an oil painting called *Rabbi in Flight* by Marc Chagall, a French national," to the owner, the same Marc Chagall, who had escaped from France and arrived in New York in July 1942, now seems quite unnecessary.[29]

As hopes for the transatlantic exploitation of modern and Impressionist pictures dimmed, a trade in these "degenerate" objects was developed in Europe by Goering himself. The confiscated collections which had gone to the Jeu de Paume, great though they were, had never been "purified." Along with the Vermeers and the Rembrandts had come stacks of Cézannes, van Goghs, Matisses, Renoirs, and, even worse, Légers and Picassos. These were all stored in a special area of the museum, well away from the Old Masters. Their importation into the Reich was technically forbidden. This was all very well for those whose ideology was pure, but to Goering, who had been exploiting these assets from the beginning, it seemed rather a waste to just let them sit in the Jeu de Paume. Accordingly, a number of top "degenerate" works had quietly been taken to Germany for his future use in the very earliest shipments from Paris.

This left plenty with the ERR; the question was how to utilize them. A German-American with the peculiar name of Mom proposed that they be sold in Portugal and that the proceeds be invested in industrial diamonds. Von Behr and the ERR were enthusiastic, but Goering's representative at the ERR, Bruno Lohse, who saw possible commissions evaporating, managed to block this proposal. Instead, a barter system advantageous to many was conceived. Between March 1941 and November 1943 eighteen exchanges of these "degenerate" pictures for more suitable works were arranged for Goering, and another ten or so for Hitler, von Ribbentrop, and Bormann. The fanatics at the upper levels of the ERR heartily approved the plan, which would enable them to "acquire for the German Reich . . . important paintings without spending foreign currency." The man behind this scheme was the same Hans Wendland who had already approached Graupe, and who with the total cooperation of Hofer and Goering encouraged this trade. Haberstock, so widely known to be operating for Linz, was outmaneuvered at the ERR and never had a chance to profit from the exchanges, which were controlled by Lohse, Hofer, and Wendland.

The catalyst for the first exchange was a *Portrait of a Bearded Man* billed as a Titian. It was offered by another German dealer, Gustav Rochlitz, who had lived in Paris since 1933 and was a close friend of Bruno Lohse. Goering usually found his prices too high, but the "Titian" caught his eye, and Rochlitz was summoned to the Jeu de Paume on

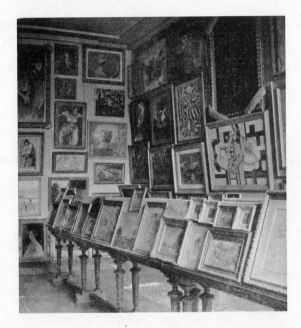

The special room for "degenerate" art at the Jeu de Paume

March 3, 1941, to choose what he wanted from a group of modern works assembled by Lohse and other staff members. History does not record what his expectations were, but he could not have been too disappointed at being allowed to take eleven paintings, carefully vetted by Goering, which included Degas's *Madame Camus at the Piano* and Cézanne's early *Douleur* (both from the Alphonse Kann collection), two Matisses, two Picassos, and one each by Renoir, Sisley, Corot, and Braque from the collections of Paul Rosenberg, Alfred Lindon, and Georges Bernheim.

The ERR pictures were carefully valued by the agency's captive French expert so that the total worth of the exchange would match the asking price of the Titian. But things were not simple; shares of the "Titian" and a Jan Weenix thrown in with it were owned, oddly enough, by Hans Wendland, to whom Rochlitz gave six of the eleven traded paintings.

This deal triggered an avalanche. Exchanges with Rochlitz followed almost weekly throughout the spring and early summer. Some were less lopsided, but another sixteenth-century portrait, supposedly of Titian's daughter Lavinia, brought forth eighteen more Impressionists and moderns. In all Rochlitz received eighty-two top-notch confiscated paintings. Of these, after the six given to Wendland, he sold twenty-five to four other

Paris dealers: Mssrs Rosner, Petrides, Klein, and a Mlle Levy. The other fifty-one he salted away for the future.[30]

The exchange process was not limited to France. It was used, as we have seen, to obtain desired works from the Kröller-Müller Museum in Holland. Hofer took nine more to trade for eleven paintings and objects from the dealer Ventura in Florence. But Switzerland would offer many more options. In April 1941 Hofer offered the Galerie Fischer in Lucerne twenty-five Impressionists from those Goering had secretly sent to Germany, in exchange for four Cranachs and two other German works. Fischer was invited to Berlin to choose what he wanted from a group of canvases (mostly from the Levy de Benzion and Alphonse Kann collections) which had been brought there especially for him from their storage at Neuschwanstein.

Soon after this, Wendland too got from Goering, in trade for a Rembrandt and two tapestries, twenty-five pictures, all from the Paul Rosenberg collection except for a van Gogh *Small Landscape* that had been owned by Miriam de Rothschild. These were shipped to Berlin for Wendland, who declared them inadequate compensation for the Rembrandt, and managed to convince Goering to pay him an extra SFr 250,000.[31]

From these nice profits Wendland and Fischer would pay Hofer an equally nice commission. It was all easily arranged. Hofer would quote an inflated price to Goering, and receive the difference from Wendland in cash or pictures.[32] When Goering hesitated, Hofer, like Posse, would suggest that others were ready to buy. Haberstock was a favorite threat. Encouraging one of these trades which involved four of Goering's favorite Cranachs, Hofer wrote that "Haberstock will happily pay . . . much higher prices for them if you do not buy. I know Haberstock would do anything to get these things from Fischer."[33] Goering bought.

The great problem for Wendland and Fischer was how to get pictures bought in Berlin and Paris into Switzerland, which had extremely strict customs laws.[34] Germany itself required considerable paperwork for the exportation of works of art, "degenerate" though they might be. The French-Swiss border was out of the question. Wendland therefore suggested that Goering send his next exchange through the diplomatic bag. He was particularly interested in this untraceable method, as Hofer had done him the favor of shipping to Germany, along with the ERR items, the six pictures he had acquired from Rochlitz, plus the four bought by Emil Bührle from Dequoy in Paris. Wendland, unlike Fischer, was not a Swiss citizen, had no license to deal there, and would have trouble extracting the paintings from Swiss Customs. Goering agreed to use the diplomatic bag.

All the pictures were sent to the German embassy in Bern, where Hofer picked them up and then took them to Wendland in Lucerne. But two of Bührle's pictures, a Renoir *Nude—The Spring* and a Greuze *Portrait of Laurent Pecheux,* mysteriously stayed behind at Carinhall. A memo from Hofer to Goering's secretary notes only that "the Reichsmarschall will decide later about these pictures." They were not returned to Bührle until August 1944.

The pictures thus brought into Switzerland were marketed through the Fischer firm, as Wendland could not legally sell there. He could bring in customers, however, and foremost among these was Bührle, whom he apparently convinced that there would be no repercussions. Bührle bought more than a dozen confiscated works, among them Miriam de Rothschild's van Gogh; the Kann Degas, *Madame Camus at the Piano;* and a number of pictures belonging to the Levy de Benzions and Paul Rosenberg.

To assuage guilt feelings, Hofer and Wendland spread the rumor that Rosenberg had died in the United States. Other major collectors were sorely tempted by their wares. Oskar Reinhardt's dealer saw at once that these were remarkable works, but when he showed a selection of photographs to Walter Feilchenfeldt for an opinion, Feilchenfeldt immediately recognized them as Rosenberg pictures. Reinhardt refused to touch them. Bührle, when advised that he might have to return the pictures, reputedly simply replied that he would buy them again if necessary. The purchase was not a secret in Switzerland. The exiled collector Robert von Hirsch wrote to a friend in New York that "only Bührle is earning really big money . . . and he . . . seems to be buying a good many Impressionists which the Germans have stolen from Paris."[35]

By the spring of 1943 the "purists" at the ERR had wrested control of the operation from von Behr and the other Goering loyalists. Even though the Reichsmarschall had traded away a large number of unsuitable modern French works, many remained in the crowded rooms of the Jeu de Paume and overflowed into spaces in the main Louvre building where works of art produced by the M-Aktion were still being processed. The depots in Germany were full too. The home office was anxious to finish with this operation so that they could concentrate their efforts on Russia.

On April 16, 1943, Rosenberg sent Hitler a report on the ERR, accompanied by a "Happy Birthday" letter and thirty-nine albums containing photographs of the gems of the agency's takings, which Rosenberg hoped "will send a ray of beauty and joy into your revered life." As for the "hundreds of modern French paintings . . . which from the German point of

view are without value as far as the National Socialistic art perception is concerned," they would "continue to trade them whenever a chance presents itself," adding that "At the completion of the action, a proposal as to the disposition of the modern and degenerate French paintings will be presented."[36]

For a time indecision on the handling of the remaining modern works seemed to reign. Rose Valland noticed that the unfortunate pictures were packed and unpacked several times. In early July 1943 at a meeting in Berlin, ERR officials were authorized to classify the nonconforming collection. On the nineteenth a commission headed by Scholz divided it into three categories. The first, with works by Courbet, Monet, Degas, Manet, and the like, was kept for trading. These had apparently been approved by the Führer. The second and third categories, which included works by Bonnard, Vuillard, Matisse, Braque, and Dufy, though not similarly approved, were retained for possible sale. These three groups were moved into a special area of the Jeu de Paume.

The modern works left, as well as Jewish family portraits and works by Jewish artists, were, according to Rose Valland, kicked in or slashed out of their frames with knives by SS men, trucked to the garden of the Jeu de Paume, and burned along with other trash on July 27.[37] The ERR inventories were carefully brought up to date—a little line was drawn through each eliminated entry, and *"vernichtet"* (destroyed) written next to it. The large (196 by 130 centimeters) *Judenporträt-Dame* of a Mme Swob-d'Héricourt "in evening dress . . . before a stone staircase with two leaping horses" was so marked along with works by Picasso, Picabia, La Fresnaye, Klee, Miró, Ernst, Arp, Dali, Masson, and Léger.[38]

The pardoned works were extremely tempting to the Paris dealers who had heard of the methodology of the earlier exchanges. Hoping to cash in on this trend, Dequoy and Fabiani, in cahoots with Lohse, offered a large Boucher/Robert entitled *Figures in a Landscape with Ruins,* four Guardis, and two Panninis, worth a total of FFr 2 million, to Linz, for which they hoped to receive some sixty carefully chosen items from Categories I and II with a total resale value of FFr 20 million. Scholz, who had never approved of Lohse, refused to authorize this exchange on the correct, if somewhat overly moralistic, grounds that the ERR was being cheated. The Boucher/Robert was later sold to auctioneer Hans Lange and thence to Linz for RM 250,000, and several of the others went to Frau Dietrich, who also passed them on.

The entrance of the Germans into the Unoccupied Zone in 1942 had opened the way for the seizure of the French Jewish collections and col-

lectors who had taken refuge there. The Vichy government had not, by late 1942, agreed to confiscation of the personal property of French Jews who had remained in the country, whom they still considered citizens. But the new, fanatically anti-Semitic Commissioner of Jewish Affairs, Darquier de Pellepoix, appointed by Laval in May of that year, was more than ready to bring the Unoccupied Zone into line with the Reich. This would soon allow the Nazi art gatherers to bring in a few things that they had missed, but not forgotten.

Just as this new area of possibilities opened up, Hans Posse died of cancer of the mouth, having worked at a devastating pace until only a few weeks before his death. For a time his assistant, Dr. Riemer, carried on as usual, supporting Haberstock, whose purchases for Linz continued to be funded by the Reichschancellery. But the devious dealer's days of preeminence were numbered, for in March 1943 Hitler named a most unlikely replacement for Posse: the director of the Wiesbaden Museum, Hermann Voss, a known anti-Nazi, who had been passed over for the more prestigious directorship of the Kaiser Friedrich Museum "for cosmopolitan and democratic tendencies, and friendship with many Jewish colleagues." Indeed, in 1940 Voss's antiwar feelings were so strong that he even wrote a poem in perfect French deploring the German invasion of Paris, in which he went so far as to say, rather prophetically:

> *Hélas je les ai vus, ces battalions de Boches*
> *Dévaliser la France au profit de leurs poches*

and to call upon the "god of mercy" to deliver "unfortunate France from the Teutons."

No one in the German art world could understand this appointment, which seems to have been the deathbed wish of Hans Posse. Voss's first interview was with Goebbels, who offered him the directorship of Dresden, next to the Kaiser Friedrich the greatest plum in Germany. When Voss stated that he was not a Party member, Goebbels reassured him that the only requirement was technical expertise. Voss accepted. A few days later he was taken by train to see Hitler at his Eastern Front headquarters. The Führer received him late in the evening, and talked for an hour "on the importance of such old princely galleries as that in Dresden, and subsequently explained his intentions with regard to the Linz Gallery." Voss was to concentrate on nineteenth-century German and Old Master paintings from other countries.[39] No one mentioned during this session that Kharkov, equal in Hitler's mind to Stalingrad in importance, had fallen to Soviet troops that day.

Voss's appointment was formally announced on March 15. One of his

first acts was to cut off further funds to Haberstock, whose voracious greed, Bormann told him, had even irritated Hitler. Voss would now channel his purchase funds, which would surpass those spent by Posse, through his own trusted agents, principal among whom was Hildebrand Gurlitt, who like Voss had been fired as director of his museum (Hamburg) earlier in the Nazi era. This was a blow to Haberstock, who was deeply embroiled in a four-way competition for a French Jewish collection which had so far escaped confiscation in Vichy France—that of Adolphe Schloss.

This collection, consisting of some 330 works by mostly minor Dutch seventeenth-century artists, was especially desirable as a large percentage of the pictures were signed and dated. In 1939, like so many others, the Schloss family had entrusted their collection to a relative, a Dr. Weil, who put it away in a bank vault in the tiny village of La Guenne, near Tulle in the Limousin. Rumors about it continued to surface and in August 1942 Dequoy told Haberstock that he was going to Grenoble to talk to one of the "heirs" about a possible sale. In December of the same year a dealer reported hearing that the family "needed money and might well sell part of their holdings." Haberstock wrote back to say he would like the whole thing but added that he would only "pay he who actually delivers it."

The ripples of German desire for such collections had not gone unnoticed by Laval, who was desperately trying to appease the ever-growing Nazi encroachment on Vichy France. He was more than happy to try to exploit the "sale" of the Schloss collection, so deeply coveted by Hitler and Goering. Through the sale of the pictures, worth upwards of FFr 50 million, he might also recoup a small percentage of the crippling occupation payments levied by the Germans. Early in March 1943, therefore, Darquier de Pellepoix set to work to locate, seize, and market the collection.

On April 6 Henry Schloss, son of the collector, and his wife were preparing to go to a funeral. For some time they had lived in a villa high above Saint-Jean-Cap-Ferrat, on the Chemin des Moulins, accessible only on foot. They had that day made their way to the bus station in Nice when three men approached them and forced them into a car. The party returned to the villa, where the Schlosses were told that their abduction had been ordered by Laval himself, who wished to know the whereabouts of their collection. The three men were not ordinary policemen, but the Commissioner of Jewish Affairs for Marseilles, a police inspector, and a dealer by the name of Lefranc. The house was searched and Schloss was put in jail. Two days later his brother Lucien was arrested by German policemen who ransacked his rooms and took all his papers.

In Paris, Darquier was already making arrangements to sell the collection. Bruno Lohse was amazed to find the Vichy official present at a meeting in von Behr's office, along with Lefranc, who had been made

"provisional administrator" of the Schloss collection. The Nazis were told that they could buy paintings from the collection under certain conditions: they must promise not to confiscate it outright once it arrived in Paris, but leave it under French control, and the Louvre must be given first choice before any sales took place. After this brave beginning Darquier was forced to admit that German transport would be needed in order to move the collection to Paris.

Lohse reported all this to Goering, who agreed to the conditions, but said German trucks could technically not be employed. Von Behr remedied this by calling on one of his shady M-Aktion colleagues to provide transport. Meanwhile, Darquier's informants had done good work, and two days after the meeting Lefranc and Co. appeared at the bank in La Guenne and loaded the cases onto trucks. After the convoy—entirely German—left, the local police prefect, spurred on by angry bank officials, sent an armed French patrol to intercept the collection just south of Limoges. This was reported to Goering, who ordered the collection returned to the French immediately. But the German interest had been revealed, and the confiscation was now widely regarded as a Nazi operation. Back home Utikal wrote to the Reichschancellery denying that the fiasco, which had caused embarrassment at Hitler's headquarters, had been ordered by the ERR, and protested to Goering.

The collection did not get to Paris until October 1943, this time in French trucks. By then word of the terms of the deal had reached Hitler, who, outraged at the agreement made with the French, preempted any purchases by Goering but allowed the Louvre to make its choice, fuming all the while that he was getting only "leftovers." Hermann Voss, though he had immediately heard of the confiscation from Lohse at a little dinner chez Frau Dietrich in Munich, left the arrangements entirely to subordinates, a fact considered odd by the ERR crowd. Haberstock, who had pursued the collection for so long, was completely out of the loop. The Louvre sent René Huyghe and Germain Bazin to choose their pictures. The Louvre took forty-nine works, for which they were to pay FFr 18.9 million. Two hundred sixty-two went to Linz for FFr 50 million, and twenty-two were given to "provisional administrator" Lefranc and fed into the Paris market. Needless to say, the Schloss family got nothing. The FFr 50 million went to Darquier's agency, and Vichy never paid for the pictures "bought" by the Louvre. The part of the collection destined for Linz was photographed, a special catalogue in large type was prepared for Hitler, and the pictures were shipped to Munich in November 1943 to await the Führer's pleasure, but as far as we know, he never found time to see them.[40]

The remarkable and competitive persistence of the gatherers continued

to the very end. One of the very last lots secured was that remnant of the Mannheimer collection which had been taken to Vichy France. Mme Mannheimer herself had long since gone on to Argentina. The pictures, which she had left in the care of her lawyer, were very fine, and included Crivelli's *Mary Magdalene,* once in the Kaiser Friedrich Museum, a lovely version of Chardin's *Soap Bubbles,* and a number of Watteau drawings. All of these had been included in Mühlmann's original deal in Holland, in which he had agreed to pay the Mannheimer creditors half a million guilders and himself the usual commission when he finally got the pictures, which were destined for Linz. But Mühlmann was not the only one who knew about the Mannheimer works. Karl Haberstock, once again, wanted the deal for himself. Having lost the support of Posse, he was now attempting to work through Fernand Niedermayer, chief of the German Administration for Reich-Seized Property in France, who was persuaded that Haberstock represented Linz. But just to be safe, Niedermayer asked Hermann Voss "to inform me by return mail which paintings are to be requested for the Führermuseum." The answer was perfectly clear and not good news for Haberstock, who was stiffly informed that Niedermayer "was not in a position to take your purchasing wishes into consideration," as the whole collection was going to Linz "through State Secretary Mühlmann."[41] By the time all this had transpired, the Allied armies had landed in Normandy and were well on their way to Paris. Nevertheless, in June 1944 room was found on a train which took the twenty-seven pictures to Germany to join that part of the collection bought previously in Holland. Mühlmann, true to his word, managed to extract from the depleted Reich Treasury DFI 500,000, which he paid to the Mannheimer creditors.[42]

The pursuit, trading, and confiscation of works of art concerned only a small fraction of the Germans in Paris. The rest of the occupiers were more interested in entertaining themselves in the Paris of legend, and this, within limits, their masters allowed them to do. (Total contentment was expressed as being "as happy as God in France."[43]) Everyone from Goering down flocked to the Folies and other more exotic night spots, shopped at Cartier, and filled the restaurants and theaters.

The more intellectual also found plenty to do. The German writer Ernst Jünger, posted to Paris, was fascinated by the life of the city. He dined with poet Sacha Guitry, who wore an enormous diamond ring on his little finger; went to lectures at the Ritz, met Cocteau, and visited Picasso. But the pleasures were not enough to mask the reality of Jünger's situation. A colleague asked him to keep a file on "the struggle for hegemony in France

between the Commanding General and the Party" and another warned him that letters he had written to a Jewish friend had been found in a raided bank box. These he "carefully" tried to retrieve from the Devisenschutz-kommando.

Faced with the discovery of the decisions taken at the Wannsee Conference, he wrote that only those within the military government could prevent the drastic measures, but that all such efforts had to be hidden: "Above all any appearance of humanity must be avoided . . . to reveal this would be like waving a red flag at a bull." The firing of the moderate commander in chief for France, Otto von Stülpnagel, who had lost the "battle against the Embassy and the Party," dashed any hopes that restraint would prevail. In early March 1942 news of the death camps where "certain butchers have killed with their own hand the equivalent of the population of a small town" led him to write that "often in the middle of this seething mass of lemurs and amphibians, death, it seems to me, would be a celebration."[44] There were still three years to go.

Pangs of conscience were also felt by another member of Jünger's circle, Gerhard Heller, who had been put in charge of literary censorship at the Propaganda Office. It was his job to prevent the publication of unsuitable books. By the time he arrived, some twenty-three hundred tons of newly published books had already been destroyed. Books by Jewish authors never reached his office; these were "self censored" by French publishers. Heller saved what he could, and hid some unacceptable manuscripts away for posterity.

In the course of this work he gained entrée into certain French literary circles and eventually into the Salon of the young, American-born hostess Florence Gould, which amazingly went on all through the war, first in the Hôtel Bristol and later in a large apartment in the rue Malakoff.[45] (No one in Heller's group knew where Mr. Gould was, but he was presumed to be in the south of France.) Here one ate so well—there was even real coffee—that some of the more deprived Parisians felt quite liverish after supper. Chez Gould, Heller met intellectuals who introduced him to the world of the "truly modern" hitherto forbidden to him at home. The Salon was for him an "island of happiness" where he could find friendship in the "ocean of mud and blood" which surrounded him, and solace for his self-loathing for not having the courage to resist more openly the atrocities being committed by his compatriots.

Mrs. Gould's unprecedented freedom did not come without a price. In February 1942 she was denounced for having hidden weapons in her house at Maisons-Laffitte just outside Paris. The young Wehrmacht officer responsible for the investigation nervously wrote that "the affair must

be handled with the greatest delicacy on account of the citizenship of the proprietor. . . . Above all one must avoid giving the slightest indication that the denunciators were less interested in the weapons than in other allegedly hidden objects, viz., the art treasures and precious stocks of wine." After telephoning Mrs. Gould he met her at the Hôtel Bristol and they went to the now heavily guarded house.

The inspection turned up no arms and revealed that the collection of a hundred thousand bottles of wine was still intact, but that three valuable works of art, a triptych and two ivories, had been removed by the ERR. Mrs. Gould "declared herself ready to donate the total stock of wine for the soldiers of the Eastern territories" but "wished to reserve for herself the right to dispose of the art objects." After a conference with von Behr, the young officer wrote that "although the ERR had no right to seize this private property, the following was agreed: that Mrs. Gould present the triptych to Goering, who would donate it to the Cluny Museum, which had been her intention, and that she then give the ivories to the Reichsmarschall in token of her thankfulness to him for donating the triptych." Months passed; when Goering saw the objects he liked them so much that he took all three. The young officer was shocked, but Mrs. Gould "begged me not to take any further steps in the matter in order to avoid difficulties for her, e.g., her transfer to a concentration camp." He does not say what happened to the wine.[46]

Despite all this private social and cultural activity, Paris was not the same. The City of Light had become a dark labyrinth in the evenings where "a population of the blind" groped its way about in the strictly enforced blackout. And in the day another form of blindness prevailed. The French seemed not to see the spiffy German uniforms and parades, or even notice the friendly correctness of their new rulers. The Germans soon had a new name for Paris: "*Die Stadt ohne Blick*"[47] (the unseeing city). The new masters of France did not like this Paris; they wanted it to be the way it always had been, purified of course, but still the city of culture. To that end they attempted an extraordinarily heavy-handed program of cultural rapprochement; they could never fathom why it did not work.

Immediately after the fall of Paris, German officials had required the Office of the Prefect of the Seine to make a list of museums and principal monuments, and supply a guide to accompany them on an automobile tour. The conquerors were distressed at the extent of evacuation of museum collections. Pressure, particularly from Ambassador Abetz, immediately began for a general revival of the arts and the return of the state collections to Paris. The French demurred, pointing out that there were still machine guns on the roof of the Crillon, and that low-flying planes

passed over the Louvre daily. The lack of transport and Hitler's freezing decree guaranteed that the national treasures would not be brought forth until the Final Victory, which everyone thought would be soon. To make themselves feel better, the Nazis ordered the sandbags removed from the various monumental sculptures of the capital.

Meanwhile, the empty museums were all too tempting to German agencies searching for suitable offices and storage space. Each one was carefully inspected, and its remaining contents noted. Twelve hundred military vehicles were parked in the Grand Palais. The newly built museum of modern art known as the Tokyo, which had not yet opened, also seemed perfect for a parking garage and offices. The Palace of Fontainebleau was taken over for parties and troop theatricals and the Luxembourg was turned into Luftwaffe headquarters, complete with an apartment for Goering.

The Kunstschutz was able to correct some of these excesses, but they could not prevent their colleagues from using the museums for exhibitions. It soon became clear to the French Beaux-Arts administration that use of the museums for their traditional purpose, even if ideologically unpalatable, was preferable to their transformation into garages. The need to keep the galleries busy at all times led to a most surprising combination of exhibitions in the following years.

One of the first was at the Carnavalet, the museum of the history of Paris, which had been the residence of the famous Mme de Sévigné. It reopened with a few objects brought in from its country repository, plus others from the storage rooms of sister institutions and a few private donations. Representatives of the German embassy and Dr. Bunjes kept a careful eye on the installation in case anything Jewish should creep in. A statue by Dantan entitled *Rachel,* reputed to be of the famous Jewish tragédienne of that name, had to be removed. Jean-Louis Vaudoyer, curator of the show, simply changed the name to *La Tragédie* and put it back, but a portrait of Sarah Bernhardt lent by the Comédie-Française was rejected. The labels were carefully translated and there was a catalogue in German. Nothing could have made the Parisians more aware of their plight than references in this volume to "Gräfin von Sévigné" and "Ludwig XIV."[48]

Throughout the summer of 1940 everyone had wondered what the German policy on the exhibition of modern and contemporary art would be. All press and cultural activity was to be monitored by the Propaganda Division of the Military Government, a branch of Goebbels' Ministry which soon boasted a thousand souls. In the first weeks of the occupation this organization had been so busy with such deeply intellectual activities as pulling down statues of French heroes of the previous World War, and of

anyone British, and changing the names of streets which honored famous Jews, that it had not made any pronouncements on modern art. Nor had there been any guidance from the German Institute, which was founded to promote "European Culture" and Franco-German relations, but which had limited itself to putting on fancy receptions before concerts of German music and exhibitions of Germanic art, and to projects concerning the past such as photographing the Bayeux tapestry.

The first to brave the occupier's cultural controllers was a new organization called L'Entraide des Artistes, which was pledged to helping needy artists of all stripes. Funded by both government and private money, its headquarters was in a former Rothschild house, and it had miraculously managed to persuade all the competing Salons and groups of artists in Paris to cooperate in order to provide their less fortunate colleagues with everything from free legal advice to cheap lunches.

Since early in 1940, the Entraide had been planning a benefit show which would, for the first time, unite these disparate groups not only in charity but in the same galleries. Needless to say, this had taken considerable diplomacy, and the Entraide was determined to go ahead. They were given the Orangerie, just across the park from the Jeu de Paume, by the French. This plan was approved by the Germans, who reserved to themselves the right of censorship. To everyone's amazement they rejected only works by Jews and by Marcel Gromaire, whose antiwar paintings had been specifically condemned by Hitler when he noticed them in a show in Germany. The exhibition opened to the culture-starved city on September 6, 1940.

Emboldened by this, and anxious to retain control of the Orangerie, the Entraide, inspired by the Monet *Waterlilies* which already adorned the walls of the gallery, immediately reserved it for a Rodin-Monet show made up of the few works by the two artists which could still be found around town. Incredibly, to promote Franco-German friendship, even the Berlin and Bremen museums loaned important unpurged works by Monet.[49] The crowd at the opening did not know that next door, in the heavily guarded Jeu de Paume, workmen were just as busy installing the first exhibition for Goering, and setting aside other recently confiscated Monets, which normally would have been in the Orangerie show, to be used in his exchanges.

It was now clear that the famous Paris Salons would be allowed to continue, but not in their usual spaces in the Grand Palais, which remained full of trucks. The organizers were allowed to have the unfinished Tokyo, which Metternich had managed to save from similar use. The first to open would be the Salon des Indépendants in the winter of 1941. The commit-

tee was deluged with paperwork by the now better-organized Nazis, who demanded a declaration of Aryanism for each artist. Old jealousies reappeared. Some rejected artists were not above denouncing their more successful colleagues for having "anti-German tendencies," whose accusations the Propaganda staff earnestly and carefully investigated, but were generally unable to substantiate.

At the morning vernissage of the more conservative Salon of the Société Nationale des Beaux-Arts the German Army brass turned out in force and were led in by the French wife of Ambassador Abetz, surrounded by Vichy notables. The French hosts were puzzled when most of the military contingent abruptly left without having looked at the show, apparently in a snit because Mme Abetz had gotten all the attention. De Brinon, the Vichy commissioner in Paris, persuaded the conquerors to return the next day, and made sure they were suitably attended. Everyone had to learn the new social procedures.[50]

These Salons were the first in a long series. A new Salon of Watercolor and Drawing was invented to keep the Tokyo galleries occupied and the Germans out in the summer of 1941. The following year the Musée d'Art Moderne, planned for the building before the outbreak of war, was allowed to open. A third of the collection was brought in from the Occupied Zone depots and exhibited while the rest remained in the repository at unoccupied Valençay. (Also missing was the designated director, Jean Cassou, who had been forced to resign on racial grounds the day after his appointment, but who was quite busy putting out a Resistance newspaper in the basements of the Musée de l'Homme.) Press reaction was extremely favorable and the German authorities very much in evidence at the opening, despite the presence of works by Rouault, Matisse, Léger, Braque, Tanguy, and Vuillard, all mixed in with the "Beaux-Arts" pictures.[51]

Down in the basements quite a different sort of collection had been assembled. The lower level with its modern truck ramps had recently been taken over by the ERR as an overflow storage area for the M-Aktion. Great piles of boxes were carefully divided by a grid of numbered and lettered avenues. Each perfectly measured square contained a different category of the goods so carefully classified on the ERR laundry lists: pianos, sheets, pillows, nightgowns, toys, and so forth. Twice a month a shipment went to the Reich, but the basements would still be completely full on the day Paris was liberated.[52]

German efforts to win over the minds of the French by organizing cooperative artistic happenings were doomed to failure from the very beginning by their inability to conceal the totally cynical objectives behind such undertakings. Typical was the affair of the Salon des Prisonniers, held at

the Musée Galliéra. Posters were put up in the French POW camps in Germany urging the prisoners to create works of art which would be sold to help their comrades. The Germans, anxious to show how well they treated their prisoners, arranged for the collection and transportation to Paris of all the paintings, carvings, and sad little objects made of tin cans and other camp debris. The possibility that a totally opposite propaganda effect could be created seems never to have occurred to them.

The show, which opened in December 1940, included a small wooden altar carved by a prisoner. Before this little shrine the French Chaplain of the Camps said Mass early on Christmas Eve in the shadowy blacked-out spaces of the museum. The service was to be rebroadcast to the camps. Emotions ran high: the Nazis had not eased the curfew in Paris in order to allow the traditional midnight Mass. Yves Bizardel, curator of the Musée Galliéra, watching the kneeling crowd, noted that "hope, tenacious and fragile as a candle flame, was only a tiny stubborn glowing dot." It would not be extinguished.[53]

Side by side with these official manifestations the lives of the commercial Paris galleries and the artists who supplied them also managed to go on. "Degenerates" Braque and Picasso had returned to Paris in the autumn of 1940 after only brief absences. Braque found his studio intact and worked unmolested in the city all during the occupation, despite the presence directly across the street of a residence for German officers. Picasso, who had spent most of 1939 in a villa in Royan, north of Bordeaux, came back to his studio in the rue des Grands-Augustins, where he resumed his life of work and received the usual stream of visitors, now including Germans both admiring and suspicious. The latter came on the pretext of searching for "Jewish" works of art. Picasso and his entourage were vigilant during these visits, fearing that their interlocutors might plant an incriminating object somewhere in the vast reaches of the studio.

For the more touristy types Picasso provocatively had postcards of his anti-Fascist masterpiece *Guernica* printed up, which he handed out as souvenirs. With the more sophisticated, such as Ernst Jünger, he discussed painting techniques and the war, which, they all agreed, "should end immediately so that people could turn on their lights again."[54] Throughout the occupation Picasso's officially censored works were sold publicly at the Drouot and in discreet corners of such galleries as that of Louise Leiris, formerly Kahnweiler. Even Kandinsky, whose canvases were regularly ordered removed from dealers' exhibitions, was not prevented from painting more; his works were shown in back-room gatherings along with those of the still relatively unknown Nicolas de Staël. Matisse sold draw-

Braque in his Paris studio during the occupation

ings brought back from the Unoccupied Zone by Louis Carré, and illustrated an edition of Montherlant's *Pasiphaé,* which was published by Fabiani. Not only did the Germans not persecute these icons of "degeneracy," but in late 1941 they even courted a few of the French alumni of the Lucerne auction, who had, to be sure, toned down their unacceptable styles in the meantime, and sent them on a tour of the Reich.

This outing was the brainchild of the Propaganda Office. The invitees were told that French prisoners would be freed if they agreed to the visit. Certain material advantages, such as extra coal rations, were also promised. Many of the artists had been colleagues of Arno Breker, who had lived and worked in Paris between the wars. Twelve artists accepted, among them Derain and Vlaminck, whose Fauvism had diminished so considerably that they could almost now be considered naturalistic painters. Vlaminck had even turned to fulminating against modernism in general and Cubism in particular. Neither could have been ignorant of the fate of their fellow artists in Germany; Derain had even served, along with Braque, Ernst, Arp, and others, on a French committee organized to help condemned German artists escape from the Reich.

After a disappointing tour of the studios and exhibitions of "correct"

artists in Berlin, Nuremberg, and Munich, during which they were enter-
tained by minor officials and never even met the Führer or Goebbels, the
frail sculptor Charles Despiau noted that he had seen "as in a kaleido-
scope, the vision of a new art. And this art, grandiose, larger than life,
might perhaps have frightened rather than seduced me, had I not found
Arno Breker heading its promoters."[55] The only thing which really im-
pressed the group was the amount of state sponsorship German artists
received.

The German Institute in Paris took full advantage of the publicity gen-
erated by this tour and in May 1942 put on a retrospective of Breker's
works in the Orangerie. The idea was to promote a new "European" style.
Breker, trained in France but loyal to the Reich, was the perfect choice to
illustrate Franco-German solidarity. Laval pronounced himself "pro-
foundly touched" that Breker should grace Paris with his works, Abel
Bonnard praised Hitler for suggesting the show, and the collaborationist
press invoked the dawning of a new age of grandeur. Art critics praised the
"finished" nature of the works. Most of the artists who had travelled to
Germany, joined by Maillol, whose Jewish model had been freed at
Breker's behest, were on the exhibition committee.[56] Jean Cocteau and a
bevy of other intellectuals who flirted throughout the occupation with
Nazi ideas were seen in force at the opening. No one there seemed to know
that the bronze for some of the massive statues had come from the melted-
down monuments of Paris itself or that they had been cast with the forced
labor of French prisoners of war.

These fiascos were reflected in the cultural policies of Vichy's Révolution
Nationale, which was, fortunately for posterity, only a pallid shadow of
that of the Reich. Emphasis was on service to the state in order to achieve
National Renewal. The idea, appealing to many artists, was that painters
and sculptors would decorate public spaces with suitable but always dis-
tinctly French works. The artist was to emerge from his selfish isolation
and contribute to the public good. The director of Beaux-Arts, Louis
Hautecoeur, enthusiastic supporter of this policy, called for "greater disci-
pline" at the Ecole des Beaux-Arts, and considerable funds were allocated
for a huge conglomeration of "classical sculpture," running heavily to
nymphs and monumental vases, by seventeen artists which was placed at
the entrance of the Autoroute de l'Ouest.[57]

The problem was what to do with France's world-famous artists who,
even though not exactly "Beaux-Arts," could not be ignored. Bonnard was
courted, and Braque was invited to design an emblem for the Vichy gov-
ernment and to participate in the German trip. He declined both.[58] Vichy

Radio even sent a reporter to interview Matisse. The first effort was a great success, being limited to such questions as "Why do you paint, M. Matisse?" and "When do you consider a work finished?" which the master answered with considerable grace. Alas, when the reporter returned he made the grave error of asking Matisse his opinion of the Prix de Rome, an award given annually to students of the Ecole des Beaux-Arts. Matisse replied that "even picture postcards neglect its prize winners," and in a few further phrases demolished the Ecole as "deadly for the young artist" and as "a mutual aid society out of which nothing lasting has ever come." He was not interviewed again.[59]

Unlike Hitler's art policy, Vichy's sanctions, other than the anti-Semitic ones, never went beyond this sort of discretion and constant fulmination in the press. Early efforts to organize a Chamber of Artists, aimed at "creating order" in the profession, brought forth a flurry of opposition, and were not pushed by the moderate Hautecoeur. His successor, Georges Hilaire, appointed by Laval in 1944, tried again, but the experiment foundered on the rocky problem of defining exactly who was an artist, who an amateur, and who a professional. If, for example, the requirements specified someone whose principal income came from his art, artists like Le Douanier Rousseau would not qualify. A proposal in one committee that the artists "swear an oath that they would exercise their jobs conscientiously without ever deserting the standards of their profession" reduced the meeting to "general hilarity" after one member envisaged an artist being reprimanded for painting a bottom "too pink" or "not round enough," which was, of course, exactly what was being done in Germany. Added to this were proposals of rules for exclusion of an artist which would only occur after a complicated series of reprisals. This was so repugnant to the conferees that no artist could be found to serve on a judgmental board.[60] The principles of the Reich Chamber of Culture, laughed to death, were not to be instituted in France.

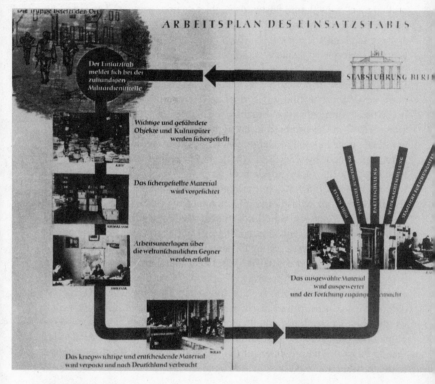

Public relations display illustrating ERR operations in the eastern occupied territories

PLUS ÇA CHANGE

The Invasion of the Soviet Union

Far to the east of Paris, in the vast lands which Hitler had conquered in the Soviet Union, the intricate legalistic quadrille justifying the confiscations and trading would be far less subtle and "correct." In these Slavic waste-lands the National Socialist fanatics did not bother with velvet gloves. Hitler's attack on his recent ally had, incredibly, once again been a sur-prise. How this could be possible, given Stalin's equivalent cynicism about their relationship, is hard to understand. Hitler, holding true to the stated policies of *Mein Kampf,* had never intended to maintain the alliance for long and had initiated planning for the invasion of Russia while the French campaign was still in progress. He had hoped to attack in the East in the fall of 1940. Discouraged by his generals, he reluctantly agreed to wait until May 1941. This delay, which would be extended to late June due to Hitler's involvement in Yugoslavia, left plenty of time for detailed plan-ning of the future occupation of Russia, and for the development of the usual turf wars between the Nazi agencies.

The basic policies would be the same as those applied to Poland. After conquest, areas would be cleansed, exploited, and Germanized. To achieve this, Hitler told the Wehrmacht, the war could not be conducted in a "knightly fashion."[1] The new territory, which the Führer, for the time being, envisioned as everything west of a line stretching roughly from Archangel to Stalingrad, would be divided into separate administrative districts run by Reichskommissars. In these the cleansing would again be cultural, racial, and ideological. Not only Jews and "Bolshevists" would be eliminated by immediate execution; much of the general Slavic popu-lation would be allowed to expire naturally when their food supplies were diverted to the worthier citizens of the Reich. Wehrmacht scruples shown in the West and even in Poland were diminished by constant references to these Bolshevists, despised by the conservative officer corps. The less at-tractive "purifying" activities at which the regular Army might balk were, as usual, entrusted to Hitler's closest cronies.

Goering, director of the Four-Year Economic Plan, now added exploita-
tion of the USSR to his responsibilities. Probably because of his Baltic ori-
gins and the fact that he had studied in Moscow, the Führer appointed ERR
chief Alfred Rosenberg to head the entire administration of the Eastern
Territories. Rosenberg, thrilled at this recognition, immediately began
producing elaborate plans for the area, which, although promoting Ger-
manization, also recommended the preservation of certain elements of
such indigenous cultures as that of the Ukraine, whose peoples he felt
could be turned against their Russian rulers, and who could be useful in
the extermination campaign against the Jews. Himmler, who disagreed
with this soft policy, was not pleased at Rosenberg's elevation and com-
plained of it to Bormann. The SS chief, who had been put in charge of
"special tasks" in Russia, did not wish any interference in his assignment,
which he described simplistically to his troops as the elimination of all
Bolshevists:

> a population of 180 million, a mixture of races, whose very names are
> unpronounceable, and whose physique is such that one can shoot
> them down without pity and compassion . . . welded by the Jews into
> one religion, one ideology. . . .[2]

In the area of security and extermination Himmler would soon prevail, but
in cultural matters the two agencies would be in constant competition for
the Soviet Union's treasures. There would be no Kunstschutz here. To
carry out their policies, Rosenberg and Himmler would call upon their al-
ready established Einsatzgruppen (Special Task Forces), certain of which
would gain their greatest and most sinister notoriety in the vastnesses of
the USSR.

Arranging for operations in Russia was merely a matter of bureaucratic
extension. There were many who were eager to volunteer. Baron von
Kunsberg, late of Paris, frustrated by the Kunstschutz and disappointed by
von Ribbentrop's lack of clout, had been looking for more fertile fields for
his unit (a hundred men and one dog), which had originally been set up by
the Foreign Minister to secure valuable records and objects as soon as na-
tions were taken by Germany. He had, therefore, offered his services to the
Waffen SS, who were not at first enthusiastic. But as the planning for Rus-
sia progressed, the usefulness of von Kunsberg's unit was recognized, and
his services were accepted on January 26, 1941, fully six months before
the invasion.[3] His group was divided into four companies, three of which
were assigned to the main Army Groups which would attack the USSR.
The fourth was to be sent to North Africa. These commandos were to be
attached to front-line SS units and would secure anything which appeared
to be of value.

After the combat phase the scholars of the SS Ahnenerbe would bring in their research institutes to collect ancient artifacts and other scientific evidence of the superiority of the Germanic races and the inferiority of the Slavs. The ERR, also a noncombatant organization, planned to begin its usual confiscations of Jewish and Masonic possessions and archives and take away "all cultural goods suitable for research into the activities of the opponents of National Socialism."

All these operations would theoretically come under the control of Rosenberg, who warned military authorities taking over in Lithuania that they should "forbid the removal of any cultural goods by any authorities whatsoever" until ERR experts could inspect them and decide their fate. Rosenberg assigned his top assistant, Gerhard Utikal, to supervise this major undertaking. At this stage Rosenberg clearly envisioned a role for selected indigenous cultural officials, for the order ended with the comment that "the state administration of museums, libraries, etc., is not affected by this order, with the exception of the right of inspection and inventory."[4]

Goering and Linz director Posse, busy in Holland and France, did not need to concern themselves with the details of these confiscations in the East. Posse could preempt all others with a word to the Führer, and Goering, his authority in the ERR secure for the time being, could have second pick.

The invasion began at 3:30 a.m. on June 22, 1941. Hitler followed events closely from a fancy new headquarters bunker, the Wolfschanze (Wolf's Lair) at Rastenburg in East Prussia, built expressly for the purpose. This operation was as flawless and fast as all the others. By July 14 Hitler's troops had taken Minsk and most of Latvia and Lithuania, advanced into the Ukraine, and reached the Luga River, less than a hundred miles from Leningrad. The Führer, confident that the inferior Slavic troops would soon cave in, even issued a directive suggesting that the size of his Army could be reduced "in the near future."[5] He was premature. Two days later at Smolensk the Red Army briefly halted the Nazi drive—a new experience for the German armies. Hitler did not consider this serious and ordered his forces to turn toward Kiev. The Army before Leningrad had also stopped because it could no longer be adequately supplied. This pause would give those in charge of protecting Russia's great collections a little, vitally needed time.

On June 22 Leningrad had lain shimmering in the strange light of the White Nights. All who write of these events are struck that the attack took place on this beautiful and festive night when Leningraders traditionally celebrate the arrival of summer. News of the invasion did not arrive at the

Hermitage until noon on June 23, an hour after the vast museum had opened. As the word passed, the galleries quickly emptied. Curators were called in, and the grim processes of evacuation were set in motion.

Although the surprise had been complete, the Russian museums had, like all others in Europe, long since ranked their objects and prepared packing materials. But evacuating the Hermitage, vast showcase of the Czarist collections, would be an incredible task at the best of times. Its holdings, some 2.5 million objects, ran the gamut: paintings, delicate porcelains, glass, coins, jewelry, massive antiquities, furniture, and every other decorative art. In the first hours director Iosif Orbeli, who had fought for years to keep the collections intact, ordered the forty most valuable items rushed to the basements. The first air raid came twenty-four hours after the notice of war. Curators patrolled the roofs ready to quench fires while their fellow citizens mobilized to build trenches and fortifications around the city.

In the constant daylight, packing went on around the clock. Art students came in to help. Paintings separated by tissue paper were rolled twenty to sixty on one cylinder, covered with oilcloth, and packed in long coffinlike crates. Works which had to be left in their frames, such as panel paintings, were crated in bunches according to size. Only one picture, Rembrandt's enormous *Return of the Prodigal Son,* got its own box. Other crates held Coptic textiles, Scythian and Hellenistic gold, eighteenth-century jewelry, snuffboxes, and even medieval German beer mugs. Specialists from the Lomonosov porcelain factory packed thousands of dishes and ornaments. To minimize shock, delicate Greek vases were painstakingly filled with crumbled cork before being wrapped. The days were hot, and work went on next to windows opened wide. The sounds of doves cooing were punctuated by the roar of aircraft over the city. As the crates were filled and sealed, relays of Red Navy sailors moved them to the entrances or basements. Soon the galleries were piled with empty frames—a sight now so familiar in the Western museums.

The first train of twenty-two boxcars containing some half a million items left on July 1. Antiaircraft guns were attached at each end. Director Orbeli, tall, bearded, and imposing, wept as it moved out. Before each station the staff halted the train and deployed guards. Miraculously unharmed, it arrived five days later in the Siberian town of Sverdlovsk, where the objects were democratically distributed among a former Catholic church, the Museum of Atheism, and the local art museum.

Back in Leningrad the packing went on. A second shipment left on July 20 with seven hundred thousand objects. These gigantic transports represented less than half of the museum's holdings and preparations for a third

Packing chandeliers at the Hermitage

continued, but by August their packing materials were nearly gone. Fifty tons of shavings, three tons of cotton wool, and almost ten miles of oil-cloth had been consumed. Far worse was the news that German forces had begun to move again and had cut the rail link to the East. On September 4 artillery shells began to fall within the city. The German front line was only eight and a half miles from the museum. Now everything that could be taken away went down to the basements, while upstairs, the immovable, giant malachite urns, enormous marble tabletops, and magnificent panelling, floors, and mosaics of the palace itself awaited their fate.[6]

It was just as well that the exhausted citizens of Leningrad were not privy to Hitler's thoughts about their city. In the evenings at the Wolf's Lair the Nazi chief held forth endlessly to his staff on his view of history and his plans for Russia, monologues that were recorded at Bormann's order. Hitler explained that Germany had missed out on the distribution of "Lebensraum" in the past because of its involvement in religious war. The founding of St. Petersburg, he mused, had been a catastrophe for Europe. It must therefore "disappear completely from the earth, as should Moscow." Only then, he theorized, would the Slavs "retire to Siberia," and provide Germans their needed space. The Führer was not worried about

the works of art in these cities. He assumed, correctly, that they had either been taken out to the east by train or stored in castles in the countryside.[7]

The scenes in these "castles" had been equally frantic as those in the Hermitage. One of the first rooms to be emptied at the palace of Catherine the Great in the town of Pushkin, formerly known as Tsarskoye Selo, was the famous Amber Room, so called because it was not only entirely panelled with delicately carved sheets of amber, but contained chairs, tables, and ornaments made of the same material. The latter were easily packed, but the panels proved too difficult to remove and were left in place.

The palaces had far less packing material than the Hermitage. To save precious paper and shavings, some things were even packed in freshly mown hay; at the Palace of Pavlovsk the carefully preserved uniforms of Czar Nicholas II and his wife's dresses were used as padding. At 5 a.m. on July 1 the first Pavlovsk shipment of thirty-four crates left for Gorky, accompanied by chief curator Anatoly Kuchumov. Work continued night and day, even as the artillery barrages began and the male work force, called to arms, diminished.

One cannot rush this sort of packing. Delicate and complex objects such as chandeliers, clocks, and furniture had to be dismantled before being wrapped. Careful records of where each separate piece had been packed were necessary. When a whole set of furniture could not be taken, a sample was chosen and sent. Some things were simply too big. At Pavlovsk the fine collection of Greek and Roman statues was dragged and pushed on carpets and planks by stalwart lady packers down into a remote corner of the cellars and walled up so cleverly that they were never discovered by the Germans. The same women managed to bury without trace most of the statuary in the park, including a fourteen-foot-high work by Triscorni depicting the Three Graces.

By August 20 three more shipments had left the palaces, which by now were filling up with refugees fleeing before the armies. Soon afterward, curator Anna Zelenova of Pavlovsk, who had directed the last operations, found that she was cut off from Leningrad. On August 31 the palace was taken over as a Red Army headquarters. Despite all, packing continued in the hope that trucks could somehow be sent from Leningrad to take the crates to safety. On September 16 Zelenova was told that Pavlovsk was within German-held territory, and that their patrols were already in the famous white birch groves of the park. She and a colleague fled on foot through the battle zone, taking the vital inventories and storage maps with them. As they made their way through the fields they could see the Chinese Theater at the neighboring Catherine Palace burning. Five harrowing

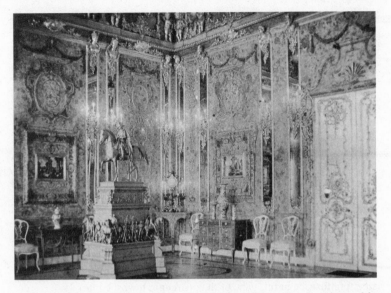

A prewar photograph of the Amber Room in the Catherine Palace. The whereabouts of the panels remains a mystery.

hours later they arrived in Leningrad on an Army truck filled with wounded. It would not be a comfortable refuge. At Pavlovsk alone some eight thousand objects remained and now awaited the arrival of the Germans.[8]

The invaders were prepared. Von Kunsberg's Second Special Battalion immediately moved into the newly conquered area. There were certain Germanic things that had been targeted for them, for the Kümmel Report which had listed such items in the West also had a Russian section. One of von Kunsberg's first objectives was the Amber Room, which had originally adorned the Prussian palace of Mon Bijou, and which, legend has it, was given to Peter the Great by the Soldier-King Frederick William II in exchange for a battalion of large Russian mercenaries. Von Kunsberg's well-equipped minions made short work of removing the Amber Room panels, which, dismantled and carefully packed in twenty-nine crates, were sent off to the museum at Königsberg, showplace for the top gatherings from the Eastern Territories. The museum lost no time in unpacking and installing its new acquisition. The *Frankfurter Zeitung* announced to the home front in a front-page article on January 3, 1942, that the unique

assemblage, "saved by German soldiers from the destroyed palace of Catherine the Great is now on exhibition." Next was the famous Gottorp Globe, a miniature planetarium in which twelve people could sit and contemplate the arrangement of the heavens depicted on the inside. The globe, made for the Duke of Holstein-Gottorp in the seventeenth century, was greatly admired by his descendant, Czar Peter III, and eventually presented to him. Now, the Nazi press reported, "through our soldiers' struggle this unique work of art has been obtained and will again be brought back to its old home at Gottorp."[9]

The Special Commandos did not limit themselves to these German creations. They and the rest of the Army, indeed not behaving in a "knightly fashion," took anything they could pry loose from the myriad palaces and pavilions around Leningrad, right down to the parquet floors. They opened packed crates and helped themselves to the contents. Mirrors were smashed or machine-gunned, brocades and silks ripped from the walls. At Peterhof, just outside Leningrad, the machinery controlling the famous cascading fountains was destroyed, and the gilded bronze statues of Neptune and Samson upon which the waters played were hauled off to the smelting furnace in full view of the distraught townspeople.

The depredations around Leningrad were just the beginning. All across the newly conquered lands those in the know went after the "Germanic" things they had long coveted. Sometimes the Germanic attribution took a bit of doing. The ubiquitous SS operative Kraut, who had worked so hard in Poland, wrote on July 18 to SS headquarters that he hoped it would be possible to "bring home" the magnificent, eleven-foot-high bronze doors of the ancient cathedral of Novgorod. These were thought to have been made originally by a Magdeburg artist in the twelfth century for the Polish cathedral of Plock, which Kraut argued was now "a town belonging to the German Reich." The doors, after a complicated history, had arrived in Novgorod in 1187. He also warned his colleagues not to be fooled by the fact that in Novgorod the portals were referred to as the Korsun Gate, "which gives the impression that they are an ancient Greek work originating from the Crimea, thus camouflaging their German origin." Kraut was disappointed to find later that the doors had been "dragged off" by the Russians.[10] This was fortunate, as the Nazis would soon ravage the cathedral and all the city's museums.

In the Baltic states, a German commission that had been negotiating for months for cultural items which it claimed belonged to ethnic Germans "resettled" in the Reich and in Poland after Stalin took over, now was able to "safeguard" the disputed items and ship them off to Danzig.[11] And Admiral Lorey of the Zeughaus, Berlin's military museum, was once again

The Tchaikovsky Museum: scores and motorcycles

informed that the Führer wished him to undertake the recovery of German weaponry lost in wars back to the Middle Ages, expense being no object.[12]

By late summer the SS Special Commandos had visited Minsk and removed the cream of the city's collections. The local Reichskommissar, Wilhelm Kube, a Rosenberg appointee, wrote to his chief expressing anger that "Sonderführer whose names have not yet been reported to me" had taken so much without his permission, and dismay that the SS, once their mission had been completed, had left what remained to "the Wehrmacht for further pillaging." A handwritten notation on this letter by Rosenberg reveals that the order to remove the Minsk treasures had come from Hitler himself. So much for the Eastern occupation chief's decree that everything should be left in place.[13]

Rosenberg's idea of preserving Ukrainian culture and nationalism in order to turn the people against Stalin was also no match for the suicidal racial fanaticism of Hitler and Himmler. Kiev would be proof of that. After its fall on September 17 its museums, scientific institutes, libraries, churches, and universities were taken over to be exploited and stripped. Everywhere in the USSR special attention was given to the trashing of the

houses and museums of great cultural figures: Pushkin's house was ran-
sacked, as was Tolstoy's Yasnaya Polyana, where manuscripts were
burned in the stoves and German war dead were buried all around Tol-
stoy's solitary grave. The museums honoring Chekhov, Rimsky-Korsakov,
and Tchaikovsky received similar attentions, the composer of the 1812
Overture being particularly honored by having a motorcycle garage in-
stalled in his former dwelling.

In early October 1941 Hitler, anxious to finish with the USSR, launched
a great offensive toward Moscow and ordered simultaneous assaults on
Leningrad and the Black Sea coast and oil fields. The Luftwaffe, from its
forward bases, was now able to fly missions aimed at the destruction of
Russian industrial targets far into the Soviet heartlands. One such target
was Gorky, which sheltered not only part of the collections of Pavlovsk
and Peterhof, but those of Leningrad's Russian Museum and many others,
all of which would have to be moved once more. The icons, pictures, and
folk art of the Russian Museum went six hundred miles east to Perm by
the undesirable method of river barge.

This time the Pavlovsk curators decided to be truly safe and remove
their things to Tomsk in Siberia, fourteen hundred miles away. The final
departure of the train, loaded amid air raids, was delayed for hours await-
ing the arrival of the families and children of museum personnel who had
been unable to find a passable route to the station. On November 8, in the
midst of an air attack, the train, pulling twenty cars of works of art, crossed
the Volga on the last remaining bridge and headed to the east. While the
German offensive continued, railroad workers hid the art-laden cars on a
siding deep in the forests for two weeks to wait out the bombings. Late one
December night they arrived in Tomsk, where the temperature stood at
−55 degrees centigrade. But there was no room in this frozen town, and the
weary train went on to Novosibirsk, which also sheltered Moscow's
Tretyakov Gallery. There the curators were given the town's theater for
storage.

The care of works of art in this climate presented unusual problems. The
402 crates were piled up outside the station, covered by tarpaulins and
canvas scenery from the theater. Everything was moved to the new quar-
ters on horse-drawn sleds guided by women from Leningrad still in their
light city clothes and shoes. Once in the theater, the crates had to be grad-
ually acclimatized in order to avoid condensation on the objects. This was
done by first lowering and then gradually raising the temperature of the
vestibule by alternately opening and closing windows and doors. The
process took three weeks. The guardians and their families would live for
two long years in the basement below. Despite the cold and the terrible

Life under siege in the basements of the Hermitage (Drawing by Alexander Nikolsky)

food, being museum people, they soon organized exhibitions from their holdings to maintain morale and pass the long months of waiting.[14]

In Leningrad the wells of courage would be more deeply plumbed. After the rail lines had been cut, Hermitage curators continued to pack and move things into the vast cellars of the complex of palaces. Smaller museums brought their holdings in. And alongside the works of art in the bombproof cellars lived a colony of some two thousand souls. During the continuing siege these subterranean spaces became a center of intellectual resistance and survival. As the winter came on, half-frozen art historians, poets, and writers worked on their research projects. Architect Alexander Nikolsky kept a visual diary of the eerie empty spaces of the vast museum in which occasional candles flickered. Only one room had electricity and a little heat, supplied by the generators of the *Pole Star,* a large yacht, once the property of the Czars and now taken over by the Navy, which was tied up to the quay in front of the Winter Palace.

Hermitage director Orbeli was undaunted. Determined to carry on as usual, he refused to cancel a long-planned program to honor the Samarkand poet Alisher Navoi. Printed invitations went out, and half-

starved participants left their fortifications and trenches to make their way through deep snow and falling bombs to the event. It was a great success. But daily the terrible cold increased and the food supply diminished. Only a thin lifeline of supplies could be brought in to Leningrad's 3 million residents on the "Road of Life," which crossed the frozen waters of Lake Ladoga. It could not save them all: in December 1941 alone more than fifty thousand died of starvation. People ate remarkable things: in the Hermitage conservators produced a jellied soup made of carpenter's glue. Soon the museum had its own infirmary for the starving and a mortuary below the library, where frozen corpses stayed for weeks until they could be removed for burial. And the shelling continued. Upstairs in the echoing palace, security was provided by a team of forty or so not-so-young ladies, who did their best to cover shell holes on the windswept roofs with sheets of plywood and deal with the snow which swirled through the shattered windows into the ice-coated galleries.

Spring brought some relief to human beings but only made things worse in the unheated museum, where thawed pipes burst and flooded the basements, forcing weakened curators to wade about to retrieve floating pieces of Meissen. Mildew blossomed on silk furniture which had to be moved out into the sun next to the vegetable gardens being planted in every available space. The only objects completely unaffected were the well-embalmed Egyptian mummies and the prehistoric remains taken from the Siberian permafrost. The siege did not end during this spring, but went on for nearly two more years. In the first three months of 1943 alone, as the bombing continued, the staff would remove, by hand, eighty tons of mixed glass, ice, and snow, much of which had to be chipped off the mosaics and parquet floors with crowbars. The thirtieth, and last, bomb would not fall on the Hermitage until January 2, 1944, twenty-five days before Leningrad was liberated.[15]

Hitler was surprised that the Soviet Union did not succumb in the five months he had allocated for its conquest. By late November 1941, as the famous Russian winter took hold, his armies, still dressed in their summer uniforms, were being pushed back from Moscow by fresh, fur-clad troops from Siberia. The Führer had done better in the south, where he now held most of the Ukraine and the Crimean peninsula, and had laid siege to Sevastopol. It was impressive, but not enough for Hitler. No retreat was allowed in the Moscow region. He would not imitate Napoleon, but would hold the line, and finish the job in the spring.

While the miserable, freezing German armies, obeying their Commander in Chief, struggled to maintain their northern positions, their more

comfortable colleagues in the south were busily setting up an occupation government and the planned "cultural" institutes. Safeguarding efforts quickly expanded. Here they did not have to worry about clearing out the houses of the nobility. This Stalin had conveniently done for them, but there was still plenty to do. Objects in private hands were seized or easily obtained by intimidation or barter. One SS officer reported to Himmler that he was sending along "several antique finds (agate necklaces, bronze figures, pearls, etc.) bought from the widow of deceased archaeologist Prof. Belaschovski, Kiev, for 8 kilograms of millet."[16] By now the SS Ahnenerbe and the ERR had joined the Special Commandos in gathering the spoils. Rosenberg, still determined to establish his ascendancy, had obtained a directive from Hitler on March 1, 1942, again ordering all agencies to cooperate with him in his confiscation of Jewish and Masonic items. Logistical support would be supplied by the Wehrmacht. This agreement left two large loopholes: it neither limited the powers of the SS nor gave the ERR any right to "safeguard" museum holdings or archaeological finds.[17]

In these areas the Ahnenerbe had moved right in. As early as July 1941 this archaeological wing of the SS had urged "action in South Russia" by a group to be headed by SS Sturmbannführer Professor Herbert Jankuhn of Kiel. By February of the next year they had proposed such genteel activities as "research into the finds and monuments of the Gothic Empire of Southern Russia," Jankuhn's speciality. Somewhat less highbrow were projects to safeguard the holdings of the Museum of Prehistoric Art in the Lavra Monastery near Kiev, and those of "the destroyed museum at Berdichev." Jankuhn later claimed to be acting in the spirit of the absent Kunstschutz; but the fact that he continually removed museum collections to SS Collecting Points and thence to Germany gives the lie to his claim of altruism. All this was approved by Himmler, who attached Jankuhn's special detail to his Waffen SS Division "Viking," which was to give it "every support possible."[18]

Other special details were proposed for the Crimea and the Caucasus. The Nazis had great plans for this sunny region. Himmler's intellectuals envisioned the Crimea as suitable for resettlement by ethnic Germans. (Hitler, musing at his headquarters, said that although the newly conquered island of Crete was nice, it was not easily accessible, but that an autobahn could be built to the Black Sea resorts to assuage the eternal Germanic quest for the sun.[19]) Meanwhile, the Ahnenerbe began shipping valuables back not only for study in Berlin but to decorate Wewelsburg, Himmler's own luxurious schloss and SS spa, where stressed officers were waited on by the inmates of a nearby concentration camp.

Rosenberg was very unhappy with these arrangements. During the spring and summer of 1942 he vainly sent out further directives ordering that all "safeguarding" be cleared with the ERR, and that all seizures which had already taken place be reported to his staff. It was not until the end of September 1942 that he managed to have museum collections added to his authorized field of activity. This only increased the competition. One SS operative who had cleared out a cache before the arrival of his compatriots triumphantly reported home that "a Dr. Brennecke of the ERR showed up at Armavir. As the museums had already been confiscated by the SS, his excursion had no results." Himmler's men were not good sports when outmaneuvered: arriving too late at another site, they complained that the ERR had "taken hold of the Crimea and confiscated everything" so that it was "impossible for the Ahnenerbe to work there."[20]

What was not removed by these specialists, despite Rosenberg's imprecations, continued to be available to the Wehrmacht and its camp followers. Entrepreneurs brought in to make the conquered territories livable for their countrymen soon had a thriving black market under way. This was often too much even for their colleagues. A building contractor from Munich was formally accused by his co-workers of taking home paintings and sculpture from the Museum of Rovno, seat of the military government for the Ukraine. He had also falsified ration cards for food and tobacco and traded army gasoline for "eggs and cognac from the natives."[21] This sort of grazing was rampant at all levels. Even Goebbels was shocked by the corruption, confiding to his diary, "Our Etappe [support] organizations have been guilty of real war crimes. There ought really to be a lot of executions to reestablish order. Unfortunately the Führer won't agree to this." The "war crimes" were not atrocities, but the action of the Etappe troops, who, when they retreated, had "abandoned tremendous quantities of food, weapons, and munitions" in favor of "carpets, desks, pictures, furniture, even Russian stenographers, claiming these were important war booty. One can imagine what an impression this made on the Waffen SS."[22]

A few German voices were raised in protest. One local commander, shocked that ancient tombstones on the King's Grave at Kolonka had been vandalized by "louts" who had scratched their names and swastikas on them, ordered his officers to instruct their troops that "similar desecrations shall not be committed again on monuments of importance to cultural history."[23] But such niceties could not survive the massive extermination programs of the leadership, or the panicky greed which would be evidenced during the coming German retreat.

The home folks in the West got quite a different picture of all this activity. The *Frankfurter Zeitung* piously reported that "it was more than the

duty of preservation of valuable works of culture that led the German military authorities, after the entrance into Riga, to assemble all . . . collections . . . it was care for the preservation of old German works." From Tallinn came the news that "what valuable treasures could be saved in the imperial palaces around Leningrad . . . are now gathered under the care of the German Army in the former Pogankin Palace in Pskov and have been made accessible to the public."[24] Another paper reported that "in Kiev a group of museums have been saved, despite the war and the Bolshevist destructions. These will be rearranged and opened soon." This group supposedly included the house and museum of the great Ukrainian poet Shevchenko, later reported by the Russians as having been totally destroyed by the Germans, but from which the latter claimed "the Bolshevists have carried away the collection of manuscripts."[25]

The "Bolshevists," who not surprisingly had done the same at the Ukrainian Academy of Sciences, were also blamed for burning that library and blowing up the cathedral before they left. Just exactly who was responsible for the various devastations in Kiev, which was taken and retaken twice by each side, was debated after the war, but the Ukrainians, who had received the Nazis as liberators only to find they were executioners, were made to pay dearly for this lapse by the returning Soviet regime.

The thorny question of whether to leave things in the USSR for the delectation of the citizens of the New Order, or ship them back to the Reich, was made moot in the summer of 1943 by the need to move the entire New Order back before the oncoming Soviet forces. All factions agreed that the Bolshevists should certainly not be allowed to repossess any objects rightfully of use to the master race. From Kharkov, in August 1943, the Ahnenerbe sent what was left of the prehistoric collections back to Kiev, whence they were to go to Berlin. In his report on this matter Professor Jankuhn sniffily criticized the ERR for having "left town" during the "winter battle of 42/43" without "having made any attempts towards safeguarding the museum holdings." The ERR had in fact removed five hundred paintings, but had handed over the (to them) less interesting prehistoric things to the Russian caretaker. Holdings from Rostov and Poltava were also moved to Kiev. They did not stay there long. By October 1943 Western newspapers reported the city to be on fire and deserted, its suburbs a totally destroyed "dead zone."

ERR dispatches note that they had to abandon their offices before the removal of the materials on hand could be completed "due to lack of loading spaces" and the fact that German artillery, located in the center of the city, was firing continually over their heads. Still, they managed to send on

both the paintings (279) and prehistoric "materials" which had come from Kharkov, their own library and office furniture, and the "materials" collected by their Department of Seizures, amounting to some ten thousand books and nearly a hundred cases of "Bolshevist" paintings, documents, and archives. This was in addition to the great butterfly collection of a Mr. Sheljuzkho, which had gone to Königsberg, and the holdings of the Ukrainian Museum of Kiev, which had already been sent off to Cracow. All the Nazi research institutes had to move back too, taking even more "materials" with them. In this chaos much deemed of value to the Reich was lost: one Ahnenerbe functionary sadly reported that his research group had lost "the entire Trogontherum skeleton, three giant deer skulls, three hundred stone hatchets . . . etc."

When, on October 5, the last civilians had to leave Kiev, custody of the remaining items was left to the desperate incumbent infantry division, which, all were assured, "places great value on further evacuation of precious articles." Gerhard Utikal reported to headquarters that the ERR detachment had heroically kept working in Kiev until the Army had told them they would be "bombed out of office," and "for the time being" had had to shift their quarters to Lvov. Another Nazi official reported reassuringly that upon arrival the Soviet troops would find "nothing of value left in the city."[26]

Kiev was not the end. The gathering of loot continued in the ever-narrowing territory held by the German armies. As late as August 1944 Utikal informed his operatives that "Reichsleiter Rosenberg had ruled that the most precious cultural riches of the Ostland could still be removed by his staff, insofar as this can be done without interfering with the interests of the fighting forces." He even included a list of suggested objects.[27]

The Red Army indeed found nothing of value left in the museums of its recaptured cities. They found instead burned and defaced buildings, ruined laboratories, books reduced to pulp, and the terrible desolation left after battles in which there was no question of surrender. *New York Herald Tribune* reporter Marcus Hindus reported the scene at Peterhof to the world:

Now that the battle is over the countryside is quiet. The quiet is not peace but death. . . . Brick dwellings, marble castles with granite towers are leveled to the ground or are battered heaps of debris and refuse. There aren't even the customary flocks of winter birds. . . . I had neither seen nor heard anything like it in France after the World War. Only windblown tall reeds rising out of deep snow give one a

feeling of some life within nature itself . . . all Peterhof is gone. It isn't even a ghost town like Kiev, Kharkov, Poltava, Orel or Kursk . . . it is a desert strewn with wreckages from which, perhaps, has been blown away some of the most exquisite and most joyful art man has created.[28]

It was not a good precedent to set for the Red Army, which, despite the Germans' refusal to admit it to themselves, would soon be on the soil of the Reich. Along with informing the foreign press, the Russians had been keeping very careful track of the damage done. An Extraordinary State Commission, established in November 1942, was systematically compiling reports which enumerated losses "in painstaking detail." An abridged list for Kiev alone ran to three and a half single-spaced pages. American Intelligence noted that the Russians had not placed an "evaluation on the losses of cultural objects" but had simply stated that "the day is not far off when we will force Germany to restore the treasures of our museums and fully pay for the monuments of our culture destroyed by the Hitlerite vandals."[29] And that day would come in just over a year.

The officers of the National Gallery of Art. Left to right: *John Walker, Harry McBride, David Finley, Macgill James, Huntington Cairns (Photo by Irving Penn)*

VIII

INCH BY INCH

The Launching of the Allied Protection Effort

> I would feel like saying: "Yes, the English and Americans are neither military-minded nor war-minded." When you make war on them you cannot crush and conquer them by surprise as the Germans have the Poles, the Dutch, the Belgians, the French even. They will take time to get ready, and when at long last they feel ready they will be cautious, make sure of their rear, and advance inch by inch, at snail's pace—not a bit like the Russian armies you admire so much. Moral: do not go to war with the slow, stupid Anglo-Saxons, unless you feel materially and morally ready to have it long and devastating.
>
> —Bernard Berenson, *Rumor and Reflection*
> July 1944

December 7, 1941, the day that lives in infamy, brought the American art establishment face to face with the realities of protection long since forced upon its European colleagues. If the Japanese had managed to cross thousands of miles of ocean undeterred to turn the huge military complex at Pearl Harbor into a smoking shambles, it seemed quite possible that they could do the same to San Francisco, and the increasing successes of the German U-boat fleet in the Atlantic underlined the vulnerability of the eastern seaboard. As quickly as they could arrange travel, the directors of the nation's principal museums converged on New York to coordinate their response to the advent of war.

Plans for this grim situation had been in the making for many months. In March 1941 the National Resources Planning Board, set up by Roosevelt to begin organizing for a possible war, had established a Committee on the Conservation of Cultural Resources, which was charged with "col-

lecting information, preparing plans, and promoting measures for the pro-
tection of the cultural resources of the United States."[1] The blue-ribbon
board included such luminaries as the Librarian of Congress, the Archivist
of the United States, the directors of the National Gallery of Art and the
National Museum (now called the Smithsonian Institution), and represen-
tatives of the American Association of Museums, the American Institute
of Architects, the War Department, and the Civilian Defense Agency, all
under the direction of Waldo Leland of the American Council of Learned
Societies.

After studying British and other European experiences, they decided
that the best way to protect the nation's collections would be to remove
them to remote bombproof refuges. In October 1941 proposals for the
building of special shelters for government-owned objects and papers
were duly submitted to the Commissioner of Public Buildings. It soon ap-
peared that money for such construction was nowhere to be found, though
funds were later provided to individual agencies to subsidize in-house air-
raid shelters. The museums and libraries were thus left to improvise their
own programs. To help them out, the committee had, in May, begun the
preparation of a how-to booklet on the wartime storage of collections,
based on advice published in a 1939 pamphlet by the British Museum. As
of December 7, 1941, it had not been published.

Fortunately, the American museums, strange amalgams that they are of
private and public financing, and responsible for untold treasures, had not
waited for these suggestions from on high. Funded by the A. W. Mellon
Educational and Charitable Trust, work immediately began to prepare
Biltmore, a palatial French Renaissance house in Asheville, North Car-
olina, to receive the brand-new National Gallery of Art's most important
works. Biltmore, erected by George Vanderbilt in the 1890s as a mountain
"retreat," was fireproof, isolated, and close to a railroad, thus fulfilling
Kenneth Clark's basic requirements.[2] In New York, preparations of a sim-
ilar nature were made. The Metropolitan Museum, after rejecting as too
damp a huge tunnel right under the building (created by the removal of
water mains in 1939) and an abandoned copper mine in upstate New York,
had also found an empty mansion, once the domicile of a colleague of
J. P. Morgan, outside Philadelphia. Though considerably less remote than
Biltmore, it was also fireproof and properly air-conditioned.[3] W. G. Con-
stable, the newly appointed chief curator of the Museum of Fine Arts,
Boston, wrote to a relation in England that his museum too was making
"plans for evacuation," and in the meantime was running practice removal
drills in the Egyptian and Classical departments.[4]

By November awareness of imminent disaster was so great that prepa-

rations for air raids were considerably advanced in most of Washington's agencies, cultural and otherwise. But the actual outbreak of war came as a shock, and while patriotic fervor swept every field, mad ideas and semi-hysteria also flooded forth. In Seattle, crowds infuriated by shopkeepers who had not complied with the blackout went on a looting rampage. A Congressman Bradley of Michigan suggested that all the gleaming white buildings of Washington be sprayed dark gray to make them less of a target.[5]

The museum directors, meeting in New York on what should have been the last festive weekend before Christmas, were fully aware of the dangers of panic; indeed, one of the main purposes of their assembly was to prepare a press release to calm hovering reporters expecting to hear that every major museum in the country would instantly be closed and stripped bare.[6]

With visions of London's blitz in their minds, the primary worry of the museum authorities was air-raid damage. In this day of remote-controlled nuclear weapons the 1941 discussion seems to emanate from a different world, but the images shown to the group in a slide show prepared by Agnes Mongan of Harvard's Fogg Museum were all too real—the walls of the Grande Galerie of the Louvre full of empty frames, the bombed-out Tate Gallery with three acres of skylights lying shattered on its floors, and the nave of Canterbury Cathedral filled with tons of earth to absorb the shock of explosions.

Many of their own institutions had hastily ordered protective actions not always the best for their works of art: at the Museum of Modern Art the major paintings on the third floor were taken down every night, put in a sandbagged storeroom in the center of the floor, and rehung every morning before the public arrived.[7] In all the museums millions of candles were ordered in preparation for power failures, fire crews were on duty around the clock, nursing stations were set up, and first-aid supplies were distributed along with gas masks. Building engineers and maintenance crews basked in unaccustomed board-room limelight. There was much solemn practical advice: "Gather up shattered fragments and wrap in cloth marked with collection number," advised one memo. "Two men should hold the picture while a third cuts the wire" and "Haste should be avoided except where it is necessary to remove works of art from immediate danger" confided another.

Engineers at the National Gallery informed the administrator, after study, that the Gallery's roof would not be suitable for an antiaircraft gun emplacement. This opinion was based not on the safety of the collections, but on the engineers' fear that the roof would not support the guns and the dome of the Gallery would interfere with the field of fire. In Boston the

Japanese galleries were immediately closed to prevent misguided demonstrations of patriotism. In New York the Met was closing at dusk, fearing that people caught in a blacked-out museum would be tempted to make off with the exhibits. The Frick had already begun to paint its skylights black, probably in vain, for, as one member dryly observed, the island of Manhattan would be quite unmistakable from the air except in the foulest weather. Indeed, skylights, so essential to the lighting of virtually every museum, would be a nearly insoluble problem from every point of view; not only could they be seen for miles, but the danger to paintings and people from shattering glass was extreme. Fear of sabotage was even greater than fear of damage—the directors envisaged bombs hidden in packages and mobs bent on destruction.

For two days these issues and others were debated: Should loan exhibitions continue? What should be evacuated and when? But on one issue the directors were united and adamant: the museums would stay open. They were fortified by a resolution of the Committee on the Conservation of Cultural Resources hand-delivered by David Finley, director of the National Gallery: there should be no general evacuation until the military and naval authorities deemed it advisable. The consensus was that it was the duty of museums to provide relaxation and a refuge from the stresses of war. If their best things were sent away, they would show objects long relegated to storage—one director wondered out loud if the public would even notice. They would provide public shelters in case of bombing. Natural History even proposed installing pianos in its shelter areas to entertain and calm the occupants.

A request from the Treasury Department for the museums' help in advertising the good aspects of American life in order to promote the sales of war bonds, greeted coolly at first, soon attracted strong support and even an endorsement as "good" propaganda. Somewhat carried away in the heat of patriotism and by the prospect of government funding, the directors discussed organizing, with the help of Ringling Brothers, a huge travelling exhibition designed to "restate great things in America," an idea MoMA had proposed in July 1940 but dropped as too expensive. In this excited condition, they attached a ringing resolution to the statement of intent they were readying for the press which declared: "That American museums are prepared to do their utmost in the service of the people of this country during the present conflict. . . . That they will be sources of inspiration illuminating the past and vivifying the present; that they will fortify the spirit on which victory depends." At the end of the reading of this text, Juliana Force of the Whitney exclaimed, "I think it is wonderful!" and Alfred Barr suggested a standing vote on "a beautiful resolution," which was done.

With the directors as they headed home were copies of a pamphlet written by George Stout, chief of conservation at the Fogg and the country's greatest expert on the techniques of packing and evacuation. A veteran of World War I who had witnessed its terrible destruction at first hand, Stout had been in Paris and Germany as early as 1933 as a member of an international committee for the conservation of paintings. From his European correspondents, whose censored letters somehow reached him from Holland, Germany, and France across the submarine-infested Atlantic, he had been gleaning precise details of the effects of modern weaponry on fragile objects. The British had learned from unfortunate experience that windows should be boarded and reinforced on the outside, as bomb blasts otherwise caused coverings to be blown inward. In Spain it was found that the concussions of such blasts could affect even pictures packed and padded in boxes. Dr. Martin de Wild wrote ominously from The Hague in early March 1941 that he had "recently examined Rembrandt's great *Night Watch,* which is now in a shelter somewhere in the dunes, well airconditioned, but in darkness. The painting is in good condition, but of course every varnish yellows in darkness." It had also been found that darkness promoted the growth of certain parasitical organisms on canvases. To impart these new findings to his colleagues, Stout devoted the January 1942 issue of his periodical, *Technical Studies,* to the subject, and organized a two-week symposium at the Fogg in March.[8]

The major museums immediately began to move their most prized objects to safety. Officials at the National Gallery of Art were clearly nervous about taking things out of Washington, despite the fact that the board of trustees had given permission for these preparations. They worried about the effect of such action on other institutions, which would follow the lead of the museum most closely in touch with the national government. Director Finley insisted that "before any removal actually takes place . . . inquiries should be made of the Committee on the Conservation of Cultural Resources, National Resources Planning Board, to ascertain whether such action would conflict in any way with the general policy of the Government."[9] There being no instructions to the contrary forthcoming from this body, the trustees saw no reason to wait, and the removal was authorized. Similar decisions were made at the Frick, the Metropolitan, and other institutions, and the cream of the great American collections now, in their turn, began journeys to undreamed-of places.

It was carefully done. The National Gallery is closed only two days of the year: Christmas and New Year's Day. On December 30, 1941, chief curator John Walker wrote a memo instructing the staff, when questioned about missing pictures, to reply that "they cannot say what paintings are on exhibition, since certain galleries are being rearranged and some paint-

ings have been temporarily removed. No statement should be given as to which pictures have been removed or as to when they will again be placed on exhibition."[10]

On New Year's Eve, after the Gallery had closed, seventy-five preselected paintings were removed from their places throughout the building. When it reopened January 2, the gaps had been filled by other works or by rearrangement of the hanging. In the storage areas the chosen pictures were inspected and packed in their specially prepared cases. On the freezing cold morning of January 6, the seventy-five (which included, suitably for the season, Botticelli's *Adoration of the Magi,* David's *Rest on the Flight into Egypt,* and the van Eyck *Annunciation,* as well as three Raphaels, three Rembrandts, three Vermeers, two Duccios, and two sculptures by Verrocchio—the *David* and *Giuliano de' Medici*) left for Union Station. Only two American pictures made the cut: Savage's *Washington Family* and the much-reproduced Gilbert Stuart portrait of the first President. The Railway Express receipt for the shipment listed the total value as $26,046,020. By January 12 the National Gallery pictures, in perfect condition, were comfortably lodged in their mountain mansion, attended day and night by rotating squads of Gallery guards and curators.

The infinite variety of the huge Metropolitan collections took far longer to remove. Galleries were quietly closed, one by one, and their contents packed in the night. By February some fifteen thousand items of every description were stashed away, having been transported in more than ninety truckloads to the wilds of suburban Philadelphia. Fearing both air raids and possible commando attacks from submarines, curators at Boston's Museum of Fine Arts, true sons of Paul Revere, kept lookouts on the roof, and moved the best objects into three buildings provided by Williams College in the calm of western Massachusetts. The Frick Collection and Philadelphia Museum of Art used vaults beneath their own buildings. The Phillips Collection in Washington sent a shipment to Kansas City, and from San Diego and San Francisco collections were removed to Colorado Springs. But at the Detroit Institute of Arts, on the personal orders of Henry Ford (who believed the possibility of attack was so remote as to be nonexistent), nothing was moved at all.[11]

Elsewhere, the work continued for months. In early November 1942 the President requested a progress report from the ever-sluggish Committee on the Conservation of Cultural Resources. The document, finally produced in March 1943, could report the removal, from Washington alone, of more than 40,000 cubic feet of books, manuscripts, prints, and drawings, plus the original "Star-Spangled Banner," all of which constituted "an irreplaceable record of the development of American democracy," to

The National Gallery of Art pictures move into their shelter at Biltmore.

"three inland educational institutions." The Declaration of Independence went to Fort Knox. The fortress-like National Archives building, built in 1934 and the first government building to be air-conditioned, in 1942 alone received nearly 175,000 cubic feet of records. Even after this influx the eighteen stories of the Archives, today stuffed to the ceilings, still had plenty of room, but these sequestrations only represented a tiny fraction of the collections and archives of the nation.

George Stout and his colleagues were not only interested in the protection of American collections. It had long been clear that the United States must, sooner or later, become involved in the war on the European continent. This conviction was especially strong in the eastern academic bastions traditionally oriented in that direction and was reinforced by the presence on these campuses of numbers of refugee professors. Those involved in war planning in the Roosevelt administration were well aware that these university communities were a vital source of the intelligence needed to pursue any campaign in a Europe virtually in the total control of the enemy. Within days of the fall of Paris in June 1940, a group of Harvard faculty and local citizens wishing to contribute to the war effort established the American Defense Harvard Group as a clearinghouse

which could direct available expertise to the most useful areas. Similar organizations sprang up at other centers of learning.

They would soon be set to work: the Selective Service Act was passed on September 16, 1940, and the War Department was faced with the preparation of millions of recruits for duty in undreamed-of places. They started from zero, but within weeks lectures and seminars were being prepared and delivered by American Defense volunteers. Later, the famous Office of Strategic Services (OSS) would include a large complement of these academics among its analysts.[12]

American art historians were no less eager than anyone else to join the growing effort, but they did not at first think of working through such groups as American Defense Harvard. Once the safety of the museums was assured, George Stout and W. G. Constable, in late September 1942, wrote to the Committee on the Conservation of Cultural Resources, still regarded as the proper forum for art matters, suggesting that a subcommittee be formed to study the physical conservation of endangered works of art in both the United States and Europe, in order to "give a lead to the world when peace comes."[13] Off the record, Constable specifically recommended against any museum directors being on the subcommittee, as they "had neither the experience nor particular interest necessary." He and Stout had in mind a technical group, which would analyze the frightening problems Stout's European friends had so vividly described. The response was bland and polite—the committee would study the matter.

Despite Constable's feelings about museum directors, they too had be-

Francis Henry Taylor, director of the Metropolitan Museum of Art

come interested in the protection of Europe's treasures. Francis Henry Taylor, director of the Metropolitan Museum, had already discussed the idea of a committee on protection with David Bruce, then president of the board of the National Gallery and soon to head OSS operations in London. They envisaged a group which might work under the United Nations Refugee and Rehabilitation Agency (UNRRA) being formed by Governor Lehman of New York. In November 1942, after conversations in Cambridge with Stout and Paul Sachs of the Fogg Museum, Taylor took the long train ride to Washington through the blacked-out autumn countryside to discuss his ideas further with "the people at the National Gallery," which, in the continued absence of action by the Committee on the Conservation of Cultural Resources, had now become the museum community's lobbying organization. This was no frivolous choice. In Washington, then as now, access was everything. The board of the National Gallery included the Chief Justice and the Secretaries of State and the Treasury, and its administrator, Harry McBride, a former State Department officer, had, since the outbreak of war, performed a number of delicate missions at the personal request of Secretary of State Cordell Hull.

Taylor was immediately ushered in to present his proposals to Chief Justice Harlan Stone, who promised to discuss the matter with FDR. A few days later, William Dinsmoor, president of the Archaeological Institute of America and another recruit to the cause, also met with the Chief Justice. The matter was formally discussed by the board of the National Gallery on November 24; David Finley was able to inform Taylor the very next day that Stone would accept chairmanship of a national committee. Archibald MacLeish, Librarian of Congress, would take Stone's nomination to the President; John J. McCloy, Assistant Secretary of War, also expressed enthusiasm.

Full of optimism after this high-level response, Taylor wrote Sachs on December 4, 1942: "I do not know yet how the Federal Government will decide to organize this, but one thing is crystal clear: that we will be called upon for professional service, either in civilian or military capacity. I personally have offered my services, and am ready for either."[14] To reinforce their actions, Taylor and Dinsmoor had both written a memorandum for presentation to the President, recommending "a corps of specialists to deal with the matter of protecting monuments and works of art in liaison with the Army and Navy." As flamboyant as the man himself, Taylor's long memo somewhat undiplomatically referred to the centuries-long dispute over British possession of the Elgin marbles, and to Napoleon's removal of the bronze horses of Saint Mark's in Venice, in the same paragraph as

the confiscations by the Nazis.[15] (Dinsmoor, clearly feeling otherwise about Napoleon, suggested that the specialist corps actually be modelled on the art historians who had accompanied the future Emperor to Egypt during the campaign of 1798.[16]) Taylor felt that an expert committee, under his leadership, should immediately be sent to Spain, England, Sweden, and Russia to study the situation and report back to the President. How this was to be accomplished, given the recent invasion of North Africa, the deadly situation at Stalingrad, and the continued bombing of Britain, was not addressed.

The Chief Justice, as good as his word, sent his recommendations to the White House on December 8, set forth in a no-nonsense memo from which all historical references had been removed and replaced by the proposal that the British and Soviet governments be requested to form similar groups. During invasions, it suggested, the committees would furnish trained personnel, many of whom were already serving in the armed forces, to the General Staffs "so that, so far as is consistent with military necessity, works of cultural value may be protected." The committee should also compile lists of looted works. At the time of the "Armistice," it should urge that the terms include the restitution of public property, and if such property were lost or destroyed, that "restitution in kind" be made by the Axis powers from a list of "equivalent works of art . . . which should be transferred to the invaded countries from Axis museums, or from the private collections of Axis leaders."[17] Three weeks later the President replied in favorable terms to the Chief Justice. The "interesting proposal," he said, had been referred to the "appropriate agencies of the Government for study." Then there was silence.

What the stymied museum men could not know was that a tremendous struggle had been going on for nearly two years in the bosom of the government over the whole concept of the control of the areas soon to be in the hands of the Allies.[18] Traditionally this had been the Army's job, but long-term occupation was a problem the military establishment had never before faced on such a scale. President Roosevelt and the Army itself favored civilian control as soon as possible. And indeed, as soon as war had been declared, civilian agencies of every stripe, government and private, of which the Harvard and museum groups were but two, began making plans, forming committees, and clamoring for attention. Uneasy at the thought of losing all control to a plethora of civilians untrained in military ways, the Army, in June 1942, set up a small Military Government Division in the office of the Provost Marshal General, and a school of military government in Charlottesville, Virginia. American Defense Harvard and the museum men, having joined forces, immediately proposed that in-

structions on the preservation of monuments and works of art be included in its curriculum.

For a while this arrangement seemed sufficient, and when General Dwight D. Eisenhower requested a civil administration section for the staff planning the invasion of North Africa, several of the newly trained Charlottesville officers plus a State Department contingent were quickly sent off. This group was to deal mainly with issues of local government. Economic problems, such as food supplies for the local populace, were rather vaguely assigned to the "appropriate civil departments of the United States and the United Kingdom." Eisenhower could hardly wait to be rid of all this and concentrate on fighting the war: "Sometimes I think I live ten years each week, of which at least nine are absorbed in political and economic matters," he commented to General Marshall.[19]

All these plans were fine on paper, but not practical in a theater of war. The civilian agencies, top-heavy with executives and planners, had few operatives on the scene, and were utterly dependent on the Army for such amenities as intelligence, shipping space, and ground transportation. But the feeling seemed to be that when things did not work, the addition of another committee would help. The War Department was not represented on any of these committees, though it was essentially the conduit through which they all had to function. The solution to this was often to send VIPs to the theater to deal directly with headquarters, as Francis Henry Taylor had in mind, a process which consumed Eisenhower's precious time and would later make him reluctant to have any nonmilitary functionaries at all in his theater.

Roosevelt and Churchill met in Casablanca in the third week of January 1943. There they decided, not without some friction, that Sicily rather than northern France would be the next Allied objective. The invasion was set for July. This would be the first time that British and American forces would jointly occupy an enemy nation. War Department officials concerned with civil affairs saw immediately that their efforts of liaison and planning would have to be greatly improved if they were to deal with expansion into another theater. All such activities were quickly centralized in a new Civil Affairs Division (CAD) under the Secretary of War, which officially came into being on March 1, 1943.

Only days after the heads of state had left Casablanca, planning was begun for Sicily. Officers were sent off to study the British occupation already set up in Tripolitania, where they would find an informal monuments protection program already in place. The resulting proposal called for the then staggering number of four hundred officers for all Civil Affairs functions. By April a training facility had been set up near Algiers,

and by May 1 the top secret plan for HUSKY, as the Sicilian invasion was code-named, was virtually complete. The idea of civilian participation was still accepted as part of the immediate postcombat occupation by both nations; the only trouble was that the total secrecy surrounding HUSKY prevented any concrete civilian planning.

If progress toward an official government body to ensure the safety of works of art had been slow in the United States, in London, where the British and various Allied governments-in-exile planned their return to the Continent, it was positively snail-like. This was in great part due to the European attitude that civilians could and should not interfere with the workings of armies in combat. George Stout and W. G. Constable in their early 1943 campaigns had written colleagues such as Kenneth Clark and Eric Maclagan, director of the Victoria and Albert, to inform them of their efforts to establish an official protection committee and ask if any similar action was contemplated in England. Both gentlemen seemed surprised at the very idea. "I find it hard to believe that any machinery could be set up which would carry out the suggestions contained in your petition; e.g., even supposing it were possible for an archaeologist to accompany each invading force, I cannot help feeling that he would have great difficulty in restraining a commanding officer from shelling an important military objective simply because it contained some fine historical monuments," wrote Clark.[20]

Maclagan agreed and was, if anything, even less encouraging: "In violent fighting damage will happen anyway . . . I do not think it would be the faintest use to have an official archaeologist at GHQ."[21] As for looting, he was not worried: "Now that there is no market outside Europe . . . only the internal looting subsists," about which nothing could be done until the "time of the Peace Treaty." Both correspondents felt that British and American troops would not damage anything on purpose, and that the admonitions to them contained in the field manuals would suffice.

There were some other signs of interest, but these concentrated almost entirely on the recovery of looted objects after the war. A Conference of Allied Ministers of Education had been formed in October 1942 to plan the cultural rehabilitation of the Continent and by midsummer 1943 was studying the thorny problem of restitution. The representatives of the occupied countries, who dominated the organization, were naturally more interested in this than the British; by far the most active of them was Karol Estreicher, the Polish representative, whose reports and letters to Francis Henry Taylor had greatly encouraged the latter's efforts.

In January 1943 the United Nations, which at that time consisted of the

U.S., the occupied countries, the British Commonwealth, China, and the USSR, had also issued a declaration calling invalid all "forced transfers of property in enemy-controlled territory."[22] Another group, the Comité Interallié pour l'Etude de l'Armistice, trying to draft a law for restitution of looted property, had been bogged down for some months by its inability to agree on the exact meaning of the key word *spolié* (looted), and as yet had produced nothing. But as the invasion of the Continent still seemed to be far off, all these initiatives remained in the realm of theory, and the physical protection of monuments was hardly mentioned.

Clark and Maclagan were correct in thinking that the British Army would handle any monuments problems by itself. But in pooh-poohing the usefulness of "an official archaeologist at GHQ" they proved less than clairvoyant, for it was none other than the famous archaeologist Sir Leonard Woolley, excavator of the tombs of the Sumerian kings at Ur in Iraq, who would eventually be appointed Archaeological Adviser to the War Office—but not until October 1943. The evolution of this post took some years, and was in the best British tradition of muddling through.

British forces had occupied Cyrene, on the coast of Libya, for several months in early 1941. At the time Libya was one of the jewels of Mussolini's new Roman Empire. The Duce had spent a great deal to restore classical ruins at Leptis Magna, Cyrene, Sabratha, and other sites all along the Mediterranean. This was not always done with archaeological accuracy in mind. Woolley later commented that "scientific research was throughout made subordinate to, or more often was altogether abandoned in favor of, theatrical display; but no visitor could fail to be struck by the imposing effect of the excavations, and to the Italian Fascist they did indeed symbolise the glories of his traditional ancestry."

The Italians retook the area late in the spring of 1941, and by summer had produced a pamphlet with the accusatory title *What the English Did in Cyrenaica,* illustrated with pictures of smashed statues, empty pedestals, and rude Anglo-Saxon graffiti, all allegedly the work of Commonwealth troops. These later turned out to be falsifications—the statues were in the Italians' own repair shops, and the graffiti, though authentic, were not on monuments. But the propaganda effects were unpleasant, and resulted in an "anxious interchange of messages between the War Office in London and GHQ, Middle East." After the nearest available archaeologist—who happened to be Woolley, stationed at the War Office on quite unrelated duty—was consulted, orders were sent to Montgomery's forces, just beginning the campaign for El Alamein, to preserve "any archaeological monuments which might come into their possession."

How exactly this was to be done, and where the monuments were lo-

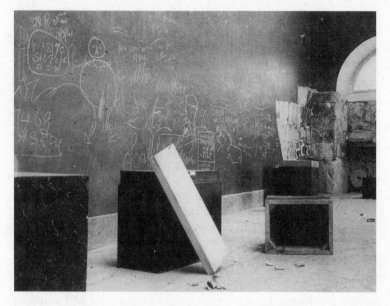

Italian propaganda photograph showing alleged Allied vandalism in Cyrene: Only the graffiti is genuine.

cated, was not specified. Taking this to heart, British soldiers quickly secured the museums and sites in Cyrene when it was recaptured. But control was more difficult at remoter sites, where, as soon as the fighting stopped, off-duty troops began carving their names in the stones, chipping away at bas-reliefs for souvenirs, and obliterating fragile mosaics by driving vehicles across them.

Fortunately for posterity, one of the first officers on the scene was Lieutenant Colonel Mortimer Wheeler, archaeologist and director of the London Museum, who reported these problems to his superiors and was immediately put in charge of protection. Equally lucky was the presence of another former London Museum curator, Major J. B. Ward-Perkins, who was able to help Wheeler supervise this enormous area. Totally in their element, the two officers soon had the Italian custodians and Arab guards, who had been found hiding in the museum at Sabratha, back at work under the watchful eye of a British NCO.

A little guidebook was printed up and both informative and warning signs were posted in the ruins. There were lectures and tours. Woolley wrote that this educational effort had been so successful that "when troops

digging a gun position in the sandhills east of Leptis came upon a Roman villa with well preserved frescoes they carefully cleared out the ruins, made a plan of the building, photographed the frescoes and filled the site in with sand, to secure its protection, before shifting their gun pit to a new position." The archaeologists surveyed all the sites and straightened out the Italian photo archives. For their own later use they carefully saved the aerial photographs utilized by Intelligence officers. All this activity was formalized in the ex post facto tradition of occupying armies by a "Proclamation on Preservation of Antiquities" issued on November 24, 1943, which defined the rights over antiquities vested in the British Military Administration, and forbade "the excavation, removal, sale, concealment or destruction of antiquities without license." A British Monuments officer remained in North Africa until occupation troops departed.[23]

Woolley at home and the officers in the field were supported in these activities by consultations with the private sector. Experts from such institutions as the Greco-Roman Museum in Alexandria and the Institute of Archaeology in London were called in to inspect sites or offer advice. There seemed no need for anything more, and American urgings for a high-level commission met with little enthusiasm. Indeed, the "establishment strength" of the Archaeological Adviser's branch consisted, rather cosily, of "the Adviser himself, Lady Woolley, and a clerk." Its motto, suitably classical, was taken from Pericles' funeral oration, and, roughly translated, read, "We protect the arts at the lowest possible cost." Woolley soon learned to avoid Army channels: "The Adviser might have his own views as to how something ought to be done and though aware that those views might not be well adapted to local conditions, wished that they might at least be taken into consideration; or he might require information not contained in the reports sent to him. For the most part, this could only be done by an interchange of demi-official letters, and whereas official communications passed through regular channels were relatively few, the 'D.O.' letter file was voluminous."[24]

The need for a detailed scenario for Sicily, the establishment of an office specifically designed to respond to civil affairs initiatives, the lobbying efforts of all parties, and the actual example of a British operation, all suddenly combined in the spring of 1943 to make the idea of the protection of monuments and works of art acceptable on the American home front. The problem would now be to weave the strands together into a single line of action; the lack of communication among the interested parties would make this unbelievably difficult and contrast vividly with the German confiscation effort so carefully directed from the pinnacles of Nazi power.

The first spark of response on art protection in Washington came on March 10, 1943, when Colonel James H. Shoemaker wrote to American Defense Harvard that he could guarantee that "information covering this area will be included in the data to be used by Military Administrative officials in occupied areas." He would, "therefore, appreciate the cooperation of Dr. G. L. Stout in providing us with information covering this matter. It would be helpful if, in the more important cases, we could have a paragraph indicating the significance of the item in question to the local population. Without this it would be difficult to exercise judgment in respect to the importance of action in any given case."[25] What this innocuous-sounding request meant to art historians was a series of lists of every important church, statue, building, and work of art for each country likely to be occupied, with justifications for the preservation of same. And it was wanted by July.

Within days the gap between academe and the military began to show. Colonel Shoemaker, responding to a rather flowery draft for the introduction of the proposed manual and lists, diplomatically suggested that "long range concepts" might be "pushed into the background" by "the pressure of immediate considerations." The Army, in other words, was not interested in art for art's sake.

In the same letter he wrote that research laboratories might be included in the lists of museums and libraries, as it "would focus attention on this subject more sharply if all of these items could be presented together in a well integrated way." Shoemaker had clearly foreseen that the U.S. government would make great efforts to obtain and preserve technology and research which might be of future use. Personnel officers, he indicated, would also respond more easily to assigning men with special expertise to such work if "research laboratories" were included—he could not very well say that most of the federal government did not give a hoot about art. This hint of cooperation with the scientific community was ignored by the art group, a bit of chauvinism which would cost them dearly.

As to the exact areas to be covered by the monuments lists, the wily Colonel, following Combined Chiefs of Staff orders to keep plans very general, merely said that he did not think the committee should feel "any restrictions," as "we wish to avoid arousing any critical reactions on the part of friendly governments in exile." The material should be "in distinctly separate units by countries." Anything which might reveal where the armies were headed next would be disastrous.[26]

In early April, Shoemaker again wrote to American Defense Harvard to say that approval had been given for "the commissioning of a few men with special competence in this field for training in military govern-

ment."[27] By now the technical manual compiled with the collaboration of Stout was virtually complete, and work had begun on the lists of monuments and collections and general cultural background material for the handbooks on each country, which were to be given to units in the field.

Within days of receiving Shoemaker's first letter, American Defense Harvard had sent out a barrage of letters asking for such information from prominent exiles living in the United States. Among them were Sigrid Undset, the Nobel Prize–winning novelist, for Norway; Jakob Rosenberg, the eminent Rembrandt scholar, for Holland and Belgium; and Georges Wildenstein for France. Paul Sachs was not pleased at the last choice, but Wildenstein so strongly resisted efforts to limit him to making lists only of art-oriented refugees—not objects—that Sachs discreetly dropped his objections. Now letters were sent to institutions all over the country asking the whereabouts of already drafted personnel suited to "monuments" training. Shoemaker, perhaps unsettled by the speed of these efforts, wrote to warn that "very few persons will be needed in this field. The number would necessarily be limited. To overdo the matter would cause it to boomerang."[28]

Another, parallel approach, on March 15, by Taylor and Archibald MacLeish to Secretary of War Stimson had also fallen on fertile ground. Their memoranda had been referred to Colonel John Haskell, the acting director of the brand-new Civil Affairs Division, who considered the idea important enough to recommend that it immediately be studied by the Operations Division, the highest-level planning group of the War Department.[29] He was supported in this by General Wickersham, chief of the School of Military Government, who recommended on April 1 that "the Civil Affairs section of each theater commander include one or two experts to assist and advise in the matter of protecting and preserving historical monuments, art treasures and similar objects." Haskell also recommended that a pool of thirty specialists and technicians in the field be formed to be available when needed, and that language on art protection be included in the Army field manual. On April 19 he met with the officers of the National Gallery, who also agreed to provide names of qualified experts. The Civil Affairs Division heard for the first time at this meeting of the proposal for a Presidential commission, and thought it sound. Four days later, over Marshall's signature, a cable went to Eisenhower to ask if he would agree to the addition of two staff advisers on fine arts, one British and one American, to the table of organization for HUSKY. His affirmative reply was received on April 25.[30]

By May the material for the handbooks had begun to reach Colonel Shoemaker. Sachs's doubts about Wildenstein's contribution were now

confirmed. Shoemaker, with the utmost delicacy, pointed out that there was a certain amount of talking down in the tone of the reports. In the French draft, for example, it appeared superfluous to say:

> Occupying authorities should respect, and make their men respect, the *classé* buildings. They will *almost invariably* find a local savant willing to explain and arrange excursions to visit these buildings; and such visits can only have a good effect, by making the old buildings more interesting to officers and troops. Attackers should, if possible, avoid obliterating entire towns. The French naturally resent the German habit of destroying everything when they leave. They will equally resent any American habit of destroying everything before arrival, if such a habit develops.

With American armies massing in North Africa for the invasion of Sicily after the grueling campaign in the desert, Shoemaker dryly noted that there would doubtless come a time for sightseeing, but that under present conditions "instructions in respect to this will appear rather ironic to officers . . . the advice in the remainder of the paragraph will also appear gratuitous to them." He concluded, with some irritation, "A line should also be drawn between practical instructions for the conservation of objects and general instructions regarding the conduct of the Army (which should be excluded)."[31] Stout gleefully reported that he had heard rumors that "the [art] historians have been going a little pedagogical with the U.S. Army. That of course is a waste of time."[32] The Cambridge Committee quickly sent off a firm set of rules urging moderation on its compilers, hoping to soothe any ruffled academic feathers with the comment that "the Committee is sure you will understand that the preparation of this material is in some degree experimental."[33]

The American Defense Harvard Group was not the only one working on such data. Since January 1943 a specially appointed committee of the American Council of Learned Societies, also convinced of the necessity for art protection, had been organizing itself in New York. In the following months New York responded magnificently. Office space was allotted at the Met. The Rockefeller Foundation gave a $16,500 grant to pay staff both in New York and at Dumbarton Oaks and the National Gallery in Washington. Miss Helen Frick turned over the full facilities of her Art Reference Library to the effort. The American Society of International Lawyers was consulted. Soon the Council of Learned Societies too was sending questionnaires to hundreds of people in any way connected to the world of art. A pamphlet describing what was known about German looting activity was prepared for distribution to members of Congress, which, it was hoped, would lead to hearings before the Foreign Relations Com-

mittee, and increase pressure for the establishment of a high-level government art-protection body.

Taylor, Finley, and Co. were, by late April 1943, quite sure that recognition of their commission was only a matter of time. Taylor now faced a dilemma, for rumor had it that President Roosevelt himself had wished the energetic director of the Met to be appointed art adviser to the Supreme Allied Commander, with the grand rank of Colonel. The fulfillment of Taylor's desire to inspect Europe's threatened monuments and be the advocate of their protection in the highest councils of the Allies seemed at hand. But, to the long-term amusement of his colleagues, the corpulent Taylor was rejected by the Army as too fat. In his place, John Walker at the National Gallery suggested Captain Mason Hammond, a classics professor from Harvard who had already been drafted and was working in Air Force Intelligence.

Hammond's superior officers could not believe he would be released for such unimportant duty, and he himself had no idea what he would be asked to do when the orders did indeed arrive. On May 27 he called Wilhelm Koehler, an emigré German art historian working on the American Defense Harvard lists at Dumbarton Oaks, having heard rumors that he was somehow involved in monuments protection. From Koehler's memo on this conversation it is clear that Hammond had never talked to Colonel Shoemaker (nor indeed did the latter know of Hammond's appointment):

> He will be sent to Algeria in a few days where he expects to get more detailed information about his commission which concerns protection of works of art. . . . An Advisory National Committee will be appointed very soon by the President, but he does not know any names; he, however, will be responsible directly to the General, not to any home organization or office. He is completely unprepared for his job and has no time to prepare himself before he leaves. He asks whether I can help him. I tell him briefly about the Committees . . . and Col. Shoemaker . . . Paul Clemen's book (which we tried in vain to get for him) . . . about personal experiences during the first World War. . . . He is exceedingly grateful for everything, having been entirely ignorant of what I was able to tell him.[34]

Desperate for more information, Hammond arranged to see Shoemaker the next morning. They got on very well, but bound as he was by secrecy, the Colonel could give the new Monuments officer no specific orders or even suggestions about what reference books might be of use in the field. Convinced that he was off to protect the monuments of Algeria, Hammond departed on June 3 to take up his undefined duties.

Hammond's conversation with Koehler does reveal that the committees

had inserted a foot in the Presidential door. It only remained for them to be formally recognized. On June 21 Secretary of State Cordell Hull signed an updated version of a letter which David Finley had drafted for him in April and managed to get it onto Roosevelt's desk. FDR initialled it "OK" within forty-eight hours, and the American Commission for the Protection and Salvage of Artistic and Historic Monuments in War Areas was finally a reality.[35] The only trouble was that the official announcement of its creation would not be made until August 20, and by then a lot would have happened. In the meantime, its existence remained a dread secret, and the already established nongovernmental groups carried on with the tasks assigned them.

They had plenty to do. On June 27 the HUSKY planners had cabled the Civil Affairs Division to "please obtain and send immediately by fast air mail material on public monuments of Italy, including Sicily and Sardinia particularly." The "Harvard" lists for these areas had been delivered to the War Department on June 12. Apologizing that they had been "hastily compiled" and were "preliminary," the CAD dispatched four copies on July 2. One week later the planners approved the idea of also supplying field units with maps on which the listed monuments would be clearly marked. Work on these, known as the Frick maps, began immediately in New York.[36] No one involved realized that brand-new military maps of Sicily were rolling off the presses at that very moment, based on new aerial surveys brought in only the week before by a reconnaissance squadron commanded by the President's son, Elliott Roosevelt.

On June 7 Mason Hammond arrived in Algiers, where, to his amazement, it was revealed to him that he was to concern himself not with North Africa, but with Sicily. He was sent directly to a training and planning center at Chrea, in the mountains some forty miles south of Algiers, where the future Allied Military Government of Sicily (housed in a hotel, a former children's sanitarium, and a ski club) was organizing itself in great secrecy, quite removed from the combat elements which would precede it. The basic regulations of this enterprise were being compiled into a handbook known as the AMGOT (Allied Military Government) "Bible." To this, Hammond, not being in possession of any of the materials being prepared so assiduously at home by his academic colleagues, added what he could on the handling of works of art and the basic protection of buildings.

The collegial atmosphere of the center, in which each officer could discuss his discipline with his peers, enabled him to gain a degree of sympathy for his area of responsibility, though many "regarded the inclusion of cultural protection in a military operation with a certain amount of hu-

morous scorn." The main problem was information, the invasion being veiled in such secrecy that Hammond could not use any of the research facilities available in Algiers. The only reference book in all of Chrea, the *Italian Touring Club Guide for Sicily*, was in equally heavy demand by other officers for details of population and geography.

Despite these limitations, he managed to produce a short history of the island and a list of the most important sites. When Major General The Lord Rennell of Rodd, the British military governor–designate, would not allow these to be reproduced and distributed for reasons of security, Hammond resorted to the spoken word: "I advised all men to whom I talked to secure local guides . . . or to find out from local authorities what monuments were in their districts." Reaction to these naive instructions seemed favorable. But as the date for the invasion approached, Hammond remained alone—his British counterpart having never been appointed—and frustrated, with little to do, painfully aware that his lowly rank precluded his advice from being heard in the highest quarters, and that the directives for the invasion merely required that works of art, churches and archives be "protected" without providing specific instruction for doing so to field officers.[37]

On July 5 the thousands of separate elements required for the Sicilian invasion had finally been assembled aboard more than two thousand ships of every size, and the greatest armada in military history set forth toward its objective, still unannounced to the majority of its passengers. Emotions ran high as one of the headquarters ships sailed out of harbor past color guards and buglers of both nations. Despite a violent storm, which hit the fleet en route, the landings on the south coast of Sicily were successful. The terrible weather had hidden the Allied approach, and initial resistance by Italian forces was not fierce—everyone noticed that the Sicilians acted more as if they were being liberated than attacked.

But the German troops in the interior were not of the same mind, and after the first euphoric days the real fighting, which would last until the fall of Messina nearly six weeks later, began, and with it revelations of the flaws in the newly created Allied organizations. To Ernie Pyle, covering the fighting, it seemed that "everything in this world had stopped except war and we were all men of a new profession out in a strange night."[38] Nowhere would this be truer than among those responsible for Military Government.

For nearly three weeks after the landing, receiving only vague reports of events, Hammond languished in the Algerian staging area at Tizi Ouzu, a school building surrounded by barbed wire where, as a later Monuments

officer commented, the "British cooking and the French plumbing" were equally deplorable.[39] During this limbo period, though frustrated by the delay, Hammond had as yet no major feelings of inadequacy, and wrote to a colleague: "I doubt if there is need for any large specialist staff for this work, since it is at best a luxury and the military will not look kindly on a lot of art experts running around trying to tell them what not to hit. However, the Adviser (for Sicily, one perhaps enough, for larger spheres probably several) should have rank enough to carry weight in staff counsels and be able to get things done in the field. They should be provided with transportation. How far they will need a secretarial staff is hard to say."[40] He would soon find out.

On July 29 Hammond finally arrived at his assigned headquarters in Syracuse. While inspecting the local monuments—the main danger to which seemed to be the use of ancient catacombs as bomb shelters by the local population, who had rearranged the relics to make life more comfortable—he was delighted to find the local Superintendent of Antiquities on the job. But before he could do much of anything, the headquarters was ordered to move on to Palermo, which had fallen to Patton's troops only on July 22. On his circuitous route from Syracuse to Palermo, made necessary by fierce German resistance in the center of the island, Hammond managed a brief glimpse of the Greek temples at Agrigento, their ruins "undamaged" to his practiced eye. Less experienced officers had trouble with such classical remains. In one of the few apocryphal monuments stories, Patton, having taken the warnings on preservation in the invasion directives to heart, was reputed to have angrily demanded of a local resident if the roofless temple before him had been damaged by American artillery. "No," answered the farmer through an interpreter. "That was done during the last war." Patton, who considered himself a history buff, was puzzled. "Last war?" he asked. "When was that?" "Oh, that," replied the Italian, "that was the second Punic War."[41]

Although professional soldiers such as Omar Bradley did not consider damage in the ancient port city of Palermo particularly serious, the press and Civil Affairs officers were shocked. It was the first city most had seen which had undergone systematic bombing. The Allied Air Forces had concentrated their efforts there in order to distract attention from the actual landing sites in the south. *Herald Tribune* correspondent Homer Bigart reported: "There is scarcely a block in which one or more of the massive stone buildings has not been reduced to dust and rubble. . . . The crumpled buildings are like a lane of grotesque tombs in the moonlight."[42]

It was hard to know where to begin; but Hammond was greeted upon arrival by a committee of Italian museum and library officials, amazingly

The damaged Museo Nazionale, Palermo. In the background, ruins of Chiesa dell'Olivella.

already set up in the chaos by Lord Rennell, the British Military Government chief. From them he learned that the great Norman monuments of the city and its environs, including the magnificent twelfth-century cathedral and cloister at Monreale, were intact, though more than sixty other churches and the National Library had been damaged. No one had been paid for months, and funds were needed for emergency repairs. Nor were the newly conquered Sicilians shy about demanding such financing. This thorny situation and the basic problems of logistics would keep him firmly tied to Palermo.

The working conditions of the entire Military Government were appalling. Hammond's office contained only a chair and a desk; he had no clerical help, no typewriter, and worst of all no transportation. (Indeed, *Herald Tribune* reporters had observed many Civil Affairs officers hitch-

hiking from one liberated town to another.) His expected British colleague had still not appeared. Fortunately he had brought his own typewriter, upon which he composed letters to the Italian authorities in a unique blend of classical Latin and the modern tongue, providing them with hilarious relief to their often grim duties. The office was also occupied by the public relations officer, and there were moments when "it resembled a madhouse, with one officer trying to satisfy the demands of newspaper correspondents and the other trying to talk Italian to two or three Superintendents at the same time."

Help did not come for five exhausting weeks, during which time Hammond had little idea of how the rest of Sicily had fared. Most of the information compiled in the United States on Italian personnel, when it did finally get to him, had proven so out of date as to be useless. The famous maps, which he had hoped to dispatch to the front, never came at all—they had been carefully stored in the library of the training center at Algiers. It was not until early September that the arrival of his British counterpart, Captain F. H. J. Maxse, and an Italian-American sergeant by the name of Nick Delfino enabled him to tour, all too briefly, the rest of the island, Delfino "by methods too devious to bear the cold light of print" having produced a small, decrepit car which soon became known as "Hammond's Peril." It was the first in a long line of similar vehicles without which considerable segments of Europe's patrimony would not have been saved.

On their forays Hammond and Maxse discovered that most movable works of art had been safely stored, and that the passage of the armies had been so fast that little damage and looting had taken place. The problem, they would find, was not so much battle, but occupation and the limbo period which preceded it, when the natives were apt to succumb to temptation and troops freed from the simple need to survive turned to souvenir collecting and graffiti painting. On more than one historic wall Hammond observed German and American inscriptions side by side. But the Allied forces had moved along so quickly that problems of this nature were few.

The Monuments men did have to evict officers camping on rare plants in the Botanical Gardens and arrange protection for the ruins of Palermo's magnificent National Library, whose bombed stacks full of rare books lay open like a sliced pomegranate to passing thieves and the elements. But in general the damage they found, except in the regions of Catania and Messina, where the battles had gone on for weeks, was minor, and most of their time was spent in brokerlike negotiations for AMGOT funds for emergency repairs. These were so generously distributed at first that many were tempted to exaggerate their need. The Cardinal Archbishop of

Palermo, who had early established a friendly rapport with General Patton, tried to slip in the complete refurbishment of his palazzo to its original splendor as "essential" work. Patton himself, lodged in the magnificent but dusty gloom of the Norman Palace, seat of the former Kings of Sicily, had asked for redecoration money. The denial of these requests would severely tax the diplomacy of the Military Government.[43]

Hammond and Maxse, not yet having Woolley in office to advise them otherwise, sent fat detailed reports on their experiences back through channels to the War Department. Fortunately, Hammond also wrote long private letters to colleagues at home, full of suggestions for improvements in the system. Much the wiser, he begged for more information and reinforcements. Sicily, with its friendly people and relatively sparse monuments, had challenged them to the utmost. And now the whole of Italy, filled with infinitely more precious things, already being invaded and bombed by Allied forces, lay before them, the last nation to be occupied by the Reich.

Protection measures vindicated: Leonardo's Last Supper *is safe behind the structure at right.*

THE RED-HOT RAKE

Italy, 1943–1945

> Here is this beautiful country suffering the worst horrors of war, with the larger part still in the cruel and vengeful grip of the Nazis, and with a hideous prospect of the red-hot rake of the battle-line being drawn from sea to sea right up the whole length of the peninsula.
>
> —Sir Winston Churchill
> May 24, 1944

The invasion of Sicily had been a stunning blow to Benito Mussolini. The once flamboyant dictator had lost support in all quarters, even from his own Fascist party. On July 25, 1943, the Party's Grand Council voted for the restoration of constitutional monarchy, and the King, after calling Mussolini to the Royal Palace, fired him, arrested him, and bundled the surprised Duce off to jail in an ambulance. Marshal Pietro Badoglio was called upon to head a new government.

The Allies, divided on just where they would move after Sicily, reacted slowly to these events. After tough negotiations, they agreed on an invasion of France in May 1944. Troops from Sicily were to be sent to England to begin training, and a reduced force would be used in Italy, where, with the presumed help of Badoglio's forces, a quick advance to a line from Livorno to Ancona was foreseen. There the Allies, well placed for bombing Germany, planned to halt.

In May, Hitler, perfectly aware that the Italians might cave in easily come an Allied invasion, had secretly ordered Rommel to set up a new Army group for the north of Italy. The Brenner Pass defenses were to be strengthened and troops infiltrated into the north. Italian performance in Sicily did nothing to improve the Führer's confidence. Still, Mussolini's fall came to Hitler as a nasty surprise. Enraged, the Führer at first wanted

German troops to take over Rome—the Vatican included—arrest the whole government, and kidnap the Royal Family. Goebbels, appalled at the negative propaganda possibilities, managed to talk Hitler out of seizing the Vatican, and his generals into limiting their response to the sending of a paratroop force to the Rome airport. But German preparations did not cease. All during August troops continued to move toward the Italian theater, while precise plans were drawn up for the occupation of the country. At receipt of the code word "AXIS" German forces would disarm the Italian Army, restore the Fascist government, and regard Italy as one more occupied country.

To Hitler the Italian situation was not merely an affair of state. It was a personal betrayal. No one symbolized the duplicity of his former ally more than Princess Mafalda, daughter of the King and wife of Prince Philip of Hesse, who had procured so many works of art for Hitler and Goering over the years. When the Prince visited the Führer's Eastern Front headquarters a few weeks after the debacle, he was politely but firmly detained there. The rest of the entourage now "avoided him as if he had a contagious disease."[1] On September 9 the Führer had the couple sent to separate concentration camps, where Mafalda eventually perished.

How much of Italy Hitler could hold would depend on the timing and location of the Allied invasion. When the British Eighth Army finally landed in Calabria on September 3, German planners assumed that the Allies would follow up this incursion with an airborne seizure of Rome in combination with Italian forces and amphibious landings on the coast near the capital. But by September 8, when after much agonizing the Badoglio government surrendered to Eisenhower and fled south, there were no Allied troops anywhere near the Eternal City. Field Marshal Kesselring immediately broadcast the code word "AXIS," and the crack German paratroops so fortuitously sent to Rome moved in.

What remained of the Fascist government was evacuated to Lake Garda. Unbeknownst to them, a new frontier had been drawn in the north: the territory down to Verona and as far over as Trieste was incorporated into the Reich under the administration of the Gauleiters of the Tirol and Carinthia, negating the Führer's generous 1938 gesture, which had left this long-disputed area in Italian hands in return for the Duce's support for the Anschluss. One day after these arrangements had been made, Hitler's friend Mussolini, his territories thus considerably diminished, was rescued in a daring commando raid and reinstalled as "Head of State." These quick actions and the hesitations of the Allies had allowed the Thousand-Year Reich to be extended to a line south of Naples reaching from the beautiful beach town of Salerno across to Bari in the east.

* * *

In the early years of the war the directors of the Italian Belli Arti, like their colleagues in other nations, had put the most precious contents of their museums in refuges, or *ricoveri*. The museum administration of Naples had sent theirs to the vast and isolated Benedictine monastery at Montevergine high above the city and about thirty miles to the east. There and at another repository at Cava, near Salerno, were eventually concentrated more than 37,000 works of art from the Royal Palace, the major museums, and private collections. The contents of the Civic Museum, as well as nine hundred cases of the most ancient documents from the Neapolitan Archives, went to the Villa Montesano near Nola. Transport was not easy: covered trucks were hard to come by, the roads were punctured by bomb craters, and anything that moved was the target of Allied dive bombers. Each trip to the refuges became an adventure, but the curators persisted, and by the early summer of 1943 nearly sixty thousand objects had been made as safe as seemed possible.[2]

The manner of the Allied progress in eastern Sicily, where German resistance was strong, was, however, most disturbing. The troops had not just stuck to the roads as the Germans had done in France. The battle had gone from village to village, up and down mountains, with much artillery activity by both sides. It was clear that the Neapolitan repositories would be in the midst of any such battle and that Montevergine, which contained the Naples "A" list, was the most vulnerable of all.

This fear was exacerbated by a ferocious German propaganda campaign which predicted that the Allies would take or destroy anything they could lay hands on. In an article which is admirable for its amazing inventiveness, even in the annals of propaganda, the *Berliner Börsen Zeitung* reported:

> The American wholesale art dealer Cadoorie and Company has given a commission for the purchase of Sicilian antiquities. This is the same business that made great purchases from European emigrants and arranged auction sales of paintings, furniture, porcelain and other art objects. The firm was also busy with this game in art treasures which were stolen during the Spanish civil war. Behind the name Cadoorie the Jew Pimpernell is hidden . . . the representative in Algiers, Sally Winestone, has arranged connections with the staff of the Anglo-American hospital ships who endeavor to carry out her commissions.[3]

In late July, therefore, Bruno Molajoli, Superintendent of the Naples Museums, went to Rome to consult his superiors. It was now felt that deposits all over Italy should be removed from the vulnerable country *rico-*

veri to safer spots, the safest of all, everyone felt, being the neutral Vatican, with whom negotiations for storage were immediately begun. But the Naples deposits, now closest to the battle zone, could not wait for long. In August 187 crates containing the most important things were readied for dispatch to the safest place the authorities could possibly imagine next to the Vatican: the immense monastery of Monte Cassino, remote and inviolable, at the top of a mountain fifty miles north of Naples. The precious cargo did not leave until September 6, only hours before Allied landing craft came ashore in the great assault on Salerno.

It was not until they arrived back in Naples that the curators heard the news of Badoglio's surrender to the Anglo-Americans and realized that Italy had overnight become an occupied country in which their erstwhile allies were as much of a danger as were the forces attacking their country. The situation in Naples was terrible: in the distance could be heard the *lugubre brontolio* of artillery fire. Bombs fell intermittently on the port and the city, while in an arc around it every road, track, or convoy, and some less mundane things such as the marvelous cathedral at Benevento, just east of Montevergine, were being demolished. The Carabinieri, Italy's national police, had been disbanded by the Germans, leaving museums and repositories without guards. Water and electricity were cut off, and all communication with the country refuges, where much still remained, became impossible.

And indeed the situation outside the city was far from ideal. Cava, near the Salerno beachhead, was filled with refugees sheltering from artillery fire, and the abbot was being held hostage by the Germans. Montevergine no longer had guards and was now directly behind the German lines, although the Benedictines managed by various subterfuges to keep troops out. At the Church of San Antonio in Sorbo Serpico, one of the last refuges to be filled, the custodian refused admission to inquisitive Nazi officers, asking them to come back the next day. In the night he called together the ladies of the village, who carried seventeen large packed crates of paintings up into the hills on their backs so that the returning Germans found nothing. His caution was justified, for on September 26, soldiers enraged at Partisan resistance in Naples soaked the shelves of the University library in kerosene and set it on fire. Its fifty thousand volumes were still burning when, on September 28, the eighty thousand precious books and manuscripts from the various archives of southern Italy were discovered at Nola by foraging soldiers and, despite two days of desperate negotiations by the custodians, deliberately burned. With them also were consumed the best ceramics, glass, enamels, and ivories of the Civic Museum, and some forty-five of its paintings. These gratuitous acts of destruction

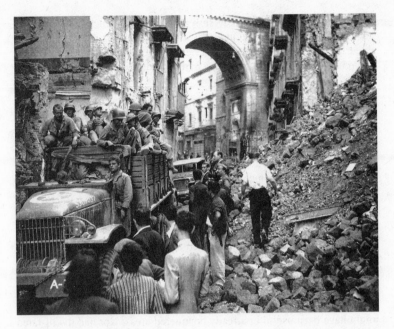

American troops enter Naples.

came as a total surprise to the Italians. They would have many more in the coming months.[4]

When, after fierce resistance by Kesselring's forces, the Allies entered Naples on October 1, the situation did not much improve. The University now endured a second wave of destruction. Allied soldiers ransacked the laboratories, hopelessly mixing up collections of shells and stones which had taken decades to assemble. Troops soon were to be seen driving about the city in jeeps decorated with hundreds of fabulously colored stuffed toucans, parrots, eagles, and even ostriches from the zoological collection. Curators were brusquely thrown out of their offices at the Floridiana Museum. British, French, and American personnel were billeted in the Capodimonte and the Royal Palace, where, with the delighted help of Neapolitan ladies of the night, they stripped brocades from the walls, presumably to be converted into garments of one kind or another. The Museo Nazionale, where despite all the evacuations five hundred objects were still in place, was designated as a hospital-supply warehouse. Eisenhower's aide flew in to find suitable lodgings for him near the huge Caserta

Palace (vacated by the Germans only days before), which had been cho-
sen as the main Allied headquarters, and which housed most of the evac-
uated decorative arts of Naples.[5] The Italian museum authorities could
find no one who seemed responsive to their protests at the use of these his-
toric buildings. Molajoli wrote later:

> The massive mechanisms of a vast army of occupation, still engaged
> in combat, came in contact for the first time with a great cultural cen-
> ter, and were faced with problems of unforeseen complexity. Despite
> the best intentions of the . . . organizations of cultural assistance set
> up by the United Nations . . . Naples had the unwanted privilege of
> serving as the experimental laboratory for these organizations.[6]

Dr. Molajoli and his colleagues could not find anyone to deal with their
problems because Major Paul Gardner, the Monuments officer assigned to
the city, did not arrive in Naples for three weeks.

Efforts in Washington had produced nearly a dozen officers to join the
beleaguered Hammond and progress with the armies to the mainland, but
they too still languished in North Africa or Sicily. Italy was divided into
fixed regions, with a Monuments officer for each one; but until an entire
region was taken, the officer was not sent to the theater, even though he
might have been useful in already conquered areas. Nor had the ill-fated
maps ever reached anyone who could use them; in fact, the set for the
Naples region had been captured when the British courier taking them to
headquarters by motorcycle was intercepted by a German patrol. Monu-
ments officers wondered for years afterward what the Germans had made
of these mysterious documents.[7] On top of this, their section of headquar-
ters remained in Sicily, split off from the rest, and totally out of contact
with events.

The Monuments men were not the only ones feeling frustrated. The
Roberts Commission, as the American Commission for the Protection and
Salvage of Artistic and Historic Monuments was now mercifully known,
its chairmanship having devolved upon Supreme Court Justice Owen J.
Roberts instead of Chief Justice Stone, had finally been legitimized on Au-
gust 20. But as of October 20 no official information at all on events in
Sicily had reached the commission members. Despite this blackout they
had forged ahead. Paul Sachs, who knew more about American museum
personnel than anyone, having trained a great percentage of them, was put
in charge of building up the roster of suitable officers. In the absence of in-
formation from the field, David Finley kept pressure on the War Depart-
ment in a long correspondence with Assistant Secretary John McCloy,
insisting that officers be assigned to tactical units and that more technical
assistance be given. He wondered if the maps had ever reached air crews,

and demanded reports.[8] The commission did not know much more than it could glean from the newspapers, and the image of the United States revealed there was not much better than that of Germany when it came to the protection of monuments.

Although President Roosevelt had broadcast a message to the Pope on July 10 assuring him that the Vatican would not be a target, the first Allied bombing of Rome on July 19 made major headlines worldwide. American planes had departed, press observers on board, with adamant instructions not to bomb anything but the targeted railroad yards. Despite all precautions, bombs fell on the ancient and especially revered basilica of San Lorenzo Fuori le Mure. Axis propaganda had a field day, broadcasting a long letter supposedly written by the Pope, in which he lamented the failure of his pleas to save the city, and called upon the Allies to "reflect upon the severe judgement that future generations will pronounce."[9]

After a second raid on August 13, the Badoglio government declared Rome an open city, an act ignored by all belligerents. When he fled the capital, the Germans announced that they had "assumed protection of the Vatican," and sealed it off with armed cordons while occupying the rest of Rome with large numbers of troops. In response, the Pope announced that he would not receive Marshal Kesselring until his troops were withdrawn from the city, and mobilized his Swiss Guard, who, armed with the latest modern weaponry but still dressed in their ancient costumes, stood eye to eye with the Germans. The standoff, vividly described by the Allied press, lasted for weeks and caused widespread consternation. "How could the Allies strike the enemy without making a battleground of the Vatican?" wondered *The New York Times*.[10]

A special report of destruction and German atrocities in and around Naples, brought back to Roosevelt by Treasury Secretary Henry Morgenthau, who had just visited the battle zone, led the Roberts Commission to begin a campaign to have the Allies declare one or more of the great artistic centers of Italy open cities, to which the contents of the repositories could be taken.[11] They found little support. A confidential feeler to the Papal Nuncio was met with sympathy, but regret that "practical problems" would make such a declaration difficult: according to the Cardinal Secretary of State, "the designation of any one town or city would inevitably give rise to recriminations and complaints from other localities not thus favored."[12]

Nor was Supreme Commander Eisenhower willing to limit his tactical possibilities in any way. McCloy replied to Finley that Eisenhower "felt that while such a city could be definitely spared bombing by the American or British armies, it was not possible to guarantee in advance that the movements of the armies might not require the shelling of such a city if it

were held by the Germans and the advance of the Allied armies thereby impeded. It was his opinion that while the idea had propaganda value, it was not feasible to try to carry it out." The Supreme Commander was not enthusiastic about placing Monuments officers with combat units either. In his view "every precaution to safeguard objects of art was being taken." As for restoration and salvage, it was a civilian problem to be solved by the Italians, perhaps with the advice of one or two British or American experts.[13]

But the prospect of civilian agencies working in the conquered areas had, by the time of the fall of Naples, died a slow and inevitable death. Obedient to FDR's stated policy, the Civil Affairs Division had asked the Combined Command, in the midst of the Sicilian battles, when such agencies should be told they could arrive on the scene. The reply was that it was much too soon. But on August 30 Eisenhower cabled that "the present state of operations will shortly permit civilian agencies to go into Sicily." The British, upon receipt of this message, were horrified. "The British government anticipates with considerable alarm the prospect of having thousands of starry-eyed American civilians running loose in Europe," read one cable. They would accept only individuals who could be integrated into the Military Government structure. By November Roosevelt finally abandoned his insistence on combined civilian-military operations in the field.[14] This was a terrible blow to the Roberts Commission, civilians all, who had envisaged themselves in action on the scene, but who were thus relegated to a purely advisory role, and not even included in the distribution list for relevant military reports.

Pressure was now entirely on the Military Government to improve matters. This was not easy. The Supreme Headquarters were divided between Algiers, Naples, and the Lower Peninsula of Italy. Military Government likewise had various divisions with their own commands. On top of this an Allied Control Commission was created to deal with the Badoglio government, which also had three separate headquarters. Little wonder that no one seemed in charge.

It was only at this juncture that, on October 23, 1943, the British War Office awarded Leonard Woolley the formal title of Archaeological Adviser to the Director of Civil Affairs. On about the same date, the Roberts Commission finally received its first reports from Mason Hammond, covering events in Sicily up to the end of August. But it was not until late November that the assigned Monuments officers, waiting impatiently in Palermo, began to be placed on the mainland. Rigidly confined to their particular regions and as usual lacking transportation, they often could do little.

Meanwhile, Paul Gardner remained alone in Naples, where the administrative apparatus of the Supreme Command continued to take over the monuments of the city. The Royal Palace became an officers' club. At Caserta the various HQs expanded geometrically to fill the two hundred rooms packed with delicate paintings and furniture which troops moved about at will. There were frequent reports of damage to Pompeii. The buildings seemed of no importance. In one of the hunting lodges at Caserta, General Eisenhower himself, instead of resorting to more conventional methods, used his pistol to kill a rat found perched on his toilet seat. (It took three shots.[15]) The medical unit assigned to the Pinacoteca, its doors generally wide open, planned to cook in the courtyard and set up cots in the galleries. There were constant complaints of rude troops breaking into locked libraries and storerooms and making off with books, coin collections, and *objets*.

Woolley, who had the great advantage of being a lieutenant colonel in the British Army and high up in the War Office hierarchy, arrived on this scene on December 1. In a series of meetings at Allied headquarters, and in a stiff letter to the chief of Military Government, he pointed out the negative propaganda and political effects of the Army's destructive activity. He mentioned that the "express desires" of the President of the United States and the British Secretary of State for War were not being observed.

The stirring up of the brass had results: a commission of inquiry was appointed to investigate the whole situation in Naples, and on December 29, 1943, Eisenhower issued to all commanders the first Allied General Order of the war on the protection of monuments:

> Today we are fighting in a country which has contributed a great deal to our cultural inheritance, a country rich in monuments which by their creation helped and now in their old age illustrate the growth of the civilization which is ours. We are bound to respect those monuments so far as war allows.
>
> If we have to choose between destroying a famous building and sacrificing our own men, then our men's lives count infinitely more and the buildings must go. But the choice is not always so clear cut as that. In many cases the monuments can be spared without any detriment to operational needs. Nothing can stand against the argument of military necessity. That is an accepted principle. But the phrase "military necessity" is sometimes used where it would be more truthful to speak of military convenience or even of personal convenience. I do not want it to cloak slackness or indifference.
>
> It is a responsibility of higher commanders to determine through

A.M.G. Officers the locations of historical monuments whether they be immediately ahead of our front lines or in areas occupied by us. This information passed to lower echelons through normal channels places the responsibility on all Commanders of complying with the spirit of this letter.

In Woolley's somewhat optimistic words, protection now became "what it always should have been, a matter of military discipline, and as such it was cheerfully accepted by the combatant forces. The tendency to regard the Monuments officer as an interloper trying to press his own point of view against the claims of military necessity was eliminated, and he was looked upon as an adviser."[16]

The whole Monuments operation was now reorganized. Its offices were brought to Naples from Palermo, and a more flexible assignment system was approved which would allow officers to be sent forward where the need was greatest. Specific instructions were sent to lower-ranking officers, and work was immediately begun on easily distributed pocket-sized booklets listing monuments for each region to replace the excessively bulky "Harvard lists."

Naples began to settle down. The medical unit left the Pinacoteca unscathed, and at Caserta, which remained the Allied headquarters until well after the war, the contents of the repositories were evacuated elsewhere. But Sir Brian Robertson, the British commander, would not give up the Royal Palace, in which complete cafeterias and bars had been installed. His cultural contribution was limited to an introduction to a guidebook for the edifice urging troops to "respect its age and beauty" so that future generations could "say without criticism or regret, 'The British used this place as a club for their men when they were here.' "[17] At least, Woolley later wrote, "the experience of the Royal Palace at Naples was never repeated in the course of the Italian campaign . . . the experience was worth the price."[18]

Everyone now felt much better about the prospect of occupying Rome. The message of protection of historic buildings had been emphasized and acknowledged. Soon they would take the Eternal City and the Germans would probably give up. Allied forces had already broken through the eastern end of the enemy front, and had apparently surprised them with their amphibious landing at Anzio, actually behind the German lines, on January 22. All that now remained was to sweep forward to breach the fortified "Gustav" line centered on the ancient mountain Abbey of Monte Cassino.

* * *

Experienced as they were at setting up occupation governments, the Germans were having a much easier time than the Allies organizing themselves as rulers of truncated Italy. It was to be treated as a "Western" nation under the puppet Fascist government. This left responsibility for the incalculable art treasures of the country technically in Italian hands, but their care in the midst of battle, given Hitler's desire to defend the entire peninsula, clearly would require the establishment of a special monuments protection organization by the German authorities. In these matters they were almost as inexperienced as their opponents, having protected nothing in the eastern battle zones, and having had little opportunity to refine battlefield techniques in the brief assault in the West. The two organizations in the vicinity concerned with such matters, a scholarly Ahnenerbe group known as the Culture Commission for South Tirol, which had been classifying "Germanic" monuments in the region, and the Kunstschutz in France, were not exactly combat-oriented.

They also had a completely new problem: global public opinion. The invasion of the Italian mainland had, for the first time, exposed the Nazis on their own turf to the untrammeled democratic press. Allied newspapers carried lurid accounts of the German excesses in Naples, and were circulating equally lurid and frequently inaccurate stories about their occupation of Rome. The looting of art and plundering of churches were said to be widespread, and it was reported that truckloads of art were being removed to the north. The French *Pour la Victoire* even ran a cartoon showing Michelangelo's *Moses* about to be transported to Dachau.

The criticism was not all from the Allied side. Birds, this time not stuffed, were also a problem for the Germans: the newly appointed ambassador to Rome, Rudolf Rahn, was shocked to see paratroops, bivouacked in the magnificent gardens of his embassy, shooting and roasting the famous white peacocks which adorned the shrubbery. His protests to the unit commander were met with some disrespect.[19]

Field Marshal Kesselring was, of course, perfectly aware of the need to protect buildings and works of art. He had immediately assigned an SS officer from his Intelligence staff, a former employee of the Hertziana Library in Rome, to supervise the posting of Off Limits notices and to remove objects from combat areas to safe storage. But implementation of a coherent plan close to the constantly moving front was not easy, and the disparate units, fighting for their lives and furious at the thought of defeat, were difficult to control. Fortunately for Kesselring, the inexplicable slowdown of the Allied advance north of Naples in late October would enable him not only to create the terrible defenses of the Gustav line, but also to consolidate certain aspects of his occupation administration. For the Ital-

French cartoon on the subject of Nazi evacuation of art from Italy

ian patrimony it was none too soon. Some of the removals to "safe storage" had rather gotten out of hand.

Despite efforts of Italian officials to stop them, thirty-nine cases of objects from the Palazzo Venezia in Rome, for years Mussolini's residence, had been taken from a *ricovero* at Gennazaio and sent off to Milan on the excuse that they were the personal property of the Duce. Far more dramatic was the activity at the Abbey of Monte Cassino, around which frantic fortification construction was in progress. The abbey itself was not in fact technically part of the extraordinary web of redoubts, bunkers, and tunnels being prepared by German engineers, but its prominent position gazing out over the valley below guaranteed that it would become a target. On October 14 the seventy-nine-year-old abbot was visited by officers of the Hermann Goering Division, part of Kesselring's Tenth Army. The division had recently moved its headquarters from Caserta to Spoleto. They informed the monk that the archives, treasure, and occupants of the monastery would have to be evacuated. The abbot, who feared that everything would be sent off to Germany, at first resisted, asserting that the contents of the abbey were the property of the Italian state, but in the end was forced to give in.

A team of packers was dispatched by the Goering Division to prepare the shipments, one of which would go to Rome and the other to the Division's headquarters in Spoleto. It is not entirely clear if the German officers knew before they began packing that the Naples treasures were in the abbey, but it did not take them long to find the cases so recently moved to this refuge. Other, smaller secret caches hidden in the vast building escaped their scrutiny. Duke Filippo Caffarelli had, in December 1942, entrusted several boxes of original manuscripts from the Keats and Shelley Memorial in Rome to Father Inguanez, chief archivist of the abbey. These rested behind a secret panel in the library. No one mentioned them to the Germans and Inguanez was able to mix them in with his own personal possessions, thereby insuring that they would go to Rome and not Spoleto.[20]

It took nearly three weeks to pack the contents of the monastery and transport them in multiple truck convoys down the hairpin road to the valley and on to their next shelters. Considering the precarious position of the German armies north of Naples, it was an extraordinary use of military effort.

Just who was to benefit from this remarkable altruism seemed all too clear to the Italians, who were quite aware of the tastes of the Division's Commander in Chief. They were not only worried about the Reichsmarschall. On October 12 the Fascist Foreign Ministry had agreed with the Germans that all portable works of art should be moved from the capital to the north of Italy. This plan was diametrically opposed to the wishes of the director of fine arts, Dr. Lazzari, who had been trying since June to get the Vatican to agree to receive and store whatever elements of the Italian patrimony could be brought back from the scattered refuges which lay in the paths of the ever-advancing armies, and who, on his own responsibility, had ordered his subordinates, including those in Tuscany, to begin arranging for all the collections they guarded to be brought to Rome. On November 2 the Vatican finally agreed to receive the Italian treasures.

Lazzari drew support for these efforts from an unexpected quarter: a group of well-known German intellectuals and diplomats based in Rome and Florence. Their concern was not entirely disinterested. The two cities had for centuries been the meccas of serious students of art history, and for Germans more than any others, they being generally credited with having invented this discipline. They had four major establishments in Italy: the German Archaeological Institute, the Hertziana Library, the German Historical Institute in Rome, and the German Art Institute in Florence. The directors and employees of these world-renowned centers had been ordered to leave Italy along with other German nationals in the panic following Badoglio's armistice.

The Roman groups in particular had planned ahead. Only days after Mussolini's fall Professor Bruhns of the Hertziana secretly asked his colleague, Dr. Sjoqvist of the Swedish Institute of Classical Studies, if he would protect the Hertziana from both the Allies and the Italians. When Sjoqvist suggested that the Vatican would be the best protector, Bruhns replied that the Holy See could only be approached through diplomatic channels, and that this would be considered high treason as it would reveal "distrust in the final victory." He would, however, try to appeal to certain Cardinals in the Vatican. Bruhns was followed in short order by Professor von Gerkan of the Archaeological Institute, who was both anti-Nazi and anti-Italian, and who also handed Sjoqvist an official letter making him responsible for his institute.

These actions were condoned by the German ambassador to the Vatican, Baron von Weizsäcker, who obtained assurances, reportedly from the Pope himself, that the Vatican would protect the libraries if necessary. The offer naturally had to be publicly rejected as "incompatible with the Reich's dignity," but the precedent of Vatican refuge had been established and certain attitudes revealed. The same Germans who wished to have the German institutes moved there also favored this refuge for the Italian patrimony. They were tacitly supported by Ambassador Rahn and the German consuls in Rome and Florence.[21]

It was into this milieu that Bernhard von Tieschowitz, who had replaced Count Metternich in Paris as Director of the Kunstschutz, arrived on October 31, to set up a similar organization for Italy. According to von Tieschowitz's first reports, all was for the best in the best of possible worlds, and "an atmosphere of confidence between the interested parties of both nations was established."[22]

Soon the German and Swiss press began to carry regular stories on the German rescue of the Italian patrimony. Within a few days von Tieschowitz had appointed a permanent head for the Kunstschutz, a Professor Evers from Munich, who would arrive in a few weeks. Arrangements were begun to bring the contents of the nearest *ricoveri* back into the city. On November 15 the Vatican declared itself ready to receive the first shipments, and trucks were commandeered by von Tieschowitz to bring back the contents of the Palatine Museum, the Borghese Gallery, and various Roman churches.

During all of this, von Tieschowitz constantly reassured arts officials that the "initiative and direction of action will lie with the Italians, while, apart from the direct protection of works of art and of the immovable things in the zones of operation, the Germans will limit themselves to collaboration in the executive phase," pointing out to them also the "political

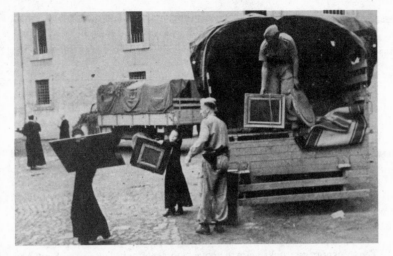

Small seminarians help the Germans move art into the Vatican.

significance of this double action."[23] The Italians, suspicious of ultimate German motives despite the folksy atmosphere, continued to urge that the Tuscan deposits too be brought to the Vatican. Though transport would be dangerous, they suggested that the priceless things could be marked with red crosses, be moved at night, or be guaranteed by an international agreement of some kind.

While these discussions were in progress, Ambassador Rahn, on November 10, went to Hitler's Eastern Front headquarters to try to persuade him not to defend Florence, which in existing German plans was the pivotal point of the so-called Arno defense line. Hitler vaguely agreed only that Florence should be "protected" and that it was "too beautiful to destroy."[24] But Rahn did report to von Weizsäcker at the Vatican that the Führer had issued a special order that "those works of art which we owe to the genius of the Italian Nation are to be returned to the open cities of Florence and Rome, where they can be protected from terror bombing and safely preserved for Europe."[25] The matter seemed decided. The next day von Tieschowitz told officials in Rome that the Tuscan works should be concentrated in Florence. The Romans did not agree with this policy, and all during November and December deluged their Florentine colleagues with calls and letters pressing their case. But the German will prevailed. If the Italians had had any doubts that their nation was an occupied one, they were now enlightened.

And daily there were other disturbing reports. German soldiers had raided the Cathedral of Gaeta and the lovely Villa Lante at Bagnaia, endangering its frescoes. They had forced their way into the Castel Sant'Angelo, which was being used as a staging area for the objects from the *ricoveri,* and turned the gardens at Tivoli into an ammo dump. Most worrying was the refusal, despite repeated urging by von Tieschowitz himself, of the Hermann Goering Division to return the Monte Cassino shipment they held at Spoleto. Italian curators were not allowed to check the condition of the paintings; even the SS art historian appointed by Kesselring claimed that he had not been allowed to inventory the cases, and could only report that they were properly sealed.

With constant badgering from von Tieschowitz, who ultimately appealed to Kesselring himself, the recalcitrant Goering Division finally agreed to return part of their holdings. Von Tieschowitz ensured that they would do so by announcing this fact at a press conference. The actual delivery was to be occasion for a full-fledged propaganda and media circus. The transporting trucks were to arrive "with solemnity" at Castel Sant'Angelo, after stopping for photo opportunities at the Coliseum and other suitable sites. The whole thing would be filmed for distribution in the Reich. Italian officials suspected that this ceremony "had a political reason, particularly after the accusations of filching made . . . on the British radio and the German desire to point out that these are false." The Romans were ordered to attend the ceremony, but only as "testimony to the act of reconsignment."[26] Everybody wore their best uniforms. There were speeches, and some four hundred cases were duly unloaded for the cameras.

The only trouble was that the Naples pictures were not included. These arrived in a subsequent shipment on January 4, 1944, and were received with equal ceremony at the Palazzo Venezia. It was noticed immediately that fifteen crates were missing. The German commander of the convoy explained that two trucks had been damaged by machine-gun fire, and would arrive shortly. The nightlong vigil of Italian custodians waiting to receive them was in vain: the pictures never came. Indeed, they never would, for they had already arrived at Reineckersdorf, the headquarters of the Hermann Goering Division outside Berlin.[27] The timid Professor Evers, who by now had arrived to take von Tieschowitz's place as Kunstschutz chief, not being inclined to jeopardize his life, refused all access to the storerooms. The Italians would not know which pictures were missing until the Allies liberated the city.

Although Hitler had declared his wish that the Italian national patrimony remain at home, he did not include the inventories of the four great German institutes in this category. Two of them had been chartered after World War I by the Benedetto Croce Agreement (part of the hated Ver-

sailles Treaty), which required them to stay in Italy in perpetuity. This only made the Führer more eager to return them to the Fatherland. Ambassador Rahn, during his visit to the Wolf's Lair, had urged his chief to allow the collections, which contained many works of art as well as valuable books, to remain in Italy as an emblem of German prestige.

Hitler asked for an opinion from the institute directors themselves. Desperate to keep their organizations intact, but feeling sure that the proper response should be a fervent desire to return them to Germany, the directors, represented by Professor Bruhns of the Hertziana, based their request to stay on the "impossibility of arranging safe transport owing to the bombardments of all lines of communication." This defeatist excuse so enraged Hitler that he ordered that the libraries be sent to the Reich immediately. Bruhns now returned to his Swedish friend, lamely explaining that the evacuation was necessary because of the dangers of Allied bombing. Sjoqvist did not make it easy for him: "On my questioning how such an hypothesis could be reconciled with the bringing to Rome of all the materials from Monte Cassino, he remained slightly embarrassed." Somewhat more sympathetically Sjoqvist did note that he was sure Bruhns feared for the lives of his family if he did not comply.[28]

The Hertziana holdings were packed in early January 1944, and arrived at a "salt mine near Salzburg" a few weeks later. The other institutes did their packing as slowly as possible, vainly hoping that an Allied offensive would prevent shipment. The first carloads moved north as part of a troop train which was bombed while on a bridge; some cars fell into the river and others burned to ashes, but not the books. Subsequent transports also miraculously arrived in the Fatherland without damage. Hitler's rage was now vindicated, but "his" libraries were doomed to several more weeks of harrowing adventure. As of March 4, 1944, some six freight cars of books, documents, photographic archives, and works of art still sat homeless on rail sidings in the Reich—while Bruhns desperately tried to find room for his treasures in the overflowing German refuges. In Rome no one was quite sure where they had ended up.

The landing at Anzio and the frontal attack on the lowering mountains around Monte Cassino, which the Allies had begun with such high hopes of a rapid advance to Rome, was stopped within days by the well-prepared German defenses and the dreadful weather. In mud and rain, freezing and constantly exposed to artillery barrages on the bare mountainsides, the Allied armies lay in misery with the windows of the great abbey looking down upon them. Little wonder that it soon became a hated obstacle and the symbol of their powerlessness to advance.

There was no question that the American commanders—aware of pos-

sible propaganda effects and bolstered by Eisenhower's orders—considered the abbey a religious and historic monument which should be protected; nor did they consider its destruction a military necessity. In fact, reduction of the building to rubble would only enhance the German defense network in which it lay enmeshed like a fly caught in the web. But the abbey had become more than a mere building.

Press reports in Britain and the United States focused on it more than any other of the many strong points and observation posts along the Gustav line. Repeated denials by Kesselring and von Weizsäcker that the abbey proper was being used by German forces were universally treated with scorn. Vivid reporting by Ernie Pyle and others told of the high casualty rate and truly ghastly conditions. C. L. Sulzberger of *The New York Times* declared on January 29 that "abstention from shelling Monte Cassino, about which reconnaissance has remarked the presence of many German vehicles, hampered our advance greatly since the whole hillside beneath it is defended."

In England the situation was made worse by a series of debates on the protection of monuments in the House of Lords in early February, which began with the Archbishop of Canterbury and the Bishop of Chichester calling for restraint in the bombing of "the constellation of lovely cities, towns and villages in Italy." Unfortunately, the Bishops had failed to point out in their speeches that such restraint should always be subject to military necessity. A furor ensued. The *Times* letter columns overflowed with missives from angry parents declaring that their sons should not give their lives for a building. John Maynard Keynes, the eminent economist, wrote to John Walker at the National Gallery of Art in Washington that he feared "public discussion of this subject has started off on the wrong foot, and people are getting badly confused about it . . . the issue is now viewed as one between dead matter and young living bodies."[29]

Strong pressure to destroy the abbey was also forthcoming from the commanders of the New Zealand and Indian divisions whose troops would soon be ordered to take the mountain on which it stood. For days the issue was debated within the Allied commands, with the Americans and French against, and the British and New Zealanders for. Intelligence reports were studied, and the vaguest reports of a German presence taken as true. But in fact, no one really knew exactly what was behind the staring windows so far above them. Nor did anyone want responsibility for the decision; but it was finally taken by General Sir Harold Alexander, Commander of Allied Forces in Italy, on February 13.[30]

The next day warning leaflets were showered over the abbey to allow evacuation of the premises by the monks and civilians known to be inside.

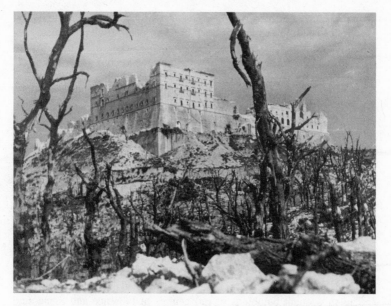

The desolate remains of the Abbey of Monte Cassino after Allied bombings

Two days later wave after wave of bombers reduced it to a rubble heap. In the valley below, troops and reporters cheered at the sight. But the Germans entrenched round the abbey were unharmed by the bombardment, and now, as the doomed Allied troops attacking the next day would discover, moved into the ruins, which acted as a natural battlement on the mountaintop. The bombing had all been in vain: after terrible loss of life, and three more months of shelling, the abbey was finally taken on May 18 by Polish troops after the Germans had abandoned it.

Immediately following the bombing the American representative at the Vatican was severely taken to task by the Papal Secretary of State, who denounced the attack as a "piece of gross stupidity."[31] A few weeks later the Pope, clearly worried about the fate of Rome, appeared before a huge crowd at Saint Peter's, and appealed to both sides to spare the city "so that their names may remain in benediction, and not as a curse through the centuries on the face of the earth."[32] Neither side wanted to be seen for eternity in such a light, and it is clear that both planned the inevitable change of hands at Rome with some care. Hitler forbade Kesselring to mine the bridges over the Tiber, and the number of German troops allowed in the

city was kept to a minimum, while Allied Monuments officers had, by December 1943, drawn up elaborate preparations for the immediate protection of buildings.

There was no further danger of bombing: in February the Allied Air Forces under General Lauris Norstad were finally supplied with special maps, showing important monuments on aerial photographs taken by the Air Forces themselves. The elusive Frick maps had proved unsuitable; the Air Force maps had the advantage of showing the bombardier exactly what he would see through the bombsight. Italian cities were divided into three categories. Category A included Rome, Florence, Venice, and Torcello, which "in no circumstances were to be bombed without authority from this Headquarters." The Vatican City was regarded as neutral and off limits, as were Irish convents and other Papal properties scattered through the peninsula. Category B covered such cities as Ravenna, Assisi, San Gimignano, Urbino, and Spoleto, which could be bombed if it was considered essential. ("Full responsibility will be accepted by this HQ.") But Siena, Pisa, Orvieto, Padua, and scores of others in the last group, near which there were "important military objectives . . . which are to be bombed, and any consequential damage is accepted," were on their own.[33]

The subsequent bombings of rail centers at Florence and Siena, and such vital areas as the harbor of Venice, were usually masterpieces of precision, but there were still losses. On March 11 bombs destroyed forever the frescoes by Mantegna in the Church of the Eremitani in Padua and narrowly missed the tiny Arena Chapel, decorated by Giotto, only a few hundred yards away. Each such mistake was trumpeted in the German and Fascist press. The Italian puppet government even put out a set of postage stamps showing "destroyed" monuments and vividly illustrated pamphlets with such titles as *The War against Art, Liberators over Bologna—The Stones Speak,* and *Torino, ferita—mutilata.*

On June 2, 1944, Allied forces finally reached the outskirts of Rome. Kesselring in another of his brilliant retreats now withdrew his badly battered troops out of the city to regroup just to the north. On June 4 the American Fifth Army entered the city without encountering resistance. This time every precaution had been taken to avoid embarrassing incidents. Indeed, one Monuments officer, sent forward to assess damage, had entered the city ahead of the combat troops.

Cables from General Marshall, sent days before, ordered that Vatican officials be immediately informed of "the efforts that the Allied Armies have made in Italy to save Church property and historic arts monuments from damage," and be given copies of the marked bombing atlases. He also required that Monuments officers be sent into Rome immediately "for

the purpose of compiling an inventory of damage caused to non-military objectives . . . due to Allied bombing."[34]

On June 5 the Pope spoke to a huge crowd, made up to a great extent of Allied soldiers, and thanked God that Rome had not been destroyed. The same day, Monuments officer Perry Cott had arrived in the city, where all museums and galleries were closed and placed under guard. By June 7 conferences with Italian fine arts officials were in full swing, and Lieutenant Cott was busy inspecting buildings and writing an article for the *Corriere di Roma* explaining the functions of the Monuments officers "to dispel German propaganda to the effect that this is a purchasing commission."

Cott was immediately told of the purloined Naples pictures and of the dubious art deals done by Philip of Hesse and others, but his early investigations revealed no major cases of looting by German troops within the city which would be of use in the continuing propaganda war. Soon the great treasures of the Italian patrimony held in Rome were brought out and exhibited to the press. Michelangelo's *Moses* was freed from its protective wrappings. Mosaics were stripped of the cloth coverings which had been glued to their surfaces, and all over town the bizarre brick structures built around immovable monuments came down. By August, Cott was able to organize another of the never-to-be-seen-again exhibitions which the war would make possible, making his magnificent selection from both the Roman and refugee pictures at hand.[35]

During the progress from Naples to Rome and beyond, the field organization of Monuments officers improved greatly. Two men, Deane Keller and Norman Newton, were assigned to the forward echelons of the Fifth and Eighth Armies, respectively, often arriving at a town within hours of its capture. They would immediately seek out local officials, post guards, and report damages and German depredations to colleagues who would take over as they moved on. Theirs was an odyssey that would be the dream of any peacetime traveller: up the coasts to Gaeta, San Giovanni in Venera, Ostia, and Pescara; past Palestrina and Tivoli, through the wild reaches of the Abruzzi to the fabled cities of Umbria and Tuscany. But they were the first to see the full effects of Churchill's "red-hot rake," and the dream trip was more often a nightmare.

Nor were they always well received by the locals: in one devastated village cold and hungry citizens were outraged that Monuments officers arrived before anyone else and were heard to complain that "they take more interest in old stones than in us." The shaken officer involved recommended that "no further visits be made . . . to deal solely with monuments

and works of art until it has been made known to the homeless population that plans are afoot to provide them with weatherproof shelters before winter."[36] In other places lack of interest was total. Archives specialist R. H. Ellis reported one town to be "a torpid and unsatisfactory place . . . much time wasted hunting up sleeping officials. . . . Archives finally seen with the Prosindaco, the village idiot, and a young lady who was found inside one of the rooms when it was unlocked."[37] No further explanation was given for this interesting situation.

Visiting village churches on the west coast, Keller found a pattern of pilfering and looting by retreating German troops: vestments strewn around, attempts to carve out inscriptions, scattered and rifled archives, and missing gold and silver church ornaments. Mines and booby traps were everywhere and physical damage was often terrible. In the little town of Itri, nestled in a rocky and strategic pass on the Via Appia, the Monument of San Martino was reduced to a twenty-foot heap of rubble. No church had a roof intact, and shell holes pocked walls and floors. Here and there in the devastation a statue or campanile would stand intact. In Terracina, described in the guidebooks as a "smiling little town," the bodies of more than two hundred Germans were discovered around the Temple of Jove. More were found in the museum in the Barberini Palace in Palestrina. At Frascati even the ancient galleys from the reign of the notorious Emperor Caligula, raised at great expense from Lake Nemi by Mussolini—the entire lake had been drained—were found to have been put to the torch by a retreating German artillery battalion.

North of Rome, where the Allied advance was much more rapid than had been the case in the preceding weeks, damage to the "art towns" between the Tiber and the Arno was far lighter. Orvieto's striped cathedral, high on its pedestal, was unharmed, and its movable treasures were found safely stored at Boito. Assisi, its irreplaceable frescoes by Giotto, Cimabue, and Simone di Martini joined by the evacuated works of Bergamo, Milan, and Foligno, had been declared a hospital town by the Germans and had been carefully protected by them. Siena, where flag-twirling representatives of the city wards joyously welcomed French troops on July 3, had also been so designated by Kesselring, and remained untouched except for last-minute looting of shops by the Germans, giving the lie to reports in the Nazi press that it had been totally destroyed by Allied artillery.

Italian officials of the town, German propaganda having taken its toll, were, nevertheless, suspicious of the new arrivals. The Superintendent of Fine Arts was convinced that the Allies would take everything with them when peace came and there was universal fear that French Moroccan and other "black" troops from "a different civilization" would not respect citizens or monuments.

The towered town of San Gimignano, badly shaken by artillery shells, was intact (contrary to press rumors), and heavily guarded by MPs who had put the entire town off limits to troops. And so the pattern continued: again and again the stores of priceless treasures were miraculously found to be safe and inviolate in the midst of carnage. The German Army and the Kunstschutz seemed to have generally respected the *ricoveri*. As the Allied Armies approached Florence, Monuments officers began to relax a little. They had been assured from Rome that the Florentine treasures, like those around Rome itself, had been removed from the battle zones, and were safe in the city.

As elsewhere, the Florentine collections had been sent to refuges in the surrounding countryside. In 1940 the former Medici villa of Poggio a Caiano and two other palazzos were requisitioned and soon filled with top works. The eight-ton bronze equestrian statue of Cosimo I de' Medici was dismantled and, appropriately, moved from the Piazza della Signoria to the gardens of Poggio on a cart pulled by four oxen. The trip took sixteen hours; at one point the surface of the road had to be dug out so that the ears of the horse could pass under a railroad bridge. Eighteen more refuges were eventually opened, some in private villas owned by well-known Florentines, others in such buildings as the Oratory of San Onofrio at Dicomano, where the major sculptures from the Bargello and the Duomo were stored. In November 1943 Kunstschutz chief Evers appointed Professor Ludwig Heydenreich, the well-known director of the German Art Institute in Florence, as his deputy with responsibility for the Tuscan region. Heydenreich was definitely of the same ilk as his Roman colleagues and deeply anxious to preserve the Florentine collections. The agreed policy of returning the contents of the *ricoveri* to Florence, negotiated by von Tieschowitz before he returned to France, was implemented, but due to problems of transport, and the ineffectiveness of Evers, progress was slow.

In February 1944 Evers was replaced by quite a different personality, SS Standartenführer Dr. Alexander Langsdorff, formerly of the Prussian State Museums, an archaeologist who had worked with none other than Sir Leonard Woolley before the war but who had subsequently graduated to the SS, serving at one point as a personal cultural adviser on Himmler's staff. By June constant bombing of the roads around Florence made further attempts at moving works of art unthinkable, and all agreed that everything must now be left in place.

On June 19, as the battle lines approached, the Kunstschutz and the rest of the German support staffs were moved back to Verona and other cities. Heydenreich was sent to Venice to work on protection there. Langsdorff left behind a farewell letter in which he commended himself to Sir

Leonard Woolley, and pointed out that the Kunstschutz had done its utmost to save the Florentine works.

In Florence, after the departure of these worthies, confusion reigned. No one seemed quite sure what exactly had been brought back to town and what was still in the refuges around the city. Nor, in the absence of Kunstschutz officers at field headquarters, did German troops know how to handle the deposits they encountered in the midst of their retreating lines. Kesselring therefore ordered all units to leave the contents of the deposits where they were, but to report any finds to headquarters and if necessary to hand over works to the Church.

On July 4 the German commander of Florence called in the Superintendent of Fine Arts, Signor Poggi, and told him that a huge deposit of 291 Uffizi and Pitti pictures in the Villa Bossi-Pucci at Montagnana would have to be moved, as the area was threatened by artillery. What he did not reveal was that they were already en route north. On July 3 General Greiner of the 362d Infantry Division had transported them to Bologna, where he was told to hand them over to the Cardinal Archbishop. For reasons known only to himself the prelate declined to accept this awesome responsibility. The Bishop of Modena also refused, and the pictures were temporarily deposited at the nearby resort town of Marano sul Panaro. A few days later another German unit suddenly appeared in Florence with the contents of another *ricovero* casually tossed into uncovered trucks. These were handed over to Poggi, minus two works by Cranach, the famous *Adam* and *Eve* from the Uffizi.

Upset at this evidence of paintings whizzing around the battle area with no professional supervision, Superintendent Poggi prevailed upon the German consul, still in the city, to recall Langsdorff to control further shifting about of works. Langsdorff did report to Florence, but it is clear that at Nazi headquarters in Verona his thinking about the duties of the Kunstschutz had changed. When he discovered that the Army was planning to take the "Germanic" Cranachs back to the Fatherland, he promised the reluctant officers that he himself would present them to the Führer. Then he hid them in his room at the Excelsior, without telling Poggi.

On July 18, after talking to local commanders, he informed Kesselring's headquarters, and also those of SS General Karl Wolff, who controlled all SS operations in Italy and was directly responsible to Himmler, that he was "taking in hand immediately supervision and direction of evacuation measures by our troops." He again did not bother to tell Poggi and left town without even saying goodbye, taking the Cranachs with him to the German embassy, now located at Fasano on Lake Garda. There, on July

22, he met with Wolff, who issued a special order authorizing the removal from any *ricovero* which could still be reached of "whatever could be saved of the endangered works of art belonging to the Uffizi and Palazzo Pitti in Florence," and gave Langsdorff eight precious trucks for the operation. The convoy left almost immediately for Florence, and arrived there at dawn on July 28 after three straight days and nights on the road.[38]

While this group was en route, another SS colonel by the name of Baumann, utterly uninformed in art matters but aware of Wolff's orders, had arrived in Florence and told Poggi that all the Florentine treasures including those in the city were to be moved. The unlikely duo of Poggi and the German consul were able to put him off by saying that everything except a number of huge sculptures had already left, and with straight faces toured the hapless Nazi around the biggest and least movable things they

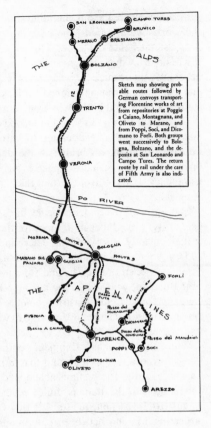

Frederick Hartt's map of the complicated travels of the Florentine works

could find, showing him such large works as Cellini's *Perseus* and the bronze doors of the Baptistry. They did not bother to show him the more movable Uffizi drawings collection, or the masterpieces from all over Tuscany which had been hidden in secret passages beneath the museum.[39]

But Poggi could not fob off Langsdorff as he had Baumann, and when the Kunstschutz chief arrived the Superintendent was forced to brief him on which *ricoveri* were in the greatest danger. Study of the military situation immediately indicated the sculpture deposit at Dicomano. Without allowing his men any sleep, Langsdorff ordered them to drive to the deserted

little town, where the only building still standing was the oratory in which the works were stored. The next three days were spent cramming the heavy statues onto the trucks with whatever machinery could be devised. It was not easy duty: the presence of the convoy attracted air strikes which constantly interrupted the work, and the drivers were forced to live on vegetables foraged from abandoned gardens, which they cooked into a sort of stew in a pot found in the wreckage of a house.

On the evening of July 30 the loaded convoy headed not back to Florence but to Wolff's headquarters at Verona. As the trucks crossed the Po on a rickety pontoon bridge in the dark of night, Allied bombs split open the cab of one and wounded its driver. Doggedly they continued on, using back roads to avoid further raids, and arrived at Verona at dawn on August 4.

The Fascist government, meanwhile, worried by this behavior on the part of its "allies," began to press for the return of the Florentine objects to their custody. But Wolff was determined to keep them under his control, and on August 5 Langsdorff was told that the Gauleiter of the new "Gau Tirol" had been ordered to find storage for the wandering masterpieces near Bolzano, well within the northern areas annexed to the Reich. The Gauleiter was carefully instructed not to choose a site near the Swiss border lest Mussolini somehow manage to whisk the works across it into neutral territory.

While the Dicomano shipment continued its journey up to Bolzano, Langsdorff ordered his assistants to return to Marano sul Panaro to arrange transport for the 291 pictures abandoned there previously, and these, also unbeknowst to the Italians, followed the sculptures toward Bolzano on August 10. It was none too soon. Perhaps tired of war, an officer of the unit protecting Marano had been entertaining the locals by driving several truckloads of the paintings around, "improvising shows here and there, in the open air, under the porticoes and in villas. The last halt . . . was at Villa Taroni, where a ball was given, with torchlight illuminations, while the paintings, a Titian among them, decorated the rooms. And sad to say, some well known Italian families, who were spending the summer in that neighborhood, came to the ball."[40]

An interim attempt to take the cache from the Medici villa at Poggio a Caiano, eleven miles northwest of Florence, on August 8, had been abandoned when Langsdorff, accompanied by SS General Wolff's aide-de-camp, was driven back by artillery fire. On August 19 Langsdorff's deputy Reidemeister was able to return to Poggio, where he found the castle full of refugees who were using the cases of paintings as bedsteads and cooking among them on alcohol stoves. Evidence that the lull in the artillery

barrage was not entirely coincidental is provided by a bizarre telegram sent at the exact same time from the German legation in Bern (via the Swiss Foreign Office) to the Department of State in Washington:

> German authorities Italy have stored in Villa Reale Poggio at Caiano . . . valuable artistic collections and archives concerning Tuscan Renaissance works. . . . German Government states there are no (repeat no) German troops in neighborhood Villa Reale and villa itself not used (repeat not) used for military purpose. . . . German Government desires inform American and British Governments it desires avoid bombardment or destruction Villa Reale.[41]

This was reinforced by similar announcements on the radio. Two days later, on August 23, thirty cases were finally removed from Poggio in the midst of renewed shellfire and taken off toward Bologna over the pitted roads. On their way back to base, not wanting to miss anything, the Germans collected forty-one pictures discovered by troops at the Villa Podere di Trefiano; these were instantly recognized by Langsdorff as being from the collection of Goering's erstwhile dealer friend, Count Contini Bonacossi.

At the same time other units had moved 196 more pictures and 69 cases of sculpture, among them Donatello's *St. George* and *David,* Michelangelo's *Bacchus,* and the Medici *Venus,* from the Villa Bocci and Castello Poppi near Bibbiena. The latter pickup had all the trappings of a Grade B movie: after a series of harassments and threats the townspeople were ordered at gunpoint to remain in their cellars while the town was mined and searches were made for hidden arms. While the citizens huddled miserably in total darkness, the Germans broke into the *ricovero,* tore open cases, and loaded what seemed to be a random selection into a single truck. In fact, the paintings jammed into the vehicle were carefully chosen and ran heavily to the northern schools so beloved of Hitler. Three Raphaels, two Botticellis, and Titian's *Concert* plus a Watteau and a del Sarto or two were thrown in for good measure. What was left behind was more amazing: Botticelli's *Birth of Venus,* Leonardo's *Adoration of the Magi,* and Michelangelo's *Doni Madonna* were scattered in the wide-open castle among the litter of the violated packing cases. Before they departed the Germans apologized to the mayor for not being able to take everything away, told him to protect the villa, and blew up the town gate and the only access road to the village.

By September 7 twenty-two truckloads containing 532 paintings and 153 sculptures, representing nearly half of the best Florence had to offer, had finally reached their mountain refuges. Arrangements at the arrival

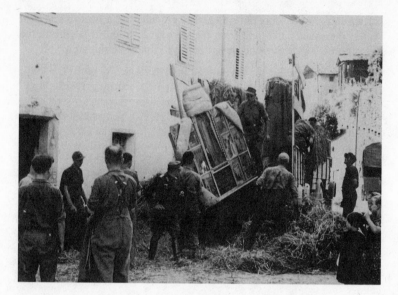

Germans unloading Uffizi pictures at San Leonardo (Kunstschutz photo)

end had not been much easier to make than those in the battle areas around Florence. Dr. Reidemeister had arrived with the first shipment at the assigned storage area, only to find that the entrances were so narrow that the trucks could not get in. This was just as well, as no one had noticed the presence of a major ammunition dump next door to the damp premises. The Gauleiter of the Tirol suggested that they continue on to the safety of Innsbruck or Bavaria, but Reidemeister later claimed that he had refused to do so as "it was the Führer's wish to safeguard these valuables on Italian soil, so that no one abroad should accuse them of looting."

An alternative site was not easily thought of; the area was full of Italian Partisans and Allied bombing was intense. Leaving the truckloads of art behind, and knowing that more were en route, Reidemeister, Dr. Josef Ringler of the Ahnenerbe's South Tirol Culture Commission, and the local Fine Arts Superintendent rushed off to look for another refuge in the remote mountain passes. The mayor of San Leonardo in Passiria showed them an abandoned jail which was perfect, but too small to hold everything. They rejected an old paper mill and one château half full of agricultural tools, offered by a kindly countess. But a coach house at the

Schloss Neumelans in Sand at Campo Tures, offered by another lady, proved ideal, and Reidemeister arranged for the trucks from Dicomano to be unloaded there on August 11.

On August 27 another shipment, which contained the famous Cranach *Adam* and *Eve,* got as far as an Army barracks in Bolzano and then ran out of gas. Rushing down to deal with this latest crisis, Ringler was shocked to find that the paintings had been loaded into the trucks without any packing materials or protection. On September 1, the quest for fuel having been unsuccessful, Ringler received the following telegram from General Wolff's headquarters: "Please load the five truckloads onto closed furniture vans, harness with horses or oxen, and convey to deposits." This being patently impossible, the search for gasoline went on. Ringler was of course competing with the retreat of the entire German Army across the Apennines. Five hundred fifty liters were finally produced on personal orders of General Wolff, but by now the weather was so bad that the convoy had to spend yet another day on the road before it was unloaded at Schloss Neumelans on September 5. Two days later, five more loads containing confiscated Jewish collections and the Contini pictures, all packed in excelsior taken out of fruit baskets found in a convent, went up to join the rest. The unloading took days, and the refuges were now full to bursting.

The remarkable and hasty evacuation of these works to the north coincided exactly with the Allied advance on Florence, which had never been formally declared an open city by either side. Allied reluctance was due to the very mixed signals being received from the Germans: on the one hand, Hitler had declared Florence to be "the jewel of Europe" and on several occasions had reaffirmed his desire that it remain unharmed. But on the other, he had again on July 3 exhorted his troops and Kesselring to hold the Arno line, to which Florence was just as pivotal as Monte Cassino had been to the Gustav line.

Florence, unquestionably an important communications and transportation center that would be useful to both armies, remained crammed full of German troops despite Hitler's declarations. Kesselring had left Rome and its bridges intact, thereby facilitating the rapid advance of Allied troops through the city, an act which Hitler now regretted. There was no question in Kesselring's mind that the situation in Florence would be the same. By mid-July tough retreating German paratroop divisions were taking up defensive positions south of the city, where on the nineteenth Hitler again ordered them to make a stand. According to one witness at Hitler's headquarters, he specifically declared that Florence itself was not to be a battleground, a statement which was communicated to the Allies through

the Vatican, and he confirmed this in conversations with Mussolini the next day.

But the next day was not an ordinary one. It was July 20, 1944, the day of the unsuccessful attempt on Hitler's life. Kesselring, whom Allied propaganda broadcasts had frequently suggested was not a strong Hitler supporter, and who had indeed often disagreed with the Führer, could not now afford to be seen as sympathetic to negotiations with the Allies or to be relaxing the defense of Italy. But even at this juncture the Allies, military and press alike, were sure that the Germans would leave Florence as quickly as they had Rome.

This confidence was not shared by those in the city. The German consul had been shocked to see a map showing plans for a large demolition area covering the central Florentine bridges, including the beautiful Santa Trinità (said to have been designed by Michelangelo) and the banks on either side. Only the Ponte Vecchio, Hitler's favorite, was to be spared. The consul protested to Ambassador Rahn, as did his Swiss and Romanian colleagues. They were told that the demolition "depended on the behavior of the Allies."

The latter, meanwhile, had made a public relations error of major proportions. On the morning of July 29 General Alexander had broadcast a message to the Florentines exhorting them to defend their city's utilities, prevent the enemy from exploding mines, and protect rail communications. Most of these instructions were already moot, the Germans having destroyed these facilities some days before, and the only effect was to endanger anyone walking about. The message ended with the fatal statement that "it is vital for Allied troops to cross Florence without delay in order to complete the destruction of German forces on their retreat northwards."[42] In case everyone had not heard the broadcast, the message was printed on leaflets and showered over the city.

During the next two days the Germans evacuated some fifty thousand citizens from the bridge areas. On August 3 the populace was ordered to close itself inside and stay away from the windows. At about ten that night Bernard Berenson, watching from his secret hiding place outside Florence, and unaware that a considerable portion of his own collection had just been destroyed, saw "a Neronian spectacle of a huge fire . . . a great explosion burst from the heart of Florence: it threw up a serpentine jet of smoke that reached the sky."[43] At the Pitti, glass rained down on displaced householders camping in the courtyard. It took three tries to destroy the beloved bridge of Santa Trinità. The next morning British troops entered the southern sections of the city. As in the case of Monte Cassino, controversy as to who was to blame for these events went on for years. Suffice it

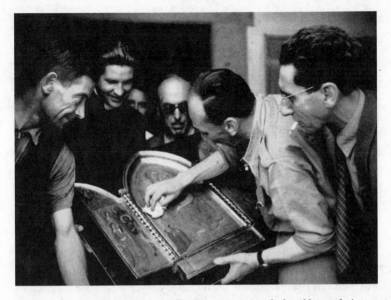

Dr. Fasola (center, with glasses) *and colleagues retrieving works from Montegufoni*

to say that it was a logical military act for Kesselring, surely approved by Hitler, to delay his enemy's advance, and indeed the Allies did not gain control of the north bank of the Arno for almost two more weeks.

With Florence in the center of the battle zone, museum officials had little idea of what had happened to their works of art. Inspection of the *ricoveri* was dangerous, but on July 20, Professor Cesare Fasola, librarian of the Uffizi, bravely set off on foot toward the front lines to check the depositories. Arriving at the Villa Bossi-Pucci at Montagnana, Fasola was amazed to find it already deserted and nearly empty: "The doors and windows were wide open and wrenched off their hinges. . . . I entered through an indescribable state of disorder only to find that an almost total clearance had been effected . . . there still remained a few priceless pictures: Perugino's *Crucifixion* lying on the ground in the midst of rubbish and debris. . . ." The library books had all been thrown down and trampled upon.

In the twilight Fasola walked on to Montegufoni, a villa owned by the eccentric Sitwell family, where he found comparable disorder and filth. The cases of the pictures had all been opened and moved, some "piled up in a dark corridor where a fetid smell left no doubt as to the use that had

been made of this passage," but few seemed to have been taken. Accord-
ing to the caretakers, the disorder had been caused by the front-line para-
chutists and SS troops who still held it. The chaos and danger to the
collections was increased by nomadic groups of refugees who constantly
passed through. For days Fasola acted as a one-man police force, begging
and pleading for his pictures with the troops:

> The best thing to do was to try to be present everywhere. Whenever
> soldiers appeared I went and met them, I greeted them, I talked to
> them, and I accompanied them on their visit to the Castle, as if it were
> a Museum. Sometimes I managed to lead them right to the other end
> of the building and to show them out. What a relief! In the meantime
> I tried to explain to them that it was a question of important works,
> admired by the Führer.[44]

After a dramatic night in the cellars ("The rattling of the machine guns
draws near, it becomes lacerating and crashes against the doors of our
shelter") the Germans were replaced by New Zealanders, and Fasola's ed-
ucational measures were begun anew. Soon after came the press; "Great
was their surprise and equally great their joy when they found themselves
face to face with our masterpieces," he later wrote. This was quite an un-
derstatement. Two British reporters, Vaughn Thomas and Erik Linklater,
had entered the castle to interview Indian troops and indeed come face to
face with Botticelli's *Primavera.* Looking around they saw more and more
familiar pictures, among them such greats as the *Rucellai Madonna.* All
were unboxed and surrounded by soldiers making tea. Outside, less than
half a mile away, they could see a line of German tanks, their guns aiming
at the villa.[45]

The four Allied Monuments officers assigned to Florence, waiting impa-
tiently behind the lines near Lake Trasimeno for the liberation of the
city, heard this news on the morning BBC broadcast. First Lieutenant
Frederick Hartt immediately set off in another of the few and legendary
Monuments jeeps, which had begun its career in North Africa and gone
on through Sicily and Sardinia. Skirting ruined towns and frequently
blocked by artillery activity, Hartt took all day to make the ninety-mile
trip north.

The next morning, with shells still screaming by, he inspected the many
rooms of stacked pictures at Montegufoni, now carefully guarded by the
Indian regiment. Most were unharmed, but some, such as Ghirlandaio's
Adoration of the Magi, which Fasola had discovered being used as a table
by the Germans, had suffered considerably. The sight of Montagnana and

other refuges still under fire brought home the enormous potential losses. Skipping the normal channels, Hartt asked BBC-man Thomas to take a message directly to the Eighth Army commander and ask for extra guards for these and future deposits. The discovery of the *ricoveri* had caused such excitement that General Alexander himself, the Supreme Commander for Italy, came to visit the scene on August 3, to the immense gratification of Professor Fasola, to whom he seemed a "Homeric hero."

Hartt, now assisted by various colleagues grouped at Montegufoni, spent the next days driving and climbing to the other *ricoveri* to check their contents and post guards where he could. There was no question of moving anything in this constantly shifting battlefield, especially as Florence itself was not secured. Hartt and Langsdorff must have been nearly in sight of one another on more than one occasion as the extraordinary minuet of the masterpieces proceeded. For the Allied Monuments officers, encounters with great works in strange places were often overwhelming. Opening a storeroom which had also been used by the Germans as a garage at Torre a Cona, Hartt saw "in the sudden sunlight which streamed through the outer doors . . . the colossal statues by Donatello and Michelangelo . . . still in their protecting crates. Unable to suppress an exclamation of shock and wonder I climbed over the crates, identifying with great emotion one after another until I found myself gazing through the bars of a crate into the agonized face of Michelangelo's *Dawn,* every tragic lineament disclosed by the light from the door."[46]

Although Allied troops arrived in the southern section of Florence on August 4, they could not move into the center until after the eleventh, when the Germans withdrew from the river. The northern parts of town remained in German control until the third week of August. In the meantime, life on both sides of the river was miserable. The Pitti and the Boboli Gardens had become a great refugee center where six thousand citizens evacuated before the bridge demolition were living in terrible squalor.

When Hartt first entered the courtyard of the Pitti on August 13 he was greeted with jubilation and relief by the two top Florentine art officials, Drs. Poggi and Procacci, who related the recent events with great emotion. They went immediately to the river. Huge piles of rubble lay along the banks, but it was still possible to cross the Ponte Vecchio. The ruins were filled with mines, and raw sewage spewed out over the devastation. Herbert Matthews of *The New York Times* reported that "Florence as the world knew it is no more," and although the great monuments remained intact, "it will not be the Florence of the Medici, it will not be that perfection, that utterly harmonious atmosphere that made it unique in the world."[47] At the Uffizi all the windows and skylights were gone and decorative frescoes

hung down from the walls. Someone had written in chalk below the statue of Dante in the colonnade of the empty Uffizi:

> *In sul passo dell'Arno*
> *I tedeschi hanno lasciato*
> *Il ricordo della loro civiltà*[48]

(In the crossing of the Arno/The Germans have left/A souvenir of their good manners).

Allied control was not total until late August. This was sometimes a mixed blessing, as the problems of Military Government already encountered in Sicily and Naples began to recur. Lieutenant Hartt was relentlessly pursued by villa owners trying to have their houses declared "*monumenti nazionali*" and thereby avoid billeting of troops, and by homeless refugees who confused him with the displaced persons officer Lieutenant Dart. Army units schemed to be allowed to set up in the Pitti Palace, and repair estimates and proposals by the hundreds arrived to be pushed through the various bureaucracies.

There were more frivolous requests: one Florentine count, immaculately attired in "a white linen suit, a blue shirt and a boutonnière,"[49] came to discuss the reopening of the race track in the Cascine. Despite these irritations the Monuments officers found plenty of volunteers who patrolled the city each morning and picked up fragments of sculpture and architecture knocked off by the night's shelling, and others who spent their days diving into the now filthy Arno to retrieve what remained of the adornments of the Ponte Santa Trinità. (All but the head of the statue of *Spring* were recovered, and that suddenly appeared on a sandbank three hundred yards downstream in 1961.)

Hardest of all was the need to deal with officers totally oblivious to historic preservation. Hartt could not persuade Army engineers to stop bulldozing away salvageable fragments of the ancient buildings blown up by the Nazis, along with the books, manuscripts, and works of art which had been inside. Happier was quite another engineering feat undertaken to return the statue of Cosimo I to the city. The oxcart in which he had departed was replaced by a ten-ton wrecker from the 477th Ordinance Evacuation Company, and the separated horse and rider were loaded in short order by an Italo-American team directed by Deane Keller. A soldier rode on the horse to lift or cut power lines. As the truck approached Florence, people in small villages cheered and rushed out from their houses. Just outside the city, a snappy escort of MPs on motorcycles joined the convoy, which now progressed with sirens sounding to the Piazza della Signoria. A carriage driver on the route raised his hat and shouted "*Cosimo, bentornato!*"

Keller's report on the event tells every detail. "This is a long report on a relatively simple operation," he admitted. But for him it was "a large and important undertaking in terms of giving pleasure to a people who have suffered and in establishing happy relations between these people and their present military governors."[50]

Despite the lion's share of attention showered upon it, Florence was not the most devastated city in northern Italy. Through the fall of 1944 great efforts were made to salvage other victims of the "red-hot rake." In the small town of Impruneta the beams of the basilica of Santa Maria lay like a giant game of pick-up sticks, covering blasted open, bone-filled tombs, shattered della Robbia plaques, and twisted paintings. Lucca, Pistoia, and Arezzo had much damage. Pieve had been systematically blown up, house by house, by the retreating Nazis; the only thing still standing was an enormous terra-cotta *Assumption of the Virgin* by della Robbia in a little chapel, itself on the verge of collapse. The townspeople refused to let Monuments officers remove the relief to safety, crying, "*E tutto quello che ci rimane!* [It's all we have left!]" When they returned some months later they found the relief secured, the streets cleared, and even a suspension bridge, built by the villagers themselves, spanning the river.[51]

The full effects of battle had fallen on Pisa and its port city of Livorno, where intense fighting had gone on for nearly forty days. Picking his way through the deserted and mined ruins on September 3, Deane Keller made his way with trepidation to the famed group of monuments known to the most untutored tourist. The Leaning Tower stood intact, if somewhat pockmarked. The Cathedral's roof was full of holes, the Baptistry unharmed. But the Campo Santo, the ancient cemetery of the city which forms one side of the famous square—built according to tradition on earth brought back by the Crusaders in the thirteenth century and surrounded by delicate Gothic galleries which enclosed some forty thousand square feet of frescoes by Benozzo Gozzoli and a host of other artists—lay in a twisted, fire-blackened mass before him. So intense had been the heat that the lead of the roof had melted and run down across the frescoes and tombs. Hanging fragments of painted plaster lay open to the rain. It had been this way since a July 27 artillery bombardment, probably Allied and probably aimed at the Leaning Tower, which was thought to be a German observation post.

Keller realized immediately that only fast action could save the Campo Santo. General Hume, the highest-ranking Civil Affairs officer, inspected the ruins within days. Fresco specialists were sent from Florence and Italian soldiers attached to Fifth Army, directed by American engineers,

Pisa: Under the Army's protective roof, restorers work on the frescoes of the Campo Santo.

worked to lift the sheets of lead from the floors. Everyone pulled together, including the Fascist former Superintendent of Pisa, who otherwise would have been in jail. Conditions were not easy. For three more weeks the Germans bombarded Pisa from the other direction. Water and light were not reconnected for nearly six months; there was little food other than Army rations. The few restaurants still standing could offer only "unidentified boiled vegetation" to the group working to get a temporary roof up before the autumn rains. The effort succeeded: by mid-October a canvas shelter was in place, thousands of fragments had been collected, and the frescoes had been secured with various ingenious forms of netting and supports.[52]

As if everyone had not had enough, the rains certainly came in October, swelling the Arno, which flooded the Florentine ruins, and making the Army's life miserable for what would be a second winter holed up before

another of Kesselring's seemingly unending series of defensive lines. And still, as winter approached, Allied Monuments officers remained ignorant of the fate of nearly half of Florence's greatest treasures.

Churches and villas full of museum collections were not the only things in the Tuscan hills. In the midst of this gigantic battlefield daily life of a sort went on for private citizens both native- and foreign-born. Tuscany had always attracted a large and cultured expatriate community. In and around Florence, installed in houses overflowing with precious books, paintings, and *objets,* lived professors of the German Art Institute, intellectual British spinsters, consuls of many nations, odds and ends of various Royal families, and art-world celebrities such as Bernard Berenson and Sir Harold Acton.

At the outbreak of war many of Allied origins found themselves technically enemies of Italy, but Mussolini's Fascist government, already so long in power, was not intolerant of these longtime residents and in general they were left in peace. The fall of Mussolini brought confusion, which soon changed to dread as inhabitants noted the arrival of great numbers of Germans. The Badoglio surrender changed everything. Communications were controlled by censors. Private cars were confiscated. A whole secret life developed as Italian families hid sons and husbands who had abandoned their army and now sought to avoid German manpower roundups. Others hid Allied prisoners of war released by the Italians. Anti-Jewish measures, enacted by Mussolini at Hitler's urging, but far less stringently enforced, were soon brought into line with the rest of the Reich. Transports to concentration camps began in October 1943, and on November 30 a law was passed authorizing the seizure of Jewish property; in Italy too the confiscations could now begin.

More frightening to everyone than the Germans was the new Republican Fascist government, which consisted of the worst remaining elements of the old regime, thirsting for vengeance. Anyone even remotely related to the Italian Royal Family or the court was regarded by Fascists and Nazis alike as a traitor and was in grave danger. The Florentine SS/Gestapo— made up of Italians—was under the leadership of a certain Carità, who belied his name by arresting retired ladies-in-waiting and torturing members of distinguished Florentine families. This was often too much even for the Germans, and especially their consul Gerhard Wolf, who frequently negotiated the releases of Carità's victims.[53]

Hostages, reprisals, and confiscations became the order of the day. The Italian King's coin collection was sent to SS headquarters in Verona and the collections of the Duke of Bourbon Parma were removed to Castle

Dornsberg, near Merano.[54] By October 1943 reports of confiscations of furs, jewelry, and silver began to be heard. On the fourth, Marchesa Iris Origo, an Anglo-American married to an Italian, wrote: "Spend the day in packing linen, blankets, silver etc. to be concealed in an attic which we will wall up in preparation for the German retreat."[55] By November her family's house in Fiesole, the famous Villa Medici, had been requisitioned. The Germans did allow her to remove the most valuable furniture and the linen, glass, and china, an uncommonly kind gesture, the occupying unit's commanding officer being mainly interested in the piano, as he was a composer who had written an opera about Napoleon.[56]

The retreating paratroops did not come until the following summer. In June 1944 units of Germans, some civilized, some not, followed one another in rapid succession at another Origo villa in the Val d'Orcia south of Siena, sleeping everywhere, bathing in the laundry rooms, setting up and removing artillery in the gardens. Just beyond these, bands of trigger-happy Partisans, sometimes of unclear politics, roamed the woods and were apt to appear with demands for food and other necessities which more and more they simply "liberated." Meanwhile, Allied bombs fell on villages for no apparent reason, and leaflets rained down from the sky with dramatically opposed instructions from each side. It was hard to know what was going on. In the middle of June, when the Marchesa asked a German officer if he was going to the front, he laughed and replied, " 'And where do you think *you* are?' " Surprised, she wrote, "This is a new idea to me, who, like most civilians, think that the front is somewhere we are not."[57]

Feeling that their presence was a restraint on looters, villa owners stayed in their houses as long as they could. But on the twenty-second of June a German artillery officer warned the Origos that they should leave immediately. The troops now arriving were the filthy and exhausted echelons of the First and Fourth Paratroop Divisions, who after years of fighting no longer cared about anything but the most basic necessities of survival. Eight days later, the front lines having passed on, the Origos returned to find the villa a shambles, a scene to be repeated randomly all across Italy and France. The Marchesa's description of this violation of personal life serves for them all:

As we drive up to La Foce, chaos meets our eyes. The house is still standing, with only one shell-hole in the garden facade . . . and several in the roof. . . . In the garden, which has also got several shell-holes and trenches for machine-guns, they have stripped the pots off the lemons and azaleas, leaving the plants to die. The ground is

strewn with my private letters and photographs, mattresses and furniture stuffing. The inside of the house, however, is far worse. The Germans have stolen everything that took their fancy, blankets, clothes, shoes and toys, as well, of course, as anything valuable or eatable, and have deliberately destroyed much of sentimental or personal value. . . . In the dining room the table is still laid, and there are traces of a drunken repast; empty wine-bottles and smashed glasses lie beside a number of my summer hats (which presumably have been tried on), together with boot-trees, toys, overturned furniture and W.C. paper. . . . The lavatory is filled to the brim with filth, and decaying meat, lying on every table, adds to the foul smell. There are innumerable flies. In our bedroom, too, it is the same.[58]

The exact location of the missing Florentine masterpieces remained a lingering mystery to Allied Monuments officers and ostensibly to Italians of both sides throughout the fall and winter of 1944–1945.[59] From their side the Allies kept up propaganda pressure, accusing the Germans of looting and theft. This was rebutted by Langsdorff, who was also being badgered by the Fascist Italian government, and who as early as September 18 had asked von Weizsäcker at the Vatican to inform authorities there of the location and safety of the articles.

As the propaganda continued, the Germans began to prepare a careful inventory and damage assessment of the holdings which despite all were generally in good condition. Fascist Minister of Education Biggini was persuaded to broadcast a comment on the "loyal co-operation of the German Fine Arts authorities in the protection of Italian works of art," and on October 17 Langsdorff held a press conference in Milan on the same lines. But privately the Fascists now challenged him to prove the truth of his claims, and the presence of the objects in Italy, by allowing them to inspect the *ricoveri*.

This was also promoted by certain of his own colleagues, led by former Florentine Kunstschutz chief Heydenreich, who suggested that the Führer should announce that the Florentine works were "being held in trust for the Italian nation" under the direct care of the Kunstschutz, and that a committee of German experts, which he cleverly urged should include Dr. Voss, director of the Linz collection, should be formed to inspect the pictures at regular intervals.

Soon pressure for information on the fate of the Florentine treasure became so intense that Hitler, on the recommendation of Ambassador Rahn, gave permission for Carlo Anti, Fascist Director General of Fine Arts, to inspect the deposits on November 28. A few days later Anti announced the

safety, but again not the location, of the treasures to the outside world. In the meantime, Allied Monuments officers in Florence had heard from the Vatican, which informed them only that the cache was at "Neumelans in Sand," a mysterious name not to be found in their reference books. If Florentine Superintendent Poggi realized where this was, he did not inform his Allied colleagues.

A visit to the refuges by quite a different delegation on December 10, 1944, seemed to the few who knew of it to make clear the true destination of the magnificent collections. Bormann's assistant von Hummel from the Reichschancellery and Professor Rupprecht from the Linz organization arrived with a Munich dealer named Bruschwiller. The Führer Reserve was being updated. As usual, none of the Kunstschutz officers was privy to the consultations of these gentlemen. Immediately following their tour, General Wolff was ordered by Himmler to take the contents of the *ricoveri* to Austria. This he refused to do on the always plausible grounds of lack of transport. But perhaps to show that his loyalty was unwavering and his belief in the ultimate triumph of the Fatherland unfailing, he ordered photographers to prepare an album of the contents of the *ricoveri,* carefully designed to match previous such volumes from Poland and France, for the Führer's birthday on April 20, 1945.[60]

By January everyone, Allied, Kunstschutz, Fascist, or otherwise, believed for their various reasons that the treasures, now completely in the control of the SS, were intended for the Führer's collections. They could not know that the objects had become pawns in the elaborate end game of the war in Italy. The central figure in this shadowy web of events was SS General Wolff himself, whose rank put him second only to Himmler in the Nazi hierarchy.

Wolff had for years been Himmler's personal assistant and liaison with Hitler and von Ribbentrop, and as such had their trust and total access to the highest circles. The Führer, aware of Wolff's talents, had sent him to Italy as a quasi governor general who would keep an eye on Mussolini.

As the ultimate defeat of Germany became more and more apparent, Wolff began to think it imperative to open negotiations with the Allies. His first initiatives were conveyed to an American OSS office in Switzerland, headed by Allen Dulles, where they were regarded skeptically, it being well known that Hitler wanted to divide the Allies and try to get the United States and Britain to join him against the Russians. The SS General now had to wait for further opportunities while maintaining his apparent loyalty to the Reich. The works of art were extremely useful in his double game. By refusing to give them to the Italians, and having the album made for Hitler, he made clear that he was saving them for the Führer Reserve.

*Alexander Langsdorff (*second from right*) showing British MFAA officer J. B. Ward-Perkins the Kunstschutz repositories*

By refusing to allow them to be removed from within the boundaries of what the Allies considered Italian territory, he demonstrated his good faith in that quarter.

Wolff did not hide his negotiations. In an early February meeting he convinced his Commander in Chief that he was indeed promoting Allied dissension. Shaken by Hitler's physical condition and his adamant refusal to consider an end to the fighting, even after the failure of the Battle of the Bulge, Wolff returned to Italy determined to redouble his efforts. Dulles finally agreed to see him on March 8. To prepare for the meeting, the General had sent ahead a sort of résumé of his career and good deeds in Italy which included, to the amazement of the OSS men, a list of almost all the Florentine works of art they had ever heard of, which Wolff claimed to be able to deliver to them.[61] By April 13 the negotiations had progressed so well that Wolff had even agreed to have an OSS radio operator installed in his headquarters in order to facilitate communications.

But the Allied High Command, determined to pursue an unconditional surrender to the bitter end, obsessed with the idea of a Bavarian Redoubt, and accused by Stalin of bad faith for these separate negotiations, on April

20 ordered the OSS to break off all contact. This was extremely awkward. Before Dulles could inform Wolff he discovered that the SS General and representatives of the Wehrmacht, whom he had persuaded with great effort to join him, had already arrived in Switzerland prepared to sign a surrender. While Dulles radioed Supreme Headquarters in Caserta hoping for a change in policy, Wolff received yet another exhortation from Hitler, ordering his armies to hold out at all costs. Wolff realized that he must return to his headquarters in order to prevent chaos, but the other members of his party stayed behind. Before he left, he handed Dulles a handwritten note indicating the locations of the Florentine treasures and advised him to send Army units to protect them from plunder. Four days later the Allies reversed their policy, and the German officers were flown to Caserta, where in absolute secrecy they signed the surrender of Italy, which was announced to the world on May 2.[62]

Within days Monuments officers and Italian Fine Arts personnel were on their way to the Brenner Pass. Here on the borders of the Reich the world seemed upside down: in Bolzano, Germans of "colossal arrogance," not yet confined to POW camps, outnumbered the victors ten to one and were living and feasting happily in the best hotels while the Americans camped miserably in tents and "the Military Government Provincial Commissioner had to plod about the town on foot, hot, red faced and dusty, while haughty and glittering SS Generals sped past in motor cars loaded with blondes."[63] Dulles's assistant, Gero von Gaevernitz, invited to see Wolff a week later, found much the same scene: the German Army "enjoying springtime in the Alps . . . consuming their remaining supplies of food and drink. . . . It was a peaceful scene, rather like lunchtime at the M-G-M studios." He too had trouble getting a hotel room away from the conquered, and was received in great style at Wolff's headquarters in the Palace of the Dukes of Pistoia. Farther up the road to the Brenner the Monuments men found no Americans at all. The countryside seemed entirely in the power of heavily armed Germans.[64] But it was worth the trip: in the narrow jail cells at San Leonardo there they all were, without cases and squeezed dangerously together: Titian's *Philip II,* Caravaggio's *Bacchus,* the great Bellini *Pietà,* and, modestly hidden under an old bedspread, Cranach's *Adam* and *Eve.*

At Campo Tures, or "Neumelans," Langsdorff impatiently awaited them. Here a number of pictures were packed in cases newly labelled "Kunstwerke aus Italienischen Staatsbesitz." Reidemeister and Langsdorff, brought down to earth during frequent interrogations administered by British Wing Commander Douglas Cooper, collector and art historian turned specialist Intelligence officer, and by the unglamorous life in the

Fifth Army brings the Florentine treasures home.

POW enclosures, cooperated fully. After the inventories and lists were checked, all but ten works, which included a pair of tiny and extraordinarily valuable paintings by Pollaiuolo depicting the Labors of Hercules, were accounted for.

The public relations importance of this recovery was enormous, and Fifth Army—and anyone else who could get into the act—threw themselves into the arrangements for the return of the treasures with gusto. A heavy guard was posted around the buildings. The Italian Resistance found packers. Fifth Army Commander Lucien Truscott's personal plane was sent for fire extinguishers. It was a big operation, and there was no little pride involved:

> The day the Germans took stuff to the jail at San Leonardo it was raining. The trucks were open and old, the pictures were covered with a few blankets and resting on loose straw. U.S. Army, it is hoped, will do a bang up job just the opposite of this.[65]

A train was made up of thirteen freight cars, some with special doors, interspersed with guards' vans. Special cranes lifted the sculptures. On went Michelangelo's *Bacchus* and Donatello's *St. George.* Everyone was very nervous: the priceless shipment, listed simply on the waybill as "Art Treasures," was valued even then at $500 million.

In Florence a batch of crates were unloaded onto beflagged trucks and, escorted by two jeeploads of curators and Monuments officers, paraded through the hot streets with a sign reading simply, *"Le opere d'arte fiorentine tornano dall'Alto Adige alla loro sede* [The art works of Florence return from the Alto Adige to their home]." In the shade of the packed Piazza della Signoria, Fifth Army General Edgar E. Hume officially gave the cases to the mayor of Florence. "A spontaneous ovation was given the General by weeping and emotionally touched citizens," Keller later reported. Hartt was overcome by the "sincerity and spontaneity of the population," who crowded around General Hume, "embracing him, weeping with joy, striving to touch his uniform." The war seemed really over. Later, the ever-practical Keller noted, "a good banquet followed."[66]

Within weeks of these festive events the Monuments officers in Italy found their jobs had come to an end. Disappointed and frustrated at having to leave many of their projects unfinished, they were moved on. It would be up to the Italians themselves to complete the job. To one man in particular it seemed far from finished: Rodolfo Siviero, mysterious member of the Italian Resistance, who had been collecting tidbits of art-related intelligence for years, was not satisfied with the return of the national collections alone. Much from Italy had been confiscated and been sold or given to the Nazi hierarchy. Siviero felt that all these objects should return to Italy. He would find that many did not agree.

X

TOUCH AND GO

The Allies Take Over:
Northern Europe, 1944–1945

> I cannot resist the temptation to recount the efforts
> made to save my treasures. It illustrates how little
> planning and plotting mattered; how much it was
> touch and go.
> —Bernard Berenson, *Rumor and Reflection*
> October 1944

Immediately after Roosevelt and Churchill had decided on the invasion of
Northern Europe in August 1943, the Joint Military Staffs had begun to
discuss strategy for the event. The shadows of World War I affected both
camps. To the Americans the proper place for fighting Germany was not
Italy or Africa, but the north of France. The British, remembering the ter-
rible attrition of trench warfare in Flanders, were reluctant to enter this
territory again. But at the Teheran Conference in early December, with
pressure from Stalin, who had long wanted a second front, the invasion
policy was reaffirmed. Roosevelt informed Eisenhower of his appointment
as Supreme Allied Commander on the way back from the Conference.

Now Eisenhower was where he had always wanted to be. The excite-
ment of the coming campaign in France was all-encompassing. The Amer-
ican leaders envisioned a swift withdrawal of forces from the European
theater for possible redeployment in the Far East after the inevitable Al-
lied victory, which, they felt sure, would take place in 1944. The occupied
nations would revert to the control of their duly elected governments and
Germany would be punished so that it could never burst forth again. Just
exactly how all this was to be effected remained to be determined, al-
though plenty of people had very strong ideas on the subject.

* * *

To Lieutenant Colonel Sir Leonard Woolley in London it was quite clear from events in Italy that there was no time to waste on preparations for the European invasion, even though no one yet knew exactly when that would take place. He appointed the Slade Professor of Fine Arts at Cambridge, Geoffrey Webb, to direct Monuments operations for SHAEF (Supreme Headquarters, Allied Expeditionary Force), as Eisenhower's headquarters were known, and brought in an American officer, Calvin Hathaway of the Cooper Union Museum, to assist. Together, in December, they drew up the first draft of the directives which would be given to Monuments officers in the European theater.[1] They proposed that a lieutenant colonel and two majors head the operation and particularly insisted that officers in the field not only be concerned with the protection of buildings and the prevention of looting but with "evidence . . . of theft by the Germans . . . with a view to subsequent compensation or restitution under the terms of the peace settlement." They included a clause requiring that reports be sent directly to the Roberts Commission once a month as well as to Civil Affairs headquarters in London.

By March, Mason Hammond and a number of other officers had been sent north from Italy to join in this effort, and by April the Monuments men, divided into groups responsible for planning for different countries, plus a pool of eight men who would be assigned to forward elements of each Army, were all organized. They were determined to avoid the rigid system which had been so disastrous in Italy. The "pool" officers were to be sent to whatever region or Army, British or American, needed them most. Lists and handbooks were prepared, and maps supplied to the Air Force. The long technical instructions written by Stout and Constable were boiled down into a two-sided instruction sheet.

It all seemed marvelous on paper, but in the last weeks before D-Day, reality hit. SHAEF took one look at the list of 210 protected monuments in Normandy and rejected it because there would be no place left for the billeting of troops. The Monuments men gently pointed out that many of the monuments were prehistoric stone circles and dolmens, unsuitable for residence, and at least 84 were churches. Mollified, the strategists accepted the list.[2] Much worse was the fact that the final "table of organization" for the invasion left the MFAA (Monuments, Fine Arts, and Archives) section, as they were now called, out entirely, with the result that within days other parts of the Army began refusing to send them supplies or mail as they had no exact "status."[3] This was not rectified (with many apologies, it must be said) until May 29, three days after Eisenhower had sent out an eloquent order, similar to the one issued for Italy, exhorting all commanders to "protect and respect" historical sites,[4] and a sup-

London Daily Mail *cartoon, March 1944, responding to German art destruction propaganda (Cartoon by Illingsworth* © London Daily Mail)

porting directive stating that Monuments officers should be "utilized to the best advantage in the areas for which they are responsible"—thus proving that they really did exist.

The efforts of the Roberts Commission had by now also persuaded the Navy to release George Stout from a job dealing with airplane paint and had secured the services of First Lieutenant James Rorimer, former curator at the Cloisters in New York, so that the Monuments contingent now numbered seventeen. But Stout's proposal for a mobile group of ten or so conservators had not been accepted. As it turned out, he would, for most of the campaign across France and Germany, be a group of one.

News of London developments still did not reach the Roberts Commission through official channels, but only through private letters from Woolley and his protégés in England. These friendly missives did nothing to cheer up the news-starved Commission, which was already worried by Woolley's domination of the MFAA organization. They had, in fact, already begun a campaign to have an American officer of flag rank, loyal to them, assigned to England to replace Woolley in the councils of SHAEF. For this job they found a reserve brigadier general with architectural training named Henry Newton. So anxious were they to get someone overseas to compete with Woolley that they chose to keep Newton on even after his rank was reduced to colonel for the incompetence he had demonstrated while commanding an Engineer battalion in maneuvers earlier that year.

(The problem had been that Newton "did not have an Engineer company in the right place at the right time," which had led to enormous traffic jams of tanks at a river crossing. This was to be all too characteristic of his future performance.) In a long apologia addressed to Paul Sachs, Newton dismissed his error as a "picayune" matter.[5] Sachs was still impressed by the former general and felt that "only he can speak for the General Staff and the Armed Forces *as well as for us*" and therefore coordinate the work of "our good fellows."

Fortunately, one RC member, Librarian of Congress Archibald MacLeish, had already been given a London mission on a State Department delegation led by then Congressman J. William Fulbright, and had gone over by air armed with a list of questions related to the status of works of art owned by private collectors. MacLeish's mission brought him into contact with the Conference of Allied Ministers of Education, which had still not taken any very concrete steps to decide how to control movable works of art at the end of hostilities. He was now able to brief them on actions taken in the United States by the Roberts Commission.

The RC had also begun to receive copies of the Treasury reports on the intercontinental machinations of the art trade. It seemed to them that at the liberation of Europe there might be an explosion in sales of the illegally acquired objects bottled up on the Continent since the establishment of the British blockade. Such a dispersal would make recovery almost impossible. According to the 1943 declaration of the exiled governments in England, "illegally acquired objects" meant anything at all transferred in territory occupied by the Axis, even if the transaction appeared to be legal. An immediate freeze on the movement of works of art from the Continent at the moment of an Armistice was recommended by many, including Georges Wildenstein, who piously warned that a barrier should be set up against the "functioning of the diabolic plan prepared by the enemy for his profit for the post war period."[6]

In response to these fears the RC had recommended to the Treasury in February that Customs agents be instructed to hold any art objects entering the United States worth $5,000 or more, or any object of historic, scholarly, or artistic interest which was suspect, until satisfactory proof of origin was submitted. The Commission would assist in these investigations.[7] This came into force on June 8, 1944, as Treasury Decision 51072.

Shortly thereafter, the United Nations Monetary and Financial Conference (known as the Bretton Woods Conference) issued an international resolution reasserting the January 1943 declaration. Furthermore, since "in anticipation of their defeat" enemy leaders were transferring assets, which included works of art, "to and through neutral countries in order to conceal them and perpetuate their influence, power and ability to plan fu-

ture aggrandizement and world domination," the United Nations recommended that the neutral countries prevent the exploitation of these assets within their borders.

All American embassies were now ordered to gather information on the assets and activities of Axis nationals in their jurisdictions and relay it to the State Department under the code name "Safehaven." This would be added to the data already being gathered by the economic warfare agencies of the various nations. The art market was considered an especially likely place for the concealment and international movement of assets, the theory being that Nazis could hold their ill-gotten works for some years, until public interest had subsided, and then sell them. Nobody mentioned it, but non-Nazis could, of course, do likewise.[8]

All of these initiatives were now conveyed to the nine Allied Ministers of Education, who had created their own Commission for the Protection and Restitution of Cultural Material, known as the Vaucher Commission. This group envisioned nothing less than a vast pool of information listing every work thought to have been taken or illegally sold; every dealer, curator, artist, or official who might have related information; every reported victim and his location; as well as an index of places to be protected. All this would be gleaned from reports and rumors brought by refugees, spies, and Resistance groups, German press clippings, secret messages, and personal letters, and be put in useful form for a supposed postwar restitution agency—a compilation that would be an incredible task even in the computer age. In London they planned to make cross-referenced card files which would be microfilmed for distribution. Only one country was already prepared: the indefatigable Karol Estreicher of Poland had made such a list, not always accurate, based as it was on the rawest intelligence, but certainly impressive in its revelation of the massive dislocations of his nation's patrimony.

Now more than ever, the RC felt the need for someone who would serve as liaison between the civilian committees and the Army. By late April 1944 Newton, embroiled in his rank problems and Civil Affairs Division orientation, still had not appeared. MacLeish wired back that "the British have taken over organization of the Monuments officers in this theater in consequence of the non-arrival of Newton."[9] Newton was, in fact, about to leave. To make quite clear to the Army his duties as the RC saw them, chairman and proper lawyer David Finley wrote a long letter to General Hilldring of Civil Affairs which ended as follows:

> If it is consistent with War Department policy, the Commission hopes that Colonel Newton will be in a position to carry out certain vitally important tasks which may not be strictly within the jurisdiction of

the War Department and the Theater Commanders, such as liaison work with the British and other European commissions and essential conference work with British officials and art advisors to the British Government.[10]

This was a terrible mistake. Hilldring replied that Newton was authorized to do all the things mentioned in the letter

except those in the last paragraph. . . . As the Commission itself seems to recognize, these matters are beyond the province of both the War Department and the Theater commanders. For this reason the War Department is unable to authorize Col. Newton to take any actions in connection with the suggestions appearing in the last paragraph.[11]

So it was that Newton flew off to England, arriving there on May 6, having been forbidden by his military superiors to do most of the tasks the Roberts Commission wanted him to carry out.

The unfortunate colonel, whose expectations had been inflated by the RC's briefings and his access to the very highest circles of government while in Washington, was stunned at his reception in London. Once there, he found that there was no question of him replacing Geoffrey Webb, much less Woolley. Nor did his first encounters with the British and American officers (who had been working together for many months), during which his anti-Woolley bias was clearly expressed, endear him to anyone. Newton reported back that Woolley and the American Major General Ray W. Barker, deputy chief of planning for the invasion, who had more than a thousand officers under his command, had invited him to a meeting and noted suspiciously that they were "on excellent terms officially and personally."

A later meeting with Woolley, Webb, and Barker he termed "largely an effort to ascertain just why and what I was doing in London . . . the entire two hours was spent with me parrying words and phrases . . . at times the silence was prolonged . . . but I simply let them introduce the next subject." He was outraged when the two British officers suggested that he could be more effective in Washington, and retorted that "the War Department did not propose to have their representative 3000 miles from the scene of activity where he would be ineffectual." Barker, whose own superior officer was British, did not like this chauvinistic attitude one bit. Pointing at Eisenhower's office, he reminded Newton that "policies in this theater are made by the man in there and not by the War Department or the American Commission."[12]

More meetings of a similar nature with the top D-Day brass followed. By late May, Newton had raised so many hackles that Eisenhower's Deputy Chief of Staff wrote back to the Civil Affairs Division describing him as "aggressive and full of his subject." Hilldring of the CAD told the RC that if they wanted a representative in London they should appoint a civilian; Newton, "as a member of Eisenhower's staff," could not represent anyone else. A few days later Hilldring ordered Newton to "refrain from writing directly to members of the RC on all but strictly personal affairs" and to report directly to him, and he would "see to it that the Commission is kept informed by sending them appropriate extracts from your reports."

This was not at all what the Commission had had in mind when recruiting Newton. It seemed that they were back to square one in their campaign for information.[13] It was all a comedy of misunderstanding. From their bastions in Washington both the RC and the Civil Affairs Division had a completely mistaken view of Newton's position. Though they disagreed on his duties, they both thought of him as an important member of Eisenhower's team. The fact was that Newton had no command powers or subordinates at all at SHAEF and was regarded by Americans and British alike only as a floating representative of the War Department authorized to report back to Washington, and someone who was not necessarily to be trusted. His outsider status was made blatantly clear by the American officer Marvin Ross, who would speak French to his British colleagues in Newton's presence.

The Army planners for Europe had already done all they were willing to do for art and were unwilling to create a slot for Newton. By now seventeen men had been designated for MFAA work under expanded rules, pushed by MacLeish and Fulbright, which would allow them to sequester movable works of art and seek information on looters. The Army felt it would be up to the civilians to decide after hostilities what would be done with the objects that were found and that this issue should not be a military problem.

But the Roberts Commission members at home were absolutely convinced that control of the vast numbers of works of art known to have changed hands would necessarily involve the Army, and continued their campaign to install their own man and circumvent Woolley, whom they correctly viewed as insufficiently interested in restitution problems which did not much affect Britain. Meanwhile, Met director Francis Henry Taylor, who had been dying to get into the fray from the beginning, managed to get Army approval to go to London later in the summer.

It was not until July 27, 1944, with the reconquest of France well under way, that RC members MacLeish and Dinsmoor (who had wangled a tour

of the Italian theater) reported back and told all. "These reports give us our first real news of what is going on abroad," wrote Finley rather wistfully. The Commission particularly wanted fresh news which could be given to the press to enhance the American image. They were infuriated that Woolley had already been able to write articles on the events at hand, based to a large degree on work done by Americans, and publish these pieces in British periodicals months before they were fed their few paltry crumbs of information by the CAD. The stories, picked up by American magazines, naturally credited the British War Office.

Indeed, by July 1944, one month after D-Day, the RC had not yet received any field reports later than February from any theater, and these were so highly classified that they could not be published.[14] The day after these briefings they applied for clearance for yet another representative, Sumner Crosby, to go to London after Taylor. It was clearly necessary, as Hilldring had stated, to have someone of their very own there at all times.

This was further underlined by the fact that they had so far not heard anything from Newton, who, persuaded he could do nothing at SHAEF in London, and excluded from the invasion of France, had written his own orders and gone to Italy. There he was having a thoroughly good time, going around with the officers in the field and meeting important people. (He even managed to get an audience with the Pope and to present him with his third set of MFAA handbooks and maps, not realizing that both General Marshall and Dinsmoor had done so before.) Despite the distractions, Newton was writing perceptive letters and reports to the RC from Italy, but as he was required to send these through channels, they were not being passed on, and, in fact, the Commission did not even know where he was. Dinsmoor had only been able to report that when last heard of, Newton had been at sea, approaching Livorno. In early August, Finley, still in the dark, wrote to Assistant Secretary McCloy demanding assurance that "Col. Newton's organization is now working effectively in England, and that an adequate number of officers have been assigned to France."[15]

New Yorker Taylor was making other waves in his efforts to deal with the government. Through the State Department he demanded that the Civil Affairs Division inform the SHAEF high command that "I am authorized by the Roberts Commission to advise them concerning fine arts personnel."[16] This pronouncement went right across the normal channels of some five agencies, a definite Washington faux pas. To make things worse, General Julius Holmes, Deputy Chief of G-5, SHAEF, discovered Taylor in the lobby of the Hôtel Crillon in Paris shortly after its liberation and long before any civilians were supposed to be there. Exasperated, he wrote Hilldring to say that he did "not know what we can do to calm these peo-

ple down." Eisenhower, he said, "fully realizes both his short and long term responsibilities in this connection. . . . For your private ear I feel that this constant pushing has not helped matters in the slightest."[17] Hilldring tattled to the RC and warned that "the inevitable result of civilian appearances in operational areas will be an order from the Theater Commander excluding them entirely."[18] By now much permanent damage had been done: the Allied High Command and the Monuments men in the field had begun to regard the Roberts Commission less as an ally and more as a badly informed and interfering adversary.

Unpopular though all this might have been, the Commission was in fact beginning to make headway. Its pushy emissaries had brought back much interesting information. Taylor had managed to make contact with Jaujard and the French museums; he also had made a serious start on drafting a realistic restitution policy. From Jaujard and others he had heard of the immense trade and confiscations which were still going on in the shrinking Reich.

Through his Washington contacts he also knew enough to be quite sure that there would be no armistice resembling that of Versailles, as the occupied countries expected, but rather a "surrender to a Tripartite Supreme Authority," i.e., Russia, Britain, and the United States. Allied advances were now so rapid that it was felt in the highest circles that Germany might collapse at any moment. Taylor, feeling that there was no time to waste, had already cabled home to ask that all the files compiled by the American committees be microfilmed and brought to London by the next RC emissary.

Meanwhile, post-surrender policy was being discussed in London by the European Advisory Council, an entity set up by Big Three foreign ministers in October 1943. Taylor and his colleagues were convinced that the ultimate fate of thousands of displaced works of art would depend on these deliberations, and they were determined to see that the United States was properly represented in any restitution decisions. To make sure of this, they opened an RC office in London with a staff of two, and arranged to keep a representative there full-time.

To get around the U.S. Army's reluctance to supply intelligence, Taylor turned to a more sympathetic source: the OSS. Here was an organization which did not have to work through Army channels. Access was no problem—its ranks were full of friendly academics and the London office was headed by former National Gallery President David Bruce. Bruce had initiated contact with the Roberts Commission soon after his recruitment to the secret agency in 1942. He had wanted to have an OSS analyst attend RC meetings and had hoped to send agents into Europe under MFAA

cover, ideas that met with negative responses from everyone: Finley, Eisenhower, and the Army staff.

Ignoring these objections, Taylor began discussions with the OSS in London in August 1944. The idea of investigating Nazi looting not only appealed to the RC but fit in well with the OSS's counterintelligence operation which was compiling dossiers on Nazi agents on the Continent who might be a threat after the German military forces had been defeated. The OSS, like the economic agencies, was interested in tracing and preventing the flow of assets to places of refuge where they might be used to finance the postwar survival of Nazism. And not least, the agency was beginning to compile evidence for future war crimes prosecutions. By late November 1944 an Art Looting Investigation Unit had been set up, staffed by art historians recommended by the Roberts Commission. They were technically listed as members of the armed forces, but "as members of an OSS unit . . . have facilities for movement both in military zones and neutral countries perhaps not fully enjoyed by the members of other services."[19] Entirely separate from the Monuments men attached to the armies, they would report directly to the Commission.

Even this did not quiet the anti-Woolley obsession of the commissioners, whose information from the French front was still minimal, and who had finally recognized that Newton would never be persona grata at SHAEF headquarters. The CAD recognized this too and supported an additional civilian representative, indicating that despite his naughtiness Taylor would be "desirable." But Taylor was not interested. Finley this time proposed someone who would be comfortable in the most eminent circles, military or otherwise, in the United States or Europe: the philanthropist and amateur art historian John Nicholas Brown.

Brown was no stranger to the preservation of monuments, having been involved in the restoration of Hagia Sophia in Istanbul and various similar projects. His status was unusual: he was officially a civilian but was given the "simulated" title of lieutenant colonel, the equal of Woolley, and he would be in uniform. At meetings in Washington Brown was given the impression that he would be Special Cultural Adviser to Eisenhower and serve on his personal staff.

All these chauvinist turf wars might as well have been happening on the moon as far as the Allied combat forces were concerned. Eisenhower's Great Crusade had finally begun. The free men of the world, he said, were marching together to victory. Incredibly, despite the millions of men involved in the planning of the invasion of Normandy, there had been no leaks, and the landing, cloaked by stormy weather, was a surprise to the

Germans, lulled, as their opponents had been before them, into complacency by a series of false alarms. On the afternoon of D-Day, June 6, 1944, Churchill reported to the House of Commons that all was going according to plan. By June 10 the Allies had taken a sufficient strip along the coast to allow Churchill and all the Chiefs of Staff to go across in a pair of destroyers and see the situation for themselves. It was a beautiful day. In the midst of the battle scenes, Churchill noticed that the fields were full of "lovely red and white cows basking or parading in the sunshine." On the way home the happy PM had his destroyer sail down the coast so he could fire a few shots at the German positions. To Roosevelt, waiting anxiously in Washington, he wrote that he had had a "jolly day . . . on the beaches and inland," and described the fifty-mile-long mass of shipping deployed along the coast as "stupendous."[20] But after Italy they all knew this was just a beginning. It would not take the German armies long to consolidate their resistance.

The first Monuments officer ashore in France was a New York architect, Bancel LaFarge, who arrived in the first week after D-Day. Because of the enforcedly small size of his territory, centered on Bayeux, he was able to cover most of it in the first days on foot and by hitchhiking. Bayeux he found quite intact, and inhabited by the official architect of the Monuments Historiques, who was surprised to find that there were Monuments officers in the Allied armies. Among other things LaFarge learned the recent history of the Bayeux tapestry, which, he was told, had been removed to the repository at Sourches, also the refuge of a number of other important works from the Louvre. The existence of this repository, despite the secret messages acknowledged by the BBC, was news to LaFarge and he immediately sent it on to higher headquarters.[21]

As the beachhead slowly expanded, other colleagues began to arrive. George Stout, in action at last, celebrated the Fourth of July anchored off Utah Beach; fireworks were provided by an enemy attack during the night. Intact Bayeux was not to prove typical of what he would soon encounter. For days before the fall of Caen the towers of its two great abbeys had been visible in the distance, raising hopes that the rest of the town might not be too badly damaged. But LaFarge and Stout found the city 70 percent destroyed by Allied bombing and the population very angry when they finally arrived there. In the next weeks, before the Allies broke through the German lines and began their headlong rush toward Paris and the Netherlands, such scenes would become the norm.

They could not at first believe the destruction. "So total is the ruin that a description, however strong, would be an understatement of the fact," re-

Vire: fall 1944

ported British officer Dixon-Spain after seeing the little Calvados town of
Vire. Saint-Lô, where the Germans had built trenches and bunkers in and
among the old buildings, was worse, and not just because of the bombs. In
the rubble of the tracery of the windows of the great Church of Notre
Dame lay broken and rifled tabernacles and safes. Inside were stacks of
"grenades, smoke bombs, ration boxes and every conceivable sort of de-
bris. There were booby traps on the pulpit and the altar. At the entrance, a
stick of dynamite was attached with string or wire to a piece of masonry
wall which had fallen."[22] Inside the thirteenth-century parish church in La
Haye-du-Puits, James Rorimer discovered an intact German antiaircraft
gun which had escaped destruction when Allied bombardiers, marked
maps in hand, had carefully avoided bombing the historic edifice.[23] To
save the remains of these shattered churches from zealous engineers and
souvenir seekers, Stout cordoned off the ruins with the white tape used to
indicate dangerous mined areas.

As in Italy, the Monuments officers sought out shell-shocked, dis-
traught, and fearful local arts officials. In Coutances, Rorimer helped ex-
tract cases containing the collections of the local museums from a damp

basement in which they had been stored by the Germans four years previously, during which time the curators had been forbidden to see them. Shocked, the Americans watched as the now mold-covered objects were unpacked. Rorimer thought they "looked more like Camembert cheese than works of art." This they hoped was an exception: everywhere in Normandy they had been told of the good intentions of the Kunstschutz, but no one really knew what they might find at the great national repositories still behind German lines.

And indeed the Kunstschutz, which continued to function until the very last, and was instrumental in ejecting numerous obstreperous retreating units from listed buildings, was under great pressure and often unable to control the destructive and acquisitive instincts of troops made vicious by the new experience of defeat. Italy was not the only place from which the retreating Nazi forces decided to take a few baubles. On June 18 Dr. von Tieschowitz, who had returned to France as Kunstschutz chief after setting up operations in Italy, received a telegram from his High Command: "The Reichsführer SS, in agreement with the French Minister of Education, wishes the Matilda [Bayeux] tapestry to be brought to Paris immediately for safety reasons." SS transportation would be provided. Himmler, it seems, had expressed his fears for this "Germanic" treasure to Ambassador Abetz. (He was not apparently concerned about the great Medici series by Rubens, or the rest of the masterpieces in the same repository.) In the night of June 26–27 the tapestry was taken from Sourches to the Louvre. Von Tieschowitz wrote to a colleague in Angers that the Bayeux business was a terrible blow, but that he believed that now the tapestry "would probably stay in Paris, perhaps in a French bank." He was mistaken. His own work, he understandably added, "becomes more and more problematical and difficult."[24]

As the fifth year of the war had approached, in the western occupied countries the superficial politeness and "*korrektion*" which had served to disguise both the blatant desire for total control by the conquerors and the hatred of the oppressed had begun to wear very thin. Hunger and the exhaustions of a deprived daily life lived in cold houses and along darkened streets combined with the permeation of news of German defeats to consolidate resistance and bring hope. People no longer tried to disguise the looks of hatred "like scorpion bites," which in Jünger's words could only "bring us destruction and death." It was clear to all that the West would soon again see active warfare. German defenses along the coasts were strengthened. More troops were moved into Italy and the south of France, where increased bombing forced many residents, including Henri Matisse,

whose daughter was a very active Resistance member, to move away from the coasts and up into the hills.

By the early spring of 1944 SS units had begun to wander about the countryside in the former Unoccupied Zone to seek out and punish resisters, and generally vent their rage at the turn the war had taken. They no longer bothered to consult their Vichy colleagues before striking. Early in the morning of March 30 they descended on the Château of Rastignac in the Dordogne, where, in 1940, the Bernheim-Jeune family had hidden their paintings. Unfortunately for the owners, M. and Mme Lauwick, the house was a replica of the White House in Washington, and the family had British connections. The residents were lined up outside for three hours. From the house they could plainly hear drawers crashing to the floor and the splintering of wood. They also could hear gunshots in the nearby village, marking the execution of the mayor. Next they too were taken to the town and lined up against a wall, within hearing of other executions.

Meanwhile, after five truckloads of loot had been removed from the château, it was set afire by a special team dressed in fireproof suits. Having completed this task, the Nazis moved on to the outbuildings, where silver from the house was distributed to the soldiers. The Lauwicks were eventually released; in the ashes of the house they found the twisted remains of many beloved objects, but no trace of the Bernheim-Jeune paintings. After the liberation they wrote sadly that all had been lost, as the Germans had not seemed to be "connoisseurs," and had probably, in their ignorance, burned the pictures, if indeed they had ever found them. They did not know that the choice of Rastignac was far from random: only three weeks before the fire several members of the Bernheim-Jeune family had been arrested by the SS in Nice and relieved of their money, papers, address books, jewelry, a Manet, and a Pissarro before being lucky enough to be released.[25] None of the Rastignac pictures have been found. The only clue to their existence is the recent tantalizing testimony of a woman who remembers as a child seeing rolled canvases being loaded into Nazi trucks.[26]

The last refuges of the French national collections were also now smack in the middle of an area of great Resistance activity. They had been moved, once again, from the pleasant town of Montauban after German forces had marched across the Tarn bridges in November 1942. The curators, gazing helplessly down on the moving columns from the windows of the Ingres Museum, could think only of what one Allied bomb aimed at this Army might do to the thirty-five hundred masterpieces in their care. Although the German troops themselves seemed more interested in taking pictures

of the beautiful city and the river than in war, it was clearly time to move on. Out came the packing cases again; but the choice of refuges was now much more difficult. From Pau and the Resistance came the word to choose places far from cities, railroads, bridges, and seacoasts.[27] This did not leave much. A few of the most valuable things were moved to the smallish Château of Loubéjac, north of Montauban. Much more space was needed, for now the collections of many of the provincial museums of the north and the Rhône Valley were coming to join the others. By April 1943 the collections were redistributed in more than a dozen new places. The main Louvre collections were in the châteaux of Montal, Lanzac, and Latreyne near Souillac in the Dordogne; Bordeaux was at Hautefort, and Nancy at Cieurac, to mention only a few. Life became ever more bucolic for the custodians, but had certain compensations. At one refuge the local mayor put on an illegal pig roast for the meat-deprived art historians. At the Château of Latreyne they even bought a cow, named "MN" for Musées Nationaux, but, being inexpert in these matters, discovered too late that it was a beef cow, which soon stopped producing milk.

All these repositories had to be inspected regularly, a procedure that was not always straightforward. The collections from Narbonne and Carcassonne were stored in two Benedictine abbeys where the monks and nuns had taken the vow of silence. After an inspection at the Abbey of Calcat, curator André Chamson was led to the refectory to share the monks' meal. He was not sure if they had understood all his instructions, but during the silent repast, as usual, one monk read a passage from the Bible, which Chamson remembered roughly as follows:

> Then Caesar ordered him to come before him and said: Deliver unto me that which has been entrusted to you or I shall put you to death. And he replied: You may put me to death but I shall never surrender that which has been given unto my protection.

No further comment seemed necessary. At Saint-Scholastique, the neighboring convent, both the rule forbidding the presence of men and the vows of silence were waived for the sake of art. For an hour the nuns chattered away before retiring again from the world. But there were sometimes more than pictures at these remote and silent places. At Saint-Guilhem-le-Désert the cellars contained not only works from the museums of Nîmes and Montpellier but cases of machine guns and an agent recently parachuted in by the British. These the museum people required to be moved.[28]

The most important refuges were, in the summer of 1944, those grouped around Souillac in the Dordogne. Staff was not hard to find: the job of museum guard carried with it exemption from the increasingly frequent

forced-labor roundups, and for some it offered even more. Eleven of René Huyghe's guards at Montal were Alsatians condemned to death in absentia by the Nazis. Through an arrangement with Vichy official and Resistance member Gérard André they were given false papers and jobs with the Musées. The Germans never thought to investigate these guards, assuming that jobs of such awesome responsibility would never be given to "criminals."[29]

Huyghe (who held the rank of major), his Alsatian guards, and many others were actively involved in Resistance groups, in which they were known by false names. The repositories helped the clandestine efforts in many little ways such as sharing their precious gasoline supplies. At first this was all very patriotic and harmless, but after D-Day it became extremely dangerous for the collections. Roving troops bent on revenge might easily do to the refuges what they had done to Rastignac. At every depot Off Limits signs issued both by the Kunstschutz and the Resistance were kept ready for whichever fighting force might appear. René Huyghe kept a set in his hat.

Valençay, where the great Louvre sculptures were stored, was visited by elements of the SS division "Das Reich," a tough bunch seasoned by months of action in the USSR, and fresh from their infamous massacre of civilians in the village of Oradour. They were looking for resisters who had skirmished with a German tank column a few days before in and around the stables of the vast château. The Louvre guards were marched out of the building and forced to lie down on the lawn while the SS fired at the windows. Director Gerald van der Kemp defiantly asked them if they wanted to be responsible for the loss of the *Venus de Milo*. When fire broke out in the château, the SS commander assured van der Kemp that the guards could go to put it out, but when they stood up they were sprayed with machine-gun fire, and one was killed. For weeks after this the château grounds were occupied by one or another force; when the Germans had finally retired, the Free French arrived. Musées director Jaujard had to appeal directly to their chief, General Koenig, to move his troops to another encampment before calm could be restored around the château.[30]

The weeks of suspense as the Allied forces moved toward Paris were anxious ones in the repositories. There was no longer any authority at all. The Vichy government was powerless. Allied planes flew over by the hundreds, heading east. Despite the chaos some things worked: the postal service miraculously continued to deliver paychecks to museum personnel, who could at least buy whatever sustenance was available. There was one last scare: from the Beaux-Arts offices in Paris came an order to calculate the cubic footage of all the stored objects belonging to the Musées Na-

René Huyghe (standing, second from right) *and his "troops" at Montal*

tionaux, which like the Florentine treasures were to be evacuated for
safety beyond the Maginot line, now apparently considered of some use by
the Germans. To discourage such a move, the curators stalled and drew up
hugely inflated estimates of their holdings. Of this initiative nothing more
was heard. The last picture had gone to the Reich. In their châteaux the
masterpieces awaited the liberation.

In the first week of August 1944 the Allied armies finally breached the
German defenses in Normandy and began the drive to Paris. This only in-
creased the dangers of sporadic and uncontrolled action to the refuges.
Chambord, its great white mass clearly visible from the air, was used as a
rendezvous point for Allied bomber squadrons. This led to frequent aerial
battles overhead, during one of which an English plane crashed on the
lawn after skimming the tall chimneys of the château. In early August
there was intermittent fighting in the neighborhood. Nervous Germans
fired indiscriminately when suspicious of Resistance activity; on the
twenty-first they blew up the bar where the museum guards usually
gathered. Forty men were held as hostages while the huge château was

carefully searched for weapons or fugitives and all personnel were ques-
tioned. Four of the hostages were shot just four days before Chambord was
liberated.

Other places were beginning to suffer from the liberators. On August 9
the American Monuments officer Robert Posey was finally able to get to
Mont-Saint-Michel, which he had assumed to have been placed off limits.
The signs were indeed in place, but this most famous of tourist attractions
was not exactly empty. Still, Posey saw little damage, and reported that
small groups of well-behaved American personnel were visiting the site
"in charge of an officer in each case." This was soon to change. By the time
James Rorimer got there ten days later, total bedlam reigned. French bars
and hotels eager for business had opened up as soon as they could.
Drunken soldiers drove jeeps up and down the narrow and steeply stepped
streets. A British general and his lady friend were cozily installed in one
of the hotels. Each day, Rorimer reported, "more than a thousand soldiers
came, drank as hard and as fast as they could, and feeling the effects, be-
came boisterous beyond the power of local control." Stocks of food and
fuel were rapidly running out and rumor had it that large groups of Air
Force men seeking rest and recreation were on their way. Rorimer, with
the help of the mayor, managed to secure the abbey, post guards on its bat-

*Rorimer meets
Bazin at Sourches,
before Goya's*
Time.

tlements, ban the jeeps, and forbid the sale of liquor in the town. His new strict policy was so effective that he himself was arrested for several hours by MPs suspicious of his lack of transportation or connection to any recognizable unit.[31]

A few days later, Allied officers set off to check on the repository at Sourches and others in its vicinity. As they passed through the countryside, children ran out to offer them wine and fresh fruit. At Sourches they were met by Germain Bazin, who, to prevent bombing, had had his men put the enormous letters *MN* on the lawn. Fuel having run out, he had kept charcoal fires burning constantly in the cellars to control humidity. He had succeeded: despite all, the Rubens of the Medici Gallery, the enormous *Wedding at Cana,* and all the rest were intact. From Bazin, Rorimer and his colleagues heard all about the odious Abel Bonnard, and enough about the status of the rest of the national collections to feel that "it is not necessary to ask the French officials, as did the Germans, for complete lists of depositories and their contents." The terrible responsibility for these collections would remain with the French.[32]

The Western occupied countries had remained full of Germans until the very end. Supervision of German officials in France had largely been taken over by the SS chief General Oberg after the Commandant of Paris, von Stülpnagel, had committed suicide or been murdered after the July 20 coup attempt. But by the end of the first week of August 1944, the exodus was well under way. Chimneys again smoked in the summer heat as documents were burned. Parisians who up till now had remained maddeningly calm, limiting themselves to small provocations such as wearing red, white, and blue clothes on Bastille Day, became more overt in their display of feelings. Railroad workers went on strike. German civilians dragging huge bags to train stations could find no porters. Their requisitioned cars, grotesquely laden with the contents of their requisitioned apartments, developed strange engine problems and record numbers of flat tires. Even the Vichy powerful, who had made the most careful arrangements, were not immune: Abel Bonnard had arranged for a convoy of three cars to take himself, his aides, his family, and his files to safety in Germany. Alas, his chauffeur had been subverted by the Resistance, and the cars vanished. Bonnard had to appeal to his friend Abetz for a ride east.[33]

The complex network of dealers began to unravel. Considerable effort now went into the saving of self and assets. Alois Miedl left Holland in July, heading for Spain. He took some twenty paintings with him and told his assistant to send others to Berlin, where they were stored in three banks. (Miedl had already entrusted to a lawyer in Switzerland six of Paul

Rosenberg's pictures that Hofer had kindly sold to him for a not inconsiderable sum.) Gustav Rochlitz waited until after D-Day to ship his remaining stocks, which included fifty-one of the paintings he had obtained through the ERR, off to five locations in Germany. He himself did not depart until August 20, only days before the fall of Paris. On July 13 Bruno Lohse wrote Hofer to tell him that Hugo Engel, Haberstock's protégé, had fled, and that Haberstock now found himself "in difficulties." But Lohse was still sufficiently businesslike to devote part of the letter to arrangements for the purchase of two sculptures for Goering.[34]

What was left at the Jeu de Paume, "degenerate" and otherwise, was hastily packed in 148 cases and taken on August 1 to the railroad yards to be loaded onto a waiting train. Of the fifty-two cars, the ERR objects took up five; the rest of the space was reserved for a final shipment of miscellaneous items collected by von Behr's M-Aktion. Rose Valland, just as indefatigable as von Behr, managed to record the numbers of the freight cars in which the ERR crates were packed. She informed Jaujard, who contacted Resistance elements in the French railways.

The train, fully loaded, sat on a siding next to dangerous gas storage tanks at the Ambervilliers station awaiting a slot on the jammed tracks heading back to the Reich. A week passed. After much fussing by von Behr the train finally left, but, alas, "because of its extremely heavy load" it developed "mechanical problems" which necessitated a forty-eight-hour stop at Le Bourget. Next it moved on to Aulnay, still in the suburbs of Paris, where it was put on another siding because it needed a new locomotive. It was still there on August 27 when a detachment of General Leclerc's army, informed by railroad officials of the precious contents of the cars, captured the train and its guards. The commanding officer was Alexandre Rosenberg, Paul's son, who had quite unknowingly recovered twenty-four Dufys, four Degas, three Lautrecs, eleven Vlamincks, ten Utrillos, sixty-four Picassos, twenty-nine Braques, twenty-five Foujitas, ten de Segonzacs, more than fifty Laurencins, eight Bonnards, and works by Cézanne, Gauguin, Modigliani, Renoir, and so on, many of which he had last seen in his own house.[35]

The human occupants of the Jeu de Paume had also left on August 16 with the main body of the German occupation government, in considerable panic at the news that they might be liable for active military duty within forty-eight hours "in defense of the Reich." It helped to have connections. Bruno Lohse managed to find a safe job for a time in one of Goering's Berlin regiments, and later at the ERR repository in Neuschwanstein. After the Allied drive had been halted in Holland, von Behr too was given a new assignment by Alfred Rosenberg: to transfer all

remaining M-Aktion objects and any other "valuables safeguarded by the ERR" in Holland back to the Reich.[36] The subsequent Battle of the Bulge did not slow him down. On January 15, 1945, with the German armies in retreat from the Ardennes, von Behr and Utikal were still discussing the possibility of relieving the Gauleiter of Westphalia of responsibility for the evacuation from Arnhem of confiscated books of interest to the ERR.[37] It was not until Allied armies actually crossed into Germany that von Behr retreated with his wife to his family schloss. Other staff members distributed themselves among the various ERR depots in Germany.

Dr. von Tieschowitz, thinking already of a very different future, sent as many Kunstschutz records as possible to his former chief, Metternich, in Bonn so that he could put them in safety in "our Rhineland depots."[38] Similar calculations and struggles of conscience were taking place all over Paris, as they had in Italy, and indeed the very existence of the city now depended on the honor of one man.

A less likely rebel than the stiff and stocky little Prussian, booted and spurred and covered with medals, immortalized in contemporary photographs, can hardly be imagined. But General Dietrich von Choltitz, the brand-new commandant of Paris, as all the world now knows, after a career of total loyalty, chose not to carry out the repeated orders of his commander in chief to do to Paris what had been done to Warsaw only weeks before. This had not been easy. Teams of engineers and demolition experts had been sent by other agencies to mine the Seine bridges. Infantry and Luftwaffe units had been ordered to prepare for house-to-house fighting and bombing which would convert Paris to "a field of ruins." The Grand Palais was blown up two days before the Allies arrived. Explosives were placed in Notre Dame, the Madeleine, the Invalides, the Luxembourg, and even Hitler's favorite, the Opéra.

Bombarded by orders for annihilation from Hitler, von Choltitz, without actually disobeying an order, procrastinated and even managed to talk the SS out of taking the Bayeux tapestry off to the Fatherland. The General had help from many quarters. At the Sénat, mines were placed in the basements and the gardens. The caretaker reported all to the préfet de la Seine. When this had no effect he turned to the workers in the power company, and the Sénat was soon stricken with a series of inexplicable blackouts during which workmen managed to disconnect the detonators.[39] The strain became unbearable as the Allies, slowed by disagreements in their councils over whether or not to occupy Paris, hesitated a few miles outside town. But when von Choltitz surrendered on the afternoon of August 25, all the bridges and monuments were intact.

The Louvre and the Jeu de Paume were in the heart of the uprisings

which began nearly a week before Paris was liberated. Impatient staff had to be prevented by Jaujard from prematurely raising the French flag over the museum. All curators were told to stay at their posts and refrain from joining the rebellious crowds in the streets. Arriving at the Jeu de Paume, Rose Valland found that the building had been made part of the German defenses in the Tuileries, which were crisscrossed now with trenches. In the night the terraces had been festooned with barbed-wire barriers. Although the galleries had been cleared, the basements contained large numbers of contemporary works by non-French artists. In the fighting around the German headquarters a few days later, 9 German soldiers would die defending the little museum; 350 more surrendered and were taken to a prisoner-of-war cage set up in the Cour Carrée of the Louvre. Liberators and crowds swarmed over the Jeu de Paume. Mlle Valland, trying to keep them out of the basements, was suspected of collaboration, and forced to open the storage areas, a machine gun held to her back. Luckily for her, no German had sought refuge there, and she soon persuaded her compatriots to leave the building.

In the main complex of the Louvre, where anxious guards patrolled the ancient roofs, ready to put out fires, and all available curators were assigned day and night posts in the vast galleries below, nothing was damaged. But Jaujard, Aubert, and several others were, like Rose Valland, summarily taken prisoner by the Free French troops. While they were extricating themselves, the POWs in the Cour Carrée panicked. Breaking the windows of the museum, they scattered and hid in Egyptian sarcophagi, behind statues, and in all the myriad corners of the building. It took hours to find them all. That evening there was a final German air raid. Then it was over. Paris was free.[40]

On either side of the City of Light the Allied armies swept on toward Alsace and up to Antwerp and Ghent, over to Luxembourg and into Holland. They were stopped short of Bruges. In late September they reached Arnhem in the west of Holland. The approach of the front caused a now familiar reaction in Belgium. The principal repository for the Belgian collections was the ancient moated castle of Lavaux St. Anne, located about fifteen miles south of Dinant near the French border. Evacuation back to Brussels had begun in July. In mid-August came reports that the château was being attacked by a strange group of armed civilians suspected to be Germans. The architect Max Winders, in charge of Belgian repositories, managed to rush gendarmes to the scene and the marauders withdrew. The convoys continued. The last one, crawling in close formation down the narrow road along the Meuse at Dinant, was attacked by Al-

Belgium: Monuments officer Daniel Kern advising on repairs in Namur

lied dive bombers. Three gendarmes were killed, but Dr. Winders commandeered other trucks and went on, and the paintings survived with little damage.

Other people in Belgium had ideas about moving things too. Museum officials in Bruges, who had kept many of their greatest works in the town under German supervision, managed to smuggle nine of their most precious pictures out under the noses of the German guards. The cases, which included two of the greatest masterpieces of the Western world, Memling's *Shrine of St. Ursula* and van Eyck's *Holy Virgin with Canon van der Paele,* were not missed from the stacks filling the repository. They were secretly taken to the vaults of the Société Nationale in Brussels—which may have been the cleverest move of the war, for the chief of the Kunstschutz in Belgium, Dr. Rosemann, now felt the urge to "safeguard" too.

From the earliest days of the occupation he had been most careful to provide exemplary shelter for the delicate Michelangelo *Madonna and Child,* which is the glory of the Church of Notre Dame at Bruges. It was noticed that both he and his assistant kept photographs of the sculpture on their desks. At first, because of its popularity with the occupiers, it was not hidden away, as were so many things, but was taken down from the side altar where it normally stood, and placed in a specially constructed shelter on the north side of the church.

In the first week of September 1944 German officials began leaving Belgium. Dr. Rosemann, having packed up his photographs, stopped by for a last visit to the Michelangelo, lamenting to the sacristan that "he could not leave Belgium without a final look." Before departing he casually ordered a number of mattresses to be placed in the little shelter. The Bishop of Bruges arrived the next morning to inspect the church and order the shelter walled up. He was just too late. In the night two German officers with a contingent of guards had appeared, claiming to have orders to remove the statue "to protect it from the Americans." The tall windows of the church were covered. Working only with flashlights, they had wrapped the marble sculpture in the mattresses and loaded it into a Red Cross truck. As an afterthought they took ten paintings. There was so little room in the truck that two wings of a large triptych by Pourbus had to be left behind.[41]

The next day the Bishop received a pious letter from a Lieutenant Dr. Figlhuber, who identified himself only as "Special Representative of the High Command." The Lieutenant Doctor stated that experience in Italy and France had proven that the Anglo-Americans were removing masterpieces of the European Spirit and Genius in order to put them in their museums or sell them to private collectors. It was therefore the duty of the German Reich to preserve these treasures for Europe and for the Catholic Church. In closing he assured the Bishop that "during the safeguarding the dignity and sanctity of the House of God were carefully respected." While this edifying document was being perused, the *Madonna* languished on a nearby dock waiting to be loaded onto a small German naval vessel, the sea being the only way out for the beleaguered Nazi forces. The officer in charge of this operation later reported in terms which might have described many a Netherlandish seascape that "in the late afternoon of September 7, as a result of a storm which suddenly arose, the sea was so disturbed that safe transfer from the lighter could not be guaranteed." The transfer was eventually accomplished. It was just as well for the Belgian authorities not to have too precise an image of how their treasure had left them.[42]

*　*　*

In their newly expanded territory the "flotation" system devised for the Allied Monuments officers was a very mixed blessing. They had attained freedom and mobility, but without means to make use of it. The fact that they sometimes belonged to no specific unit and still were of very low rank made the problems of transportation more difficult than ever. George Stout managed to procure a decrepit German Army Volkswagen for himself. This miserable machine, which broke down in every conceivable manner, and by November even lacked a roof, nevertheless proved invaluable.

On September 17 an urgent, secret message sent Stout rushing to Maastricht. The Dutch government desired protection for the masterpieces stored in one section of the endless limestone tunnels near the town, which stretched into Germany, and through which many people had escaped from the Reich. Unfortunately the news also reached the BBC. Stout heard their broadcast on the radio of his Volkswagen. Soon the repository, perilously close to the German lines, was receiving unwelcome visitors and publicity. But the news, conveyed to the outer world by *New York Times* war correspondent Anne O'Hare McCormick in a vivid report, was full of wonder. Turning away from the "mud and blood of the world of war," where the atmosphere was "dark with danger," she was escorted into the caves, mined since Roman times, where some eight hundred paintings hung on endless steel racks, and was overwhelmed by the "sense of life flowing out of the glowing color and exuberant vigor of these immortal works of art. . . . Seeing the buried treasure under embattled Maastricht is to glimpse again the meaning of the struggle for a civilized peace."[43] George Stout, equally pleased that the pictures were in good shape, but less flowery, helped the Dutch set up a vital phone link to the repository and recommended that they leave everything right where it was.

It was not until Aachen, where Stout was joined by MFAA colleague Walker Hancock, a well-known sculptor in civilian life, that he came face to face with the ghastly conditions which now prevailed in Germany's cities. Nothing they had seen in Normandy could compare to the devastation wrought by months of bombing. For two weeks they had watched from afar as the city burned. Now, given a lift by a group of photographers and reporters, the men responsible for preserving what might be left of Charlemagne's capital slowly made their way into town.

Aachen was totally deserted. The new military government had ordered everyone out. Gutted houses spewed their contents into the streets. Allied troops had not restrained their desire to pick up items so exposed, some of which were not what one would expect. As Hancock watched, amazed, "on a lean horse, a G.I. galloped by, bedecked with the complete feathered regalia of an Indian chief." The city was a skeleton, and, as he would later

observe, "a skeleton city is more terrible than one that the bombs have completely flattened." Hancock, wary of shells which still whistled down, continued on to the cathedral:

> All the doors were standing open in that strange cluster of churches that is the cathedral of Aachen. Once inside the dark octagon that forms its nucleus I felt suddenly secure. For more than eleven centuries these massive walls had stood intact. That *I* should have arrived just in time to be the sole witness of their destruction was reassuringly inconceivable.[44]

A bomb had gone through the roof and into the high altar without exploding, but in general the wonderful octagonal church and its delicate tracery were intact. To his surprise Hancock found the vicar, shaken but still at his post. He told the American that his most important need was to reconstitute the fireguard of six Hitler Youth teenagers, whose job it had been to patrol the roof of the cathedral. Stout and Hancock found the boys in a suburb, on a street being used as an Allied artillery emplacement. Their terror of the American officers soon vanished when they found they were being recalled to duty. After a quick investigation by Counter Intelligence Corps officers, passes were arranged for the boys, and for one of their mothers, who would cook for them and the vicar at the cathedral. Hancock noted that "their faces were alight with a radiant joy. It was as if no further cares existed for them." The Americans told them to brush their hair and not wear their uniforms. As they left "we saw them starting on the long walk down into the hell-hole. We saw too, faces in every window, watching them." The relationship of the Allied conquerors to the German people was not going to be a simple problem.

Before they left Aachen the officers checked the empty museums and refugee camps, hoping to find, as they had in France, some museum employee who would help them locate and protect the city's collections. They did not succeed, but in the wreckage of the Suermondt Museum's offices they did find a marked copy of its catalogue with the notation that certain objects had recently been moved from Meissen to Siegen. Hancock reflected that only the most precious objects would have been moved all the way across Germany in the present conditions. But Siegen lay across the Rhine, between Cologne and Marburg, and they would not get there for a very long time.

After Aachen, Stout was called back to SHAEF and appointed "Special Emergency Inspector." This was in response to the hundreds of dutiful reports of "Michelangelos," (the generic term for paintings), now coming in from combat units who were encountering works of art hidden in the Ger-

*The high altar at
Aachen, fall 1944*

man border areas. They all knew by now that it was their duty to protect these things, but there were still no directives to tell them where the works should be taken or exactly who was responsible. Walker Hancock had brought one collection to the nearest headquarters in a weapons carrier following a tank column "laboring through the dark December forest. The gilded rococo frames glistened indecently in that moving mass of brown, green and olive drab. We looked at each other, laughed, and said together, 'God! What a war!' " This picturesque method of evacuation was clearly not ideal, but the Army still adamantly refused transportation to the floating Monuments men.

Adherence to regulations was so total that Stout, a Naval officer, was even refused foul-weather gear by Army supply officers and was forced to buy his own field coat. For the same reason he also had the greatest

difficulty finding a place where he was allowed to eat or sleep. The eventual arrival on the scene of Colonel Newton, ineffectual though he might have been at higher levels, provided some relief. Newton, being a regular Army colonel, was given a staff car and for a few weeks in November took Stout on a "tour of inspection" of the territory for which he was responsible, which ranged from Beauvais to Brussels to Paris. They discovered a number of threatened collections, but for the moment the only solution seemed to be to leave them where they were under the protection of local Military Government, "until they can lodge objects in custody with responsible civilian administrative officials." By the end of one month of roving, Stout gave up this system, and got himself attached to Twelfth Army. This required him to arrange for written orders to justify each inspection trip, but now at least he would be given room and board after his sixteen- or eighteen-hour days of scrounging his way around the icy roads of Belgium and France.[45]

Things were much more civilized for another Monuments man who had arrived in Normandy in late August complete with truck and driver. This was Major Lord Methuen, attached to the British Twenty-first Army Group. His luxurious equipment allowed Methuen to take over inspection of the monuments listed by the Allies in virtually the entire liberated area west of Paris and on up to Brussels and Antwerp. It was no small job: there were nearly eight hundred sites in Calvados alone. Methuen was very thorough. For the next eight months he toured about his area, his inspection stops greatly enhanced by the fact that he had numerous relations in the countryside and had previously done much work with the Demeures Historiques.

Damage was completely random and caused by both sides. Next to one trashed house would be another still bearing Kunstschutz Off Limits notices, its contents secured and completely intact. On the way Methuen did nice sketches and watercolors of the visited sites, and discovered a number of little-known ones. All this he recorded in a gracefully written diary full of historical notes, observations of nature, and occupation stories, which would be elegantly published in 1952. At the time it was the only source of information anyone had, he being the only truly mobile informant.

As he travelled Methuen took French officials around with him so that they too could evaluate damage. Together they made plaster casts of burned sculpture about to turn to dust, propped up roofs, and saved precious fragments. On his routes were all the shrines of Impressionism. Honfleur was intact. Giverny, its various studios filled with over a hundred of Monet's paintings, had suffered from shelling which had destroyed three pictures and damaged others. But the garden was just as it should be:

"a blaze of dahlias and michaelmas daisies." Methuen arranged for assistance for Monet's daughter-in-law, who was in residence, so that she could repair broken skylights and windows. This done, he and his French colleague "had our sandwich lunch here supplemented by some excellent wine and fruit kindly provided by Madame Monet in the yellow dining-room hung with Japanese prints."[46]

Monuments work in and around Paris had none of the bucolic compensations of Lord Methuen's territory; on the other hand, there were no tottering church towers or piles of rubble. The glorious palaces and monuments were generally unharmed, if often windowless; the Archives Nationales, for example, had lost no fewer than seven hundred panes of glass. Indeed, the intact dwellings of the French nobility were a terrible temptation to the American brass, who, feeling victorious, wanted to be lodged in style. Despite Woolley's optimistic view that the Naples investigation had established MFAA authority, the Monuments officers again found themselves in the middle of a struggle.

Lieutenant James Rorimer had entered Paris with the entourage of the commander of the "Seine Section," which included the city and environs. They arrived only hours after the German surrender to find that an Allied antiaircraft unit was setting itself up in the Tuileries, British signals groups camped in the gardens of Versailles had thoughtfully draped the statues with camouflage nets, and the empty-seeming Jeu de Paume, so conveniently located, was being requisitioned for a troop post office. After repeated urgings the Tuileries group did move, but not until the gardens had been bombed by German planes. Rorimer managed to block the post office, but, despite all, units were housed in the Petit Palais. All this paled beside the struggles for the great Royal Palaces of Versailles and Fontainebleau.[47]

It is not clear exactly why the advance teams for the Supreme Headquarters decided to lodge their chiefs in and around Versailles—they certainly did not consult their Monuments officers. For their commanders they wanted nothing but the best. An empty house in the town had been taken over for General Eisenhower. Town Major O. K. Todd decided it needed sprucing up, and sent Jacques Jaujard a request for furniture from the collections belonging to the Palace and the Mobilier National. Believing that this was a personal request from Eisenhower, Jaujard felt compelled to approve the list, which included eleven paintings (one a van Dyck and two by Oudry depicting fables by La Fontaine) as well as a superb eighteenth-century desk and equally superb carpets, sculptures, and engravings.

Both the French liaison officer and the chief curator of Versailles, who

had been approached by Todd, were unaware of the official military lists which put Versailles and its collections off limits. They wanted "to be helpful." Rorimer heard of all this at 7:30 a.m. on September 16. A lieutenant does not normally remove the Supreme Commander's furniture, but despite this discrepancy in rank the items taken from Versailles were on their way back within twenty-four hours. Over Rorimer's protests the Mobilier National objects stayed behind in the house, which was still full of workmen; its director, M. Fontaine, saw nothing wrong with lending things to such a distinguished visiting dignitary, as he had done many times in the past. His goodwill turned out badly: the furniture disappeared, and five years later, charges were brought against him for its loss. Appalled, Rorimer, back at the Met, wrote in his defense, as did General Eisenhower.[48]

At Fontainebleau the problems were not limited to the gardens and surrounding houses. Eleven hundred troops bivouacked in the elegant park had to be removed to the forest and discouraged from using the ornamental canals to practice simulated Rhine crossings. It was harder to dislodge some of their officers from inside. A certain Colonel Potter had adamantly refused to vacate the Louis XV wing. When he was again asked to move, both by the Commanding General of the entire region and the French Beaux-Arts, he went over their heads and got approval to stay from the Deputy Theater Commander, which he did until his unit moved on.

French hospitality often made enforcement of the off limits policies more difficult. At the Château of Grosbois the grounds and stables had been approved for requisition, but not the house proper. The son of the owner, Prince Godfrey Tour d'Argent, had invited fifteen officers to stay in the château as his "contribution to the war effort and the comfort of the officers." They had accepted without written permission from their superiors, who, nervous at the irregular situation, called in the MFAA. Rorimer's attempt to reason with one of the very comfortable officers was not a success:

Captain Beasley was very unpleasant about "historic buildings" when I explained to him the reason for my visit. He was still in his bath at 1130. Two electric heaters were going in one room and another was in his bedroom. There were three bottles of Cognac on his dresser and a box with about a dozen wine bottles on the floor. When I explained the situation of the famous building and magnificent collections . . . and that it might happen that the General would not want the Château used by our forces in view of existing directives—which I placed in evidence, Captain Beasley told Captain Smyth to be sure

to get my name and said that if the General ordered him to move out he would "move out and then in." . . . Neither the Prince nor the officers knew who was paying for the additional current consumed by our units.[49]

The gentry were not shy. As soon as it was known that Rorimer's office was the one which dealt with "damages done to the palaces and castles of France, my office was besieged with broken-down countesses, German sympathizers, compassion-seeking victims of German brutality, all as difficult to deal with as the exacting American officers who also had complaints to register. It soon developed that the enlisted men in the outer office were no match for the exasperated art collectors and château owners whose wild gesticulating and deafening presence gave my office all the aspects of a madhouse."[50] To deal with this onslaught he hired a tough upper-class French secretary and sent the soldiers away.

The problems were serious. In the fall of 1944 coping with the billeting of troops and the damage they caused would consume much of the time of the MFAA men responsible for the vast areas inhabited by Allied troops. The lists so carefully prepared beforehand did not include hundreds of less famous châteaux in the countryside; the most responsible billeting officer therefore felt free to requisition them and objected to troops, once installed, being moved. Units passed through in series and each one would have to be newly informed of what was off limits. As the winter, which would set records for low temperatures, came on, more and more shelter was required. This increased tenfold during the Battle of the Bulge, as continual reinforcements were poured into the theater. Soon the complaints were so numerous that the situation was described in one report as "explosive." Directives on the subject, issued at regular intervals, had little effect on the cold and exhausted combat troops. As one normally gentle soul explained to Walker Hancock, "If right after the battle you came into a beautiful room in a château, you *had* to shoot the chandeliers."[51]

Fortunately the two to three thousand U.S. Infantry troops who had first taken and then had to defend the château of Haute Koenigsbourg north of Colmar, where the Germans had stored some of the greatest treasures of Alsace, had been relatively restrained. They had trashed the former bedroom of Kaiser Wilhelm II, stolen some banners, and used tapestries from the Château de Rohan as rugs and blackout curtains. But a series of rooms filled with the greatest profusion of medieval and Renaissance paintings and sculpture were untouched, and this "astounding array," Monuments officer Marvin Ross reported, "paled in contrast" to the multiple panels of Grünewald's great Isenheim altar, which he found in a dry and airy cellar

"well placed in the center of the room, heavily braced by large timbers" and guarded by a M. Pauli, who had "slept in the room at all times."[52]

The MFAA men determinedly travelled about in response to reports of damage by both sides, and kept track of the many incidences of wholesale looting by the enemy. From the Château of Chamerolles the Germans had carted off 1,700 paintings and drawings, 150 rugs and tapestries, and a carload of silver. The floors were littered with wine bottles and broken furniture. No two places were alike. Human frailties and strengths were everywhere revealed: at Gien, GIs had taken objects from the château and bestowed them on the more available ladies in the village. Another house, its magnificent collections in perfect condition as its owners had collaborated with the Nazis, was endangered not by Allied troops, but by the locals who, after the noble lords had been sent off to jail, became "excited by conditions" there. The proprietor of Vaux-le-Vicomte refused to put his château off limits and wrote that "our deep desire to welcome our allies will cause us to use this restriction only in case of true necessity. On the contrary, we look forward to many visits 'très sympathiques' after these years of another occupation."[53] There was a certain amount of keeping up with the Joneses. The American-born Countess Gourgaud, a recent widow, told Monuments officers that she would like to have "a few rooms used by visiting officers as her contribution to the war effort. All the neighbors have troops, and she is anxious to have some too."[54]

Certain cases were not so straightforward. At the unfortunate Château of Dampierre, the Germans not only had built a bar right in the salon in front of a large Ingres but had used a collection of manuscript letters of the seventeenth-century prelate Bossuet for toilet paper. A truly devoted retainer had salvaged these, purified them, and returned them to the library. No sooner had the Nazis left than a boisterous, if less imaginative, group of GIs appeared and began driving nails into the boiseries and building fires indiscriminately. Monuments officers were puzzled when, after all this, the owner, the Duc de Luynes, still wanted to have "a group of senior officers or some exclusive Allied unit" in the house. His Grace, it seems, wished to protect his domain from "the seething communism in the neighborhood."

All this soon became routine, but there was nothing routine about the frantic calls which came into Rorimer's office in November. It appeared that the villa of a M. Robert de Galea, located on the Seine near Paris, had been requisitioned. Both the owner and Paris museum officials were distressed, as the house apparently contained a large number of works from the former collection of the famous dealer Ambroise Vollard, who had left half his estate to Mme de Galea. Vollard had died in 1939, just before the

war started, since which time there had been no news of the collection; nor did anyone know just what it had contained. (The confiscation of more than six hundred items from it which Martin Fabiani had tried to ship to the United States [see pages 92–93] was still a secret.) Rorimer went off to investigate, expecting an impressive number of works, but he was not prepared for what he found: on the walls of the freezing villa more than a hundred unframed paintings by Renoir, Cézanne, Degas, and other masters were tacked up in overlapping layers. Many more were stacked up around the house.

Rorimer could not reverse the requisition order, as the villa itself was not a historic building, and all procedures had been properly followed. He offered to take all the paintings to proper storage in Paris, but M. de Galea, for reasons known only to himself, refused. When Rorimer came back a few days later, everything had disappeared. Nothing more was heard until late March, when M. de Galea appeared once again, this time in a terrible state. He had, it seems, hidden his collection in a small and carefully camouflaged lodge used for duck shooting on an island in a lake surrounded by swamps near Chantilly. This wild place was now about to be used for bombing practice by the U.S. Air Force. Rorimer was able to divert the bombers with an emergency call. The documents do not relate exactly where the pictures went next; but, despite all, they did survive.[55]

The SHAEF planners in their long winter of preparation for D-Day had expected to find Paris a starving city riven with social unrest and threatened with disease. They were quite amazed, therefore, to find the inhabitants of the City of Light orderly, healthy, chic as ever, and sitting in their usual cafés. The food, scanty to be sure, was still tasty, and gas and coal were lacking, but Paris, statueless, bullet-pocked, and festooned with German street signs though it might be, was just fine. It was also very expensive. In order to prevent inflation, Allied forces had been given an extremely low exchange rate of fifty francs to the dollar and could not compete with the heavy spending in public places, such as nightclubs, by French civilians. On the black market, which flourished, the dollar brought anywhere from 125 to 225 francs.

The GIs were not the only ones to be shocked by the prices. Kenneth Clark and John Rothenstein, imagining French collectors and dealers would be impoverished and anxious to sell their pictures, rushed to Paris soon after its liberation to look for bargains for the National Gallery and the Tate, respectively. They found instead "a sense of prosperity and social gaiety, which made London seem very drab. The only difficulty was a shortage of fuel. This meant that the skies were clear of smoke and that

the streets were empty of traffic, except for a few Army jeeps. Never again will Paris look so beautiful."[56]

The art market, of course, they found to be booming. "The Germans were the best customers the dealers had ever had. When I visited the dealers I knew, including Jews, I was laughed at," Clark wrote.[57] The trip was not entirely casual. The two museum directors had been sent over in an RAF bomber with the approval of British Foreign Secretary Anthony Eden and Ambassador Duff Cooper, who felt that the Americans were trying to keep British subjects out. Rothenstein, undoubtedly referring to the visit of Francis Henry Taylor and influenced by German propaganda, had heard "persistent rumors that the Americans were taking unfair advantage of the presence of their forces in Paris and that large numbers of their officials and businessmen, including art officials and dealers, were actively pursuing their national or personal interests." He too found little he could afford at the dealers'.

At Martin Fabiani's gallery Rothenstein greatly admired an edition of the works of Buffon illustrated by Picasso which the dealer had published. Alas, it had long since been sold out, but Fabiani generously promised to find Rothenstein a copy.[58] Not long after this visit opportunist Fabiani, making a quick shift, put on a show to benefit British war wounded, which featured a number of high-grade works lent by M. de Galea, a fancy catalogue by Louis Aragon, and, *pièce de résistance,* a painting by Winston Churchill.[59]

Liberators in the know, beginning with Hemingway, who left a box of live grenades at Picasso's studio, sought out their icons and found them safe. Picasso was mobbed. Kenneth Clark wrote that his studio was "stratified. . . . On the ground floor there were G.I.s and American journalists; then came communist deputies and prominent party members who showed signs of impatience; then came old acquaintances; and finally one came to Picasso."[60] Others went to Gertrude Stein's fabled apartment. She was not yet there, though she had indeed been liberated by the Allied armies coming up from Marseilles. She, Miss Toklas, and their dog, Basket, did not return to Paris until December, again with the portrait by Picasso in the car, which served as a passport when they were stopped by armed Resistance members. Only a few things were missing from the apartment, taken at the last minute by roving SS troopers who had intended to destroy the "degenerate" Picassos there but, clearly no longer the supermen they once were, had been chased off by gendarmes called by the neighbors.[61]

Despite the meagerness of their collections the museums soon reopened. The Carnavalet was first again with a show in September. The Louvre put

Hanging Picassos for the Salon d'Automne, 1944

on a special exhibition of the Bayeux tapestry with the part showing the defeat of the British tactfully folded behind more palatable scenes. The galleries containing its unevacuated sculptures were opened too, but just in case the bombs came again, all the statues were carefully placed with their backs to the windows. The most precious things could not yet come home, for there was no coal to heat the vast museum spaces. But there was a Salon d'Automne at the Tokyo, and here Tate director Rothenstein finally saw convincing evidence of the rigors of the occupation in the "lassitude and frustration" expressed in many works. To him it even showed in many of the paintings by Picasso, who had been specially honored by a sort of retrospective of seventy-four pictures within the Salon. Picasso's extreme modernism, plus his controversial and much-publicized membership in the Communist party, aroused so many from this lassitude that there were riots in the galleries, during which his canvases were ripped from the walls. Twenty gendarmes had to be posted in the rooms for the duration of the show. When Rothenstein described the changing of the guard in the galleries, Picasso was delighted and said, "Just like Buckingham Palace, isn't it?"[62]

* * *

In their peregrinations around the châteaux in the countryside and the houses, palaces, and museums of Paris, the Monuments men had also been collecting information on the millions of things which had disappeared, presumably to the Reich. It was nearly impossible to be precise. Objects hidden or misplaced by collectors, Jewish and otherwise, appeared unexpectedly in closets, armoires, and barns, near and far from their proper locations. Boiseries from one château were found a few miles off in a neighboring one. Some things had not been hidden or stolen at all. Guy de Rothschild found a missing Boudin in his stables. In Robert de Rothschild's Paris house, inhabited by a German general throughout the war, all was impeccably in place.

The owners themselves, who had left objects in the hands of retainers, friends, lawyers, and bankers, often had no idea where to start looking. Some things were entirely forgotten. Although German troops had been billeted in the château of the jeweler Henri Vever and had taken a collection of gold coins, they had not found his magnificent Islamic miniatures, though it was assumed that they had. Vever died peacefully during the occupation, and the miniatures, left to his family, were packed away and would not reappear until 1988. Inventories, if they existed at all, could be maddeningly vague. One officer wrote, "It is still not possible to ascertain what was hidden by . . . collectors before and during the German occupation, what the Germans destroyed in contradistinction to what they carried away . . . what was moved from one house to another by the Germans and what has just been mislaid during a period of disorder."[63]

Little was as yet known of the details of the art trade and the operations of the ERR, and for a very long time the single best source on this subject, Rose Valland, trusting no one, kept her carefully collected data to herself, though she did hint at her knowledge. After a time no one was certain if she really knew anything or not. She did know enough about bureaucracy to be sure that if she turned over her precious lists and photographs to SHAEF they might disappear without trace.

In her dealings with James Rorimer over the installation of the post office at the Jeu de Paume she felt she had found an American who did not "give the unfortunate impression of having arrived in a nation whose inhabitants were not important." Rorimer was first impressed by the accuracy of her knowledge when they went together to inspect the famous train liberated by Alexandre Rosenberg, but it was not until December that Mlle Valland finally agreed to take him to the former haunts of the ERR. The tour began with a garage at 104, rue Richelieu, where they found thousands of confiscated books divided according to subject and destination and stacked up, ready for shipment to Germany. They went on to Lohse's

apartment and various ERR offices where Rorimer picked up numbers of German documents which gave the MFAA men their first detailed insights into Nazi confiscation activity.

In his diary Rorimer noted that Mlle Valland, though recently appointed Secretary of a newly created French committee for recuperation of art, "has not yet given the French authorities all of her information about the destination and location of works of art sent to Germany." This, according to a later book by Rorimer, she confided to him alone over a candlelit supper, with champagne, *chez elle*. Mlle Valland's own book omits the romantic details, but her trust in Rorimer is clear, and she duly presented her lists both to her French colleagues and to the MFAA officer, whom she urged to go to Germany as soon as possible to make sure that the Allied vanguards would be aware of the ERR repositories. But Rorimer could do no more than send this information on to the forward echelons. He himself would not be sent to Germany until March 1945, by which time a number of things were no longer where Mlle Valland thought they were.

There had, of course, been plenty of preparing in Germany for the inevitable Allied incursion onto the Continent in the north. The storage places stuffed with confiscated works which awaited the Reich's victory in order to be displayed not only would never be emptied into Hitler's museums and government palaces; they were now in considerable danger from the aggressive bombing tactics of their former owners.

The Berlin museums, like everyone else, had begun preparations to shelter their own collections from air attack in the thirties.[64] During the Sudeten Crisis things were put in basements and a few very important ones in the vaults of the Reichsbank, but they were ordered back on display by the Nazi government so as to calm public opinion. Somewhat resentful, the curators intensified their in-house preparations. Rumors of the coming invasion of Poland reached them on August 25, 1939. By this hour the French and British collections were already on the road. Nothing in Berlin had been moved, nor were there instructions from the Nazi government. This time the Prussian Minister of Finance told the director of the Antiquities Division, Carl Weickert, to take charge of finding shelter for the Berlin collections and not worry about intervention. For the time being, though the collections were packed, they stayed in the city, stacked in fortified basements or in the vaults of the Mint and the Reichsbank. A protective structure was placed around the virtually immovable Pergamon altar.

Other jurisdictions, less confident than Berlin of their cellars and defenses, had begun to send things to the country. Soon there was hardly

a schloss in the Reich without stored treasures. The Vienna museums had established 108 repositories in Austria. Dresden occupied 60. The Rhineland museums, closest to an enemy after the fall of Poland, sent a great deal to the east of Germany, while the Bavarian collections were scattered south of Munich.

A bombing raid on Berlin in December 1940, which blew away the Pergamon frieze protection like so much cardboard, led to reconsideration of matters. In early 1941 the altar was dismantled with great effort—it was necessary to take down the outer wall of the museum—and, each piece having been carefully marked, was moved to the Mint, which itself was reinforced with several layers of concrete. The fabulous Trojan gold treasure, thought to have been owned by King Priam of *Iliad* fame, was moved in three chests from the Prehistory Division to a vault at the Prussian State Bank.

As the bombing increased it was soon clear that even this might not be adequate. Still, no one considered moving things out of town, but discussed using space in the huge antiaircraft towers, surmounted by guns, which were being built by Speer and were said to be able to withstand any known assault. Although many of the museum directors disliked the idea of being under military control, it was decided to place the best Berlin objects in these towers. Between September 1941 and September 1942 this operation was slowly accomplished. There were two towers: the one at Friedrichshain held the cream of the Kaiser Friedrich Museum, or Gemäldegalerie, much of the print collections, the Islamic holdings, and the famous bust of Nefertiti; the other, near the Zoo, sheltered, among other things, the paintings of the purged Nationalgalerie, and the Trojan gold.

In the year it had taken to accomplish this storage the military situation had totally changed. The war in Russia was not progressing as expected and bombing increased steadily. The previously unthinkable idea of fighting within Germany had crept into everyone's mind, and although no one yet envisioned Berlin as a battlefield, evacuation of the collections from the city was once again discussed. But it was not until March 1943 that Weickert, reinforced by a directive from the Propaganda Ministry to find absolutely secure storage for all collections, was able to persuade his colleagues to consider sending them to the deep mines dotted around Thuringia, and nothing was actually moved until June 1944. The first items went to a mine at Grasleben, about thirty-five miles west of Magdeburg, on the busy day of June 6. Despite the news of the Normandy landings and the new horror of incendiary bombs, only the second-class items still left in the museum cellars were sent.

In January 1945 the Wehrmacht suddenly ordered the museums to clear out of part of the Zoo tower. In the few hours a day in which there was no bombing, the precious objects were transferred to the Friedrichshain tower. But the Russians were now so close that it was all too clear that even this would not be safe. The terrible fire bombing of Dresden which began on February 13 intensified all fears. There were rumors that everyone would be evacuated from Berlin. Museums director Kümmel begged his Ministry for permission to move things to the West. The Ministry agreed, but even at this juncture some division directors, balking at the idea of moving things on the dangerous roads, withheld approval. Exasperated, Culture Minister Rust asked Hitler for a decision. The Führer, whose own collections, as we shall see, had long since been taken to safety, and who was by now aware of Allied plans made at Yalta for the partition of Germany, finally gave the order for evacuation on March 8, 1945.

Control of the operation was given to Ministry official F. K. Thone, who had taken the earlier loads to Grasleben. Skipping over the turf-conscious directors, he worked directly with the curators of each division, who, while nervous at their defiance of their bosses, bitterly recognized that Berlin was finished. Paul Ortwin Rave of the Nationalgalerie was to escort the first convoy, containing forty-five cases of the top paintings from the Kaiser Friedrich Museum, to a group of mines in the Werra district. It left on March 11. In the preceding night the Mint was badly hit, and a large section of it burned. Water from the fire fighting rose to knee level in some storage areas. It took days for the vaults to cool down enough so that curators could begin salvage operations.

The remote Werra district, southwest of Erfurt, had been chosen because it was assumed it would be just inside the proposed United States Zone. The Berlin pictures had not been assigned to any particular mine. The convoy stopped first at Hattorf, a potash mine near Phillipsthal, which was already filled with the collections of the Prussian State Library. They, being a different jurisdiction, refused to take the paintings in. After much discussion the trucks moved on to the Ransbach shaft, a mile away, which was mostly reserved for SS archives and "cultural" material. But it was soon clear that the humidity levels in this mine were not suitable for long-term storage, and with the help of mine technicians the search for a better refuge continued, ending finally at the Kaiseroda mine near Merkers-on-the-Werra. Seven more convoys, containing objects from various divisions, were taken there. The last load arrived on March 30, after which the proximity of the front lines and continuous artillery fire prevented further work. Rave, with his family, stayed at Merkers to await his fate and that of his charges.

There were other things far more tempting to human greed at Merkers. In the shadowy tunnels were stacked a hundred tons of gold bars, thousands of bags of currency, and the hideous gold trophies wrenched from the bodies of Jews and other "*Untermenschen*," which had been given the highest priority for evacuation from Berlin and had gone straight to Merkers after the Reichsbank had been severely damaged in February. As the last works of art were moved in, the Reichsbank, now aware of Patton's approach from the West, tried to take its holdings out. Moving the gold again proved hopeless, but they did manage to get 450 huge sacks of paper reichsmarks away before the entire operation was, incredibly, halted by the insistence of the German railroad workers on observing Easter Sunday. Goebbels could not believe it: "One could tear one's hair when one thinks that the Reichsbahn is having an Easter Holiday while the enemy is looting our stores of gold," he fumed in his diary.[65]

The last two convoys to leave besieged Berlin went in considerable confusion to the more accessible Grasleben mine on April 6 and 7. They contained masterpieces of the Nationalgalerie which had never been packed in boxes and some 50 cases from the Museum of Prehistory, exact contents unknown due to the subsequent loss of inventory lists—but apparently not the Trojan gold. Dr. Unverzagt, director of the Prehistory Museum, had not, he later stated, at the last minute been able to find the key to the area of the Zoo tower containing the Trojan treasure, and, when he finally did, could not identify which were the cases containing the gold. This implausible inability to put his hand on the 3 cases containing the greatest treasure of his museum has led to suspicions of the motives of Unverzagt, who had been closely associated with the Ahnenerbe and whose former assistant, Alexander Langsdorff, was at the same moment holding the Uffizi collections in their mountain hideout. He had, however, earlier on managed to send 450 other cases from his collections off in river barges to another mine at Schönebeck on the Elbe, not far from Magdeburg. Back in Berlin the flak towers were far from empty. It had not been possible to move the Pergamon frieze, most of the sculpture, five hundred large paintings from the Gemäldegalerie, and many antiquities. King Priam's ancient golden treasure also now remained behind in the path of the coming battle.

The Linz project curators and their Führer were, by 1943, just as anxious as anyone to seek shelter for their collections. Things were stored all over the Reich. The Führerbau in Munich was chock-full, even though nearly eighteen hundred paintings had already been sent to Kremsmunster in Austria. The Dresden Museum, headquarters for Posse and later Voss, had

*Partial diagram of
the complex of
chambers at Alt
Aussee*

held the Koenigs drawings and many later acquisitions for a time before
transferring them to Schloss Weesentein, twelve miles east of the city. The
Czech Monastery of Hohenfurth was filled mainly with furniture and *ob-
jets* from the Mannheimer and Rothschild collections, and the Ghent al-
tarpiece was at Neuschwanstein. The Linz second-in-command, Gottfried
Riemer, began to search for a safe refuge in which to consolidate the dis-
persed collections, which were still growing.[66]

He was not alone in this quest. By the summer of 1943 an Austrian
official, Dr. Herbert Seiberl, had completed an investigation of the

labyrinthine network of salt mines in the Salzkammergut, a chic summer resort area high in the mountains southeast of Salzburg. They were perfect: remote and constant in humidity and temperature. The most suitable was at Alt Aussee, where the main chambers lay more than a mile inside the mountain, reachable only by tiny special trains. There were few entrances and exits and the mines were worked by a close-knit group of mountain men who had been there for generations. Seiberl's belief that the conditions would be ideal was supported by his discovery of a little chapel inside the mines in which oil paintings had been hanging since 1933 without ill effect. Access would be dangerous: the one rail line was nine miles away and the road up to the mine narrow and very steep. It would also be necessary, as the British had discovered, to construct accommodations for the art works inside the vast chambers.

Seiberl was thinking of this place not for the Linz holdings, but for the Austrian collections, now for the first time within range of Allied bombers coming from Italy. But word of this perfect hideaway soon reached Riemer, and it was immediately claimed for the exclusive use of the Führer. No other organization was to bring anything to the mine, though an exception was made for Seiberl's own Institute of Monuments Protection in Vienna.

The arrangement met with Hitler's approval. Workers were exempted from military service to build the needed structures; miles of cables and shelves were installed. The area was transformed. There were offices and restorers' studios. The Gauleiter of Oberdonau, in whose domain Alt Aussee lay, came to inspect. Armed guards were posted. The Gauleiter of the Tirol, who controlled the art-loaded north of Italy, tried to get the mine area transferred to his jurisdiction and had to be reprimanded by Himmler. Dr. Pochmuller, director of the mines, described the scene as a madhouse. He knew works of art were coming, but was not quite prepared for the magnitude of what began to pour in as soon as the spaces were ready. Dr. Seiberl had taken full advantage of his special status, and load after load appeared not only from Viennese museums such as Schönbrunn but from small towns and churches all around the country. In the next year 1,687 paintings came from the Führerbau. They were joined in the fall by the Ghent altarpiece, which had a special room built for it, and 992 other cases from Neuschwanstein. In October, unharmed by her sea voyage, the Bruges *Madonna* arrived to join her compatriot. The Naples masterpieces from Monte Cassino were sent in March 1945 by Goering, who did not wish them to be found in his own collections. On the way up, blocked by snow, they spent two weeks in a little pension in the village of St. Agatha.[67]

The owner of most of these treasures was, by mid-March 1945, living in much the same conditions as they. From deep underground in his bunker beneath the Reichschancellery the Führer managed to control what was left of his nation only by the fear his loyal followers could still inspire in their fellow citizens. But Hitler still hoped. The final architectural model for the rebuilding of Linz had been delivered to him on February 9, and he had taken it with him to this nether region, where he frequently sat gazing at the tiny representation of his vast dream museum arranged in a splendid allée of gleaming white buildings which rose up from the Danube. The contents of Alt Aussee, absolutely safe, now only awaited its completion.

In quite another mood, in August 1944 Hitler had ordered all military installations, utilities, communications, archives, monuments, food stores, and transportation facilities destroyed as the German armies retreated, so that only a wasteland would await the Allies. In mid-March 1945 he broadened this policy to include industries and infrastructure and added an order for the complete evacuation of areas which were soon to be battle zones. This impossible responsibility was entrusted to the local Gauleiters. Albert Speer, who had proposed a more realistic program, was removed from office for a time, but eventually managed to compromise with the Führer and change the order for destruction to "disabling," all the while working against Hitler's orders.[68]

In addition to the scorched-earth order, on every front soldiers and Gauleiters were commanded to fight to the last or face execution, Hitler's theory being, as Wolff had found out in Italy, that if they held out long enough, the Western Allies would join with Germany to defeat Bolshevism. In this scenario Germany would remain intact, and the purloined treasures would be used. They must, therefore, be kept from the enemy as long as possible. Indeed, in his will, written the day before his suicide, Hitler stipulated that his collections should be given to the nation.

Not all of Hitler's followers understood the subtleties of what should and should not be saved. Gauleiter Eigruber of Oberdonau had taken Hitler's scorched-earth decrees deeply to heart and was persuaded that the works of art at Alt Aussee should not fall into the hands of the Bolshevists or "International Jewry." In addition, the valuable salt mines must be "disabled." (The Gauleiters in general, as Speer had discovered, were not an art-oriented group. In Essen the Gauleiter had suggested to him that the partially bombed cathedral be torn down completely since it was "only a hindrance to the modernization of the city." Speer was able to save the cathedral but many another historic building was demolished.[69]) The story of Eigruber's fanatic desire for destruction, and the efforts to stop him, has become the legend of Alt Aussee. What actually happened is far from

clear, for in the dying days of the Reich there was much maneuvering for self-salvation and all testimony by those involved at Alt Aussee must be viewed in this light.

The basic legend tells us that Eigruber put bombs in the mines with the intention of blowing up everything, and that heroic Austrian Resistance workers removed them and thereby saved the priceless works for humanity. It was not quite so simple.[70] All agree that Eigruber's assistant, Inspector Glinz, visited the mine on April 10 and 13, 1945, with eight crates marked "Marble—Do Not Drop," which he said were Eigruber's personal property, and which were to be carefully stored within. On the thirteenth a top-level committee consisting of Bormann's assistant von Hummel and all the principals responsible for the mine also arrived to discuss the "disabling" of the mine complex. Von Hummel, sworn to secrecy earlier by Eigruber, was well aware of the Gauleiter's plan. He was also aware that Hitler had ordered this and other repositories sealed and the works of art preserved at all costs, and that Eigruber must have received similar orders, which he, distrustful of everyone since the fall of Vienna, had simply chosen to ignore. Von Hummel now confided this to the mine officials, good Nazis all, still wary of the power of the Führer. Von Hummel was persuaded to call Bormann and ask for a Hitler order to stop the process. The order came immediately and von Hummel sent a colleague to inform Eigruber. But these verbal messages did not convince the Gauleiter, who refused to reconsider his decision.

Those privy to the secret now carefully approached certain co-workers to enlist their help. In this extremely dangerous undertaking they knew they risked death as defeatists and traitors. Their next ploy was to try to persuade Eigruber that the bombs would not destroy everything inside unless the mine entrances were sealed. This would make the bombs inaccessible, but the engineers convinced the Gauleiter that they could be detonated by a long fuse to the exterior. The curators also secretly began to redistribute the most precious works to small, remote chambers in the hope of protecting them from the blast if it came. The Czernin Vermeer and fifteen top Rothschild paintings shared one chamber and other little groupings were scattered about. The Linz coin curator, Rupprecht, went rather further and took twenty-two hundred gold coins, worth $4 million, out of the mine and entrusted them to von Hummel, who was supposed to be preparing hideouts for high-level Nazis in the South Tirol. The St. Florian Altdorfers and thirty other Austrian treasures were also quietly removed to another mine at Lauffen.

By now von Hummel had told his friends at the ERR of the situation. Aghast, Robert Scholz came to the mine, and somewhat impractically

promised to send armed men to resist Eigruber and his guards when the mine custodian phoned him with a secret password. Feeling that no progress was being made, the mine chief, Pochmuller, decided the next day to order the bombs dismantled on his own responsibility. Unfortunately his telephoned orders were overheard by Eigruber's assistant, Glinz, who threatened the engineer assigned to do the job and sent heavily armed reinforcements to protect his bombs.

Desperate, the curators now even considered sending someone to be captured by the Americans, but in the end limited themselves to enlisting the aid of the salt workers, who had long suspected that something was afoot. Their cooperation was not entirely altruistic. The miners were very anxious that their sole source of livelihood not be made unworkable. Soon the conspirators had also subverted the head of Eigruber's guard.

Von Hummel, meanwhile, produced a useless letter which stated that the Führer had "last week" again decided that the works of art should be kept from the enemy but not be destroyed.[71] He had to write "last week" because Hitler had in the meantime committed suicide. Who was now the ultimate authority? Bormann had disappeared and the telephone lines to Berlin had ceased to work on April 27. Eigruber's opponents turned to the highest Party authority still available—SS Intelligence Chief Ernst Kaltenbrunner, who was well known in Alt Aussee, where he kept a mistress.

Kaltenbrunner authorized the immediate removal of the bombs and promised to so inform Eigruber. At 7:30 p.m. on May 3 the operation began. It seemed to take forever. Moving anything in the mines was difficult, and the five-hundred-pound bombs had to be hoisted onto the tiny shaft trains and be moved miles to the entrances. But by the time Eigruber had heard of the operation they were out, and he could only demand that they be kept "for future use." They were duly hidden in a pile of brush. On May 5 the mine entrances were blasted shut. Inside, the scattered masterpieces rested safely in the darkness.

The major Vienna museums had also put their things in mines, not at Alt Aussee, but just down the road in the Lauffen mine at Ischl. The facilities at Alt Aussee were far better, but upon reflection the Viennese, well aware of the eventual arrival of the Allies, preferred not to mix their collections with those of Hitler.[72] To this repository came the most precious things from the Kunsthistorisches and the Albertina. Lauffen was put in the charge of Dr. Victor Luithlen, who after April 8, when the Russians were just outside Vienna, had no further contact with his home office. He feared that his mine too would soon come to Eigruber's attention and quickly ordered sealing operations to begin.

Before these could be completed, Hermann Stuppack, cultural assistant to Baldur von Schirach, the Nazi governor of Vienna, appeared saying that his chief wished to remove the Viennese masterpieces in order to protect them from Eigruber and scatter them around the Tirol, one impossible site suggested being an island in the middle of the Bodensee. The curators protested. This was of no avail and packing up began once again. It was extremely slow packing, the hope being that the Americans would arrive before the trucks were loaded. Four days after his first visit, Stuppack returned to find that little had been done. Fed up, he sent six officers and twenty men from the task force of a Major Fabian of the elite Grossdeutschland Regiment, which was assigned to protect von Schirach, to Lauffen with orders to load the Viennese pictures on their trucks whether they were packed or not. The next day, at news of Hitler's death and von Schirach's subsequent flight, Stuppack ordered the operation cancelled; but Major Fabian had other ideas, and at gunpoint ordered the packing to continue. On May 3 the convoy moved off onto roads under constant Allied bombardment, destination unknown. Dr. Luithlen had had good reason to try to stop the shipment. Included in the 184 paintings taken were all the great Breugels, 5 Rembrandts, 7 Velázquezes, 9 Titians, and 2 Dürers, plus 49 tapestries from the renowned collections of the Kunsthistorisches Museum.[73]

In January 1945 Goering too decided to send his family and his collections away from Carinhall, which was now uncomfortably close to the Red Army. For some time he had been putting things in his own bunkers at Carinhall proper and at Kurfuerst, near Potsdam; but Carinhall was still full to the ceilings. He would not leave his beloved house to the Russians. In preparation for his flight it was mined, and items too heavy to be moved were buried in the grounds, along with a quantity of wine and silver. With Hofer, Goering toured his collections, picking out what should go. The Reichsmarschall did not at first wish to include any of the incriminating objects obtained from the ERR, but after a long argument, Hofer persuaded him to send them.[74]

Several large buses were hastily requisitioned to take the works from the enormous lodge to two of Goering's special trains, beefed up with eleven extra boxcars, which were waiting at the Forst Zinna station near Juterbog. Hofer brought more truckloads.

At one point all had to be rearranged for Frau Goering, who complained that she had not been given enough room for her personal baggage, somewhat inflated by the presence within it of a number of very valuable small paintings, Goering favorites, which he thought would provide his wife

Goering's favorite Vermeer, Christ with the Woman Taken in Adultery— *alas, a fake*

with a little nest egg in case of emergency. There were two Memling *Madonnas*—one from the Rothschilds and the other bought from Renders in Holland—another by van der Weyden from the same collection, the four small Memling angels from Goudstikker, and Goering's prized "Vermeer," *Christ with the Woman Taken in Adultery.*[75] Of this impressive-sounding lot, only two, the Rothschild picture and the van der Weyden, were of unquestioned attribution.

Carinhall was blown up and the first two trains went off to Goering's Schloss Veldenstein, near Nuremberg. Another shipment followed, but by early April this area too was under fire, and the best things were repacked and sent to Berchtesgaden on April 10. When they arrived, SS policeman Franz Brandenburg, a member of the personal bodyguard of Frau Goering, noticed that another of Goering's special trains, the "Flitzer," was already there with the last shipment from Berlin. For safety, the cars were parked in the station tunnels of both Unterstein, just up the line, and Berchtesgaden, where Hofer, lodged in one of them, awaited Goering.

The Reichsmarschall, having attended Hitler's last birthday in the depths of his Berlin bunker, arrived on April 21 and began to decide where

everything should be stored. But affairs of state intervened. On April 23, Goering, who had been convinced by confused messages from Berlin that Hitler could no longer govern, cabled the Führer to say that unless he heard otherwise, he would assume the "total leadership of the Reich." He heard otherwise. Hitler cabled back accusing him of treason and demanded that he resign all his offices. Bormann ordered Goering arrested by the SS.[76] He was held in his house at Berchtesgaden, and, after this was bombed, taken to his family castle of Mauterndorf.

Meanwhile, Hofer continued unloading the trains. A number of cases were stuffed into a dampish room in an air-raid bunker just outside Berchtesgaden, and covered for protection with tapestries. The room was sealed with a foot-thick wall of cement, which was covered with timbers made to look as if they were ceiling supports.[77] Far more remained in the trains. Brandenburg was amazed, when he arrived at Unterstein, to see men, women, and children carrying off rugs and tapestries. Food and other objects littered the station. Another policeman later testified that he had "observed innumerable persons moving antlike, from all directions toward Unterstein station. . . . The whole population seemed to be on their legs fighting to get into the cars, carrying heavy loads, sawing up big carpets, beating and scratching each other in their greed to capture a part of Goering's heritage."[78] Armed railroad guards were doing nothing to prevent the pillage. Brandenburg, trying to save something, managed to chase people off the trains by giving them the food and wine on board. There was plenty of that. The Reichsmarschall, Renaissance man that he was, had not planned to suffer in exile; he had put on two boxcarsful at Carinhall, and more had come from Veldenstein.

The good burghers of Berchtesgaden, tempted by the empty houses of the fallen mighty, were also busy in town on these final days of the Reich. They broke into the little chalet called Haus Schneewinkel, which Himmler had built for his mistress, and took the furniture. The all-powerful Bormann lost his collection of more than a thousand watercolors and drawings by Rudolf Alt to the mob. In the midst of this saturnalia the first Allied elements arrived in the outskirts of the town.[79] Brandenburg dryly reported that the station "was empty in a second."

While much of this amazing activity was taking place, Mason Hammond and Calvin Hathaway, slogging away in London at plans for the occupation of Germany, had lapsed frequently into depression at the seeming lack of interest in their doings. They were not alone in feeling that their work was for naught. Much more important issues were equally unresolved. On September 12, 1944, the European Advisory Commission had produced a

vague draft plan for the occupation of Germany after months of maddening negotiations during which the Big Three avoided any precise commitments on the subject. Germany would be divided into three zones, with the Russians in the East, but no precise lines of demarcation had been drawn. The United States and Britain would have the West, but could not even decide who would have the North and who the South. No zone was yet planned for France. How these zones would be governed and how Germany would be treated was even less clear. The American Army plans were, as a result, no more firm. Although the Civil Affairs people were organizing for the immediate problems of occupation, Robert Murphy, Eisenhower's political adviser, noted that Ike "was not paying much attention to what would happen in postwar Germany. He rightly believed that this was not his responsibility." Eisenhower felt that the occupation government should have a civilian head, and commented to Murphy: "Thank the Lord that will not be my job."[80]

Opinion in the Roosevelt administration at home was very divided on the issue of the coming occupation. The President and particularly Secretary of the Treasury Morgenthau took a hard line, the latter proposing to do to Germany more or less what Germany had done to Poland. All heavy industry, including coal production, would be eliminated. The country, rid of Nazi archcriminals who could be shot on sight, would become a barely self-sustaining agricultural nation whose excess labor would be conscripted to work in the formerly occupied lands. Secretary of War Stimson termed this idea "a beautiful Nazi program."[81] His colleague Secretary of State Hull called it "a plan of blind vengeance."

Both the State and War Departments, conscious of the disastrous aftermath of the punitive measures that followed World War I, had far more moderate plans which provided for limited economic rehabilitation of Germany. Roosevelt, in the midst of his campaign for a fourth term, indicated to Hull and Stimson that he would not necessarily adhere exactly to the draconian Morgenthau plan. It was "all very well to make all kinds of preparations for the treatment of Germany, but . . . speed on these matters is not essential at the present moment. It may be in a week, or it may be in a month, or it may be several months hence. I dislike making detailed plans for a country which we do not yet occupy."[82] As for the EAC, Roosevelt considered it an advisory organization on a "tertiary level" whose directives were not binding.[83]

In December it became clear that "several months hence" was all too accurate. The Germans, in a last desperate offensive, attacked the Allied armies, bringing their headlong advance to a halt in the snowy hill coun-

try of the Ardennes, which the Germans themselves had exploited so cleverly four years before. In the months which followed, the discussions on the treatment of Germany continued in all the committees and departments. Morgenthau's ideas were modified, but not eliminated. Unconditional surrender was confirmed, as was his proposed dismemberment of Germany, by the agreement at the Yalta Conference in February 1945 to cede East Prussia and Silesia to Poland as compensation for the large piece the Soviet Union was taking from the Poles in the East. Yalta also brought the first concrete discussion of reparations, the establishment of a zone of occupation for France, and the tentative fixing of the boundaries of the zones. It was agreed that each power would be totally independent within these areas, but that the whole would be run by a joint Allied Control Council in Berlin, which would also be divided into four sectors. Renewed planning to adapt to these decisions now continued in Washington and London.

The gentlemen at Yalta had not specified who would actually do the work in occupied Germany. Roosevelt, wanting to bring the troops back as soon as possible, returned to his visions of a civilian occupation government and offered the post of High Commissioner of Germany to Assistant Secretary of War John J. McCloy. But McCloy knew that it would take a military presence to deal with the horrendous problems of devastated Germany. He declined the offer and recommended General Lucius Clay, a brilliant organizer who had been in charge of keeping supplies flowing to the armies in Europe. On March 31 Clay was appointed Deputy Military Governor under Eisenhower. McCloy was sent over to present this surprise assignment to the Supreme Commander, who had not been consulted. After some soothing, Eisenhower agreed that, as in Italy, a Military Government was the most suitable solution, at least for the early stages of occupation.

After Yalta the Departments of State, War, and Treasury had combined to produce a detailed policy directive for the Military Government commander. Negotiations and maneuvers of Byzantine complexity followed. The result of these efforts was the infamous document known as JCS 1067, in which Morgenthau's ideas were considerably softened and many loopholes were left for improvisation, but which still retained a punitive approach. Germany, it declared, "will not be occupied for the purpose of liberation, but as a defeated enemy nation." The occupiers were urged to be just, but firm and aloof, and fraternization with German officials and population was forbidden. Living conditions were to be kept below those of the Allied nations. Reparations programs were to be enforced, and the economy "decentralized." Works of art, classified as one type of property

in the financial section of the directive, were to be "impounded regardless of the ownership thereof." There was little useful detail in this document, which noted only that "all reasonable efforts should be taken to preserve historical archives, museums, libraries and works of art."[84] Moreover, because of their "top secret" classification even these deceptively simple instructions could be revealed only to a very few high-ranking officers. The plan's vague and negative requirements would, if taken literally, make the governing of Germany essentially impossible. The Army, stuck with a job it never wanted, would be forced to improvise as situations presented themselves. Clay read this document for the first time in early April 1945, as he flew to Paris to take up his duties. The surrender of Germany was a month away.

During all these highly secret machinations the Roberts Commission representatives, in consultation with Hammond and Hathaway at SHAEF, continued to work on the formulation of a restitution policy with representatives of the Allied and occupied nations. Their requests for guidance, sent to the State Department, were virtually ignored (not surprising given the battles over occupation policy which were in progress). In London the Allied nations had produced a number of ideas, having finally agreed on such basics as the precise definition of a work of art, and what exactly was meant in legal documents by the French word *spolié,* or "looted."[85] These weighty matters having been resolved, there was general agreement that all property "taken to Germany during the occupation would be presumed to have been transferred under duress and accordingly treated as looted property."

It was also agreed that identifiable works should be returned to the governments of the countries from which they had been taken, and not to individual owners. A United States Military Government law ordered a freeze on all trade and the importation or exportation of works of art from Germany. And again it was proposed that Germany should be obligated to replace lost works with comparable objects from its own collections. To carry out this process, referred to as "restitution in kind," some sort of international commission was envisioned which would adjudicate claims. These ideas were sent for approval to the State Department by the Roberts Commission in July and November 1944, and again in February 1945.[86] The Allied governments avoided commitment on this subject, as they had on everything else. The State Department finally informed the RC that all restitution matters would have to be referred to a Reparations Commission which the Big Three had ordered to be established at the Yalta Conference. The only trouble was that as of April 1945 no Reparations Commission had yet been appointed.

* * *

Monuments men (left to right) Mason Hammond, Henry Newton, John Nicholas Brown, Calvin Hathaway, and Kenneth Lippman

John Nicholas Brown, whom the RC expected to advise Eisenhower on these matters, had arrived in London on March 9, 1945. He found a "blind town," whose blank, boarded-up windows offered only slight protection against Hitler's ultimate weapon: the V2. Indeed, shortly after his arrival he was slightly wounded by flying glass during an attack. All the iron railings in the parks had long since been melted down. Dressed in the uniforms of many nations, the inhabitants groped their way around the dimmed-out streets. But the knowledge of imminent victory gave a feeling of hope and there were jonquils in the fenceless parks and plenty of theater, the new Olivier film of *Henry V,* some heat and hot water, and amazingly good food still served with style at the Connaught and other watering spots. Hammond, Hathaway, and Crosby took Brown around London and taught him all the tricks of wartime living and transportation. They introduced him to various generals "who greeted me warmly and told me they wanted a long talk soon," he wrote to his wife.

To Brown's surprise, Newton, about whom he had been briefed in

Washington, now appeared to be the acting head of a new division called Reparations, Deliveries and Restitution, to which Brown seemed to be assigned. After five days it was painfully clear that "General Hilldring and David [Finley] had given me a complete misconception. There was no question of heading up a brand new project, choosing personnel, etc. It was all chosen and going and more or less cut and dried, at least in this planning phase. Thus there was no great grandeur. I had no aide, no great field of usefulness, and as for Gen. Ike, well he was just titular head way out yonder. To say I am aide to Gen. Ike is really ludicrous."[87]

Brown thought Newton (whom he described as a "California church architect") and the others were doing a fine job; he was so impressed by Newton's ability to circumvent Army red tape that he recommended that efforts continue to put him in charge of "all our MFAA officers." MFAA, he confided privately, "ranks in the Army *very* low." Brown took all this in good humor, but he was not without resources. When McCloy came to London, Brown "got to see him, to the amazement of the Army." McCloy told him to talk to "Major Gen. Clay, the new head of the Control Council." This proved not to be so easy, as Clay was in Paris. Brown, not as brazen as Francis Henry Taylor when it came to unauthorized travel, settled down in London and quietly immersed himself in his new subject, hoping to be useful in the diplomatic end of things presently being handled by Sumner Crosby, and eventually at SHAEF headquarters when he should be called there. Sir Leonard Woolley he found "agreeable and not difficult." But after suffering through a dinner seated next to Lady W., the other half of the team, he could only comment that she was "a combination of tactlessness and snobbery."

Brown had no trouble working with both Woolley and Newton on restitution policy. (Finley was thrilled with this rare report of harmony at headquarters.) By early April further principles of restitution were taking shape in London. Ecclesiastical property from German churches, they all strongly felt, should be exempted from use for replacement in kind. The British, Brown reported back to Washington, were against using any works of art, including German-owned ones, for reparations, and he suggested that the United States announce a similar policy which would stipulate that "cultural objects in German public or private collections may not be included in an estimate of German capital assets to be seized or held for the purpose of ultimate reparations."[88] This principle he considered "vitally necessary," and he suggested that the Treasury Department be consulted on the matter.

A few days after making these recommendations Brown was finally moved across to France and the little town of Barbizon. Newton thought it

a good time to take him on an inspection trip to Italy, and arranged yet another Papal Audience and a tour through the newly liberated north, where they were briefed on the discovery of the repositories at San Leonardo. This junket, organized in considerable style by Newton, was perhaps the final straw for his Army enemies, who angrily cabled that he was in Italy "without prior clearance" and was signing communications "Special Advisor, War Department." Brown's status was even less clear. "Requested is extent to which he may be considered to represent War Department views," one officer inquired. Hilldring at Civil Affairs replied unhelpfully to these cables from Italy that "the War Department has no knowledge as to how Newton and Brown got to your theater or why they are there," but said that "it would be appreciated if you will listen to Mr. Brown's views. Of course you are at liberty to do what you please regarding his recommendations."[89] Little did Brown know how very "low" the MFAA mission did rank in the eyes of the Army brass.

ASHES AND DARKNESS

Treasure Hunts in the Ruined Reich, 1945

In the first months of 1945 the small group of Monuments men in the forward echelons moved into the thin strip of newly conquered German territory immediately behind the front lines. It was shockingly different from what they had encountered thus far. The previous October, Aachen had given them a glimpse of the destructiveness of total war, but the constant saturation bombing and fierce resistance of the German armies since that time had further reduced the "skeleton" cities to flat wastelands of rocky rubble sometimes relieved by pockmarked cathedrals, spared thanks to the maps provided by the Roberts Commission.

The remaining inhabitants of these moonscapes lived marginally in cellars, while newly liberated groups of half-starved forced laborers and displaced persons roamed about looking for food and anything of value that might be exchanged for it. In such conditions the protection and repair of historic buildings was, for the most part, a ludicrous impossibility. Nevertheless, the MFAA officers continued to do what they could to salvage chance finds of sculpture or movable works from the smoldering heaps of stone and gather them in more protected places which could be put under guard. It was discouraging and dangerous work: on March 10 British Major Ronald Balfour was killed by artillery-shell fragments while trying to save sculptures from a fourteenth-century church in Cleve.

To George Stout, waiting impatiently for the liberation of the constantly growing list of repositories which Intelligence sources were reporting, this tragic event made the magnitude of the task set for the tiny number of MFAA officers more ominous than ever. There were now only five of them in the forward area. At fleeting meetings with the policy makers at headquarters, or by telephone, Stout tried to organize the forward placement of his colleagues and prepare procedures for dealing with the large deposits of works of art which he knew they would soon encounter. He circulated a list of German museum personnel who might reveal the locations of their repositories and thereby prevent their destruction. At the top was Count

Metternich, who had returned to his post as Provincial Curator in West-phalia after being fired by Goering. But he was not to be found in Bonn when it was taken. Nor were there any museum officials in Cologne to tell Stout where their holdings had been hidden. It was not a place in which he wanted to linger. To his wife he wrote that he felt "bitterness, hatred—the way you feel a raw north gale."[1] This was hardly surprising, considering the fact that heavy bombing of the cities to the east was still going on, and that the German radio continually broadcast bulletins such as the following:

> Like hyenas the Anglo-American barbarians in the occupied western territories are falling upon German works of art and beginning a sys-tematic looting campaign. Under flimsy pretexts all private houses and public buildings in the whole area are searched by art experts, most of them Jews, who "confiscate" all works of art whose owners cannot prove beyond doubt their property rights. . . . These works of art, stolen in true Jewish style, are transferred to Aachen, where they are sorted and packed and then dispatched to the U.S.A.[2]

Meanwhile, at every step the Army bureaucracy, impatient with the ir-ritating demands of the Monuments officers in the midst of battle, made the efficient use of the few specialists nearly impossible. Stout was refused clearance to go from one headquarters to another. SHAEF would not print Off Limits notices. Patton's Third Army, headed directly for southern Ger-many and the greatest concentration of repositories, even suggested that MFAA officer Robert Posey's presence was unnecessary, and that he be relieved. Stout and his colleagues did not give an inch, and by constant badgering of headquarters staffs and wide distribution of the above pro-paganda, managed to maintain their presence, which in a short time would be recognized at all levels as very necessary indeed.

They had known about Siegen since October. In December Mlle Val-land's revelations had added the ERR treasure castle of Neuschwanstein and four others to the list. From liberated Metz came news that the stained glass windows of the Strasbourg Cathedral and other Alsatian treasures were in a mine at Heilbronn. By the end of March, Walker Hancock had followed Stout to Cologne and on to Bonn and found Metternich's assis-tant, who added 109 depositories to the list. Rushing from one headquar-ters to another, Hancock pinpointed them on the operations maps of the three Army Corps within Third Army.[3]

Of the Berlin evacuations and the dramas in the Salzkammergut they as yet knew nothing. Stout felt that Siegen, which he knew contained Charle-magne's relics, might be the most important repository of all, and the tac-

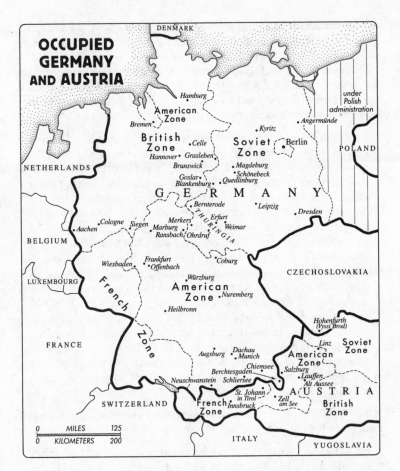

tical troops approaching the city were sent special cables with details of its possible contents. Well before the town had been taken, Stout had asked permission to go in, setting a tentative date of April 2.

On the same Easter Sunday which had so frustrated Goebbels, he and Walker Hancock set out for this objective, picking up the Vicar of Aachen Cathedral on the way. There was only one road, covered with rubble and bloodstains, which was not under fire. American patrols were still rounding up pockets of Germans, while from across the river Sieg the main German body fired sporadically. The warnings sent ahead had been heeded;

indeed, the mayor of Siegen had been amazed that one of the first questions the American commander who took the city asked was, "Where are the paintings?"[4] The Monuments men found the mine heavily guarded by members of the Eighth Infantry Division. With the Vicar they searched for the proper entrance. Up to now there had not been anything unusual about the shattered town; they had seen many in the last weeks. But once they entered the mine, Stout wrote,

> what followed was not commonplace. . . . The tunnel . . . was about six feet wide and eight high, arched and rough. Once away from the entrance the passage was thick with vapor and our flashlights made only faint spots in the gloom. There were people inside. I thought that we must soon pass them and that they were a few stragglers sheltered there for safety. But we did not pass them. . . . We walked more than a quarter of a mile . . . other shafts branched from it. . . . Throughout we walked in a path not more than a foot and a half wide. The rest was compressed humanity. They stood, they sat on benches or on stones. They lay on cots or stretchers. This was the population of the city, all that could not get away. There was a stench in the humid air—babies cried fretfully. We were the first Americans they had seen. They had no doubt been told we were savages. The pale grimy faces caught in our flashlights were full of fear and hate . . . and ahead of us went the fearful word, halfway between sound and whisper, "Amerikaner." That was the strange part of this occurrence, the impact of hate and fear in hundreds of hearts close about us and we were the targets of it all.

It took a child to relieve the tension. Stout felt something touch his hand; turning his light in that direction, he saw a small boy:

> He smiled and took hold of my hand and walked along with me. I should not have let him do it, but I did and was glad. What could have made him know that I was not a monster?[5]

This was not the shaft which contained the repository. The proper one was not much less crowded, but its occupants were Allied prisoners of war and forced laborers clamoring to know when they could go home. In a locked room measuring about two hundred by thirty feet, with vaulted bricked walls and concrete floors, were nearly six hundred high-quality paintings from the Rhineland museums, a hundred sculptures, and stacks of packed cases. Here were the manuscript of Beethoven's Sixth Symphony and the great oaken doors of St. Maria in Kapitoll of Cologne. Mold covered many of the pictures. The ecstatic vicar found six cases contain-

ing the gold and silver shrines with the relics of Charlemagne, the robe of the Virgin, and the rest of the cathedral treasure. The conditions were so bad that immediate evacuation was called for, but there was as yet no place to take the fragile objects. All Stout and Hancock could do for the moment was post guards and convince their commanders of the importance of this room. As they left, a demented old man followed them, screaming of Nazi atrocities. In the darkness they drove slowly back to their billets on roads jammed with muddy tank retrievers.

The hiding places were not all so hellish; a few days later Stout and Hancock would find another major part of the Rhineland collections in two serene and idyllic refuges utterly undisturbed deep in the country on the river Lahn.[6] Their colleagues were finding other things. The unlikely team of Robert Posey (a bluff architect definitely not part of the museum crowd) and Private Lincoln Kirstein (who had been instrumental in the

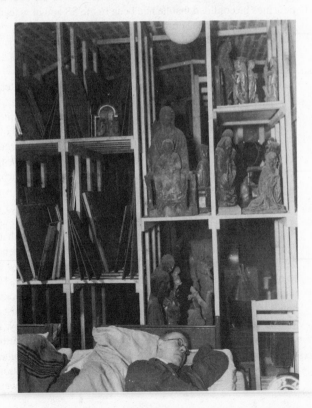

Art and Man sheltered at Siegen

founding of the Museum of Modern Art) had quite by chance discovered the hiding place of the Ghent altarpiece.

Captain Posey had been stricken with a toothache while in Trier and consulted a German dentist, who revealed that his son-in-law had been involved in Kunstschutz activities in Paris. The dentist guided Posey and Kirstein to his daughter's house, where they found Dr. Hermann Bunjes, once so helpful to Goering. The house was decorated with photographs of French monuments, undoubtedly from the documentation project undertaken by the German Institute in Paris. Bunjes, who in a very short time poured forth volumes of information—including the existence of Alt Aussee—did not fail to mention that he had once studied at Harvard and, now that the war was over, would like to work for the Americans. It also soon appeared that he would even more like to have a safe-conduct for himself and his family to Paris so that he could finish his research on the twelfth-century sculpture of the Ile de France. In the course of these outpourings he confided that he had been in the SS and now feared retribution from other Germans. Posey and Kirstein, who as yet knew little of the machinations of the ERR, found him rather charming, but could offer him nothing, and left. Charm had masked desperation: after a subsequent interrogation, Bunjes shot his wife, his child, and himself.[7]

While their fellow officers were thus engaged, another team, consisting of Captain Walter Huchthausen and Sergeant Sheldon Keck, a conservator in civilian life, had set out in response to an inspection request from a forward unit of the American Ninth Army, somewhere north of Essen. Finding their chosen route impassable, they tried to detour around, and soon found themselves on an autobahn heading east. After a time Sergeant Keck noticed that there were suddenly no other American vehicles in sight, but Huchthausen, who felt sure that they were safe, pressed on. Finally they saw American soldiers peering over the highway embankment, but when they stopped to ask directions their jeep was raked with machine-gun fire. Keck dove into a foxhole, but Huchthausen was hit. From the foxhole Keck could not see him. Another GI reported that the captain "was bleeding from the ear, that his face was snow white." While Keck was making his way to the nearest command post, Huchthausen's body was taken away by medics. For thirty-six hours Keck searched one medical unit after another before he was told of Huchthausen's death.[8]

This second loss occurred just as Patton's Third Army, racing across Germany, arrived in the Werra region of Thuringia and took the small town of Merkers. On April 6 an MP patrol stopped two women walking on the outskirts of town in violation of the curfew. After questioning them the MPs offered to drive the ladies on into Merkers. As they were passing the

entrance to the Kaiseroda mine, the women told the soldiers that it was "where the gold bullion was kept." Their story was soon confirmed by other DPs and prisoners of war who had been forced to unload the gold when it arrived, and who indicated that the mine probably contained a large part of Germany's gold reserves. This was not just a bunch of old pictures which could be protected by a couple of guards. After a few soldiers were caught with helmets full of gold coins, Patton sent an entire tank battalion and seven hundred men to guard every possible access to the mine, and ordered reports of the discovery to be censored.

Responsibility for securing this mine's contents went not to the MFAA but to the Financial Section of SHAEF, whose deputy chief was Col. Bernard Bernstein, a trusted insider from Morgenthau's Treasury Department, where heated discussions on the future of Germany were still in progress. In the absence of any firm Allied policy Bernstein acted on the basis of the latest draft "Financial Directive," proposed on March 20, which called for the impounding of "all gold, silver, currencies, securities . . . valuable papers, and all other assets" of various categories including "works of art or cultural material of value or importance, regardless of the ownership thereof."[9]

To deal with the estimated four hundred tons of art from Berlin's museums in the mine, Bernstein called in Robert Posey, who had so recently been considered superfluous by Third Army. Posey informed MFAA chief Geoffrey Webb of the find, and requested the services of technical expert Stout. By the time they arrived, the story of the gold had leaked to the world. Furious, Patton fired the responsible censor. Stout and Webb were surprised to find that Colonel Bernstein had taken custody of the entire contents of the mine and that, not being Third Army, they needed his permission to inspect the works of art. To back up his authority, Bernstein produced a letter from Patton himself. After some hours permission was granted to Stout, but not to the British Webb. Stout was told that he was to stay at the site until further notice, and was billeted with a large contingent of financial staff.

Before anything could be moved the mine was inspected by Generals Eisenhower, Bradley, and Patton, who later joked over dinner about what they could have done with the trove "if these were the old free-booting days when a soldier kept his loot." A bit of levity was badly needed. The mine visit was bracketed by their first view of a different sort of repository, the Nazi death camp at Ohrdruf—where thirty-two hundred emaciated bodies, naked and covered with lice, had lain strewn about where their captors had shot them before they fled—and the news of Franklin Roosevelt's death, which came in the night.

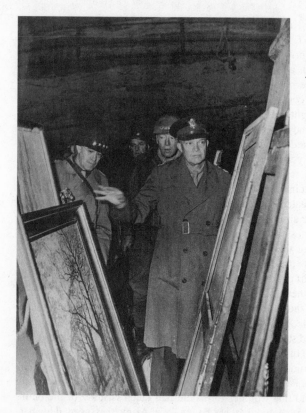

Generals Bradley, Patton, and Eisenhower examine paintings found alongside the tons of bullion hidden at Merkers.

Stout by now had found Dr. Rave, who told him of the forty-five Kaiser Friedrich Museum cases at Ransbach, which they could not inspect as the mine elevator was out of order. At Merkers itself, in addition to the crated items, there were approximately four hundred paintings from the Nationalgalerie without any protection at all. After calculating what materials he would need for normal packing, Stout noted that there was "no chance of getting them." On Friday the thirteenth he returned to Ransbach and found that seven of the Kaiser Friedrich cases had been rifled and left in disorder: "Domenico Veneziano profile *Portrait of a Young Woman* lying out on box with about a dozen other works. Case #10 very important—Dürer, Holbein, Dom. Venez. and others." But no paintings seemed to be missing. Stored along with the pictures were more than 1.5 million books and the costumes and properties of the Berlin State Theater and Opera. These too

had been ransacked, according to mine guardians, by Russian and Polish forced laborers. Rave thought that the Russian DPs, who, he noticed, always crossed themselves when they saw pictures of the Madonna, had not dared touch the mostly religious works in the Kaiser Friedrich cases, and had limited themselves to taking the more useful costumes.

On the same Friday afternoon Stout was informed by Bernstein that the art convoy would leave on Monday morning, "a rash procedure, and ascribed to military necessity," i.e., the huge Russian offensive which the visiting generals expected at any moment. Nearly a million Soviet soldiers were preparing to take Berlin and meet the strung-out British and American armies just about where the mines full of treasure lay. Behind the American front the conquered part of Germany, its armies still fighting, was in chaos, with no government, peopled by wandering millions of DPs, surrendering soldiers, and hungry citizens. Bernstein therefore felt the need to get the treasure to a secure place immediately.

The gold operation was well under way by the next day. There were no transportation problems now. Jeeps with trailers had been lowered into the mine to bring the ingots to the elevators. Each load was carefully escorted and listed as it went into thirty-two ten-ton trucks sent from Frankfurt. The crews worked throughout the night. At midnight on Saturday the fourteenth Bernstein told the Monuments officers to prepare three truckloads of art which were to be mixed in with the gold to make the loads lighter. Stout, between 2:00 and 4:30 a.m., got the proper quantity of cased objects to the mine shaft, complete with inventory lists. The gold convoy departed at 8:45 Sunday morning, escorted by two machine-gun platoons, ten mobile antiaircraft units, continual air cover, and a large number of infantrymen.

After the departure of the gold a crew of twenty-five exhausted soldiers began the delicate task of moving the four hundred unpacked pictures up from the mine chambers. To prevent the formation of salt crystals, Rave carefully washed each one as it came into the open air. At noon fifty men were added to the complement, but Stout noted that there were now "difficulties keeping men on job and with streams of salt water in main shaft." Once the pictures were in the upper mine building, they had to be wrapped in something for their journey. In his inspections of neighboring mines Stout had come across more than a thousand long sheepskin coats which had never made it to the freezing Wehrmacht troops on the Eastern Front. They would do their duty in this move and many subsequent ones. On Monday, with the help of a crew of prisoners of war, the trucks were loaded, a task that took more than twelve hours. The art convoy left Merkers on April 17, 1945, again with a spectacular escort.

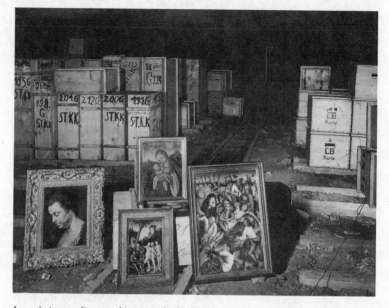

Looted pictures discovered intact in the Heilbronn mine (Photo by Helga Glassner)

The unloading, performed "by 105 prisoners of war in poor health" at the Reichsbank in Frankfurt, Stout described laconically as "complicated." The facilities there were not good. Three hundred ninety-three uncrated paintings, 2,091 print boxes, 1,214 crates, and 140 bundles of textiles were jammed into nine dampish rooms. For the moment responsibility for the cream of the Kaiser Friedrich, Queen Nefertiti, and much more was in the hands of the Financial Section of SHAEF. This made some of the brass nervous, and Stout was ordered to return as soon as possible to make a complete inventory. The anxiety was justified. On every subsequent visit Stout, who was trying to keep the objects from each museum together, found that the cases and paintings had been carelessly moved about. Eventually he managed to get everything up to the ground floor, but upon reinspection found them "stored in promiscuous fashion." And day by day the Reichsbank, the only official military depository, became more crowded as Colonel Bernstein's teams continued to scour bank vaults and hiding places for gold and currency which they brought in by the ton.[10] These deliveries would soon stop, but the flow of works of art had just begun.

Thanks to the continuing efforts of LaFarge and his staff at SHAEF headquarters, still inconveniently located in France, the weary Stout was at least getting a little more help. Rorimer had arrived from Paris, as had Lamont Moore, a former National Gallery employee, who on April 4 reported "important repositories in combat lines near Magdeburg." This was the Schönebeck-Grasleben complex, which, with gold on his mind, the local commander had immediately put under the same heavy guard as Merkers. The gold was not what he expected: Moore and Keck found, not bullion, but thousands of Polish church treasures. Farther west Rorimer, now with Seventh Army, had reported the discovery of a cache in the twin Kochendorf mines at Heilbronn just north of Stuttgart, while almost simultaneous pleas for help had come from Hancock, from a place called Bernterode in Thuringia.

Lincoln Kirstein questions a custodian at Hungen.

Heilbronn, the storage place for the museums and libraries of Alsace and Heidelberg, was flooded, its body-strewn buildings smoldering with sporadic flare-ups of flame, and jammed with Polish and Russian DPs and terrified civilians. For lack of engineering or any other support, Rorimer was forced, for the time being, to leave the mine to military guards and German mine personnel, whose political leanings were as yet unclear.[11]

Posey and Kirstein had meanwhile discovered eight large buildings full of Jewish books, anti-Semitic clippings, and religious objects from all over Europe, in the town of Hungen, where they had been stockpiled for the future use of Rosenberg's racial studies institute, which was to have been built at Chiemsee in Bavaria.[12]

Flying from one headquarters to another, with intermittent visits to

SHAEF, Stout begged for what he needed: at least 250 men to guard the repositories already discovered, access to trucks, and, above all, someplace to take the incredible quantities of art they had found, which they now knew would be hugely increased once the ERR and Linz stores were captured. These recommendations went out in reports and requests which Stout wrote night after night after his grueling day's work was done. He did not get to Bernterode until May 1.

This mine was the last place in the world one might expect to find works of art, for it was a huge munitions dump filled by the German High Command with four hundred thousand tons of ammunition and many more tons of military supplies. In its twenty-three kilometers of corridors and chambers more than seven hundred French, Italian, and Russian slave laborers had been employed. But in mid-March all the civilians had been sent away and, it was reported by the DPs, German military units had brought numerous transports to the mine, which had been completely sealed on April 2. An American ordinance unit with bomb disposal experts had discovered it on April 27. Five hundred meters down the main corridor they had noticed a freshly built brick wall. Breaking through proved quite difficult: the brick was five feet thick, and behind it was a locked door.

Never in their wildest dreams could the Americans have envisioned what they now saw: in the partitioned room were four enormous caskets, one decorated with a wreath and ribbons bearing Nazi symbols and the name Adolf Hitler in large letters. Hung over the caskets and carefully placed about the chamber were numbers of German regimental banners. Boxes, paintings, and tapestries were stacked in one area. Wary of booby traps, the frightened men, sure they had found the Führer's tomb, posted a guard and called their superiors at First Army. Further inspection revealed "a richly jeweled sceptre and orb, two crowns, and two swords with finely wrought gold and silver scabbards." To Hancock, who arrived the next day, the theatrical arrangement clearly seemed to be a shrine, suggesting "the setting for a pagan ritual." And indeed the coffins, hastily marked with handwritten cards taped to the tops, contained the remains, not of Hitler, but of three of Germany's most revered rulers: Field Marshal von Hindenburg, Frederick the Great, and Frederick William I, a fact confirmed by the bomb experts, who, taking no chances, had checked inside and seen the shrivelled but well-embalmed remains of the once plump "Soldier-King." The fourth coffin belonged to von Hindenburg's wife. Next to them was a little metal box containing twenty-four photographs of contemporary Field Marshals, topped by one of Hitler. Above were 225 banners dating from the earliest Prussian wars to World War I. In three boxes were the Prussian crown regalia, which in addition to the things al-

ready listed included a magnificent plumed *Totenhelm*. A little note assured any finder that there were no jewels in the crowns as these had been removed "for honorable sale."

In the excitement Hancock had not at first paid much attention to the pictures. There were 271 in all, strangely at odds with the military splendor about them. Among the first he examined were, to his amazement, Watteau's magnificent *Embarkation for Cythera* from the Charlottenburg Palace, Boucher's *Venus and Adonis*, Chardin's *La Cuisinière*, and several Lancrets. More in keeping with the ambience was a series of Cranachs. A large number were court portraits from the Palace of Sans Souci at Potsdam. Close examination of the whole room, to which there was only one entrance which had been locked from the inside, produced a final mystery: how had those who had brought all this in come out?

Removing the huge coffins would not be easy. To help out, First Army sent Lieutenant Steve Kovalyak, whose ability to circumvent Army regulations and obtain equipment became so invaluable to the MFAA men that they enlisted him permanently in their number. Packing started on May 3, but was delayed by constant power failures. Nerves were frayed by knowledge that thousands of tons of explosives lay in the mine levels just below. Again the lack of materials forced ingenuity upon them: this time gasproof clothing from the Army stores cushioned the Watteaus and Lancrets. The caskets were brought to the surface on V-E Day; while they worked, the men listened to news of this event on the radio. The last and heaviest coffin, which held Frederick the Great, took more than an hour to load in the elevator; as it rose slowly above ground, the strains of "The Star-Spangled Banner," followed by "God Save the King," rang out into the evening.

There was no escort for the remains of the Prussian heroes as there had been for the gold; they were deposited very quietly in the Castle of Marburg. Their accoutrements fared better. Walker Hancock had taken the crown regalia to First Army headquarters in Weimar. Commanding General Courtney Hodges took one look and immediately ordered Hancock to drive them to Frankfurt to be stored with the gold. The route would be on the autobahn, which Hancock considered now "as safe as the Merritt Parkway." General Hodges did not agree, and the treasure, jewel-less though it might be, was given two motorcycles, three jeeps with machine guns, two armored cars with antiaircraft guns, and a weapons carrier with two guards.[13]

While it was relatively easy to inspire front-line commanders to provide transportation and labor for glamorous evacuations such as Merkers and Bernterode (which Lamont Moore later described as "a very special technicolor project" and "an anti-nationalistic move prompted by the whim of

the General in the area," respectively[14]), there was markedly less enthusiasm for moving the cache at Siegen. The Eighth Division still proudly guarded the premises, which had become a military tourist attraction of sorts. Signs all over Aachen directed the curious to the mine. Soldiers were shown around and allowed to try on what they believed was Charlemagne's crown, but was in fact a reproduction. The contents of the mine were suffering terribly in the dampness, which could not be controlled without electric power; but there seemed to be no other place to take them.

Things came to a head when trucks, rare as hen's teeth, suddenly became available. Taking matters into his own hands, Walker Hancock loaded the convoy with items from Cologne and the Charlemagne relics from Aachen and sent them off to the vaults of the cathedrals of those two cities, virtually the only buildings left standing. Labor to load and unload was miraculously produced by the resourceful Kovalyak from local prisons and DP camps. This shipment violated every Army rule: no clearances for movement between different commands were obtained, and the objects were returned to the Germans. The trucks going to Aachen, surprisingly, had French drivers, reputed to be reckless. Hancock told them that they were transporting "Charlemagne himself . . . the robe of the Blessed Virgin, the swaddling clothes of the Enfant Jesus, the shroud of John the Baptist, and the bones of several other saints." Thus imbued with the fear of divine retribution, the Frenchmen drove the trucks with infinite care.[15]

The rest of the contents of Siegen did not fare so well. Struggling with famished laborers and ever more difficult transportation problems, Lamont Moore and Stout did not get the objects out until the first week of June. At the Stadtsarchiv in Marburg the Siegen treasures joined the Bernterode paintings. The delay and waves made at various headquarters had not been all bad. On May 20 word finally came from SHAEF that in order to carry out earlier directives, commanders should "with the advice of MFAA specialist officers reserve and properly equip for use as collecting depots for works of art . . . buildings suitable for the purpose."[16] Marburg thus became the first official American "Collecting Point" operating in Germany. *Faute de mieux* the Army had become, as the Roberts Commission planners and John Nicholas Brown had foreseen, responsible for a staggering horde. And it was about to increase a hundredfold.

Just after the middle of April the American Third and Seventh Armies, joined by the French First Army, now all well within Germany, had turned southeast toward Bavaria and Austria. They reached Neuschwanstein on the twenty-eighth, Munich on the thirtieth, Berchtesgaden on May 4, and Alt Aussee on May 8. Rorimer, armed with Rose Valland's information,

Siegen, 1945: Eighth Infantry Division in the museum business

arrived at Neuschwanstein just a week later. On the way there the accuracy of her information had been confirmed at the Monastery of Buxheim, also on her list, where Rorimer got a foretaste of what was to come: here were seventy-two boxes marked "D-W"—for David-Weill—still bearing the French shipping labels. Rorimer's reception was not friendly. The custodian had at first refused to open the doors. Inside, the corridors were stacked with beautiful furniture of all periods and nations, from French to Russian, and the chapel floor was covered with layers of rugs and tapestries a foot deep. In adjoining rooms he found a dormitory for a hundred evacuated children.[17]

Leaving this "minor" deposit under guard, Rorimer went on to the incredible castle at Füssen. Neuschwanstein was intact and well guarded, though it was clear from gaps in certain rooms that the ERR had made great efforts to remove what they could at the last minute. Rorimer was amazed to find more than thirteen hundred paintings from the Bavarian museums mixed in with the confiscated French works. In a vault behind a hidden steel door were boxes containing the Rothschild jewels, other precious goldsmith's work, and more than a thousand pieces of silver from the David-Weill collections. Best of all was a room containing all the meticulously kept ERR records: well over twenty thousand catalogue

cards, each representing a confiscated work or group of works, eight thousand negatives, shipping books, and even the rubber stamps with which the code names of the various collections had been marked on frames and boxes. Rorimer locked this chamber very carefully, and, using an antique Rothschild emblem, added wax seals to the door, which the guards were ordered to inspect regularly.

From the venerable custodian of the castle Rorimer learned that Bruno Lohse and a colleague were lodged in a nursing home in the town. The matron of the house, referring to the Nazis as "dogs and fiends," took Rorimer, who had brought along Counter Intelligence officers, in to see the two ERR operatives. Lohse gave Rorimer the names of the other ERR repositories, but pretended to know nothing more; to improve his memory he was arrested and locked up in the local jail.

The Neuschwanstein deposits were impressive, but no one yet knew the location of the most important items, those which had been supplied to Goering and Hitler. Following the trail, Rorimer, now accompanied by Calvin Hathaway, cautiously entered the newly conquered country to the southeast, passing the road to Schliersee, where Hans Frank would shortly be arrested, and going on to the beautiful Chiemsee with its twin islands. On one was an ancient Benedictine abbey and on the other another of Ludwig II's castles, Herrenchiemsee, an expensive reproduction of Versailles, which contained three hundred more crates of ERR loot, along with the furniture of the Residenz in Munich and a large number of sightseeing GIs.

From there they went on to Berchtesgaden. Here all was chaos. French troops had blocked the roads into the town and up to the ruins of Hitler's Berghof so that American troops could not move in, and after raising the French flag over Hitler's house had proceeded with great enthusiasm to loot it and all the other residences in the famous Nazi resort. Empty picture frames were scattered everywhere; two della Robbia tondi lay on the ground outside one of the tunnels which linked the houses. French officers were seen carrying off rugs and other objects. Order was only gradually being established by the crack American 101st Airborne Division under the command of General Maxwell Taylor.

A preliminary search of the vicinity turned up no major repository. Puzzled, Rorimer, after alerting the 101st to be on the lookout for a large cache, returned to his headquarters. On the way back he inspected and secured as best he could the Nazi party buildings in Munich, which had been looted and vandalized by the local citizenry before the entry of American troops, who were now joining in.[18]

Goering was worried about his collections too. The Reichsmarschall,

unlike many of his associates, had not swallowed poison, but had been arrested in some style, riding in his fancy car with Frau Emmy and much luggage, to what he had hoped would be a meeting with General Eisenhower himself at Schloss Fischhorn near Salzburg. In this he was disappointed; he was taken instead to a detention center at Augsburg.

Rorimer requested that Goering be interrogated about the location of his collections; meanwhile, further conversation with a now more cooperative Lohse confirmed that the probable site was Berchtesgaden, and that Hofer would probably be found wherever the art was. On May 14 Captain Zoller, a French interrogator who had sat up all night drinking wine with Goering, told Rorimer that the Reichsmarschall had announced that he was after all a "Renaissance type," and had talked at length about his collection and his intention of leaving it all to the German people. He was therefore "anxious to have his things saved." He himself had last seen them on his trains in the tunnel at Unterstein. Unlike Lohse, he doubted that Hofer would still be around.[19]

Rorimer and Hathaway rushed back to Berchtesgaden, where they learned that the day after Rorimer's previous visit officers of the 101st had indeed found Hofer, who had told them about the train, and Goering's housekeeper, who said that she had heard that things had been hidden in the passages under the houses. After some persuasion a German maintenance engineer had taken the officers to the walled-up bunker room, from which the dripping contents were taken to a small house at Unterstein. Then the 101st had started to unload the train. The news of these discoveries had never reached the MFAA officers.

While Rorimer was discussing the finds with Captain Harry Anderson, the officer in charge, Hofer and his wife (who had once worked in New York) walked up as if nothing in the world had happened, presented themselves, and asked about mutual acquaintances in America. After these politesses, they all examined the pictures gathered so far and then went on to the Goering villa. The della Robbias were still there, smashed to bits, as the Intelligence officer who had been instructed to put them in a safe place had disagreed with Met curator Rorimer's attribution and left them on the ground.

Later, back at the little house to which the contents of the train had been taken, from Hofer began to flow the provenances of Goering's acquisitions. Rorimer and Hathaway recognized one well-known collector or dealer's name after another as Hofer unabashedly worked through the stacks of pictures. Here, in total disorder, were the Louvre's fifteenth-century sculpture *La Belle Allemande;* a Rubens which had once belonged to Richelieu from the Koenigs collection; a Masolino bought from Contini

in Florence; and hundreds more. Inside and outside the train itself they found all Goering's art records, rifled and in terrible confusion. Hathaway worked through the night to put them in some order, after which the 101st, overreacting to their custodial responsibilities, refused to let him take them to MFAA headquarters for analysis. In the National Archives today, the muddy footprints of World War II boots still adorn these documents of greed.

Taking care of Goering's Berchtesgaden cache was a curator's nightmare. More than a thousand paintings and sculptures were scattered in at least six different structures, and it was most urgent to consolidate them in one place which could be guarded. The town was deluged with the curious. With great reluctance Rorimer agreed to let the 101st, which had put up a sign reading, "Hermann Goering's Art Collection Through the Courtesy of the 101st Airborne Division" over the door of the storage area, show a few items to the press. Hofer, who by now had been put under house arrest by Rorimer, but who was essential to the ordering of the collection, nearly stole the show, carelessly picking up and waving about Rembrandts and Rubens as he held forth to the media. When Rorimer warned him to be more careful, Hofer murmured, "If the Herr Leutnant will forgive me, I will be responsible for the Goering Treasures." Rorimer, who knew rather more than the reporters of the unsavory background of the collection, unceremoniously corrected Hofer's assumption. But the wily curator had had his little triumph. Marguerite Higgins of the *New York Herald Tribune* reported that Hofer, in showing off the $500 million worth of paintings, had insisted that every one had been "legally paid for." He even boasted, she said, "with a twinkle in his eye," about outbidding Hitler's agent for a Rembrandt. There was no mention of confiscations.[20]

The story, complete with many photographs, made *Life* and *Time* the next week. *Time*'s correspondent had clearly talked a bit more to the MFAA men, for he did cast doubt on Hofer's statements on legality, which included the extraordinarily blatant one that "everything taken from the Rothschild collection (which he said was 'collected') was later appraised by French experts and a price paid to the French state which of course was considerably in debt to Germany." The reporter gave a number of details about forced and otherwise dubious sales, noting that "there is considerable mention of the 'Task Force Rosenberg,' which as far as I could figure out went around France, Holland and Belgium, confiscating art collections."[21] None of the articles mentioned the MFAA officers at all.

Art professionals looked at the collection from a different perspective. National Gallery chief curator Walker, who inspected it on July 21, wrote that Goering "was obviously swindled during the years he was buying pic-

tures, but he had excellent advice when it was a matter of looting. Superb paintings from the Rothschild, Koenigs, Goudstikker, Paul Rosenberg, Wildenstein and other private collections and dealers. His famous Vermeer is a fake which must have been painted four years ago for him."[22]

Hofer's performance was topped by that of his former boss, who in the first days of his incarceration sent his valet, with an American escort, to see Frau Emmy and bring some clean laundry and, to while away the prison hours, an accordion. He also told his man to bring him the tiny Memling *Madonna* from the Rothschild collection, which was part of his wife's "nest egg." Piously stating that it did not belong to him, but was "from the Louvre,"

Walter Andreas Hofer meets the press at Berchtesgaden.

he presented it to one of his American jailers. The valet later testified that Goering had told him that the intended recipient was "a German-born naturalized American citizen who had migrated to America in 1928 and that he was the son of a Prussian Security Police master musician." The issue of this rather unusually talented father spoke German fluently with a Berlin accent, and "Goering frequently visited this officer's billet, usually returning from these visits in the early morning hours and in a fairly intoxicated state." The Reichsmarschall had sadly misjudged the appeal both of the old country and bribery to his now thoroughly American captor. The painting, with a certain amount of fuss, was returned to the 101st Airborne, and Frau Emmy was relieved of her remaining insurance pictures.[23]

In all these goings-on before the collection could be completely secured, two of the four little Memling *Angels* from the Goudstikker collection, which had also been taken from Frau Emmy and put with the rest, a Cranach, and two small van Goyen landscapes disappeared, as did a tiny painting of Madame de Pompadour attributed to Boucher. An American officer had found it lying somewhere in Berchtesgaden. On his next fur-

lough he took it to Paris and presented it, in a paper bag, to a lady friend serving in an American agency. She liked it, but thought nothing of it, and eventually brought it home. A few years later she married someone else, and hung it in a corner. It was not until much later that someone remarked that it looked like a good painting. Investigation revealed not only the attribution but that it had been confiscated from a branch of the French Rothschilds, who had long since collected their insurance and did not wish to revive old problems. The chance owners still have it, now rather more prominently displayed, in their drawing room.

After the first excitement, the tedious work of inventorying began. Lists had to be made of what was in American hands, and compared to other lists gleaned from interrogations and Goering's records. Only then would the officers know what was missing. An appeal to the good burghers of Berchtesgaden to turn in "found objects" did not get much response. Later their depredations would be more carefully investigated, but for now the MFAA had more than enough to handle: on May 8 Third Army had reached Alt Aussee, which by its sheer magnitude would eclipse every other find.

The arrival of the American presence had not been very dramatic. Commanded by Major Ralph Pearson, two jeeps and a truck full of soldiers of the Eightieth U.S. Infantry crept carefully up the steep roads to the mine head to check on the reputed repository. They were especially alert because they were entering the heart of the "Alpine Redoubt," which was supposed to be the last bastion of the fanatic core of the Nazi establishment, and they were not sure if word of Germany's surrender had reached this remote region, or that it would be honored even if it had. Not only was there no resistance: the machine-gun-toting guards sent by Eigruber surrendered like lambs, and Major Pearson was soon overwhelmed by helpful mine and cultural officials who fell all over themselves in their desire to claim credit for having saved the works of art.[24] The Americans were shown the famous bombs, and a folksy group photograph of mine workers, GIs, and art guardians was duly taken. (This image, which was widely distributed, identified the whole group as "Austrian Resistance Movement miners.") For the time being the Americans remained unaware of the exact roles of the Alt-Aussee personnel; they were more concerned with establishing order in the town and protecting the vast mine.

Posey and Kirstein, called to inspect, were delayed at the foot of the steep road up to Alt Aussee for hours by still fully armed but cheerful elements of the German Sixth Army and their camp followers, who were descending to the prisoner-of-war cages near Salzburg to surrender. Once at the minehead, it did not take architect Posey long to open an access

The Ghent altarpiece at Alt Aussee

through the blocks in the main shaft. In the second room they entered, "resting a foot off the ground, upon four empty cardboard boxes, quite unwrapped, were eight panels of *The Adoration of the Lamb.*" They had found the Ghent altarpiece. To Kirstein "the miraculous jewels of the Crowned Virgin seemed to attract the light from our flickering acetylene lamps." Farther on was the Bruges *Madonna,* still on her sordid old mattress, covered with a sheet of asphalt paper.[25]

The ancient, labyrinthine mine, in which chambers could be approached from various levels and directions, was extremely difficult to secure. Moreover, it was impossible to tell who could be trusted, as the stories of those involved in Alt Aussee's operations were equally labyrinthine. Kirstein wrote that "factions among the mine personnel were at each other's throats, each claiming the credit for having uniquely, and against the others, saved the mine."[26] Scholz of the ERR, who had made good his promise to send armed men to the mine (immediately arrested by the Americans), sent Posey a long report which, he pompously wrote, "supplements in detail the information that I had already given to Dr. Lincoln Kirstein" and was "a true account of the part played by the Special Staff, Fine Arts [ERR] in the measures taken for the prevention of this act of terror."[27] Posey, unimpressed, had the most obvious Nazis arrested and set the

rest to work. But George Stout was repelled, and wrote: "I am sick of all schemers, of all the vain crawling toads who now try to edge into positions of advantage and look for selfish gain or selfish glory from all this suffering."[28] The task before them would eclipse these emotions.

On his first visit to Alt Aussee, Stout, using available records, estimated the contents as follows: "6,577 paintings, 2,300 drawings and watercolors, 954 prints, 137 pieces of sculpture, 129 pieces of arms and armor, 122 tapestries, 78 pieces of furniture, 79 baskets objects, 484 cases thought to be archives, 181 cases books, 1,200–1,700 cases apparently books or similar, 283 cases contents completely unknown."[29] This did not include the Vienna holdings at Lauffen. Stout went back to Third Army headquarters to report on his findings. He felt the things in Alt Aussee would be safe, from the conservators' point of view, for years, and that careful plans for the safe removal and storage of the objects should be prepared. He calculated that it would take at least six weeks to "get out the bulk of the important holdings."[30]

On the day Stout had gone up to Alt Aussee, Calvin Hathaway, busily planning his next foray at Seventh Army headquarters in Augsburg, received an intriguing call from the German Army's liaison office at Zell am See, not far from the big mine. The German Supreme Command, he was told, "is in possession of valuable works of art which it wishes to transfer to the custody of the civil administration at Innsbruck." The caller did not say where or what the works were. Hathaway dropped everything and went to Zell am See, where he learned with some effort that the works were the hijacked pictures from the Vienna Kunsthistorisches and that they were now in Sankt Johann in the Tirol. At the American Forty-second Division Intelligence office in Kitzbühel, where he next proceeded in order to make arrangements to retrieve what was essentially the cream of the Vienna collection, he was forced to endure a little "lecture on the triviality and unimportance of works of art" from the commanding officer, who nonetheless did provide the required help.

In the little ski town of Sankt Johann, Hathaway's party was directed to the Golden Lion Inn, where "the preliminary reluctance of female owner and English speaking niece to admit any knowledge of works of art on premises was brought to nought by Emil God, guest of the house." God (no relation) took them next door to his house and down to a damp basement with puddles on the floor, where they found thirty-two uncrated pictures, forty-nine sacks of tapestries, and nine opened wooden packing cases. God claimed that the Germans who had left the cases there had said they contained food, and that he himself had opened them to get some. The pictures had not been unpacked. Interrogations in the little town produced

numerous versions of the arrival of the objects and of their concealment. God said SS officers had threatened him and tried to take some of the works. He whispered to Hathaway that he was sure Cellini's famous *Salt Cellar*, the only known work from the master's hand, was in one of the boxes, which does not seem to have been the case. Hathaway recommended that God be questioned further if it did not turn up. The mayor said he had not told the constantly changing American units about the cases because he "felt no confidence in American interest" and feared the objects would end up in Germany.

The Forty-second Division, noticeably more enthusiastic when apprised of the value of the little cache, now agreed to post guards and move the pictures upstairs to God's sitting room. There was the usual scramble for protective blankets and packing materials, during which the CO fiercely offered to take the former "from the beds of the Nazis of the town," which proved unnecessary when a quantity was found in a German military hospital. The pictures were taken to safe storage in the Mozarteum in Salzburg.[31] It later appeared that little Sankt Johann had been pretty busy in the last days of war: in a barn belonging to the Chief Forester, CIC agents found $2 million worth of various foreign currencies, and several sacks of gold bars, jewelry, and coins, which were to have taken care of SS chief Himmler in future years.[32]

There were other hard-core Nazis who had made careful preparations for the future. No one had been harder-core than Mayor Liebl of Nuremberg, who had so assiduously procured and protected the greatest Germanic treasures for his city. The elaborate bunkers built under the eleventh-century Kaiserburg, which extended underground well out under the streets, were a marvel of construction and climate control. In them he had put the Veit Stoss altarpiece and the Holy Roman regalia, along with Nuremberg's more legitimate collections. One access to the bunker was through a secret entrance disguised to look like a plain little shop on a small side street. From there a long concrete ramp, blocked at intervals by ten-foot-high steel doors, led to the foundations of the castle.

Despite his faith in the Führer, the thin wedge of doubt had eventually penetrated even the mayor's mind. After heavy air raids in October 1944, Liebl, having consulted Himmler, ordered special copper containers to be made for five pieces of the Holy Roman regalia: the crown, Imperial sword, sceptre, Imperial globe, and the sword of St. Maurice. The pieces were unpacked from their original cases and put in the new ones, which were soldered shut. The boxes were then, in greatest secrecy, walled up by Liebl and two city officials, Drs. Friese and Lincke, in one of the passages in the bunker complex on March 31, 1944. Liebl and the top SS leadership

then concocted a cover story to the effect that the regalia had been taken off by the SS and sunk in Lake Zell in Austria. To make the story convincing, a removal was actually staged with the help of two local SS men. Alas, Liebl, his faith shattered, burned his papers and committed suicide on April 19, as Allied troops poured into his Germanic city. The intact bunkers, to which cooperative city officials provided keys, were discovered and put under guard.

Not until June did rumors begin to circulate indicating that something might be missing. Eberhard Lutze, director of the German Museum, was taken to Ellingen for interrogation and mentioned the SS removal. The same story had been heard from the notorious SS General Josef Spacil, who was being questioned by the Allies in connection with the money caches being found in Austria. Conversations between SS officials reported by the interrogators revealed that the missing crown jewels "were slated by the chief of the German security service to become the symbols of the future German resistance movement." This was not considered to be a good thing.

Lieutenant Walter Horn, a German-speaking MFAA officer reserved for special investigations, was sent to Nuremberg. Liebl's assistant Friese swore that the copper boxes had been taken off in a car by unknown SS men. Horn was not convinced. Friese was arrested and taken to the theater interrogation center, not a cheery place, in order to confront Spacil. Before the meeting Horn questioned Friese a bit more and "under the effect of a night of solitary confinement and the pressure of a short interrogation which preceded the confrontation," Friese's Nazi loyalty evaporated and he confessed. A few days later he led a little party to the hiding place in a small room in the tunnels eighty feet below the surface of the Panier Platz. The missing objects were unearthed and put together with the rest, which had been found intact in the main storage area.[33]

Dealing with the gigantic finds of Alt Aussee, Berchtesgaden, and Siegen was only part of a field officer's endless day. In Würzburg, Monuments officer John Skilton performed one of the miracles of the occupation when he managed to build a protective roof over the shattered central vault of the baroque Residenz palace. The vault, one of the world's biggest, decorated with Tiepolo's *Olympus and the Four Continents,* had been open to the elements since a twenty-three-minute bombing raid by the Allies in March. By the time Skilton arrived in June, rain was rapidly dissolving the elaborate white rococo plaster decoration of the palace. For weeks he and his assistant scoured the countryside for wood and tar paper. By purest chance Skilton found hundreds of newly cut logs stuck in a tributary of the Main

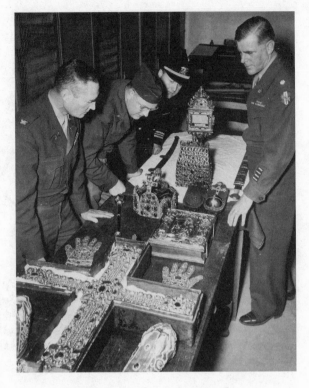

River at Ochsenfurt, and, turning lumberjack, managed to float them down to Würzburg. Later he was called upon to retrieve a barge full of medieval manuscripts which had been seen floating down the Rhine. This was found just downriver from Castle Rothenfels, which was being used to quarantine typhus cases. Giving the castle a wide berth, Skilton secured the barge. In it was the largest number of books he had ever seen in one place, which required two weeks of effort to bring to safety.[34]

In general the Monuments officers in Germany had little time to become involved in such long-term projects. They travelled incessantly and usually alone. In the course of these peregrinations they gradually discovered more than two thousand caches in everything from castles to cowsheds, in which were hidden, often with great ingenuity, not only superb works of art but the records and artifacts of the maddest Nazi undertakings and most hideous experiments. The owners of the castles or the assigned guardians of the valuables greeted the Monuments men with attitudes ranging from

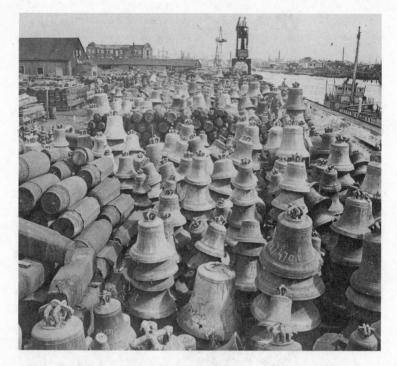

Daunting prospect: Five thousand bells looted from all over Europe await sorting in Hamburg.

nasty and suspicious, through arrogant or obsequious, to cooperative and welcoming. There were few signs of guilt or compunction. A certain number complained about their deprivations. After five years of war, the low-ranking MFAA officers, who were often not so low-ranking at home, and who frequently arrived in muddy field uniforms after hours of travel by jeep only to be received with condescension by elegantly dressed schloss owners, were sometimes hard put to be polite. One officer, confronted by an arrogant German noblewoman who complained that Polish DPs were making a mess of her schloss, sharply retorted that it was not his compatriots who had brought the Poles to Germany. There were frequent complaints about the "inconvenience" caused by the Allied occupation. The gentle sculptor Walker Hancock remarked later that it seemed not to occur to many Germans just how much "inconvenience" Hitler had caused the rest of the world.

But the MFAA men were moving too fast to brood over these slights. An excerpt from Calvin Hathaway's diary, tantalizing in its suggestive detail, gives us a little idea of the pace and variety of discoveries, all of which had to be dealt with, cross-indexed (which accounts for the strange use of capitalization), or reported to other authorities:

Friday, 1 June. At Schloss HIRSCHBERG, conversation with major domo, CORINTH (relation of the painter). . . . Cellar passageway lined with furniture brought from ITALY and installed in Schloss. . . . Two rooms in cellar, said to contain property of Baronin von HIRSCHBERG, are locked (Corinth says that the Baronin keeps the keys with her at GOSSENHOFEN) and sealed with warning prohibitions posted by chief of MUNCHEN Gestapo. Schwimmbad in cellar has furniture and draperies said to belong to BLEICHRODER and HIRSCHBERG. Boxes of books in passageway, part of library brought from Prinz Karl Palace in MUNCHEN, and are Party property. No action had been taken following my suggestion three weeks earlier that works of art belonging to Bavarian State collections be assembled in one room, which would then be posted off limits; Corinth asserts that succeeding military commanders (American) preferred to keep pictures on walls of rooms where they would look well . . . a chest of Party owned silver stored in one of the rooms of the cellar was taken away. . . . Departed Schloss HIRSCHBERG 1000 hours. . . . Schloss BERNRIED, formerly owned by Baron WENDLAND, now used for clinic operated by Swiss Legation; no works of art there. Mrs. BUSCH, an American citizen enjoying the proceeds of Anheuser-Busch beer, said to own several miles of lake frontage north of BERNRIED, and to have been in Germany during the entire war, had moved all her valuable furniture from her large house north of BERNRIED, which she had offered to Lt. Gen. PATCH for his accommodation. She is said to be in Switzerland at the moment, where she is staying with the U.S. Minister. . . . Proceeded to Schloss EURASBURG . . . owner, Kurt WOLF, owner of textile mill in Saxony, in neighborhood and being a nuisance. Furnishings of Schloss thoroughly second-rate, and not disturbed by present occupants. . . . Schloss a deposit for approximately 280 packing cases containing books and archival material evacuated from MUNCHEN; slight tendency evident to extract material from cases and leave it lying about. In carriage house off SW corner of Schloss are about 2500 bundles of archival material from MUNCHEN, stacked against walls behind rifled packing cases of evacuated personal belongings of

various individuals. Bundles most easily accessible seem to belong to
HEERESARCHIV. . . . Arrival at 2055 hrs at AUGSBURG. 112 mi.[35]

And so to bed.

The German schloss owner's suspicions were not completely unwar-
ranted, for there were of course lapses of honesty within the Allied ranks.
While the few available Monuments officers were working on the major
finds and the excited Army command was surrounding potential gold
hoards with tank battalions, the guarding of smaller refuges and individ-
ual finds was less certain. Even more difficult to control was the discovery
of works of art in the rubble of bombed buildings. For many who had
fought across Europe or lost relatives to the Nazis, "Thou shalt not steal"
simply did not apply when it came to Germany. Cases of looting by Amer-
ican forces in Germany began immediately and ran the gamut from well-
intentioned if misguided preservation attempts to blatant thievery and
arrogant intimidation of the defeated. Reports of stealing were seriously
investigated by all agencies. Some became causes célèbres.

Most spectacular among these was the affair of the Hesse jewels. The
gems in question had been buried in October 1944 under ancient flag-
stones in the subbasement of Kronberg Castle (near Frankfurt) by family
retainers of Princess Margaret of Hesse, granddaughter of Queen Victoria,
sister of Kaiser Wilhelm II, and mother of Prince Philip of Hesse, the art
procurer. It was a very considerable quantity, as several members of this
large family, fearful of what would happen at war's end, had withdrawn
their belongings from bank vaults in order to entrust them to the earth. The
jewels were packed in a lead case which was put inside a wooden box. The
hole was sealed and disguised by a stonemason. The family unfortunately
did not limit itself to hiding jewels: the mason was also asked to seal up
sixteen hundred bottles of fine old wine, construction work much harder
to conceal. Eighteen hundred less-fine bottles were left in the open.

In April 1945 Patton's Third Army arrived, gave the Hesse family four
hours to move out, and requisitioned the castle as a headquarters. The
eighteen hundred bottles quickly vanished. When the HQ moved on, the
castle became an officers' club and rest house. The staff soon found
the sealed-up wine and, while looking for more, the newly mortared stone
under which the jewels were hidden. The sergeant who found them turned
them in to the commander of the rest house, a WAC officer named Kather-
ine Nash, who assured him she would turn them over to the proper au-
thorities. This she did not do. A few months later Princess Sophie of
Hesse, who was about to get married and who had heard from a castle em-
ployee of the discovery of the jewels, asked Captain Nash if she could use

some of them for her wedding. Captain Nash said she could, but when the Princess came back to get the jewels she was told they had been stolen. This was reported to the Criminal Investigation Division of the Army, but before any action had been taken Captain Nash returned to the United States to be demobilized. The Army, suspicious of her and of her lover, a Colonel Durant, who had also left, held up both demobilizations in order to keep the pair under military jurisdiction. The by now newlywed couple, but not the jewels, were found in a hotel in Chicago. After interrogation they confessed and were arrested along with the sergeant who had found the cache, and who had been promised a cut of the take. The gems were found in a locker in the train station where they had been left by the fence, who had lost his nerve and abandoned them. They had, for the most part, been pried out of their priceless original settings.

After the arrest the Army put on a full-fledged press conference in the Pentagon. The press ogled such impressive items as a "12 carat canary yellow diamond" and "stacks of pearls, star sapphires and rubies." It seemed that Mrs. Durant had not limited herself to the jewels, but had found plenty of other goodies in the castle. She had sent home a whole service of vermeil flatware with stone-studded handles, several volumes of letters to Queen Victoria; a Bible, tenderly inscribed in Victoria's own hand, which the British monarch had given to her daughter when she married Emperor-to-be Friedrich in 1858; and numerous other books, medals, golden fans, and watches, the whole estimated at first to be worth $1.5 million, a figure later revised to $3 million. The Army, seemingly unabashed by the scandal, called it the "greatest theft of modern times." The Durants were taken back to Germany for a trial described as "stormy." Testimony was given by many members of the Hesse family and their retainers. The defense said that the Hesses had "abandoned" the jewels when they buried them and that their claims were invalid as certain family members had been Nazis. Mrs. Durant said she had been questioned under duress in an insane asylum and would have made any statement just to get out, and that the Army had promised not to prosecute her. She even appealed to the Supreme Court. It was of no avail; she got five years, and her husband fifteen.[36]

Other luckier thieves were saved for a time by circumstances beyond Army control. About the same time American forces took Merkers and Grasleben they also moved into a small town on the edge of the Harz Mountains. Quedlinburg was a favorite SS site. In 1936 Himmler had wished to celebrate the thousandth anniversary of the death of King Henry I of Saxony, a forebear of the Holy Roman Emperors, whose successful and widespread conquests had earned him the title of "founder of Germany." The King and his wife, Matilda, who had established several con-

vents and had been sainted by the Church, were supposedly buried in the church at Quedlinburg. Himmler envisioned a yearly festival, to be called the *Heinrichsfeier.* The first event was duly celebrated despite the fact that the King's bones seemed to be missing. Later excavations by large squads of SS archaeologists produced some in time for the next year's festival, which featured their reinterment. Heavy researches in the region continued to produce parallels between the lives of Heinrich I and Heinrich Himmler, who secretly considered himself to be the Saxon King's reincarnation. The Quedlinburg church was secularized and turned into an SS shrine, decorated with all the suitable Nazi trappings and symbols, in which SS officers acted as tour guides.[37]

At some point in the war, to save them either from the SS, the Russians, or the Americans, the Quedlinburg clergy took the priceless treasures of their church—delicate reliquaries of rock crystal on gold stands, a silver casket set with ivory reliefs and precious stones, and the fabulous *Samuhel Gospels,* written entirely in gold ink and bound in a gold cover also set with jewels—to a mine shaft near the town. After the hiding place was accidentally discovered by a soldier of the American Eighty-seventh Field Artillery, a guard was posted who kept out Germans and refugees, but allowed his buddies free access to see the "Nazi loot."

One of these was Lieutenant Joe Tom Meador, of Whitewright, Texas. Meador, who had won three Bronze Stars in combat since D-Day, was also, it seems, an art lover. Upon seeing the things in the mine he wrapped several in his coat and removed them. Getting rid of the treasures was simple: he packed them in small boxes and mailed them home. His fellow officers were perfectly aware of the theft, but, as one remarked much later, they had been in combat for nearly a year and nobody cared.

It would not be the last time Meador was tempted. After the war he took a job as a teacher at the American University of Biarritz, run by and for the Army. Classes were held in a requisitioned villa belonging to a French marquise, who was permitted to occupy one room. From her Meador stole a quantity of silver and china. For this he was court-martialled and reprimanded. The church authorities in Quedlinburg had meanwhile reported the theft of their treasures to the Army and an investigation was begun. Pursuit of the matter lapsed when Quedlinburg was sealed off in the Russian Zone. The case, one of hundreds, was dropped in 1949. Meador returned to Texas, where he showed his little collection to friends and family, who thought it was nice but did not question its origins. Meador never tried to sell anything, and as far as the world knew, the Quedlinburg treasures were gone forever.[38]

More difficult to judge was the Robin Hood type. In April 1945 an art-loving naval reserve officer named Maley, who was fluent in German,

asked to see the University of Würzburg's famous collection of Greek vases. In the course of his visit the curators confided to Maley that the doorless rooms in which the vases were stored were not secure and that the collection was being raided by looters every night. The American officer was so upset that he contacted the harried local MFAA officer, Captain Giuli, and volunteered to organize a work party at his own expense to take the vases to safety. This offer was accepted and the work was done. Maley wrote a proper report and the MFAA officer inspected the new arrangements. What Giuli did not know, and Maley did not mention, was that the Naval officer had packed up one superb vase (and several small cups) in a crate, telling the surprised German curator in charge that another Würzburg University official had insisted on giving it to him as thanks for his help on condition Maley would lend it to the Art Institute of Chicago. Maley then left, having duly shipped the vase off to that city.

The German curator reported all to the U.S. authorities and by May 8 an investigation had begun. It took some months for the case to move through channels to Washington. In August the CAD asked the Roberts Commission to find out if the Art Institute had received such an object. Lo and behold, Chicago did have the vase. The director of the Art Institute, Daniel Catton Rich, did not explain on what grounds the object had been taken in but produced a letter from Lieutenant Maley "which clarifies the situation," in which Maley repeated his earlier claim, but agreed that the vase should be returned immediately to Germany and "regretted that his effort seems to have miscarried." The CAD sent the vase back, but made the Art Institute do the packing.[39] No one was punished or reprimanded in this case or in many similar ones, the Army and the RC being more interested in recovery than in punishment and its inevitable negative publicity.

The things which were being properly guarded and reported were becoming a greater and greater problem. The one Collecting Point established at Marburg was already filling up with objects found in the north and was much too far from the major repositories in Austria and Bavaria. Munich, only a few hours from them, was the obvious place to set up a second center. James Rorimer in his first brief trip there had been impressed by the two recently looted Nazi party buildings, the Führerbau and the Verwaltungsbau, which stood side by side on the Königsplatz. Hitler's offices and the grand room where Frau Dietrich had held her little art shows for the Führer had been ransacked, as had the vaults and studios in which his collection had been processed and stored. The floors were strewn with fancy framed photographs of Hitler, books, writing paper emblazoned with Nazi emblems, and reams of Party records.[40]

Much of what had been in the vaults had been stolen, including most of

the Schloss collection, which had arrived too late from France to be sent to the mines; but the fabric of the buildings was essentially intact and perfect for the MFAA's needs. The problem now was how to keep such desirable space away from Patton's Third Army, which was just about to set up its headquarters in Munich. Rumor had it that Patton himself had his eye on Hitler's former offices. To counter this the lowly MFAA officers had only the SHAEF directive ordering the establishment of a Collecting Point. And formal authorization would have to come from Third Army, in whose territory Munich lay. Fortunately it was Robert Posey, Third Army's own Monuments officer, who was technically in charge at Alt Aussee.

To run the new Collecting Point, Stout and LaFarge had chosen Lt. Craig Hugh Smyth, another officer stolen from the Navy through the efforts of Paul Sachs back in Washington. Smyth was superbly qualified: he had been one of the first curators hired at the brand-new National Gallery of Art, and had accompanied its evacuated pictures to the repository at Biltmore. He would now, virtually overnight, have to prepare an equivalent organization to handle a quantity of art which would dwarf that of his former place of work, and do so in far different conditions. He got off to a fast start. Two hours after he arrived in Munich on the evening of June 4, 1945, he was taken to see the future Collecting Point.

Earlier in the day Rorimer had toured the city with the Third Army Property Control Officer and persuaded him that another option, the Haus der Deutschen Kunst, still entirely draped with billowing dark green fishnet-like camouflage, was too small and would not do. They had gone on to the Nazi party buildings, where Rorimer intimidated the Property Officer by pointing out the "absurd security" which was being provided for the remaining valuables in the building by blocking certain access passages with grenade explosions, and stated that it was the best place for the Collecting Point and should be secured immediately. The Property Officer gave tentative permission, but warned that final authorization would be necessary. Smyth agreed on the suitability of the building. The next morning he moved into the vast complex. Rorimer, having started him off, left immediately for Neuschwanstein.[41]

The task facing Smyth was enormous. In a devastated city and nation where almost nothing functioned, where every scrap of building material that remained was coveted by hundreds of people, he had to set up, in a war-blasted building, a safe refuge for some ten thousand works of art, among them some of the most important in the world. It would have to be secure, and not only weatherproof but heated and humidified to suit its precious contents. And the objects would not come one by one in carefully

Truckloads of art outside the Munich Collecting Point

packed cases from which they would be gently lifted by white-gloved experts. They would come in endless truckloads, day after day and night after night.

Smyth could not wait for official Third Army authorization to start organizing. The Machiavellian maneuvering for this he left to Posey and his éminence grise, Private Lincoln Kirstein. The premises had to be cleared of units billeted there and cleaned up. What was left of value had to be inventoried. Shattered windows and shell holes in the roof had to be repaired. Bomb squads were called in to check for booby traps and leftover explosives, which were found in large numbers. Smyth soon discovered a maze of tunnels, connecting the buildings to each other and to various outbuildings, that would have to be blocked or guarded. The whole complex would have to be surrounded by a barbed-wire fence. On top of all this, living and eating areas complete with cooking facilities would have to be provided for staff, workers, guards, and truck drivers, who also had to be hired or requested through various bureaucracies. The mayor of Munich was called upon to provide manual labor. MPs were grudgingly assigned by Third Army. Smyth himself would have to assemble an expert staff from approved lists of supposed non-Nazis, who had to be cleared by Military Intelligence. Immediate help was forthcoming from another Naval officer, Hamilton Coulter, an architect who took over the physical repairs.

Things were going along smoothly by June 9, when the Third Army Accommodation Officer, a full colonel, suddenly appeared to see if the buildings "could be used otherwise by Third Army, and whether any other buildings would do as a repository." Smyth and Co. pulled out all the stops. The enormous value of the incoming works was vulgarly emphasized; the perfection of the building for their purposes pointed out. The Third Army's and Patton's Images in History as Protectors of the World's Greatest Treasures were suggested, and the impropriety of Patton occupying the same rooms as the hated Nazi dictator was mentioned. The colonel left without making a decision, but they had won: the building formally became the Collecting Point on June 14. Everyone was in fact happy. Patton's men took over the Haus der Deutschen Kunst, cradle of the Reich's purified art, and turned it into a spiffy mess and officers' club, decorated with huge Third Army symbols. Inside, a transformed German oompah band played the latest "degenerate" American hits during cocktails and dinner.

The next days were frenzied. Now that the Collecting Point was an "authorized" unit it could begin to draw supplies and services. The units occupying most of the rooms moved out, trying to take all the furniture with them; no sooner had they left than the Counter Intelligence Corps tried to move in, bringing along huge locked safes full of documents. Cleaners arrived, but could only work half days, as they had to spend the other halves in desperate searches for food for their families. Before Germans could be hired they had to fill out the dreaded *Fragebogen* (questionnaire) on which one was supposed to list any Nazi affiliations, and be cleared by Military Government investigators. This was a dilemma for Smyth, who was sure that a number of the essential engineering staff who kept the heating plant working were Nazis. For the time being they stayed. But the biggest problem was still Third Army, the source of Smyth's security force. Guards were arbitrarily withdrawn, and no permanent force was assigned; thus each new squad had to be briefed on the complex floor plan and problems of the two buildings.

Meanwhile, Smyth knew that all around him were priceless things waiting for a secure refuge. On June 14, the very day on which the Collecting Point was authorized, he had gone to inspect the "art cache taken from Dr. Frank's house and brought to . . . HQ. . . . Opening one case found among other things Leonardo's *Lady with the Ermine*. In the same crate were a Dürer portrait, three Rembrandts including the Czartoryski landscape, six other paintings, and several drawings." There was no sign of the Czartoryski Raphael. Smyth packed them away again until the Verwaltungsbau could be made secure. But there would be no way to pack up again the

eight truckloads of paintings which were due to arrive from Alt Aussee in just three days.

The Russians had been finding and emptying repositories with equal, if not greater, thoroughness than their Western allies. They had had plenty of practice by the time they got to German soil. For over a year they had been discovering the stacked-up caches left by the ERR and the Ahnenerbe in a trail which ran through the Baltics and Poland to Berlin and the Silesian countryside. The initial impetus had been to retrieve their own things, but the extraordinarily nasty and thorough destruction the Germans had left behind encouraged the removal of whatever came to hand.

Pavlovsk curator Anatoly Kuchumov, travelling for the most part on foot, had begun his search in the immediate vicinity of the palace. The first objects found had simply been thrown into the mined parks. Bits of brocade, tables with sawed-off legs, chairs made into stools, and chopped-up moldings were found in bunkers. Carved doors of rare woods had been used to cover trenches. In billets and gardens in the surrounding villages he found statues from the palaces; a life-size portrait of Peter the Great, cut from its frame, was crumpled in an attic.

By September 1944 Kuchumov had progressed to Estonia, travelling as best he could. In the small city of Vyr he found a repository filled with furniture from the Catherine Palace. His further discoveries illustrate all too clearly how widely the Germans had marketed his nation's patrimony. Wandering about the town, peering into windows, he saw in one house a familiar-looking table. He politely asked to examine it. Underneath he indeed found an inscribed museum inventory number. In a cafeteria where he stopped for lunch, he saw cooks using two eighteenth-century Japanese bowls from Pavlovsk to mix dough. As he drove out of Vyr in an Army truck he spotted a heap of leather-bound books and smallish sculptures in a roadside ditch and picked them up. In the end nearly a boxcarload was retrieved on this foray. And on he went. In Tallinn he took palace chairs literally out from under astonished Red Army staff officers. In Riga were four hundred paintings, eight thousand cameos, and more. Another boxcarload went east. By war's end Kuchumov had reached Königsberg, the principal Nazi repository for the Eastern Occupied Territories. The castle had been bombed and burned, and odds and ends of furniture were scattered in the endless rooms and underground chambers and tunnels so beloved by the Nazis. But nowhere in the vast spaces could he find the twenty-nine wooden cases containing the fabled Amber Room panels, which were said to have been hidden there.[42]

* * *

The Red Army had meanwhile met Allied forces in Germany and laid siege to Berlin, which they proceeded to bombard as thoroughly as the Nazis had Leningrad, Sevastopol, and so many other cities. All around them lay country filled with art-packed mines, caves, and castles. The Soviets were not unprepared. The Red Army, popularly depicted as a savage horde, in fact had a highly organized group of trained art specialists who carefully removed the best things before the less refined troops were turned loose. They were not interested in protecting buildings or preventing looting; they were part of the so-called Trophy Commission, whose objective was the gathering of valuable movable objects of all kinds, from heavy machinery to food, and its removal to the Soviet Union.

The Russians arrived at Berlin's Museum Island on May 2, three weeks after the American capture of Merkers. In those weeks the museums had been part of the final defense of the city. Bombardment was constant. The two curators responsible for the enormous expanses of the Nationalgalerie and the Pergamon, Kaiser Friedrich, Altes, and Neue museums had tried to protect what was left from the German defenders who, among other things, wanted to use the remaining parts of the Pergamon altar to build protective barricades. The first Russians appeared only hours after the abandonment of the premises by German forces.

The very next day Dr. Kümmel, director of the Berlin Museums, was taken on a tour of all museum buildings and the Zoo flak tower by the Russians. It was a depressing experience. The Pergamon was badly damaged; its Far Eastern division had lost its glass roofs, and delicate reliefs were exposed to the elements. In the Kaiser Friedrich the Ravenna mosaics were shattered. Offices and storerooms were trashed and looted. Ominously, German museum officials were not now permitted access to the damaged storage areas in the New Mint or the Schloss Museum.

Removal of works from all these sites by the Russians began four days later, which was five days before the final German surrender. They started with the repositories and museums which would later be in the sectors of Berlin assigned to the Western Allies, taking things to a Collecting Point in Karlshorst, well within the future Soviet Zone. Evacuation of the Flakturm Zoo, which would be in the British sector, went on for a month. Director Unverzagt of the Prehistory Museum, who had remained on the site, was forced to hand over the holdings of his museum, which presumably included the Trojan gold. Pictures from the Nationalgalerie which had been left there were taken to a schloss outside Berlin where the best were selected to go to the USSR and the rest were left to whoever wanted them and soon began to appear in Berlin shops.

Events at the Flakturm Friedrichshain, which still held large numbers of

Signorelli's Pan, *said to have perished at Friedrichshain*

things, among them many oversize, first-quality pictures, are less clear. The assigned German guards were not able to get to the tower for two days after the Russians arrived, but when they did, all seemed well. Checking again on May 5 they discovered that some of the storerooms had been entered; the next day they arrived to find that one floor had been set afire and was still burning. Smoke and heat prevented access to the other areas. When Kümmel and his Russian escort came on the seventh, the tower was unguarded and open to looters, who had indeed been busy. Damage assessment was virtually impossible in the unlighted spaces. Kümmel begged the Russian officers to post a serious guard, but this seems not to have been done. In the next ten days looting continued and there was another fire, which reduced whatever had been left inside to ashes. Unbeknownst to the despairing Berlin curators, the Russians had taken away a large truckload of the ashes and rubble, which they carefully sifted for small objects; but much remained untended in the vast heap inside the bunker.[43]

Removal of the objects remaining in vaults on the Museum Island, safely within the Russian sector, was delayed until later in the year. The Russians were not undiscriminating. They took almost everything but

Hitler's favorite nineteenth-century kitsch. Berlin officials later huffily complained that no proper documents and receipts were given for these removals. To this day the Germans do not understand the Russian actions. As late as 1984 one curator resentfully wrote of the Russians, much of whose patrimony in those May days still languished in Nazi repositories, "The removals were called 'safeguarding' by the Soviet Occupying power. We could not understand the point of this. From what or whom should they be protected? We were perfectly capable of caring for these things." The curator's superior at the time, Dr. Kümmel, author of the report which had laid out the total stripping of France, could perhaps have explained.

In the two months between the fall of Berlin and the Allied arrival there, the museum administration tried to maintain a semblance of organization and make their buildings somewhat habitable. The remaining objects were carefully sheltered, and the eternal list making, this time to determine what was lost, began once more. No one knew how long he would be employed. On May 17 the Russians authorized a carefully vetted city government known as the Magistrat, and museum officials were rehired if they had not been Nazis. (Only six, among them Kümmel, who was fired and later arrested by the Americans, were so designated.) Offices were set up under the name "State Museums of Berlin," as the Prussian state, which had previously run things, no longer existed. The State Museums' mission was to gather together what they could and reopen "for the people."

Somewhat less official was an effort begun by an art historian named Kurt Reutti, who persuaded the Magistrat to allow him to form a group which would gather up the works of art strewn about the offices and houses of the former Nazi powerful. Reutti and his unit, given the innocuous name of Central Office for Registration and Maintenance of Art Works, or Zentralstelle for short, poked through the ruined public buildings after the Russians had taken their fill. It was dreadful work: in the unlighted basements they frequently encountered unremoved bodies and unexploded mines. For transportation they had only a small handcart from the Staatsbibliothek. City workers were told to bring to the Zentralstelle any object they found. Untrained in such matters, they brought in tons of worthless junk. This rather worked to the unit's advantage: a Russian officer who came to check up on its operation took one look and left in disgust. In the next years this organization would do its main work not in the ruins, but in the countryside around Berlin and in the shadowy world of black-market dealings and subterfuge which would flourish throughout the Cold War.[44]

Another Russian Trophy unit had arrived in what was left of Dresden on May 8. Major Natalia Sokolova, who immediately toured the ruins of the

Zwinger and the rest of the city, felt sure nothing could have survived—but then she reminded herself that the Hermitage curators had managed to save their paintings despite the "barbaric conditions" of the Leningrad siege, and assumed that the Germans had done the same. And indeed, the Russians soon discovered the evacuation plans for all of Saxony, which were explained to them by the Dresden museum people at Schloss Weesenstein, where much of the city's collections and a certain amount of Linz stock were still stored.

The investigators went first to the village of Grosscotta, where they descended into a dark, wet quarry tunnel. Far down the shaft their flashlights finally picked up the glimmer of gold. Before them stood a truck jammed with unpacked paintings. The first to appear in the flickering light was Rembrandt's *Abduction of Ganymede,* then Giorgione's *Slumbering Venus,* Titian's *Lady in White,* and Dürer's magnificent *Dresden Altar.* In a special crate was the *Sistine Madonna* by Raphael. At Weesenstein the Russians found most of the Dresden prints and drawings; mixed in with these were the Koenigs drawings which Posse had bought in Rotterdam. In a sandstone cave and a barracks near the Czech border they found more than a hundred other top Dresden pictures, some dripping wet, and hauled them up to the surface with a winch, which was first tested by bringing up three curators. In all, about seventeen hundred pictures were sent to the USSR in a heavily guarded train on which a special structure was built for the large works.[45] In Moscow, at the Pushkin Museum, they joined the Pergamon altar and the rest of the Berlin objects. Later arrivals were distributed to the storerooms of the Hermitage and various other museums. No one in the West would see them for quite a time.

Not all Russian removals were so officially regulated. There were too many hiding places. In some repositories troops burned objects or simply threw them out the windows to make room for living space. Officers who developed tastes for everything from antiquities to junk shipped it home unhindered in vast quantities. That their motives were not necessarily commercial is demonstrated by the adventures of the evacuated works from the Bremen Kunsthalle.

In 1944 the Nazi mayor of Bremen had ordered the removal eastward of the holdings of the Kunsthalle. The reluctant staff complied. It was difficult to find a suitable refuge, but the director, Herr von Alten, had a friend, the dashing Count Konigsmarck, who lived with his mistress in Schloss Karnzow near Kyritz, about fifty miles northwest of Berlin. This gentleman agreed to take in the collection. The Kunsthalle holdings were packed as compactly as was possible; all the best prints and drawings were removed from their mats and put in folders, one of which held more than twenty-five Dürers, and then in boxes. The paintings were removed from

their frames. The collection arrived safely at the lakeside schloss and was stored in the cellars. As the Red Army got closer, the Count walled the collection up in a small room and put metal file cabinets in front of the new wall. Only his mistress, Fräulein von Kutschenbach, was told of the location of the cache. When the Russians reached the town, the pair rowed out onto the lake, slashed their wrists, and prepared to die. The Count fell overboard and expired, but the Fräulein, having a change of heart, called for help and was taken off to a hospital in Kyritz, where she stayed for some months.[46]

It did not take the Russians long to find the storeroom. Viktor Baldin, an architect in peacetime, was called in to examine its contents. He found the drawings scattered "like so many leaves after an autumn storm," and was overwhelmed by their quality: a van Gogh study for his *Starry Night,* the Dürers, and works by Goya, Rubens, and Rembrandt. When his superiors showed little interest and declined to provide transportation to remove the find, Baldin chose some four hundred sheets and put them in a suitcase which he guarded carefully. During his time in Schloss Karnzow he found other prints and drawings spread all around the countryside. He bought or bartered for those which Russian soldiers had picked up, in one deal trading a pair of boots for a Dürer *Head of Christ.* Some could not be saved: in the woods he came upon a stack of drawings which the rain had reduced to a pulp. In July 1945 the Russians withdrew from the area, leaving the schloss to the mercy of the local inhabitants and Fräulein von Kutschenbach, heiress to the Count's estate. The adventures of the Kunsthalle works were far from over.

Nothing more was heard of them until 1946, when a Berlin dealer asked Zentralstelle official Reutti to check on a big Cranach woodcut he had been offered which bore the Kunsthalle stamp. He said his client had 134 more with the same marking. Investigation revealed that others in Berlin had been offered Bremen objects. Two hundred eighteen more were reported to be at the house of another dealer, whose initial reluctance to produce them was overcome by the threat that the authorities would tear up the floors to find them if necessary. It seemed that they had all come from the same source near Kyritz.

Reutti, travelling on black-market gasoline, drove out to the village in August. In the house of a printer they found hundreds more sheets, among them Dürer's delicate watercolor of *Irises,* a number of Kunsthalle paintings, and furniture from Schloss Karnzow. At the deserted castle itself the storeroom lay wide open, filled with empty boxes and what appeared to be trash. It wasn't. Under an old candle end was an Altdorfer *Nativity.* In another heap was Dürer's *St. Onofrius.* Enough fragments of a Caspar David

Friedrich painting were found to make reconstruction of it possible. Requests for further investigation in the small town, where most of the officials were related to the original seller, were rejected by the police chief on the interesting grounds that he had sixty-four murders to investigate and was too busy.

For the next twenty years works from Bremen continued to appear on the Berlin market. Some were seized. A Masaccio *Madonna and Child* traced back to Fräulein von Kutschenbach was found hidden in a potato sack in 1951; in 1956 a woman brought in a Cranach and was given DM 150 and a pound of coffee. Two more Dürer watercolors emerged in 1962, but it was not until 1990 and the end of the Cold War that Viktor Baldin, who had carefully guarded his suitcase of drawings since 1945, was able, through Mikhail Gorbachev, to suggest that they be returned to Bremen. Negotiations for their return began after an exhibition of the drawings at the Hermitage in 1992.

It was Reutti who took Rose Valland to Carinhall after the Russians had finished with it. All that remained of the enormous complex was a gable end decorated with Goering's coat of arms and his daughter's playhouse, a miniature of the Palace of Sans Souci. The grounds were littered with eighteenth-century French statues knocked off their pedestals and pieces of the columns and temples the Reichsmarschall had loved to collect. Gravelike holes indicated where large, rolled-up paintings and other treasures found by the Russians had been buried. In this devastation Mlle Valland found a considerable number of the confiscated works on her list, but at least a dozen, including a small marble group depicting the Rape of Europa, from the Maurice de Rothschild collection, had vanished without trace, either to Russia or into the depths of the lake before the house, where, local fishermen reported, strange things snagged their lines. In a far corner of the gardens she found Goering's copy of the *Nike of Samothrace:* "A pathetic Victory of wet plaster, eroded and melting in the rain, while the real one, its wings spread wide, had already come back to the Louvre."[47]

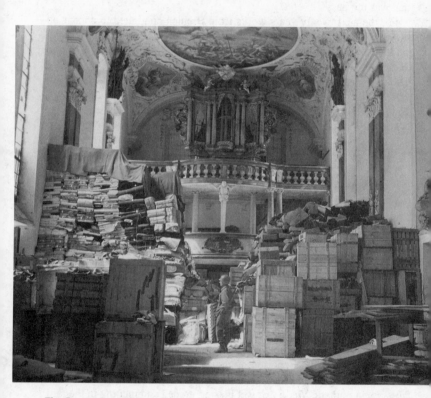

The German repository at Ellingen: contents unknown. One of the hundreds for which Monuments officers were responsible.

XII

MIXED MOTIVES

*The Temptation of Germany's
Homeless Collections*

The death of Franklin Roosevelt had occurred less than a month before the meeting of the victorious armies, which were moving across Germany from both East and West. To his Vice President, Harry Truman, who had not even been shown the protocols of the Yalta Conference, now fell the terrible responsibility of postwar Germany. Truman and his men did not share Roosevelt's strong desire to accommodate and support the Soviet Union after the war. To handle reparations discussions with the USSR and Britain, Truman chose a tough oilman and Democratic fund-raiser named Edwin Pauley who, as a Special Assistant, reported directly to the President and not to Treasury Secretary Morgenthau.

Pauley felt that the United States should get a major share of the $20 billion worth of reparations which the Big Three had agreed to take from Germany, and should do so soon, as he had discovered in late April that the Russians were already taking everything, cultural and otherwise, that they could move from the areas controlled by their armies. The instructions being prepared for him to take to the Reparations Conference in Moscow therefore contained clauses which would keep the U.S. in this competition: in the "initial period" of occupation each nation would be allowed to remove essentially whatever it liked from its Zone. The Zone Commander would decide if the removal was "consistent with the purposes of occupation" and would be bound by any "relevant agreed policies which may be formulated . . . by the Allied Control Council" and the Reparations Commission. In the limbo period before these bodies began deliberations, this would leave plenty of leeway.[1]

Pauley stopped in London in late May 1945 on his way to Moscow. He and his companion, Isadore Lubin of the Treasury, were briefed on arts matters by John Nicholas Brown and Colonel Newton. The attitude of the team from Washington came as shock. Brown wrote that he had gained the

impression that "the boys who are headed for Moscow do not have quite the same theories about Art as I have. If the thing should go from bad to worse I can always come home and make the contacts or the proper amount of stink. . . . It might be fun. But I do not think it will go that far as the British are entirely on my side."[2] Roberts Commission representative Sumner Crosby too reported that Pauley, General Clay, and Colonel Bernstein, the former Treasury official who had supervised events at Merkers, "favor the use of works of art as a basis for reparations" and had argued that "the United States does not wish to claim such material recompense as industrial equipment or labor. In fact they say there is little in Germany that the United States wants unless it is art or cultural property. It is proposed, for instance, that an international trusteeship be established to take over the best items in German museums and collections until Germany has proved itself worthy of their return. Additional arguments are raised that no adequate housing exists in Germany for storing or exhibiting art." He added that none of the Western Allies shared this view, and that the "United States must prove to the world that we have no intentions of fulfilling Nazi propaganda and that we are sufficiently civilized not to engage in looting ourselves."[3]

That Pauley meant business was made clear by his statement at a press conference in Paris that the gold found at Merkers would be considered as a source of reparations by his commission.[4] Worried Monuments men remembered only too clearly that Colonel Bernstein had considered the paintings stored alongside the gold bullion there as "assets" too. John Brown therefore immediately sent Clay a long memorandum underlining the primarily custodial responsibilities of the Army, in which he emphasized that use of cultural material for reparations was "a policy not generally approved in the United States and Britain." The Army, he advised, should not become involved in complicated issues of restitution, but should leave that to an independent inter-Allied commission.

To emphasize the dimensions of the custodial tasks and the need for more personnel to deal with them, Brown used what would prove to be unfortunate imagery: "A vast store of heterogeneous objects and records will come under the control of the US Military Government. The present indications are that the number of deposits in Germany is so large, and their contents so extensive, that a great burden will immediately fall upon Military Government. . . . The magnitude of the task of taking an inventory of works of art taken into custody can perhaps be grasped by pointing out that there may well be several million items in the US Zone alone. Manifestly it would be impossible carefully to catalogue so vast and varied a hoard . . . with the MFAA personnel as at present available or contem-

plated."[5] It was no exaggeration: Brown's numbers were correct and ever-increasing.

The lines at which the Soviet and Allied forces had halted were not those agreed to as the boundaries of the final zones by the European Advisory Council during their long months of deliberation in London. Allied armies were more than a hundred miles into the proposed Soviet Zone of Germany along a four-hundred-mile front. On June 5 Stalin had refused to agree either to a summit meeting with Truman or to any convocation of the Allied Control Council if withdrawal to the agreed boundaries did not take place. With Eisenhower's approval Truman ordered this to begin in Germany on June 21. Stalin, still busy consolidating his hold on the east of Germany, moved the date forward to July 1. Nothing at all was decided about Austria, and Truman only suggested vaguely that arrangements there be "left to local commanders." The potential situation was frightening: British elements had been ordered out of Vienna by the Soviets, and no one knew if and when Stalin would make further demands.

Within the area of overlap, which included the salt-mine region of Thuringia, there were still hundreds of unevacuated repositories. Word of the withdrawal order reached the Roberts Commission through State Department channels. Fearing that the contents of the unevacuated caches would end up in Russian hands, a delegation rushed to see McCloy. After explaining that in their opinion "the American Army is at present in the position of Trustees who might be held accountable afterwards if it abandons the works of art now in its possession," they requested that "all works of art which had been looted by the Germans from any sources or were displaced and stored in the territory now occupied by our Army" be taken to the American Zone. McCloy immediately cabled Eisenhower to ask that the art be moved back along with Army materiel. The State Department endorsed this policy. Ten days later David Finley was called in on a Saturday afternoon by Civil Affairs director Hilldring to define more precisely what should be removed. The State Department had felt that collections in private or public collections indigenous to the region should not be included. The order, with this change, which Finley felt was not as clear as might be desired, was personally approved by President Truman and went out on June 18, 1945.[6]

The Army was told to comply with the instructions of the President "as fully as time permits."[7] There was not much of that, as the withdrawal had been set for July 1. It is abundantly clear from Finley's memo that the RC knew that the Linz and Goering collections had been found, but had received no information as to their contents. Even less was known about the

objects which would now be added to those already in the American Zone. To remedy this unsatisfactory situation, preparations were immediately begun to dispatch John Walker to Germany to see exactly what the Army was holding; if there was to be any possibility of the United States receiving some of this booty, a matter that would presumably be settled by Pauley and Co. at the Reparations Conference in Moscow, which had convened on June 11, the RC wished to be prepared.

The diaries of all the Monuments men record sudden conferences, meetings, and changes of plan in the third week of June. Craig Smyth noted that Posey had suddenly gone to Frankfurt. "Reason for trip: order from War Department to hasten bringing in loot from areas that may be turned over to the Russians. Effort to get everything inside zone." On the twenty-first the Presidential directive was the subject of a major strategy session in Frankfurt that would be, until quite different motives brought them together later in the year, the only time so many representatives of the various Army groups and the SHAEF command would assemble in one place. (Indeed, so unusual was it for these officers to meet, and so militarized had they become, that when OSS operative James Plaut unexpectedly encountered Lincoln Kirstein, with whom he had been closely associated for years in efforts to launch what later became the Institute of Contemporary Art in Boston, they both came to attention and saluted.[8])

It was clear to all that a great deal more storage space would be needed. On the following day, LaFarge and Rorimer went to Wiesbaden and managed to secure another large building, the Landesmuseum, the former bailiwick of Linz chief Voss, as their third Collecting Point.

Reception of the withdrawal directive accelerated the already feverish pace of the field operatives. George Stout, who had gone up to Alt Aussee on June 15 with his famous sheepskin coats to begin the six-week evacuation process, did not at first know of the Presidential directive. He managed to get off one convoy on June 16, but his whole careful plan was upset by the sudden removal of transport and the additional officers he had been promised. As there was still no telephone communication with Third Army, he went to Salzburg to phone Posey, and the reason for the schedule changes was soon explained.

Stout, who had been joined by his new assistant Thomas Carr Howe (director of the San Francisco Legion of Honor Museum) and Lamont Moore, was racing against time. On June 24 he "arranged to go on longer day 0400–2000." The logistics were exhausting. He was responsible not only for the moving and packing of the mass of objects but also for the care and feeding of the drivers, loaders, and guards; the organization of the convoys; and the rescue of trucks that broke down in remote places. Night

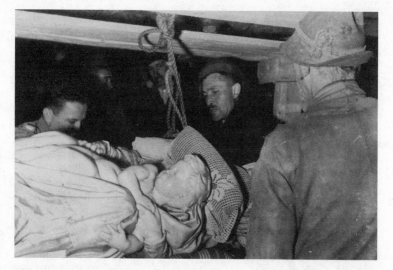

Alt Aussee: George Stout supervises removal of the Bruges Madonna; *note mattresses and lace-curtain packing material.*

and day the MFAA men and the mine staff still dressed in their distinctive, button-covered white uniforms, rode back and forth in the shadowy chambers on the miniature trains. Innumerable truckloads wound down the precipitous roads to Munich, 150 miles distant. It rained and rained. Food was scarce; "All hands grumbling," Stout wrote.

When packing materials ran out they sent loads of tapestries instead of pictures while they waited for the sheepskin coats, crates, and excelsior to be recycled after the objects had been unpacked in Munich. Perfectionist Stout would not release anything that was not properly packed, and the convoys were so unreliable that by the July 1 deadline the Belgian masterpieces still had not been moved. But there having been no settlement of the issue of the Austrian boundaries by that date, the evacuation continued on into July. By the nineteenth, one month after the Alt Aussee team had started, they had moved eighty truckloads which had contained 1,850 unpacked paintings, 1,441 cases full of others, 11 large sculptures, 30 pieces of furniture, and 34 large packages of textiles—and this still left a large amount for the next generation of Monuments officers. Exhausted, George Stout left for Paris and home on July 29, having spent just over a year in Europe. He had taken one and a half days off.

The British, though not in agreement with the American policy,

nonetheless cooperated in this operation. At Schönebeck, one of the Berlin repositories, the Americans had in the first days of liberation taken only large quantities of documents relating to the giant Siemens industries, and not the art, before handing the area over to the British. Nearby the barges sent from Berlin by museum director Unverzagt had, since April, remained half unloaded at their quay, the rest of their cargo stacked up outside the mine. In the last three days before Schönebeck was left to the Soviets, the British moved all this, along with reams of archives, to a temporary Collecting Point in the former Imperial Palace at Goslar, well within their Zone.

British Monuments officer Felix Harbord, not entirely immune to the fact that the Duke of Brunswick was related to the British Royal Family, also undertook the evacuation of the ducal schloss of Blankenburg. Here, the local Provincial Conservator, Karl Seeleke, had, with considerable bravery and the help of the entire town, including the sons of the Duke, stored the treasures of Brunswick. This operation, begun June 25, Harbord managed to continue until July 23, moving his cargo to Goslar on ever-varying routes through the Harz Mountains in relays of thirty British Army trucks escorted by three armored cars until the Red Army had secured the last road.[9]

Those on the receiving end of these massive transfers worked just as hard as their mobile colleagues. The day before the first convoy was to arrive at the Munich Collecting Point the situation there was still terrible. Although a weatherproof room was ready and a registration system for incoming works had been devised, there was no steady guard unit assigned. The neighboring Führerbau had been broken into, the communicating tunnels were far from secure, and there still was no fence—there was not even a telephone. Half the picture handlers had been rejected as Nazis, and others, probably equally suspect, had quickly been hired from a Munich moving firm. Five hours before the trucks were due in, the guard detachment announced that it was leaving and would be replaced by another, which of course would not be familiar with the building. Lieutenant Smyth was forced to go in person to headquarters to fight for a guard battalion for that night.

On June 17 the first major delivery arrived from Alt Aussee: eight trucks containing large numbers of top ERR pictures. By late July, Smyth would be responsible for 6,022 "items," many of them cases with multiple contents, so that the actual total was far higher. Among them were the Altdorfer altar from St. Florian, the Belgian treasures, the Monte Cassino pictures, the cream of the Budapest Museum, the Czernin Vermeer, the

A curator's nightmare: one of the crowded storage rooms at the newly opened Central Collecting Point in Munich

Rothschild Vermeer and their jewels, an ancient primitive statue from Saloniki, most of Goering's collection, and far more. Fortunately the barbed-wire fence had finally been put up, and the staff had been expanded to cope with the deluge. In the front office a secretarial pool of judiciously chosen but good-looking young German baronesses and other well-born ladies typed away—an arrangement criticized by the humorless Posey as inappropriate. But the security of the building was still marginal, the only fire protection was that which could be provided by the war-torn city, and many rooms were not yet weatherproof. There were more dramatic problems: despite sweeps by bomb experts an explosion on July 20 killed a sixteen-year-old worker and blew out all the power in the Collecting Point.

This episode unfortunately occurred two hours after the arrival of Bancel LaFarge and John Walker, who had come to view the repositories for the Roberts Commission. Walker found "everything perfectly arranged and functioning beautifully," but noted that the "building was shaken" and "bomb disposal squads are going to search for the fifth time for booby traps." When Smyth took him on a tour of Hitler's quarters Walker thought it interesting "not only because of its bad taste, its bar, which had pornographic murals [Ziegler's] . . . its Pullman style furniture . . . but also because of a childish love of secret passages . . . leading from one building to another and even under the square in front."[10]

The visitors discussed various problems with Smyth, including the possibility of heating the Collecting Point during the coming winter. It was far from a sure thing. Smyth wrote: "If not, job easy. If so, need more officers, preferably supply or engineering to help. If not, can have jury-rig—not elaborate, absolutely simple. If so, must be conceived in more permanent terms because of necessity of rebuilding for insulation." Later there arose the question of where the coal for heating would come from. "Reply: Group CC would have to decide and furnish. Question: how to proceed at present. Reply: proceed as if Galleries were to be heated."[11] A bit later Smyth told his staff only that they would be able to keep the gallery "a little above freezing." Group CC was General Clay's turf. And Clay was at the Potsdam Conference at that very moment, trying to get a clear mandate for the running of the American share of the shattered German nation.

The Wiesbaden Collecting Point was still in an embryonic stage. Experience at Munich had shown that architectural training, at least at the beginning, was just as important as museology. And the three-hundred-room Landesmuseum certainly needed someone who could make it habitable in the shortest possible time. Fortune brought the MFAA another exceptionally dedicated officer in the person of Captain Walter Farmer, an engineer with architectural and interior design experience. Farmer, longing to be released from his unit—which was engaged in the dreary business of building POW cages—had offered his services to the MFAA office at SHAEF and was immediately accepted. He was ordered to take over on July 1 and to have the Collecting Point ready by August 20. This was an eon compared to the two weeks granted Smyth, but still not very long.

The Landesmuseum was not in any better shape than the Munich buildings had been. One large area had been occupied by a Luftwaffe machine shop, and the remains of five antiaircraft gun emplacements graced the roof. U.S. Twelfth Army had a clothing depot in the art galleries; the Rationing Office was in Archaeology. DP families lived in every other viable space. There were no unbroken windows at all, and the heating had not been used for years. Farmer's first act was to make the perimeter secure. He was assigned a labor force of 150 German sappers, still in their uniforms, who began putting up fences and floodlights. To find out where building materials might be hidden, he ordered a meeting of local contractors in the movie theater.

Soon the museum's windows were glazed, tons of rubble and flak fragments were cleared from the roofs, and interior doors, 90 percent of which had been blown off their hinges, were rehung. Most miraculous of all, the heating system was coaxed into operation; the proper humidity so vital to panel paintings was provided by putting wet blankets in the air ducts and

keeping certain areas of the floors wet. Staff was hired and plenty of art historical advice was forthcoming to Farmer from other MFAA officers working in Frankfurt. One such was Edith Standen, a WAC captain and former curator of the Widener Collection who had been assigned the immense and tedious job of inventorying the artistic contents of the Reichsbank in Frankfurt in preparation for its move to Wiesbaden. (Hers was musty and exhausting work. The crates, Nationalgalerie pictures, and golden Polish church treasures were one thing, the two-foot-high stacks of rugs and charred archives quite something else.)

By late July, Farmer, exhilarated by his job, wrote with some understatement that "everything necessary has been obtained by one means or another." His confidence was fortunate, for he was about to be given responsibility for the entire assemblage of works of art evacuated from Berlin, plus much more. It was, as Smyth had found in Munich, not easy. Farmer too had his problems when it came to security. Noting that he "hated to make money estimates, but the average American demands it," he casually mentioned to the local commander that the incoming works were worth more than $50 million. This made such an impression that he was given extra guards. He needed them. In the first week the Collecting Point was open, fifty-two truckloads, impressively escorted by tanks, arrived. And they kept coming: "Three more truckloads of prints yesterday, and Thursday two truckloads of gold and church ornaments and a bit later six truckloads of paintings etc.," Farmer reported. There were no hours left for unpacking the objects or contemplation. Even the famous head of *Nefertiti,* which Farmer was especially proud to be guarding, would have to wait until 1946 to be viewed.[12]

In late August the British too transferred most of their holdings to a permanent Collecting Point in a vast schloss at Celle, thirty miles northwest of Brunswick. Here were taken objects from the Berlin collections, found in the mines which had come under British jurisdiction. From Schönebeck and Grasleben, which had been looted and where a fire that had started in the film archives had burned for days and caused extensive damage, the objects arrived in terrible confusion and poor condition. Director Harbord, more interested in reviving theater and putting on exhibitions, left administration of the Collecting Point entirely to a German dealer and collector named E. J. Otto who had volunteered his services. Harbord's successors were not much more enthusiastic about the tedious processes of opening and checking the contents of the thousands of crates of German-owned objects at Celle which contained, among other things, the priceless Gans collection of Roman gold objects.

Repeated attempts by Berlin officials to gain access to the Collecting

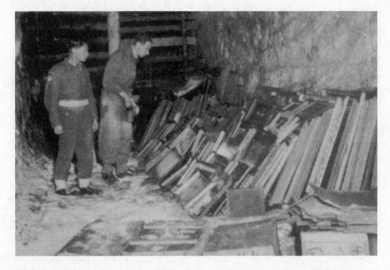

British officers faced with hundreds of uncrated Nationalgalerie pictures at Grasleben

Point were resisted by both Otto and the British. It was not until September 1947 that a new assistant, using inventory lists recently sent from Berlin, discovered that thirty-two pieces of the gold hoard were missing. By now it was impossible to tell at what point they had been removed. Otto and his staff were all fired by the embarrassed British, and a police investigation instituted. A curator from the Schloss Museum in Berlin was put in charge of the Collecting Point. Further inventorying revealed that more gold items had vanished. They have never been found.[13]

While the field officers were engaged in these strenuous activities, certain of their peacetime colleagues were collecting people and information. The OSS Art Looting Investigation Unit, consisting of naval officers/art historians James Plaut, Theodore Rousseau, and Lane Faison had begun operations in Germany in late May 1945, in a gingerbread-covered villa conveniently located not far from Alt Aussee. Their information was not only of interest to the MFAA officers; their principal sponsorship was by the Army Judge Advocate's office, which was investigating war crimes. Before they arrived in Germany the three officers had already looked into Alois Miedl's activities in Spain and attempted without success to extradite him. They had done further preliminary work in France and England, drawing on the documents collected by the Intelligence agencies of vari-

ous nations. Since the previous autumn Army authorities had had lists of the Nazi art principals, and Douglas Cooper of British Intelligence had been questioning any POWs taken to England who seemed to have art backgrounds. Lists of suggested questions and names of Nazi agencies were distributed to all Intelligence units. By the time the Alt Aussee interrogation center was set up, Mühlmann, Lohse, Hofer, Goering's secretary Gisela Limberger, and all of the Reichsmarschall's records were in custody.

The work of arrest and interrogation was not so pleasant: Frau Dietrich dropped all the charm she had displayed to the Führer when Lane Faison came for her account books, but soon calmed down when she saw the pistol (never used) he wore.[14] Once in captivity, the German art purveyors spoke volumes. Hofer seemed able to remember every transaction, reeling off the details of certain of them with ease while avoiding those which revealed his own venality. Mühlmann, after trying to escape twice and responding initially with contempt, eventually talked a great deal, even telling his captors little anecdotes about Hitler and Hoffmann. His testimony is full of claims: that he tried to keep collections together, that he tried to save things for Austria, that he helped preserve Polish treasures. But unlike many of his colleagues, he had no illusions about the reality of his acts and at the end of one statement wrote, "The Third Reich had to lose the war because this war was based on robbery and on a system of injustice and violence, which could only be broken from the outside. Every individual has now to pay personally for the mortgage which the German people has accepted."[15]

Some had paid already. Bunjes was not the only suicide: von Behr was found, still in his uniform, together with his wife in his apartments at Schloss Banz near Bamberg. They had gone out in style by drinking an excellent vintage (1918) champagne laced with cyanide. In a storeroom deep in his cellars, walled up for an unknown posterity, were all the records of Alfred Rosenberg's ill-fated Ministry, which now would be used as evidence at Nuremberg. Haberstock and his records were found nearby at the castle of the Baron von Pollnitz, who had been so helpful in the retrieval of the Wildenstein collection from its Louvre guardians. Gurlitt was there too. After Haberstock was arrested, von Pollnitz told Frau Haberstock that he would hide the dealer's remaining pictures if she would reveal their whereabouts. She declined this offer. MFAA officers later by chance found some of them in the famous Schloss Thurn and Taxis in Württemberg.

Hermann Voss was different. He managed to travel to Wiesbaden, where he offered to assist the Americans in the recovery of the Linz collections

from Alt Aussee. It seems never to have occurred to him that his wartime activities would be viewed as criminal by the Allies; he expected that the Americans would arrange for his wife and his personal papers to be brought from Dresden so that he could donate them to some public institution or university, where he no doubt planned to continue his studies. He even presented the Monuments men with a copy of his poem deploring the German conquest of France. He was, therefore, quite amazed to be arrested immediately by Walter Farmer and sent off to Alt Aussee to be interrogated.[16]

It took longer to track down ERR executive Gerhard Utikal, who knew all too well what was in store for him and had started working on a farm under an assumed name. His wife and two small children were found in a small Bavarian town. When "confronted with the alternative of either revealing her husband's whereabouts or of being interned herself," she yielded his address. The officer who had located Frau Utikal was later congratulated by MFAA officer Thomas Howe for the "discretion and psychological skill used in dealing with [her]."[17]

As the Nazi art gatherers and their records were brought in, the OSS trio slowly began to comprehend the staggering magnitude of the German operation. The more they learned, the less sympathy they had for those who had traded with and for the Nazis. And indeed the evidence of cynical collaboration was devastating. Reports and questioning produced endless examples of betrayal and corruption, and of the extraordinary ability of the Germans to compartmentalize and rationalize their actions. Their responses for the most part have a terrible similarity: they were only protecting the art; they were only following orders. These statements were backed by reams of stamped and notarized testimonials from wives, doctors, and colleagues who always mentioned that those being questioned helped this or that Jew, and only gave lip service to the Nazi party.

After the months of investigation Plaut, Rousseau, and Faison produced three very long and overwhelmingly detailed "Consolidated Interrogation Reports." Another on the Dienststelle Mühlmann was written by Jan Vlug, a Dutch Intelligence officer working with them. Separate reports were also filed on each of the principals. Again and again the feelings of the writers penetrate their official prose. In the middle of his endless pages of details Vlug allows himself to exclaim that Mühlmann is "obstinate, he has no conscience, he does not care about Art, he is a *liar* and a *vile* person." Rousseau felt that his analysis of the Goering collection "dispels any illusion that might remain about Goering as the 'best' of the Nazis. In this one pursuit in which he might have shown himself to be in fact a different type of man, he was the prototype of all the worst in National Socialism. He

The OSS team: Theodore Rousseau (left) and James Plaut at their interrogation center (Inset: Lane Faison, July 1945)

was cruel, grasping, deceitful and hypocritical . . . well-suited to take his place with Hitler, Himmler, Goebbels and the rest."[18] Faison recommended that the Linz operation be declared a criminal organization. Nazi looting, he wrote, was different from that of any previous war in having been "officially planned and expertly carried out . . . to enhance the cultural prestige of the Master Race."[19]

Despite their disgust the OSS and MFAA men were human. Craig Smyth, who later had to supervise the house arrest of Hermann Voss, found it difficult to treat so eminent a scholar as a criminal and had him report daily to someone else. Monuments officer Charles Parkhurst, sent to question the widow of Hans Posse, whom he found living on the proceeds of sales of the pathetic contents of two suitcases of family bibelots, described her as a "gentle, elderly person" and broke off his interrogation when she began to weep. In the few answers she did provide it was clear that she was very proud of her husband's accomplishments. She even showed Parkhurst photographs of Hitler at Posse's state funeral, but of his actual transactions she clearly knew nothing.[20] Plaut doubted that Bruno

Lohse had really known the extent of Goering's evildoing and noted that both he and Fräulein Limberger had become despondent when all was revealed. Rousseau and Faison too, after weeks of questioning Miss Limberger, were convinced that despite the fact that she had read the damning daily correspondence from Hofer to Goering, she bore no blame. When they had finished with her, Faison could not bring himself to leave her at the squalid internment camp to which she had been assigned and instead asked her where she would like to go. She named the Munich dealer Walter Bornheim, he of the suitcases full of francs, and a principal supplier to both Linz and Goering. Faison consented, and left her at the military post in Gräfelfing, where Bornheim lived.[21]

In June 1945 both the Americans and the Europeans, who by now had established their own recovery commissions at home, still believed that an international restitution commission would be set up. The day the Reparations Conference opened in Moscow, in a breakthrough for the British, the European Advisory Council back in London agreed that German works of art should not be used for reparations "pending restitution."[22] After this had been completed, according to their thinking, claims would be made to the still dreamt-of international commission for the "replacement in kind" of missing or destroyed items, an idea particularly dear to the French. None of this could take place until the structure of the four-way occupation of Germany had been agreed upon by the Big Three at their summit conference which would begin on July 17 in Potsdam, just outside Berlin.

By the second week of July, SHAEF headquarters in Frankfurt swarmed with officers and diplomats preparing for the coming conference. John Brown had arrived on June 12, after a tour of the American-held repositories, and was billeted in a comfortable, fully furnished "middle-class" house lacking only hot water. These amenities, he discovered upon reading his billeting notice, had been guaranteed in the following manner: "Occupants will not be notified prior to four hours before they must complete evacuation, so that the houses will be left habitable. Occupants will not be permitted to remove furniture, rugs or furnishings."[23] John Walker had joined him there, living on the princely per diem of $7.00 per day, to prepare for his inspection trip. Brown, who had finally met with Clay to discuss MFAA thinking, was optimistic that "something really constructive will eventuate from this meeting at Potsdam. . . . I sense a feeling in the air. . . . President Truman is a great man in his quiet way."[24]

MFAA discussions concentrated on the future inter-Allied restitution commission and its relation to Military Government. Its duties, they felt,

would be eased by the continuing recovery of major works from their refuges, which would obviate the need for replacement in kind from the German patrimony. No one in this group had any knowledge of the quite different plans being made at the highest levels of the United States government, though they were aware that not everyone thought as they did. In his diary Walker noted in passing that Colonel Leslie Jefferson, head of the division of which MFAA was a branch, was "a hard boiled regular Army colonel with no interest whatever in art. He wants U.S. to get something out of this war. Dislikes French."[25]

The Allied Commission for Reparations had begun its deliberations on June 11 in Moscow. From the beginning Pauley realized that the Soviet Union intended to take anything it could move out of its zone of occupation. The United States, he felt therefore, should "claim all we can accept . . . we cannot use plants, machinery and labor. But we can take, and should assert to the fullest extent our demand for gold currencies, foreign assets, patents, processes, technical know-how of every type."[26] Works of art were not specifically mentioned in this message but were most definitely included in Pauley's thinking, for on June 26 Eisenhower was informed "at the President's request" that any removals of property under control of U.S. forces in Germany and Austria for the purpose of restitution "should first be submitted . . . for the approval of the United States Representative of the Reparations Commission."

To make the process "more efficient," a member of Pauley's staff, who had no connection to any of the already established MFAA agencies, was assigned to Eisenhower "with authority to act promptly on matters submitted." Works of art would only be returned to the government of an Allied nation when "evidence submitted to my representative conclusively establishes identity of particular works of art. Prior to each and every delivery of an art object to any Allied Nation a proper statement shall be sent . . . to the effect that the value of the art object returned may or may not be included in the final reparations accounting for each nation."[27]

Since each Allied nation was to get a certain percentage of Germany's remaining wealth, the more the other nations' reparations slices could be reduced by works of art and other objects, the more assets would be left for the United States. Pauley was not referring to items such as the Bruges *Madonna*. He was thinking of the billions of reichsmarks' worth of art which had been purchased by the Nazis. Somewhere along the line he had talked with Walter Andreas Hofer, who had stated to him that all Goering's pictures had been "legitimately acquired" and revealed how much had been paid for them.[28] To Pauley these were assets like any others which

might accrue to America. But by July 14, three days before the Potsdam Conference would convene, the Allied representatives in Moscow had not been able to define precisely who would get what shares of Germany's assets, or even which nations would be included; nor could they agree on exact definitions of restitution, war booty, or trophies.[29] It was becoming more and more certain that each power would do as it pleased in its own zone. Within the American administration itself, controversies raged over the inclusion of works of art and gold in the reparations pool. Thanks to British prodding, art was again removed from the reparations accounts in the final working papers prepared for discussions at the summit. The only thing that was definite was that "Mr. Pauley is of the view that the U.S. should assert as large a claim to reparations as possible and that we should seek payment in German gold and external assets."[30]

At the same time, General Lucius Clay, the newly appointed Deputy Military Governor of Germany, had been involved in other, more frustrating negotiations in which the machinery of the Allied Control Council, the presumed governing body for all Germany, was to be determined, and in which the Soviet Union had so far outsmarted the Americans, who had wrongly assumed that the team spirit of the combat period would carry over into postwar arrangements. In various proclamations on June 5, Eisenhower and Soviet Marshal Zhukhov had formally dissolved the national government of Germany and given themselves supreme power. They had also stated that the occupying powers must agree unanimously on any matters affecting Germany as a whole, but that if such agreement could not be reached, each Zone Commander could decide matters for his own zone without reference to the others. Organization of the Control Council was postponed until after the Summit; thus there was no central authority which could limit or even criticize the actions of the Zone Commanders once the armies had withdrawn behind their assigned boundaries.

In retrospect the task facing Clay in July 1945 seems impossible. The numbers of refugees, freed forced laborers, displaced persons of every nationality, and homeless Germans roaming the countryside increased daily. Food and fuel supplies remained pathetically inadequate; transportation and communications were wrecked. Clay saw everywhere "human suffering beyond reason." And there was the huge American combat force to be fed, supplied, and redeployed to the Asian theater of operations. The custody of millions of works of art was but one of Clay's awesome responsibilities in this terrible limbo.

As soon as the Russians had grudgingly granted permission, the British and Americans began to converge on the wasteland that was Berlin to set

up their Military Governments and prepare for the Potsdam Conference. The heads of state assembled on July 15. Truman came without Morgenthau, who had resigned in protest after not being invited. As the Conference progressed, Clay conferred with Stimson, McCloy, Pauley, Hilldring, and others. He told Stimson that the United States was the custodian of "the greatest single collection of art in the world."[31] With him he had a proposal for dealing with this "collection" from which it is clear that Clay wished, as much as possible, to rid himself of the problem of caring for the mountains of art the Army had unwittingly acquired. The works were divided into three categories:

Class A, consisting of works of art taken from the countries overrun by Germany readily identifiable as publicly owned, and works of art taken from private owners in the overrun countries by seizure and without compensation.

Class B, consisting of works of art taken from private collectors in the overrun countries for which some compensation is alleged to have been made to the owners.

Class C, consisting of works of art placed in the U.S. Zone by Germany for safekeeping which are bona fide property of the German nation.[32]

His suggestions for the disposition of these works were based both on the physical situation in Germany as of July 17 and on the recommendations of the Monuments men and reparations adviser Pauley. Since "neither expert personnel nor satisfactory facilities are available in the U.S. Zone to properly safeguard and handle these priceless works of art," the memo stated, Class A and B works should be returned to the countries from which they were taken. For the Class B works "receipts may be taken so that the return of compensation made by the Germans may be settled at a later date, perhaps as a charge against reparations payments." Then came the bombshell that suggested that Class C works "might well be returned to the U.S. to be inventoried, identified, and cared for by our leading museums." Clay recommended that they "be placed on exhibit in the U.S., but that an announcement be made to the public, to include the German people, that these works of art will be held in trusteeship for return to the German nation when it has re-earned its right to be considered as a nation."

On July 17 there was a general discussion at Stimson's Potsdam lodgings which lasted for over an hour, "consisting mostly of the topic of captured art in US Army hands."[33] General Clay stated that he hoped to get approval for his plan. Stimson "agreed in general with this policy," as did Secretary of State James Byrnes. They did not need much convincing. By now all those present at Potsdam had seen the hideous condition of

bombed-out Berlin; they had also seen trains on sidings with top-heavy loads of loot preparing to leave for the Soviet Union. Clay met with President Truman on July 18 and immediately received "informal approval" for his art-evacuation plan.

None of the MFAA people had seen Clay's memo. John Nicholas Brown, theoretically Cultural Adviser to Eisenhower, only arrived in Berlin on the day Clay received Truman's approval, where he "held himself available in case there should be a call from the Big Three Conference."[34] Meanwhile, he accompanied the local MFAA contingent on inspection tours of the city. The closest he ever got to Eisenhower in his tour of duty was as a member of the audience at the flag-raising ceremony at the new American headquarters in Berlin, performed in the presence of President Truman on July 22. On the twenty-sixth he wrote home that a Colonel Reid "had looked for me . . . on being summoned to the Conference Area. He hoped to take me with him."[35] But Brown, not notified in time, had gone off to look at a large statue of a lion claimed by the Danish government, and missed his chance.

The first news of the Clay memo came to the Monuments men at headquarters in Frankfurt on July 29. Mason Hammond wrote immediately to Calvin Hathaway in Berlin that he had heard that "General Clay talked to President Truman about restitution of works of art and persuaded him . . . to take German works to the United States to hold in custody and show to the U.S. populace." Upon inquiry it appeared that "the thing had come from General Clay with the request that there be no circulation or release until after the conference."[36] Mason Hammond disobeyed this order and told Hathaway to try to find out discreetly "whose bright idea it is to ship German art out to the U.S."[37] He also made a secret copy of the memo and had it brought to the attention of Eisenhower's Political Adviser Robert Murphy. Meanwhile, the document had reached Pauley and his colleague William Clayton, an Assistant Secretary of State concerned with Economic Affairs. They approved the idea, except for one thing: they did not wish to state that the Class C works of art would be returned to the German people, but rather that "their eventual disposition will be subject to future Allied decision."[38] This not only was apparently approved by the Secretary of State (who failed to consult Clay), but was transmitted verbatim in letters to Foreign Ministers Molotov of the USSR and Bevin of Britain.

John Nicholas Brown did not see the offending memo until his return to Frankfurt from Berlin on August 1. Furious, he wrote to Hathaway that it was "very upsetting, for so much of the document savoured of the language we had been using, but with a reverse English at the end. . . . Well,

we shall see. . . . My first reaction was that I should make this a cause and request my immediate return to the US."[39] Clay, for different reasons, was no less angry. On August 2 he cabled Washington that the lack of a

> public statement of future intent with reference to German Art . . . is of course in conflict with informal approval of President. . . . I am apprehensive that removal of German Art without statement of future intent to return would not be acclaimed by public at large. . . . I am not sure that Clayton and Pauley's letter gave cognizance to President's informal approval of trustees holding of German Art . . . therefore request further instructions.[40]

Clay was quite right to say that this policy would not be "acclaimed." But the negative reaction was to any removal of objects from Germany at all. Brown sent him a strong protest indicating his outrage at not being consulted and—in contrast to his earlier reports, written before the opening of the Collecting Points—asserted that there were now indeed satisfactory facilities and adequate personnel to care for the works of art. He pointed out that much of what the Americans held belonged to institutions in other zones and that transporting works of art across the Atlantic was as dangerous as leaving them in Germany. But his main objections were moral: taking Germany's heritage "under the questionable legal fiction of 'trusteeship' seems to the writer, and to his associates in the MFAA Branch, not only immoral but hypocritical" and would be regarded with "distrust and disfavor by our Allies." He felt that it would "indeed be humiliating" to have the German propaganda that portrayed MFAA activities as looting turn out to be true, and suggested that the cream of the German collections be sent to the United States and the formerly occupied countries in a series of loan exhibitions while the German museums were being reconstituted, and not "as taken by some quasi-legal act of war."[41] To his wife he fumed that:

> I have been very much chagrined that there was decided while I was sitting in Berlin a policy which I have advised against ever since I came over here. There is obviously no need for an adviser if his advice is not even asked. . . . I must say that I leave this tour of duty with the feeling of failure in the accomplishment of my mission, a sad state of affairs and a depressing state of mind.[42]

His bitterness would be somewhat assuaged in a final meeting with Clay during which the general revealed to him in confidence that the promise to return the works to Germany in the future had the backing of President Truman himself.

Responding to Clay's objections, Secretary of State Byrnes cabled Pauley that the United States "should set a high standard of conduct in this respect." The works of art should be "safeguarded," but it must be clear that they "will eventually be returned intact, except for such levies as may be made upon them to replace looted artistic or cultural property which has been destroyed or irreparably damaged."[43] This demi-retreat was too late. Stiff objections to the removals had been received from both Britain and, hypocritically, Molotov of the USSR. Byrnes and Pauley, forced to back down, softened their language in a letter notifying the Roberts Commission that "this government fully intends to return all art objects of bona fide ownership as soon as conditions ensuring their proper safekeeping have been restored."[44] This letter guaranteed the return of longtime state-owned treasures, but it left a large loophole in the matter of items legally acquired from individuals, or bought in the neutral nations by the Nazi collectors.

The Roberts Commission, angry at not having been consulted, was riven by the controversy. Their latest emissary to Germany, John Walker, had not heard of the Clay proposal until he had arrived in London on August 14 on his way home and was shown an undated copy by a Clayton assistant.[45] Dinsmoor and Francis Henry Taylor were delighted that the German works were coming to the United States, feeling that it was "proper that the American people should have an opportunity to see these collections," and Taylor passionately declared that he "would interpose no objections to whatever decision the Government might make regarding the use of cultural objects for reparations purposes . . . the American people had earned the right in this war to such compensation if they chose to take it." Informed by the OSS Art Looting office in London that Woolley "deplored the implications" of the proposed removals, Taylor brushed aside the British objections; the British, he felt, should follow the American example. He was not worried about propaganda: "I believe that we must have the courage to take our own good counsel and act in the best interests of a nation which has lavished its blood and treasure upon an ingrate Europe twice in a single generation."[46] After "reading the documents and letters between high authorities," he was confident that Truman and Byrnes would keep their word, noting that the Army's inability to guarantee continued high-class personnel in Germany made transfer of the objects to the United States "obvious."

Others did not quite agree. Sumner Crosby was so furious that he wrote a passionate letter of resignation, later withdrawn to be sure, and Roberts Commission secretary Charles Sawyer, suspicious of Pauley's motives, noted prophetically that "the physical presence of these objects in the

country would lead to strong pressure to retain at least some of them under some pretext or another."[47]

David Finley, director of the National Gallery, had another worry: the Army had requested that the evacuated works be stored in his museum, an enormous and expensive responsibility. For this he needed approval from the highest-ranking member of the Gallery's board of trustees, Chief Justice Harlan Stone, who was on vacation in New Hampshire. Finley travelled through the night to see Stone. The Chief Justice felt that "if the government asks us to take care of these paintings, we must do it. It is a duty which we could not escape if we wanted to, and certainly we do not want to." Finley, mission accomplished, did not even stay for lunch, and returned immediately to Washington.[48] The Gallery's responsibility was officially confirmed by a letter from Acting Secretary of State Dean Acheson on September 14 which also informed Finley that Clay had "been asked to supply information regarding the storage space needed . . . so shipments can commence in the very near future." The State Department was quite aware of the marginal propriety of this arrangement. The whole project was to be kept secret, Acheson cabled to Murphy in Germany, until an announcement could be synchronized with that which "will have to be made in Washington in the near future to counter rumors and anticipated criticism concerning action."[49]

The MFAA contingent in Germany was not officially privy to these high-level arrangements. Indeed, they felt sure that nothing would ever come of the project given the shortage of transportation in Germany and the vast quantity of German-owned art. They were, therefore, horrified to receive a request from the War Department asking for estimates of how much storage space would be needed to house the entire German patrimony. Mason Hammond immediately cabled John Nicholas Brown, who had returned to the United States in late August, to say that the "matter of which you disapprove is being pressed—suggest you make inquiries at once and at top."[50] In Germany, Hammond raised such a fuss that he was given an interview with General Clay, to whom he gave three "good reasons" for not carrying out the plan: "one, that of moral grounds; one that it was a severe criticism of U.S. control; and one that it was practically very difficult to do."[51] Clay did not budge, however, and the announcement of the plan was set for September 17.

But the Army had begun to be nervous. In Washington, Hilldring of the Civil Affairs Division wrote to the Roberts Commission that "certain technical experts" had said it would be more dangerous to move the pictures than to leave them in Germany, and asked for advice. This doubt had been

planted in the good general's mind by RC secretary Charles Sawyer, who opposed the operation and who had told the CAD that "the Department of State was also beginning to have doubts as to the wisdom of the Potsdam decision."

It was also far from clear just how much would need to be moved. The first estimates concerning storage were not encouraging: about thirty thousand square feet would be needed to house the German-owned objects already in the Collecting Points, and there were 677 known repositories in the U.S. Zone which had not yet been investigated. In the meantime, John Nicholas Brown's memo disagreeing with Clay had arrived in Washington and was sent to Assistant Secretary of War McCloy, who was also rumored to be doubtful. This was followed by a visit from Brown himself. McCloy cabled Clay "for your up to date estimate . . . after consulting the experts at your disposal there," adding that "if there is a real need for this action we should take the risk of any unfavorable comment." He assumed that "there would be some process of selection whereby only the really perishable articles would be shipped."

There is no evidence that Clay consulted anyone before replying irritably,

> It is true that conditions here for storage of German art are improving, however, the same people who do not approve of removal of German art objects to the US urged early and immediate action on return of objects to liberated areas on grounds our facilities were entirely inadequate to protect these pieces. . . . It was their concern . . . that developed my concern for the preservation of German art objects.

He had, he said, never contemplated the return of less valuable objects. He also believed that "the American public is entitled to see these art objects until they can be returned to their proper places in Germany." In clear reference to the Russians and the French, he rejected the advisability of returning objects to other zones "if we desire to preserve them for the German people." He concluded by saying that he did not "feel strongly about the final decision" but that "it will not be helpful to us here if such recommendations are changed because of the views of subordinates who have returned home."[52] Still, Hilldring postponed the announcement of the operation until the whole problem could be discussed by the experts on the Roberts Commission at their next meeting.

This took place on September 25, 1945. The Commission had asked Crosby, Brown, Walker, Stout, and Plaut to appear as "technical advisers" and make statements. But, Brown recalled, when these gentlemen arrived they were treated in a most bizarre manner, being at first "herded into a

separate room, and kept waiting one and a half hours before we were allowed to appear and then en masse, each to give a brief talk to the Commission. It was an embarrassing moment and one rather infra-dig. None of us felt we could express fully the more subtle of our feelings in so open a meeting."[53] Their written memos were accepted.

Stout thought transportation equally dangerous as the unheated winter conditions of Germany, but noted that action would "probably be based on considerations of policy as well as physical protection." Plaut of the OSS, who later withdrew his statement, wrote with some emotion that the action was no better than that of the Nazis, using quotes from ERR reports which had used almost identical language to explain their "safeguarding" activities to back up his points. Brown reiterated that the pictures should come only as a loan exhibition. John Walker, chief curator of the National Gallery, said that although the Collecting Points he had seen were adequate, there were hundreds more he had not visited, and that he did "not have the necessary information to approve or disapprove of General Clay's recommendation." He noted that every Monuments officer he had met was anxious to come home, and advised against antagonizing the Army, as "nothing can be done to preserve these works of art without the full and sympathetic cooperation of our Army leaders." The moral question, he felt, had been answered by the assurances of the President and the Secretary of State, but Walker did say that due to the chaotic conditions in Germany, "the policy of a wise custodian would be to bring at least part of this irreplaceable treasure to the safest haven available, and that would seem to me, at the present time, to be the United States."[54] The Commission's ultimate recommendation was a most strangely convoluted piece of buck-passing:

> After full consideration it was resolved that the Commission is not in possession of facts which would authorize it to conclude that General Clay's recommendations, upon which the President's decision was based, were unsupported by facts within his knowledge.

To this they added the recommendation that objects held by the United States belonging to museums in other zones be treated in the same manner as those indigenous to the U.S. Zone.[55] This, of course, opened the way to the removal of anything from the Berlin museums which might be at the Collecting Points.

The next day press releases from the White House and the National Gallery announced the plan to bring the German works to the United States "with the sole intention of keeping such treasures safe and in trust for the people of Germany or"—tantalizingly—"other rightful owners"

because "expert personnel is not available within the American Zone to assure this safety." References to Germany's need to "re-earn" its right to the works were eliminated. John Brown was philosophical; he wrote to LaFarge in Germany that "our protests have kept the Government clean."[56] George Stout was more cynical: "Did these fellows in Washington actually wangle the Army? And then use the Roberts Commission to cover themselves up? . . . I never thought that some of those big brass museum directors were anything more than a first class job of taxidermy, but gawd-amighty, I thought they would manage to keep on looking like men."[57]

At the National Gallery, in response to the Army's decision, Chief Curator Walker now ordered a list of Germany's top masterpieces to be prepared by Hanns Swarzenski, a German exile who had been given temporary employment at the Gallery's repository at Biltmore. From memory, prewar catalogues, and a microfilmed copy of the Berlin evacuation documents, he compiled a list of 254 paintings, 73 sculptures, and 39 *objets*. Swarzenski wrote to Walker that if he "had listed more than these, there would be no limit where to stop . . . but probably I have forgotten a lot from the smaller museums like Stuttgart and Karlsruhe."[58]

On the list, made without any reference to the present locations of the works, were 102 works from the Kaiser Friedrich Museum in Berlin, Watteau's *Gersaint's Shopsign* from Charlottenburg, Daumier's *Don Quixote* from the Nationalgalerie, 2 Chardins from Potsdam, 43 pictures from the Städel in Frankfurt, Manet's *Execution of Maximilian I* from Mannheim, 26 works from the Alte Pinakothek in Munich—including Dürer's *Saints* with the note "probably too fragile"—9 from Nuremberg, and more from Dresden, Vienna, Karlsruhe, Stuttgart, and Kassel. Assembling this selection would not be easy. No one knew exactly where all the works were. John Walker had seen the unopened Kaiser Friedrich crates in Frankfurt prior to their transfer to Wiesbaden, but there were as yet no complete inventories of the holdings of the Collecting Points, where new items arrived daily and where priority was being given to those items slated for return to other Allied nations. The Munich pictures were still where the Germans had left them, in the rural repositories of Dietramzell, Ettal, and Raitenhaslach, and, despite Walker's advice during his July visit, had not yet been brought to the Collecting Point.

Requests to the MFAA officers, now aware of the possible removal of the works, for detailed information had purposely been delayed with encouragement from LaFarge and Kuhn at headquarters. Edith Standen, asked for lists of masterpieces at Marburg and Wiesbaden, "listed only things I saw with my own eyes, gave them fifteen paintings, . . . all belonging to museums outside our zone. I rather hated doing it; Bancel and

Charles Kuhn take the line that supplying information is not actually supporting an infamous policy, so I go along."[59]

Indeed, most of those involved in Monuments work still doubted that anything would actually happen; Perry Cott, for instance, wrote from Vienna that everyone there was "completely agreed on the inanity of the project . . . it will probably die a natural death when the people who proposed it realize the material difficulties involved in putting the plan in operation."[60] Even Count Metternich had denied the circulating rumors of an American art grab when queried by friends. They were all overly optimistic. In early October, McCloy had commented on the pervasive fear of the Russians and the "almost medieval isolation of existing life" in Germany, over which hung the terrible dread of cold and disease in the coming winter, which could result from the lack of coal.[61] This situation was not calculated to make Clay change his mind about ridding himself of the responsibility for Germany's art treasures.

The National Gallery immediately began arrangements to send its administrator and State Department troubleshooter, Colonel Henry McBride, to Germany to organize the transfer of the pictures. News of his arrival evoked unanimous reactions of rage and disbelief from the officers in the field. None of them knew of the top secret political and economic considerations which had led to his appearance, and they all resented the implications of incompetence the removals conveyed. Suspicions of the National Gallery and the Metropolitan were rampant. Hathaway wrote from Berlin of "the swindle by which the National Gallery's to benefit."[62] Edith Standen described "the state of utter misery we are all in now. . . . Walker Hancock perfectly simply said it was absolutely impossible for him to be associated with the project; his dealings were primarily with the people, not the things. Col. McBride has threatened us all (in a nice way) with court martials."[63] The courage of these responses was extraordinary. Court-martial was not an idle threat, and defiance of superiors who might affect the rest of one's career in the museum field was not to be ignored.

The first exact orders were cabled to Walter Farmer at the Wiesbaden Collecting Point:

Higher headquarters desires that immediate preparations be made for prompt shipment to the UNITEK [US] of a selection of at least two zero zero German works of art of greatest importance. Most of these are now in Art Collecting Point Wiesbaden. Selections will be made by personnel from Headquarters US Forces European Theater who will assist in packing and shipment by motor transport to Bremen.[64]

McBride was not quite prepared for the brusqueness of his reception. Upon arrival at Frankfurt on November 5, he approached Naval Lieutenant Charles Parkhurst, a former National Gallery registrar, to discuss details of the move. Parkhurst refused to have anything to do with it. Surprised, McBride reminded him that he had been "ordered to do this," and told him, not in such a "nice way," that he could not afford to refuse "because you have a wife and two children." Parkhurst walked out on him. It was not until Bancel LaFarge from headquarters intervened that Lamont Moore, also a National Gallery alumnus, could be persuaded to do the packing and accompany the shipment to the United States. McBride found an old friend, Commander Keith Merrill, who had nothing to do with MFAA and who was bored with his paper-pushing job in Frankfurt, and assigned him as a second escort officer. "Lower folks have been difficult, but some gradually being convinced," he optimistically cabled home.

On November 7 LaFarge, Moore, and McBride arrived at the Wiesbaden Collecting Point to begin organizing the move. McBride immediately got off on the wrong foot with Walter Farmer by commenting negatively on the latter's carefully placed pools of humidifying water, which, not unnaturally, he assumed were evidence of leaks in the roof. After McBride had left, a revolution began in Farmer's office. Thirty-two of the thirty-five Monuments officers in the theater managed to come to or communicate with Wiesbaden in the next days and sign the document of protest, formally composed by Everett Lesley, which came to be known as the Wiesbaden Manifesto. After several eloquent introductory paragraphs it stated:

The Allied Nations are at present preparing to prosecute individuals for the crime of sequestering, under the pretext of "protective custody," the cultural treasures of German-occupied countries. A major part of the indictment follows upon the reasoning that even though the individuals were acting under military orders, the dictates of a higher ethical law made it incumbent upon them to refuse to take part in, or countenance, the fulfillment of these orders. We, the undersigned, feel it our duty to point out that, though as members of the armed forces, we will carry out the orders we receive, we are thus put before any candid eyes as no less culpable than those whose prosecution we affect to sanction.

We wish to state that from our own knowledge, no historical grievance will rankle so long, or be the cause of so much justified bitterness, as the removal, for any reason, of a part of the heritage of any nation, even if that heritage may be interpreted as a prize of war. And

though this removal may be done with every intention of altruism, we are none the less convinced that it is our duty, individually and collectively, to protest against it, and that though our obligations are to the nation to which we owe allegiance, there are yet further obligations to common justice, decency, and the establishment of the power of right, not of expediency or might, among civilized nations.[65]

The Founding Fathers would have been proud.

Twenty-five officers signed. Five others, not present, wrote supporting letters. Three, including James Rorimer, agreed, but felt they could not sign. Rorimer instead, the next day, wrote to his commanding officer asking to be relieved.[66] The request was refused. The Manifesto, meant as an internal protest, went to the chief MFAA officer at headquarters, Bancel LaFarge, who, to protect his colleagues, filed it away and sent it no farther.

But such strong passions could not be concealed for long. Above all, the men who had been working day and night at the mines and Collecting Points with Germans felt shame. Walker Hancock thought he had betrayed them. When, with embarrassment, he told Professor Hamann of Marburg of the decision, Hamann said, "If they take our old art, we must try to create a fine new art." Then, after a long pause, he added, "I never thought they would take them."[67] Farmer wrote, "You can't imagine how hard it is to try to justify in the eyes of other people something that you think horrible."

The angry officers did not conceal their feelings from Janet Flanner, correspondent for *The New Yorker,* who was in Wiesbaden doing research for a series of articles on the ERR. On November 9 she cabled home that "a couple of days ago the Monuments men at Wiesbaden received official word to ship from their depository to the US 400 [*sic*] of its finest German owned pictures." This "export project casually suggested by American officials at Potsdam," she declared, "is already regarded in liberated Europe as shockingly similar to the practice of the ERR."[68] The artful leak appeared in the November 17 edition of Miss Flanner's magazine.

It was by now clear to McBride, struggling for the first time with the familiar problems of weather, transport, and the lack of packing materials, that this initial shipment would have to be limited to objects at one Collecting Point. Wiesbaden, which held so many German-owned pictures, was the obvious choice. He cabled back to Washington that the shipment would come almost exclusively from the list prepared by Walker and Swarzenski at the National Gallery. The final selection of 202 pictures, all but 2 from the Kaiser Friedrich Museum, was made by McBride and the officers in charge of the shipment.[69] Both the delicacy and the high qual-

ity of the chosen paintings were staggering. Three-quarters of them were on panel, which is the most susceptible to changes in temperature and humidity. The list included 5 van Eycks, 5 Botticellis, 4 Dürers, a Bosch, several Breughels, 2 Vermeers, a Giorgione, 8 Masaccios, 3 Memlings, 15 Rembrandts, 4 Titians, a Velázquez, a Georges de la Tour, 2 van der Weydens, and much more.

McBride was still determined to pursue one picture not at Wiesbaden which the National Gallery really did covet: the Czernin Vermeer. This was in an entirely different category, as it was considered to have been legitimately bought by Hitler, and therefore a possible candidate for reparations due the United States. But McBride was too late. When he arrived at the Munich Collecting Point on November 12, he found the picture packed and ready for return to Vienna, it having been decided that Austrian-owned property should be under control of the U.S. forces there. The transfer was to be effected personally by Andrew Ritchie, the MFAA officer responsible for Austria, who was adamantly opposed to the removal action. Collecting Point Chief Craig Smyth, another Wiesbaden Manifesto supporter, unpacked the picture for McBride but managed to turn odious military regulations to his own advantage: he refused to surrender the Vermeer on the grounds that he had no orders for this action from Third Army, under whose jurisdiction the Collecting Point came.[70] McBride did not insist. Nor was there anything else on his list at Munich: the Alte Pinakothek pictures, and much else, had not yet been brought in. Impressed by operations at the Collecting Point, McBride intimated to Smyth that the whole policy of removal would be "reconsidered during the winter."[71]

At home, although no one had seen the Manifesto, rumors of the vehement response of the Monuments men caused consternation all around. John Nicholas Brown wrote to Edith Standen to say that he was "distressed to find the state of depression and disappointment now evident in the ranks of the MFAA." The matter, he said, must "not be allowed to fall out of perspective." He was sure of the good faith of the government, and although he deplored the whole project, he felt that "if a few works of art can possibly be shipped . . . by way of token to the USA the matter will blow over in time and all parties will be more or less satisfied."[72] Paul Sachs was disturbed by "all the silly talk reflected in the typical *New Yorker* article" and urged that Secretary of State Byrnes clarify the government's intention. The latter was already defending himself at a higher level. Now that the removal was a fait accompli, he had deigned to answer the British Foreign Secretary's letter of protest, written over two months before. Byrnes's reply revealed a distinct change of heart. Stating that the delay was the re-

sult of "my desire to meet your wishes in this matter, which involved discussions with a number of officials," he explained sheepishly that there would not be any large movement of art treasures to the United States, but only "one carload," which, he lied, was an action "strongly recommended by our experts in the field who are convinced that the selection they have made cannot be properly cared for in Germany during this winter."[73] The fun was just beginning.

Never had things been so well packed. The insides of the cases were lined with waxed paper taken from Wehrmacht stores. Each selected picture, laboriously extracted for the first time from its original Berlin crate, which may have held a dozen or so items, was fixed in slots specially built into the interior of the box to be used for shipping, which was sealed and again wrapped in waterproof paper originally designed to be used as poison-gas protection.

Rain poured down as the cases were loaded into trucks for their trip from Wiesbaden to the heavily guarded express train to which were attached two stripped-down but heated hospital cars which would bear the forty-five cases to Le Havre, from whence they would sail for New York. After the cars had been loaded, escort officer Merrill noticed that it was taking an extraordinarily long time for the German yard engineer to find the Paris Express. It soon became clear that the delay was deliberate: the Germans had perhaps learned a thing or two from the French Resistance. Merrill pulled out his pistol and held it to the engineer's head. They got to the Express in time.

On the way to Paris they had to detour around a train burning on the main line, and chop the ventilators off the roof when they could not get through one tunnel. The precious cargo then sat on the dock at Le Havre for a week in bitter cold, using a small steam engine connected to the cars to keep the temperature at 60 degrees. At last they were lashed down in the officers' dining room of an Army transport, whose regular occupants were now forced to eat in two sittings while happy MPs, gorging on officer fare, guarded the cases day and night. The pictures arrived in New York on December 6 and were unloaded with impressive security and secrecy, after which they were driven to Washington in a convoy moving at thirty-five miles per hour, escorted by relays of troopers from the various states through which they passed. The transfer was officially described as "uneventful."[74]

Notoriety had, alas, preceded them. On November 24, before they had even left the Continent, the *Washington Times Herald* announced the shipment, proclaiming that "the preservation of German art treasures is con-

The German works arrive at the National Gallery of Art. Left to right: *Walker, McBride, Merrill, Finley, Moore*

sidered more important than the fate of German women and children and the repatriation of war-weary G.I.s."[75] This was exacerbated by a report in *Stars and Stripes*—which should have known better—that the shipment was made up of paintings looted from other European countries by the Nazis. The story was picked up by *The New York Times,* intrigued by the secrecy surrounding the arrival of the ship and the refusal of its escorts to talk, and published under a headline reading, "$80 Million Paintings Arrive from Europe on Army Transport." They too, apparently oblivious of a War Department press release giving the facts, assumed that the pictures were Nazi loot. Feelings about the National Gallery were not improved in professional museum circles in New York when Francis Henry Taylor, who had been given no details at all on the arrival of the shipment, or its final composition, was awakened in the middle of the night by the press and was unable to answer their questions about the mysterious cargo.[76]

To quiet things down, the Chief Justice issued another corrective statement on December 14. But by now letters of protest to editors and the Roberts Commission were pouring in from the public and from MFAA officers in the field who were working eighteen-hour days to return the said

loot to the liberated nations. Craig Smyth even sent a little album of photographs showing the adequacy of storage facilities at his Collecting Point. Andrew Ritchie called on David Finley at the Commission to mobilize the major art associations in the United States to "initiate action in Washington to correct the present unilateral procedure."[77] Lincoln Kirstein, now out of the Army, sent a letter containing the text of the Manifesto, minus signatures, to the *Magazine of Art*.[78]

During January things escalated. After former MFAA officer Charles Kuhn published an article in the *College Art Journal* which also revealed the contents of the Wiesbaden document, the head of the College Art Association wrote a letter of protest to the Secretary of State saying that the integrity of the United States was in question. Roberts Commission member Paul Sachs was so angry when he read this that he resigned from the CAA, "stormed down to Washington, and aroused those morally lethargic gentlemen of the RC into cursing maledictions against all signators of the Manifesto and raising the most blood curdling din that all should be court-martialled."[79] Francis Henry Taylor too defended the removals in a spirited comment to *The New York Times*. David Finley, who unbelievably had still not seen the Manifesto, could not understand that the word of the President and the Chief Justice might be doubted. The "ill founded charges of bad faith," he stated, were an embarrassment to the government, which "is doing an act of unprecedented generosity in protecting German owned art not only for Germany but for the world."[80] The National Gallery director did not see a full copy of the Manifesto until February, and then only because it was sent to him by the editor of the *Magazine of Art*. In his letter of acknowledgment Finley wrote that he had been "curious to see the text."[81]

General Clay only heard of the controversy when his houseguest, Eleanor Roosevelt, visiting Germany in her capacity as journalist, asked him about the fuss in the press, and in particular about the Wiesbaden Manifesto, which, of course, he had not seen. This caused a certain amount of "harrumphing around." Bancel LaFarge was called on the carpet, but told Clay that the Manifesto had saved the Army from "being confronted with some 32 MFAA officers to be court-martialled." Fortunately no serving officer had leaked the document, and LaFarge, determined to defend his people from punitive action, took all responsibility on himself, writing to Thomas Howe, "I shall do it gleefully, and tell them so." In this no-win situation the general took no action.

The controversy simmered through the spring, fueled by the subsidiary question of the propriety of exhibiting the paintings to the public, and reached its apogee in May, when ninety-five art historians led by Juliana

Force and Frederick Clapp, directors of the Whitney and the Frick, respectively, addressed a passionate petition to President Truman saying that many, including the Germans themselves, "may find it hard to distinguish between the resultant situation and the 'protective custody' of the Nazis." They had finally gone too far. Congresswoman Frances Bolton read all the previous government statements guaranteeing return of the works into the Congressional Record. The *Washington Post* called the petition an "absurd accusation" and said that the Army deserved high praise for its salvage of the works, adding, somewhat ungrammatically, that there "would be no vandalism in permitting Americans to see and draw inspiration from these great heritages of the past."[82]

But the Army and the Commission had had enough publicity for the time being. Against Clay's wishes, they agreed that the pictures should not be shown until "the integrity of our intentions can no longer be disputed," i.e., until after it had been announced that they were about to be shipped back.[83] For now the "202," as they had been dubbed, stayed in seclusion in the air-conditioned vaults of the National Gallery of Art. The illogical and convoluted workings of American democracy had had their effect: there was no question of any further shipment of works belonging to German museums to the United States.

For years all those involved in this controversy remained bitter, and to this day those who were in the field, and who indeed were not privy to the political machinations now revealed in the archives, fall back into their passionate belief that the officers of the National Gallery engineered the transfer of the art to fill in the vast empty spaces of their new museum. Francis Henry Taylor, quoted as declaring more than once that "we should get something out of this war," is also not regarded as innocent. The evidence does not support this view. There is, however, plenty of evidence that Treasury officials supported such a concept, and that the "pushing" of the arts people for more personnel and materials had convinced Clay, at the time of Potsdam, that he could not guarantee the safety of the rescued collections. It is equally clear that once the policy had been decreed, the National Gallery accepted the stewardship of the pictures and the possibility of an unprecedented exhibition with alacrity, as any museum would. The beginning of the Cold War did not make it impossible that the pictures might stay in Washington for a very long time, an additionally pleasant prospect.

John Walker and Francis Taylor were, in fact, extremely interested in acquiring certain other German-owned works. This Walker showed early on by his queries about the Czernin Vermeer, and by notations in the diary of his 1945 trip to the German repositories, especially Berchtesgaden,

where the Goering collection was being processed. As was his habit, he made lists of the works he saw, with brief comments next to the titles. Next to certain works bought by Goering from Fischer in Lucerne he wrote a little "NG" for National Gallery. The five Cranachs and one Lochner so indicated would certainly have filled gaps at the Gallery. Further on he commented: "Those coming from Swiss dealers, I feel need not be returned."[84] A year after Potsdam, Walker returned to Europe. From London he wrote Finley, who was encouraging him to try to see General Clay over the disposition of the photographic archives at Marburg, "Perhaps a more important reason to see Clay would be to try and get some of the Goering collection bought in Switzerland and from Contini in Italy. None of those paintings and sculptures should go back to their countries of origin. And some of the works of art are very fine. These should be put at our disposal for the benefit of the American Museums."[85] In this he would be disappointed.

Meanwhile, the 202, in their sequestered storage area, were a terrible temptation, even to those who most vehemently opposed their presence. For various reasons of curiosity and nostalgia they came to have a secret peek at the pictures, still under the care of Lamont Moore, their curator since the dissolution of the RC in June 1946. Lincoln Kirstein came with Chrisopher Isherwood, as did fellow Monuments officer Edith Standen and Sotheby's Peter Wilson. From time to time a request for exhibition would surface and be suppressed by the Army, fearful of another explosion of public opinion. Rumors of possible showings brought forth pleading letters from other American museums longing to get an exhibition for themselves.

In October 1946, eager to be rid of their controversial charges, the Army had cabled Clay to see if the paintings could be returned. But the general was still unwilling to turn them over to the Russians, in whose zone the Kaiser Friedrich Museum stood, and equally unwilling to give the Soviets grounds for protest by keeping the works in Wiesbaden. He recommended instead that they be put on show in Washington, and that a public statement be made that they would stay on show until a "responsible German government has been formed to receive them."[86] This the War Department was not brave enough to do. It was not until January 1948 that action was forced upon them.

Clay, surprised by a State Department announcement that it would soon replace the Army as the governor of Germany, told his wife to start sending home their clothes and began tidying up outstanding problems in preparation for his departure. On the thirty-first he cabled the War De-

partment that the German paintings should be returned without publicity to Munich and Wiesbaden before he left. Relations with the Russians were now so bad that he no longer worried about upsetting them. (Indeed, only weeks later they began the series of maneuvers which would culminate in the Berlin Blockade, and keep Clay in Germany for another year and a half.) The State Department, mindful of Congresswoman Bolton and others' desire that the works be shown to the American public, cabled back, "If they are returned to Germany without prior exhibition in Washington we anticipate renewal campaign of criticism."[87] Amazed at this complete gyration, Clay, who had long advised a show and long been refused, retorted that it now seemed much too late to show the 202 at home, and pointed out the propaganda value their return would have in Germany, but consented to a quick exhibition accompanied by a firm announcement that they were being sent back.[88]

Congressional interest at first was limited to a special meeting of a subcommittee of the Senate Armed Services Committee headed by Wayne Morse of Oregon, to "have available to any one interested the reasons why these art treasures are being returned to Germany." The Army witnesses cited the White House statement, The Hague Convention of 1907, the Rules of Land Warfare, and Clay's assurances that the pictures could now be cared for. The Senate was satisfied.[89]

The Army now asked the National Gallery to hang the pictures immediately "for a reasonable amount of time"—about a month. The museum, given virtually no notice, hastily began preparations for the exhibition, which was scheduled to open March 17, 1948. There was no time to plan a fancy opening, but Finley did write a personal letter to Truman inviting him to see "the most important exhibition of paintings from European Museums ever shown in this country." There was no time for a catalogue either, and a simple checklist with the careful title "Paintings from the Berlin Museums Exhibited at the Request of the Department of the Army" quickly went to press. Newspapers and magazines supplied plenty of publicity. From the beginning the journalists favored extending the exhibition beyond the paltry four weeks planned in Washington. At the very least, it was felt, they could be shown at the Metropolitan in New York, whence the pictures would be shipped back to Germany. Many charged that the collection was being virtually handed to the Russians. Pressure mounted from interested museums. But the Army was determined to avoid all risks and ship the pictures back on schedule.

No one was prepared for the incredible popularity of the show. The opening day drew 8,390 visitors to the exhibition, which was guarded by a spe-

The "202" on view: the National Gallery's first blockbuster

cial contingent of MPs in spiffy full dress. On the following Sunday, an unheard-of 35,593 were counted. By the end of the first week the total was 109,779; by April 1 the quarter-of-a-million mark had long been passed. The newspapers kept a running count. Letters to editors and Congressmen piled up from citizens demanding to see the pictures. Many pointed out that two other shows, one of equally prestigious refugee works from Vienna's Kunsthistorisches and another of French tapestries, were already circulating in Europe and on their way to the United States. There was even a letter supporting further display in America from the editor of the Berlin *Tagespiel*, the largest German daily, who, after seeing the show in Washington, wrote that a tour across the country would promote better understanding. At the same time, the Communist takeover of Czechoslovakia exacerbated anti-Soviet feeling. By April 2 pressure to show these treasures to the rest of the United States was so strong that Senator William Fulbright introduced a bill suggesting an American tour, with entrance fees for the benefit of a UNICEF fund for the prevention of tuberculosis among German children. Upon hearing of this, Clay angrily wrote back that much publicity had already been given in Germany to the return of the pictures, and that "any failure to return these articles now would be interpreted as an intent on our part to retain the items and in addition,

would play directly into the hands of the Communists with their constantly reiterated propaganda of American exploitation."[90]

But these comments were completely overshadowed by the publicity blitz at home. The show had by now become the most "in" thing to do. Ingrid Bergman came and stayed for three hours. On the fifth of April, 62,983 visitors, twice the capacity of the Washington Senators' home stadium, were counted, and a small unexpected group consisting of President Truman and his guards were not. Truman carefully said that the collection should be returned "as soon as it was safe to do so." Meanwhile, exhausted Gallery staff coped with more and more VIP visitors who were determined not to miss the art event of the season, and who were squeezed in alongside whole touring families fresh from viewing the cherry blossoms. Mrs. Henry Ford took a special train from Detroit. John D. Rockefeller and Lady Astor were given a quiet lunch at David Finley's house after pushing through the mobs. The Duke of Windsor, arriving the day before the show was due to close, cabled to see if he could still see it. He could. The exhibition was extended an extra week. Final attendance would be close to 1 million.

On April 17 the Armed Services Committee held a second hearing. The Army, still desirous of returning its charges and keeping its word in Germany, now resorted to the principles stated in the mutinous Wiesbaden Manifesto to defend its point of view. The Army was backed by the State Department but refuted by former ambassador William Bullitt, who described western Germany as a "danger zone with the Red Army at its gates" and the Soviet government as determined to conquer the world for Communism. The Senators, somewhat puzzled by the fuss, suggested asking the Germans themselves for approval. The National Gallery witnesses, utterly dependent on Congress for operating funds, would not take a stand, although John Walker came closest to outright disapproval of a tour by quoting the Gallery's own policy against lending any of its panel pictures. He was eclipsed by Perry Rathbone of the St. Louis Museum and a team from the Met, armed with reams of statistics and charts of how many things they had shown and moved since 1938 without damage, who pointed out that passage of the bill would enable the entire Middle West and some 12.5 million people in Greater New York to see the show. It was all over. The people had spoken, and the bill never came to a vote.

General Clay, who was now dealing with a semi-blockade of Berlin by the Russians and who had in fact sounded out German officials (who did not object to the tour), felt that an Act of Congress would be a bad precedent. He proposed that the 202 be exhibited "at the suggestion and with the approval of the Armed Services Committee, based on recommendations of

the Military Governor after consultation with representative Germans" and be sent back in a number of separate shipments every few months.[91]

Fifty-two of the most fragile pictures, all on panel, were returned immediately. The rest, under military guard at all times and escorted by German curators, would slowly progress around the United States, visiting New York, Philadelphia, Chicago, Boston, Detroit, Cleveland, Minneapolis, San Francisco, Los Angeles, St. Louis, Pittsburgh, and Toledo. Because of "adverse climatic conditions," the Deep South lost out.

Fifty-four pictures left after Boston, and the rest sailed from New York on April 22, 1949, again escorted by Comdr. Keith Merrill, who had helped bring them over in 1945. Some 10 million people had seen them, and several hundred thousand dollars was raised for German children, who wrote touching thank-you notes to the various participating institutions. There was no damage to any of the pictures, which rejoined the rest of the Berlin collections in Wiesbaden on May 4. While they had been travelling in the New World the Berlin Airlift had come and gone, but they would not return home until 1955, and then to the Dahlem Museum in the United States sector, not to the shattered Museum Island, which now lay behind the Iron Curtain.

Craig Smyth, director of the Munich Collecting Point, with U.S. and foreign officers. Left
to right: *Marcelle Minet, France; Craig Smyth; H. de Bry, France (back); Alphonse
Vorenkamp, Holland; Doda Conrad, U.S.; Raymond Lemaire, Belgium; Charles
Parkhurst, U.S.; and Pierre-Louis Duchartre, France*

THE ART OF THE POSSIBLE

Fifty Years of Restitution and Recovery

The 202 German-owned paintings that had come to America and caused such a fuss were, of course, only an infinitesimal percentage of the millions of displaced works which continued to be discovered daily by Allied forces. There was no controversy over what should be done with the things which had been taken "by seizure or without compensation from the overrun countries." They were to be returned to those countries, but just how was not so simple. In the West, liberated since the summer of 1944, there was, by the time of the German surrender, considerable agitation by the various recuperation committees for immediate action. Indeed, the director of the Belgian museums, Dr. van Puyvelde (who had spent the entire war in England in scholarly pursuits, and whose only military experience had been a few Sunday drills in Brussels' Grand Place in World War I, but who had, to the considerable amusement of his colleagues, arrived home dressed in the battle dress of a full colonel), had commandeered a convoy of twenty-five trucks and without any authorizations headed for Germany to retrieve the Ghent altarpiece.[1] This incursion was not well received by either Posey at Alt Aussee or Rorimer at Heilbronn, both of whom were still desperately trying to secure the works for which they were responsible and who in any case could not simply hand them over. The Belgians were thus forced to retreat empty-handed. (At about the same time Rose Valland, also sporting a uniform and the rank of captain, but less well equipped when it came to transportation, was refused access to Neuschwanstein, where she too arrived unheralded to check the confiscated French collections.) Van Puyvelde's visit got a flurry of publicity in the press and inspired the Poles to ask the London office of the RC for similar "SHAEF permits."[2]

To calm everyone down, John Nicholas Brown proposed, in late May 1945, the immediate return of a number of universally recognized works and a program of "ad-interim" restitution to be agreed upon between the U.S. Army and the respective recipient nations.[3] This was a delicate mat-

ter. The Americans, not wishing to become embroiled in claims disputes and deploring the "precipitate and unwarranted action of the French and Belgian governments," felt that it was essential to keep careful control of the objects. Sumner Crosby cabled, "The entire procedure must appear as an act of good will on the part of our armies, and not as an accession to claims presented by the Occupied Countries."[4] The Army saw in the plan an easy way to rid itself of an unwanted burden. If there was quick and unilateral action, there would be far less for the long-discussed but still nonexistent inter-Allied restitution commission to deal with and the more difficult problems related to unidentifiable and Nazi-purchased items could be quickly solved. The principle of ad interim returns was approved in late June by all concerned, and reaffirmed at Potsdam.

The Ghent altarpiece was the first work of art to be returned. Soon after Potsdam, John Brown rushed off to Brussels to make arrangements. It was decided that the Prince Regent of Belgium would formally accept the altarpiece in ceremonies at the Royal Palace in Brussels on September 3, the first anniversary of the liberation of the city. In mid-August the panels were packed in their ten boxes in Munich and, escorted by Captain Posey, loaded onto a military plane. Back in Brussels a delegation of dignitaries and a detachment of armed guards assembled at the airport to await them. But at the hour appointed there was no sign of the plane, and after "a long wait in the rain, various members of the party drifted into town." After six hours absolutely everyone had gone and Brown initiated anxious inquiries. Worried MFAA officers preferred not to imagine that after all its adventures the altarpiece could have been lost. The plane did eventually arrive and the Ghent altar, home at last, spent its first night back in Belgium ignominiously locked in the garage of the American military mission.[5]

Two days after the ceremony of transfer Mason Hammond, on a visit to London, was besieged by the representatives of the other "overrun" countries, all clamoring to have their treasures returned and their representatives admitted to the Collecting Points. Hammond counselled patience, as the U.S. Military Government was "complex" and might "appear to move slowly." But the State Department too noted that the return of the altarpiece "may be expected to spur on the efforts of other claimant nations" and urged quick acceptance of the foreign representatives. This did not include the Axis powers: former belligerents Italy and Hungary would have to "wait in line" to reclaim their treasures until after the "liberated countries of the Allies" had received theirs.[6] Now things moved very fast. Eisenhower had already personally ordered that the Veit Stoss altar be prepared for return to Poland, and in early September sent a member of his

staff to recommend to Craig Smyth that as much as possible go back to the various nations "in bulk." On the fifteenth a directive from headquarters officially set the process in motion and specifically required the immediate return of the Michelangelo *Madonna* to Belgium and "fifty of the finest and most representative paintings of French origin" to Paris.

Responsibility for organizing this enormous transfer of art objects once more fell entirely on the beleaguered MFAA contingent. Items from each country would first have to be identified, then be extracted from the general mass and taken to separated areas for inventorying and packing. Transportation would then have to be arranged to take them home. Although the American MFAA officers had at first not been pleased at the idea of dealing with foreign representatives, they now realized that their help was essential. The French, normally sticklers for checking each object, themselves suggested that the ERR things sent to Neuschwanstein, for which German documentation had been found, be returned to Paris unopened and inventoried there in the presence of an American representative. Shipments were planned in rotation so that no country would seem to have preference, and a token first delivery of major works was prepared for each one. In Munich each nation was assigned an office and given a German curatorial assistant, though no one was sure if certain representatives would be able to bring themselves to work with Germans at all. (Smyth worried especially about Estreicher from Poland, whose brother had perished in Nazi confinement.) Fearing disputes, the Americans in all cases reserved the right to have final say as to whether or not an object could be released. And so the return began.

Soon streams of art were flowing in both directions at the Munich Collecting Point. The Bruges *Madonna,* to the disappointment of all present who had longed to see her, was returned in the wrappings Stout had devised at Alt Aussee, looking much like a very large Smithfield ham. A little delegation saw her off to the airport. Rorimer arranged for the seventy-three cases containing the stained glass windows of Strasbourg Cathedral to go there direct from their refuge in the Heilbronn mine. They were received with enormous ceremony, which also served to celebrate the return of Alsace to French control. In the midst of it all, Rorimer, to his great satisfaction (and after a certain amount of lobbying by Rose Valland), became the first Monuments man to receive the Legion of Honor.

Two days after the Strasbourg delivery the first paintings went back to Paris. These were more or less the same ones, mostly Rothschild property, which had left on Goering's first train, plus the Mannheimer paintings taken at the last minute from France. The Americans had hoped for a little ceremony in Paris, but the French quickly put the shipment in storage

Neuschwanstein reluctantly gives up its treasures.

until more owners could be represented. In October, Holland received the Koenigs/van Beuningen Rubenses, the Rathenau Rembrandt *Self-Portrait,* a large number of Goudstikker works, and Goering's fake Vermeer. Craig Smyth escorted them, and their arrival was celebrated by an unprecedented lunch in the Rembrandt room of the Rijksmuseum. The Dutch, going all out, set the tables with china, silver, and glass from the museum's magnificent collections and served the astonished guests an elegant meal of oysters, plover's eggs, and venison. They were not showing off: little other food was available in the strictly rationed Dutch markets.[7]

After these initial "technicolor" returns, things became less elegant. The shipments "in bulk" were to begin from Neuschwanstein. LaFarge put Edward Adams, an American Quartermaster Corps major, in charge and informed him that he would have to live off the land when it came to labor and materials. As art expert Adams had with him a charming but distinctly unmilitary French officer, Hubert de Bry, an authority on eighteenth-century French painting. At the castle some six thousand items plus the office files and papers of the ERR waited to be moved down winding staircases and across snowy terraces to the trucks far below. The only distraction to serious work was a large collection of erotica confiscated by the

ERR, stacked up in a central hallway. The first train of twenty-two cars laden with 634 cases left after two weeks; by December 2, a month later, all identifiable French works in the castle had been returned to Paris.[8]

While this was going on, the Munich Collecting Point was shipping out as many as twelve carloads a week filled with every conceivable type of object. Wanda Landowska's clavichord and Chopin piano, found in a German officers' club, went home to Paris. The Czernin Vermeer, defiantly protected from removal to America, was hand-carried back to Vienna by Andrew Ritchie, chief of MFAA for Austria. (Ritchie locked himself in a sleeping compartment with the picture and a splendid picnic of pheasant and Burgundy supplied by a French colleague.) From the impregnable bunkers of Nuremberg the Holy Roman regalia also were to go back to Vienna by train. The operation was shrouded in secrecy in order to prevent any revival of Germanic nationalism. When workers were unable to get the huge box containing the silk coronation robe (which had to be packed flat in order to prevent damage) into the special steel boxcar assigned for the trip, Ritchie was forced to commandeer a C-47. Headquarters, always impressed when it came to crown jewels, gave him the same pilot who had flown Goering to Nuremberg for his trial.[9]

The Veit Stoss altar, also in Nuremberg, did not go back quite as expeditiously as Eisenhower had hoped. The large figures were blocked in the bunkers by tons of other stored items and could not be extracted for some months. Moving them and certain other Polish treasures, including the *Lady with the Ermine,* would require a train of no less than twenty-seven cars. By the time all this had been arranged it was April 1946, and all too clear that the Polish government-in-exile would not be returned to power anytime soon. The "government of national unity" agreed upon at Potsdam was dominated by Soviet-backed Communists who would not necessarily welcome the publicity generated by the return of the altar by the U.S. Army. But orders were orders and official trips into the Eastern nations precious few, so that the basic party of MP detail and escort officer grew into a large group which included a number of reporters and several ladies. Only Captain Lesley, the MFAA officer responsible for the works of art, had exactly the right travel documents; nor had anyone consulted the American embassy in Warsaw about the delivery.

The train set out from Nuremberg on April 28. As Lesley reported later:

No more inept time of year for the return could possibly have been chosen. The arrival of Poland's supreme treasures, brought by the U.S. Army as a gesture of democratic friendliness, happened to coincide with the workers' celebration on the First of May and the Polish

National Independence Day, the third of May. The altar, and all persons connected with it, thus immediately became unwittingly a focus for demonstrations of solidarity and resistance against the incumbent government. The presence of U.S. personnel who, at the same time, gave the people of Cracow an opportunity to connect their emotional reverence toward the national shrine with democratic procedures was exquisitely embarrassing to the authorities in the U.S. Embassy.[10]

At first it was all sweetness and light. The train was greeted at the Polish frontier by cultural officials. At Katowice the station was filled with singing choirs sent from the Catholic schools. In Tunel children completely decorated the train with green boughs and Polish representative Estreicher hung Polish and American flags on the sides of the cars. The platform at Cracow was lavishly decorated in the same manner. There was an honor guard, and a band played as the altar was greeted by the City President and the Archbishop. At each stop there were flowery speeches of gratitude for the American effort. On May 1 the American delegation toured Cracow Castle and even reviewed the May Day parade. But the next day the entire group, MPs and all, was suddenly whisked off for an out-of-town overnight tour. When they got back they found that thirty people had been shot in demonstrations during the Polish National Day parade.

Nonetheless, the program to celebrate the return of the altar, scheduled for May 5, was not cancelled. But access to the welcoming Mass and the vicinity of the Church of Our Lady was forbidden to the public and the lunch following was boycotted by the Archbishop. The event was even less comfortable for the Americans, who had been informed in the middle of the previous night that one of their enlisted men had shot two members of the Polish Communist militia and that an investigation was in progress. All American personnel were ordered back to the train, which was scheduled to leave the next day. The Poles produced a number of witnesses who went to the train and identified a Private Bagley as the culprit. When his fellow soldiers gave him an alibi, the Poles produced more "witnesses," surrounded the train with armed guards, and refused to let it leave until Bagley was surrendered to them. Meanwhile, to the consternation of U.S. embassy officials who had been called in, the irregularity of almost everyone's travel documents had been revealed. The escort party's status was illegal and the embassy could not help them.

In the midst of all this, another MP, Private Vivian, came forward and confessed that he, and not Bagley, had fired his pistol at several men who had tried to rob him. This godsend provided the embassy with a Machi-

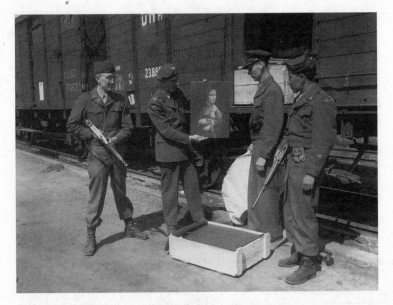

Karol Estreicher welcomes Leonardo's Lady with the Ermine *home.*

avellian solution to the tense situation. Bagley, "with the most unselfish and commendable fortitude," agreed to be handed over to the Polish secret police so that the train could depart. Once the train was under way, Vivian "confessed" and was "arrested." This information was transmitted back to Poland along with a request for Bagley's release. The Cold War being young, this extraordinarily risky maneuver worked; one can only hope that Private Bagley got a medal.

A few years later the Poles made up for this graceless incident. John Nicholas Brown, visiting Cracow, was taken to a Mass at the Church of Our Lady, where the magnificent altarpiece had been reinstalled in all its glory. His escort was Karol Estreicher. After the service they went to a nearby workers' restaurant for lunch. When Estreicher told the assembled crowd, which included the priest who had said Mass, that Brown had been responsible for the return of the altar, they all cheered and made much of him. Brown could not know then that the charming and grateful priest would later become Pope John Paul II.

Once the trainloads and truckloads had arrived back in the countries from which they had been removed, it was up to the various national commit-

tees to decide to whom the contents belonged. In France the Commission de Récupération Artistique, organized in September 1944 and officially authorized in November, included Jacques Jaujard, Rose Valland, René Huyghe, and other familiar figures, and was directed by Albert Henraux, vice president of the Conseil des Musées Nationaux. It was most suitably housed at first in the Jeu de Paume. In a pattern followed by Holland and Belgium, the Commission would receive and identify the works, but leave actual restitution to agencies of the Foreign and Finance Ministries, the principal one in France being the Office de Biens et Intérêts Privés, or OBIP.

As soon as the existence of the Commission was made public a deluge of claims poured in from residents of France and refugees all over the world who had had no news of their possessions for years. Letters and cables of reassurance went out as soon as was possible to those whose collections were known to be intact. Maurice de Rothschild, staying in Toronto, was amazed to hear that many of his things were at Latreyne in the Dordogne. But for others the problem was far more difficult. The rub was proof of ownership. The works were stored in the Jeu de Paume and in various warehouses where one was faced with a bewildering array of paintings or furniture. Certain other Rothschilds felt so much at a loss that they hastily summoned their old family retainers, "who seized their bicycles and soon were at the scene like truffle hounds, accurately placing each object. 'That's the Vermeer [*The Astronomer*] from the Baronne Edouard's dressing room' and so on," they would remind their employers.[11]

Other owners, less well served, found the process more daunting. Mr. and Mrs. Hans Arnhold came back from New York to salvage what they could of the things they had brought to Paris from Germany in the thirties. Mrs. Arnhold was so undone by her first visit to the dusty warehouse of furniture that she never returned. At the Jeu de Paume they found a few pictures, but much, including six large eighteenth-century portraits of Prussian royalty, was simply not there. In the following years they recovered a few more belongings quite by chance. Mrs. Arnhold saw a mother-of-pearl box, inlaid with the family's initials, in a Paris antique dealer's window. Some of the furniture turned up at a Zurich dealer; these pieces they simply bought back.[12] Thousands of other families, refugees and château owners alike, whose works of art had gone to dealers or been removed not by the major Nazi looting agencies but by the neighbors, soldiers, or persons unknown, were not even this lucky; they recovered nothing at all.

If the retrieval of lost objects held at the official repositories was a painful task, the tracing of those dispersed through the trade was even

more so, and not to be undertaken by the fainthearted. The articles had generally passed through multiple jurisdictions, and the new owners were and are not always willing to relinquish them even in the face of overwhelming evidence. No case illustrates these difficulties better than the decades-long struggle of Paul Rosenberg and his heirs, whose possessions reposed not only in France and Germany but also in the neutral country of Switzerland.

Rosenberg started his quest very early on. He had lost more than four hundred pictures from both his private and business holdings. In July 1942 he sent a list of the paintings he had been forced to leave in France to the U.S. Customs authorities. In 1944, as soon as communication with France became possible, Rosenberg, in long letters to his brother Edmond, who had remained in France, tried to catch up on four years of family news and business. From Edmond, Paul heard details of the dispersal of his pictures and learned that his house and offices in Paris had been stripped and requisitioned by the Nazis. He was prepared for a long fight and asked Edmond to present his first claims to the Commission de Récupération.

The beginning was easy. The Commission immediately returned the objects which had been on the train liberated by Alexandre Rosenberg and found in Abetz's little cache at the German embassy. Soon more came in from Neuschwanstein. Mme Rosenberg not only had an inventory of the furniture but had marked each piece with an identifying number, which made trips to the terrible warehouse most productive. After these returns Paul was so grateful that he donated thirty-three works to the French museums and promised others to the Louvre. Edmond had meanwhile started proceedings against various employees who had appropriated the odd object. In the same suit, five dealers including Fabiani and Petrides were cited as having illegal possession of Rosenberg works. Petrides, claiming that he had never knowingly bought a picture stolen from a Jew, nevertheless produced two Matisses and a Utrillo, which he had obtained from Rochlitz, "a merchant known in art circles for twenty years."[13] Fabiani gave back twenty-four pictures without protest and at the same time tried to interest Rosenberg in some sort of deal related to the Vollard pictures which still languished in Canada. At least four more batches of Rosenberg works were recovered from Germany by the Commission between 1946 and 1948.

Rosenberg had known from the earliest days through a lawyer in Zurich about the paintings which had gone to Switzerland, and had warned Henraux that the Swiss statute of limitations for claims of theft was five years. This did not leave them much time. Information relating to the confiscations had been furnished to the French embassy in Bern in December

Reverse of a looted Paul Rosenberg picture showing ERR labels

1944, but the embassy had shown little interest in the recovery of these French assets. All available intelligence on illicit art trading in Switzerland had thus far been produced by the British Economic Warfare Office and American legation officials, who had blacklisted the principal culprits. In February 1945 British MFAA investigator Douglas Cooper was sent to Switzerland to represent not only the MFAA but also the interests of the French Recuperation Commission. British embassy officials gave him the cover title of "Technical Adviser to the British Trade Delegation," which was negotiating with the Swiss on the now rather sticky question of German-Swiss economic relations and the disposition of German assets.

Armed with the "Blacklist Section's" information, Cooper began his rounds. A lawyer named Wiederkehr, listed for holding works acquired by Alois Miedl and anxious to be cleared, was most cooperative and expressed delight that he could help the Allies in their search for looted art. He told a skeptical Cooper that he had tried to inform the American consul about the paintings he held, but had not had a reply. He said he had not been suspicious about Miedl's property until the Bretton Woods announcements regarding Nazi assets abroad, and that he had then shown the pictures to Nathan Katz, who immediately recognized them as Rosenberg property (not difficult, as this was clearly marked on the backs). He had then put them in a bank and refused Miedl's request that he send them to Spain. It was a nice selection which included van Gogh's *Self-Portrait with a Bandaged Ear* and four works by Cézanne.

As Cooper's investigation went on, the complicated web of inter-

relationships woven by those dealing with the Nazis was slowly revealed. Dealer Theodore Fischer's story changed from day to day as the pressure grew. On his premises Cooper found thirty-one pictures looted from French collections of which ten could immediately be identified as Rosenberg property. He soon discovered which pictures Herr Emil Bührle had bought, and found that Fischer not only had sold confiscated works in his auctions but had sent others to Rio de Janeiro and offered a looted Seurat to the Basel Kunstmuseum, which they had rejected as stolen goods. After these revelations the Swiss government became more cooperative and quickly agreed to freeze and require a census of "German-owned" objects. They also agreed to make the sale of such works illegal and to try to retrieve those which had been smuggled into the country. Having achieved this, Cooper left in March 1945, to return to the Italian theater.[14]

Despite its promises of cooperation, the Swiss government had, by September 1945, made no effort to recover the works pointed out to them by the Allies and had not implemented the promised sanctions. Paul Rosenberg decided to go there himself. In early September he arrived in Zurich, lists and photographs in hand, and began a series of confrontations. At the Galerie Neupert he was shown his own Matisse *Femme au fauteuil jaune* and told that it came from a "private collection." When Rosenberg said it had been stolen from him, Neupert claimed to have it on consignment from a sculptor called Martin. Martin told Rosenberg a long story of how he had acquired the picture from a friend in France who turned out to be in prison. Neupert admitted having seen another Rosenberg Matisse, *Harmonie bleue,* which he had sold to a French Jew named Aktuaryus, who in turn had sold it to Bührle.

Next Rosenberg visited Bührle himself, who, he noted, "was surprised to see me," having apparently chosen to believe the rumor that Rosenberg was dead. Rosenberg told Bührle that he was mistaken if he thought he could settle matters by simply repurchasing the pictures, and accused him of having knowingly bought stolen goods. Bührle replied that he would return the works to Fischer if he got his money back and that Rosenberg could then negotiate with the dealer. Fischer in turn declared unconvincingly that he had been given the pictures by Hofer as settlement for a debt and had tried to send them back to Germany once he discovered their provenance, but that the Allied delegations in Switzerland had advised him not to do so as "it would then be impossible to retrieve them." This statement did not deter Rosenberg, and after a few days he was approached by an intermediary representing Fischer, Bührle, and now Wendland, who was terrified that the Swiss would extradite him to Germany, where he was wanted by the Allies. This trio "made new propositions" and offered a cer-

tain sum which would be paid through clearing in France. Rosenberg was sure that this move had been encouraged by the Swiss government, which wanted to avoid bad publicity. Soon he received a second offer to take back 80 percent of the pictures and leave 20 percent. But Rosenberg was on a crusade and wanted an official, government-to-government settlement.[15]

Shortly after this, Cooper returned to Switzerland and also met with Herr Bührle. The industrialist told Cooper that Fischer had first claimed that the pictures were "degenerate" works from the German museums, but that his adviser and dealer Fritz Nathan had warned him that this was not true. Bührle had then consulted his lawyer, who told him that if the pictures turned out to be stolen he would "have to give them back to Fischer against compensation." Despite all this advice he admitted that he had twice bought from Fischer, the second time on Wendland's recommendation. At the end of the interview Cooper advised Bührle to "make the gesture of placing his pictures at the disposal of the Swiss government," as the bad faith of both Fischer and Wendland was beyond doubt and the Allies were about to turn over all their evidence to the Swiss. Bührle agreed to "take action within the next week."[16]

The Swiss Office of Compensation, again prodded by Cooper, promised to start investigations of all the Swiss firms named by him; the Political Department assured him that a special commission of investigation would "soon" be set up under their Interior Department. A Dr. Vodoz of that agency seemed impressed by the documentary evidence produced by Cooper, but said that the claimant governments would have to retain private Swiss lawyers and take their cases to the local cantonal courts before any works could be seized. If they failed in this process, the Allied claimants would then have to take action "against individual owners within the framework of the Swiss code." When Cooper pointed out that Sweden had set up a centralized commission to deal with loot, Vodoz smoothly replied that it was not a federation like Switzerland.

Bührle's "action," which came shortly after this meeting, was also not quite what Cooper had had in mind. Bührle now claimed in a written statement not to have "had the slightest idea" that the pictures he had bought were of dubious provenance, especially as he had bought them from Fischer, "an important Swiss house of good reputation." Despite his previous admissions to Cooper, he wrote that Rosenberg's visit of September 6 was the "first time he had had exact information on the illegally removed pictures," and that he had "spontaneously declared himself ready to cancel the sale." This was followed by a letter to the good Dr. Vodoz, who had in the past personally helped Bührle with certain customs difficulties related

to the undocumented importation of the pictures he had bought in Paris from Dequoy and which his lawyer had been sent to retrieve from Goering in 1944. Bührle informed Vodoz that he had learned "from Cooper and Rosenberg's recent visits" that certain pictures he had bought seemed to have been looted from France and that Rosenberg had asked him to hand them over to the French embassy. This Bührle said he could not, of course, do; however, he stated, he had agreed to return them to the dealers in return for the purchase price as "it naturally is upsetting to me to have stolen objects in my collection."[17]

Meanwhile, letters on this subject arriving at the Swiss Foreign Office were answered with vague replies. In late November the OSS, joining the fray, sent Plaut and Rousseau to Bern to pursue the matter. They soon discovered that M. Peyrot des Gachons of the French embassy, who was supposed to be pressuring the Swiss, "was not inclined to take his investiture too seriously." Nor had the Swiss government taken any further steps whatsoever. The OSS men persuaded Dr. Vodoz to produce customs records which might reveal questionable imports, and found an ex-employee of the German legation who had actually delivered the diplomatic bags full of pictures. They questioned Wendland, who began to talk. They discovered that the Swiss government had given Fischer confidential Allied documents, and that the Swiss Syndicate of Art Dealers had forbidden its members to volunteer any information on the subject. This whirlwind of activity produced a small advance: on December 10, 1945, the Swiss federal government passed a law legalizing return procedures for properties removed from the German occupied territories, but did not provide any authority for investigations or a "special commission," one excuse being that so far only seventy-five works of art were involved. Again they promised this would be done "soon" and the French embassy "promised" it would make a claim under the new ruling.[18]

But time was running out. As part of the general American withdrawal the OSS unit was scheduled for dissolution in the spring of 1946, and there was in fact little justification for further U.S. involvement, except, as Plaut wrote, "to maintain leadership in the settlement of international issues of a moral and cultural nature." The Swiss were apparently not encumbered with such high-flown morality. After the departure of the Allied investigators they lapsed again into nonactivity, and the case was kept alive only by sporadic inquiries from MFAA officers in Germany seeking to extradite Wendland, who was eventually permitted by the Swiss to go to Rome. There he was finally arrested by American MPs in June 1946.

Paul Rosenberg continued to press his claims through the French Foreign Office. In April 1947 he was informed that his case would be heard

in Lucerne, and was given one month to prepare. This impossible time limit was not observed, and indeed it took well over a year to prepare the necessary depositions. There were eight defendants. Wendland was not among them, having long since confessed and returned the one Rosenberg picture he still had. Four of the smaller dealers now settled and surrendered theirs. The rest went to court, though Bührle had realized the case was hopeless and Miedl could not participate as he was in Spain. This left Fischer as the prime and most adamant defendant.

The defense was far worse than the crime. Not one of the defendants denied having knowingly bought stolen goods; instead, they attempted to discredit Rosenberg's title to the paintings on the grounds that the confiscations had been carried out with the consent of the legal government of France at the time. They even tried to twist The Hague Convention to their own ends. With the help of the French Recuperation Commission and the now disbanded OSS men, who supplied Rosenberg with the documents of the Nazi confiscation process, he and his Swiss lawyer demolished the defense. To its eternal credit the Lucerne tribunal, on June 3, 1948, ruled in Rosenberg's favor and ordered the pictures returned.[19]

Having won his fight on principle, Rosenberg did later sell the purloined pictures, and many others, to Bührle. Today they are demurely listed as "acquired from a French private collection in 1951" or the like. The introduction to a recent catalogue for a show of Bührle's collection at the National Gallery of Art notes that "as the war neared its end he succumbed once more to the urge to buy" and discovered "thanks to Paul Rosenberg, further important works." And, the writer innocently continues, "a brief note of 1944 (preserved by chance) informs us that in a relatively short time Bührle had purchased twelve paintings by artists from Corot to Matisse. The magnificent group documents his voracious appetite for painting and his need to experience works of art at first hand."[20]

By 1953 Rosenberg was still missing seventy-one pictures; five years later this figure had fallen to twenty. Gathering his documentation once again, he submitted a claim to the Federal Republic of Germany, which had in July 1957 passed a law authorizing monetary compensation for such losses. After two years of negotiation the Germans offered less than half the amount claimed. Paul Rosenberg having died by then, his family accepted the German offer; but this was still not the end of it. Since 1958 seven more paintings have been accounted for, if not all recovered. One had been given to the Rothschilds by mistake. In 1970 a lawyer in Cologne wrote to Alexandre Rosenberg to say that unnamed clients had his Degas *Deux danseuses* and would like to make a deal. The Rosenbergs had several options: they could go to court and try to get it back, and if they did,

repay the German government for its value; they could buy it back; or they could accept a payment from the new owners and transfer title to them. Alexandre, tired of the endless process, chose the third course. The payment was far below market value. "I do not like so enriching the successors to thieves," he wrote, "but have come to learn that the defense of one's own and one's family interests is somewhat like politics and indeed life itself. It is principally the art of the possible."[21]

Other Rosenberg pictures continue to surface in the trade. In 1974 the heirs were able to seize a Braque, *Le Guéridon au paquet de tabac,* at a Versailles auction. This is not an easy process: the original owner must have excellent documentation and convince the relevant enforcement agencies of the justice of his claim. If there is any warning, the picture is likely to be withdrawn by the usually anonymous consignor, as did happen in the case of another missing picture, Degas's *Portrait of Gabrielle Diot.* This drawing was advertised in 1987 in a full-page ad placed by a Hamburg dealer, complete with the Paul Rosenberg provenance, but disappeared again when too many inquiries were forthcoming.

Retrieving collections such as that of Paul Rosenberg was hard and unpleasant work. Even more so was the job of deciding whether the things for which the Nazis had paid should or should not be returned to their original owners. This nasty duty fell to the national commissions of recuperation, who had to determine if a sale had been "forced" or if collaboration was involved. Some who had sold for vast sums to the Nazis were not shy about reclaiming their former possessions, and the publicity surrounding the return of the works would make it difficult for the more discreet to hide. With much press coverage the French Commission put on an exhibition of three hundred recovered works in January 1946. Most had never been seen in public before and almost all belonged to private collectors, traditionally wary of the tax man, whose names were carefully left out of the catalogue.

The two Rembrandts sold by wine mogul Etienne Nicolas to Haberstock (see page 163) were not in the catalogue at all, though they were in the show. There they were spotted by the Fraud section of French Customs, which formally requested that the Commission block their restitution to Nicolas as the agency planned to seize them and give them to the Louvre.[22] Nicolas resisted for a time, referring in his correspondence to "the pictures confiscated from me by the Germans," but soon settled, informing Henraux at the Commission that he had always meant to give them to the Louvre, which of course was true.[23] This was not quite enough for the government, which then fined him the exact amount he had received from

the Germans on the grounds that he had "contributed materially to the impoverishment of the State."

In Belgium, Emile Renders (see page 107) had much the same experience, although it was he who brought suit and not the government. In the court's view, his long-term bargaining with Goering for higher prices overrode the Reichsmarschall's threats, and his pictures went to the Belgian state. Count Jaromir Czernin reclaimed his Vermeer the day after Ritchie brought it back to Austria, on grounds that it had been extorted by the Nazis. An Austrian tribunal held that this claim had no relation to the facts, and published the Count's little thank-you note to Hitler (see page 49). He appealed this decision, according to one source, with the backing of an unknown American who wanted to buy the Vermeer.[24] This was rejected, and the picture now hangs in the Kunsthistorisches, which had, of course, hoped that the Führer was buying it for them.

No one in Holland ever publicly discussed van Beuningen's very profitable sales to Posse (see page 111), but there was perhaps no need to do so: his recovered paintings and the rest of his collections were soon donated to the Boymans Museum and his name added to its title. Though it was assumed for a long time that the Koenigs drawings which Posse had bought from him had perished, the fact that they had gone to the USSR was gradually revealed by clues in the writings of East German scholars. In 1983 a Baldung Grien from the collection was offered to the Boymans by a Berlin lawyer representing an unknown Soviet client who hinted that there were more where that had come from. The offer was withdrawn when the Dutch government intervened; a few years later the drawing turned up in the hands of the American collector Ian Woodner. He resisted restitution until his death in 1991, when it was returned by his estate. The Netherlands Office for Fine Arts, successor to its recuperation commission, in 1989 published an elaborate catalogue of the 526 drawings still missing, most of which were believed to be in the Soviet Union. In 1992 this was officially confirmed by the Russian Minister of Culture, and it is assumed that they will soon return to Rotterdam.

More complicated for the committee was the disposition of the Mannheimer and Goudstikker collections. It was all very businesslike. Although under the Dutch law declaring all transactions with the Nazis illegal the Mannheimer works were considered to have been confiscated, the proceeds of their sale had been used to settle their owner's debts to Dutch citizens. The committee therefore felt that Mme Mannheimer had no claim on the objects that came back to Holland. The best things were taken by the Rijksmuseum, and the rest of the enormous collection was sold at auction for the profit of the Dutch state. The paintings which Mühlmann had

garnered at the last moment in France had, however, gone back to that country. The Dutch were not about to give up on these works, which had been part of Mühlmann's original contract. Representatives of the Rijksmuseum entered into negotiations with Mme Mannheimer in Paris. This was tricky, as her late husband had also had French and British interests, but in the end a deal was struck and Mme Mannheimer was allowed to keep a number of works,[25] among them the charming Chardin *Soap Bubbles,* which eventually came to the United States and was sold to the Met.

The Goudstikker case was equally complex. Alois Miedl had kept his word and protected Desi Goudstikker's share of the company, which had been carefully invested in Dutch stocks and currency and not in Reichsmarks. Behind him he had left, in some disarray, what remained of the Goudstikker art and real estate. When Mrs. Goudstikker arrived back in Holland she found the old staff of the firm, including those who had sold it, there to greet her. Knowing little of what had transpired, she was unsure of how to regard them. It was up to her to prove that the sale of the firm had been forced and that the price paid was too low. The latter issue was made more difficult because Goudstikker had, in the thirties, consistently undervalued or written off works, and more than 160 pictures were on the books as having been worth one guilder. Nor were the Dutch authorities persuaded that the sale engineered by the Goudstikker employees had been forced. Mrs. Goudstikker, who had not been involved in the firm's business affairs, was now afraid she would lose everything, and gave up her claim to the pictures sold to Goering. For a time she tried to get back the things which were still in Miedl's name, but after six years gave that up too; all the recovered works went to the Dutch state. In the end she bought back the three houses Miedl had taken over, but soon had to sell Castle Nyenrode and the Amsterdam headquarters of the firm. Beautiful Ostermeer she offered to the Dutch government in return for permission to live in a cottage on the grounds. The gift was refused, as it was not endowed, and that house too was sold.

The idea of a freeze on the art trade in the formerly occupied countries come the liberation, proposed by both Georges Wildenstein and Jacques Seligmann in the early days of the war, evaporated without trace. As Kenneth Clark discovered, the continental trade had continued with only slight interruption, the only place where there was a freeze being Germany. Indeed, the Wildenstein firm was one of the first to resume its international operations. Well before the fall of Germany, their man Dequoy showered both the New York and London offices with chatty cables full of news and

proposed sales, and set in motion the claims process for the objects confiscated from the firm. He even became something of a Resistance hero for a time. A story in *The New York Times* on September 11, 1944, under the headline "Paris Gallery Foiled Nazi Art Collectors," ran as follows:

> Frenchmen have revealed with relish how at least in one case the Nazis paid for French loot but never received the goods. Roger Dequoy, manager of the Georges Wildenstein Art Gallery, had a four-year fencing match with German art collectors ending in a complete victory for him. Nightly, during the Nazi occupation, M. Dequoy and his staff moved Renoirs, Manets, Goyas, valuable 18th century furnishings, rugs and tapestries into hiding places. . . . Once the Nazis learned the picture collection was stored in the vaults they demanded the right to purchase from it. Knowing he would get only a tenth of the real value of the collection, M. Dequoy managed to substitute inferior paintings before the arrival of the purchasers.

By late 1944 not one dealer's doors had been closed by the authorities. This seeming insouciance on the part of the French upset the OSS investigators whose mounting stacks of evidence pointed straight to numerous Paris dealers, but who could get little cooperation from their French counterparts, the Direction Générale des Etudes et Recherches (DGER)—the result more of chauvinism and political turmoil than of inaction.

Laws were, in fact, passed aimed at prosecuting those who had profited illegally from trading with the enemy. A DGER agent reported that after an official Art Dealers Association meeting in early January 1945, the principal members had met secretly to decide what their "attitude" would be toward the financial decrees. The situation of the art dealers was "delicate," he reported, as some 80 percent of them had done significant business with the Germans, much of which had not been entered in their books. They had reckoned without the meticulous habits of the Nazis. "The secret of their operations is difficult to keep since certain operations are already known and the objects have been found in Germany." For fear of financial reprisal, they had agreed not to provide any information at all, a situation which, the agent felt, could delay the more important objective of the recovery of confiscated works of art.[26]

By April 1945 Lefranc, the Vichy agent who had engineered the Schloss affair (see page 172), was in jail and others were being investigated and fined, which had the effect of depressing the auction business at the Drouot and promoting underground trading for cash. The DGER found this deplorable: the strict measures, they lamented, were driving sales abroad. Though they agreed that the worst offenders should be punished,

they recommended to the Commission de Récupération Artistique that collectors and merchants should be encouraged to revive the art trade, and should especially seek out nineteenth-century French works in occupied Germany, where they could surely be obtained cheaply, and where "American artistic centers have already sent representatives." Only by exploiting this opportunity would Paris remain "the indispensable artistic center of the entire world"; neglect of it would "condemn them to watching the center of the art trade move across the Atlantic."[27]

But the Commission de Récupération and the French representatives at the Collecting Points felt otherwise. Commandant Pierre-Louis Duchartre at Munich told Henraux that the image of a corrupt Parisian market would please those who "would be happy to see the Paris art trade damaged" and urged that the government send more help to the delegation at the Collecting Point, which the DGER had so far refused to do. Indeed, the lack of personnel had forced Duchartre to hire two slightly dubious Yugoslav refugees, who had so far been a great success and turned up twenty-one of the missing Schloss pictures in and around Munich.[28]

Martin Fabiani was arrested in September 1945, but not before he too had managed to wangle a visa to go to London, where he was put up at the Wildenstein suite at the Dorchester.[29] He was forced to pay a whopping FFr 146 million fine. His troubles did not end for a long time. There was still the matter of the five or six hundred (the figures vary) Vollard pictures stuck in Ottawa, where they were being carefully tended in the storerooms of the National Gallery of Canada. These he could not claim, as he had at last been put on the Allied Blacklist and could not get a visa. There was another little complication: Vollard's will had specified that his collection be inventoried, which had never been done in his lifetime, and that it then be divided among several heirs, of which the City of Paris was one. This Fabiani and co-heir de Galea had failed to do before the outbreak of war, so that no one really knew what had been in the collection at the time of Vollard's death.

It was now abundantly clear why M. de Galea had not wished Rorimer to take his pictures to Paris and had instead hidden them in a duck blind. On June 2, 1949, the City of Paris put a restraining order on the Fabiani collection. They were just too late. Diplomatic inquiries revealed that the pictures had been released to Fabiani and a M. Jonas in Ottawa on May 30 and had been taken, it was thought, to London and the USA. The French sent a note to the U.S. State Department requesting help, noting that "their sale in the United States would defraud the French Treasury of a large sum in foreign exchange."[30] Just how Fabiani had managed to get to Canada and how all was resolved among the interested parties is unclear, but he

continued to trade in Paris for many more years, and even wrote a charming, if not entirely accurate, book about his dealings.

By 1947 twenty more French dealers had been fined, among them Dequoy and Petrides. Their German colleagues Lohse and Rochlitz (the latter gleefully delivered to Paris by James Plaut after a long ride across France in an unheated Jeep) were in French jails. Efforts by the Commission de Récupération and French Customs to bring charges against the Wildenstein firm were, however, rejected in 1949 by the courts on the grounds that there was no proof of voluntary sales to the enemy.[31]

Similar trials for "economic collaboration" took place in Holland. The museum community there, according to the waspish reports of British MFAA officer Ellis Waterhouse, first on the scene in 1945, was a shambles. Many of its distinguished members had died or retired. Hannema, director of the Boymans, had been thrown into jail by the citizens of Rotterdam. The Dutch restitution commission was riven by what Waterhouse termed "local art politics" and self-preservation tactics. Things finally settled down when two men who had been out of the country during the war, Alphons Vorenkamp and Dr. A. B. de Vries (the latter having spent the war years in Switzerland after being dismissed from the Rijksmuseum by the Nazis), were put in charge. Citizens were required to submit lists of objects taken to Germany and dealers were questioned.

The MFAA and OSS officers in their brief time in Holland took a dim view of the Dutch dealers and their captive experts, Friedländer and Vitale Bloch, who, Waterhouse contemptuously wrote, "is now busily reinsuring by turning King's evidence." He was equally suspicious of the dealer de Boer, accusing him of trying to get on "any commission of Dutch experts which might eventually go to Germany to examine restitution claims" and "wishing perhaps to cover some of his own traces." Goering's favorite, Hoogendijk, on the other hand, he found to be "of good intentions" but "obsessed with the problem of the five religious works ascribed to Vermeer." As well he might be: if they were fakes, which seemed more and more likely as Holland emerged from the hothouse atmosphere of the occupation and the pictures were exposed to international scrutiny, he could be liable for considerable sums.[32]

Accounts of the Dutch collaboration investigations are, like those of every country, unedifying. The depositions and hearing reports are full of gossipy testimony, innuendos of anti-Semitism, Communist leanings, and cronyism. De Vries himself got into trouble for returning thirty-one pictures without the consent of his colleagues to Nathan Katz, who had helped him in Switzerland. The problem was that the Commission felt that

these works had not been a "forced sale." To make matters worse, Katz immediately shipped ten of them off to Switzerland, where they were inaccessible, and where at least one, Rembrandt's *Portrait of Saskia* (ex. Ten Cate), soon appeared in the "voracious" Bührle's collection. The matter was quietly settled by requiring Katz to give three pictures back to the Dutch state.

De Boer hid nothing and maintained that all his sales had been forced, pointing out that his wife and many of the colleagues he had helped were Jewish. He said he had charged the Germans ridiculous prices in order to keep the good things in Holland but that they had bought anyway. He was not further prosecuted. Who after all was to say where survival ended and collaboration began?[33]

The only full-fledged art trial to result from the events of the war in Holland seems to have been that of the Vermeer forger Hans van Meegeren, who was arrested not for fraud but for economic collaboration. Van Meegeren had warned his intermediaries not to sell to the Germans, but had not reckoned with Goering's Vermeer obsession. When the Reichmarschall's *Christ with the Woman Taken in Adultery* returned to Holland, investigators naturally wished to know exactly from whence it came so that accounts could be settled. Van Meegeren, as one of the previous owners, was routinely questioned. When he refused to reveal the picture's origin he was taken to jail, where he declared that he had painted it himself, and, furthermore, that he had done all the rest as well. Van Meegeren was acquitted of collaboration charges and became a folk hero. He was retried for forgery in 1947. The trial was quick: the experts did not much want to testify to their failings in public. The press found them anyway. It was the forger's last moment of glory; he died soon after the trial. He had made a reputation of sorts: in November 1990 the picture he had painted for the court, the *Young Christ Teaching in the Temple,* was sold for $23,000 at Sotheby's.[34]

German dealers were just as eager as their colleagues to get their trade going again, but all dealing had been prohibited well before the invasion of Germany by Military Government law. Again the trade went underground. In some areas, in order to prevent underworld activity and interzonal smuggling, local commanders devised their own licensing systems and allowed dealers' associations. They were not only thinking of stolen Old Masters: they also wished to promote opportunities for the modern painters so long suppressed by the Third Reich.[35] But no one went so far as to permit the export of works from Germany, and all sales of works valued over DM 1,000 had to be reported. Those dealers known to have done business with the Nazis were not licensed, and indeed most of them were

under some form of detention, but they had not given up. In 1949, when licensing requirements for most other businesses were relaxed by General Clay, the dealers were ready to start anew. The effect of this, MFAA officer Theodore Heinrich wrote from Wiesbaden, "has been the appearance in the art dealing trade in this area of several dealers previously refused licenses because of notorious malpractices during the Nazi regime."[36] The licensing and export laws were immediately reinstituted for the art trade and remained in place for the duration of the American occupation.

The shipments out of Germany, massive though they were in the first year of occupation, in no way kept up with the "items" which continued to arrive at the Collecting Points from every conceivable quarter. To the things discovered in hiding places were added thousands of others brought forth by Military Government Law 52, which required German citizens to report all property acquired in foreign countries during the war and allowed them to return it to the authorities, no questions asked.

By April 1, 1946, a total of 23,117 items had been logged into Munich, while 5,149 items, representing 8,284 actual objects, had been returned. The December 1950 summary for Wiesbaden reported that 340,846 items had been returned since its establishment, a rather meaningless statistic given the fact that one single "item," a library, had contained 1.2 million objects, and another, 3 million. In the storerooms some 100,000 items still remained to be liquidated, and more would trickle in during the last two years of occupation.[37]

The United States Army had certainly not planned to deal with all this. By the spring of 1946 most of the original Monuments officers who had fought across Europe and found the great caches had gone home, leaving the job of restitution to a much reduced number. The Army, assuming that the return of identifiable loot would be completed by September, at which time responsibility for the remaining items would be turned over to the German Länder, or states, planned by then to limit the number of Monuments officers to twelve. The Roberts Commission itself, which had barely survived the Congressional budget process in 1945, ended operations in June 1946, turning its records over to the Office of International Information and Cultural Affairs of the State Department, headed by Miss Ardelia Hall. Before it disbanded, there still being no international agreement on the subject, the Commission went on record to say that "cultural objects . . . should not be considered or involved in reparations settlements growing out of World War II."[38]

But termination of operations in the fall of 1946 proved to be impossible. Indeed, many repositories had not even been revisited or emptied at

that date, and the Collecting Points were still full of objects of unknown provenance. The Army, despite all its efforts to rid itself of the burden, had become the recuperation commission for an enormous number of works which could not simply be shipped off "in bulk," and whose disposition the MFAA officers adamantly believed should not be left to the Germans. The very eagerness of the Military Government to be rid of the art prolonged the process, for after the euphoria of the big discoveries the old demons of lack of personnel and transportation reappeared with a vengeance, and measures such as cutting down coal allotments to the Collecting Points, which made working conditions miserable, slowed progress even more.

By 1947 the whole picture in Germany had begun to change. The big repositories were nearly empty and the Monuments men were faced with the very different problems of tracking down individual works which had vanished into the hands of thieves and black marketeers, both Allied and German. This required a certain amount of detective work in the field, and even the use of disguise. MFAA officer Edgar Breitenbach, fluent in German, roamed the villages around Berchtesgaden dressed in lederhosen, attempting to recover objects from the Goering collections from the reluctant locals. An extensive ring of fences who had been trading in the things stolen from the Führerbau in Munich was slowly exposed by underhanded techniques. The trails sometimes led to unexpected places: it was discovered that six paintings bought for General Clay's office had been looted from Holland, and they were quickly replaced.

The conditions of return also changed. As the Cold War took hold, the Monuments officers had to deal with the claims of citizens of countries dominated by the Soviet Union who had fled to the West and now, as refugees, claimed title to objects held at the Collecting Points. Strict adherence to the tenet of returning things to the country from which they had been removed would, in these circumstances, have to bend to political realities. A case in point was that of the Lvov Dürers so beloved of Hitler (see page 68). This was a particularly thorny problem as Lvov, formerly Polish, was now in the USSR. The drawings had in truth been quite forgotten in the vastness of the Collecting Point, where they had remained in the packing case in which they had come from Alt Aussee.

In April 1947 the MFAA office at headquarters received a letter informing them that Prince Georg Lubomirski, currently living in Switzerland, wished to claim the drawings as his property and donate them to the National Gallery of Art in Washington. This was not quite accurate, as the Prince had simultaneously written to the firm of Rosenberg and Steibel in New York to ask them to help him recover the works, after which he

Albrecht Dürer, Selbstbildnis mit linker Hand (1493)

Früher Lemberg, Museum Lubomirski

planned to sell them. It took until January 1948 for this inquiry to reach the Collecting Point. The current director, Stewart Leonard, unpacked the drawings and reinterrogated Kajetan Mühlmann, still in custody, about details of their removal. Going by the book, he explained to the Prince that the drawings could only be released to nations, and not individuals. Lubomirski protested, pointing out that the Russians had confiscated everything he had left behind and claimed that he was the legal heir to the Lubomirski estates. Bernard Taper, the American MFAA investigator assigned to the case, who had heard many a story, was not so sure, and noted in his report that he "seemed to remember having read somewhere that the Lubomirskis had donated these drawings to the Lvov Museum."[39] Nonetheless, the Prince was told to pursue his claim.

A few months later the MFAA officers were informed that the Army had been authorized "to return to refugee nationals or non-nationals of the So-

viet Union or Soviet satellites objects independently claimed by them" and were told to return the Dürers to Lubomirski "without publicity." This was fine with the Prince, for not only did he not have a valid claim, the Dürers having indeed been given to the museum in the 1840s, he also had not told most of his relations about what he was doing. The drawings were sold in New York and the Prince, to the chagrin of the rest of the family, lived happily ever after, in some style. But the Lvov Museum, now in the independent nation of Ukraine, did not forget. Before his tragic death in 1992 at the hands of thieves, its director, Dmitri Shelest, inspired by the example of the Netherlands government in its quest for the Koenigs collection, had been considering making an international claim for the drawings.[40]

The United States was not the only custodian nation to have problems with claims from the nations now under Soviet control. It would take the Canadian government nearly fifteen years to extricate itself from the complications surrounding the return of the Cracow Castle tapestries to which it had given refuge in 1940.

The problem of the Hungarian Crown of St. Stephen, another cause célèbre, took even longer to resolve. It had been brought to Seventh Army Headquarters in May 1945 by a Hungarian colonel named Pajtas and an escort of twelve men, all sworn to guard it with their lives, which they had indeed been doing since 1943, moving it from place to place to keep it from the Red Army. The crown was packed in a locked chest with three locks, for which Pajtas claimed not to have the keys. Seventh Army promised not to force the box open and stored it under heavy guard, but word of the discovery leaked out and the press clamored to view it. A few weeks later the keys were "found," but when the box was opened it was empty.

Colonel Pajtas now sheepishly admitted that he had known this all along and had in fact himself hidden the crown and other elements of the Hungarian regalia in a secret spot. The Americans pointed out that inability to produce the crown could lead to accusations of theft, which would not be good publicity for them, and persuaded Pajtas to retrieve it. This was done without official authorization in the dead of night. The regalia were found in a mud-covered oil drum. Pajtas and the MFAA men washed the jewels off in a bathroom and put them back in their original box, where with much hoopla they were displayed for the press, after which, sealed with wax imprinted with the dog tags of the Seventh Army Property Officer, they were taken off to the Reichsbank in Frankfurt to join all the other crowns.[41]

Despite Hungary's status as an Axis-allied country which was supposed

to wait until last for restitution, in April 1947 the United States, in a futile effort to stabilize the country's political situation, returned a number of things, including a large quantity of silver and gold bullion removed by the Nazis and the contents of the Budapest Museum. But the ill-fated Prime Minister Ferenc Nagy, fearing that the arrival of the crown would exacerbate unrest, made it known that he preferred that the sacred object not be returned. After a time the Army quietly sent it to Fort Knox. The Hungarians made sporadic claims and threats that were resisted until 1977, when President Jimmy Carter decided the crown could go home. The process was still fraught with controversy. Hungarian refugees in the United States protested and marched on the White House. The Hungarian government had a different problem: they had heard that the crown was to be returned by *Mrs.* Carter and cabled that "with all respect for the emancipation of women, we should very much prefer a high U.S. official and possibly a delegation from the U.S. Congress." The Congress, always up for a junket, happily obliged, and the crown was delivered by Secretary of State Cyrus Vance and a group from the Hill on January 6, 1978.[42]

In August 1948 General Clay tried to set a final deadline for restitution to the occupied lands. The foreign representatives at the Collecting Points were told that all their claims must be submitted by September 15, and that action on them would end on December 31. Working day and night, the MFAA representatives completed hundreds of cases, but to the dismay of the claimant nations many remained unresolved at the time of the deadline. They need not have worried: the men at the Collecting Points would continue for three more years to arrange the return of identifiable objects to claimant nations. This left the so-called internal loot: objects confiscated from German nationals, legitimate German-owned cultural property, and, most difficult of all, the unclaimed property of the dead, or "heirless property."

Clay had ordered as early as April 1947 that German-"owned" property be turned over to the German administrations of the Länder, which were to pass their own regulations for distributing the property. The MFAA officers did not find this at all acceptable, fearing that the Germans, once in control, would not check the origins of such works and return material that proved to be loot. And indeed Länder officials had immediately complained that the December 1948 cutoff for claims allowed too much time. After proposing various ideas advantageous to Germany, such as lower liability for lost works, they finally refused to pass a general restitution law as it could not be applied in the Russian Zone, where no one was bothering with restitution at all. The ball was thus back in Clay's court, and the

Chaplain Samuel Blinder sorts Torah scrolls at the Offenbach Collecting Point.

Military Government was forced to supervise regulation of the internal as well as the foreign restitution process. This was done in cooperation with the German courts and regulated by the provisions of Military Government Law 59, passed in November 1947. After a time the French and British did the same in their zones, and through this process hundreds of thousands of objects were released to German claimants.[43]

The problem of "heirless" Jewish property still remained to be solved. Traditionally, unclaimed cultural property reverted to the state and was distributed among museums and libraries. This was clearly out of the question for nations where whole populations had been killed or forced to flee, never to return. The idea of a supranational commission of cultural adjudication which would try to salvage and decide on the disposal of works of art, so long discussed in the free nations during the war, at last came into being for the unclaimed Jewish property. The process was not smooth. The French and British were opposed to the whole idea; the Russians, as usual, did not participate at all. But in the United States Zone a regulation was added to Military Government Law 59 allowing a charitable or nonprofit group to act as a "successor organization" which, instead of an individual state, could claim heirless Jewish property. The Jewish

Restitution Successor Organization (JRSO), founded in New York in 1947 to represent Jewish groups from all over Europe and Palestine, took on this task. A second organization, Jewish Cultural Reconstruction, worked with the JRSO on the difficult task of distributing religious and cultural objects to groups worldwide. Final arrangements on the details of transfer and shipping were not completed until February 1949.

As usual, Clay pushed the issue: the JCR was given an impossible three months to organize removal of the heirless objects from the U.S. Zone. There were more than a quarter of a million books—as well as thousands of Torah scrolls, ceremonial textiles, and ritual vessels—still at the Offenbach Collecting Point alone, where the objects Lincoln Kirstein had found at Hungen and much more had been taken. This had been distilled down from the original million or so by the extraordinary efforts of Captain Seymour Pomrenze, a former employee of the National Archives in Washington, who had sent back tons of books to the Western occupied nations.

Mercifully for the three scholars attempting to divide the books, the deadline was extended for a further three months. The vast majority of objects went to Israel and the United States, but the distribution was fraught with conflicts. The few Jews remaining in Germany did not wish the relics of their devastated communities to go abroad, even though many of their people were in the receiving countries. Nor did German gentile communities always give up valuable Jewish manuscripts and archives with grace. The disputes would go on for many years and become entwined with the settlements eventually arranged between Germany and the state of Israel.[44]

Despite all Clay's efforts, the Collecting Points were still not empty when he left Germany in May 1949. The remaining stores of art and archives would require the attention of specialists for many more years. For the final American push Ardelia Hall at the State Department recruited old hands Thomas Howe and Lane Faison, who closed down the Collecting Points in September 1951. The remaining "items," still quite a number, were handed over to another German "Treuhandstelle," or Trustee Agency, which in the next ten years returned to their owners some sixty thousand "items" representing over a million objects, of which nearly three-quarters went outside Germany. About thirty-five hundred lots were then distributed among German museums and institutes, from which, with proper documentation, it is said, they may still be claimed.[45]

If working out these solutions was difficult for the policy makers, the implementation of them, which fell to the MFAA men, was doubly so. For them the problems were human, and their principles and emotions were

constantly challenged as their work revealed some of the least edifying aspects of human nature. These feelings were not diminished by the Nuremberg trials, which began in late 1945. The testimony, in which art figured strongly, provided a dreadful continuo to their discoveries. Nor could anyone remain unaffected by the corrupt atmosphere of the immediate postwar years in Germany, where the fallacies of the plan to suppress the economy soon became apparent. The cigarette became the accepted currency everywhere. For a few Camels one could buy anything from a Rembrandt to a cabbage, depending on the need of the seller. People lied and schemed to find work and sustenance. The food situation continued to be so bad that one office even sent a formal memo to its MP detachment authorizing a German employee to go through the canteen garbage cans. The letters of MFAA personnel are full of pleas for shipments of soap and food from home for German acquaintances, who would invite them to little parties, hoping that they would appear with something edible, which of course they did.

The Monuments men found some solace in time spent on an aspect of their mission which had been neglected in the first frenetic months: the revival of a non-Nazi cultural milieu in Germany. They put on concerts and exhibitions. Seldom have museum directors had such a choice of objects.

At Wiesbaden, Edith Standen (who succeeded Walter Farmer as director), with unparalleled resources at her disposal, put on a series of shows attended by thousands of Germans. From the outset of his tenure at the Munich Collecting Point, Craig Smyth made plans for its eventual conversion into the art historical institute which it is today. By 1946 special arts liaison officers were brought over to promote cultural revival. Among them was Hellmut Lehmann-Haupt, who in the course of his investigations of the effect of government control on the arts was the first to analyze and classify the records of the SS Ahnenerbe and thereby reveal the extent of Himmler's "archaeological" activities in Poland and the USSR.

Black humor of a sort was provided by the unabashed claims made on the Military Government by a number of the principal movers of looted art. In the years following their various house arrests, trials, and interrogations, Haberstock, Fischer, Lohse, and even Frau Goering asked for favors and claimed works taken from them, which were, in fact, scrupulously returned if legal title could be proved. The Reichsmarschall's wife appeared in Collecting Point director Lane Faison's office in April 1951, hoping to recover a small Flemish fifteenth-century *Madonna* which she insisted had been given to her, and not to her husband, by the city of Cologne. She was not humble. Faison's diary records that she arrived "in a snazzy flat black derby . . . a spirited Brünnhilde. Put on a good show.

Denied agreeing to put part of Goering pictures on market (via Haberstock and Wildenstein firm) in return for help in her de-Nazification." Her claim was not pursued.[46]

Haberstock, who by 1951 was reported to have set up shop in Munich near the Haus der Deutschen Kunst, and to have reestablished his contacts with his prewar trading cronies in Paris,[47] was seemingly so worried about his reputation that he wrote to Janet Flanner at *The New Yorker* to complain about inaccuracies in her description of his wartime operations in a series of articles she had written on the looting process. He did not deny having traded for the Führer, but complained that she had said he drove a Mercedes when in fact it had been a Ford.[48] Later he wrote to Ardelia Hall at the State Department proposing that she investigate the theft of some books by U.S. Army personnel which might "injure the reputation of the Army abroad, but which could be cleared up within the scope of your activity," and offering to provide their names. Miss Hall declined his noble assistance, replying that "the case had already been investigated with no result."[49]

Outrageous behavior was not limited to Germans. The Yugoslav representative at the Munich Collecting Point, a Mr. Topic, falsely claimed 165 paintings, which as of 1960 had not been recovered.[50] But this was a mere skirmish compared to the years-long battle for the disposition of the Italian works held at the Collecting Points.

Restitution to Germany's former ally had been put off to the very last. In due course such clearly looted items as the Naples pictures from Monte Cassino were returned, as were the contents of the great German Art Historical Institutes whose founders had specifically required that they be in Italy. But the works given to Hitler and Goering by Mussolini or bought by them on the Italian market, which John Walker had hoped might come to the United States, were a different question. Stewart Leonard, director of the Munich Collecting Point in 1947, did not believe they should be returned. In this he was strongly backed by his German colleagues, some of whom wrote long righteous papers explaining why the works should stay in Germany. Opposing the holders of these opinions was the colorful and mysterious self-appointed savior of the Italian patrimony, Rodolfo Siviero.

Siviero was said to have formed a secret unit dedicated to art protection which had worked all over Italy with regional units of the Partisans. Agents of this group had penetrated the Italian Fascist secret police and after the German takeover were able to monitor German cable traffic. They had therefore known of the intentions of the Kunstschutz to remove art works to the north, but had been powerless to stop the transfer alone,

and had, according to Siviero, secretly warned the Allied command of the plot.[51] This information does not seem to have reached the proper authorities. When the Allies took Siena in 1944, Siviero offered his services to Deane Keller, but the MFAA officer, not sure of the Italian's motives or politics, put him off. Siviero approached Keller again in Florence, volunteering to "involve himself" with the Americans in the recovery of the missing Uffizi treasures, but this time the Counter Intelligence Corps rejected the offer.[52]

Siviero was next heard from in 1948 in his capacity as chief of the Italian recuperation effort, presenting to the U.S. Military Government a claim not only for the works given away by Mussolini but for those bought by the Nazis from Contini and other Italian dealers. In 1946 the Italian government had declared all transactions made under "political pressure" as null and void. It seemed logical that the United States should return all works of art identifiable as being of Italian origin to Italy, as had already been done for Austria and everyone else. But in the eyes of the United States, Austria and Italy were not in the same category. Austria, despite its enthusiastic welcome of the Führer, was regarded as an "overrun" nation, not as an Axis ally, but because of voluntary alliance with Germany up to 1943, Italy's claim was not considered as automatic.

This idea was intolerable to Siviero, who now began an all-out campaign. The items in question he described as having been "exported from Italy in a clandestine manner or sold or donated in violation of the Italian law."[53] He did not limit himself to communication with the Military Government, but made sure that the American State Department and the Italian press heard about it too. Collecting Point director Leonard (who later admitted that his own attitude was "intransigent"[54]) and the Germans produced reams of documents showing that many of the works claimed were not national treasures; that many were not even of Italian origin, having been offered on the market in other countries before being brought to Italy; and that the sales had not been at all secret. Soon the argument came to the notice of General Clay, now deeply embroiled in the Berlin Airlift. His fervent desire to rid himself of yet more art was augmented by the need to promote pro-Western policies in Italy, which, many feared in 1948, might go Communist. Clay therefore ordered the immediate return of the works requested by Siviero.[55]

Stewart Leonard refused to carry out the order, going so far as to produce negative documentation. He had some success: Clay compromised but ordered thirty-nine of the hundred-plus pictures sent off while the rest were being investigated. Leonard was so upset that he resigned and sailed for home, but not before he had sent further protests to the Legal Division

Rodolfo Siviero (right) *receives Naples masterpieces removed from Monte Cassino from Monuments officer Edgar Breitenbach.*

of the State Department. The Corsini Memling *Portrait of a Gentleman,* the Spiridon *Leda and the Swan* (at that time attributed to Leonardo), and sixteen other works were shipped out by Leonard's hastily appointed successor, Stephen Munsing. In their coverage of the event, the German newspapers referred to Siviero as a "pirate who takes advantage of the political situation."

Before any more pictures could be dispatched, the effect of Leonard's protests on the State Department, sensitized by the dramas of the 202, became clear. They did not have the result he intended. Over the signature of Acting Secretary of State Lovett came a long telegram deploring rumors that "proposals for the sale of works of art for purposes of relief are being increasingly advanced." The United States government should never, he said, "directly or indirectly aid in the sale and dispersal of art from Europe." The cable included rumors that "French dealers are attempting to gain access to the collecting points on the ostensible grounds of aiding in the identification of art" and that "certain American museum officials are openly advocating the sale of objects from Nazi and German public collections"—the source for the latter being a remark by Theodore Rousseau,

who had left the OSS to become curator of paintings at the Met, quoted in *The New Yorker:*

> America has a chance to get some wonderful things here during the next few years. German museums are wrecked and will have to sell. . . . I think it's absurd to let the Germans have the paintings the Nazi big-wigs got, often through forced sales, from all over Europe. Some of them ought to come here, and I don't mean especially to the Metropolitan, which is fairly well off for paintings, but to museums in the West which aren't.

Lovett's cable ended with a demand for a public statement from Munich denying that any such policy was contemplated.[56]

Meanwhile, in Italy, Siviero had announced to the press that he had "won a diplomatic victory over the Americans in Berlin and overcome German sabotage in Munich" by recovering national treasures which the unprincipled Nazis had stolen "shortly before we heroically eliminated them from our country in 1945." This revisionism was too much for Monuments officer Theodore Heinrich, who happened to be in Florence. He confronted Siviero, threatening to take the matter up with the American embassy, and forced him to make a public retraction.[57]

Siviero now returned to Munich to pursue his quest for the rest of the objects on his list. He bribed German staff at the Collecting Point to tell him what was there and even tried to influence director Munsing by offering him a luxurious trip to Italy.[58] But he overplayed his hand; on June 1, 1949, his credentials were withdrawn on the grounds that "Mr. Siviero is reported to be a Communist who is conducting a virulent press campaign against U.S. restitution policy and who has spread many untruths concerning the U.S. government, the Munich Collecting Point and the personnel attached thereto."[59] Nothing daunted, Siviero continued his campaign from Italy. Things escalated to such a degree that 125 German employees at the Collecting Point sent a petition to President Truman. This was answered by an equally fiery broadside signed by the intellectual members of Italy's ancient Accademia Nazionale dei Lincei. The Italian government hastily removed Siviero "from further duty in connection with this activity because it was found that he could not deal successfully with the Americans and because he had entered into press polemics which proved embarrassing to the Italian government."[60]

It all died down for a time, but a year later Siviero was back in the fray. His insistence on the illegality of some sales was considerably weakened, in the view of his opponents, by the circumstances surrounding the disposition of the Spiridon *Leda.* Once it had returned to Italy it had not been

given to the former owner, the Countess Margaretha Spiridon-Callotti, but had been kept by the Italian state. The Countess had sued for its return, asserting that the painting had been "extorted" from her in 1941; but an investigation by Siviero had led to charges against her for attempting to defraud the state. In its case against the Countess the Italian government now used the exact same arguments as had the Collecting Point officials: that the picture had not even been brought to Italy until 1939, and then for purposes of sale. To this they added the gossipy accusations that the Countess had celebrated the event with a party, had thrown in a Leonardo drawing for the Führer, and had invested her ill-gotten gains in the palatial former residence of Barbara Hutton known as the Abbey of San Gregorio.[61] The State Department now backed the Collecting Point officers, and nothing more was returned to Italy by them.

Siviero never changed his tune. Whenever possible he belittled the American role in the recovery of the Uffizi treasures and took the credit for himself, bringing forth periodic protests from former Monuments men. But for Italy his persistence was successful. In 1953, after the departure of the Americans, a special accord with the Adenauer government brought back most of the remaining objects on his list. Indefatigable and obsessed, he continued until his death in 1983 to hunt down art taken from Italy. Along the way his glory came from a series of exhibitions of recovered works which culminated in a posthumous one in his honor at the Palazzo Vecchio in Florence. The lavish catalogue repeats all Siviero's mythic themes, which, as was his custom, are embellished by a number of amusing variations.

Long after the American Monuments officers had left Germany, Rose Valland, like her Italian counterpart, continued her quest to retrieve or account for every single thing that had left France. She too had her days of glory: André Malraux awarded her the Légion d'honneur and the Medal of the Resistance. In 1964 her story was revealed, rather inaccurately, to the world in a film entitled *The Train,* which starred Paul Scofield as von Behr, Burt Lancaster as the Resistance Hero, and the glamorous Suzanne Flon as Rose. But after a time her persistence and her knowledge of collaboration and shady deals began to make her unpopular among those not wishing to be reminded of the events of the war. She was particularly reluctant to set a final date for claims on the unidentified and not very high-grade leftovers which remained after the better objects had been distributed among the museums. These had become an administrative headache for everyone, and many felt they should be sold. By 1965 Mlle Valland's stubbornness had driven the director of the Musées de France to suggest to her

that it might be time to look forward to peace and fraternity, forget the past, and leave the disposition of the works to the living, which "would take nothing away from the respect for the dead."[62] But Resistance heroine Valland never would compromise, and in her last years retreated entirely into her world of secret documents, which at her death were relegated, unsorted and chaotic, to a Musées storeroom in Malmaison.

In Germany as well, the dedicated continued to search. Wilhelm Arntz, a lawyer, spent years trying to track down every single "degenerate" picture removed by the Nazis, in the process uncovering considerable unsavory activity by auctioneers, dealers, and museums. Kurt Reutti, who had started the Zentralstelle in Berlin, scoured the East German countryside, travelling hobolike from place to place in empty boxcars or whatever vehicle he could find. His reception was sometimes mixed: in one village two ladies defended their possession of a stolen picture with pickax and shovel, while another gently led him to her house, where he was amazed to find the Kadolzburg altar from the Erasmus Chapel of the Berliner Schloss. The Russians had thrown it on the ground, and the old lady had saved it because she "could not let the Lord God just lie there." Most extraordinary was his discovery of a group of large Chinese temple figures missing from the collections of Baron von der Heydt. These he traced to a remote house in Angermünde, northeast of Berlin on the Polish border. Upon arriving Reutti was told that the "Chinese stuff" was on the dump:

> It was a big dump. A man was splitting small logs on the head of a grey stone twelfth-century Tiger. Further on two goats jumped around two more stone faces which peered demon-like out of a pile of half rotten straw. Next to this in a pig sty was a big Chinese bronze drum full of manure.[63]

He had arrived just in time, for the woodcutter had planned to drag away the "junk" and throw it in a lake. (Reutti wondered to himself what theories of intercontinental trade this might have inspired in future archaeologists.) Baron von der Heydt had trouble getting the things to Switzerland, where he had taken up residence since the war, but the East Germans finally surrendered them in exchange for two butter knives and a tea glass and strainer which had once belonged to Lenin. Reutti was succeeded by searchers of equal passion such as Klaus Goldmann, curator of the Museum für Vor- und Frühgeschichte in Berlin, who spent years on his particular obsession, the location of the Trojan gold. Not until 1992 was that mystery solved by the revelation that the treasure did indeed go to Russia in 1945.

* * *

After the mid-fifties the question of Nazi loot was no longer of great interest except to museum professionals and dispossessed owners, though sporadic finds and returns did cause little flurries. The two tiny Pollaiuolo panels from the Uffizi entitled *Hercules Killing the Hydra* and *Hercules Suffocating Antaeus,* which had been unaccounted for in 1945, turned up in the hands of a former Wehrmacht soldier who had emigrated to California. The Soviet Union returned most of the Dresden and Berlin collections to the German Democratic Republic in the late fifties. In 1955, with the help of Miss Hall at the State Department, the Czartoryski family, after threatening a suit, got a cash settlement for two of the medieval enamels they had hidden so long before in Poland. The pieces had been sold to the Boston Museum by Wildenstein, who had found them in Liechtenstein. It was not an unfriendly arrangement; afterward, the Czartoryskis and Wildenstein joined forces in an attempt to trace their missing Raphael, which the Metropolitan wished to buy. But this effort, alas, came to naught, and the picture remains lost.[64]

For a long time there was little further news of the fate of missing objects. In Washington, Miss Hall and her successors toiled away on cases of theft by military personnel and whatever else came to their attention. In Austria, several thousand unidentified works languished in the castle of Mauterndorf until their presence was revealed by *ArtNews* reporter Andrew Decker in 1984. And in all nations, most of the records relating to confiscation and recovery lay classified and often sealed for terms of fifty years and more. The United States Army retired and then destroyed files on which there had been no action for a number of years, among them the one relating to the unsolved theft of church treasures from the small East German town of Quedlinburg.

This was too bad, for after decades of silence rumors began to circulate that certain objects from the treasure were being offered for sale in Switzerland. Joe Tom Meador, the light-fingered GI, had died in 1980 and his sister and brother had inherited the objects. They then seem to have sold a number locally. Their lawyer, more sophisticated, felt that the objects might bring more on the New York market, and had the gold and jewel-encrusted *Samuhel Gospels* appraised. The heirs were stunned to discover that this piece alone might be worth upwards of $2 million, but deeply disappointed when the appraiser also told them that it was probably stolen and therefore unsalable. Despite this advice, in the next few years they sent out feelers to dealers and museums. The Getty turned them down, as did Sotheby's. One Paris dealer who was willing to play offered the *Gospels* around Europe at the exorbitant price of $9 million.

By now rumors of the availability of the manuscript were spreading

nicely. In Washington, Willi Korte, a free-lance German researcher who had done considerable work in the American archives for Klaus Goldmann in his efforts to trace the Trojan gold, consulted an American lawyer, Thomas Kline, for advice on how to track down the owners and retrieve the treasure. But in 1990, before he could find them, news came that an entity called the German Cultural Foundation of the States had bought the *Gospels* from a Bavarian dealer for $3 million, of which two-thirds was paid to the Meadors on delivery. The Bavarian had acquired it in Switzerland, and was secretly negotiating the sale of a second Quedlinburg object through the same channels.

A sale of this magnitude inevitably attracted press attention, and William Honan, covering the story for *The New York Times,* began his own investigation to identify the sellers. It did not take long. As soon as their names were published, Meador's old Army friends began to call Honan to report that they well remembered that Meador had taken the Quedlinburg objects. A little research in the Army files revealed his hometown. Korte and Kline rushed to Texas to try to negotiate with the family. After first agreeing to let the duo photograph the remaining objects and put them in a safe place, the Meadors suddenly changed their minds. Kline, by now representing the Quedlinburg Church authorities, obtained a restraining order which prohibited removal of the pieces, but in the meantime two more vanished from the bank.

The German Ministry of the Interior and the Cultural Foundation, who had not previously known the identity of the sellers, now offered to negotiate a settlement. In the end the Meadors got $2.75 million for the objects still in their possession. The German Cultural Foundation, which had been prepared to pay far more, did not wish to bring charges against them and even allowed a fancy little show at the Dallas Museum of Art before the ancient relics returned to a newly installed treasury at the Quedlinburg Church. The U.S. government was less relaxed: the Meadors will now have to deal with the IRS and possibly the FBI. Though many deplore this paying of "ransom" for stolen goods, the whole affair has had the salutary effect of inspiring a number of other ex-GIs or their families to turn in things they "found" during their duty overseas.[65]

The search for missing works of art still goes on. International law enforcement agencies and private foundations such as the Institute for Art Research in New York keep an eye on the markets. The reunification of Germany and the raising of the Iron Curtain have led to the renewal of investigations all over Europe. In the now accessible areas of eastern Germany, treasure hunters and adventurers scour long-sealed passages and

Still missing: Giovanni Bellini, Madonna and Child, *from the Kaiser Friedrich Museum, Berlin*

remote caves, hoping to find the Amber Room or see the gleam of gold. The French Foreign Ministry has retrieved Rose Valland's papers and is busily perusing them at the Quai d'Orsay. Scholarly groups in Germany and Eastern Europe are attempting once again to list losses, while the Russian and German governments are negotiating the still politically potent issue of restitution of objects held by their respective nations.

This is, therefore, a story without an end. It has been sixty years since the Nazi whirlwind took hold, sweeping the lives of millions before it. Never had works of art been so important to a political movement and never had they been moved about on such a vast scale, pawns in the cynical and desperate games of ideology, greed, and survival. Many were lost and many are still in hiding. The miracle of it all is the fact that infinitely more are safe, thanks almost entirely to the tiny number of "Monuments men" of all nations who against overwhelming odds preserved them for us.

NOTES

CURRENCY VALUES, 1939

$1.00 = RM 2.50
$1.00 = FF 50
$1.00 = Dfl 1.90
$1.00 = SF 4.30

Dfl 100 = RM 133
FF 20 = RM 1

ABBREVIATIONS

AAA	Archives of American Art, Washington, D.C.
ANF	Archives Nationales de France, Paris.
CIR	Consolidated Interrogation Report
DIR	Detailed Interrogation Report
FRUS	Foreign Relations of the United States
LC	Library of Congress, Manuscript Division, Washington, D.C.
MFAA	Monuments, Fine Arts, and Archives
NA	National Archives, Washington, D.C.
NGA	National Gallery of Art, Washington, D.C.
OSS/ALIU	Office of Strategic Services/Art Looting Investigation Unit
RC	Roberts Commission
RG	Record Group
SD	State Department, Washington, D.C.
SG	Secretary General
UST/FFC	United States Treasury, Foreign Funds Control, Washington, D.C.

I. PROLOGUE: THEY HAD FOUR YEARS

1. M. Feilchenfeldt, interview with author, 1986.
2. J. Pulitzer, Jr., letter to author, November 20, 1986.
3. Ibid.
4. Quoted in P. Gardner, "A Bit of Heidelberg Near Harvard Square," *ArtNews,* Summer 1981.
5. P. Assouline, *An Artful Life* (New York, 1990), p. 258.
6. AAA, Barr Papers, Barr to Mabry, July 1, 1939.
7. *Beaux Arts,* "La Vente des oeuvres d'art dégénérés à Lucerne," July 7, 1939. Translated by author.

8. A. Hentzen, *Die Berliner National-Galerie im Bildersturm* (Berlin, 1971), p. 53.

9. Barr Papers, various letters.

10. Alfred H. Barr, "Art in the Third Reich—Preview 1933," *Magazine of Art,* October 1945, p. 213.

11. Ibid., p. 214.

12. Barr Papers, undated note.

13. Institute of Contemporary Art, *Dissent: The Issue of Modern Art in Boston,* exhibition catalogue (Boston, 1985), p. 32.

14. H. Lehmann-Haupt, *Art under a Dictatorship* (New York, 1954), p. 15.

15. Cited in B. Hinz, *Art in the Third Reich* (New York, 1979), p. 49.

16. Ibid., pp. 49–50.

17. Lehmann-Haupt, op. cit., pp. 37–40.

18. Hentzen, op. cit., p. 61.

19. A. Speer, *Inside the Third Reich* (New York, 1970), p. 93.

20. B. M. Lane, *Architecture and Politics in Germany 1918–1945* (Cambridge, Mass., 1985), pp. 156–58.

21. Hinz, op. cit., pp. 25–26.

22. Speer, op. cit., p. 49.

23. Ibid., p. 27.

24. Hentzen, op. cit., pp. 10–16.

25. Lehmann-Haupt, op. cit., p. 75.

26. Baltimore Museum of Art, *Oskar Schlemmer,* exhibition catalogue (Baltimore, 1986), p. 204.

27. Galerie Nierendorf, *Fünfzig Jahre 1920–1970,* exhibition catalogue (Berlin, 1970), pp. 14, 68–69.

28. Marlboro Fine Arts, *Nolde: Forbidden Pictures,* exhibition catalogue (London, 1970), p. 5.

29. Lehmann-Haupt, op. cit., p. 87.

30. *Nolde,* p. 10.

31. *The Diary and Letters of Kaethe Kollwitz,* ed. Hans Kollwitz (Chicago, 1955), p. 125.

32. P. O. Rave, *Kunstdiktatur im Dritten Reich* (Hamburg, 1949), p. 41. Translated by author.

33. Hinz, op. cit., p. 35.

34. NA, RG 260/394, Mühlmann testimony.

35. This quote and following from Hinz, op. cit., pp. 37–38.

36. Rave, op. cit., p. 66.

37. F. Roh, *Entartete Kunst* (Hannover, 1962). This book lists the removed works of all museums in detail.

38. Hentzen, op. cit., p. 29. Translated by author.

39. Rave, op. cit., pp. 55–56. Translated by author.

40. See Hinz, op. cit., p. 2; Rave, op. cit., pp. 54–55, translated by author; Hentzen, op. cit., various. Also Staatsgalerie Moderner Kunst, *Dokumentation zum Nationalsocialismus im Bildersturm* (Munich, 1987).

41. Hentzen, op. cit., p. 38. Translated by author.

42. Ibid., p. 39.

43. Roh, op. cit., p. 251.

44. NA, RG 260/438, MFAA interrogation of Angerer, May 20, 1947.

45. Cited in S. Barron, ed., *Degenerate Art,* exhibition catalogue, LACMA (New York, 1991), p. 135.

46. A. Huneke, "On the Trail of Missing Masterpieces," in Barron, op. cit., p. 122.

47. Hentzen, op. cit., p. 44; Rave, op. cit., 65.

48. Interview with Feilchenfeldt; and *Dokumentation,* p. 152.

49. Roh, op. cit., pp. 124–25. For far more detail see also Huneke, "Missing Masterpieces," in Barron, op. cit.

50. Cited in Huneke, "Missing Masterpieces," in Barron, op. cit., p. 128.

II. PERIOD OF ADJUSTMENT

1. N. Henderson, *Failure of a Mission* (New York, 1940), pp. 93–96.

2. W. Shirer, *The Rise and Fall of the Third Reich* (New York, 1960), pp. 302–8; fn. p. 303.

3. Account of policy based on correspondence in NA, RG 260/417, File "Cultural Life in Germany and Occupied Territories. I."

4. R. Huyghe, interview with author, Paris, January 1990.

5. *Art News,* November 25, 1939.

6. Ibid., January 27, 1940.

7. Ibid., September 16, 1939, p. 16.

8. *Dissent,* p. 36.

9. Ibid., p. 32.

10. NA, RG 239/84, DIR Bornheim.

11. NA, RG 239 and 260, various sources: DIR Hoffmann; CIR Linz; Dietrich interrogations, 1945. See also note 25.

12. NGA, Library, Parkhurst Papers, "Statement of K. Haberstock," June 4, 1945, p. 5.

13. NA, RG 260/407, Haberstock evidence, Thormälen testimony.

14. Ibid., Kunisch, Reichsminister und Prussische Minister für Wissenschaft, Erziehung und Volksbildung, to Hitler, November 24, 1935; and to all directors, December 17, 1935.

15. NA, RG 260/405 IV, Haberstock correspondence.

16. Interview with Feilchenfeldt.

17. NA, RG 260/386, Posse correspondence.

18. Speer, *Inside the Third Reich,* p. 90.

19. Ibid., pp. 36–38.

20. Ibid.

21. S. Welles, *The Time for Decision* (New York, 1944), pp. 118–19.

22. NA, RG 239/85, OSS/ALIU CIR 2, Rousseau, "The Goering Collection," September 13, 1945.

23. NA, RG 260/172, Goering interrogation, December 22, 1945; and 260/82, birthday lists.

24. Henderson, op. cit., p. 123.

25. NA, RG 239/77, OSS/ALIU CIR 4, Faison, "Linz: Hitler's Museum and Library," December 14, 1945, p. 2.

26. W. Schellenberg, *Memoirs* (London, 1956), pp. 50–51.

27. W. Shirer, *Berlin Diary* (New York, 1941), p. 111.

28. D. Wilson, *Rothschild* (New York, 1988), pp. 370–71.

29. Shirer, *Berlin Diary,* p. 189.

30. NA, RG 59, SD Cable 862.4016/2103, Geist, Berlin, to Secretary of State, April 11, 1939.

31. NA, RG 260/388, Posse-Bormann correspondence.

32. Speer, op. cit., p. 109.

33. NA, RG 260/415, complete file of German records on transfer.

34. NA, RG 260/185, Nuremberg Document 1499-PS.

35. See E. Kubin, *Sonderauftrag Linz* (Vienna, 1988), pp. 21–22. From a file in Kunsthistoriches Archives, Duveen to Mühlmann, March 2, 1939, and Dworschak to Amt Reichsstatthalter, Wien, April 4, 1939. Also NA, RG 260/388, Dworschak to Posse, October 20, 1939.

36. NA, RG 260/394, Mühlmann interrogations.

37. S. L. Faison, note to author, February 1993.

38. D. Tutaev, *The Consul of Florence* (London, 1966), pp. 11–12.

39. NA, RG 260/298.

40. CIR Linz, Attachment 1.

41. NA, RG 260/386 II, ledgers for Linz operation.

42. NA, RG 260/388 II, Bormann to Buerckel.

43. Columbia University, Hathaway Papers, Limberger to Zentralstelle für Denkmalschutz, Vienna, October 23 and November 19, 1939.

44. NA, RG 260/388, Posse-Bormann correspondence, May 16, 1940.

45. NA, RG 260/298, Statement of Dr. Buchheit, Director, Bavarian National Museum, April 18, 1946; also OSS/ALIU DIR Buchner.

46. NA, RG 260/388, Posse-Bormann correspondence.

47. Ibid., Posse to Bormann, May 27, 1940.

48. NA, RG 260/387, Posse Report, June 1940.

49. NA, RG 260/438, original Reichschancellery file on purchase.

50. *Beaux Arts,* August 18, 1939, letter from Maria Teresa Le—(illegible) and Rafael Alberti.

51. ANF, RG F21-3981, Report to the Ministry of Education, November 13, 1939.

52. Ibid.

53. K. Clark, *The Other Half* (London, 1977), p. 1.

54. See *The National Museums and Galleries: The War Years and After* (London, 1948).

55. See A. Frankfurter, "Rescued Prado at Geneva," *Art News,* July 15, 1939; *Magazine of Art,* July 1939; and J. Russell, "Masterpieces Caught Between Two Wars," *The New York Times,* September 3, 1989.

56. R. Gimpel, *Diary of an Art Dealer* (London, 1986), p. 446.

57. See P. Corémans, *La Protection scientifique des oeuvres d'art en temps de guerre* (Brussels, 1946).

58. M. Hours, *Une Vie au Louvre* (Paris, 1987), p. 43.

59. Ibid., p. 44. Translated by author.

60. Ibid., p. 46.

III. EASTERN ORIENTATIONS

1. A. Hitler, *Mein Kampf* (London, 1974), pp. 596–98.

2. Shirer, *Third Reich,* p. 532.

3. NA, RG 59, SD Cable 740.00/1906 #1120, Warsaw, June 26, 1939.

4. See S. Lorentz, *Museums and Collections in Poland, 1945–1955* (Warsaw, 1956); C. Estreicher, *Cultural Losses of Poland* (London, 1944); *Nazi Kultur in Poland* (London, 1945).

5. E. Raczynski, *In Allied London* (London, 1962), pp. 66–67.

6. NA, RG 59, SD Cable 740.00116 EW 1939/96 #1075, September 22, 1939.

7. Schellenberg, *Memoirs,* p. 75.

8. R. C. Lukas, *The Forgotten Holocaust* (Lexington, 1986), p. 3, n. 9.

9. Shirer, *Third Reich,* pp. 938, 944.

10. O. Abetz, *Histoire d'un politique franco-allemand* (Paris, 1953), pp. 113–14.

11. Leonard Papers, Washington, D.C., H. Lehmann-Haupt, "Cultural Looting of the Ahnenerbe," OMGUS, Berlin, March 1, 1948, no. 183, p. 60.

12. *Nazi Kultur,* p. 100.

13. T. Potocki, interview with author.

14. See A. Potocki, *Master of Lancut* (London, 1959).

15. NA, RG 260/394, Mühlmann testimony.

16. G. Mihan, *Looted Treasure* (London, 1944), p. 62.

17. NA, RG 260/416, 417, Ahnenerbe documents.

18. NA, RG 239/77, CIR Linz, Attachment 5.

19. NA, RG 239/85, CIR Goering, p. 31.

20. Mühlmann testimony.

21. NA, RG 260/430, MFAA "Report on the Cracow Altarpiece," November 8, 1947.

22. NA, RG 260/394, Barthel to Mühlmann, December 19, 1939.

23. NA, RG 260/430, Breslau correspondence.

24. Speer, *Inside the Third Reich,* pp. 94–95.

25. NA, RG 260/430, account of Kraut's activities based on extensive files of SS correspondence.

26. *Berliner Morgenpost,* February 10, 1942.

27. NA, RG 260/430, Grundmann testimony. Also D. Frey, "Report on My Activity in Poland," 1947. University of Regina, Heinrich Papers.

28. D. Frey, *Bausteine zu Einer Philosophie der Kunst,* ed. W. Frodl (Darmstadt, 1976), p. ix.

29. NA, RG 239/9, DIR Dienststelle Mühlmann.

30. Potocki, op. cit., pp. 282–83.

31. Grundmann's actions from his testimony, and his Diary, kindly provided to author by C. Friemuth.

32. NA, RG 238/66c, Frank diary, various entries. Frank kept an hour-by-hour diary during his entire tenure in Poland. It is preserved at the NA as part of the Nuremberg trials evidence.

33. Grundmann testimony.

34. Frank diary, March 17, 1945.

IV. LIVES AND PROPERTY

1. D. Sutton, "L'Amateur accompli: Frits Lught," in *Treasures from the Collection of F. Lught at the Institut Neerlandais* (Paris, 1976).

2. Interview with Feilchenfeldt.

3. A. Venema, *Kunsthandel in Nederland, 1940–1945* (Amsterdam, 1986), p. 56.

4. S. K. Binkhorst, interview with author.

5. D. H. Goudstikker von Saher, interview with author.

6. Ibid.

7. Ibid.

8. A. Scherpuis, "Een Heer in de Kunsthandel," *Vrij Nederland,* November 10, 1990. Courtesy of S. K. Binkhorst.

9. NA, RG 239/11, SHAEF First Canadian Army Report, September 2–16, 1944.

10. H. Brubach, "Survivors," *The New Yorker,* August 27, 1990, p. 74.

11. P. Guggenheim, *Out of This Century* (New York, 1987), p. 196.

12. Ibid., p. 219.

13. R. Valland, *Le Front de l'art* (Paris, 1961), chap. 2; L. Mazauric, *Le Louvre en voyage, 1939–1945* (Paris, 1978), chap. 2.

14. Mazauric, op. cit., p. 45. Translated by author.

15. Y. Bizardel, *Sous l'occupation* (Paris, 1964), pp. 11–12.

16. A. Barr, *Matisse* (New York, 1951), p. 255.

17. Mazauric, op. cit., pp. 58–59. Translated by author.

18. W. Shirer, *The Collapse of the Third Republic* (New York, 1971), pp. 786–87.

19. R. Murphy, *A Diplomat among Warriors* (New York, 1964), p. 41.

20. W. Churchill, *The Second World War* (Boston, 1951), vol. II, p. 153.

21. Guggenheim, op. cit., p. 219.

22. NA, RG 239/75, Rosenberg to Henraux, December 15, 1944.

23. Barr, op. cit., p. 256.

24. D. Wilson, *Rothschild* (New York, 1988), p. 372.

25. NA, RG 239/74, Bernheim-Jeune deposition.

26. M. Fabiani, *Quand j'étais marchand de tableaux* (Paris, 1976), pp. 22–23.

27. SD, RG 59/10, Ardelia Hall Records, Dispatch 9E135341, July 13, 1949.

28. NA, RG 239/82, British Economic Advisory Board Report, July 3, 1945.

29. UST/FFC, Report NY 8-943, RG 131/785, May 28, 1942.

30. See M. Davies and I. Rawlins, *War Time Storage in Wales of Pictures from the National Gallery* (London, 1940).

31. J. Rothenstein, *Brave Day, Hideous Night* (London, 1967), p. 84.

32. R. Breitman, *Architect of Genocide: Himmler and the Final Solution* (New York, 1991), p. 117.

33. M. Kater, *Das Ahnenerbe der SS* (Stuttgart, 1974), p. 171.

34. Ibid., pp. 174–77.

35. *Goebbels Diaries,* ed. L. P. Lochner (New York, 1948), p. 434.

36. NA, RG 260/185, Keitel to CIC-OKW, July 5, 1940.

37. Ibid., Report on Activities of the ERR in the Netherlands, Nuremberg Document 175-PS.

38. F. Duparc, *Een eeuw wedstrijd voor Nederland's cultureel erfgoed* (The Hague, 1975), p. 28.

39. NA, RG 260/394, CIR Dienststelle Mühlmann, Vlug, December 25, 1945.

40. Duparc, op. cit., p. 28.

41. NA, RG 239/85, CIR Goering, p. 139; CIR Dienststelle Mühlmann, pp. 46, 29.

42. NA, RG 260/387, Posse-Bormann correspondence, September 23, 1940.

43. Duparc, op. cit., p. 230.

44. NA, RG 239/83, Waterhouse, "Report on Amsterdam," May 13, 1945; and 239/79, "Traduction #3448 for J. Vlug."

45. All accounts of Plietzsch activities from CIR Dienststelle Mühlmann.

46. See Venema, op. cit.

47. Ibid., p. 62; and NA, RG 239/61, SHAEF Report, LaFarge, "Removal of Works of Art from the Netherlands," December 29, 1944.

48. NA, RG 239/77, CIR Linz, Attachment 2.

49. Venema, op. cit., p. 218.

50. NA, RG 260/394, Mühlmann interrogations.

51. NA, RG 239/80, OSS/ALIU Miedl Report 2, Rousseau, undated.

52. CIR Goering, pp. 65–74.

53. LaFarge Report; CIR Goering, p. 68.

54. CIR Goering, pp. 92–94, Attachments 41–44, and p. 60.

55. Venema, op. cit., pp. 238–53; and CIR Goering, pp. 74–76.

56. Venema, op. cit., pp. 254–66; CIR Goering, p. 82; NA, RG 260/387, Posse correspondence, "Memo for Bormann," May 10, 1941.

57. NA, RG 239/84, DIR Hofer, p. 7.

58. Venema, op. cit., pp. 267–70; and CIR Goering, pp. 80–83.

59. CIR Goering, p. 62.

60. H. von Schirach, *Der Preis der Herrlichkeit* (Munich, 1975), pp. 196–97; and Venema, op. cit., pp. 143–44.

61. OSS Miedl Reports.

62. CIR Linz, Attachment 60, October 14, 1940.

63. Ibid., Supplement, p. 8.

64. Account based on Venema, op. cit., pp. 173–85; CIR Linz, pp. 36–38; OSS Miedl Reports.

65. Mühlmann interrogations.

66. NA, RG 260/387, Bormann to Hannsen, October 13, 1940.

67. CIR Linz, Attachment 8.

68. NA, RG 260/387, Posse-Bormann correspondence, February 4, 1941.

V. LENITY AND CRUELTY

1. W. Shirer, *The Collapse of the Third Republic*, p. 880.

2. A. Horne, *To Lose a Battle* (London, 1979), p. 647.

3. R. Aron, *Histoire de Vichy* (Paris, 1954), p. 72.

4. Cited in Shirer, *Third Republic,* p. 914.

5. Shirer, *Berlin Diary,* July 9, 1940, p. 449.

6. R. Murphy, A Diplomat among Warriors, p. 43.

7. Shirer, *Third Republic,* p. 781.

8. Speer, *Inside the Third Reich,* pp. 170–73.

9. NA, RG 260/428, Keitel to Lorey, June 24, 1940, p. 449.

10. Aron, op. cit., pp. 232–36.

11. Horne, op. cit., p. 652.

12. NA, RG 239, Metternich, "Concerning My Activities as Adviser on the Protection of Monuments, 1940–42," undated.

13. Mazauric, *Le Louvre en voyage,* p. 79.

14. J. Cassou, *Le Pillage par les Allemands* (Paris, 1947), p. 77.

15. Abetz, *Histoire d'un politique franco-allemand,* p. 143.

16. Valland, *Le Front de l'art,* pp. 235–36.

17. Cassou, op. cit., pp. 80–81. Army ordinance of July 15, 1940.

18. Ibid., p. 82.

19. Valland, op. cit., pp. 235–36. Abetz to von Brauchitsch, August 8, 1940.

20. NA, RG 239, Hentzen interrogation, June 22, 1945.

21. Metropolitan Museum library, "Bericht auf Erlass des Herrn Reichsministers und Chefs der Reichskanzlei . . ." known as Kümmel Report, completed December 31, 1940.

22. See F. H. Taylor, *The Taste of Angels* (Boston, 1948); E. R. Chamberlain, *Loot* (New York, 1983); P. Clemen, *Protection of Art During War,* vol. 1 (Leipzig, 1919).

23. Metternich Report, p. 7.

24. NA, RG 260/411, "Zusammenarbeit der Chefs der Militärbewaltung . . ." Report, September 13, 1940.

25. G. Lowry, *A Jeweler's Eye* (Washington, D.C., 1988), p. 11.

26. NA, RG 260/411, Keitel to CIC France, September 17, 1940.

27. NA, RG 260/429, Abetz Report, February 1, 1941.

28. Cited in C. Friemuth, *Die Geraubte Kunst* (Brunswick, 1989), pp. 29–30.

29. Aron, op. cit., p. 209.

30. Valland, op. cit., p. 55ff.

31. NA, RG 239/85, CIR Goering; Valland, op. cit., ch. 8.

32. Cassou, op. cit., pp. 132–33.

33. CIR Goering.

34. Cassou, op. cit., p. 105.

35. NA, RG 239/85, OSS/ALIU CIR 1, Plaut, "Activity of the ERR in France," August 15, 1945, Attachment 4.

36. NA, RG 239/77, CIR Linz, Attachments 56a and 56b.

37. NA, RG 260/427, ERR Records, Landowska correspondence.

38. CIR Linz, Attachment 56.

39. NA, RG 239/82, "Report on Measures for the Seizure of Jewish Property," January 29, 1941.

40. Valland, op. cit., p. 75.

41. NA, RG 260/410–13, ERR correspondence.

42. NA, RG 239/85, CIR ERR, p. 53.

43. Ibid., Attachment 9, p. 6.

44. Ibid., pp. 20–21.

45. NA, RG 260/387, Posse correspondence, January 30 and 31, 1941.

46. L. B. Dorléac, *Histoire de l'art: Paris 1940–44* (Paris, 1986), p. 301.

47. Mazauric, op. cit., pp. 135–36.

48. Cassou, op. cit., pp. 92–98.

49. CIR ERR, Attachment 9.

50. Ibid., Attachment 5, December 18, 1941.

51. Ibid., OKH to CIC France, January 28 and February 8, 1942.

52. NA, RG 260/411, von Behr Directive, February 21, 1942.

53. NA, RG 260/413, COD Plan of Transport, March 1, 1942.

54. NA, RG 260/414, Pottier to Seligman, October 28, 1942.

55. NA, RG 260/185, Progress Report of Dienststelle Westen to July 31, 1944, Nuremberg Document L188.

56. *Nouveau Journal,* March 24, 1942, p. 2.

57. Bizardel, *Sous l'occupation,* pp. 93–101.

58. Mazauric, op. cit., pp. 81–85.

59. Ibid., p. 128.

60. Interview with Huyghe, Paris, January 1990.

61. Valland, op. cit., pp. 130–36.

62. NA, RG 260/428, various Reichschancellery records and reports; 260/181, Buchner correspondence.

63. *New York Herald Tribune,* February 26, 1943.

64. Aron, op. cit., p. 564.

65. NA, RG 239/76, SHAEF Report, March 6, 1945.

66. See CIR Goering; Valland, op. cit., ch. 17; Metternich Report, pp. 13–14. Also Huyghe interview.

67. Assouline, *An Artful Life,* p. 262.

68. G. Stein, *Wars I Have Seen* (New York, 1945), p. 69.

69. J. Weld, *Peggy, The Wayward Guggenheim* (New York, 1986), pp. 210–11.

70. Guggenheim, *Out of This Century,* pp. 223–24.

71. C. McCabe, "Wanted by the Gestapo: Saved by America," in J. Jackman and C. Borden, eds., *The Muses Flee Hitler* (Washington, D.C., 1983), p. 82.

72. Weld, op. cit., p. 212.

73. McCabe, op. cit., pp. 102–103.

74. V. Fry, *Surrender on Demand* (New York, 1945), p. 113.

75. Weld, op. cit., p. 218.

76. Ibid., pp. 218, 233–34.

77. Fry, op. cit., pp. 101–103.

78. Ibid., p. 130.

VI. BUSINESS AND PLEASURE

1. NA, RG 239/6, "The Bunjes Papers: German Administration of the Fine Arts in the Paris Area," Control Council for Germany, British Element, February 16, 1945, p. 45.

2. *Nieuwe Rotterdamsche Courant,* March 25, 1942.

3. ANF, RG AJ40/1673, Bunjes Papers.

4. *Nouveau Journal,* December 14, 1942.

5. K. E. Maison, *Honoré Daumier* (New York, 1968), pp. 16, 157.

6. NA, RG 239/85, CIR Goering.

7. NA, RG 239/84, Schenker Papers.

8. NA, RG 260/32, Hesse testimony, July 13, 1945.

9. NA, RG 239/77, CIR Linz, Supplement, p. 8.

10. NA, RG 239/84, DIR Bornheim.

11. NA, RG 260/404, Dietrich Records.

12. NA, RG 260/387, Posse correspondence, February 24, 1941.

13. NA, RG 239/77, OSS Special Report on the Firm of Wildenstein, Cooper, September 20, 1945, p. 1.; UST/FFC, Report NY 8-943, RG 131, Butler to Pehle, October 9, 1941.

14. See OSS Cooper Report, September 20, 1945, and UST/FFC, Report NY 8-943.

15. NA, RG 239/84, DIR Haberstock.

16. Assouline, *An Artful Life,* p. 282.

17. UST/FFC, RG 131/719, intercept, Wildenstein to Dequoy, April 2, 1941.

18. ANF, RG AJ38, Inventory of Records of Commissariat Général aux Questions Juives. The records themselves are sequestered, but the inventory and its introduction are informative.

19. Assouline, op. cit, pp. 283–84.

20. NA, RG 260/412, Kunstschutz Reports, May 15, 1941.

21. ANF, RG AJ40/614, Dossier Wildenstein.

22. Cooper Report, Attachment B.

23. UST/FFC files, various intercepts.

24. Ibid. Also NA, RG 260/82, British Economic Advisory Branch Report, March 7, 1943.

25. NA, RG 239/14, Dinsmoor to Cairns, December 11, 1943.

26. NA, RG 239/7, Censorship intercept.

27. *Art Digest,* January 15, 1941, p. 2; *Art News,* September 1941, p. 26.

28. NA, RG 239/7, UST/FFC, Report NY 8-2818, January 18, 1944.

29. Ibid., N.Y. Art Market File.

30. NA, RG 239/84, DIR Rochlitz.

31. CIR Goering, Attachment 1, Hofer to Goering, September 26, 1941.

32. NA, RG 239/84, DIR Hofer, pp. 5–6.

33. Getty Center, Cooper Papers, Hofer to Goering, July 18, 1941.

34. Following based on Cooper Papers, Reports on Looted Works in Switzerland, January 21, 1945; and NA, RG 239/37, March 22, 1945.

35. NA, RG 239/39, Safehaven Report 225, von Hirsch to unidentified recipient, August 24, 1942.

36. NA, RG 260/188, Rosenberg to Hitler, April 16, 1943. Nuremberg Document 015-PS.

37. Valland, *Le Front de l'art*, pp. 180–81.

38. Getty Center, Arntz Archive, list and letter, Valland, December 10, 1962.

39. NA, RG 239/84, DIR Voss.

40. NA, RG 239/79, DGER Report on Schloss collection, undated; CIR Linz, pp. 29–34; DIR Lohse; Valland, op. cit., chap. 13; NA, RG 260/405, Haberstock correspondence.

41. CIR Linz, Attachment 35a.

42. Venema, *Kunsthandel in Nederland,* p. 153.

43. G. Heller, *Un Allemand à Paris* (Paris, 1981), p. 189.

44. E. Jünger, *Journal* (Paris, 1951), various.

45. Heller, op. cit., pp. 62–63.

46. NA, RG 260/410, "The Gould Case," Report of Chief of Military Administration for Northwest France, July 27, 1943.

47. P. Audiat, *Paris pendant la guerre* (Paris, 1946), p. 29.

48. Bizardel, *Sous l'occupation,* pp. 58–60.

49. Ibid., p. 65; Dorléac, *Histoire de l'art,* pp. 51, 118.

50. Bizardel, op. cit., pp. 71–77.

51. Dorléac, op. cit., pp. 121–23.

52. Bizardel, op. cit., pp. 147–49.

53. Ibid., p. 92.

54. Jünger, op. cit., p. 186.

55. Cited in Dorléac, op. cit., p. 94.

56. Ibid., pp. 93, 420.

57. Ibid., pp. 29, 54.

58. J. Flanner, *Men and Monuments* (New York, 1957), p. 163.

59. Barr, *Matisse,* pp. 562–63.

60. Bizardel, op. cit., pp. 123–24.

VII. PLUS ÇA CHANGE

1. Shirer, *Third Reich,* p. 830.

2. Himmler speech, July 13, 1941, cited in R. Breitman, *Architect of Genocide,* p. 177.

3. Ibid., p. 283.

4. Rorimer Papers, New York, Rosenberg to Reichskommissar of Kovno, August 20, 1941.

5. Shirer, op. cit., p. 853.

6. Account based on S. P. Varshavskii, *Saved for Humanity* (Leningrad, 1985), and H. Salisbury, *The 900 Days* (New York, 1969).

7. A. Hitler, *Monologe im Führer Hauptquartier, 1941–1944,* ed. W. Jochman and H. Heim (Hamburg, 1980), August 6, 1942, p. 330, and July 11 and 12, 1941, p. 40.

8. Account based on S. Massie's excellent *Pavlovsk: The Life of a Russian Palace* (Boston, 1990), chap. 11.

9. *Deutsche Zeitung in den Niederlanden,* July 15, 1943, p. 5.

10. Leonard Papers, Washington, D.C., Lehmann-Haupt, "Cultural Looting of the Ahnenerbe," Document 279a.

11. Ibid., Documents 224, 251, 286.

12. NA, RG 260/428, Keitel to Lorey, September 3, 1941.

13. NA, RG 260/185, Kube to Rosenberg, September 29, 1941, Nuremberg Document 1099-PS.

14. See Massie, op. cit., chap. 13.

15. Account of Hermitage events based on Varshavskii, op. cit.

16. Ahnenerbe Document 271, April 8, 1943.

17. NA, RG 260/185, Führererlass, March 1, 1942.

18. Ahnenerbe Documents 225–27; and Kater, *Das Ahnenerbe der SS,* p. 155.

19. *Monologe,* op. cit., p. 39.

20. Ahnenerbe Document 295.

21. NA, RG 260/438, Bender File.

22. L. Lochner, ed., *The Goebbels Diaries 1942–43* (New York, 1948), April 20, 1943, p. 338.

23. NA, RG 260/412, Generalkommando von Förster, July 19, 1943.

24. *Pester Lloyd Abendblatt,* May 20, 1943.

25. *Kolnische Zeitung,* April 4, 1942.

26. Ahnenerbe Documents 273 and 275. Also NA, RG 260/185, Utikal Reports October 21 and 26, 1943, Nuremberg Document 035-PS.

27. *The Trial of the Major War Criminals before the International Military Tribunal,* vol. 7, p. 97. USSR Document 376, Utikal Directive August 23, 1944.

28. *New York Herald Tribune,* February 17, 1944.

29. NA, RG 239/19, OSS R&A Report 2555, September 20, 1944.

VIII. INCH BY INCH

1. *The Protection of Cultural Resources Against the Hazards of War* (Washington, D.C., February 1942), p. iii.

2. NGA, Archives, RG 17a, Evacuation File.

3. C. Tomkins, *Merchants and Masterpieces* (New York, 1973), p. 283.

4. AAA, Constable Papers, Constable to "M.B.", June 15, 1941.

5. *Washington Post,* December 17, 1941.

6. NGA, Library, "Minutes of a Special Meeting of the Association of Museum Directors on the Problems of Protection and Defense Held at the Metropolitan Museum of Art, December 20 and 21, 1941."

7. AAA, Barr Papers, Barr to Bliss, October 19, 1942.

8. G. Stout, "Preservation of Paintings in Wartime," *Technical Studies,* January 1942.

9. NGA, Archives, Evacuation File.

10. Ibid.

11. "U.S. Museums," *Art News,* January 1–14, 1942.

12. NA, RG 239/54, American Defense Harvard, Final Report.

13. Constable Papers, Constable to Leland, September 25, 1942.

14. NA, RG 239/53, Taylor to Sachs, December 4, 1942.

15. Ibid., Taylor memo for submission to the President, November 24, 1942.

16. NGA, Archives, RG 17a-WWII, Proposal Regarding Protection of European Monuments.

17. NA, RG 239/53, Stone to FDR, December 8, 1942.

18. For exhaustive and surprisingly fascinating detail on this issue see H. L. Coles and A. K. Weinberg, *Civil Affairs: Soldiers Become Governors* (Washington, D.C., 1964).

19. Ibid., p. 3.

20. Constable Papers, Clark to Constable, February 25, 1943.

21. Ibid., Maclagan to Constable, February 26, 1943.

22. NA, RG 239/19, SD Bulletin, January 9, 1943.

23. See C. L. Woolley, *A Record of the Work Done by the Military Authorities for the Protection of the Treasures of Art and History in War Areas* (London, 1947).

24. Ibid., p. 8.

25. Constable Papers, Shoemaker to Perry, March 10, 1943.

26. Ibid., Shoemaker to Perry, April 3, 1943.

27. Ibid., Constable to Stout, April 10, 1943.

28. Ibid., Shoemaker to Constable, April 19, 1943.

29. NA, RG 165/463, CAD Records, Haskell memo for Bundy, March 26, 1943.

30. Ibid., correspondence and memos, April 1943.

31. Constable Papers, Shoemaker to Perry, May 14, 1943.

32. Ibid., Stout to Constable, May 26, 1943.

33. Ibid., Sachs to various, June 17, 1943.

34. NA, RG 239/53, memo on Protection Project, May 30, 1943.

35. NA, RG 239/12, Hull to FDR, June 21, 1943.

36. NA, RG 165/463, CAD correspondence, July 1–6 and 27, 1943.

37. NA, RG 239/27, Hammond, "Report on Work in Italy," undated.

38. E. Pyle, *Brave Men* (New York, 1944), p. 18.

39. T. Sizer, "A Walpolean at War," *The Walpole Society Notebook,* 1946, p. 68.

40. NA, RG 165/463, Hammond to Reber, July 24, 1943.

41. NA, RG 239/47, cable, Lang to Calhoun, July 7, 1944.

42. *New York Herald Tribune,* August 10, 1943.

43. NA, RG 239/56, Events in Sicily from various field reports filed by Hammond and Maxse.

IX. THE RED-HOT RAKE

1. Speer, *Inside the Third Reich,* pp. 307–308.

2. See B. Molajoli, *Musei ed opere d'arte di Napoli attraverso la guerra* (Naples, 1948).

3. *Berliner Boersen Zeitung,* August 12, 1943, p. 2.

4. NA, RG 239/24, Filangeri, "Report on Destruction," September 30, 1943.

5. H. C. Butcher, *My Three Years with Eisenhower* (New York, 1946), p. 434.

6. Molajoli, op. cit., p. 47.

7. Hammond, "Report on Work in Italy," p. 18.

8. NA, RG 239/13, Finley-McCloy correspondence.

9. *Daily Telegram,* July 21, 1943.

10. *The New York Times,* September 11, 1943.

11. NA, RG 239/13, Finley to McCloy, October 2, 1943.

12. NA, RG 239/18, Apostolic Delegate to Cairns, May 4, 1943.

13. NA, RG 239/51, McCloy to Finley, undated.

14. Coles and Weinberg, *Civil Affairs,* pp. 216–14.

15. Butcher, op. cit., p. 460.

16. Woolley, *Record,* pp. 23–24.
17. NA, RG 239/58, Guidebook to The Royal Palace, Naples.
18. Woolley, op. cit., p. 28.
19. Tutaev, *The Consul of Florence,* p. 42.
20. NA, RG 239/59, AMG Report 65, pp. 40–41.
21. Ibid., Sjogvist, "Pro Memoria," October 2, 1944.
22. Ibid., AMG Report 49, von Tieschowitz, "Report to Rahn," November 19, 1943.
23. Ibid., "Daily Reports," p. 7.
24. Tutaev, op. cit., pp. 93–94.
25. NA, RG 239/64, Cooper and De Wald, "Report on the German Kunstschutz in Italy," June 30, 1945.
26. Von Tieschowitz Daily Reports, p. 10.
27. RC, Final Report, June 1946, p. 80.
28. Sjoqvist, op. cit., p. 6.
29. NGA, Library, Parkhurst Papers, Keynes to Walker, February 15, 1944.
30. M. W. Clark, *Calculated Risk* (New York, 1950), p. 322.
31. D. Hapgood and D. Richardson, *Monte Cassino* (New York, 1984), p. 227.
32. *The New York Times,* March 13, 1944.
33. NA, RG 165/463, CAD Section 4, Office of Director of Operations, February 23, 1944.
34. Ibid., War Department Cables 54038 and 46439, June 3, 1944.
35. NA, RG 239/58, Cott, Field Report, July 11, 1943.
36. NA, RG 239/38, Pinsent, AMG Report 24, p. 11.
37. NA, RG 165/463, quoted in undated draft speech by John Walker.
38. Movements of Florentine works from NGA, Library, Hartt Papers, Keller Report, February 17, 1945; Enthoven Report, February 21, 1945; Reidemeister Report, June 1945; Ringler Report, undated.
39. Tutaev, op. cit., p. 210.
40. C. Fasola, *The Florentine Galleries and the War* (Florence, 1945), p. 69.
41. NA, RG 239/19, Harrison to Secretary of State, no. 5428, August 19, 1944.
42. Tutaev, op. cit., p. 289.
43. B. Berenson, *Rumor and Reflection* (New York, 1952), p. 382.
44. Fasola, op. cit., p. 61.
45. NA, RG 239/15, Erlich to Sachs, August 4, 1944.
46. F. Hartt, *Florentine Art under Fire* (Princeton, 1949), p. 30.
47. *The New York Times,* August 30, 1944.
48. Hartt, op. cit., p. 47.
49. D. Lang, "Letter from Florence," *The New Yorker,* September 25, 1944, p. 71.
50. Hartt Papers, Keller Report on moving of statue, February 17, 1945.
51. Hartt, op. cit., p. 92.
52. Events in Pisa based on NA, RG 239/59, Keller, Field Reports, September–November 1944.
53. Tutaev, op. cit., p. 92.
54. De Wald-Cooper Report, p. 12.
55. I. Origo, *War in Val d'Orcia* (London, 1984), p. 91.
56. Ibid., p. 113.
57. Ibid., p. 206.
58. Ibid., p. 234.
59. Following based on De Wald-Cooper Report, part 3.
60. Hartt Papers, Ringler Report, pp. 12–13.

61. A. Dulles, *The Secret Surrender* (New York, 1966), p. 93.
62. Ibid., pp. 162–65, 184.
63. Hartt, op. cit., p. 105.
64. Dulles, op. cit., p. 245.
65. NA, RG 239/64, Keller Report, May 22, 1945.
66. Ibid., p. 7.

X. TOUCH AND GO

1. Columbia University, Hathaway Papers, note by Hathaway on document, January 8, 1961.
2. Woolley, *Record,* p. 43.
3. Coles and Weinberg, *Civil Affairs,* pp. 864–65.
4. Ibid., p. 864.
5. NA, RG 239/52, Newton to Sachs, February 2, 1944.
6. NA, RG 239/7, Wildenstein, "Works of Art—Weapons of War and Peace," *La République française,* December 1943. Included as Exhibit "A" in UST/FFC, Report NY 8-2818.
7. NA, RG 239/5, Minutes of RC meeting, February 3, 1944.
8. NA, RG 239/49, Safehaven Project Circular, January 16, 1945.
9. NA, RG 165/463, SD Cable 3281, April 21, 1944.
10. Ibid., Finley to Hilldring, April 28, 1944.
11. Ibid., Hilldring to Finley, May 2, 1944.
12. Ibid., Newton to Hilldring, May 23, 1944.
13. Ibid., Hilldring to Holmes, Cairns, Newton, June 23 and 28, 1944.
14. Minutes of RC meeting, July 27, 1944.
15. NA, RG 239, Finley to McCloy, August 5, 1944.
16. NA, RG 165/463, CAD memo, August 21, 1944.
17. Ibid., Holmes to Hilldring, September 11, 1944.
18. Ibid., Hilldring to Cairns, September 19 and 22, 1944.
19. NA, RG 239/9, Rousseau to Stokes, February 24, 1945.
20. Churchill, *The Second World War,* vol. 6, pp. 12–15.
21. NA, RG 239/24, LaFarge Reports, June 21–24, 1944.
22. J. Rorimer, *Survival* (New York, 1950), p. 15.
23. Rorimer Papers, New York, Rorimer diary, August 9, 1945.
24. ANF, AJ40/573, Bayeux Tapestry File. Courtesy of I. Vernus.
25. NA, RG 239/74, Bernheim-Jeune deposition.
26. Reported to author by Hector Feliciano, Antenne Deux, Paris, May 1993.
27. Mazauric, *Le Louvre en voyage,* pp. 139–41.
28. Ibid., pp. 167–68.
29. Interview with Huyghe.
30. Valland, *Le Front de l'art,* p. 195.
31. Rorimer diary, August 18 and 19, 1944.
32. Ibid., August 23–24, 1944.
33. See Audiat, *Paris pendant la guerre.*
34. NA, RG 260/182, Lohse to Hofer, July 13, 1944.
35. Valland, op. cit., pp. 184–87.
36. NA, RG 260/411, Rosenberg memo, November 24, 1944.

37. Ibid., Hearing summary, January 15, 1945.

38. ANF, AJ 40/573, von Tieschowitz to Busley, June 22, 1944.

39. Rorimer, *Survival,* p. 59.

40. Valland, op. cit., pp. 210–11.

41. NA, RG 239/11, AMG Report 11, "Excerpts from MFAA Report to Oct. 1, 1944."

42. NA, RG 260/386 VI, Figlhuber memo, September 7, 1944, and German Navy memo, September 9, 1944.

43. *The New York Times,* April 12, 1944.

44. This and following Hancock quotes: W. Hancock, "Experiences of a Monuments Officer in Germany," *College Art Journal,* May 1946; and interview.

45. AAA, Stout Papers, diary, various entries.

46. Lord Methuen, *Normandy Diary* (London, 1952), October 23, 1944, p. 62.

47. Rorimer diary, various entries, September 1944.

48. Rorimer Papers, SHAEF Report, February 13, 1945.

49. Rorimer diary, October 26, 1944.

50. Rorimer, *Survival,* p. 89.

51. W. Hancock, interview with author.

52. NA, RG 239/28, Ross, "Report on Visit to Strasbourg 10–17, December, 1944," January 4, 1945.

53. Rorimer Papers. Sommier to Rorimer, October 30, 1944.

54. Ibid., Eighth Report, November 12, 1944.

55. Rorimer diary, March 22, 1945.

56. Clark, *The Other Half,* p. 71.

57. Ibid., p. 73.

58. Rothenstein, *Brave Day, Hideous Night,* p. 140.

59. Fabiani, *Quand j'étais marchand de tableaux,* pp. 140–41.

60. Clark, op. cit., p. 72.

61. J. R. Mellow, *Charmed Circle* (New York, 1974), p. 457.

62. Rothenstein, op. cit., p. 143.

63. Rorimer Papers, Thirteenth/Fourteenth Report, March 10, 1945.

64. The following account is based mainly on I. Kühnel-Kunze, *Bergung, Evakuierung, Rückführung: Die Berliner Museen in den Jahre 1939–1959* (Berlin, 1984); also various articles by and interviews with Klaus Goldmann of the Museum für Vor- und Frühgeschichte, Berlin, especially his "Der Schatz des Priamos," in *Sonderdruck aus Heinrich Schliemann: Grundlagen und Ergebnisse moderner Archäologie 100 Jahre nach Schliemanns Tod,* ed. J. Herrmann (Berlin, 1992).

65. D. Botting and I. Sayer, *Nazi Gold* (New York, 1984), p. 11.

66. NA, RG 239/77, CIR Linz, pp. 78–80.

67. Kubin, *Sonderauftrag Linz,* pp. 71–79.

68. Speer, *Inside the Third Reich,* p. 459.

69. Ibid., pp. 314–15.

70. Following based on Kubin, op. cit., chaps. 2 and 3, which cites many Austrian accounts; NA, RG 260/186, Scholz report to Posey, May 20, 1945; CIR Linz; CIR Goering; DIR-Voss; and many others.

71. NA, RG 260/186, von Hummel to Sieber, May 1, 1945.

72. Kubin, op. cit., p. 130.

73. NA, RG 239/28, Report, unsigned, presumably by Luithlen, May 12, 1945. Also Kubin, op. cit., pp. 130–37.

74. NA, RG 239/85, CIR Goering, pp. 170–73.

75. CIR Goering, pp. 173–74.

76. Shirer, *Third Reich,* pp. 1112–1118.

77. NA, RG 239/77, memo, Newkirk to Sixth Army, August 1, 1945.

78. NA, RG 260/439, Oberkommissar Boos testimony. Report on Field Trip to Berchtesgaden, Taper and Breitenbach, Part 3: General History of Goering Train, for Leonard, September 1, 1947.

79. Ibid., p. 6.

80. Murphy, *A Diplomat among Warriors,* pp. 228–29.

81. LC, Stimson Papers, diary, reel 128.

82. C. Hull, *Memoirs* (New York, 1948), FDR to Hull, October 20, 1944, p. 1621.

83. Murphy, op. cit., p. 228.

84. *Morgenthau Diary* (Washington, D.C., 1967), vol. 2, pp. 1294, 1302.

85. NA, RG 239/38, Harvey to Kefauver, July 18, 1944.

86. Summarized in FRUS, 1945, vol. 2; and Grew to RC February 27, 1945.

87. John Nicholas Brown Center, Brown Papers, JNB to his wife, various, April 1945.

88. NGA, Archives, Minutes of RC meeting, April 26, 1945.

89. NA, RG 165/463, War Department Cables FX74971 and 82956, May 13 and 15, 1945.

XI. ASHES AND DARKNESS

1. AAA, Stout Papers, GS to his wife, March 19, 1945.

2. NA, RG 239/10, DNB broadcast of March 17, 1945, quoted in Stout memo to ComNavEu, April 7, 1945.

3. Hancock, "Experiences," p. 288.

4. Ibid., p. 289.

5. Stout Papers, GS to his wife, April 4, 1945.

6. Hancock, op. cit., pp. 293–94.

7. L. Kirstein, "In Quest of the Golden Lamb," *Town and Country,* September 1945, p. 183; NA, RG 239/11, Third Army Field Reports, April 1945; Kirstein, interview with author.

8. Keck statement on incident, Ninth Army, April 7, 1945. Courtesy of C. H. Smyth.

9. *Morgenthau Diary,* vol. 2, pp. 1131–1132.

10. This account based on AAA, Stout diary; and the report of Col. C. L. Morris, "G-5 Functions in ETOUSA OPS," April 26, 1945, NA copy courtesy of K. Goldmann.

11. Rorimer Papers, Rorimer diary, May 23 and 24, 1945.

12. NA, RG 239/11, Posey Field Report, April 9, 1945.

13. NA, RG 239/77, AMG Report 159, Hancock, May 12, 1945, and Stout diary.

14. AAA, Howe Papers, Moore to Howe, May 13, 1946.

15. Interview with Hancock.

16. NGA, Library, Smyth Papers, SHAEF Document AG 000.4-2 GE-AGM, May 20, 1945.

17. Rorimer, *Survival,* p. 164, and diary.

18. Rorimer's and Hathaway's diaries for early May are the principal sources for Berchtesgaden events. See also Rorimer's *Survival.*

19. Rorimer diary, May 10, 1945, and *Survival,* pp. 199–200.

20. *New York Herald Tribune,* May 20, 1945.

21. *Time,* May 28, 1945.

22. NGA, Archives, Walker diary, 1945.

23. NA, RG 260/33, CID Report TPMCID15, March 22, 1948.

24. Kubin, *Sonderauftrag Linz,* pp. 141–43.

25. Kirstein, op. cit., p. 186.

26. Ibid., p. 189.

27. NA, RG 260/186, Scholz Report, May 20, 1945.

28. Stout Papers, GS to his wife, May 15, 1945.

29. Stout diary, May 21, 1945.

30. Ibid., June 5, 1945.

31. Columbia University, Hathaway Papers, Hathaway diary, May 21–24, 1945.

32. Botting and Sayer, *America's Secret Army* (New York, 1989), p. 228.

33. NA, RG 260/34, Horn Report, August 14, 1945.

34. J. Skilton, *Défense de l'art européen* (Paris, 1948), chaps. 3 and 4, and p. 86.

35. Hathaway diary, June 1, 1945.

36. Based on various newspaper accounts, June 1946–April 1947, NGA, Parkhurst Papers,

37. Kater, *Das Ahnenerbe,* pp. 44, 80, 90–94.

38. Based on *New York Times* articles and investigations by William Honan, Summer 1990.

39. NA, RG 165/172, CAD Records, April–October 1945.

40. Rorimer diary, May 9, 1945.

41. Account of establishment of Munich Collecting Point based on Smyth's official diary, kindly provided to author, and on conversations with him; Stout and Rorimer diaries; and monthly reports of Collecting Point. See also C. H. Smyth, *Repatriation of Art from the Collecting Point in Munich after World War II,* March 13, 1986 (The Hague, 1988).

42. Account of Kuchumov's travels taken from Massie, *Pavlovsk,* chap. 17.

43. See Goldmann, "Der Schatz des Priamos," in *Sonderdruck aus Heinrich Schliemann,* ed. J. Hermann (Berlin, 1992), and Kühnel-Kunze, *Bergung, Evakuierung, Rückführung* (Berlin, 1984).

44. Getty Center, Arntz Archive, Reutti, "Reports on Post-War Activities," MS.

45. N. Sokolova, "Die Rettung der Dresdener Kunstschatze," in *Jahrbuch 1960, Staatliche Kunstsammlungen* (Dresden, 1961).

46. Reutti, "Die Katastrophe von Karnzow," in op. cit., pp. 85–108. Also *The New York Times,* November 24, 1990, and *Washington Post,* August 16 and 17, 1990.

47. Reutti, "Carinhall" (unpaged), in op. cit.; and Valland, *Le Front de l'art,* p. 150.

XII. MIXED MOTIVES

1. *Morgenthau Diary,* vol. 2, pp. 1371–1373.

2. John Nicholas Brown Center, Brown Papers, JNB to his wife, May 30, 1945.

3. NGA, SG, Excerpts from Crosby Report on Mission to Europe, March 8–June 10, 1945.

4. LC, Finley Papers, unidentified clipping, by-line Associated Press, Paris, June 9, 1945.

5. Brown Papers, memo to Deputy Military Governor, HQ, U.S. Group Control Council, June 1, 1945.

6. NGA, SG, Finley memo, June 18, 1945.

7. NA, RG 165/463, War Department Cable 18531, June 18, 1945.

8. J. Plaut, interview with author.

9. C. Friemuth, *Die Geraubte Kunst,* pp. 123–25.

10. NGA, Archives, Walker diary, 1945 trip to Europe, July 19, 1945.

11. NGA, Library, Smyth Papers, Smyth diary, July 24, 1945.

12. "History of the Wiesbaden Collecting Point, 13 July 1945–5 March 1946." This and various letters, courtesy of W. Farmer.

13. Kuhnel-Kunze, *Bergung, Evakuierung, Rückführung,* pp. 107–109; Friemuth, op. cit., pp. 130–31, 139–40.

14. S. L. Faison, note to author.

15. NA, RG 260/394, CIR Dienststelle Mühlmann, op. cit., p. 57.

16. NA, RG 239/84, DIR Voss, op. cit.

17. NA, RG 260/32, Horn Report, November 27, 1945, and Howe to Horn, December 28, 1945.

18. NA, RG 239/85, CIR Goering, op. cit., p. 176.

19. NA, RG 239/77, CIR Linz, op. cit., p. 86.

20. NA, RG 260/33, Parkhurst memo, July 6, 1945.

21. S. L. Faison, interview with author.

22. FRUS, 1945, vol. 2, p. 943, EAC (45) 59.

23. Brown Papers, Edwards to JNB, May 11, 1945.

24. Ibid., JNB to his wife, May 15, 1945.

25. Walker diary, July 12, 1945.

26. FRUS, 1945, vol. 1, *Conference of Berlin,* Washington, D.C., 1960, Document 356, Pauley to Secretary of State, June 19, 1945, p. 511.

27. Ibid., Document 360, Pauley to Eisenhower, June 27, 1945, p. 514.

28. NA, RG 260/32, memo of conversation, Hammond, July 5, 1945.

29. *Conference of Berlin,* Document 376, memo to delegation, July 14, 1945, p. 538.

30. Ibid., Document 378, U.S. delegation working paper, July 14, 1945, p. 550.

31. LC, Stimson Papers, Kyle diary, July 17, 1945.

32. *Conference of Berlin,* Clay memo, "Art Objects in US Zone," vol. 1, p. 924.

33. Kyle diary.

34. Brown Papers, JNB to his wife, August 7, 1945.

35. Ibid., August 7, 1945.

36. Columbia University, Hathaway Papers, Hammond to Hathaway, July 29, 1945.

37. Ibid., July 31, 1945.

38. *Conference of Berlin,* Documents 924 and 964, Pauley and Clayton memo for Clay, July 30, 1945.

39. Hathaway Papers, JNB to Hathaway, August 2, 1945.

40. NA, RG 200, Clay Papers, Clay to WARCAD, August 7, 1945. Courtesy of John Taylor.

41. Brown Papers, Report, August 10, 1945.

42. Ibid., JNB to his wife, August 12, 1945.

43. FRUS, 1945, vol. 2, p. 945, Byrnes to Pauley, August 14, 1945.

44. NGA, Archives, Byrnes to Roberts.

45. NGA, Archives, Walker diary, August 14, 1945.

46. NGA, SG, FHT to Cairns, September 3, 1945.

47. Ibid., memo of meeting, August 31, 1945.

48. D. E. Finley, *A Standard of Excellence* (Washington, D.C., 1973), p. 162.

49. FRUS, 1945, vol. 2, p. 948, Acheson to Murphy, September 11, 1945.

50. Brown Papers, Hammond to JNB, September 1945.

51. Ibid., Hammond to JNB, September 14, 1945.

52. NGA, SG, Clay to McCloy, September 21, 1945.

53. Brown Papers, JNB to LaFarge, September 27, 1945.

54. NGA, SG, Walker statement at RC board meeting, September 25, 1945.

55. Ibid., Supplement to minutes of meeting of September 25, 1945.

56. Brown Papers, JNB to LaFarge, September 27, 1945.

57. AAA, Howe Papers, Stout to Howe, January 6, 1946.

58. NGA, Archives, "Hanns" to Walker, undated (received by NGA on October 15, 1945).

59. Brown Papers, Standen to JNB, October 28, 1945.

60. NA, RG 239/13, Cott to Sawyer, November 7, 1945.

61. NA, RG 200/10, Clay Papers, NX 55599 cable from McCloy, October 10, 1945.

62. NA, RG 239/9, Hathaway to Phillips, October 25, 1945.

63. Brown Papers, Standen to JNB, November 7, 1945.

64. Courtesy Walter Farmer, Seventh Army to OMG for Stadtkreis Wiesbaden, undated.

65. NGA, Library, Standen Papers.

66. Rorimer Papers, Rorimer to Edwards, November 8, 1945.

67. Howe Papers, Hancock to Howe, August 8, 1945.

68. NGA, Library, Parkhurst Papers, cable, November 9, 1945. "Letter from the Rhineland," *The New Yorker,* November 17, 1945, p. 57.

69. L. Moore, telephone conversation with author.

70. Smyth diary, November 12, 1945.

71. Ibid., November 12, 1945.

72. Brown Papers, JNB to Standen, November 16, 1945.

73. FRUS, 1945, vol. 2, p. 955. Byrnes to Bevin, November 27, 1945.

74. Account based on official reports of Moore and McBride. Also *Keith Merrill: A Memoir* (1968), p. 202. Courtesy of Mrs. R. Seamans.

75. *Washington Times Herald,* November 24, 1945.

76. NGA, SG, Sawyer to Cairns, undated.

77. NGA, Archives, Ritchie to Finley, December 10, 1945.

78. Howe Papers, Kirstein to Howe, January 21, 1946.

79. Ibid., LaFarge to Howe, March 2, 1946.

80. NGA, Archives, Finley to Rich, January 30, 1946.

81. NGA, SG, Finley to Morse, February 12, 1946.

82. *Washington Post,* May 18, 1946.

83. NA, RG 165/172, WDGSS, memo of telephone conversation, Hilldring to Echols, May 3, 1946.

84. Walker diary, July 21, 1945.

85. LC, Finley Papers, Walker to Finley, July 11, 1946.

86. *The Papers of General Lucius Clay: Germany, 1945–1949,* ed. J. E. Smith (Bloomington, 1974), p. 268. Document 160, October 4, 1946.

87. Ibid., p. 552, February 6, 1948.

88. Ibid., p. 555, February 6, 1948.

89. U.S. Congress, Senate Committee on Armed Services, *Hearings on S2439: A Bill to Provide for the Temporary Retention in the US of Certain German Paintings,* March 4 and April 16, 1948, Washington, D.C.: USGPO.

90. Ibid., p. 11.

91. *Papers of General Lucius Clay,* pp. 634–37, April 23, 1948.

XIII. THE ART OF THE POSSIBLE

1. NA, RG 239/14, clipping from *La Libre Belgique,* May 28, 1945.

2. Ibid., Estreicher to Crosby, June 1, 1945.

3. John Nicholas Brown Center, Brown Papers, "Ad-Interim Restitution," memo, May 28, 1945.

4. NA, RG 239/44, Crosby, "Report on Mission to Europe," June 23, 1945.

5. NGA, Library, Smyth Papers. Hammond, "Report on TDY Brussels 5/9/45." Various letters, JNB to A. K. Brown, August 1945.

6. NA, RG 239/41, Murphy to Secretary of State, September 11, 1945, and Acheson to Murphy, September 18, 1945.

7. NA, RG 239/28, U.S. Ambassador Hornbeck dispatch, October 24, 1945.

8. E. E. Adams, "Looted Art Treasures Go Back to France," *The Quartermaster Review,* September–October 1946.

9. A. Ritchie, "The Restitution of Art Loot," *Gallery Notes* (Albright Art Gallery, Buffalo, N.Y.), July 1946.

10. NGA, Library, Lesley Papers, Lesley, Statement on Return of Altar, undated. Also NA, RG 260/3, Bumbar, WAC, MFAA, "Informal Report Covering Return of Veit Stoss Altar," May 24, 1946.

11. S. M. Alsop, *To Marietta from Paris, 1945–1960* (New York, 1975), p. 171.

12. Mrs. A. M. Kellen, New York. Telephone conversation with author.

13. NA, RG 239/6, Petrides to Henraux, April 19, 1945.

14. NA, RG 239/37, Cooper, "Report on Visit to Switzerland," March 22, 1945.

15. Getty Center, Cooper Papers, "Rapport de M. Paul Rosenberg sur son voyage en Suisse," September 1945.

16. NA, RG 239/82, Cooper, "Note of a Conversation with Herr Emil Bührle," Dispatch 13144, December 10, 1945, U.S. Legation, Bern.

17. Getty Center, Cooper Papers, Bührle, "Exposé concernant l'acquisition de tableaux," October 15, 1945, and Bührle to Vodoz, October 17, 1945.

18. NA, RG 239/82, OSS/ALIU, Plaut and Rousseau, "Memo on Investigations in Switzerland," December 9, 1945.

19. Rosenberg Archive, New York, transcript of decision of Chambre des Actions en Revendication de Biens Spoliés, Tribunal Fédéral Suisse, Lausanne, June 3, 1948.

20. NGA, *The Passionate Eye,* exhibition catalogue (Zurich, 1990), p. 22.

21. Rosenberg Archive, A. Rosenberg to H. G. Blechschmid, February 12, 1971.

22. ANF, RG F21, Non-côté, Dossier Jaujard, Douanes to Henraux, January 30, 1946.

23. Ibid., Nicolas to Henraux, undated.

24. Kubin, *Sonderauftrag Linz,* pp. 44–45.

25. Venema, *Kunsthandel in Nederland,* pp. 488–90.

26. NA, RG 239/80, DGER Report, January 1945.

27. Dossier Jaujard, DGER to Jaujard, October 4, 1945.

28. Ibid., Duchartre to Henraux, January 27, 1946.

29. OSS/ALIU, RG 239/7, Wittmann, "Activity of the ALIU in France," October 25, 1945–February 6, 1946.

30. SD, RG 59/10, Ardelia Hall Records, Vollard File.

31. Dossier Jaujard, Gascon to Jaujard, March 25, 1949.

32. NA, RG 239/27, AMG Report 159, Annexure X, "Report on the Western Provinces of Holland," May 1945.

33. See Venema, op. cit., pp. 494–97 and 234–44.

34. See Lord Kilbracken, *Van Meegeren, Master Forger* (New York, 1967).

35. NGA, Library, Standen Papers, MS, "MFAA 1945–47."

36. NA, RG 260/86, Heinrich to RDR Division, January 25, 1949.

37. AAA, Howe Papers, "Summary of December 1950 Monthly Report of the Central Collecting Point, Wiesbaden."

38. *Report of the American Commission for the Protection and Salvage of Artistic and Historic Monuments in War Areas* (Washington, D.C., 1946), p. 46.

39. NA, RG 260/34, memo, Taper to Leonard, January 14, 1948.

40. Princess J. Lubomirska and D. Shelest, conversations with author, Washington, D.C., December 1991.

41. Rorimer, *Survival,* pp. 155–57, and various diary entries. Also memo, Quinn to G-5, Seventh Army, June 10, 1945.

42. *The New York Times,* December 12, 1977, and January 6, 1978.

43. M. Kurtz, *Nazi Contraband* (New York, 1985), pp. 194–97.

44. Ibid., Chapter 7 gives a detailed discussion of the establishment of the JRSO.

45. J. Dornberg, "The Mounting Embarrassment of Germany's Nazi Treasures," *ArtNews,* September 1988, p. 139.

46. Faison diary entry, April 25, 1951, quoted in note to author.

47. Howe Papers, Heinrich to Faison, February 13, 1951.

48. Leonard Papers, Washington, D.C., Haberstock to Breitenbach, August 13, 1947.

49. SD, RG 59/10, Haberstock to Hall, July 1, 1956.

50. SD, RG 59/10, Yugoslavia File.

51. See R. Siviero, *Arte e Nazismo* (Florence, 1984).

52. NGA, Library, Hartt Papers, Keller to Hartt, undated.

53. NA, RG 260/260, note to MFAA, OMGUS, June 14, 1948.

54. Leonard Papers, Leonard to unknown, August 3, 1948.

55. NA, RG 260/260, AG 007PD, Garde to Director, OMGUS, Bavaria, June 19, 1948.

56. Ibid., A-736, 2743, Lovett to USPOLAD, Berlin, December 24, 1948.

57. Standen Papers, Heinrich to Standen, January 4, 1949.

58. S. Munsing, interview with author, Washington, D.C.

59. NA, RG 260/260, Draper to Hawkins, July 5, 1949.

60. Ibid., HICOG memo to Schott, November 23, 1949.

61. Ibid., article from *Die Tat,* Zurich, March 12, 1950.

62. Louvre Museum, Archives, Dossier Valland, Chatelain to Valland, April 1, 1965.

63. Getty Center, Arntz Archive, Reutti, "Post-War Activities," translated by author.

64. SD, RG 59/10, "St. Patroclus" File.

65. Based on author's interview with T. Kline. Also conversations with William Honan, and *New York Times* coverage 1990–1992.

BIBLIOGRAPHY

BOOKS

Abetz, Otto. *Histoire d'un politique franco-allemand.* Paris: Stock, 1953.

Adam, Peter. *The Art of the Third Reich.* New York: Abrams, 1992.

Alsop, Susan Mary. *To Marietta from Paris, 1945–1960.* New York: Doubleday, 1975.

American Commission for the Protection and Salvage of Artistic and Historic Monuments in War Areas. *Report of the American Commission for the Protection and Salvage of Artistic and Historic Monuments in War Areas.* Washington, D.C.: U.S. Government Printing Office, 1946.

Aron, Robert. *Histoire de Vichy.* Paris: Fayard, 1954.

Assouline, Pierre. *An Artful Life.* New York: Grove Weidenfeld, 1990.

Audiat, P. *Paris pendant la guerre.* Paris: Hachette, 1946.

Barr, Alfred H. *Matisse.* New York: MoMA, 1951.

Barron, Stephanie, ed. *Degenerate Art.* Exhibition catalogue, LACMA. New York: Abrams, 1991.

Berenson, Bernard. *Rumor and Reflection.* New York: Simon & Schuster, 1952.

Bernhard, M., and K. Martin. *Verlorne Werke der Malerei, 1939–1945.* Munich: Ackermans, 1946.

Bird, Kai. *The Chairman.* New York: Simon & Schuster, 1992.

Bizardel, Yvon. *Sous l'occupation.* Paris: Calmann-Levy, 1964.

Boothe, Clare. *Europe in the Spring.* New York: Knopf, 1940.

Botting, Douglas, and Ian Sayer. *America's Secret Army.* New York: Watts, 1989.

———. *Nazi Gold.* New York: Congdon and Weed, 1984.

Brassai. *Picasso & Co.* New York: Doubleday, 1966.

Breitman, R. *Architect of Genocide: Himmler and the Final Solution.* New York: Knopf, 1991.

Bureau Central des Restitutions. *Répertoire des biens spoliés en France durant la guerre 1939–1945.* Berlin, 1947.

Burkhard, Arthur. *The Cracow Altar of Veit Stoss.* Munich: Bruckmann, 1972.

Butcher, H. C. *My Three Years with Eisenhower.* New York: Simon & Schuster, 1946.

Cassou, J. *Le Pillage par les Allemands des oeuvres d'art appartenant à des Juifs en France.* Paris: Centre, 1947.

Chamberlain, E. R. *Loot.* New York: Thames and Hudson, 1983.

Churchill, Winston. *The Second World War.* 6 vols. Boston: Houghton Mifflin, 1951.

Clark, K. *The Other Half.* London: John Murray, 1977.

Clark, Mark W. *Calculated Risk.* New York: Harper, 1950.

Clay, Lucius D. *Decision in Germany.* Garden City, N.Y.: Doubleday, 1950.

Clemen, Paul, ed. *Protection of Art During War: Reports.* Leipzig: Seeman, 1919.

Coles, H. L., and A. K. Weinberg. *Civil Affairs: Soldiers Become Governors.* Washington, D.C.: U.S. Army in World War II, Special Studies, 1964.

Collins, Larry, and Dominique LaPierre. *Is Paris Burning?* New York: Simon & Schuster, 1965.

Comnène, N. P. *Firenze città aperta.* Florence: Vallecci, 1945.

Comune di Firenze. *L'Opera retrovata: Omaggio a Rodolfo Sivierio.* Florence, Palazzo Vecchio: Cantini, 1984.

Contemporary German Art. Exhibition Catalogue. Boston: The Institute of Modern Art, 1939.

Corémans, P. *La Protection scientifique des oeuvres d'art en temps de guerre.* Brussels, 1946.

Davidowicz, L. *The War Against the Jews: 1933–1945.* 1975. Reprint. New York: Bantam, 1976.

Davidson, Eugene. *The Trial of the Germans.* New York: Macmillan, 1966.

Davies, Martin, and I. Rawlins. *War Time Storage in Wales of Pictures from the National Gallery.* London: His Majesty's Stationery Office, 1940.

de Jaeger, Charles. *The Linz File.* Toronto: Wiley, 1981.

de Launay, Jacques. *La Belgique à l'heure allemande.* Brussels: Legrain, undated.

Dittrich, Christian. *Vermisste Zeichnungen des Kupferstichkabinetts Dresden.* Dresden: Staatliche Kunstsammlungen, 1987.

Dorléac, L. B. *Histoire de l'art: Paris 1940–44.* Paris: Sorbonne, 1986.

Dulles, Allen. *The Secret Surrender.* New York: Harper & Row, 1966.

Duparc, F. *Een eeuw wedstrijd voor Nederland's cultureel erfgoed.* The Hague: Staatsuitgeverij, 1975.

Eisenhower, David. *Eisenhower at War 1943–1945.* New York: Vintage, 1987.

Elen, Albert. J. *Missing Old Master Drawings from the Koenigs Collection.* The Hague: Netherlands Office for Fine Arts, 1989.

Entartete Kunst. Munich: Austellungführer, 1937.

Estreicher, Charles. *Cultural Losses of Poland: Index of Polish Cultural Losses during the German Occupation.* London, 1944.

Fabiani, Martin. *Quand j'étais marchand de tableaux.* Paris: Julliard, 1976.

Fasola, Cesare. *The Florentine Galleries and the War.* Florence: Monsalvato, 1945.

Finley, David E. *A Standard of Excellence.* Washington, D.C.: Smithsonian, 1973.

Flanner, Janet. *Men and Monuments.* New York: Harper, 1957.

Foreign Relations of the United States. Washington, D.C.: U.S. Government Printing Office. Various.

Foreign Relations of the United States, 1945. Vols. 1 and 2, *The Conference of Berlin.* Washington, D.C.: U.S. Government Printing Office, 1960.

Frank, Niklas. *In the Shadow of the Reich.* New York: Knopf, 1991.

Frans Hals Museum. *Frans Hals Tentoonstelling.* Exhibition catalogue. Haarlem, 1937.

Friemuth, Cay. *Die Geraubte Kunst.* Westermann: Brunswick, 1989.

Fry, Varian. *Surrender on Demand.* New York: Random House, 1945.

Galerie Fischer. *Gemälde und Plastiken Moderner Meister aus Deutschen Museen.* Auction catalogue. Lucerne, 1939.

Galerie Nierendorf. *Fünfzig Jahre, 1920–1970.* Exhibition catalogue. Berlin: Ruckblick Dokumentation Jubileumsausstellung, 1970.

Gimpel, René. *Diary of an Art Dealer.* London: H. Hamilton, 1986.

Goebbels, Joseph. *The Goebbels Diaries 1942–1943.* Edited by Louis P. Lochner. Garden City, N.Y.: Doubleday, 1948.

Golden Gate International Exposition. Art exhibition catalogue. San Francisco, 1940.

Guggenheim, Peggy. *Out of This Century.* New York: Universe, 1987.

Hapgood, David, and David Richardson. *Monte Cassino.* New York: Congdon and Weed, 1984.

Hartt, Frederick. *Florentine Art under Fire.* Princeton: Princeton University Press, 1949.

Heller, Gerhard. *Un Allemand à Paris.* Paris: Seuil, 1981.

Henderson, Sir Nevile. *Failure of a Mission.* New York: Putnam, 1940.

Hentzen, Alfred. *Die Berliner National-Galerie im Bildersturm.* Berlin: Grote, 1971.

Hinz, Berthold. *Art in the Third Reich.* New York: Pantheon, 1979.

Hitler, Adolf. *Mein Kampf.* London: Hutchinson, 1974.

———. *Monologe im Führer Hauptquartier, 1941–1944.* Edited by W. Jochman and H. Heim. Hamburg: Knaus, 1980. Monologues were recorded by Heim and edited by Jochman later.

Hommàge à Herman Voss. Strasbourg, 1966.

Horne, Alastair. *To Lose a Battle.* London: Penguin, 1979.

Hours, Magdeleine. *Une Vie au Louvre.* Paris: Laffont, 1987.

Howe, Thomas C. *Salt Mines and Castles.* New York: Bobbs Merrill, 1946.

Hull, Cordell. *Memoirs.* New York: Macmillan, 1948.

Institute of Contemporary Art. *Dissent: The Issue of Modern Art in Boston.* Exhibition catalogue. Boston, 1985.

International Military Tribunal. *The Trial of the Major War Criminals before the International Military Tribunal.* Nuremberg, 1947–1949. 42 volumes.

Irving, David. *Goering.* New York: Morrow, 1989.

———. *Hitler's War.* New York: Avon, 1990.

Jackman, J. C., and C. M. Borden. *The Muses Flee Hitler.* Washington, D.C.: Smithsonian, 1983.

Jünger, Ernst. *Journal: 1941–1943.* Paris: Julliard, 1951.

Kater, M. *Das Ahnenerbe der SS.* Stuttgart: Deutsche Verlags-Anstalt, 1974.

Kearns, M. *K. Kollwitz: Woman and Artist.* Old Westbury, N.Y.: Feminist Press, 1976.

Keegan, John, ed. *The Times Atlas of the Second World War.* New York: Harper and Row, 1951.

Kesselring, Field Marshal Albert. *Memoirs.* London: Kimber, 1953.

Kilbracken, Lord. *Van Meegeren, Master Forger.* New York: Scribner's, 1967.

Kollwitz, Kaethe. *The Diary and Letters of Kaethe Kollwitz.* Edited by Hans Kollwitz. Chicago: Regency, 1955.

Kopper, Philip. *America's National Gallery of Art.* New York: Abrams, 1991.

Kubin, E. *Sonderauftrag Linz.* Vienna: ORAC, 1988.

Kühnel-Kunze, Irene. *Bergung, Evakuierung, Rückführung: Die Berliner Museen in den Jahre 1939–1959: Ein Bericht mit 43 Anlagen.* (Jahrbuch Preussischer Kulturbesitz.) Berlin: Mann, 1984.

Kunsthaus Zurich. *Sammlung Emil G. Bührle.* Exhibition catalogue. Zurich, 1958.

Kurtz, Michael. *Nazi Contraband: American Policy on European Cultural Treasures 1945–1955.* New York: Garland, 1985.

LaFarge, Bancel. *Lost Treasures of Europe.* New York: Pantheon, 1946.

Lane, Barbara Miller. *Architecture and Politics in Germany 1918–1945.* Cambridge: Harvard, 1968, 1985.

Larsson, Lars Olaf. *Albert Speer: Le Plan de Berlin, 1937–1943.* Brussels: AAM, 1983.

Lehmann-Haupt, Hellmut. *Art under a Dictatorship.* New York: Oxford, 1954.

Lorentz, Stanislaw. *Museums and Collections in Poland, 1945–1955.* Warsaw: Polonia, 1956.

Lowry, Glenn. *A Jeweler's Eye.* Exhibition catalogue. Washington, D.C.: Smithsonian, 1988.

Lukas, R. C. *The Forgotten Holocaust.* Lexington: University of Kentucky, 1986.

Luza, Radomir. *Austro-German Relations in the Anschluss Era.* Princeton: Princeton University Press, 1975.

Maass, Walter B. *Country Without a Name: Austria under Nazi Rule 1938–1945.* New York: Ungar, 1979.

Maison, K. E. *Honoré Daumier.* New York: New York Graphic Society, 1968.

Marlboro Fine Arts. *Nolde: Forbidden Pictures.* Exhibition catalogue. London, 1970.

Massie, Susan. *Pavlovsk: The Life of a Russian Palace.* Boston: Little, Brown, 1990.

Mazauric, Lucie. *Le Louvre en voyage, 1939–1945.* Paris: Plon, 1978.

Meisnner, Hans Otto. *Magda Goebbels.* New York: 1980.

Mellow, James R. *Charmed Circle.* New York: Praeger, 1974.

Merrill, Keith A. *Keith Merrill, American.* Privately printed, 1968.

Methuen, Lord. *Normandy Diary.* London: Robert Hale, 1952.

Mihan, George. *Looted Treasure: Germany's Raid on Art.* London: Alliance, 1944.

Ministerio della Pubblica Instruzione, Direzione General delle Antichita e Belle Arti. *La Ricostruzione del patrimonio artistico italiano.* Rome: La Libreria dello Stado, 1950.

Molajoli, Bruno. *Musei ed opere d'arte di Napoli attraverso la guerra.* Naples: Soprintendenza Alle Gallerie, 1948.

Morgenthau, Henry. *Morgenthau Diary—Germany.* Washington, D.C.: United States Senate Judiciary Committee, U.S. Government Printing Office, 1967. 2 volumes.

Moulin, Raymonde. *Le Marché de la peinture en France.* Paris: Minuit, 1967.

Murphy, Robert. *A Diplomat among Warriors.* New York: Doubleday, 1964.

Musée de l'Orangerie. *Les Chefs d'oeuvre des collections privées françaises retrouvées en Allemagne.* Exhibition catalogue. Paris, 1946.

Museum Boymans. *Kunstschatten uit Nederlandse Verzamelingen.* Exhibition catalogue. Rotterdam, 1955.

National Gallery of Art. *The Passionate Eye: Impressionist and Other Master Paintings from the E. G. Bührle Collection.* Exhibition catalogue. Zurich, 1990.

———. *Twenty-fifth Anniversary Report.* Washington, D.C., 1966.

The National Museums and Galleries: The War Years and After. London: His Majesty's Stationery Office, 1948.

Nicolson, Harold. *Diaries and Letters.* New York: Atheneum, 1967.

Origo, Iris. *War in Val d'Orcia.* London: John Murray, 1984.

Oskar Schlemmer. Exhibition catalogue. Baltimore: Baltimore Museum of Art, 1986.

Palais des Beaux-Arts. *Chefs d'oeuvre récupérés en Allemagne.* Exhibition catalogue. Brussels, 1948.

Polish Ministry of Information. *Nazi Kultur in Poland.* London, 1945.

Potocki, A. *Master of Lancut.* London: W. Allen, 1959.

Prelinger, Elizabeth. *Käthe Kollwitz.* Exhibition catalogue. New Haven: Yale University Press, 1992.

Pretzell, Lothar. *Das Kunstgutlager Schloss Celle 1945–1958.* Celle: 1958.

The Protection of Cultural Resources Against the Hazards of War. Washington, D.C.: Committee on the Conservation of Cultural Resources, National Resources Planning Board, February 1942.

Pyle, Ernie. *Brave Men.* New York: Dutton, 1944.

Raczynski, Edward. *In Allied London.* London: Weidenfeld & Nicolson, 1962.

Rave, P. O. *Kunstdiktatur im Dritten Reich.* Hamburg: Mann, 1949.

Roh, Franz. *Entartete Kunst.* Hannover: Fackeltrager Verlag, 1962.

Rorimer, James J. *Survival.* New York: Abelard, 1950.

Rosenberg, Alfred. *Memoirs of Alfred Rosenberg.* Edited by Serge Lang and Ernst von Schenck. New York: Ziff-Davis, 1949.

Roters, Eberhard. *Galerie Ferdinand Möller, 1917–1956.* Berlin: Mann, 1984.

Rothenstein, J. *Brave Day, Hideous Night.* London: Holt, Rinehart & Winston, 1967.

Roxan, David, and Ken Wanstall. *The Rape of Art: The Story of Hitler's Plunder of the Great Masterpieces of Europe.* New York: Coward-McCann, 1965.

Salisbury, Harrison. *The 900 Days.* 1969. Reprint. New York: Da Capo, 1985.

Samuels, Ernest. *B.B.: The Making of a Legend.* Cambridge: Harvard, 1987.

Schellenberg, Walter. *Memoirs.* London: Deutsch, 1956.

Schirach, Henriette von. *Der Preis der Herrlichheit.* Munich: Herbig, 1975.

Schuster, Peter Klaus, ed. *Nazionalsocialismus und Entartete Kunst: Die Kunststadt München 1937.* Munich: Prestel, 1987.

Shirer, William. *Berlin Diary.* New York: Knopf, 1941.

———. *The Collapse of the Third Republic.* New York: Pocket, 1969, 1971.

———. *The Rise and Fall of the Third Reich.* New York: Simon & Schuster, 1960.

Simon, Matila. *The Battle of the Louvre: The Struggle to Save French Art in World War II.* New York: Hawthorne, 1971.

Siviero, Rodolfo. *Arte e Nazismo: Esodo e ritorno delle opere d'arte italiano 1938–1963.* Florence: Cantini, 1984.

Skilton, John. *Défense de l'art européen.* Paris: Editions Internationales, 1948.

Smith, Jean Edward. *Lucius D. Clay.* New York: Holt, 1990.

Smyth, Craig H. *Repatriation of Art from the Collection Point in Munich after World War II.* The Hague: Gerson Lecture, Schwartz/SDU, 1988.

Speer, Albert. *Inside the Third Reich.* New York: Macmillan, 1970.

Staatsgalerie Moderner Kunst. *Dokumentation zum Nationalsocialismus im Bildersturm.* Munich, 1987.

Stein, Gertrude. *Wars I Have Seen.* New York: Random House, 1945.

Taylor, Francis Henry. *The Taste of Angels.* Boston: Little, Brown, 1948.

Taylor, Telford. *The Anatomy of the Nuremberg Trials.* New York: Knopf, 1992.

Time-Life Books. *World War II* Series.

Tomkins, Calvin. *Merchants and Masterpieces.* New York: Dutton, 1973.

Trevor-Roper, H. R. *The Last Days of Hitler.* New York: Macmillan, 1947.

Tusa, Ann and John. *The Nuremberg Trial.* New York: McGraw-Hill, 1985.

Tutaev, David. *The Consul of Florence.* London: Secker & Warburg, 1966.

U.S. Congress. Senate Committee on Armed Services. *Hearings on S2439: A Bill to Provide for the Temporary Retention in the US of Certain German Paintings,* March 4 and April 10, 1948. Washington, D.C.: U.S. Government Printing Office.

Valland, Rose. *Le Front de l'art.* Paris: Plon, 1961.

Varshavskii, S. P. *Saved for Humanity.* Leningrad: Aurora, 1985.

Venema, A. *Kunsthandel in Nederland, 1940–1945.* Amsterdam: Arbeiderspers, 1986.

Walker, John. *Self-Portrait with Donors.* Boston: Little, Brown, 1974.

Warsaw Accuses. Exhibition catalogue. Warsaw: Ministry of Culture & Art and Ministry of Reconstruction of the Country, 1945.

———. *Papers of General Lucius Clay: Germany, 1945–1949.* Bloomington: Indiana University Press, 1974.

Weld, Jacqueline B. *Peggy, The Wayward Guggenheim.* New York: Dutton, 1986.

Welles, Sumner. *The Time for Decision.* New York: Harper, 1944.

Werth, Alexander. *Russia at War.* New York: Carroll & Graf, 1964.

Wilson, Derek. *Rothschild.* New York: Scribner's, 1988.

Woolley, Sir Charles Leonard. *A Record of the Work Done by the Military Authorities for the Protection of the Treasures of Art and History in War Areas.* London: His Majesty's Stationery Office, 1947.

Works of Art in Italy: Losses and Survivals in the War. Vols. 1 and 2. London: His Majesty's Stationery Office, 1945.

Zachwatowicz, Jan. *Protection of Historical Monuments in People's Poland.* Warsaw: Polonia, 1956.

ARTICLES

Adams, E. E. "Looted Art Treasures Go Back to France." *The Quartermaster Review,* September–October 1946.

Barr, Alfred. "Art in the Third Reich—Preview 1933." *Magazine of Art,* October 1945.

Breitenbach, Edgar. "Historical Survey of the Intelligence Department, MFAA Section, in OMGB, 1946–1949." *College Art Journal* 2 (Winter 1949–50).

Brubach, Holly. "Survivors." *The New Yorker,* August 27, 1990.

Chetham, Charles. "Henri Matisse's *Bathers with a Turtle.*" Museum Monographs I, City Art Museum of St. Louis.

Decker, Andrew. "A Legacy of Shame." *ArtNews,* December 1984.

Dornberg, John. "The Mounting Embarrassment of Germany's Nazi Treasures." *ArtNews,* September 1988.

Frankfurter, Alfred M. "Rescued Prado at Geneva." *Art News,* July 15, 1939.

Gardner, Paul. "A Bit of Heidelberg Near Harvard Square." *ArtNews,* Summer 1981.

Goldmann, Klaus. "Berliner Kulturschatze-unterwegs." In *Die Reise nach Berlin.* Exhibition catalogue. Berlin: Siedler Verlag, 1987.

———. "Der Schatz des Priamos." In *Sonderdruck aus Heinrich Schliemann: Grundlagen und Ergebnisse moderner Archäologie . . . ,* J. Hermann, ed. Berlin: Akademie Verlag, 1992.

Hammond, Mason. "Remembrance of Things Past." In *Proceedings, Massachusetts Historical Society,* vol. 92, Boston, 1980.

Hancock, Walker. "Experiences of a Monuments Officer in Germany." *College Art Journal,* May 1946.

Kirstein, Lincoln. "In Quest of the Golden Lamb." *Town and Country,* September 1945.

Kuhn, Charles L. "German Paintings in the National Gallery: A Protest." *College Art Journal* 5 (January 1946).

Matthews, Herbert L. "Spanish Art Survives." *Magazine of Art,* August 1937.

Norris, Christopher. "The Disaster at Flakturm Friedrichshain." *Burlington Magazine* 94, no. 597 (December 1952).

Plaut, James S. "Loot for the Master Race." *Atlantic Monthly,* September 1946.

Renau, Jose. "L'Organisation de la defense du patrimoine artistique et historique espagnol pendant la guerre civile." *Mouseion,* 39–40, nos. 3–4 (1937).

Ritchie, A. "The Restitution of Art Loot." *Gallery Notes* (Albright Art Gallery, Buffalo, N.Y.), July 1946.

Russell, John. "Masterpieces Caught Between Two Wars." *The New York Times,* September 3, 1989.

Scherpuis, A. "Een Heer in de Kunsthandel." *Vrij Nederland,* November 10, 1990.

Sizer, Theodore. "A Walpolean at War." *The Walpole Society Notebook,* 1946.

Sokolova, N. I. "Die Rettung der Dresdener Kunstschatze." In *Jahrbuch 1960, Staatliche Kunstsammlung.* Dresden, 1961.

Stout, George. "Preservation of Paintings in Wartime." *Technical Studies,* January 1942.

Sutton, Denys. "L'Amateur accompli: Frits Lught." In *Treasures from the Collection of F. Lught at the Institut Neerlandais.* Paris, 1976.

Watt, Alexander. "Notes from Paris." *Apollo,* August 1937.

Wildenstein, Georges. "Works of Art—Weapons of War." *La République française,* December 1943.

Williams, S. A. *The Polish Art Treasury in Canada.* M.A. thesis, Osgood Hall Law School, York University, Toronto, 1974.

UNPUBLISHED MATERIAL

PUBLIC COLLECTIONS

Archives of American Art, Washington, D.C.
——. Alfred H. Barr Papers.
——. W. G. Constable Papers.
——. Thomas Carr Howe Papers.
——. Lamont Moore Papers.
——. Andrew Ritchie Papers.
——. James J. Rorimer Papers.
——. George Stout Papers.

Archives Nationales de France, Paris.
——. Record Group AJ38. Records of Commissariat Général aux Questions Juives.
——. Record Group AJ40. German records of occupation.
——. Record Group F21. Fonds concernant archives des directeurs et sous-secrétaires d'Etat des Beaux-Arts.

Columbia University, New York. Rare Book and Manuscript Library.
——. Calvin Hathaway Papers.

Getty Center for the History of Art and Humanities, Los Angeles.
——. Wilhelm F. Arntz Archive.
——. Douglas Cooper Papers.
——. Johannes Felbermeyer Photograph Collection.

John Nicholas Brown Center for the Study of American Civilization, Providence, R.I.
——. John Nicholas Brown Papers.

Library of Congress, Manuscript Division, Washington, D.C.
——. David E. Finley Papers.
——. Huntington Cairns Papers.
——. Henry L. Stimson Papers.

Louvre Museum Archives, Paris.
——. Dossier Rose Valland.
——. Dossier Jacques Jaujard.

Museum of Modern Art, New York.
——. Hellmut Lehmann-Haupt Collection.

National Archives, Washington, D.C.
——. Record Group 59. Records of the Fine Arts and Monuments Adviser, 1949–1960.
——. Record Group 59. General Records of the Department of State. Decimal Files, 1940–1944, 1945–49.
——. Record Group 165. Records of the Civil Affairs Division.
——. Record Group 200. National Archives Gift Collection. Personal Papers of Gen. Lucius Clay.
——. Record Group 238. Nuremberg Trial Records.
——. Record Group 239. Records of the American Commission for the Protection and Salvage of Artistic and Historic Monuments in War Areas.
——. Record Group 260. Records of the United States Occupation Headquarters. World War II. Ardelia Hall Collection: Records of the Collecting Points.

National Gallery of Art, Washington, D.C.
——. Archives and General Records.
——. Records of Office of Secretary General.
——. Library—Rare and MS. Section.
——. Edward E. Adams Papers.
——. S. Lane Faison Papers.
——. Frederick Hartt Papers.
——. E. P. Lesley Papers.
——. Charles Parkhurst Papers.
——. Craig Hugh Smyth Papers.
——. Edith Standen Papers.
——. Photographic Archive.

University of Regina, Saskatchewan, Canada.
——. Theodore Heinrich Papers.

Department of the Treasury, Washington, D.C.
——. Record Group 131. Foreign Funds Control.

PRIVATE COLLECTIONS

Stewart Leonard Papers, Washington, D.C.
James J. Rorimer Papers, New York.
Archives of Paul Rosenberg, New York.
Curt Valentin Papers, Washington, D.C.

INTERVIEWS AND CONVERSATIONS

Sylvie Béguin
Dr. Sonia Kramarsky Binkhorst
J. Carter Brown
Perry Cott
S. Lane Faison
Walter Farmer
Marianne Feilchenfeldt
Klaus Goldmann
Mason Hammond
Walker Hancock
Frederick Hartt
Thomas C. Howe
René Huyghe
Anne Marie Kellen
Lincoln Kirstein
Thomas Kline
Raymond Lemaire
Lamont Moore
Denys Myers
Stephen Munsing
Lucie Ninane
Charles Parkhurst
James Plaut
Thomas Potocki
Mrs. James Rorimer
Mrs. Alexandre Rosenberg
Desirée H. Goudstikker von Saher
Dmitri Shelest
Craig Hugh Smyth
Edith Standen
Mr. and Mrs. Jacques Stern
John Walker
Daniel Wildenstein
Otto Wittmann

INDEX

Numerals in *italics* indicate illustrations.

PHOTO SOURCES

Aurora Publishers: 189, 195

Bildarchiv preussischer Kulturbesitz: 73

John Nicholas Brown Center for the Study of American Civilization, Providence, Rhode Island: 381

S. L. Faison: 381 (inset)

From the Resource Collections of the Getty Center for the History of Art and the Humanities, Santa Monica, California, Wilhelm F. Arntz Archive: 21; Johannes Felbermeyer Collection: 37, 345, 438

Klaus Goldmann: 378

Walker Hancock: 341

René Huyghe: 289

Lincoln Kirstein: 337

National Archives, Washington, D.C.: 17, 26, 42, 54, 60, 66, 86, 89, 112, 133, 140, 158, 167, 181, 184, 193, 216, 225, 233, 240, 247, 256, 259, 264, 269, 271, 284, 290, 295, 299, 307, 313, 319, 331, 334, 351, 352, 368, 373, 413, 430, 433

Gallery Archives, National Gallery of Art, Washington, D.C.: 202, 209, 398, 403

Photographic Archives, National Gallery of Art, Washington, D.C.: 78, 363, 444

The National Gallery, London: 95

Novosti: 191

Rorimer Collection: 138, 336

Mrs. Alexandre Rosenberg, New York: 91, 416

Craig Smyth: 210, 324, 347, 359, 375, 406

Solo Syndication & Literary Agency Ltd.: 275

Wildenstein & Co., Inc.: 92